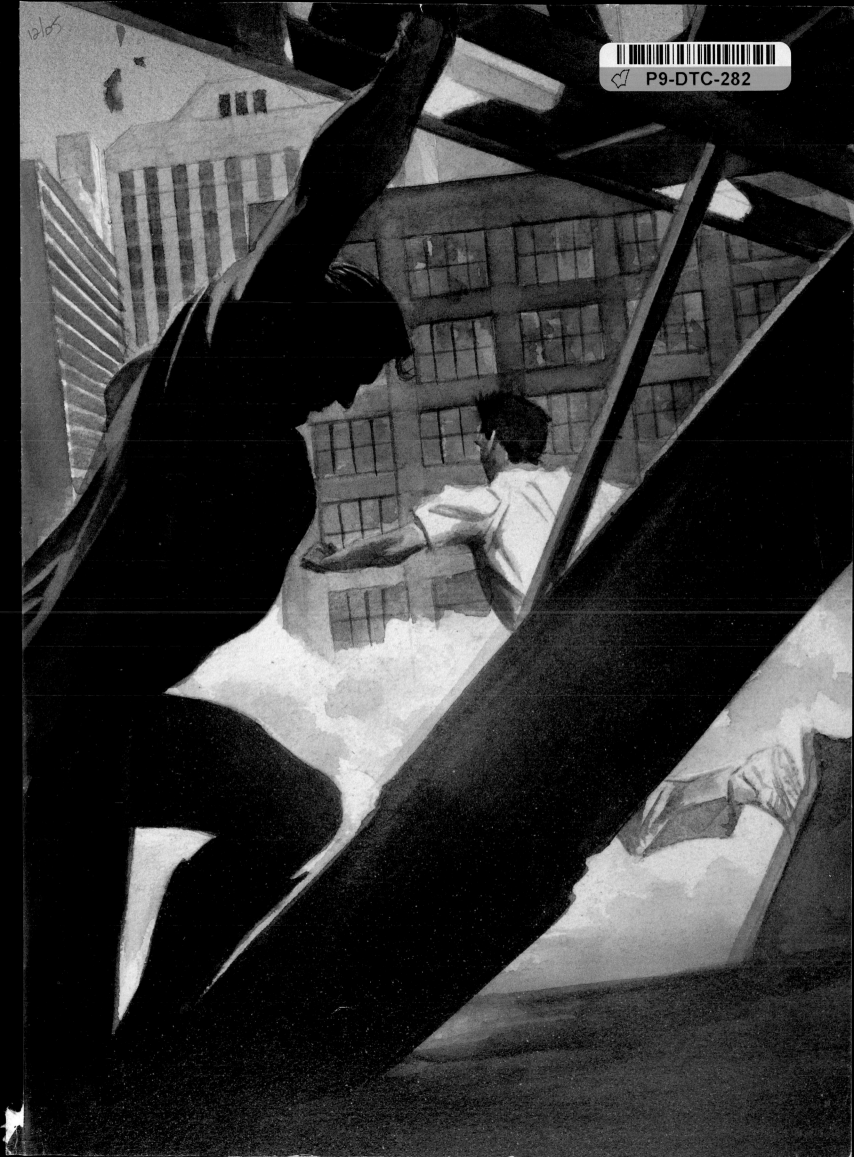

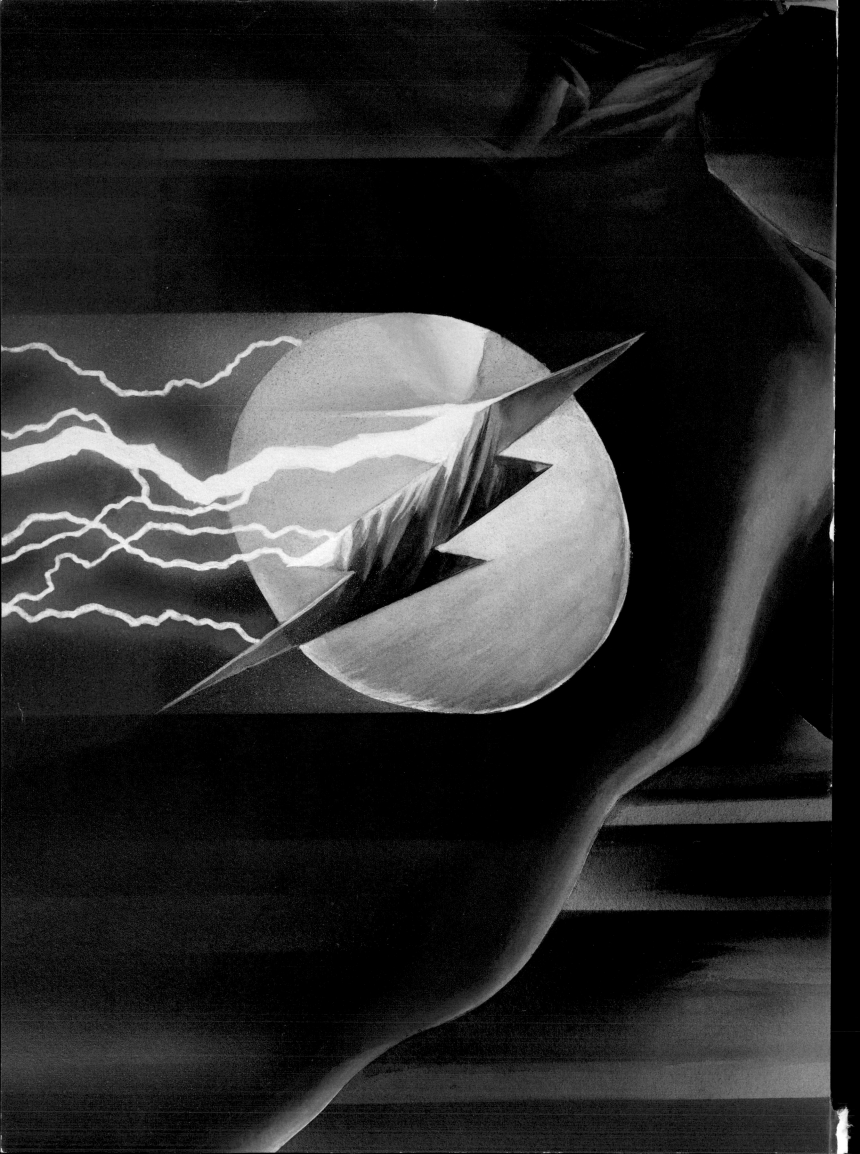

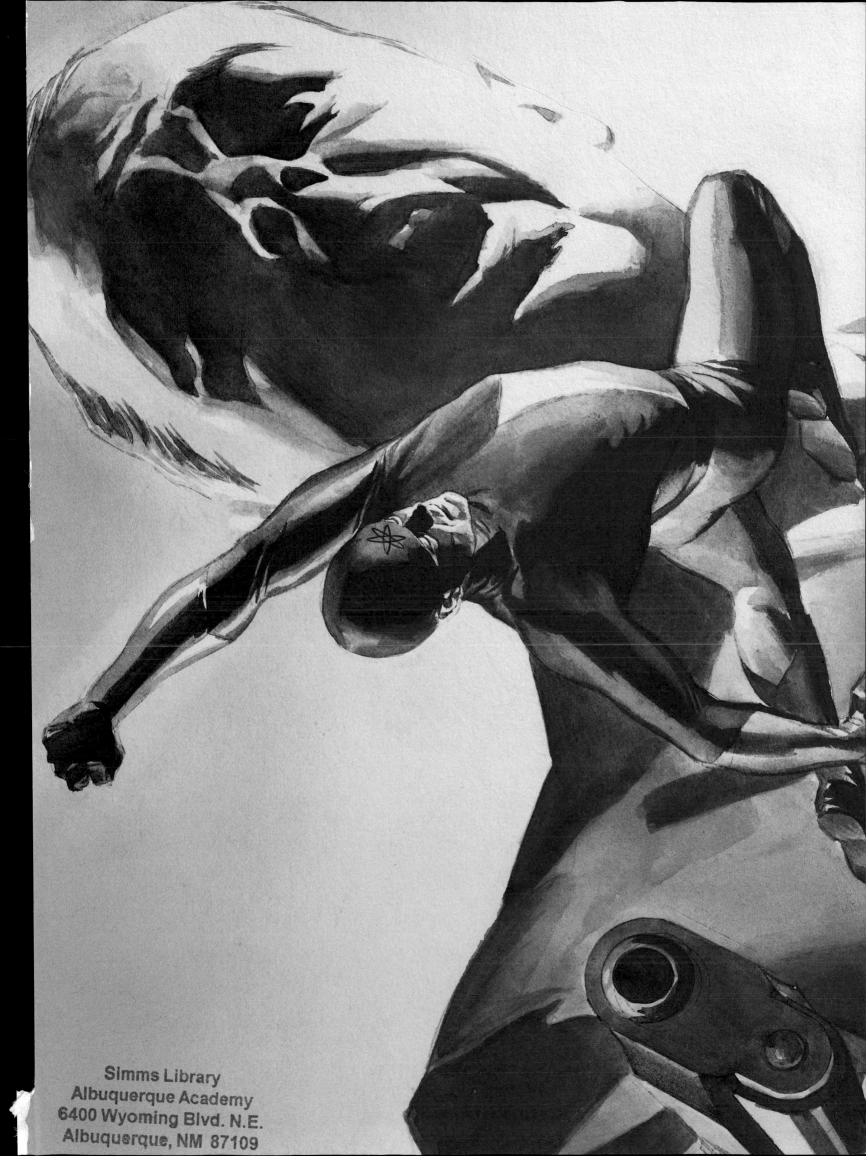

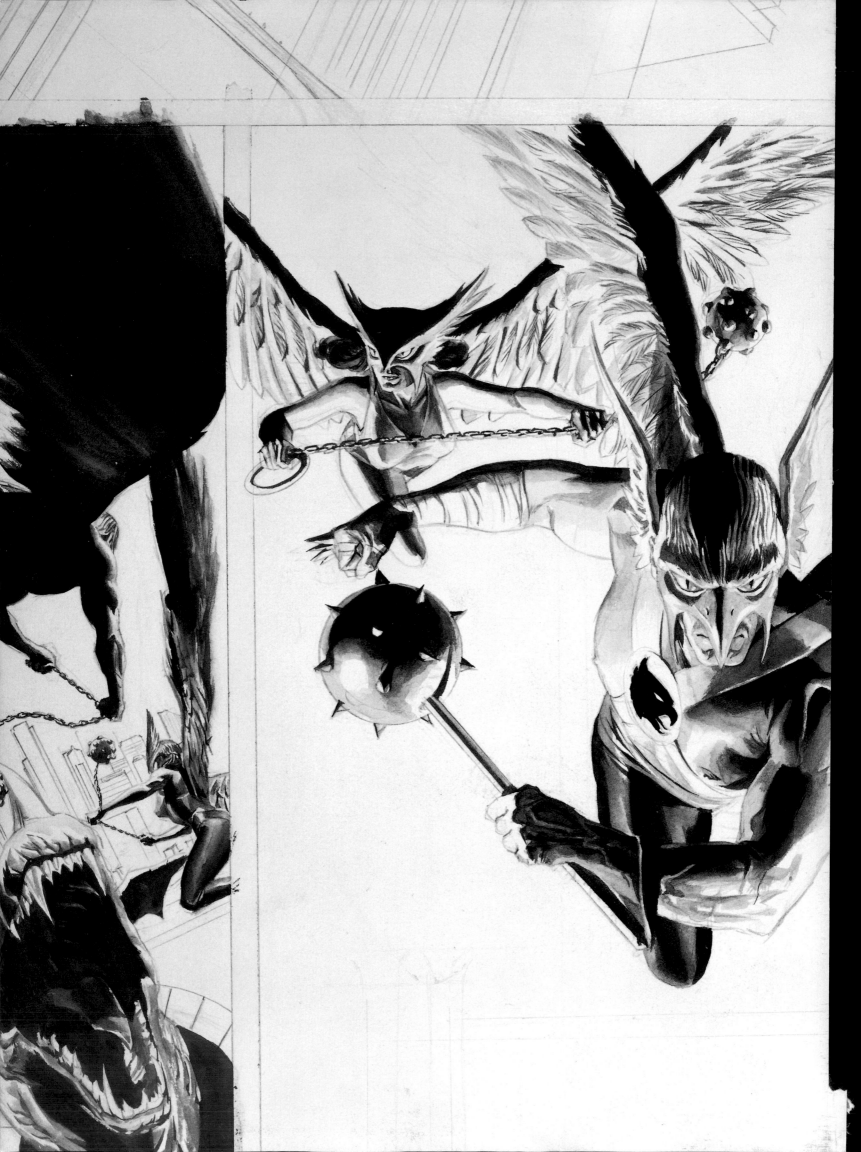

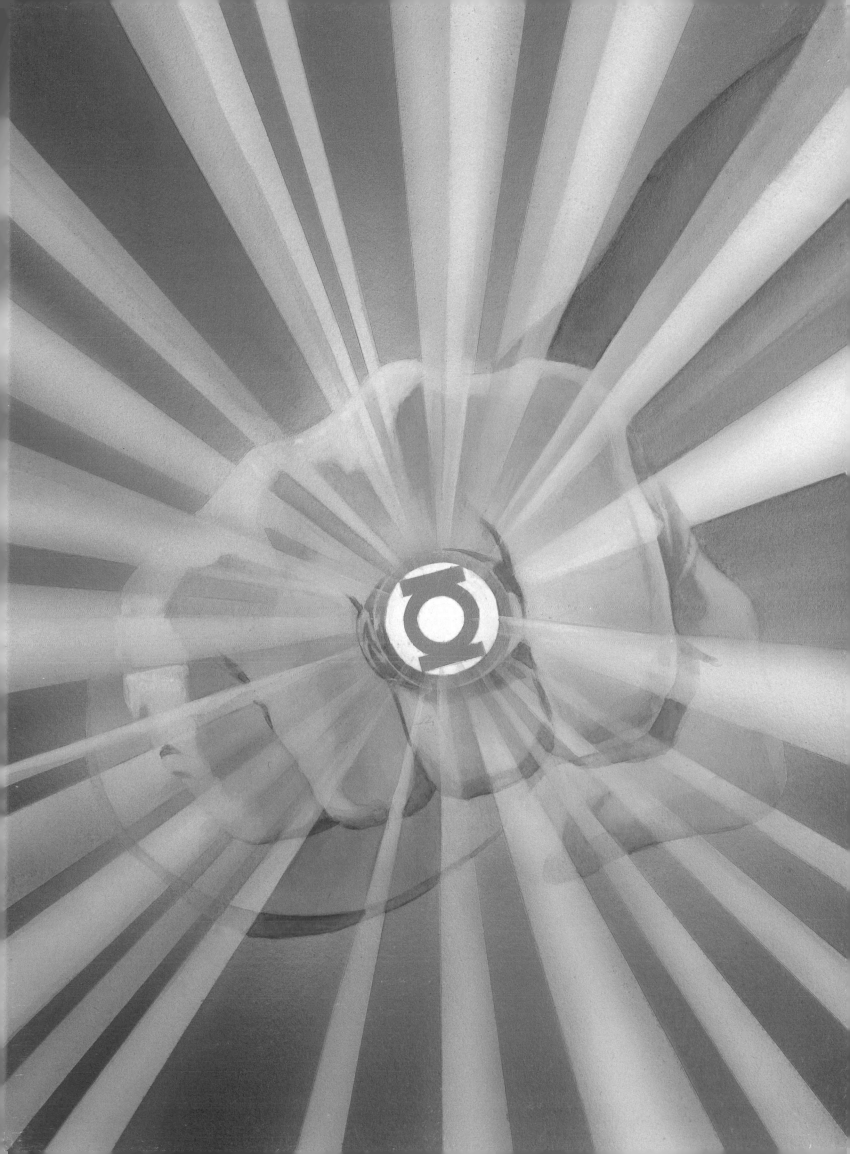

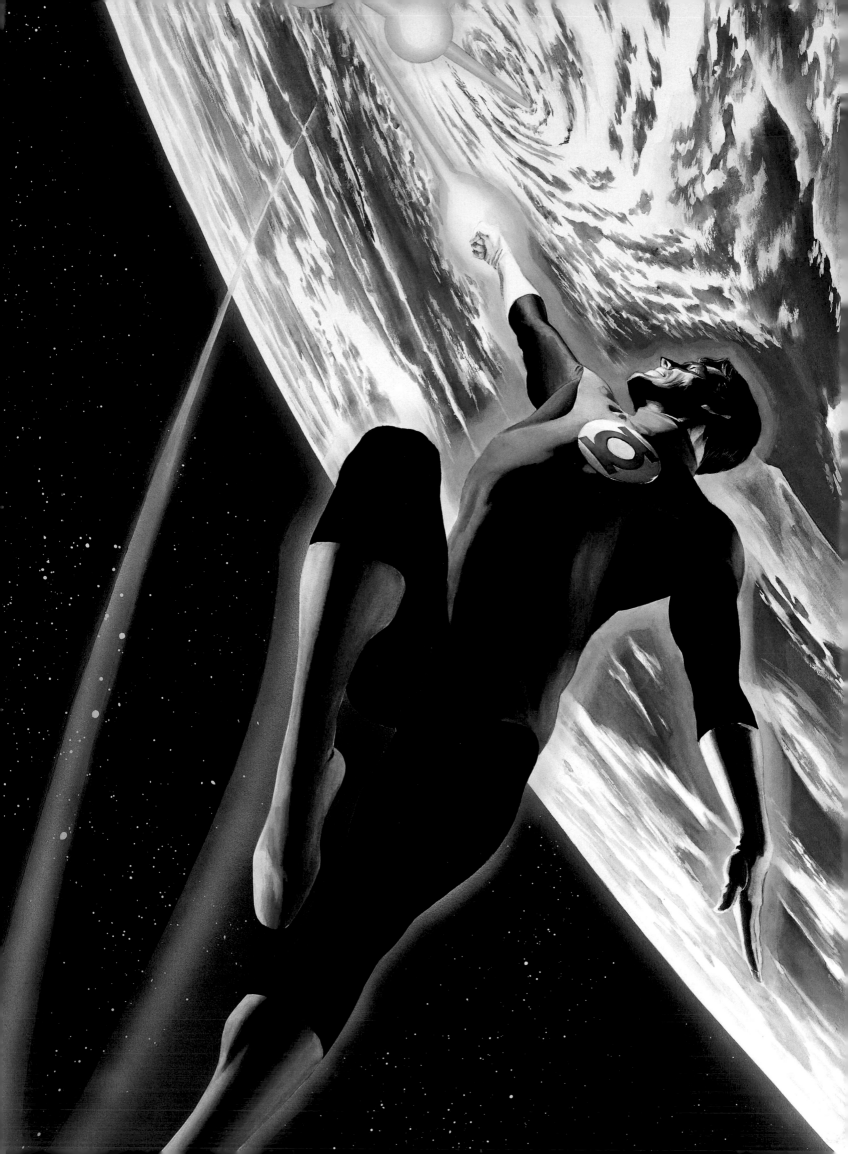

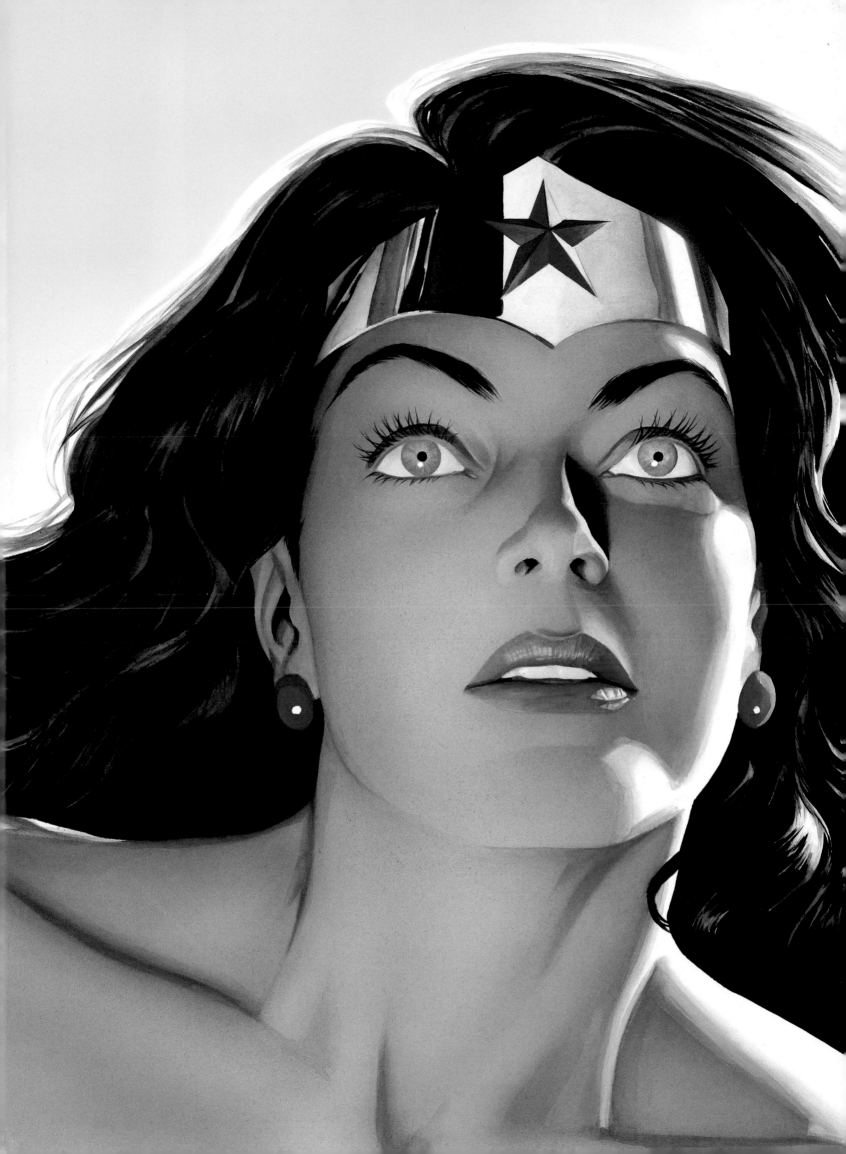

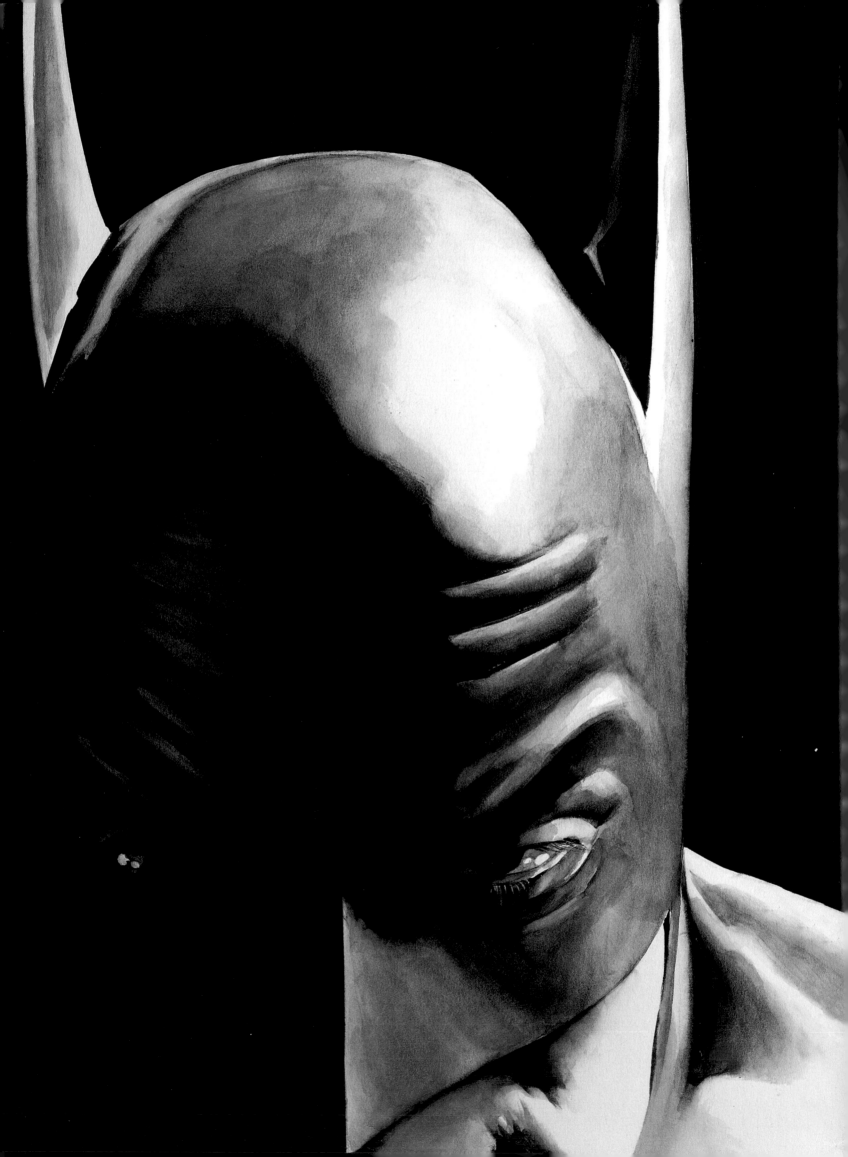

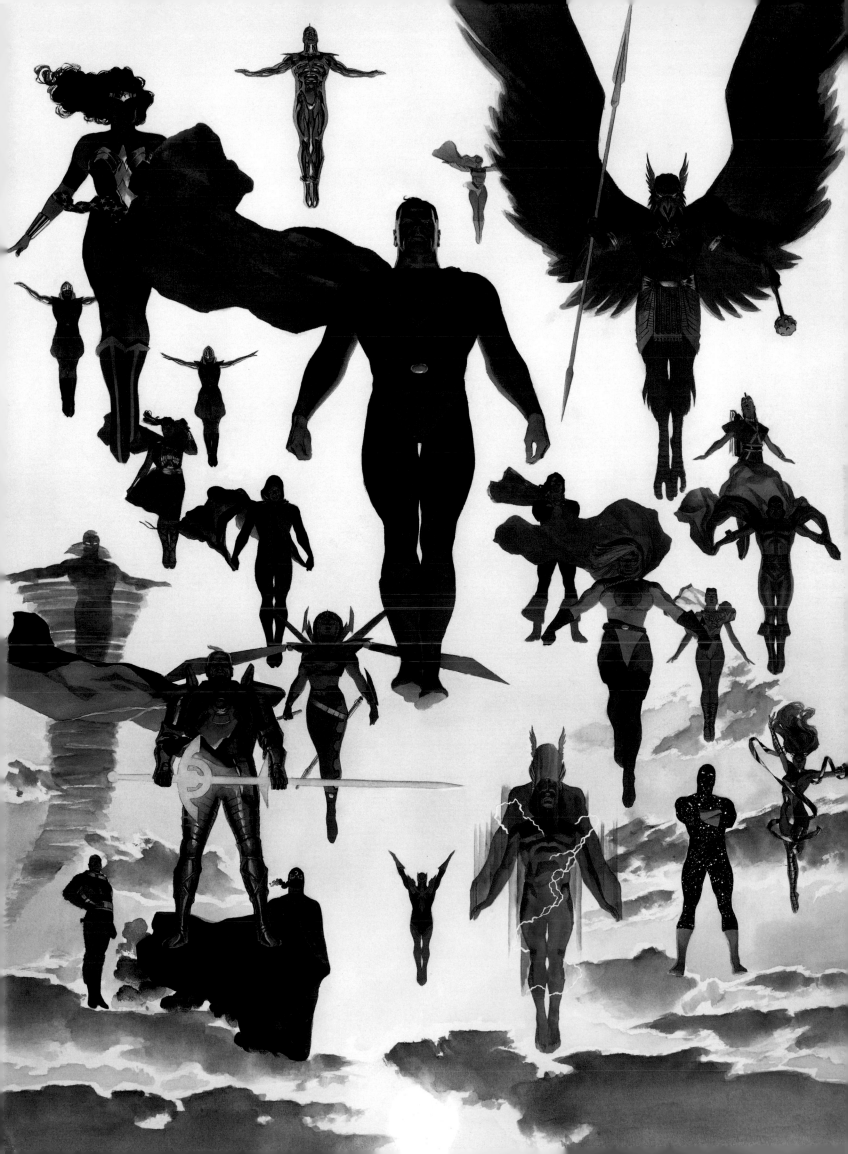

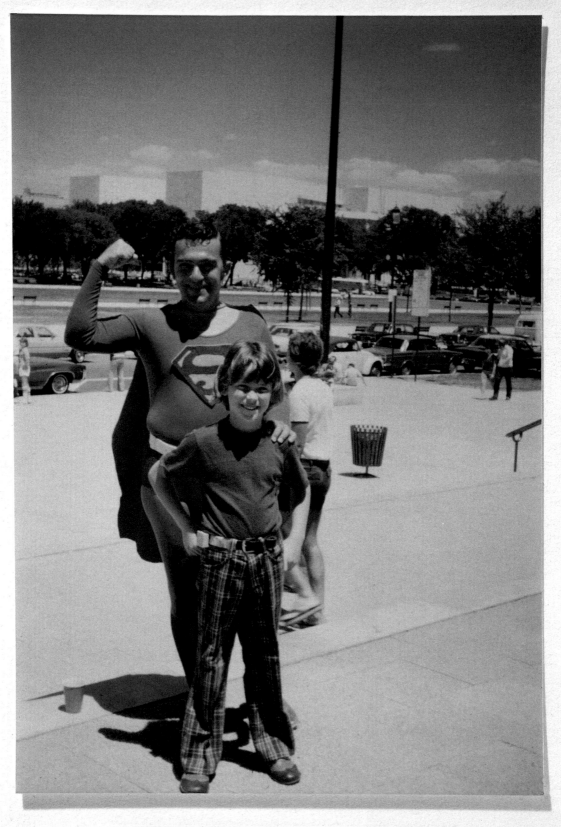

Air and Space Museum
1977

Here is a myth:
In America, if you work very hard,
with enough determination and persistence,
you can become anything you want.

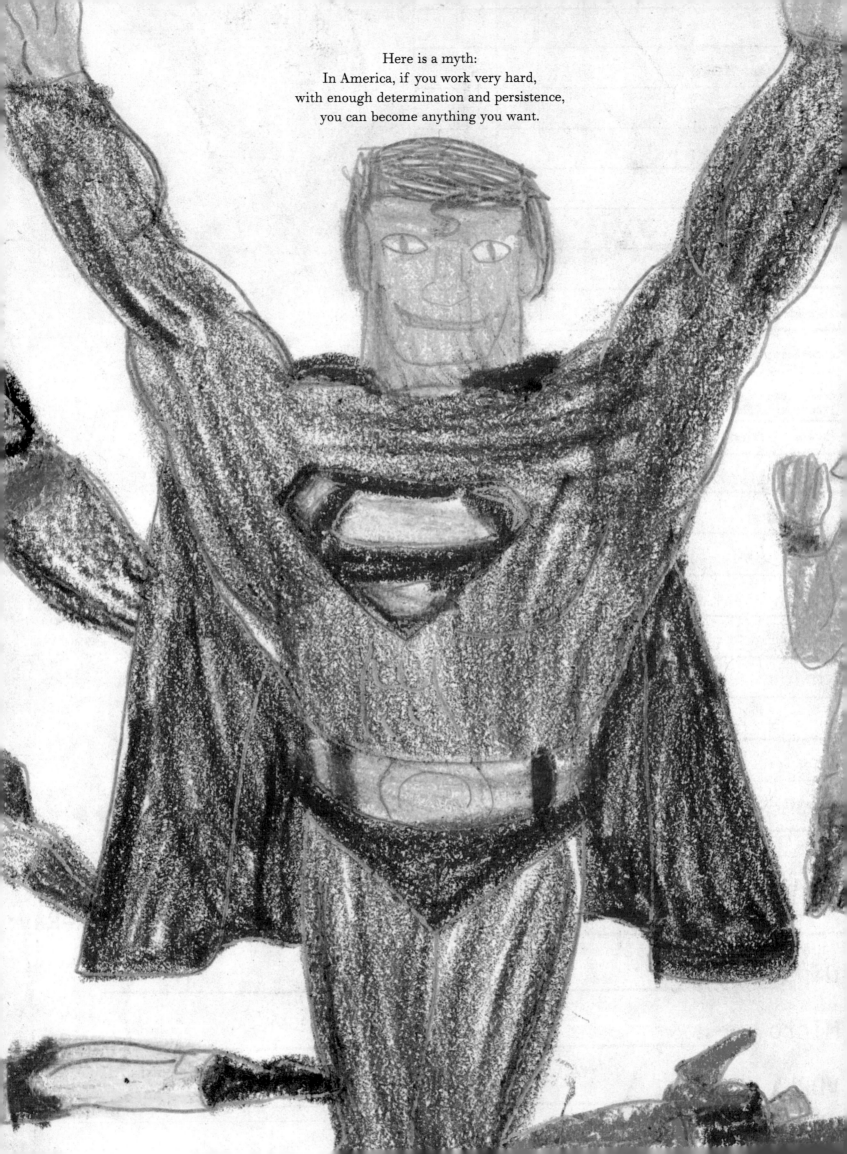

BELOW: Alex Ross, age 32.

OPPOSITE: Superman by Alex Ross, age 32 (2002).

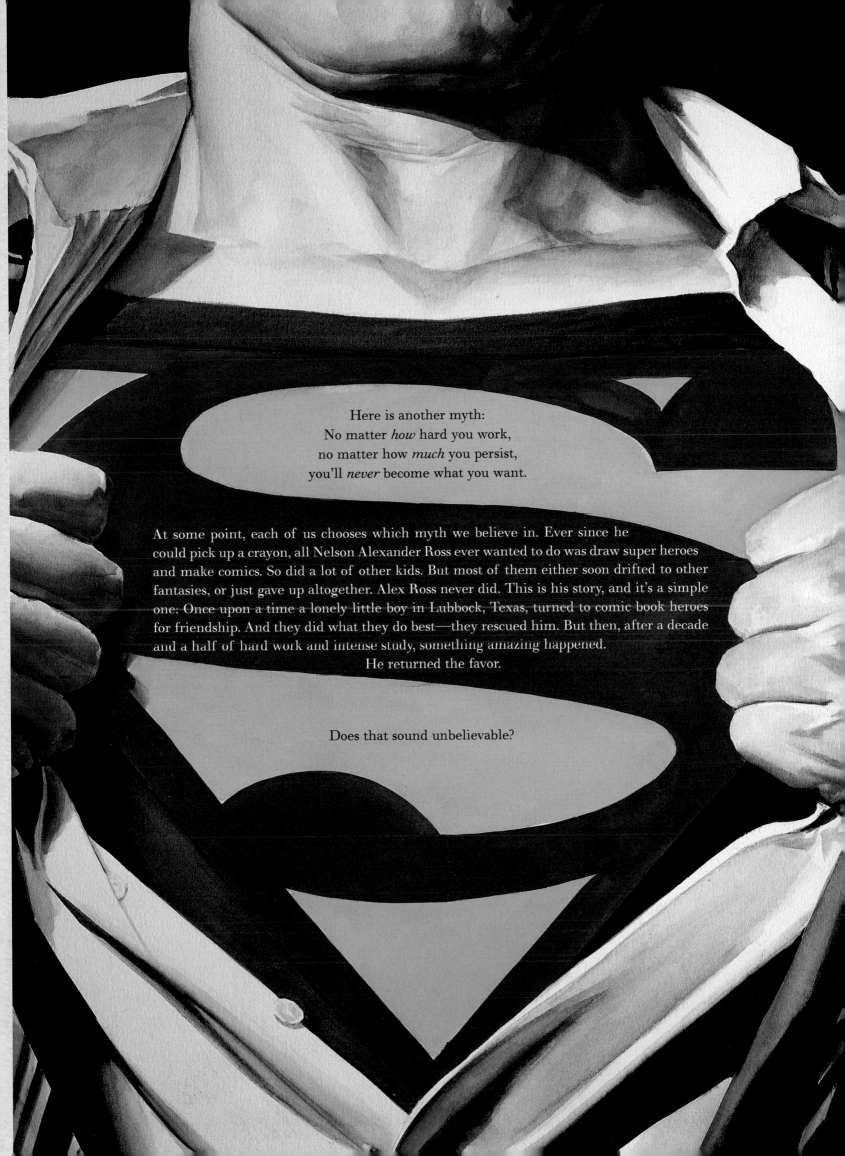

Here is another myth:
No matter *how* hard you work,
no matter how *much* you persist,
you'll *never* become what you want.

At some point, each of us chooses which myth we believe in. Ever since he could pick up a crayon, all Nelson Alexander Ross ever wanted to do was draw super heroes and make comics. So did a lot of other kids. But most of them either soon drifted to other fantasies, or just gave up altogether. Alex Ross never did. This is his story, and it's a simple one: Once upon a time a lonely little boy in Lubbock, Texas, turned to comic book heroes for friendship. And they did what they do best—they rescued him. But then, after a decade and a half of hard work and intense study, something amazing happened.
He returned the favor.

Does that sound unbelievable?

MYTHOLOGY.

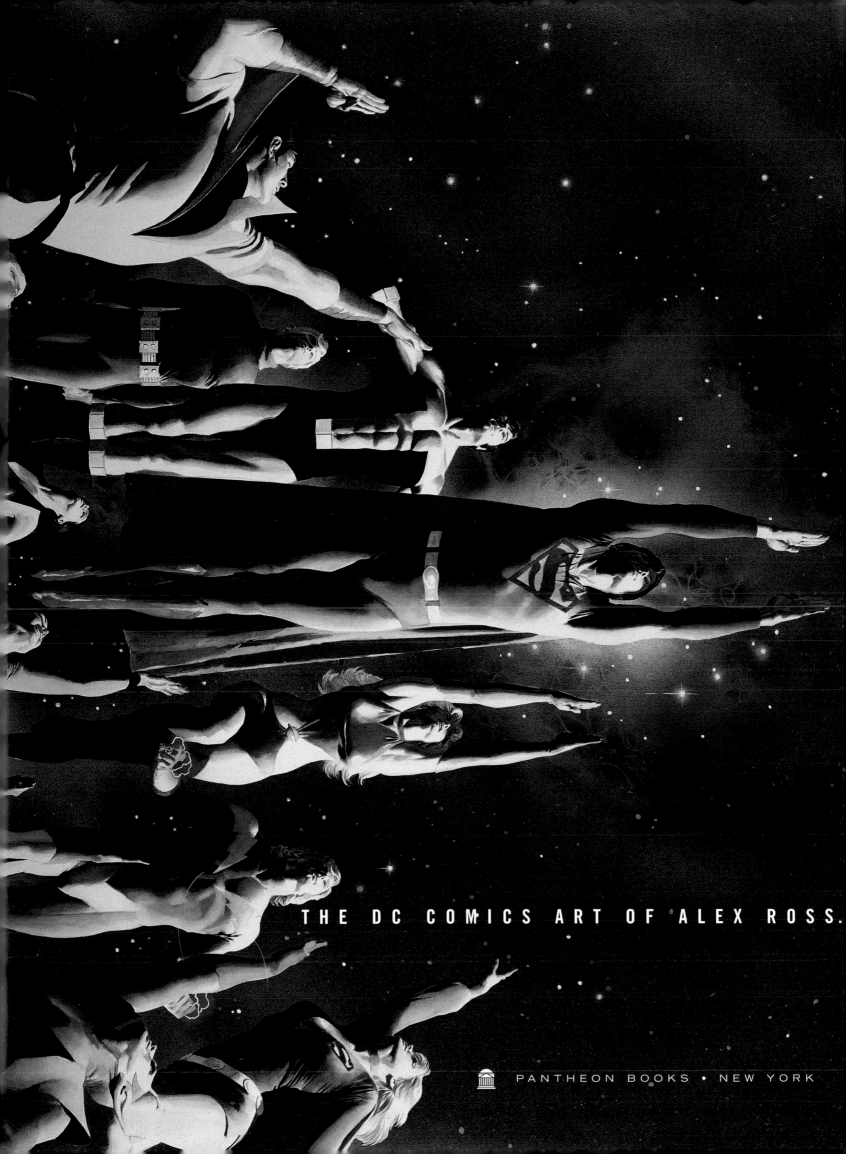

THE DC COMICS ART OF ALEX ROSS.

PANTHEON BOOKS · NEW YORK

ART-DIRECTION, DESIGN, TEXT, BY
CHIP KIDD.

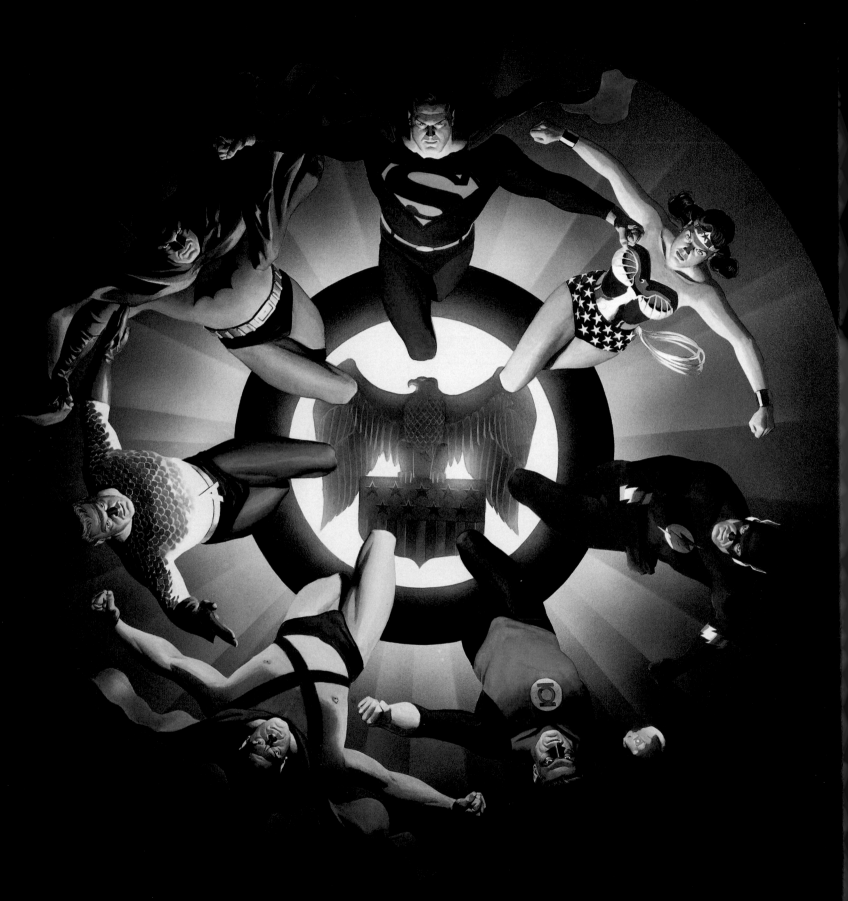

PHOTOGRAPHED BY GEOFF SPEAR.

Published in the United States by Pantheon Books,

a division of Random House, Inc., New York, and simultaneously in

Canada by Random House of Canada Limited, Toronto.

Pantheon Books and colophon are registered

trademarks of Random House, Inc.

Library of Congress Cataloging-in-Publication Data

Ross, Alex, 1970-

Mythology : the DC Comics art of Alex Ross / Alex Ross ;

text by Chip Kidd ; introduction by M. Night Shyamalan ;

photography by Geoff Spear.

p. cm.

ISBN 0-375-42240-4

1. Ross, Alex, 1970- 2. Heroes in art.

3. Comic books, strips, etc.--United States--History--20th century.

4. DC Comics, Inc. I. Kidd, Chip. II. Title

NC1429.R7628 A4 2003 741.5 092—dc21 2003046740

www.pantheonbooks.com

www.dccomics.com

Book design by CHIP KIDD. Printed in China

First Edition

9 8 7 6 5 4 3 21

2 4 6 8 9 7 5 31

PRECEDING PAGES, IN ORDER: ENDPAPERS: Detail, Superman, *JLA: Secret Origins* (2002)

Cover, *The Flash: Stop Motion* (Pocket Books, 2004); Detail, The Atom, *JLA: Secret Origins* (2002)

Detail, Hawkman, *JLA: Secret Origins* (2002); Cover, *Green Lantern: Hero's Quest* (Pocket Books, 2004)

Green Lantern, *JLA: Liberty and Justice* (2003)

Cover, *Wonder Woman: Spirit of Truth* (2001)

Cover, *Batman: The Stone King* (Pocket Books, 2002)

Poster, *Kingdom Come* (1996)

Cover, upcoming Superman novel (Pocket Books, 2004)

Superman wax sculpture by Mike Hill (2000)

Detail, Superboy and the Legion of Super-Heroes lithograph
(Warner Bros. Studio Stores, 1999)

Justice League plate (Warner Bros. Studio Stores, 1998)

THIS PAGE: Sketch, The Flash (circa 1999)

OVERLEAF: Detail, *Superman: Peace on Earth* (1998)

Detail, Shadow Lass, Superboy and the Legion of Super-Heroes lithograph
(Warner Bros. Studio Stores, 1999)

EVERY EFFORT HAS BEEN MADE TO TRACE THE OWNERSHIP OR SOURCE OF

ALL ILLUSTRATED MATERIAL FOR THE PURPOSE OF GIVING PROPER CREDIT. WE REGRET ANY

INADVERTENT ERROR CONCERNING THE ATTRIBUTION GIVEN TO SUCH MATERIAL AND WILL

BE PLEASED TO MAKE THE APPROPRIATE ACKNOWLEDGMENTS IN ANY FUTURE PRINTINGS.

for Lynette

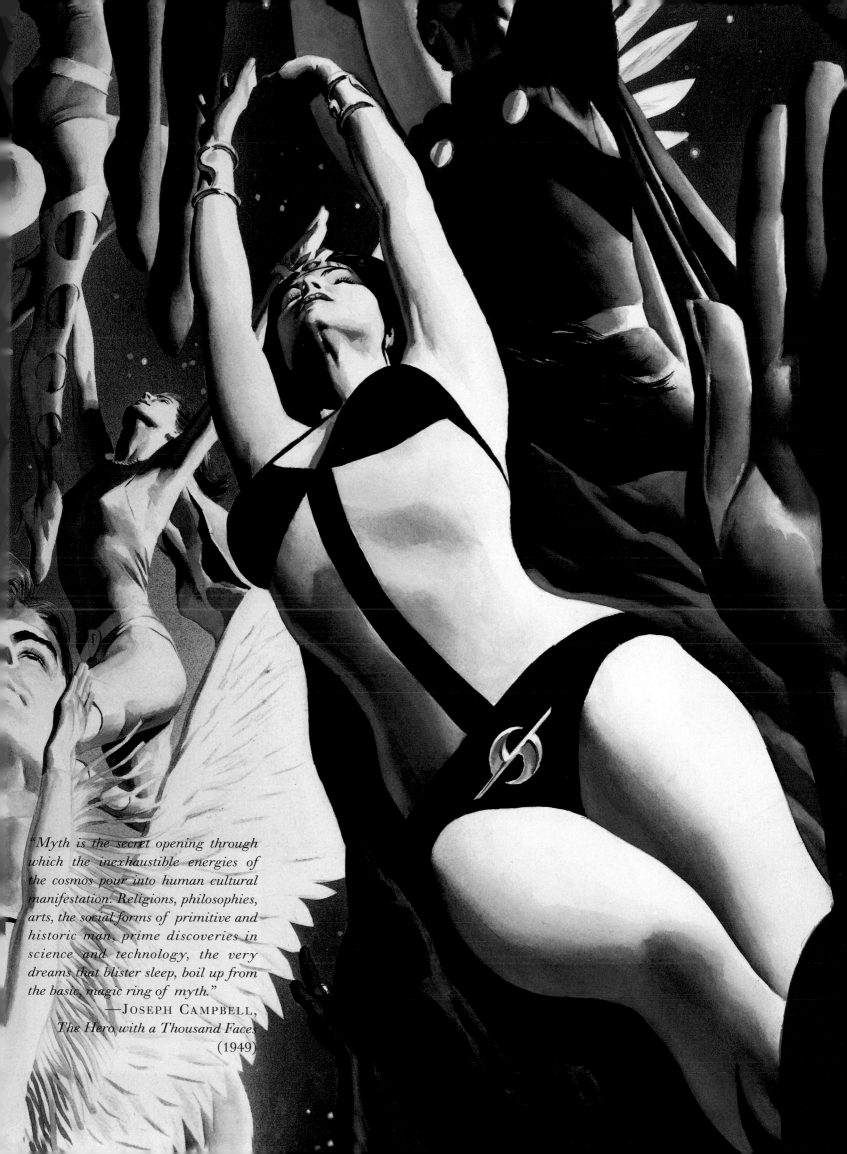

"*Myth is the secret opening through which the inexhaustible energies of the cosmos pour into human cultural manifestation. Religions, philosophies, arts, the social forms of primitive and historic man, prime discoveries in science and technology, the very dreams that blister sleep, boil up from the basic, magic ring of myth.*"
—JOSEPH CAMPBELL,
The Hero with a Thousand Faces
(1949)

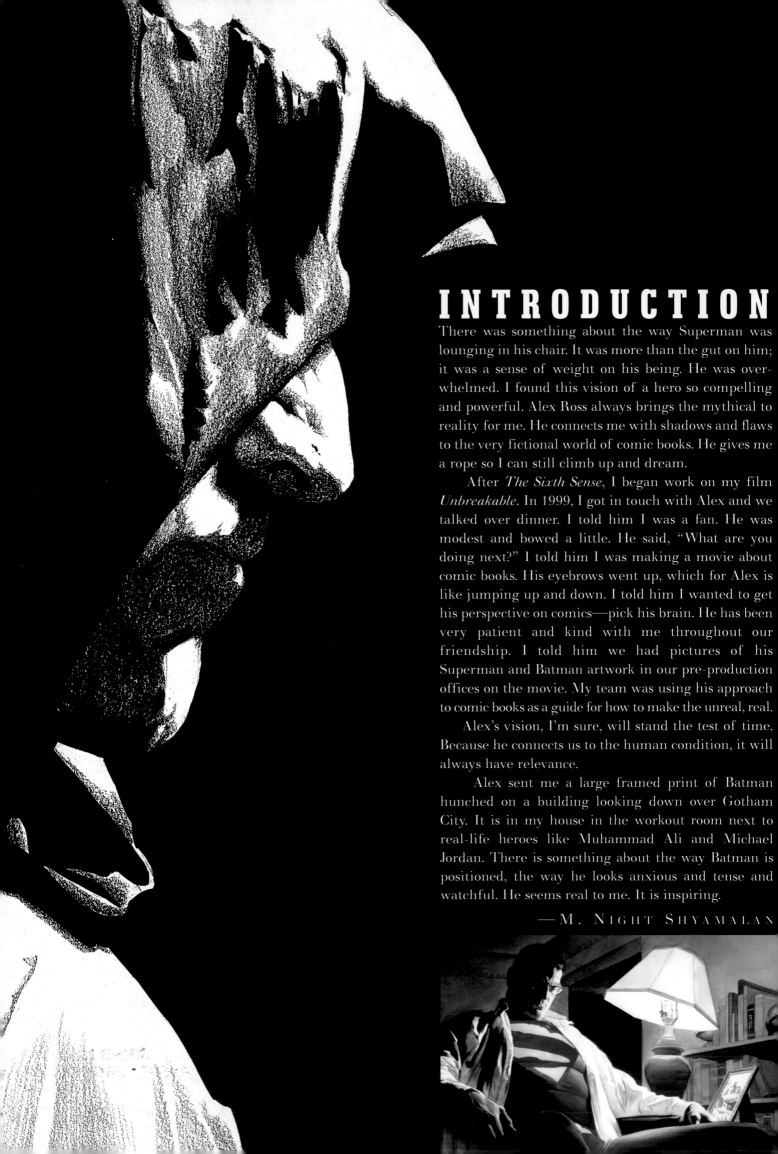

INTRODUCTION

There was something about the way Superman was lounging in his chair. It was more than the gut on him; it was a sense of weight on his being. He was overwhelmed. I found this vision of a hero so compelling and powerful. Alex Ross always brings the mythical to reality for me. He connects me with shadows and flaws to the very fictional world of comic books. He gives me a rope so I can still climb up and dream.

After *The Sixth Sense*, I began work on my film *Unbreakable*. In 1999, I got in touch with Alex and we talked over dinner. I told him I was a fan. He was modest and bowed a little. He said, "What are you doing next?" I told him I was making a movie about comic books. His eyebrows went up, which for Alex is like jumping up and down. I told him I wanted to get his perspective on comics—pick his brain. He has been very patient and kind with me throughout our friendship. I told him we had pictures of his Superman and Batman artwork in our pre-production offices on the movie. My team was using his approach to comic books as a guide for how to make the unreal, real.

Alex's vision, I'm sure, will stand the test of time. Because he connects us to the human condition, it will always have relevance.

Alex sent me a large framed print of Batman hunched on a building looking down over Gotham City. It is in my house in the workout room next to real-life heroes like Muhammad Ali and Michael Jordan. There is something about the way Batman is positioned, the way he looks anxious and tense and watchful. He seems real to me. It is inspiring.

—M. NIGHT SHYAMALAN

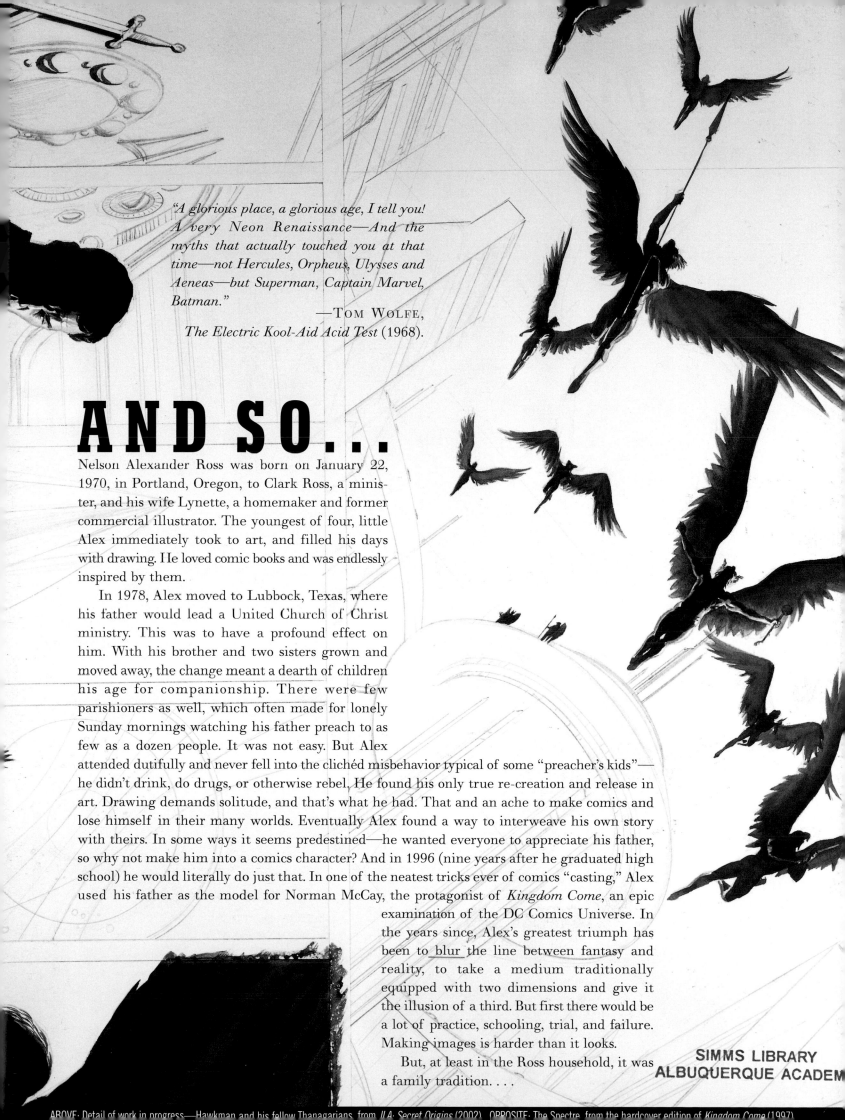

AND SO...

Nelson Alexander Ross was born on January 22, 1970, in Portland, Oregon, to Clark Ross, a minister, and his wife Lynette, a homemaker and former commercial illustrator. The youngest of four, little Alex immediately took to art, and filled his days with drawing. He loved comic books and was endlessly inspired by them.

In 1978, Alex moved to Lubbock, Texas, where his father would lead a United Church of Christ ministry. This was to have a profound effect on him. With his brother and two sisters grown and moved away, the change meant a dearth of children his age for companionship. There were few parishioners as well, which often made for lonely Sunday mornings watching his father preach to as few as a dozen people. It was not easy. But Alex attended dutifully and never fell into the clichéd misbehavior typical of some "preacher's kids"—he didn't drink, do drugs, or otherwise rebel. He found his only true re-creation and release in art. Drawing demands solitude, and that's what he had. That and an ache to make comics and lose himself in their many worlds. Eventually Alex found a way to interweave his own story with theirs. In some ways it seems predestined—he wanted everyone to appreciate his father, so why not make him into a comics character? And in 1996 (nine years after he graduated high school) he would literally do just that. In one of the neatest tricks ever of comics "casting," Alex used his father as the model for Norman McCay, the protagonist of *Kingdom Come*, an epic examination of the DC Comics Universe. In the years since, Alex's greatest triumph has been to blur the line between fantasy and reality, to take a medium traditionally equipped with two dimensions and give it the illusion of a third. But first there would be a lot of practice, schooling, trial, and failure. Making images is harder than it looks.

But, at least in the Ross household, it was a family tradition. . . .

ABOVE: Detail of work in progress—Hawkman and his fellow Thanagarians, from *JLA: Secret Origins* (2002). OPPOSITE: The Spectre, from the hardcover edition of *Kingdom Come* (1997)

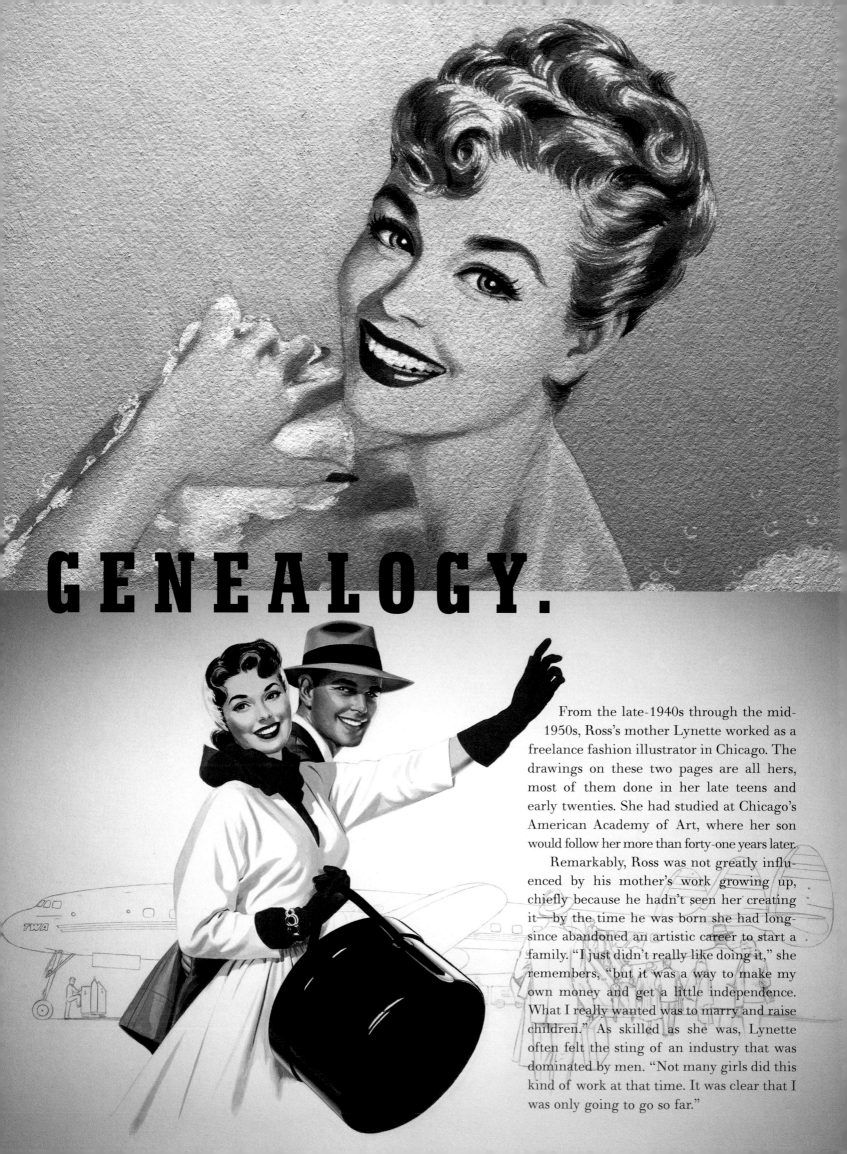

GENEALOGY.

From the late-1940s through the mid-1950s, Ross's mother Lynette worked as a freelance fashion illustrator in Chicago. The drawings on these two pages are all hers, most of them done in her late teens and early twenties. She had studied at Chicago's American Academy of Art, where her son would follow her more than forty-one years later.

Remarkably, Ross was not greatly influenced by his mother's work growing up, chiefly because he hadn't seen her creating it—by the time he was born she had long-since abandoned an artistic career to start a family. "I just didn't really like doing it," she remembers, "but it was a way to make my own money and get a little independence. What I really wanted was to marry and raise children." As skilled as she was, Lynette often felt the sting of an industry that was dominated by men. "Not many girls did this kind of work at that time. It was clear that I was only going to go so far."

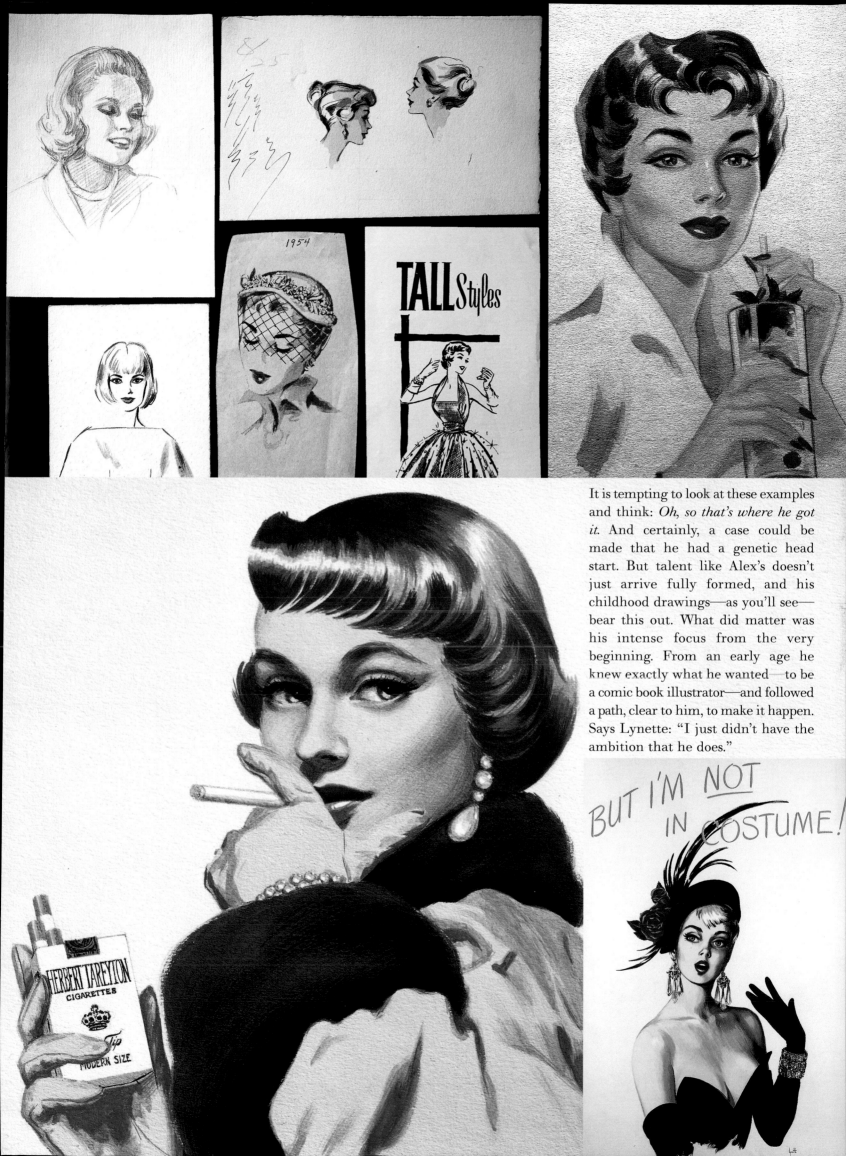

It is tempting to look at these examples and think: *Oh, so that's where he got it*. And certainly, a case could be made that he had a genetic head start. But talent like Alex's doesn't just arrive fully formed, and his childhood drawings—as you'll see—bear this out. What did matter was his intense focus from the very beginning. From an early age he knew exactly what he wanted—to be a comic book illustrator—and followed a path, clear to him, to make it happen. Says Lynette: "I just didn't have the ambition that he does."

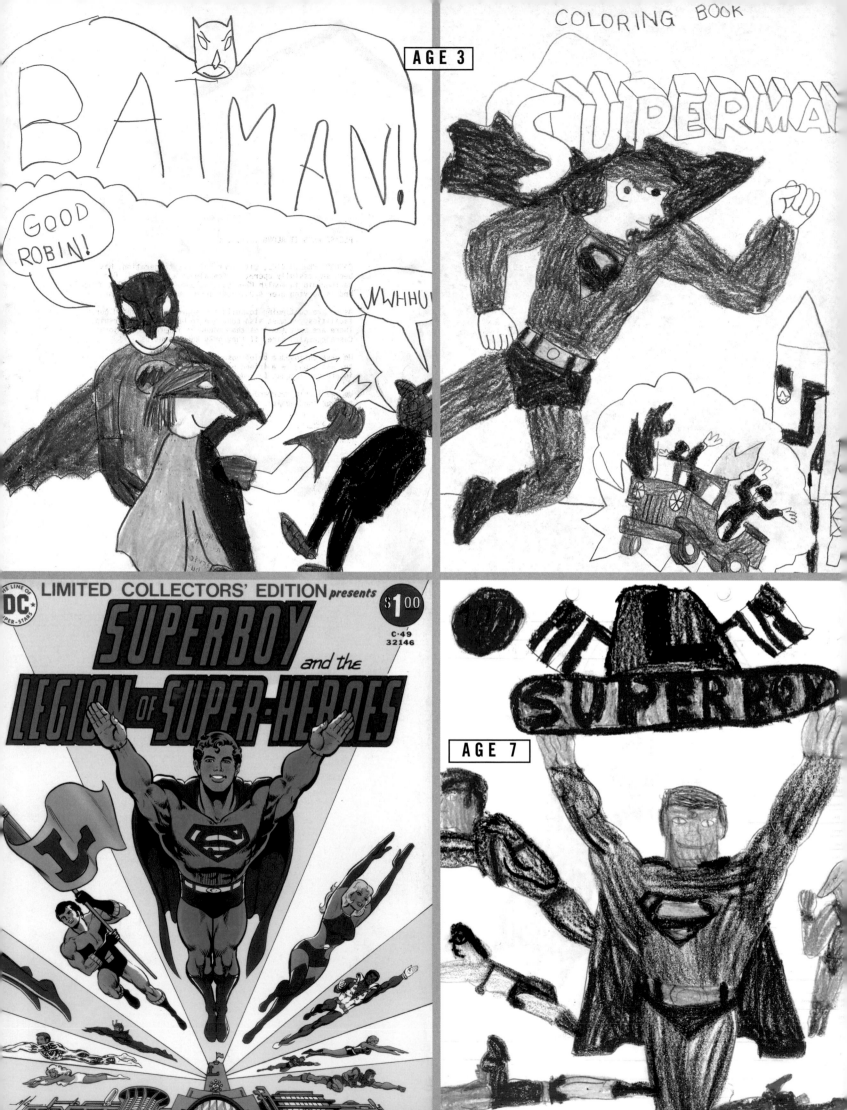

What is it about the pantheon of DC Comics super heroes that has always fascinated Alex? "The flamboyance, the mystery. They're the ultimate people. To me, sports figures seemed mundane by comparison. Once I showed interest in drawing comics, my mother would buy me titles aimed at kids. *Spidey Super Stories* is the first I remember. I also pored over Michael Fleisher's encyclopedias on Batman, Superman, and Wonder Woman from the 1970s.

"As an adolescent you need order in your world, and super heroes have that, a sense of ethics that would never change— they would never be less than perfect, fighting for their ideals. They deal succinctly with moral issues, in a way that religion doesn't. Or rather, religion does, but in a much more complicated and often confusing manner."

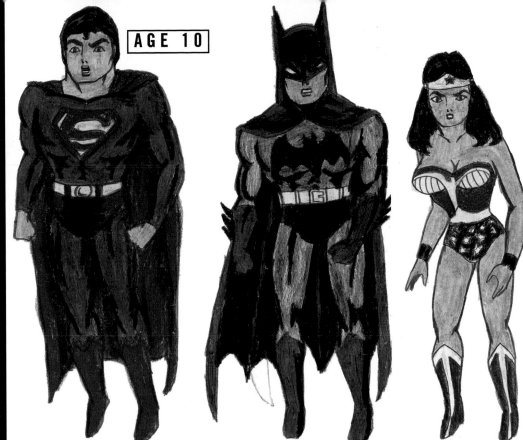

AGE 10

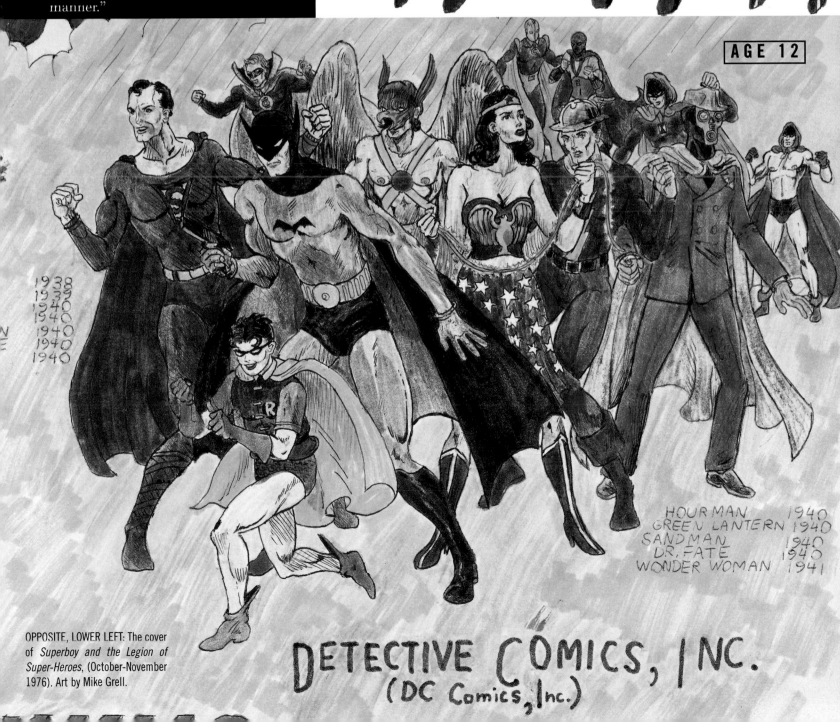

AGE 12

1938
1939
1940
1940
1940
1940

HOURMAN 1940
GREEN LANTERN 1940
SANDMAN 1940
DR. FATE 1940
WONDER WOMAN 1941

OPPOSITE, LOWER LEFT: The cover of *Superboy and the Legion of Super-Heroes*, (October-November 1976). Art by Mike Grell.

DETECTIVE COMICS, INC.
(DC Comics, Inc.)

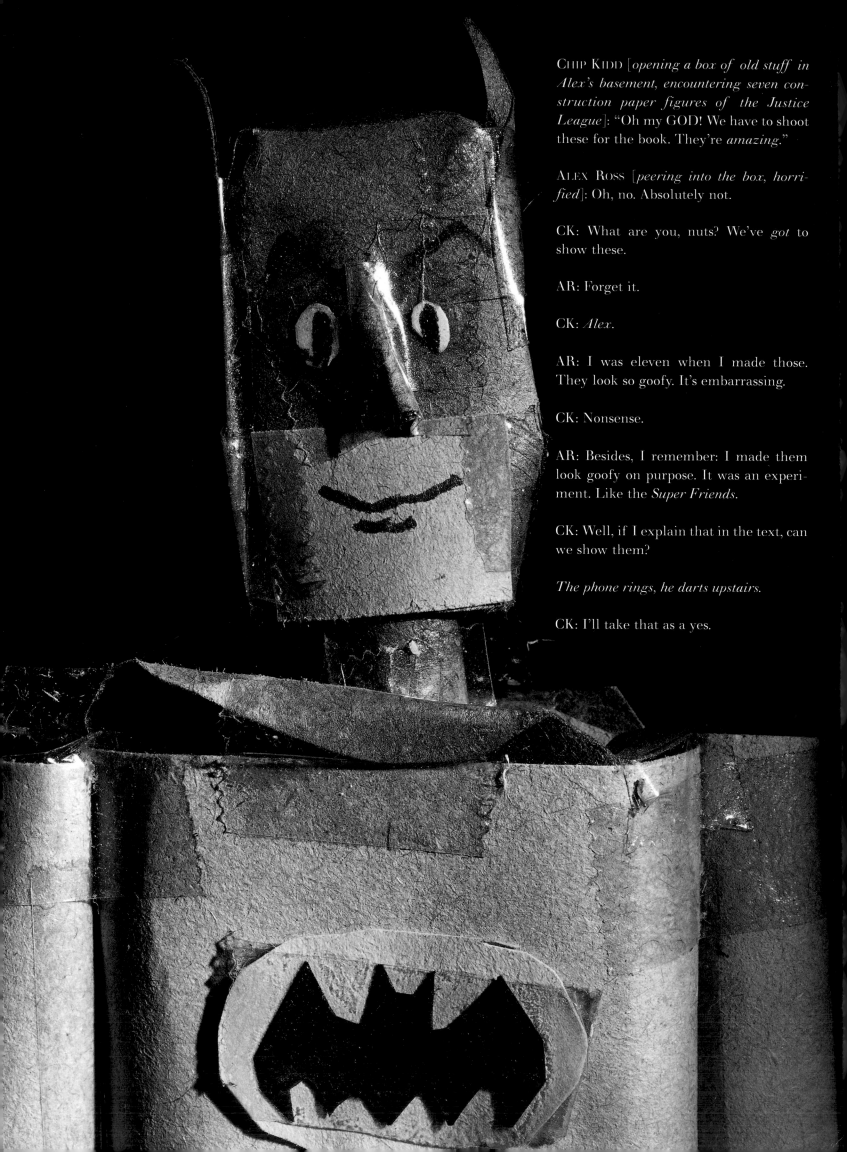

CHIP KIDD [*opening a box of old stuff in Alex's basement, encountering seven construction paper figures of the Justice League*]: "Oh my GOD! We have to shoot these for the book. They're *amazing.*"

ALEX ROSS [*peering into the box, horrified*]: Oh, no. Absolutely not.

CK: What are you, nuts? We've *got* to show these.

AR: Forget it.

CK: *Alex.*

AR: I was eleven when I made those. They look so goofy. It's embarrassing.

CK: Nonsense.

AR: Besides, I remember: I made them look goofy on purpose. It was an experiment. Like the *Super Friends.*

CK: Well, if I explain that in the text, can we show them?

The phone rings, he darts upstairs.

CK: I'll take that as a yes.

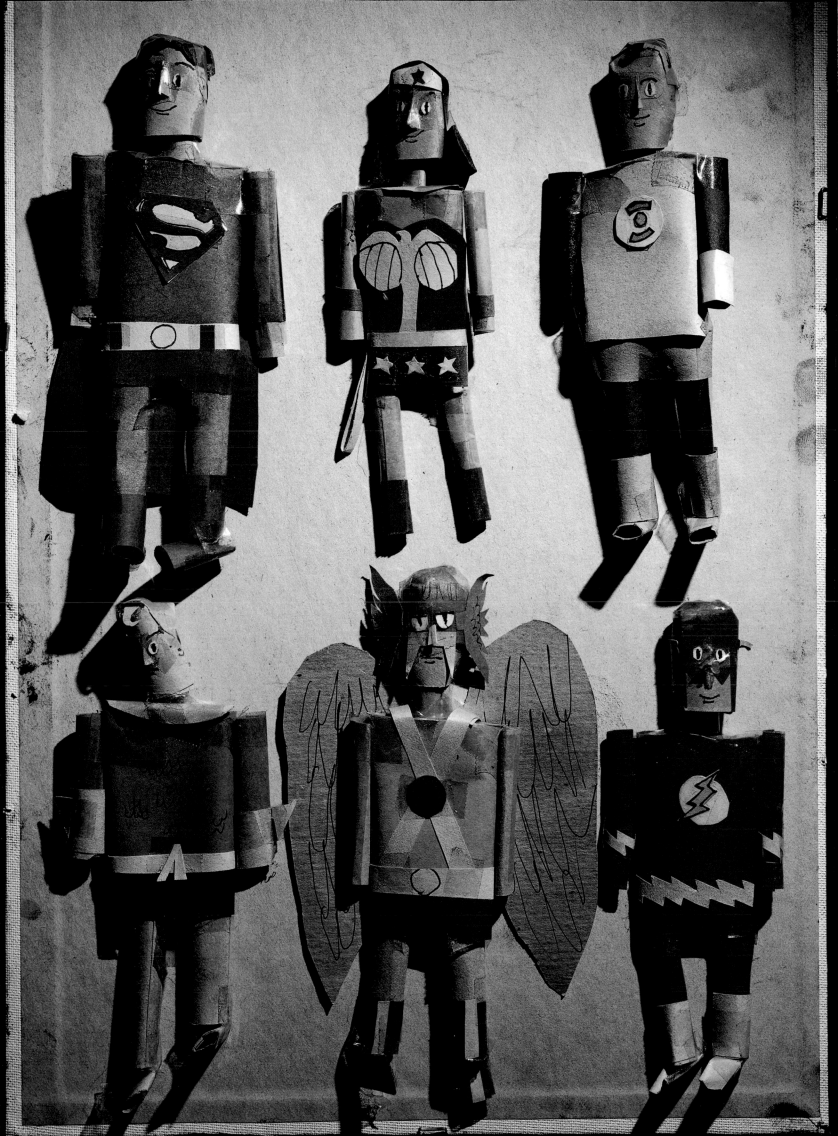

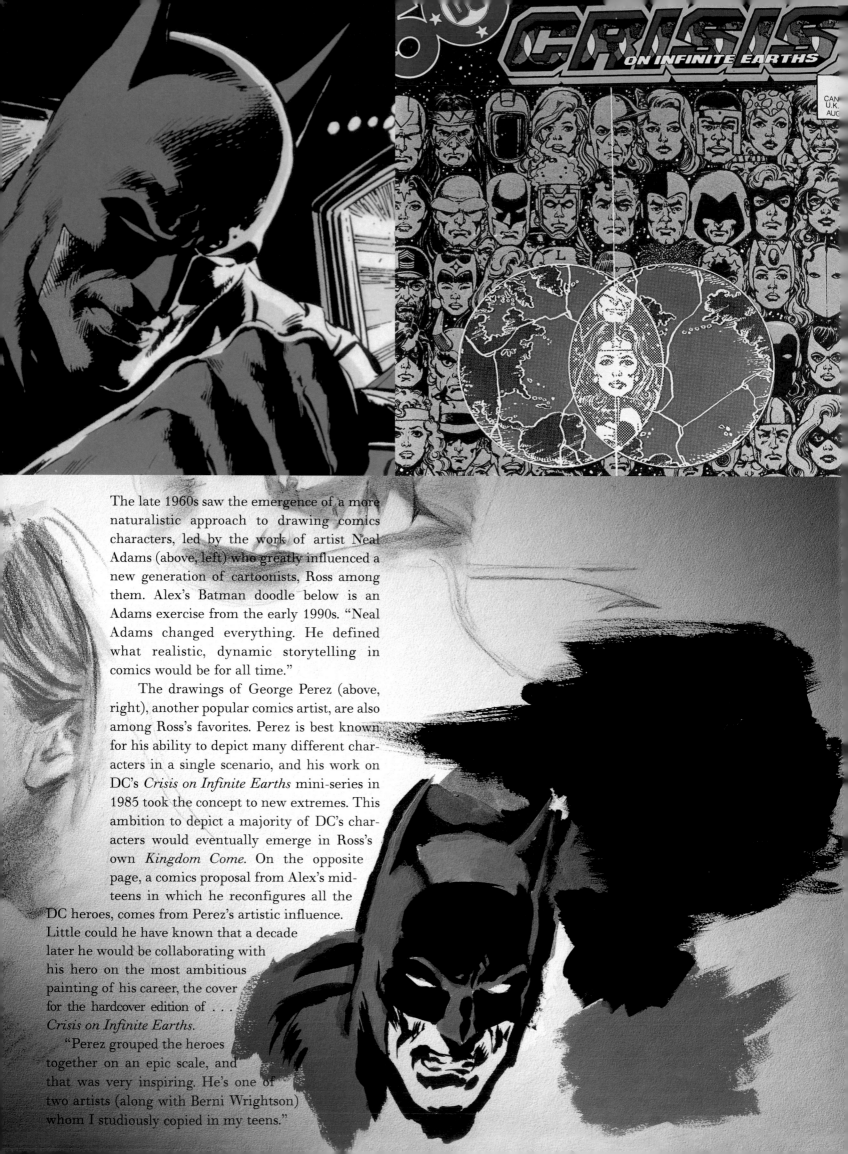

The late 1960s saw the emergence of a more naturalistic approach to drawing comics characters, led by the work of artist Neal Adams (above, left) who greatly influenced a new generation of cartoonists, Ross among them. Alex's Batman doodle below is an Adams exercise from the early 1990s. "Neal Adams changed everything. He defined what realistic, dynamic storytelling in comics would be for all time."

The drawings of George Perez (above, right), another popular comics artist, are also among Ross's favorites. Perez is best known for his ability to depict many different characters in a single scenario, and his work on DC's *Crisis on Infinite Earths* mini-series in 1985 took the concept to new extremes. This ambition to depict a majority of DC's characters would eventually emerge in Ross's own *Kingdom Come*. On the opposite page, a comics proposal from Alex's midteens in which he reconfigures all the DC heroes, comes from Perez's artistic influence. Little could he have known that a decade later he would be collaborating with his hero on the most ambitious painting of his career, the cover for the hardcover edition of . . . *Crisis on Infinite Earths*.

"Perez grouped the heroes together on an epic scale, and that was very inspiring. He's one of two artists (along with Berni Wrightson) whom I studiously copied in my teens."

In the history of the multiverse the EARTHS 1,2,3,4,S,X, and C are well known but few know of the far-advanced world of EARTH - 10 where in the year 2050 was formed the

This futuristic team comprised of superior-heroic beings protect the planet EARTH and solar system of SOL from any dangerous and threatening forces.

The JUSTICE UNION of EARTH holds a headquarters base upon the moon along with other satelites orbiting earth.

The JUEs members are collective counterparts from the other alternate earths super-heroes and have their powers magnified 10 times. In this advanced world there are no super-villains and virtually all crime and poverty have been eliminated.

The groups adversarys come from outside the planet earth and have formed a society of superior-villains principally led by the brilliant but mad Lex Lethal and murderously insane Killer.

This tells the story of the alternate universe of EARTH - 10.

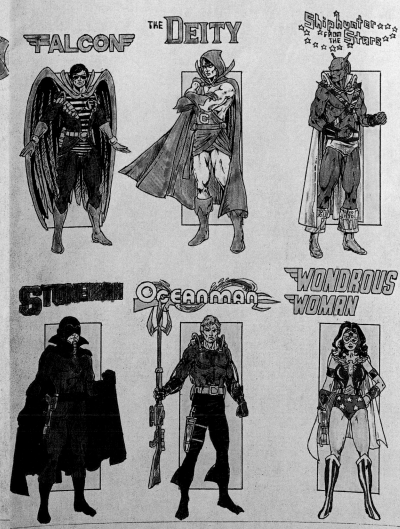

The following is a visual list of the super-beings who form the organization of the JUE.

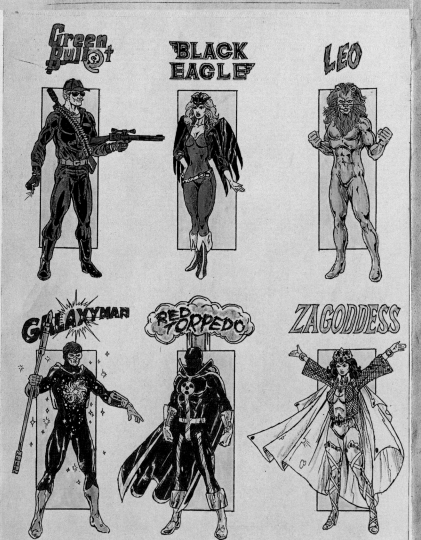

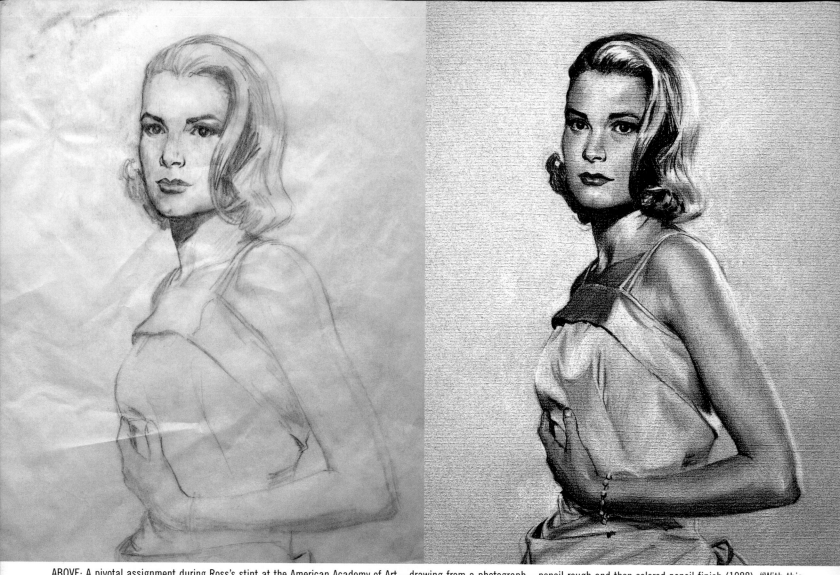

ABOVE: A pivotal assignment during Ross's stint at the American Academy of Art—drawing from a photograph—pencil rough and then colored pencil finish (1988). "With this solution I proved to myself that I could draw 'photo-realistically' by eye, without relying on the Artograph—which is basically an old-fashioned tracing machine and something I didn't want to become dependent on." BELOW: Oil portraits of Lynette and Clark Ross by Alex (1989), done in an effort to get portrait work.

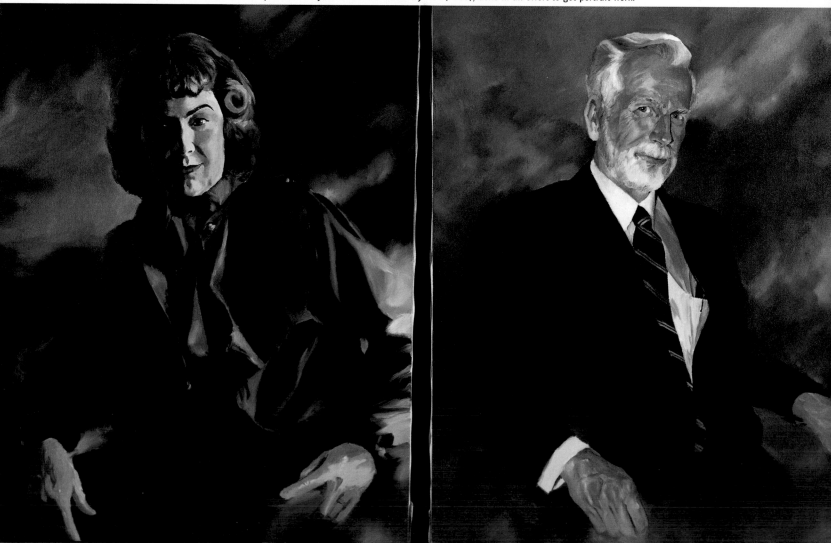

"Alex always turned his assignments in early," recalls Rich Kryczka, one of Ross's instructors at the American Academy of Art from 1988 to 1989. "And it always drove the other students crazy." Kryczka and Ross have remained friends, partly due to their mutual love of comics. "I gave a Batman-themed Halloween party once, and Alex came as the Joker. He couldn't speak all night because part of his costume was a wire rig that fit into his mouth and gave him a permanent smile. That nutty faithfulness to detail—that's Alex."

In 1989, Ross was hired by the Leo Burnett advertising agency in Chicago, where he created ad layouts, animatics, and commercial storyboards for the next three-and-a-half years. The money was good, but he never saw the job as anything other than a stepping-stone to the comics field. Even his renderings for a beer commercial, below, have a super-heroic theme. "I imagined that getting into comics was going to be extremely difficult, and I wanted a job in the meantime that would require figure drawing and storytelling."

It was at Burnett that Alex met Frank Kasy, a veteran commercial illustrator and art director whose work appears on the right. Kasy would eventually play a major role in Ross's career, though one he could have scarcely imagined when they first met—Kasy would become the live model for Alex's version of Superman. "Frank was an interesting character—definitely the king of the art department castle. He would often use himself as a model in his own work, so it seemed logical that I would, too."

Alex's break into the comic book industry came earlier than expected (he was all of nineteen), with *Terminator: The Burning Earth* (Now Comics, 1989), based on the hit Arnold Schwarzenegger movie. "It was offered to Jim Wisnewski, one of my co-workers at Burnett, and he passed the chance on to me. I showed Now my portfolio and they gave me the job." An inauspicious beginning, but it was his foot in the door and got the attention of the editors at Marvel Comics.

5. WENDY: Whoppp! But for some reason, I can't find anyone to argue with me.

6. I want someone to say Wendy, Lite's it cuz it's got great Pilsner taste.

7. So I can say not BUCKO!!

8. Lite's it cuz it's less filling, so I can stay light on my feet.

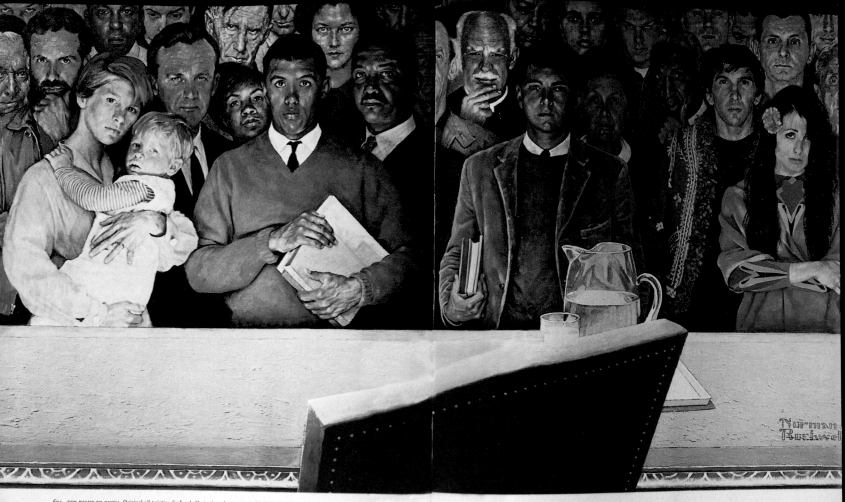

601. THE RIGHT TO KNOW. *Original oil painting for* Look *illustration, August 20, 1968. Collection Mr. and Mrs. Irving Mitchell Felt.*
Courtesy Bernard Danenberg Galleries, New York

INFLUENCES,

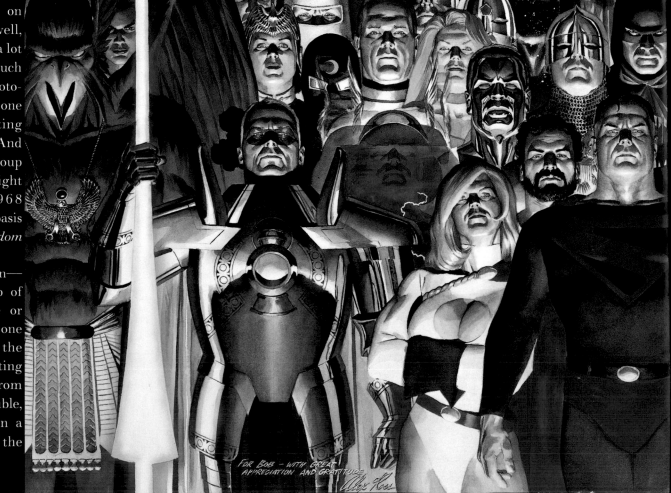

The name most often mentioned as an influence on Ross is Norman Rockwell, and it's true they share a lot of the same methods, such as relying heavily on photographs to inform how one obtains certain lighting and textural effects. And Rockwell's signature group portraits—like "The Right to Know" from 1968 (above)—formed the basis for Ross's cover of *Kingdom Come #2* (right).

"I love the illusion—that you have a group of people standing three or four deep and yet no one recedes, everyone is the same size, and the lighting mysteriously comes from below. It's totally impossible, but if you render it in a representational way, the viewer accepts it."

A NEW APPROACH by ANDREW LOOMIS

IDEAL PROPORTION. MALE

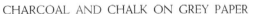

CHARCOAL AND CHALK ON GREY PAPER

A. HIGHLIGHT : "NOON"
B. HALFTONE = "TWILIGHT", B+LAST LIGHT
C. SHADOW = "NIGHT"
D. REFLECT = "MOONLIGHT"
E. CAST SHADOW = "ECLIPSE"

I will admit: I'd never heard of Andrew Loomis (1892-1959) until Alex showed me a book of his work, but the instant he did, it explained a lot. As a stylist Alex actually owes far more to this twentieth-century illustrator than he ever did to Rockwell, or anyone else. Loomis's illustrations graced the pages of many of the major national magazines of his day. He also wrote books on art instruction, and the images on this and the next page are from his *Creative Illustration* (1947) and *Figure Drawing For All It's Worth* (1946). "Loomis's realistic approach infected me with the desire to make all my work, comics and otherwise, fully believable."

TONAL PROBLEMS WORKED OUT
IN A PRELIMINARY CHARCOAL
STUDY MAY RESULT IN A MORE
DIRECT AND SPONTANEOUS FINAL
PAINTING. "IT PAYS TO PLAN IT."

BUILDING FROM THE SKELETON

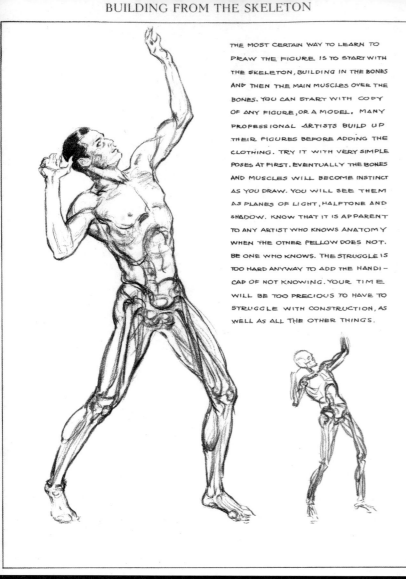

THE MOST CERTAIN WAY TO LEARN TO DRAW THE FIGURE IS TO START WITH THE SKELETON, BUILDING IN THE BONES AND THEN THE MAIN MUSCLES OVER THE BONES. YOU CAN START WITH COPY OF ANY FIGURE, OR A MODEL. MANY PROFESSIONAL ARTISTS BUILD UP THEIR FIGURES BEFORE ADDING THE CLOTHING. TRY IT WITH VERY SIMPLE POSES AT FIRST. EVENTUALLY THE BONES AND MUSCLES WILL BECOME INSTINCT AS YOU DRAW. YOU WILL SEE THEM AS PLANES OF LIGHT, HALFTONE AND SHADOW. KNOW THAT IT IS APPARENT TO ANY ARTIST WHO KNOWS ANATOMY WHEN THE OTHER FELLOW DOES NOT. BE ONE WHO KNOWS. THE STRUGGLE IS TOO HARD ANYWAY TO ADD THE HANDI-CAP OF NOT KNOWING. YOUR TIME WILL BE TOO PRECIOUS TO HAVE TO STRUGGLE WITH CONSTRUCTION, AS WELL AS ALL THE OTHER THINGS.

ANATOMY TEST

DO YOU KNOW YOUR MUSCLES? LET'S FIND OUT, TO BE SURE.

WRITE IN THE NAMES OF THE MUSCLES THEN REFER BACK TO YOUR ANATOMY AND SEE IF YOU WERE CORRECT. IF YOU CAN'T DO IT, YOU NEED MORE STUDY. GO BACK AND GET IT THIS TIME. YOU WILL NEVER BE SORRY!

THIS LOOKS LIKE A JOB FOR...

In 1993, Ross received his first commission from DC Comics. It was for an illustration of Superman, for the cover of a prose novel called *Superman: Doomsday & Beyond*. Recalls editor Charles Kochman: "I'd just started working for DC Comics in January 1993, and one of the first projects I was editing was a tie-in to the 'Death of Superman' storyline that was running in the comics. Bantam Books was publishing an adult hardcover by Roger Stern that was going to have a more graphic cover approach, and their young readers division, where I used to work, was publishing a junior novelization by Louise Simonson.

"I wanted the book to have a painted cover—something to distinguish it from the comics.

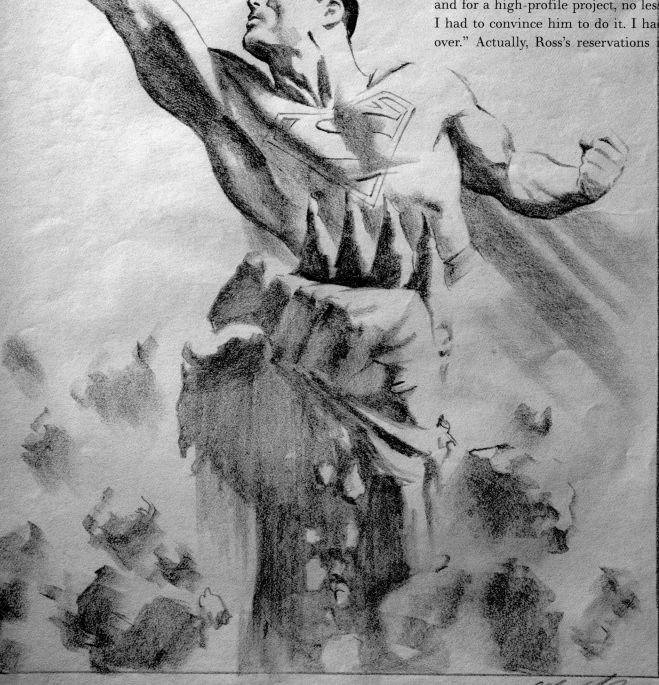

Our creative director at the time, Neal Pozner, had samples from several illustrators who he felt could do the job, and handed me a folder to look through. They were all talented, but there was something about the work of this Alex Ross guy that stood out from the others. I remember one sample in particular: The Human Torch, from a series to be published that fall called *Marvels*. I'd never seen a comic book illustration that realistic. It was as if the man were really on fire. I thought, if the Human Torch were real, this is what he would look like. It was startling, especially in the context of the time—no one was *painting* super heroes then, at least not in the way Alex was.

"I called Alex up," recalls Kochman, "and offered him the assignment, which you would think he'd jump at—here's DC Comics calling, offering him his first chance to draw Superman, and for a high-profile project, no less. But instead I had to convince him to do it. I had to win him over." Actually, Ross's reservations involved him

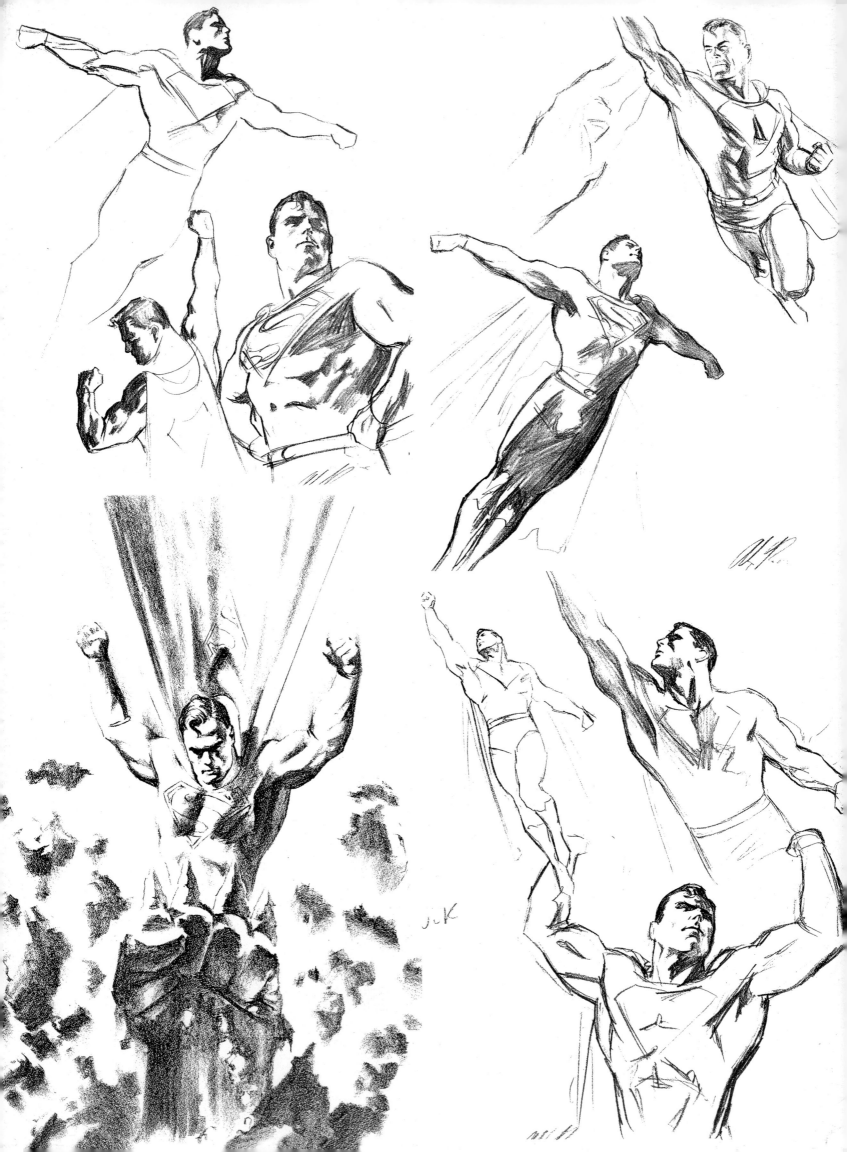

having to render the Man of Steel with long hair, a short-lived modification adopted by the then-current editorial team. But no such "restrictions" were ever given. Alex recalls: "I appreciated that I was able to render the classic version of the character—I felt strongly about that, and I was thrilled to draw Superman in an 'official' capacity."

Ross finished the cover that May, and the book was published in August. When *Marvels* (a painted mini-series chronicling the early history of the Marvel Comics charac-ters) was released, Alex was catapulted to stardom. The stage was finally set—now what did he want to do next?

The answer lay in the DC Comics universe. *Kingdom Come* (an epic story extending the mythology of Superman, Batman, Wonder Woman, Captain Marvel, and a pantheon of other super heroes) was published in 1996, to critical and commercial success. But more on that later. In order to appreciate the impact of Ross's re-imagining of these classic icons, let's first take a look at each of them, starting with . . .

OPPOSITE: More preparatory sketches for *Superman: Doomsday & Beyond*, (Bantam Books, 1993). BELOW: The final cover image.

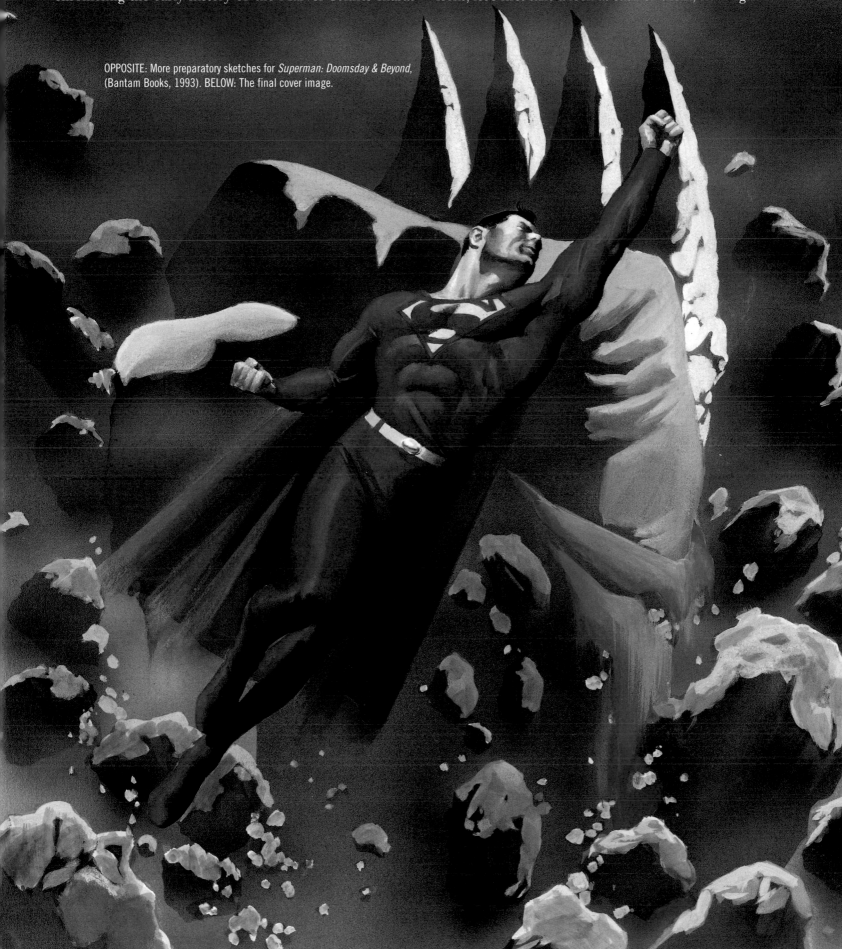

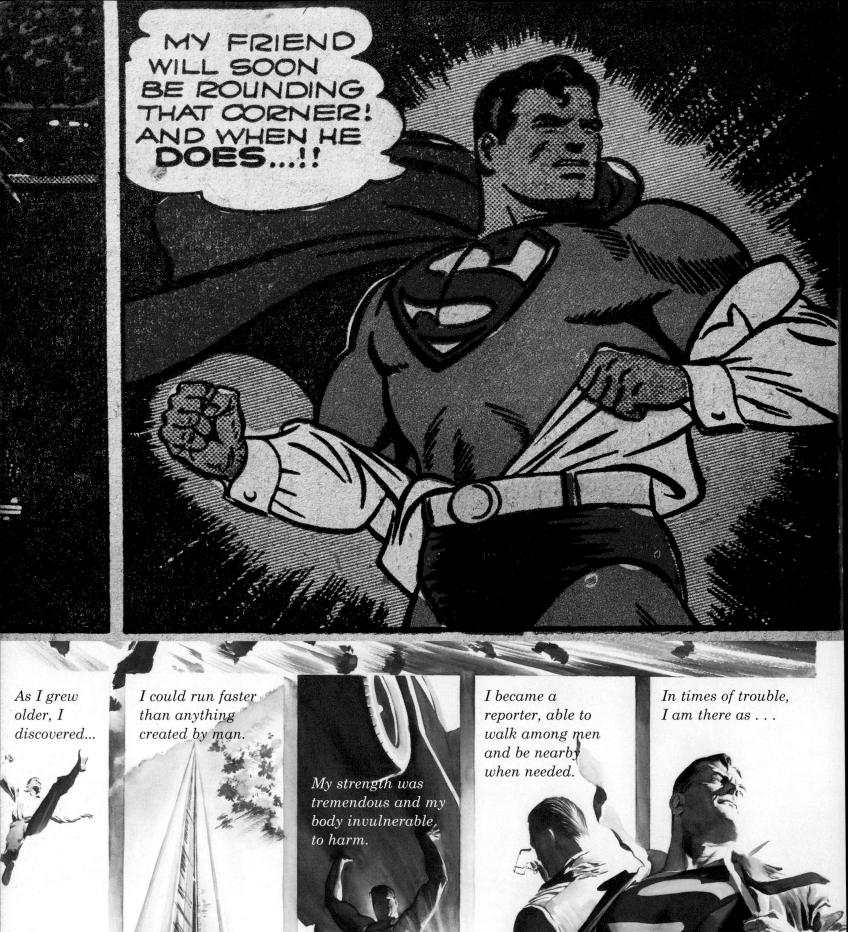

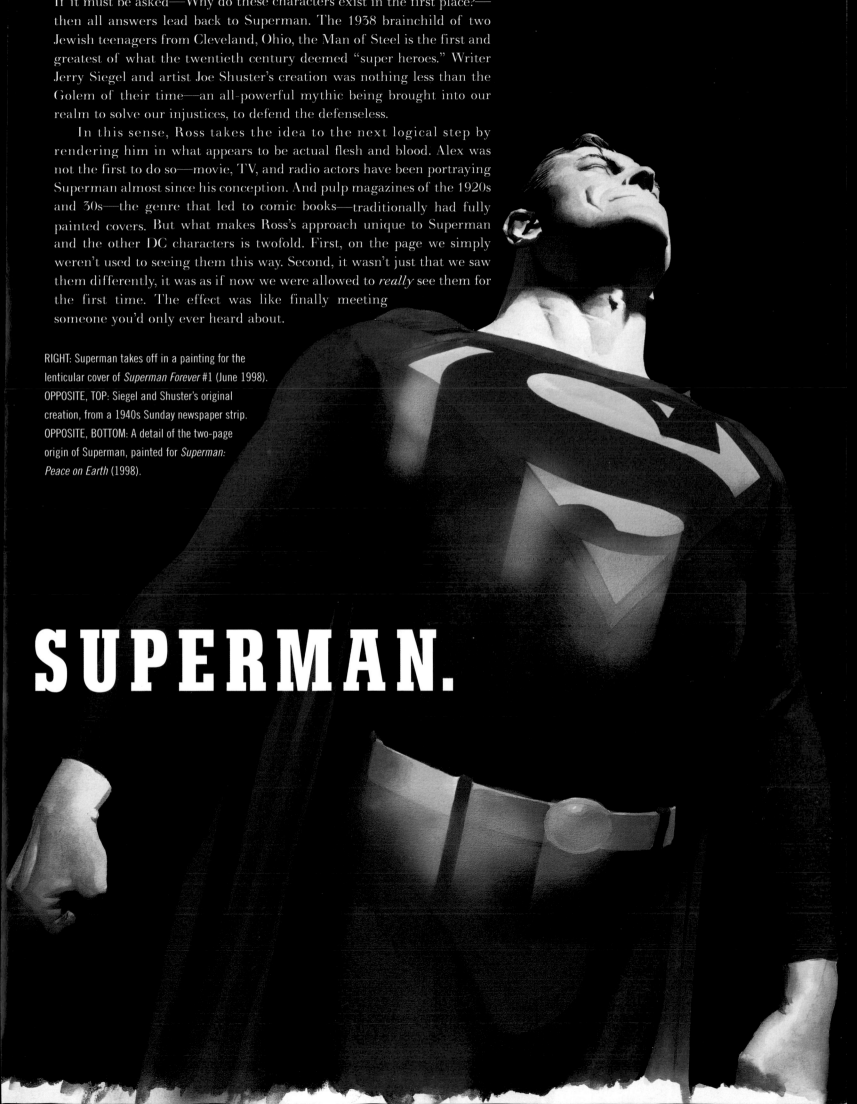

If it must be asked—Why do these characters exist in the first place?—then all answers lead back to Superman. The 1938 brainchild of two Jewish teenagers from Cleveland, Ohio, the Man of Steel is the first and greatest of what the twentieth century deemed "super heroes." Writer Jerry Siegel and artist Joe Shuster's creation was nothing less than the Golem of their time—an all-powerful mythic being brought into our realm to solve our injustices, to defend the defenseless.

In this sense, Ross takes the idea to the next logical step by rendering him in what appears to be actual flesh and blood. Alex was not the first to do so—movie, TV, and radio actors have been portraying Superman almost since his conception. And pulp magazines of the 1920s and 30s—the genre that led to comic books—traditionally had fully painted covers. But what makes Ross's approach unique to Superman and the other DC characters is twofold. First, on the page we simply weren't used to seeing them this way. Second, it wasn't just that we saw them differently, it was as if now we were allowed to *really* see them for the first time. The effect was like finally meeting someone you'd only ever heard about.

RIGHT: Superman takes off in a painting for the lenticular cover of *Superman Forever* #1 (June 1998).
OPPOSITE, TOP: Siegel and Shuster's original creation, from a 1940s Sunday newspaper strip.
OPPOSITE, BOTTOM: A detail of the two-page origin of Superman, painted for *Superman: Peace on Earth* (1998).

SUPERMAN.

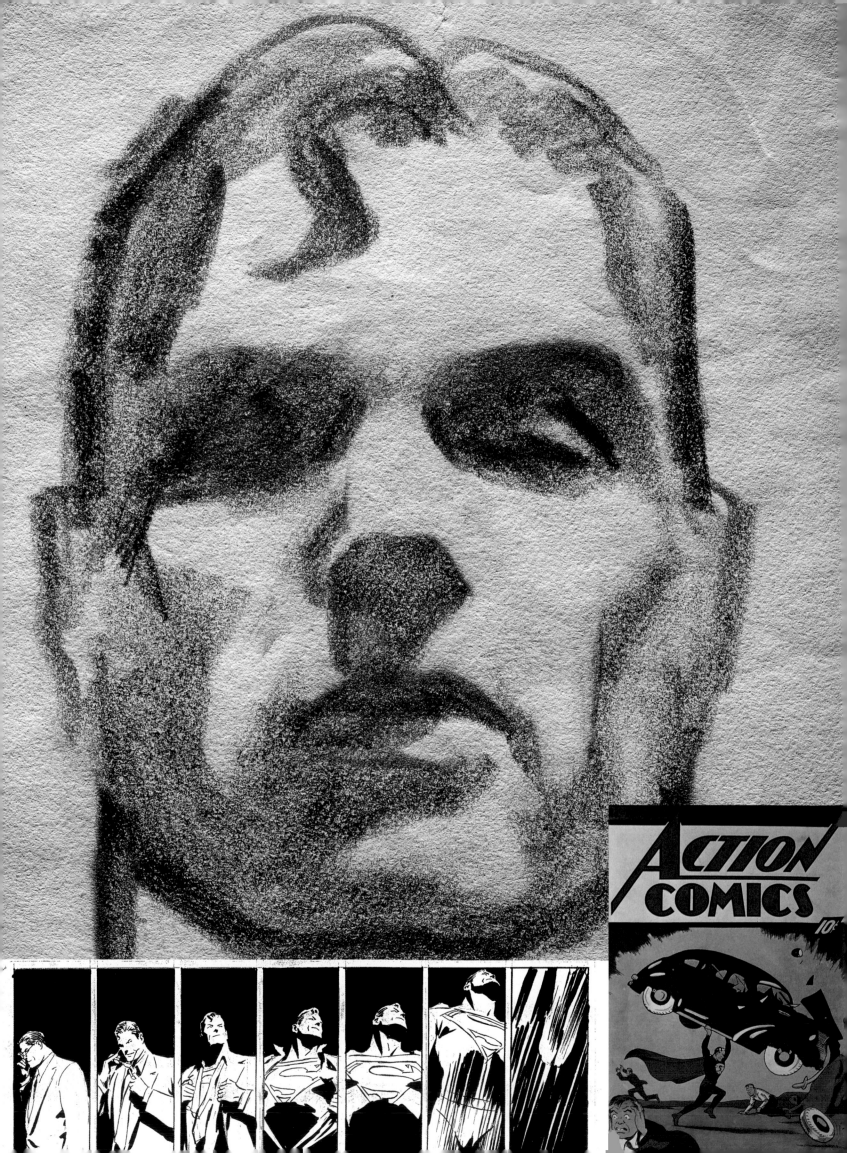

BELOW: A re-creation of Joe Shuster's cover (opposite, lower right) of *Action Comics* #1 (June 1938). OPPOSITE, TOP: Detail of a 1991 pencil sketch of Superman's head. OPPOSITE, LOWER LEFT: Pen-and-ink study of Clark Kent changing into Superman, to be used for a lenticular cover of *Superman Forever* #1 (June 1998).

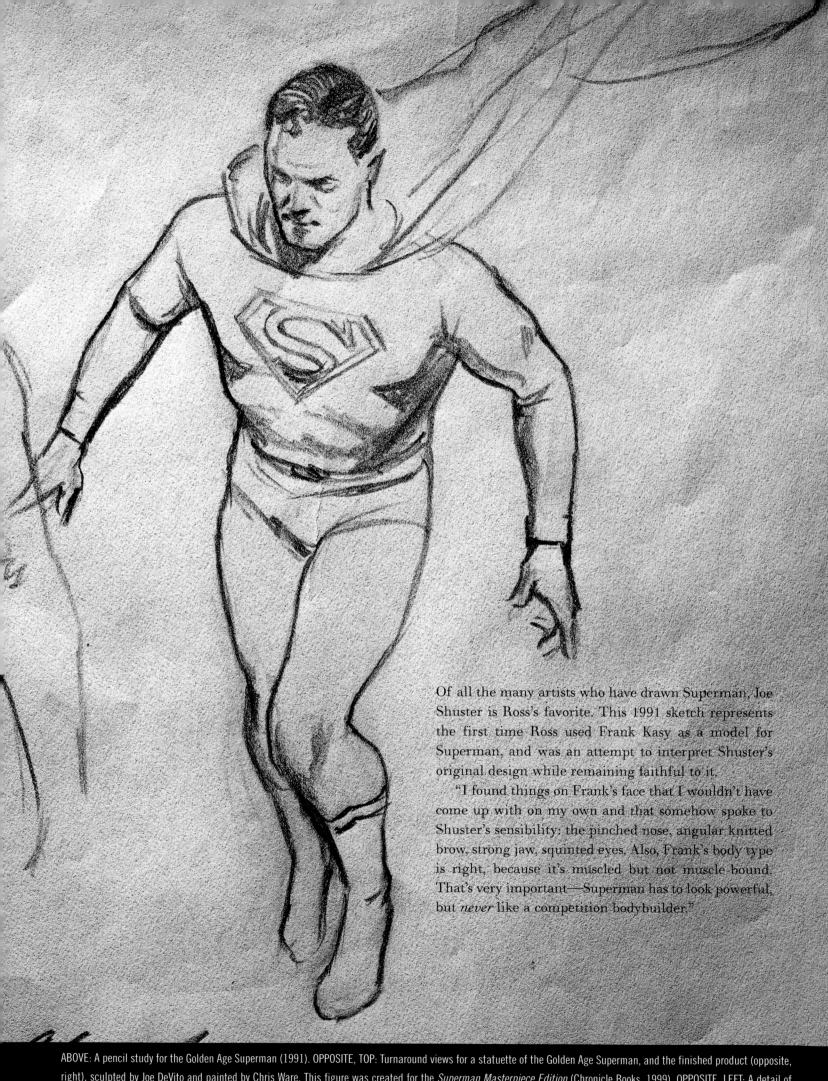

Of all the many artists who have drawn Superman, Joe Shuster is Ross's favorite. This 1991 sketch represents the first time Ross used Frank Kasy as a model for Superman, and was an attempt to interpret Shuster's original design while remaining faithful to it.

"I found things on Frank's face that I wouldn't have come up with on my own and that somehow spoke to Shuster's sensibility: the pinched nose, angular knitted brow, strong jaw, squinted eyes. Also, Frank's body type is right, because it's muscled but not muscle-bound. That's very important—Superman has to look powerful, but *never* like a competition bodybuilder."

ABOVE: A pencil study for the Golden Age Superman (1991). OPPOSITE, TOP: Turnaround views for a statuette of the Golden Age Superman, and the finished product (opposite, right), sculpted by Joe DeVito and painted by Chris Ware. This figure was created for the *Superman Masterpiece Edition* (Chronicle Books, 1999). OPPOSITE, LEFT: A detail of Joe Shuster's cover of *Superman* #1 (Summer 1939), and Ross's re-creation of it for the cover of *Superman: The Complete History* (Chronicle Books, 1998).

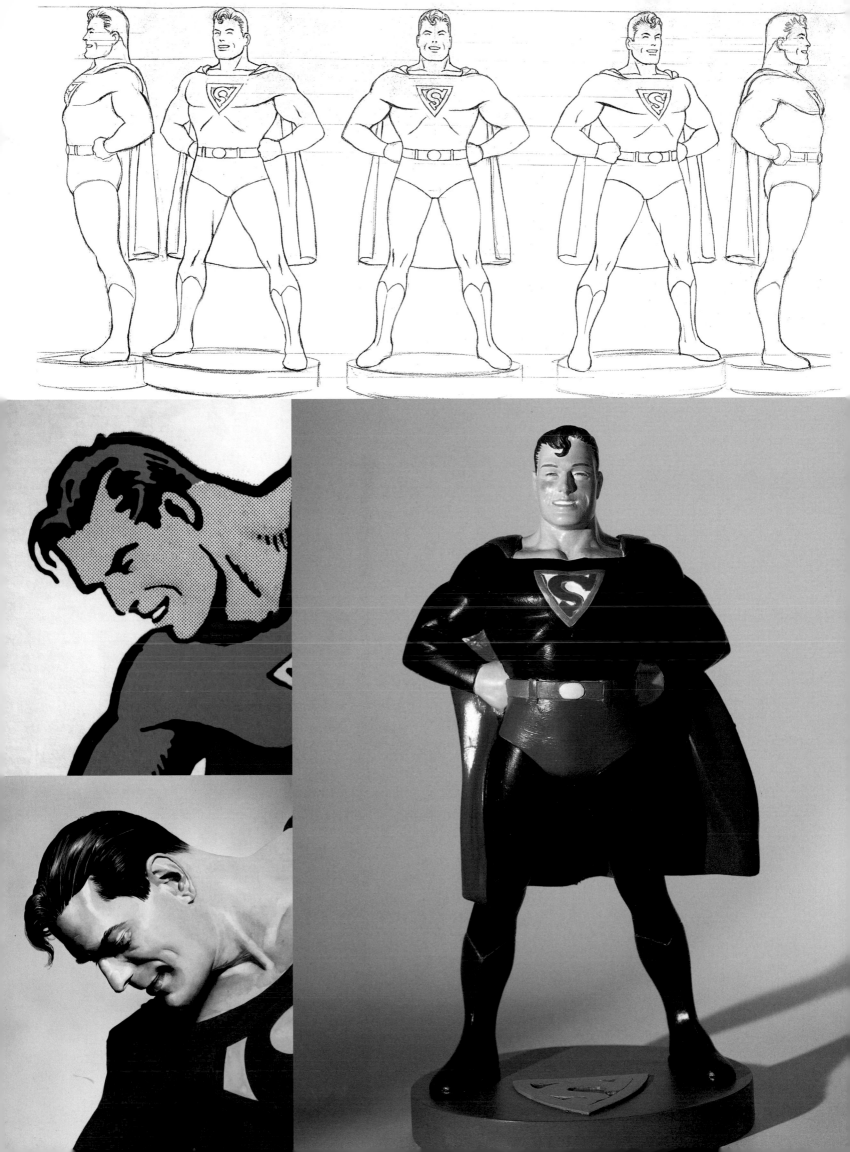

This 1998 pencil study was proposed for a Warner Bros. Studio Store lithograph but went unproduced. The deceptively simple device of tilting the cityscape is what makes Superman actually seem to be flying. "When you tilt the horizon line, you create a sense of vertigo—we're not watching the moment, we're IN the moment. The element of movement is extenuated."

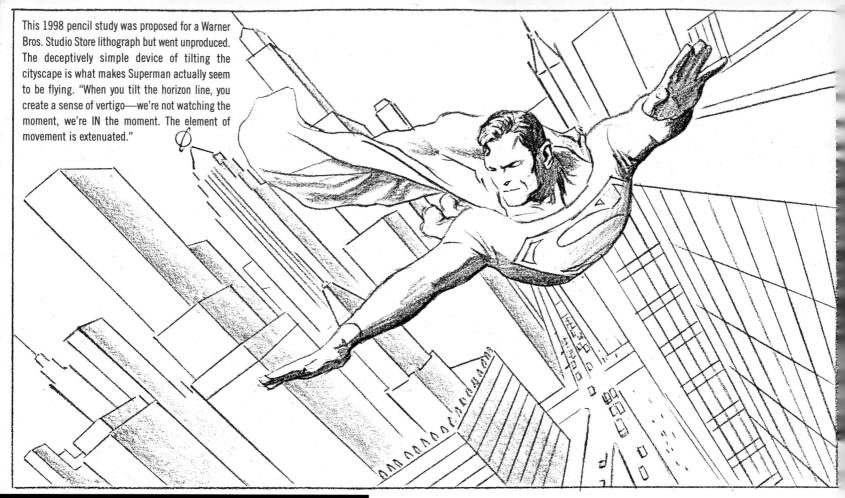

OPPOSITE: This 1998 lithograph, sold through the Warner Bros. Studio Stores, is Ross's interpretation of the classic cover of *Superman* #1 (Summer 1939) by Joe Shuster (below), and evokes the cityscape photographs of Bernice Abbott. Alex was disappointed that he wasn't able to retain the original's oval design, seen in his pencil study to the right. He also isn't happy with the rendering of Superman's head. "I'd redo it if I could. It's too small, and doesn't look naturalistic. Also, he should be more silhouetted. And—oh, don't get me started"

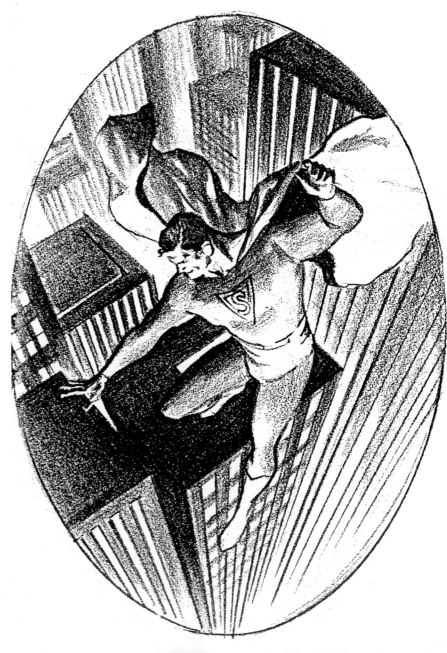

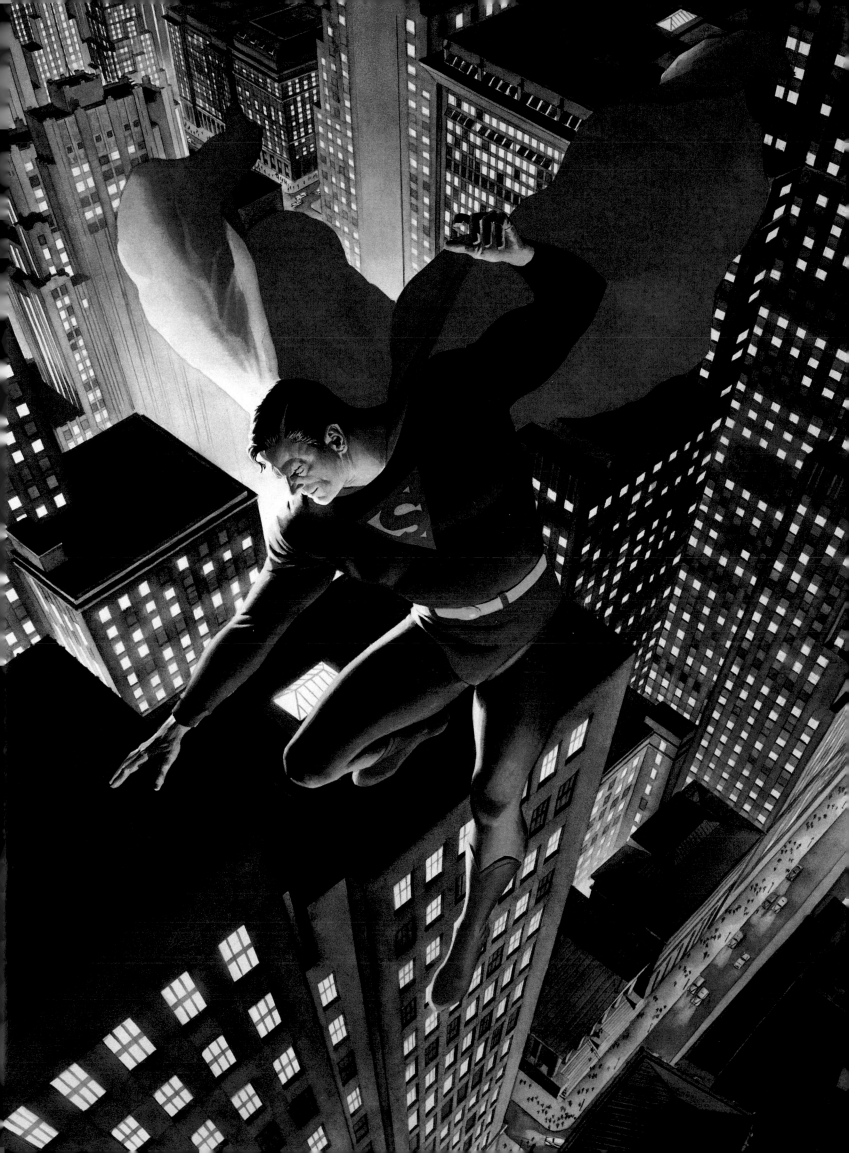

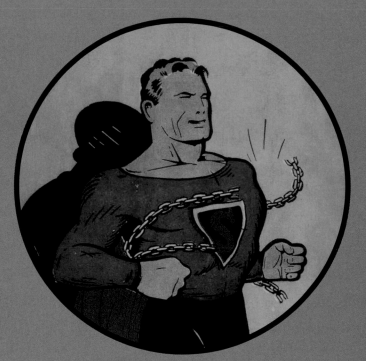

ABOVE: The back cover of *Superman* #1 (Summer 1939) featured this iconic Joe Shuster drawing of Superman breaking chains, which Ross recreated (below right) for the back cover of *Superman: The Complete History* (Chronicle Books, 1998). OPPOSITE, TOP: Superman takes off, in the last of a sequence of paintings for the lenticular cover of *Superman Forever* #1 (June 1998). OPPOSITE, BOTTOM: Superman pencil turnarounds for video game development (1999). RIGHT AND BOTTOM LEFT: Thumbnail concepts for *Superman: Peace on Earth* display (1998).

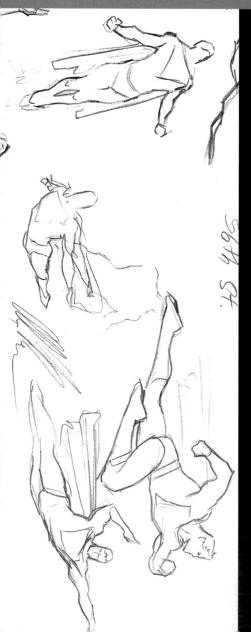

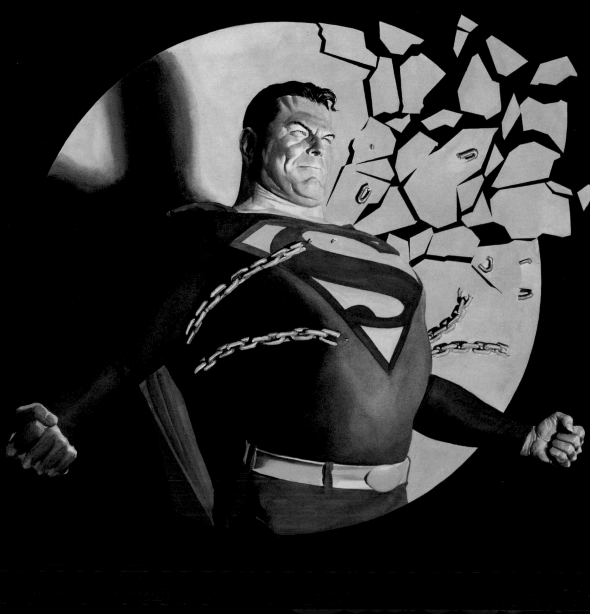

SUPERMAN HEAD TURNS

"I very much wanted to create the new standard by which Superman should be drawn, and by that I mean: take him back to his roots. Of course that didn't happen, but it was definitely worth aiming for. He deserves it. Superman should never reflect any fashionable trend or other affectation of a specific era—hairstyle, speech patterns, etcetera. He is beyond that. He is out of time."

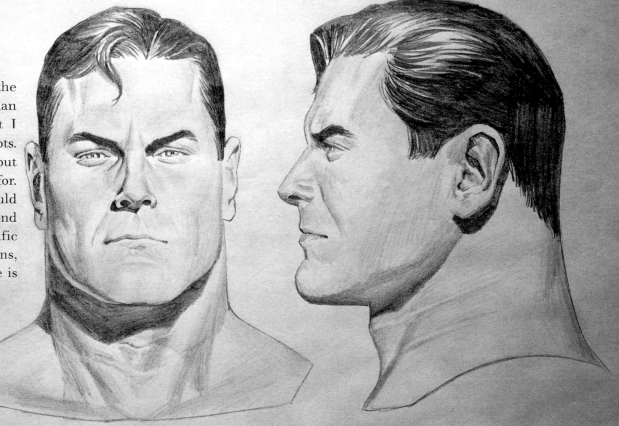

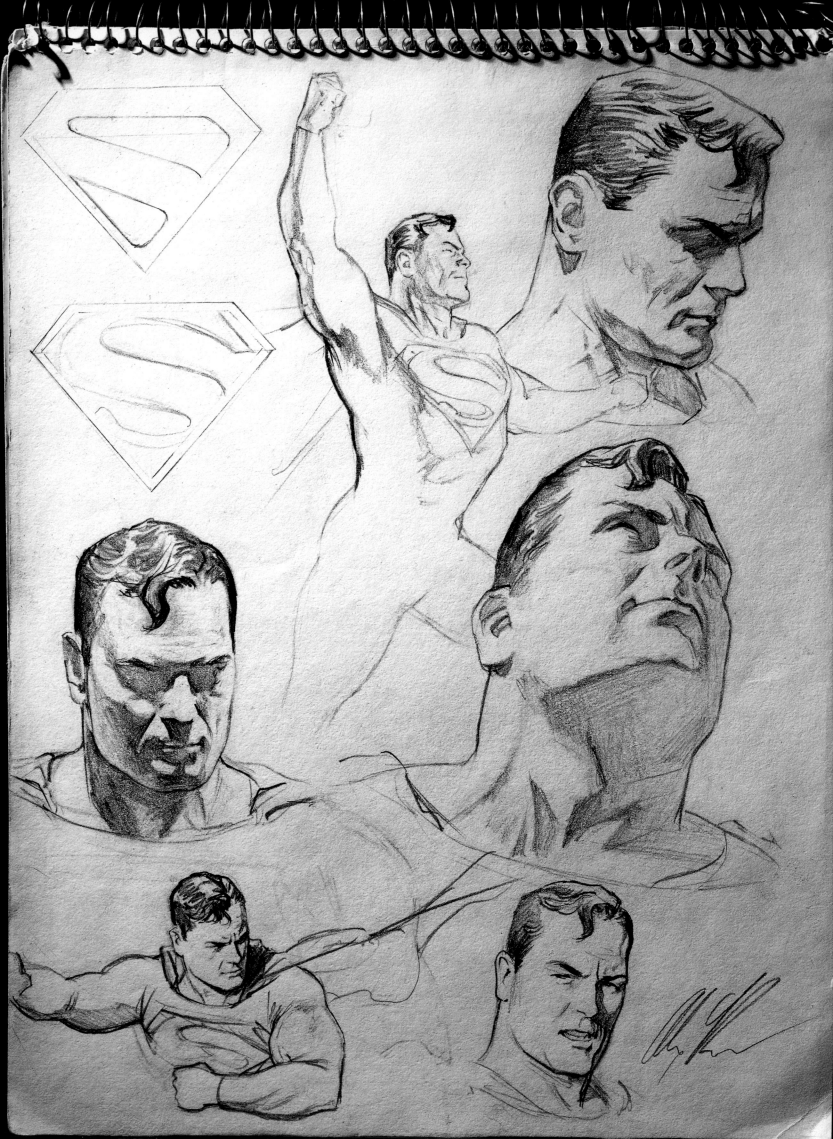

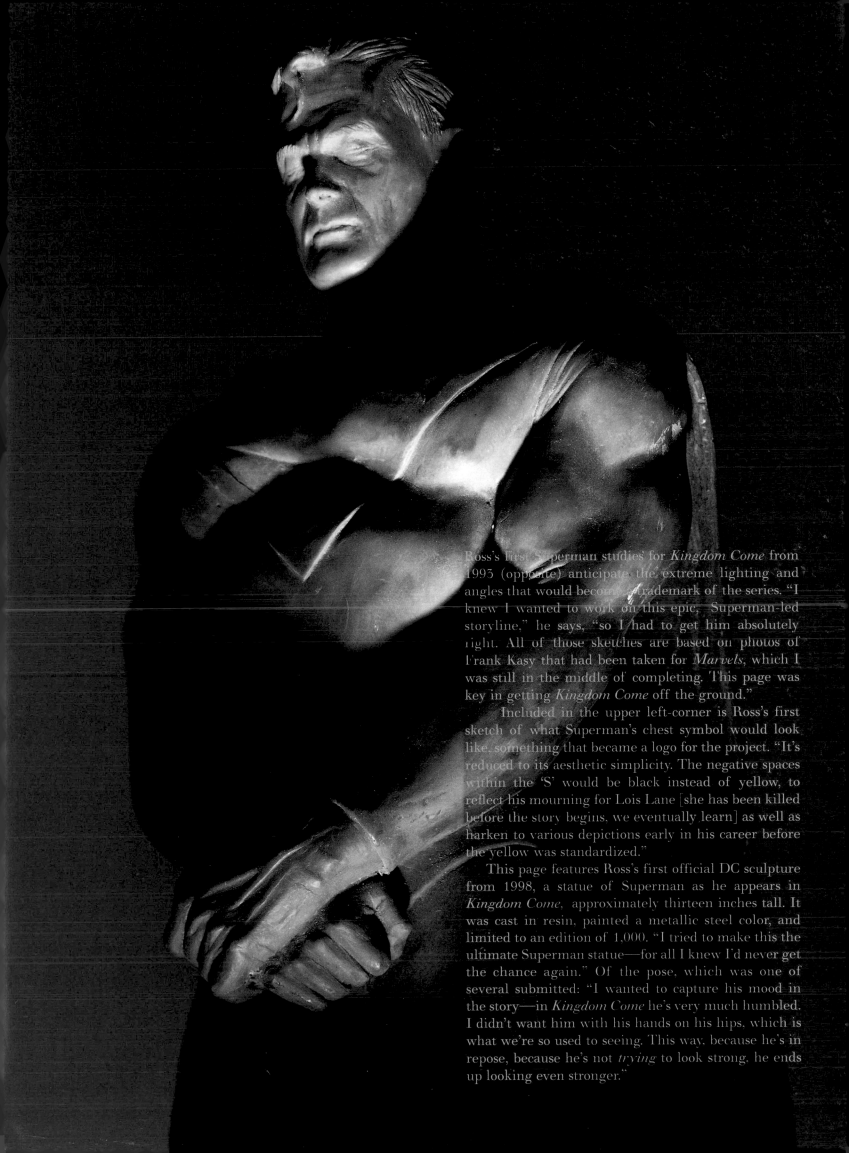

Ross's first Superman studies for *Kingdom Come* from 1993 (opposite) anticipate the extreme lighting and angles that would become a trademark of the series. "I knew I wanted to work on this epic, Superman-led storyline," he says, "so I had to get him absolutely right. All of those sketches are based on photos of Frank Kasy that had been taken for *Marvels*, which I was still in the middle of completing. This page was key in getting *Kingdom Come* off the ground."

Included in the upper left-corner is Ross's first sketch of what Superman's chest symbol would look like, something that became a logo for the project. "It's reduced to its aesthetic simplicity. The negative spaces within the 'S' would be black instead of yellow, to reflect his mourning for Lois Lane [she has been killed before the story begins, we eventually learn] as well as harken to various depictions early in his career before the yellow was standardized."

This page features Ross's first official DC sculpture from 1998, a statue of Superman as he appears in *Kingdom Come*, approximately thirteen inches tall. It was cast in resin, painted a metallic steel color, and limited to an edition of 1,000. "I tried to make this the ultimate Superman statue—for all I knew I'd never get the chance again." Of the pose, which was one of several submitted: "I wanted to capture his mood in the story—in *Kingdom Come* he's very much humbled. I didn't want him with his hands on his hips, which is what we're so used to seeing. This way, because he's in repose, because he's not *trying* to look strong, he ends up looking even stronger."

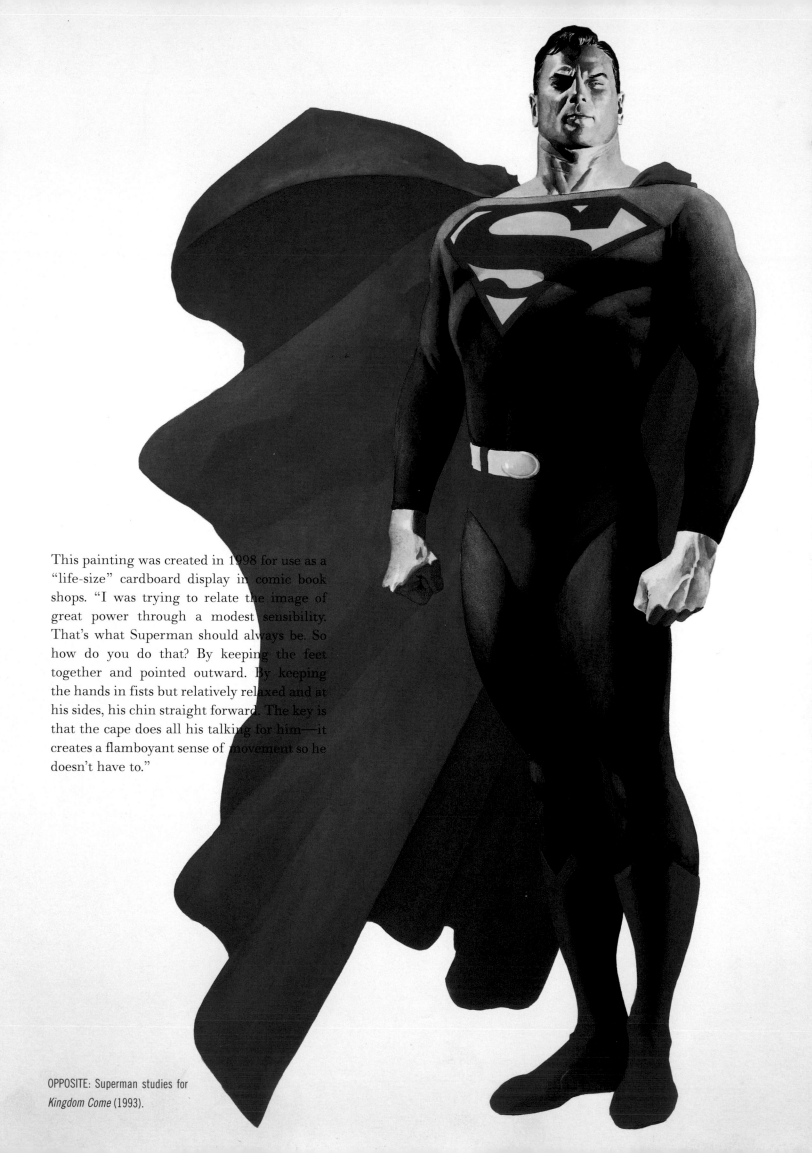

This painting was created in 1998 for use as a "life-size" cardboard display in comic book shops. "I was trying to relate the image of great power through a modest sensibility. That's what Superman should always be. So how do you do that? By keeping the feet together and pointed outward. By keeping the hands in fists but relatively relaxed and at his sides, his chin straight forward. The key is that the cape does all his talking for him—it creates a flamboyant sense of movement so he doesn't have to."

OPPOSITE: Superman studies for *Kingdom Come* (1993).

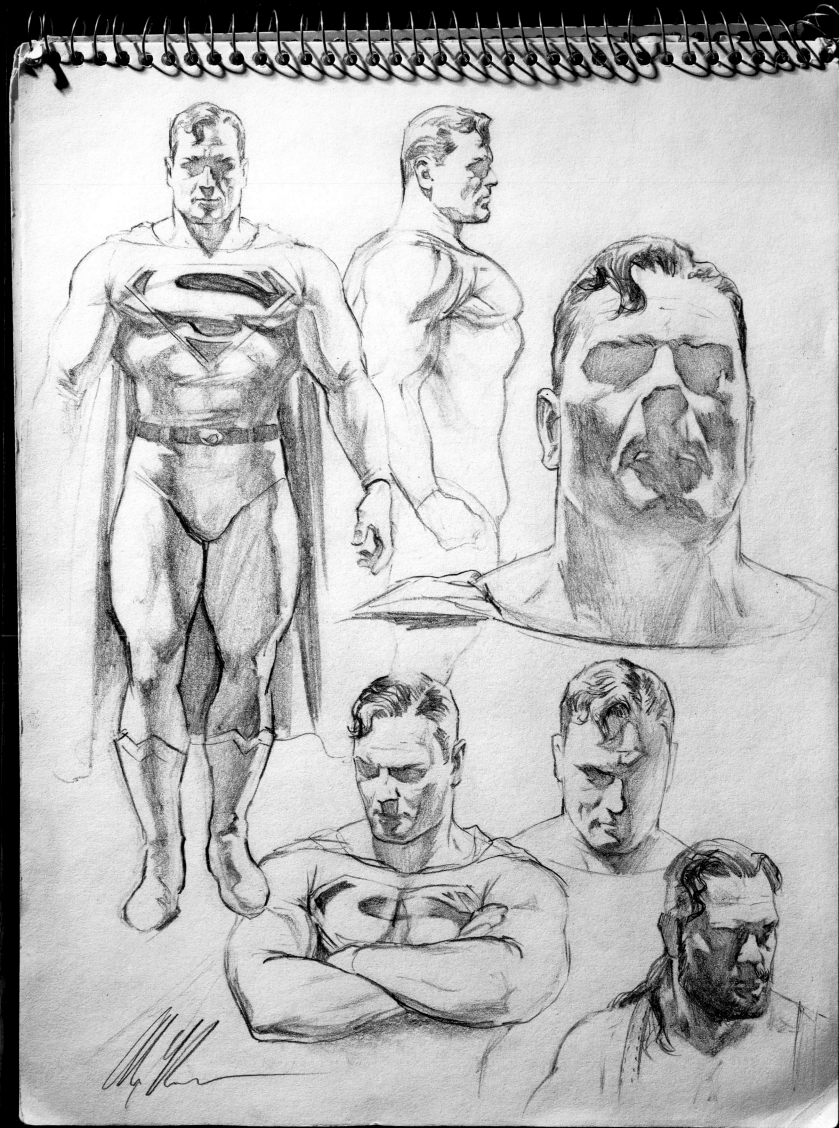

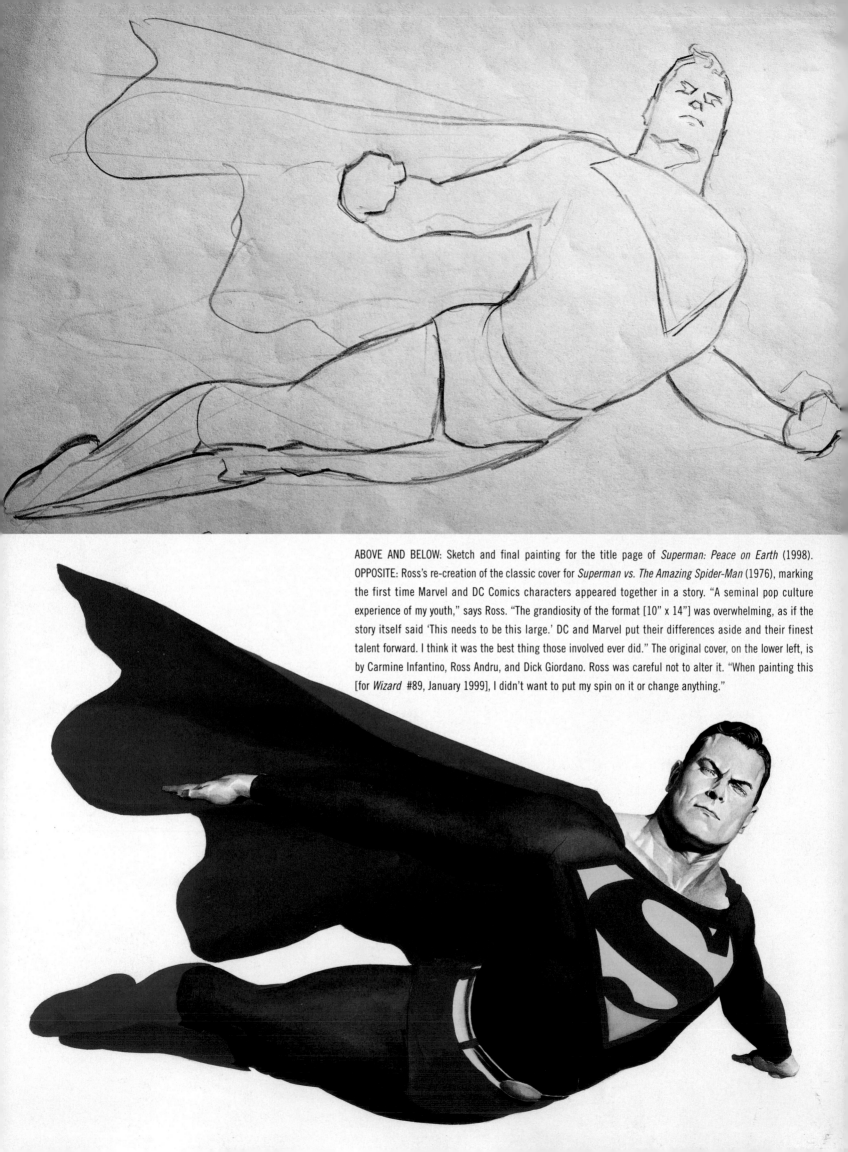

ABOVE AND BELOW: Sketch and final painting for the title page of *Superman: Peace on Earth* (1998). OPPOSITE: Ross's re-creation of the classic cover for *Superman vs. The Amazing Spider-Man* (1976), marking the first time Marvel and DC Comics characters appeared together in a story. "A seminal pop culture experience of my youth," says Ross. "The grandiosity of the format [10" x 14"] was overwhelming, as if the story itself said 'This needs to be this large.' DC and Marvel put their differences aside and their finest talent forward. I think it was the best thing those involved ever did." The original cover, on the lower left, is by Carmine Infantino, Ross Andru, and Dick Giordano. Ross was careful not to alter it. "When painting this [for *Wizard* #89, January 1999], I didn't want to put my spin on it or change anything."

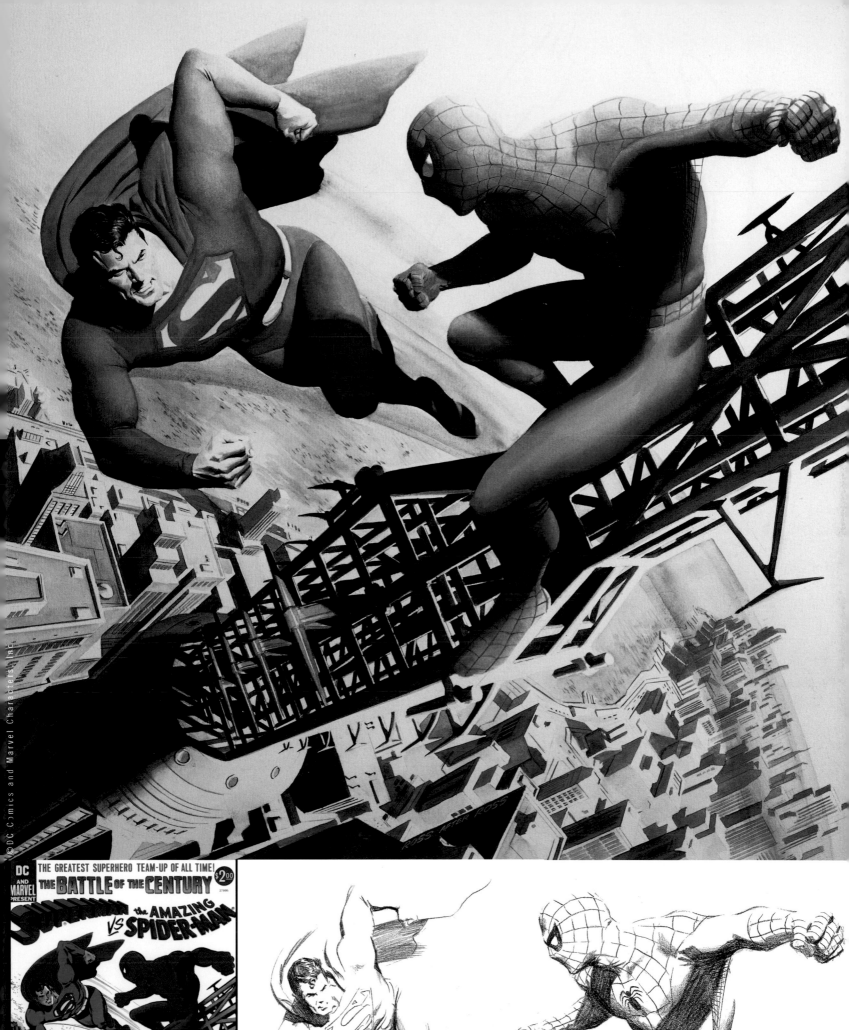

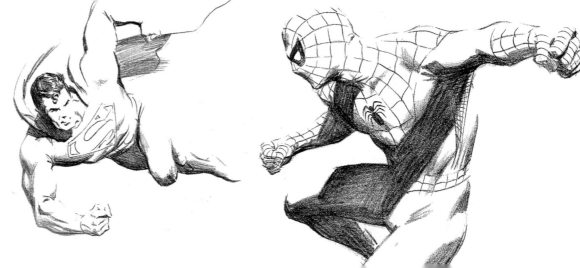

SUPERMAN

6'3"

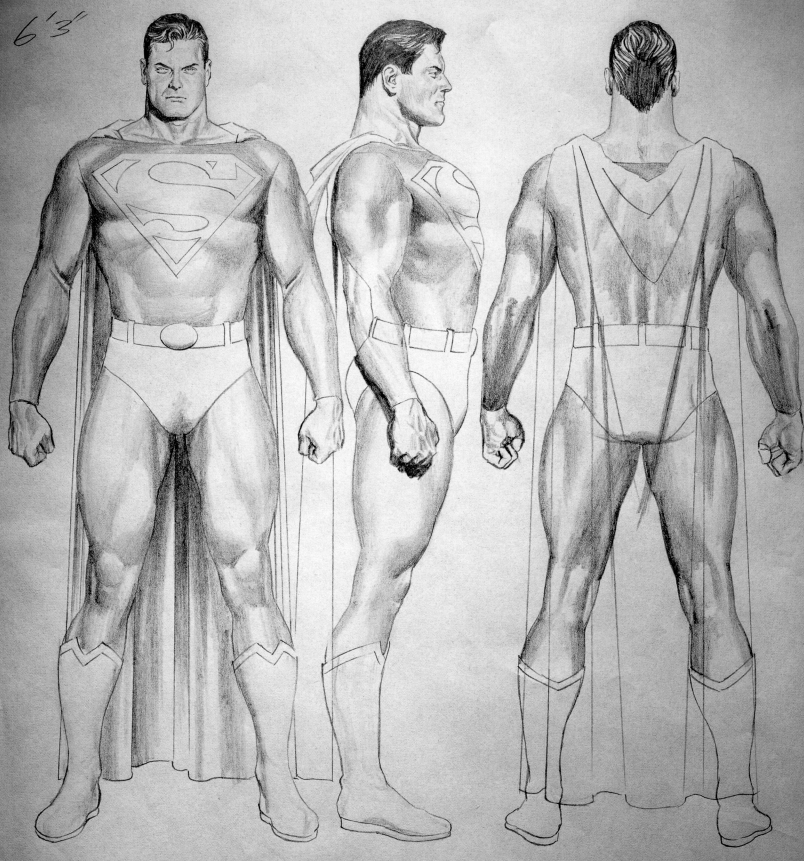

To say that Mike Hill, a British sculptor and model maker, is a fan of Ross's work doesn't begin to tell the story. Hill has worked professionally for the London wax museum of Louis Toussaud (a relative and rival of the famous Madame's), where he's produced likenesses of Anthony Hopkins and Keanu Reeves. In 1999 Hill set out to make a life-size likeness of Ross's version of Superman. The result is as convincing as it is eerie. "The difference between this and what I usually do," says Hill, "is that for the celebrity work I start out with something real and make it fake. This was the opposite—I took Alex's drawings and made them into a physical likeness that never existed in the first place." And why? "Well, I had to, didn't I? Look, what Alex does is show us what these characters would look like in our world, and what I do complements that. This isn't Christopher Reeve, or George Reeves, or any other recognizable actor. It *is* Superman."

Ross was delighted, and eagerly added the sculpture to his private collection. "The whole thing was Mike's idea. I gave him photos, drawings. I even got him fabric so that the color was just right. We had a ball working on that thing."

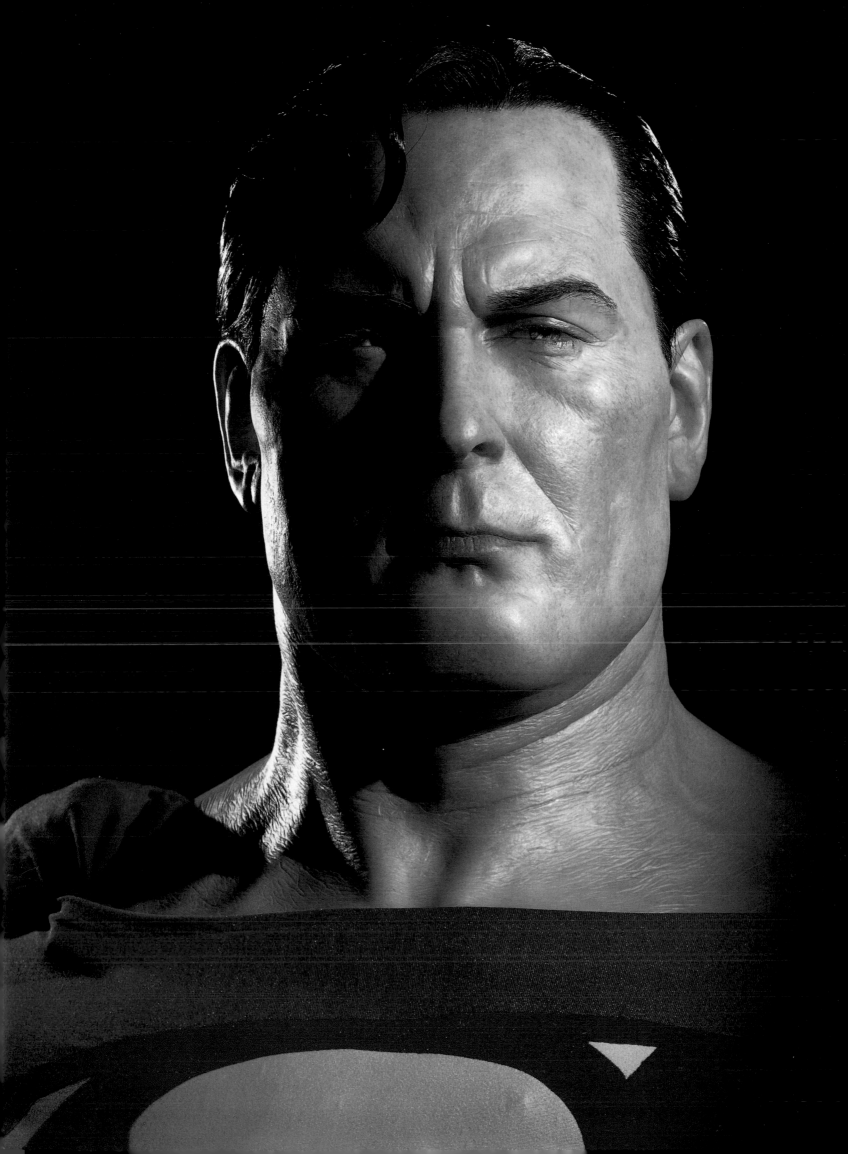

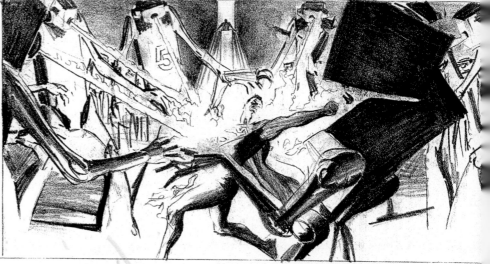

"ANIMATION" STYLE.

ABOVE, LEFT: Still from *The Mechanical Monsters*, a Superman cartoon by the Fleischer animation studio (1941). ABOVE, RIGHT: Ross's interpretation (circa 1998).

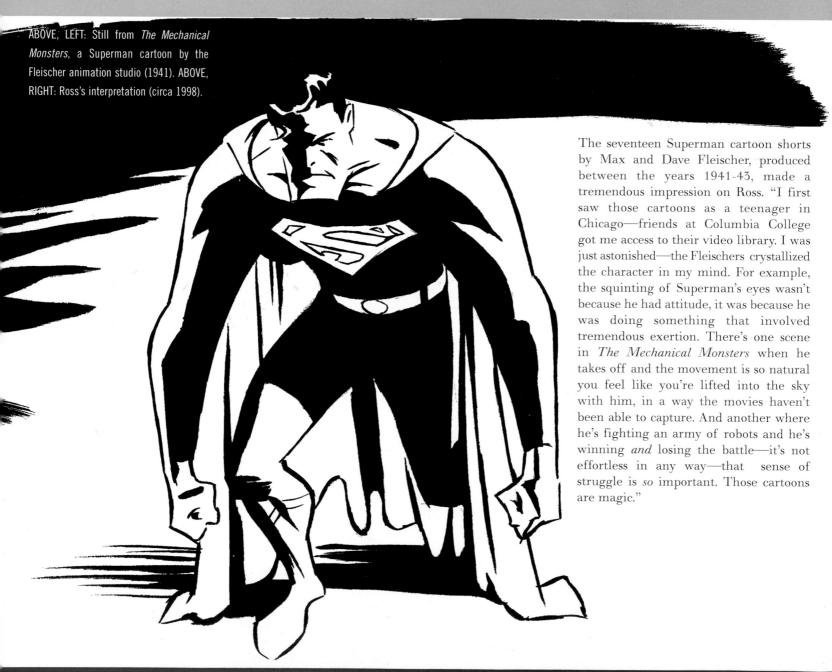

The seventeen Superman cartoon shorts by Max and Dave Fleischer, produced between the years 1941-43, made a tremendous impression on Ross. "I first saw those cartoons as a teenager in Chicago—friends at Columbia College got me access to their video library. I was just astonished—the Fleischers crystallized the character in my mind. For example, the squinting of Superman's eyes wasn't because he had attitude, it was because he was doing something that involved tremendous exertion. There's one scene in *The Mechanical Monsters* when he takes off and the movement is so natural you feel like you're lifted into the sky with him, in a way the movies haven't been able to capture. And another where he's fighting an army of robots and he's winning *and* losing the battle—it's not effortless in any way—that sense of struggle is *so* important. Those cartoons are magic."

The line drawing above and those on the following pages are exercises inspired by the work of animator Bruce Timm, who developed his reductive, angular style to make the characters easier to animate. "Bruce and I became friends in 1994," says Ross. "I've always greatly admired his work— the energy, the economy of line. I did these drawings in 1997 for a proposed 'animated style' one-shot comic (to be written by Paul Dini) that would have involved Superman meeting Captain Marvel. Instead *Peace on Earth* took over, and this project got put on the shelf."

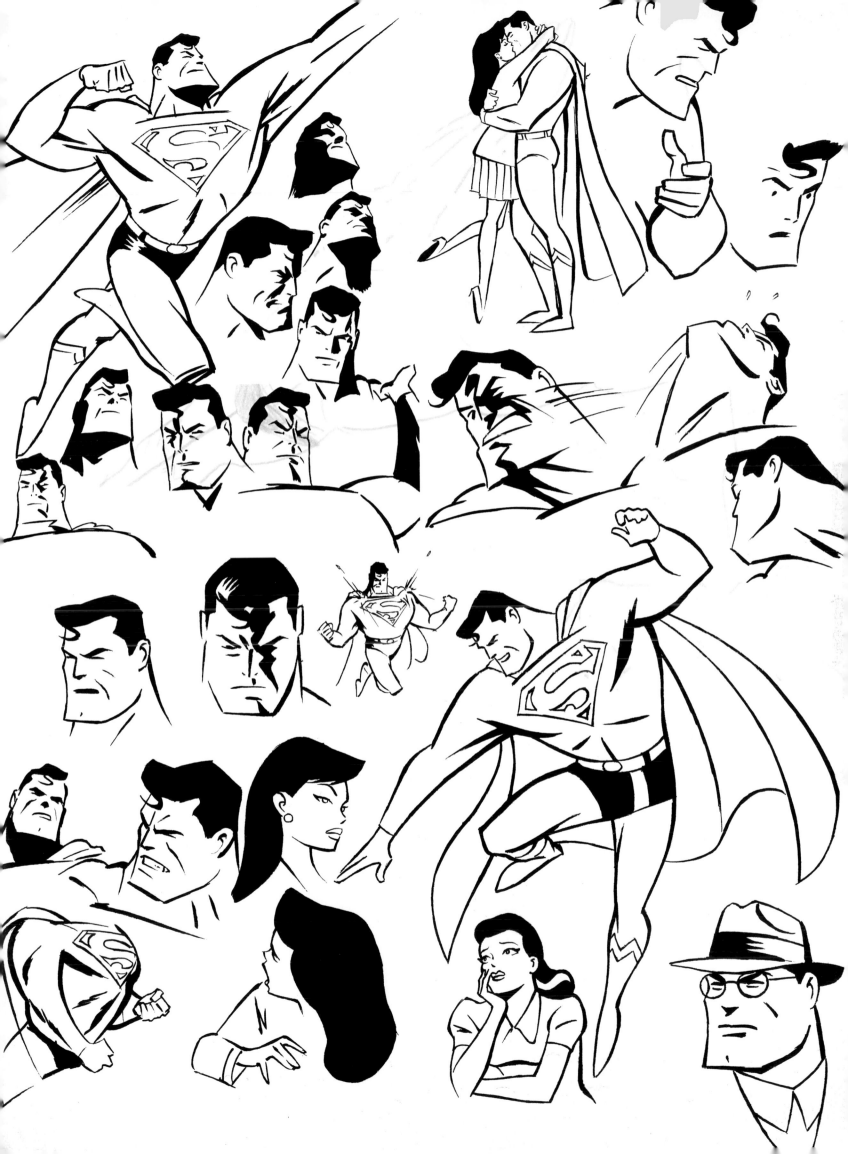

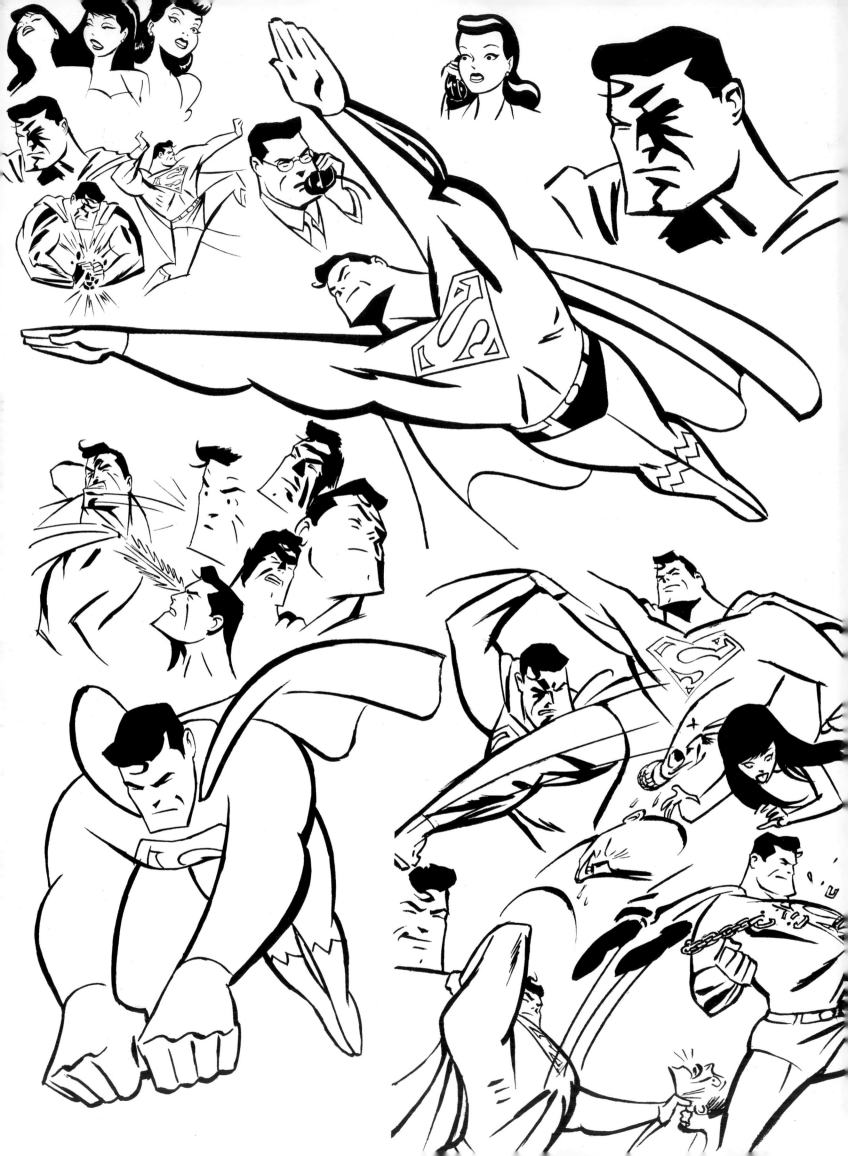

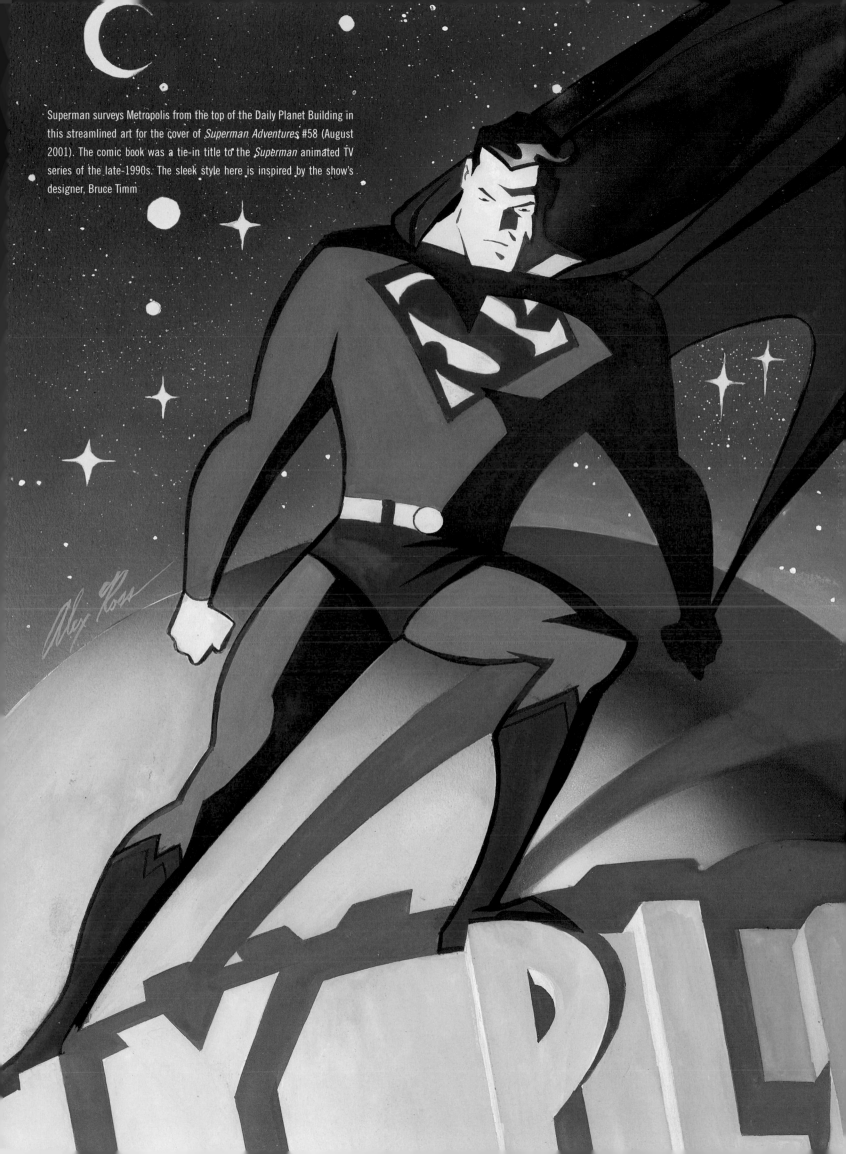

Superman surveys Metropolis from the top of the Daily Planet Building in this streamlined art for the cover of *Superman Adventures* #58 (August 2001). The comic book was a tie-in title to the *Superman* animated TV series of the late-1990s. The sleek style here is inspired by the show's designer, Bruce Timm

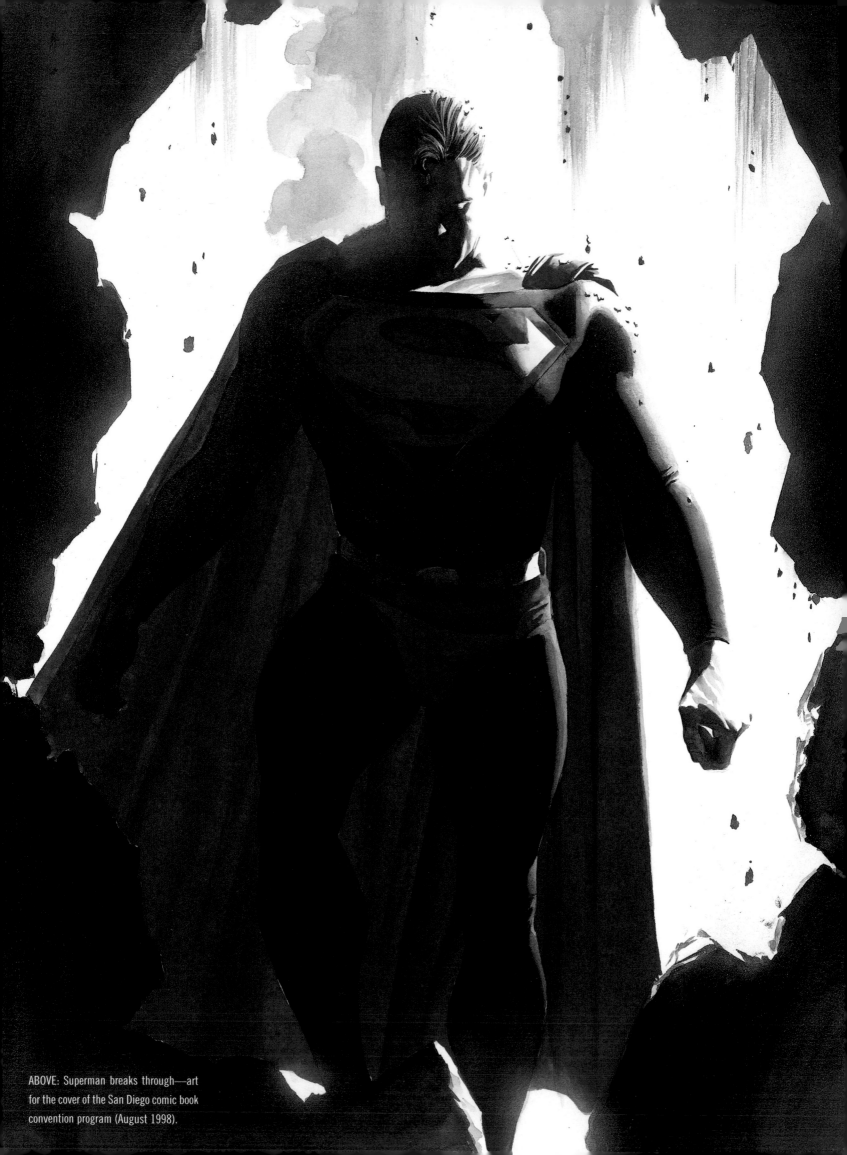

ABOVE: Superman breaks through—art
for the cover of the San Diego comic book
convention program (August 1998).

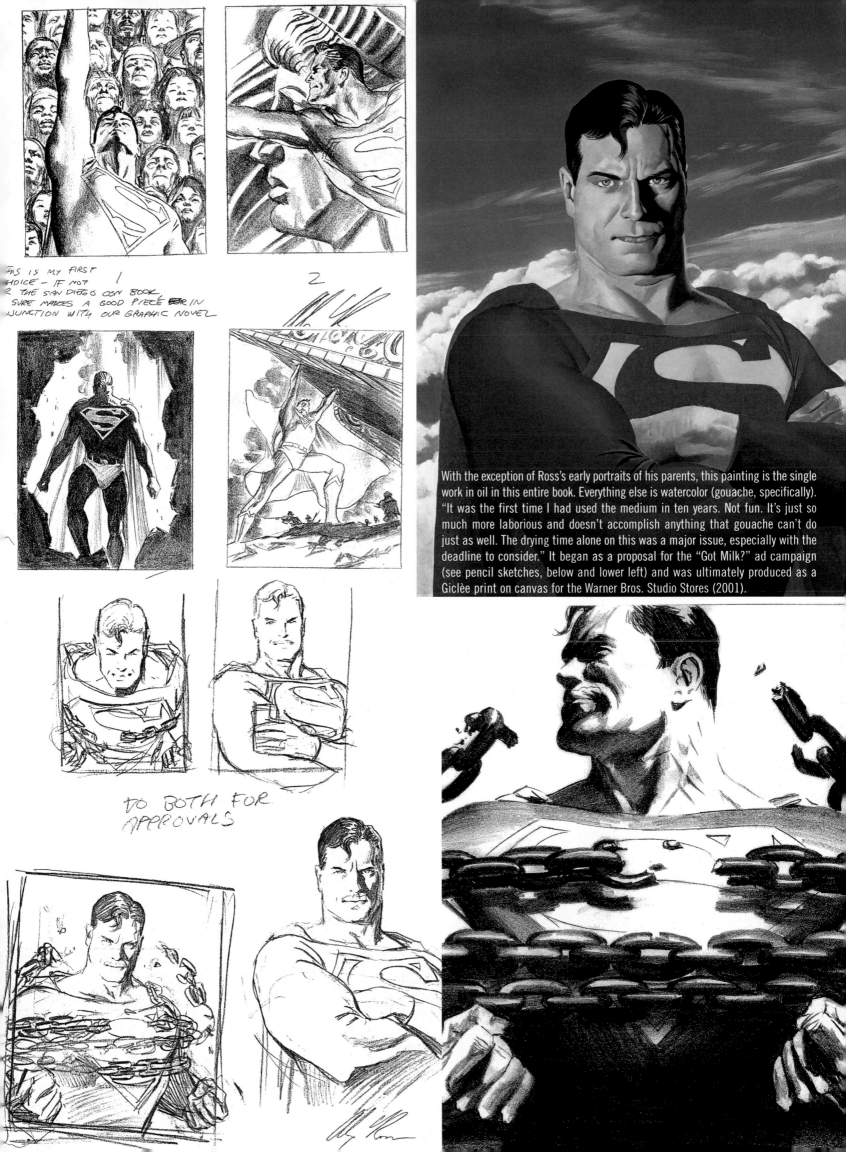

THIS IS MY FIRST
CHOICE — IF NOT
2 THE SAN DIEGO CON BOOK
SURE MAKES A GOOD PIECE ERR IN
JUNCTION WITH OUR GRAPHIC NOVEL

1

2

DO BOTH FOR
APPROVALS

With the exception of Ross's early portraits of his parents, this painting is the single work in oil in this entire book. Everything else is watercolor (gouache, specifically). "It was the first time I had used the medium in ten years. Not fun. It's just so much more laborious and doesn't accomplish anything that gouache can't do just as well. The drying time alone on this was a major issue, especially with the deadline to consider." It began as a proposal for the "Got Milk?" ad campaign (see pencil sketches, below and lower left) and was ultimately produced as a Giclèe print on canvas for the Warner Bros. Studio Stores (2001).

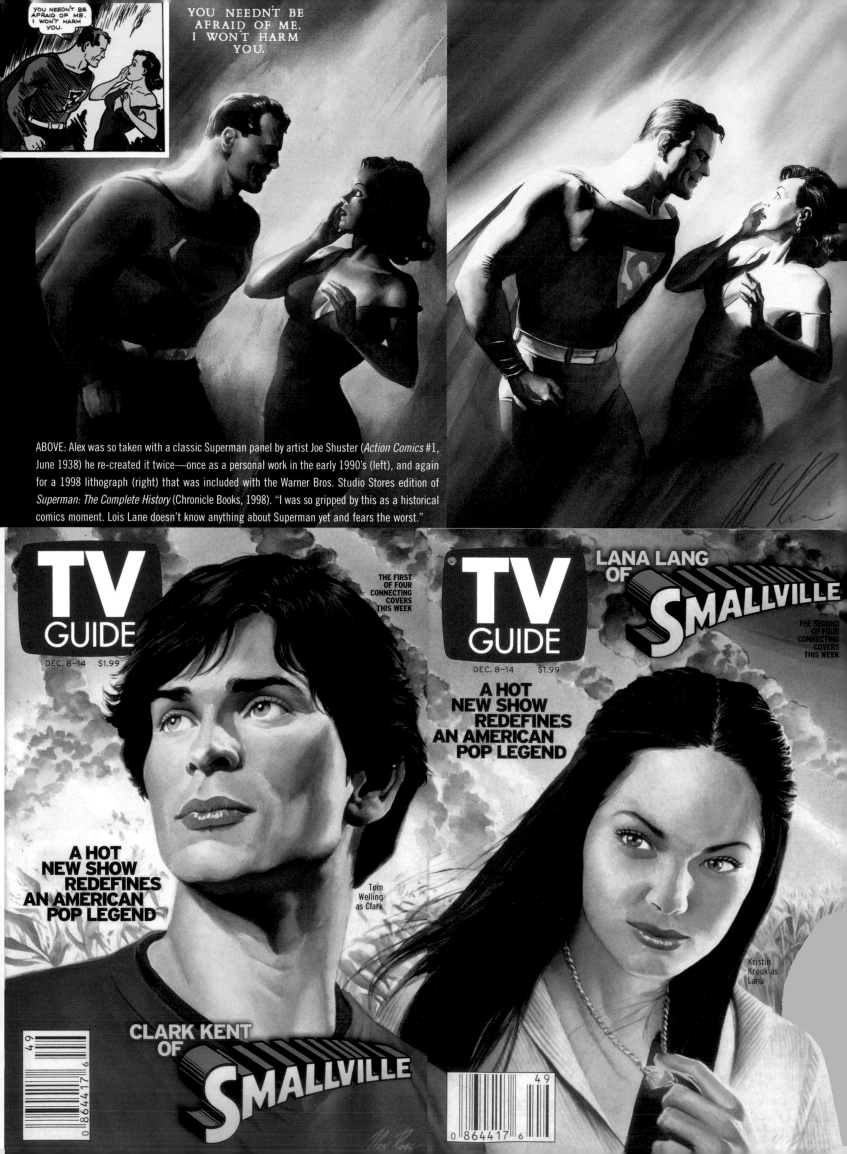

ABOVE: Alex was so taken with a classic Superman panel by artist Joe Shuster (*Action Comics* #1, June 1938) he re-created it twice—once as a personal work in the early 1990's (left), and again for a 1998 lithograph (right) that was included with the Warner Bros. Studio Stores edition of *Superman: The Complete History* (Chronicle Books, 1998). "I was so gripped by this as a historical comics moment. Lois Lane doesn't know anything about Superman yet and fears the worst."

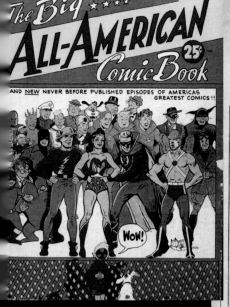

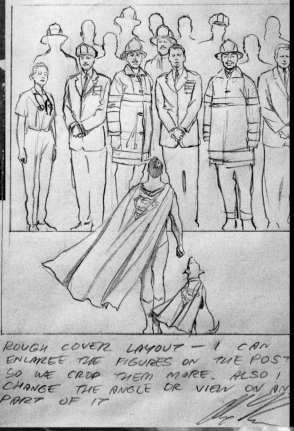

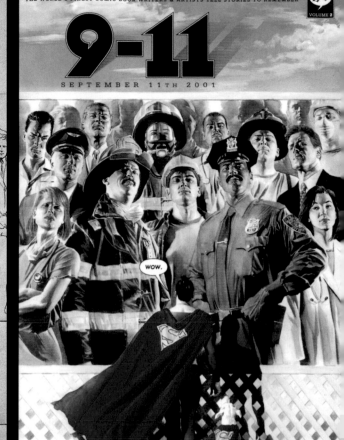

9-11
SEPTEMBER 11TH 2001

WOW.

ABOVE: The classic cover of *The Big All-American Comic Book* #1 (1944) provided the inspiration for the cover (right) of the *9-11* benefit anthology (2002). BELOW: This set of four *TV Guide* covers from 2001 features the *Smallville* TV show. "This was a very pleasant project to do, and it went very smoothly. The show is great—it has a strong spiritual connection to the character that I totally identify with."

ROUGH COVER LAYOUT — I CAN ENLARGE THE FIGURES ON THE POST SO WE CROP THEM MORE. ALSO I CHANGE THE ANGLE OR VIEW ON AN PART OF IT

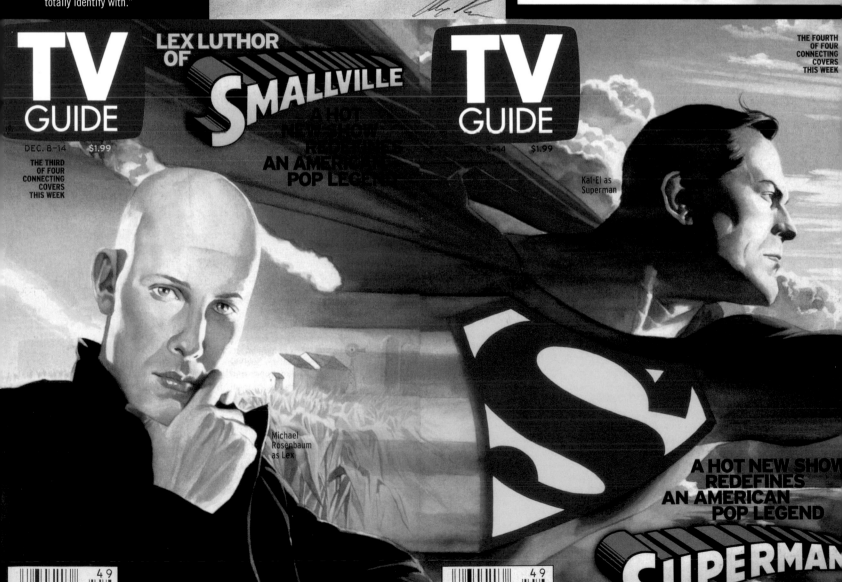

TV GUIDE

LEX LUTHOR OF **SMALLVILLE**

A HOT NEW SHOW REDEFINES AN AMERICAN POP LEGEND

TV GUIDE

THE FOURTH OF FOUR CONNECTING COVERS THIS WEEK

DEC. 8-14 $1.99

THE THIRD OF FOUR CONNECTING COVERS THIS WEEK

Kal-El as Superman

Michael Rosenbaum as Lex

A HOT NEW SHOW REDEFINES AN AMERICAN POP LEGEND

SUPERMAN

DEC. 8-14 $1.99

SCIENCE MYSTERY MAGIC MYTH

LEFT: Ross's first sketches and notes for what would become known as the "tabloid books" (1997). BELOW LEFT: An early cover concept for *Peace on Earth* (1998). BELOW RIGHT: The final cover of *Peace on Earth* (1998).

DC COMICS CELEBRATES 60 YEARS
OF THE GREATEST ARCHTYPES
OF THE MEDIUM.

THESE WERE THE FIRST.

1998	SUPERMAN: PEACE ON EARTH
1999	BATMAN
2000	SHAZAM!: MONSTER SOCIETY
2001	WONDER WOMAN

"When Alex and I first started working together in 1993," recalls DC Comics editor Charles Kochman, "he and I talked about collaborating on a project, perhaps a series. We wanted to do something that wasn't quite a comic, more of an all-ages picture book that harkened back to the tabloids we had grown up reading. The stories would be self-contained, removed from the 'baggage' of continuity, and deal with the essence of the heroes and how they would deal with problems in our 'real' world. Working with editor Joey Cavalieri, *Superman: Peace on Earth* was born."

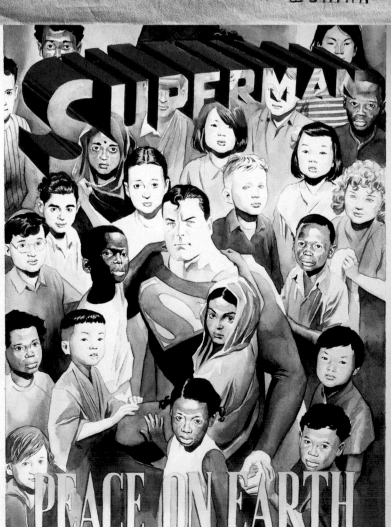

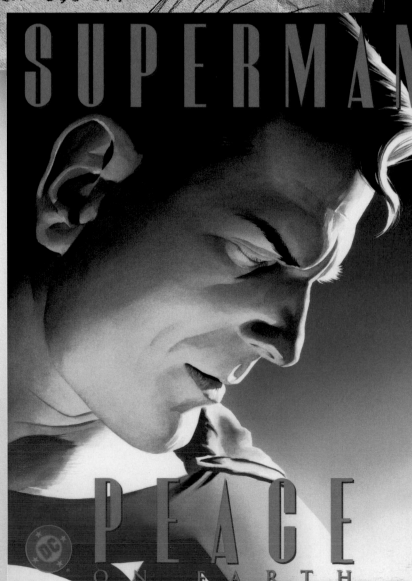

PEACE ON EARTH.

Superman: Peace on Earth, with text by Emmy award-winning writer Paul Dini, tells a story of how the Man of Steel might try to combat the planet's hunger problem, a concept that harkens back to the 1940s, when Siegel and Shuster routinely produced stories about Superman fighting in World War II.

That was then, however, and some battles are more decisively won than others. In the end, despite all his best intentions, Superman is no match for third-world political corruption, isolationist mistrust, and global fear of an ultra-concentrated superpower. Sound familiar?

And so, he fails miserably. But Ross did not. With the release of the book, he auctioned off all its original art through Sotheby's, with proceeds donated to UNICEF and Harper House in Chicago. A staggering $81,000 was raised. "In *Peace on Earth*," says Kochman, "Superman realizes that he can't solve all of the world's problems, and that he must lead by example. With the auctions [one for each book], that's what Alex tried to do. He put his money where his mouth is. It was a very generous gesture."

"Paul was really up to the task this project proposed," says Ross. "He has an innate understanding of these characters and their spiritual engines. He doesn't let the material get absurd or tongue-in-cheek, which is very important to me. He is also a damn fine writer."

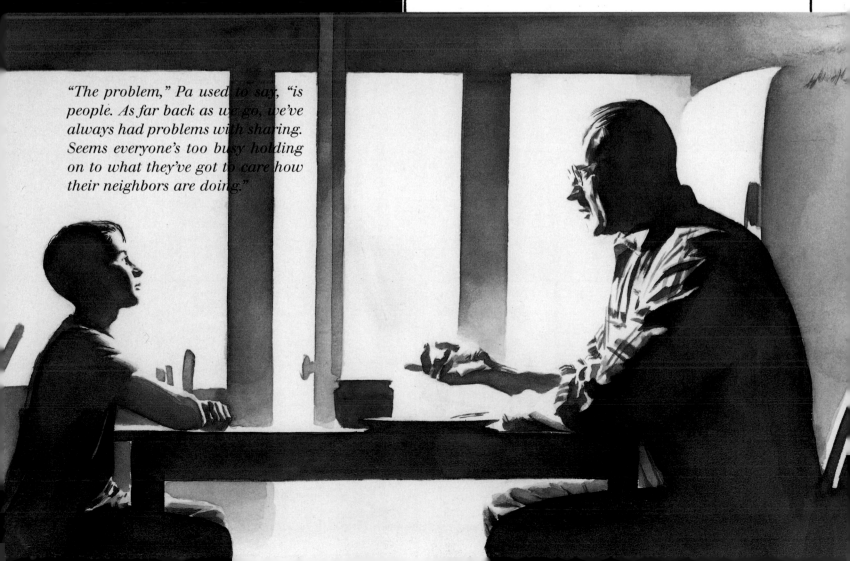

"The problem," Pa used to say, "is people. As far back as we go, we've always had problems with sharing. Seems everyone's too busy holding on to what they've got to care how their neighbors are doing."

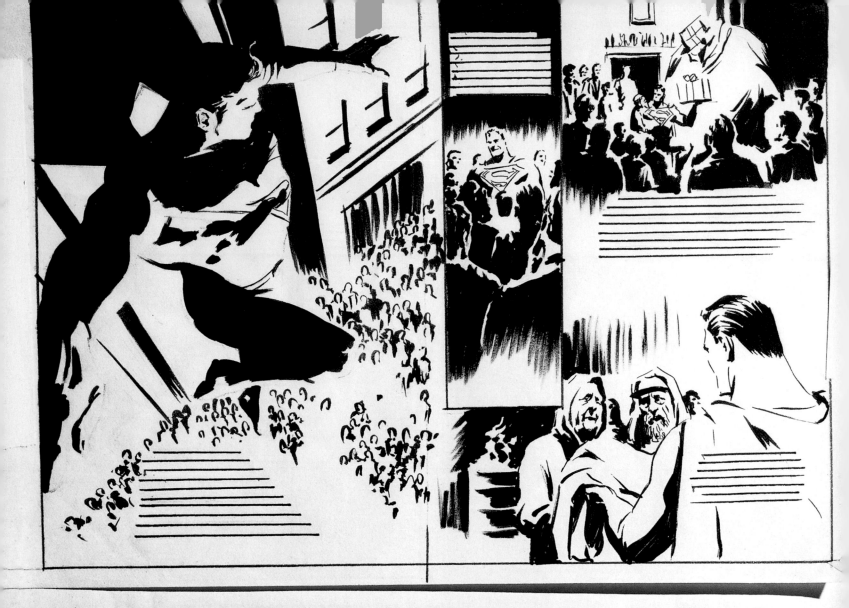

THIS EXAMPLE SHOWS A MORE INTERRUPTED FLOW OF PANEL ARRANGEMENT AND SOME VIGNETTES NOT BRACKETED BY PANEL SHAPES, ALLOWING THEM TO FLOW INTO ONE ANOTHER.

THE SCENE SIMPLY TRIES TO OFFER SOME IDEAS OF HOW SUPERMAN MIGHT TRY TO REACH OUT TO PEOPLE ON THE HOLIDAYS.

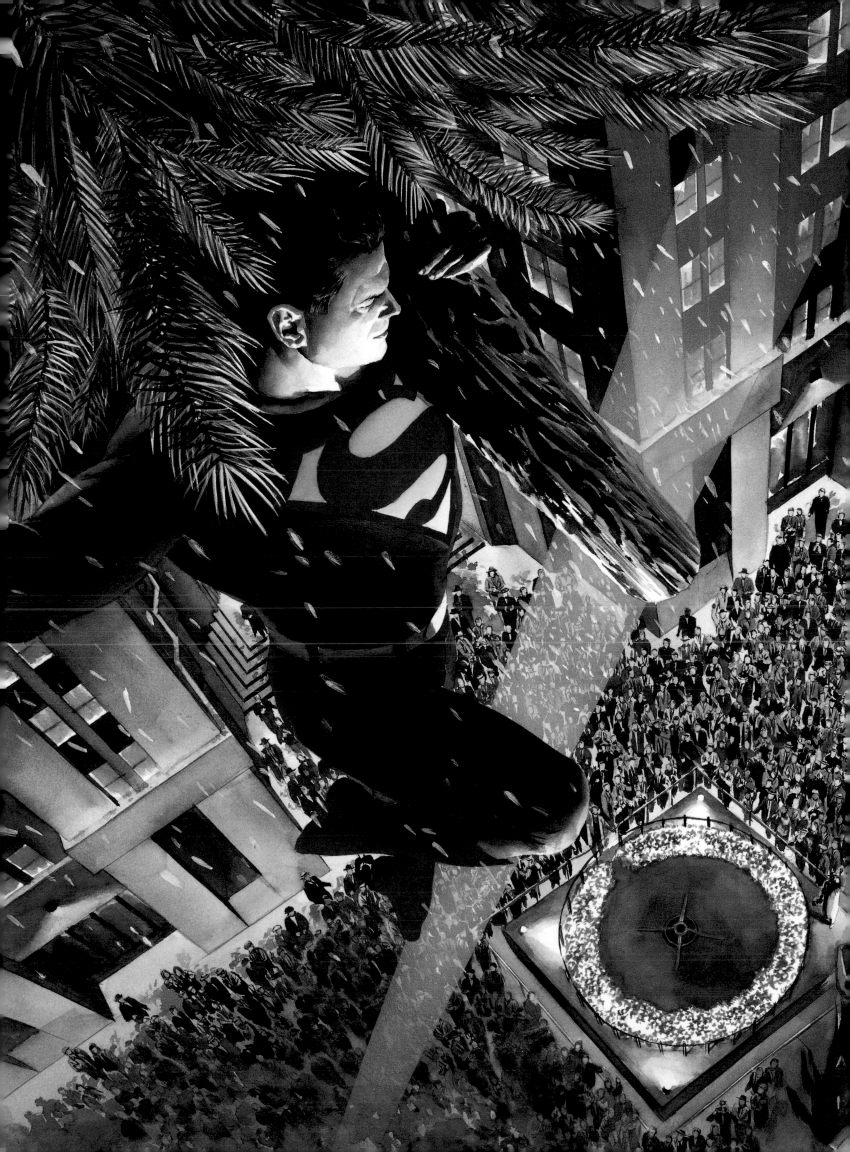

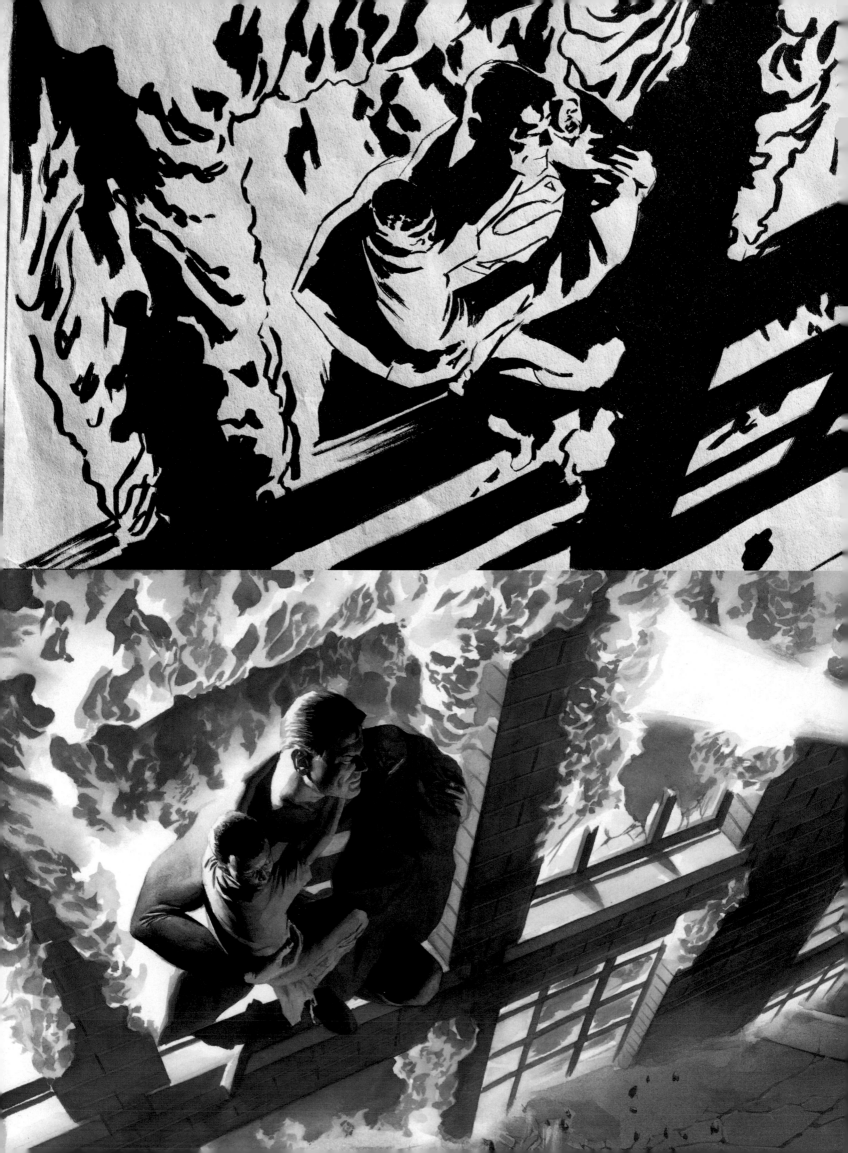

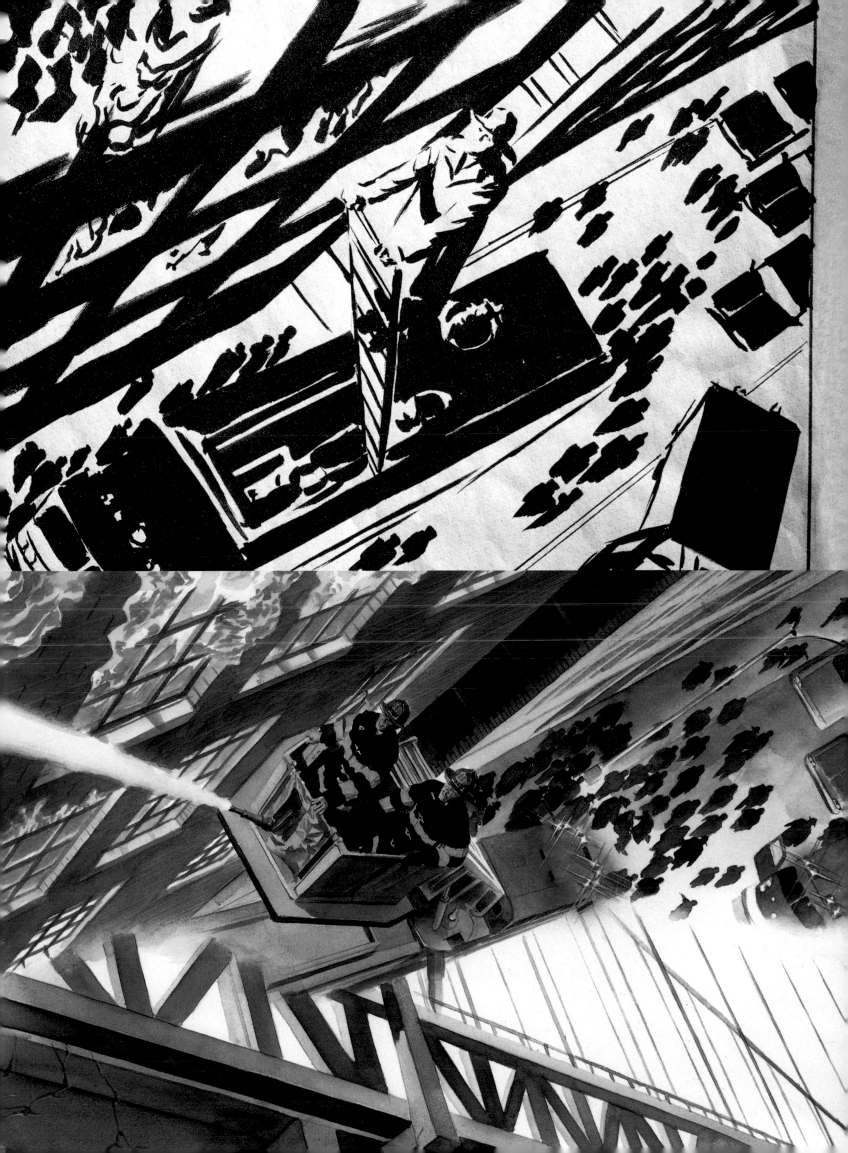

20 21 22 23

THIS IS MOSTLY A SPREAD WITH ONE PANEL INTERSECTING, SETTING THE LOCATION.

SUPERMAN IS SPEAKING BEFORE CONGRESS HERE, REQUESTING AID POSSIBLY IN HIS QUEST TO USE FOOD RESERVES TO FEED THE STARVING NATIONS.

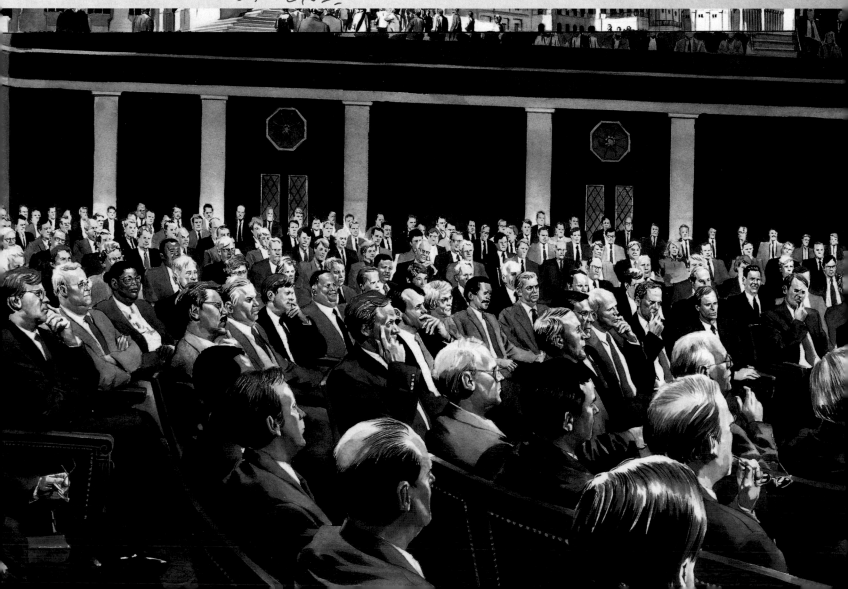

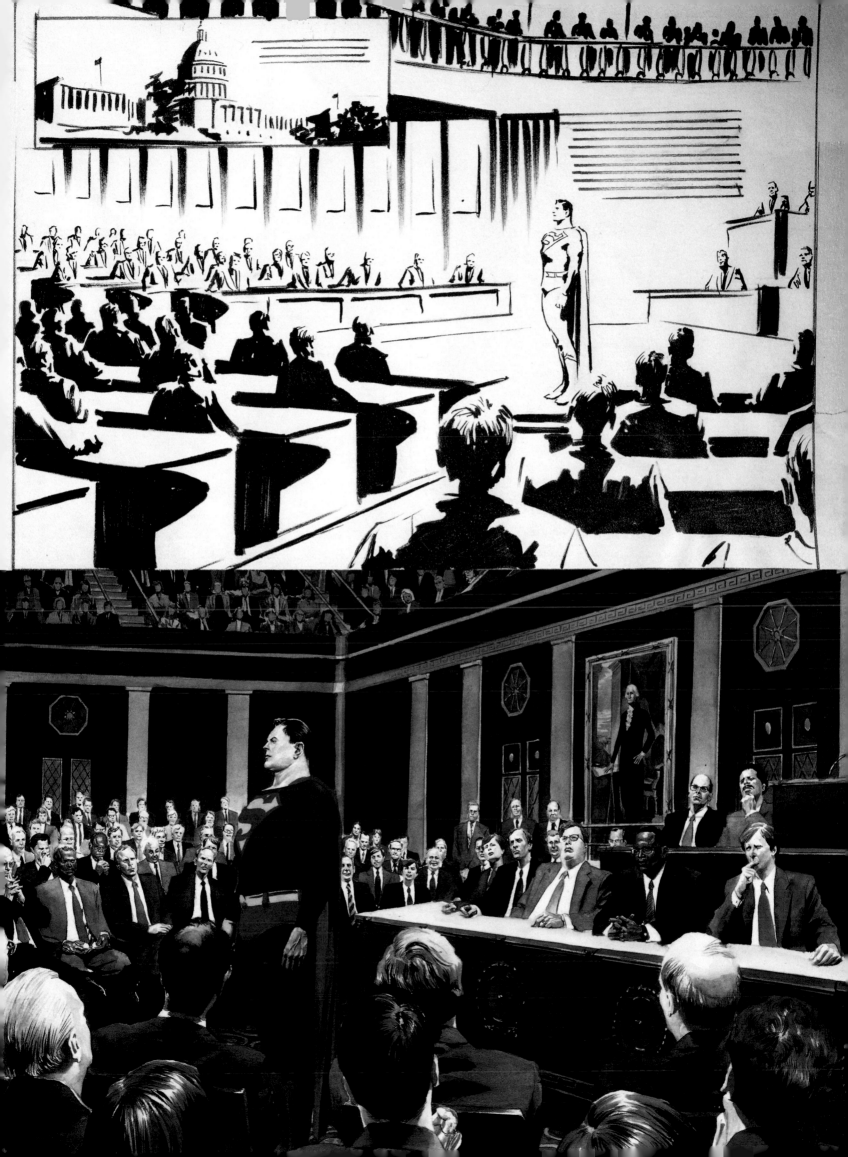

"Superman falls short of his goal throughout the story because he is the brawn that humanity shouldn't (and doesn't) have," says Ross. "In the process of trying to save people from themselves, he ends up making them reliant on him and therefore fails. It's not something that can be done by hand, it has to be done by example, and that's what he learns. To me, Superman as a fictional character is just as important as if he existed in flesh and blood—either way he is inspirational, and that's what's relevant."

On the process of making thumbnail pencil layouts (seen here at actual size): "A passionate experience, intuitive and emotional. It helps develop a clear image in my mind of what I want to see. Paul [Dini] doesn't give a page-by-page breakdown in his script, and that frees me up to figure out how to move the story along at my own pace. It's also at this stage that the DC editors respond with notes on what they think works or doesn't, and give comments like 'avoid that tangent, or try to keep this or that image out of the gutter of the book.' At this stage, I get a better overview of something at this reduced scale than I would by working on it actual size from the get-go. Blowing it up then becomes this big release."

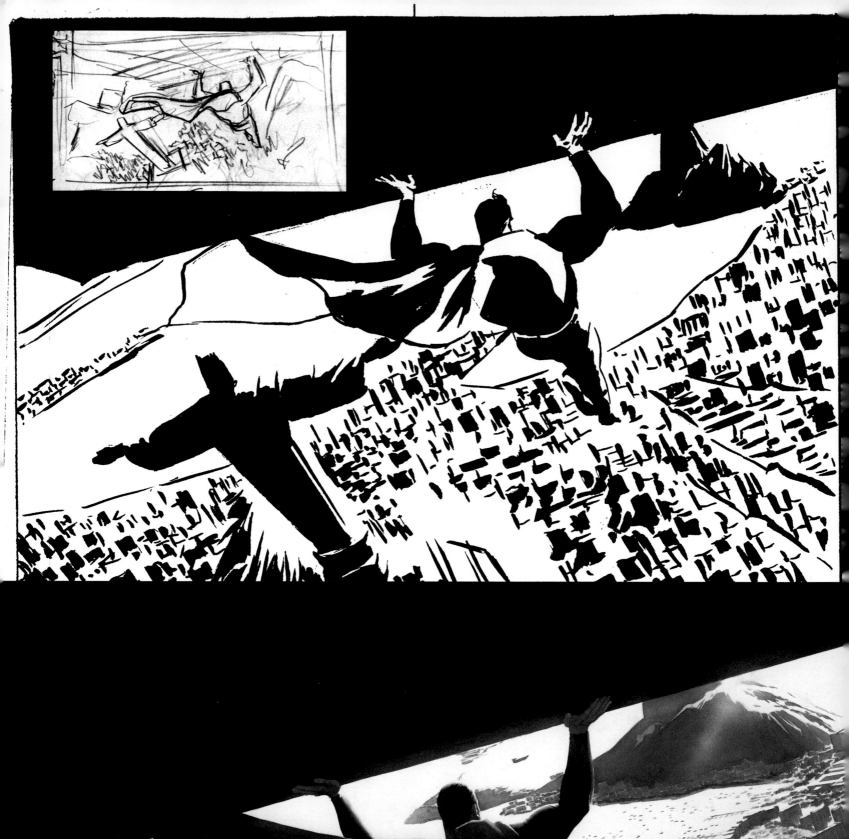
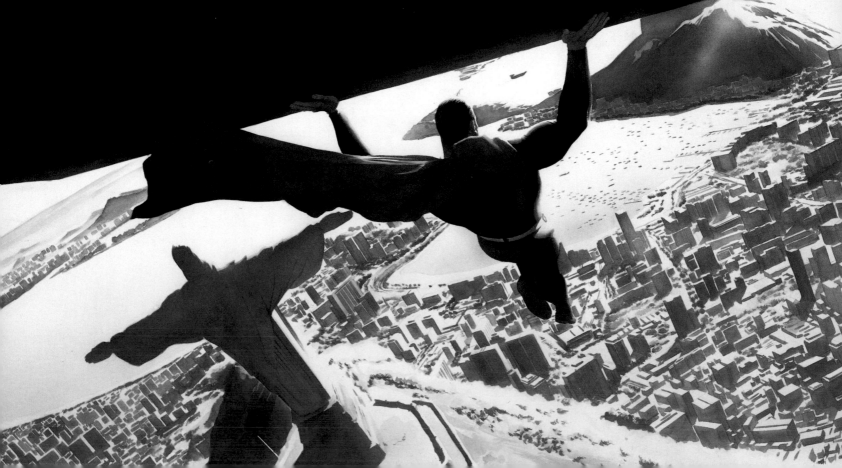

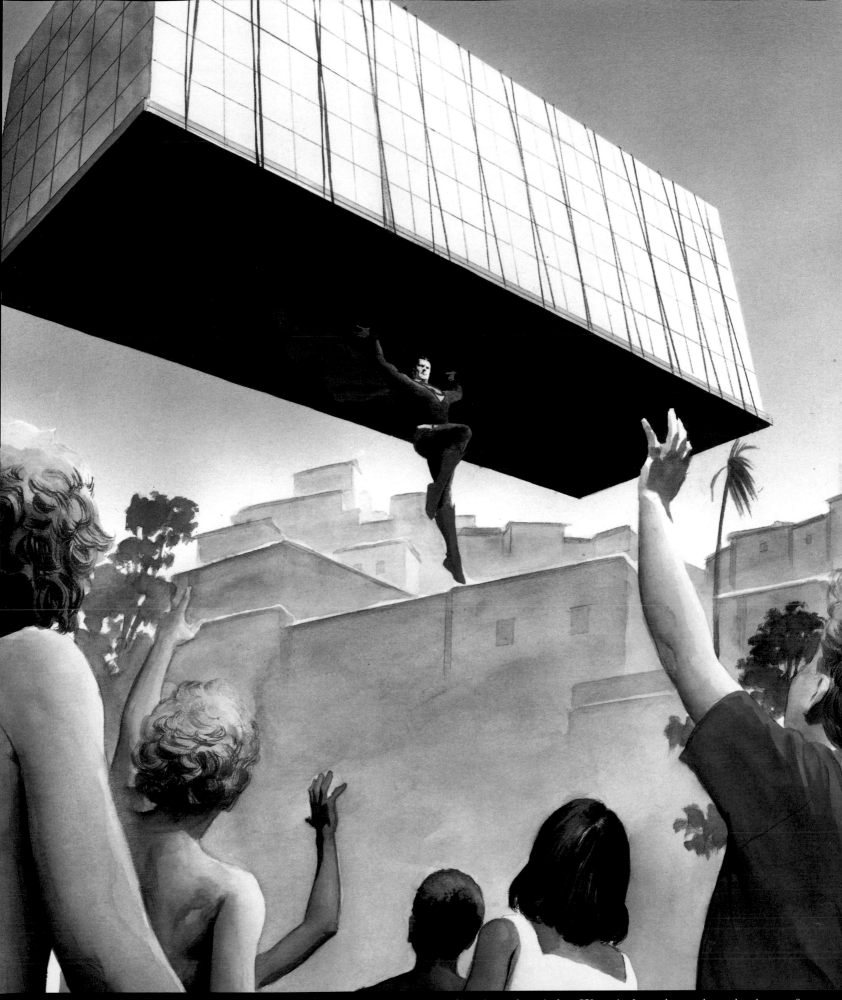

"In this story, Superman may be a stand-in for Christ, but he is also undoubtedly a metaphor for America. He's trying to fix everything by himself as opposed to inspiring others to follow his example. Paul and I weren't criticizing American foreign policy per se, we were trying to cast a benevolent eye on our country's compulsive desire to correct things in a direct, instant way—that we have not just the ability but the right. We tried to show that the best of intentions cannot always be rewarded or even be the right thing to do in every case.

"All of these 'tabloid' books take on basic problems within the human condition, which the heroes have no hope of solving. The point is: what they can ultimately do is not suggest a pat solution, but a viable first step."

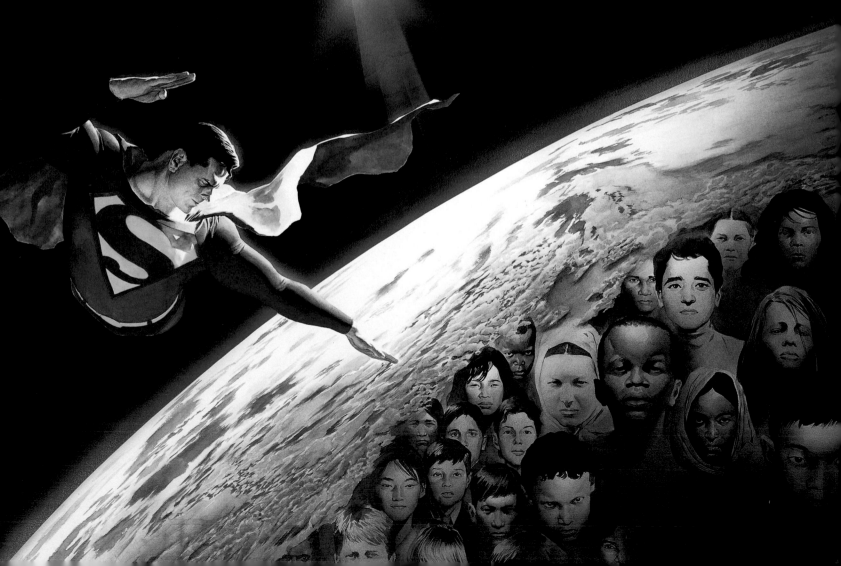

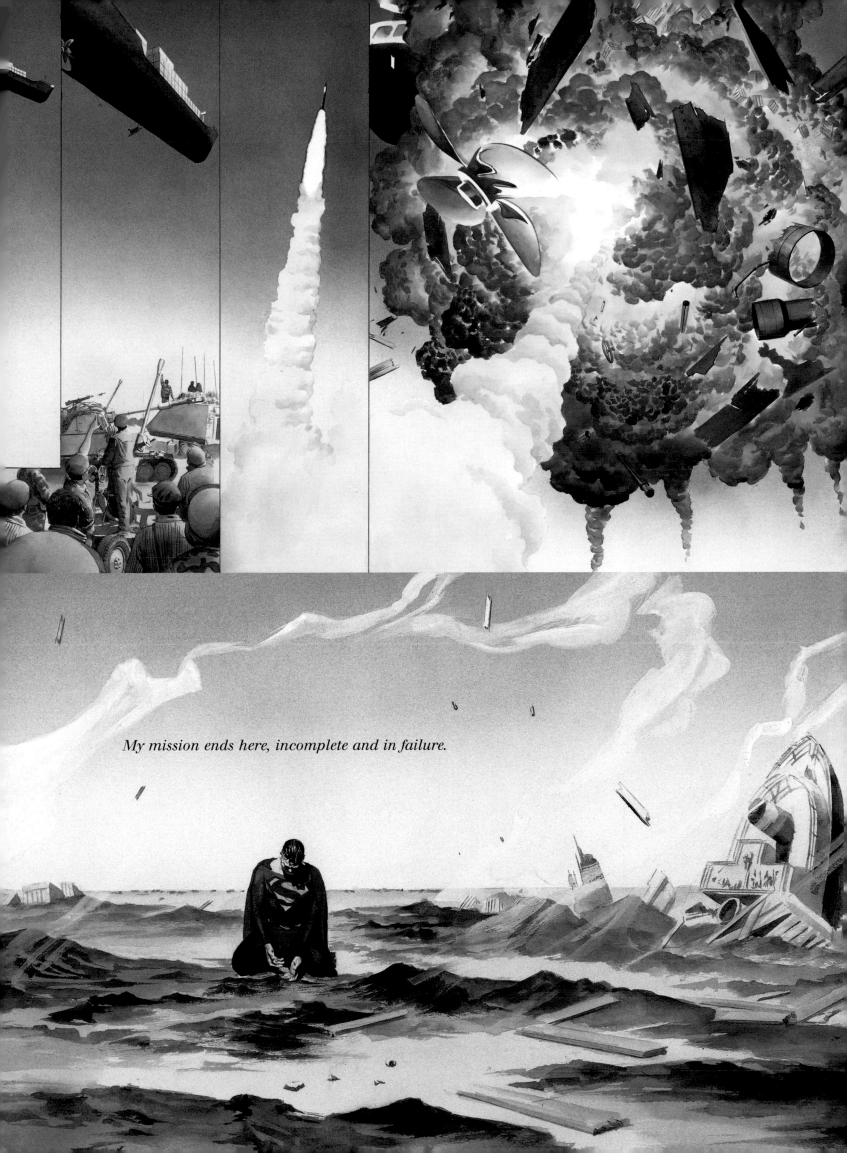

My mission ends here, incomplete and in failure.

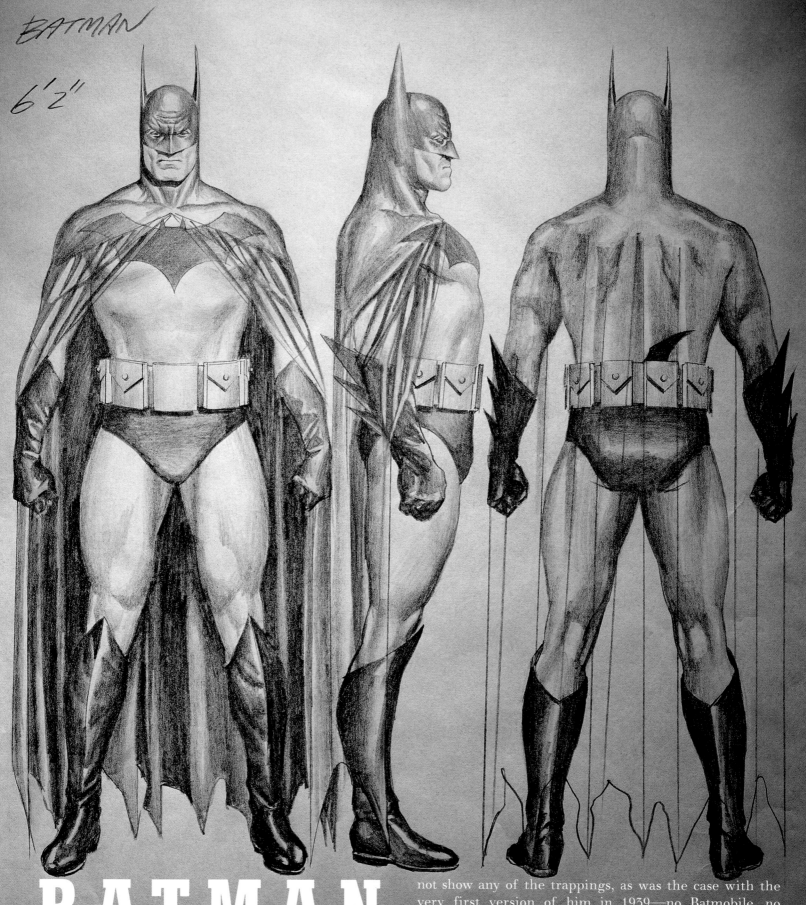

BATMAN

6'2"

BATMAN.

According to Alex: "It's difficult working on Batman because so much has already been done with him. The challenge is to bring something new to the character that doesn't feel forced or illogical. And the movies have gone so over the top with effects, gadgets, glitz, etc. So I went lo-tech with him, and took steps they wouldn't—the fact that, in the films, he has all his riches so conspicuously displayed, to me, runs counter to hiding his identity. My approach is to not show any of the trappings, as was the case with the very first version of him in 1939—no Batmobile, no Batplane. I love all that stuff, but it takes the focus away from the character himself, which is what interests me. It should all be a mystery: nobody even knows if he has a plane because no one's ever seen it. He has a rope, an unmarked car, a few crude weapons. He just appears, which is even scarier."

Another modification was to enlarge the bat-symbol on his chest. "That's inspired by Joe Staton's depiction of Batman from the 1970s. I think it totally suits him. Why wouldn't it be big? It's imposing. He's *Batman*, for heaven's sake."

ABOVE: Three turnaround views, in pencil, for video game development (1999). OPPOSITE: A detail of the two-page origin of Batman, painted for *Batman: War on Crime* (1999).

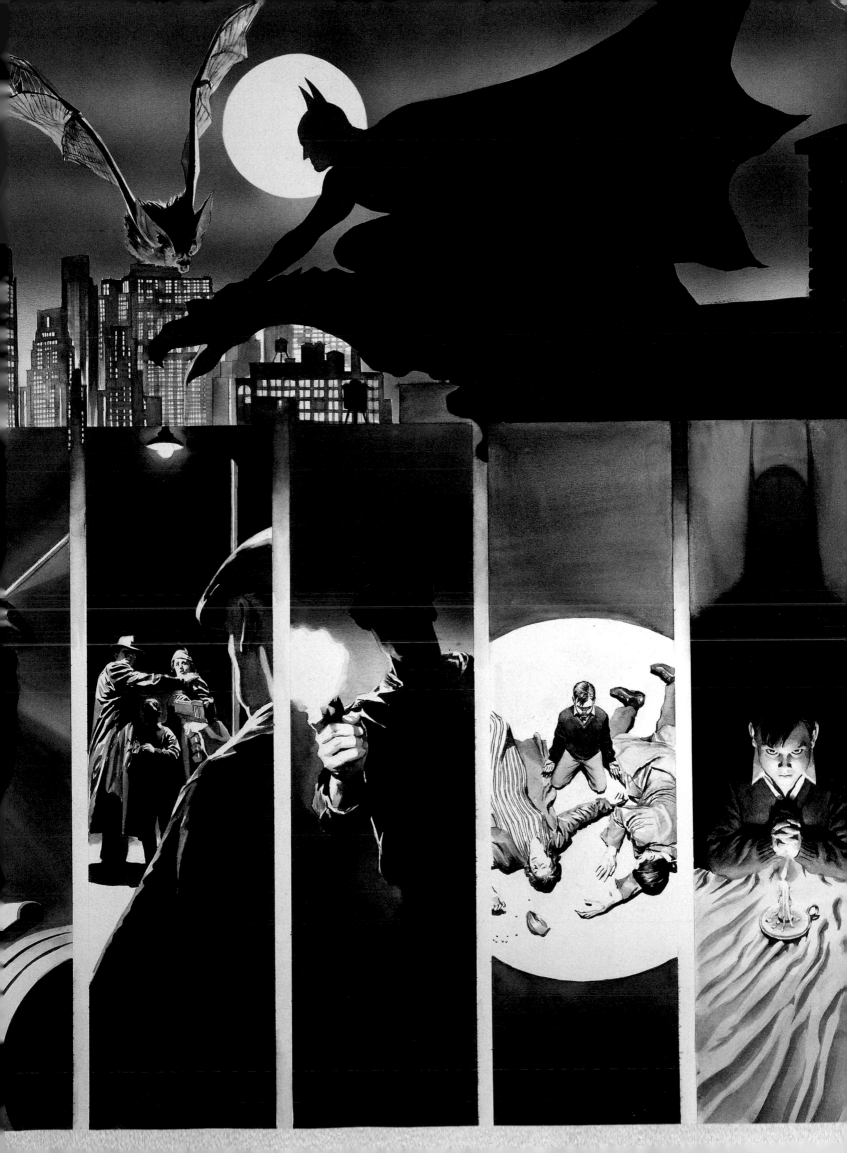

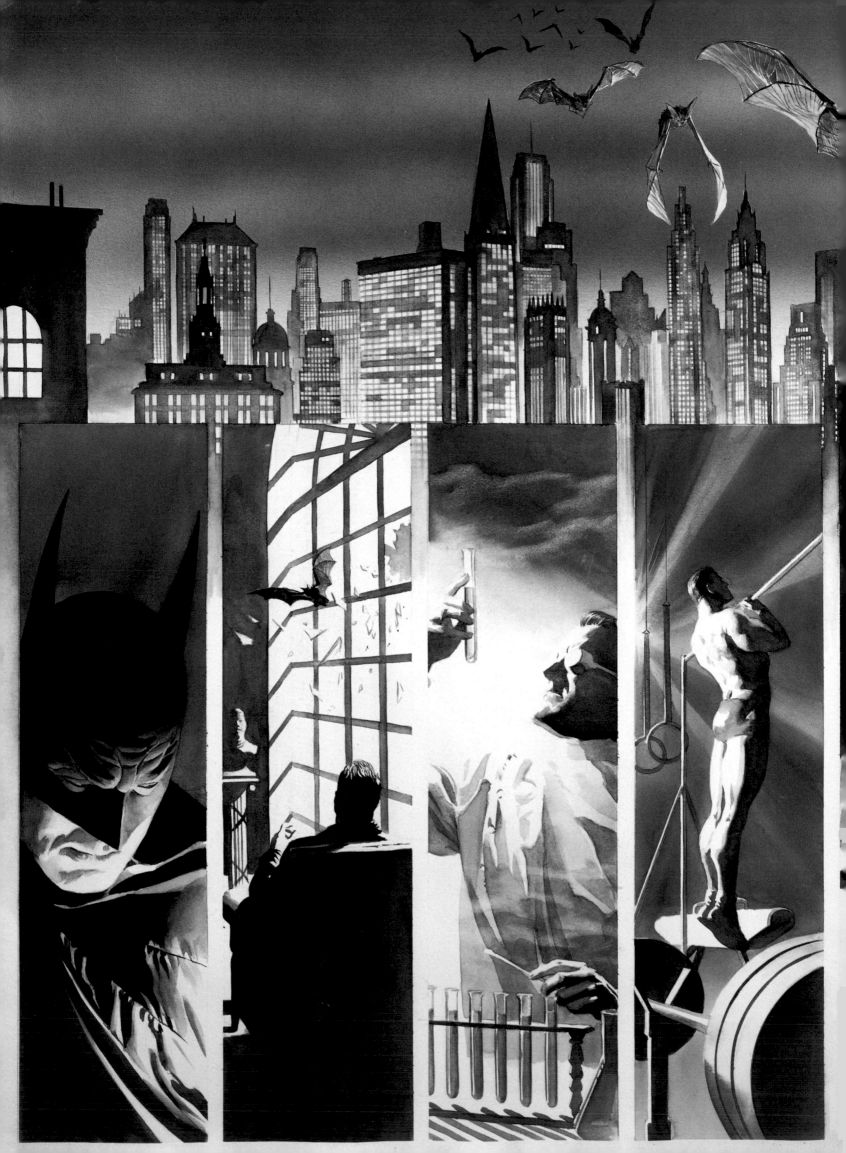

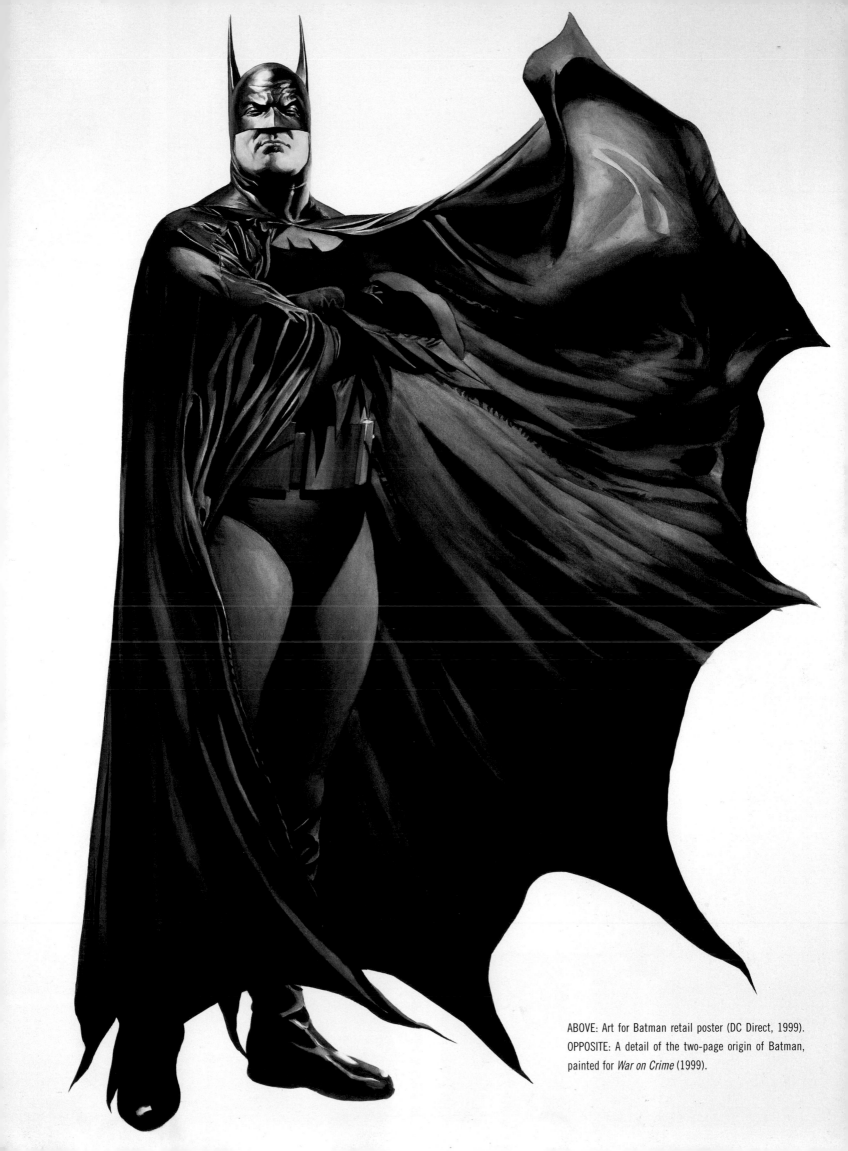

ABOVE: Art for Batman retail poster (DC Direct, 1999).
OPPOSITE: A detail of the two-page origin of Batman,
painted for *War on Crime* (1999).

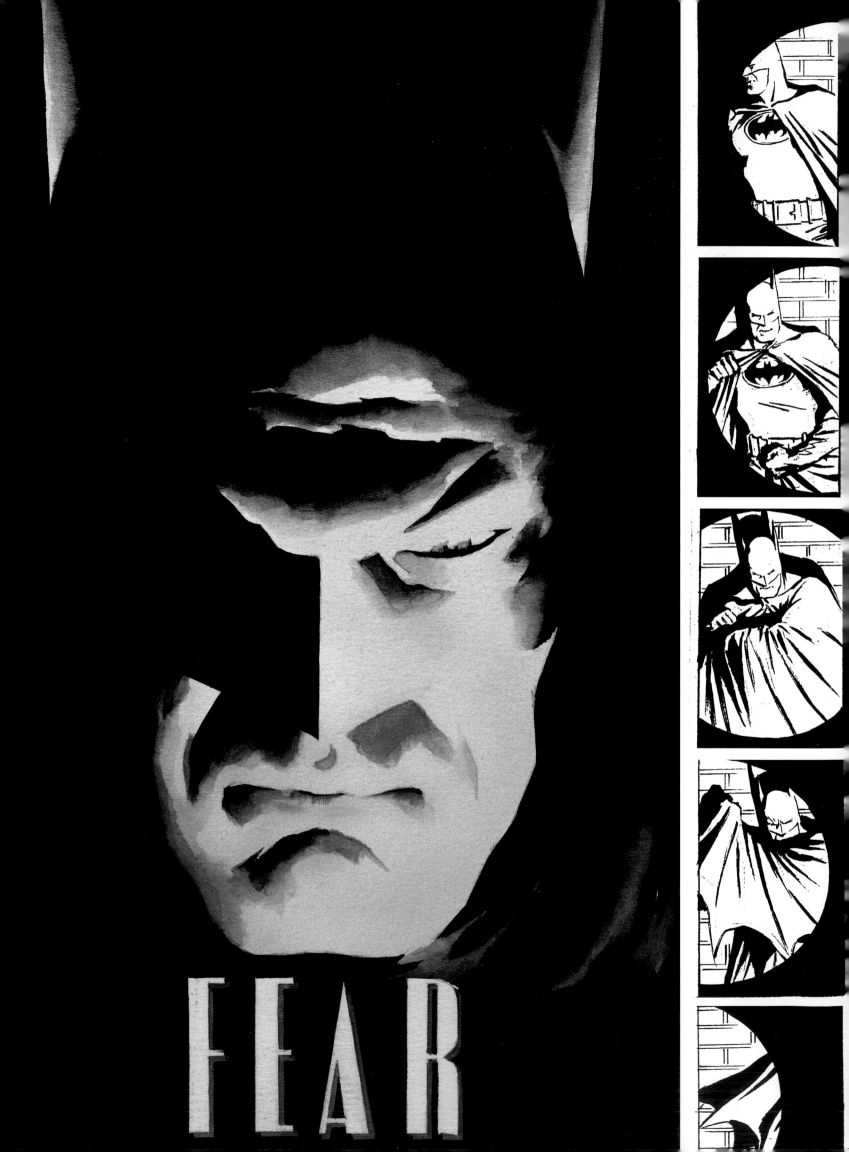

FEAR

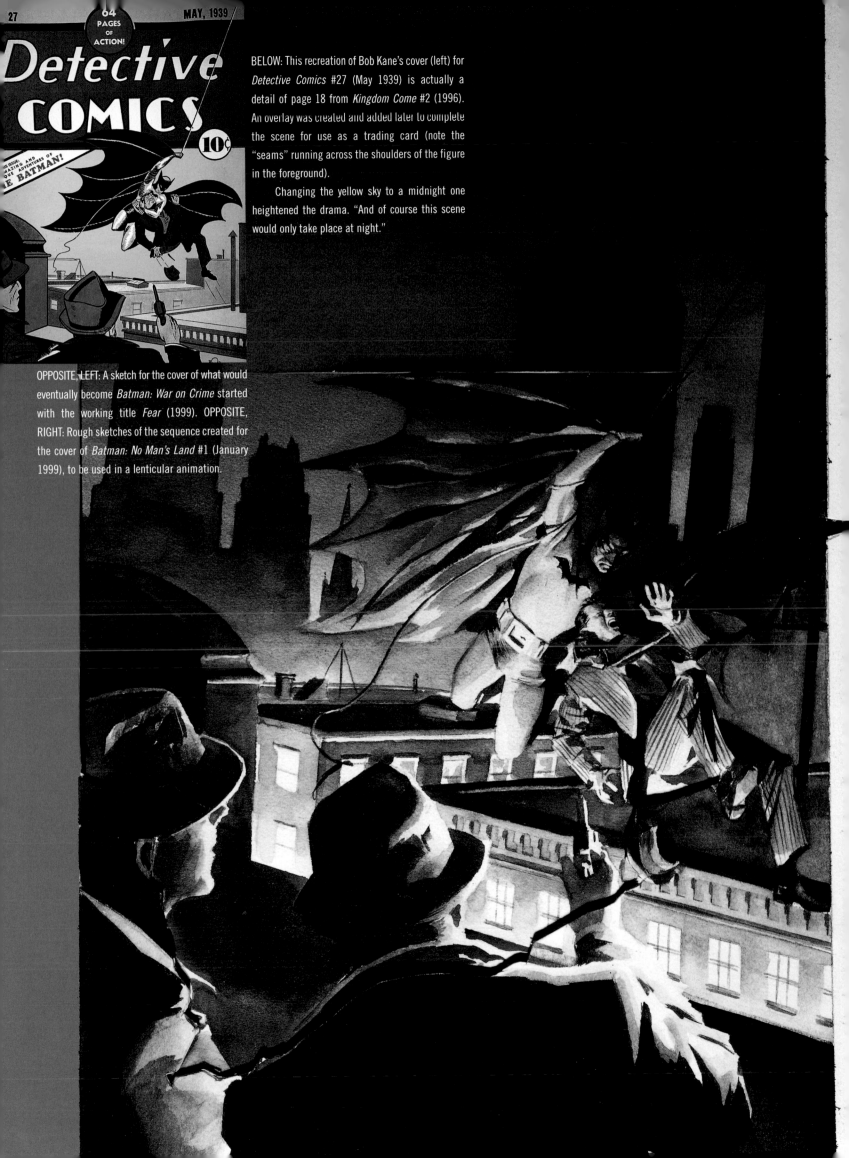

64 PAGES OF ACTION!

MAY, 1939

Detective COMICS

10¢

THIS ISSUE: AMAZING AND UNIQUE ADVENTURES OF THE BATMAN!

BELOW: This recreation of Bob Kane's cover (left) for *Detective Comics* #27 (May 1939) is actually a detail of page 18 from *Kingdom Come* #2 (1996). An overlay was created and added later to complete the scene for use as a trading card (note the "seams" running across the shoulders of the figure in the foreground).

Changing the yellow sky to a midnight one heightened the drama. "And of course this scene would only take place at night."

OPPOSITE, LEFT: A sketch for the cover of what would eventually become *Batman: War on Crime* started with the working title *Fear* (1999). OPPOSITE, RIGHT: Rough sketches of the sequence created for the cover of *Batman: No Man's Land* #1 (January 1999), to be used in a lenticular animation.

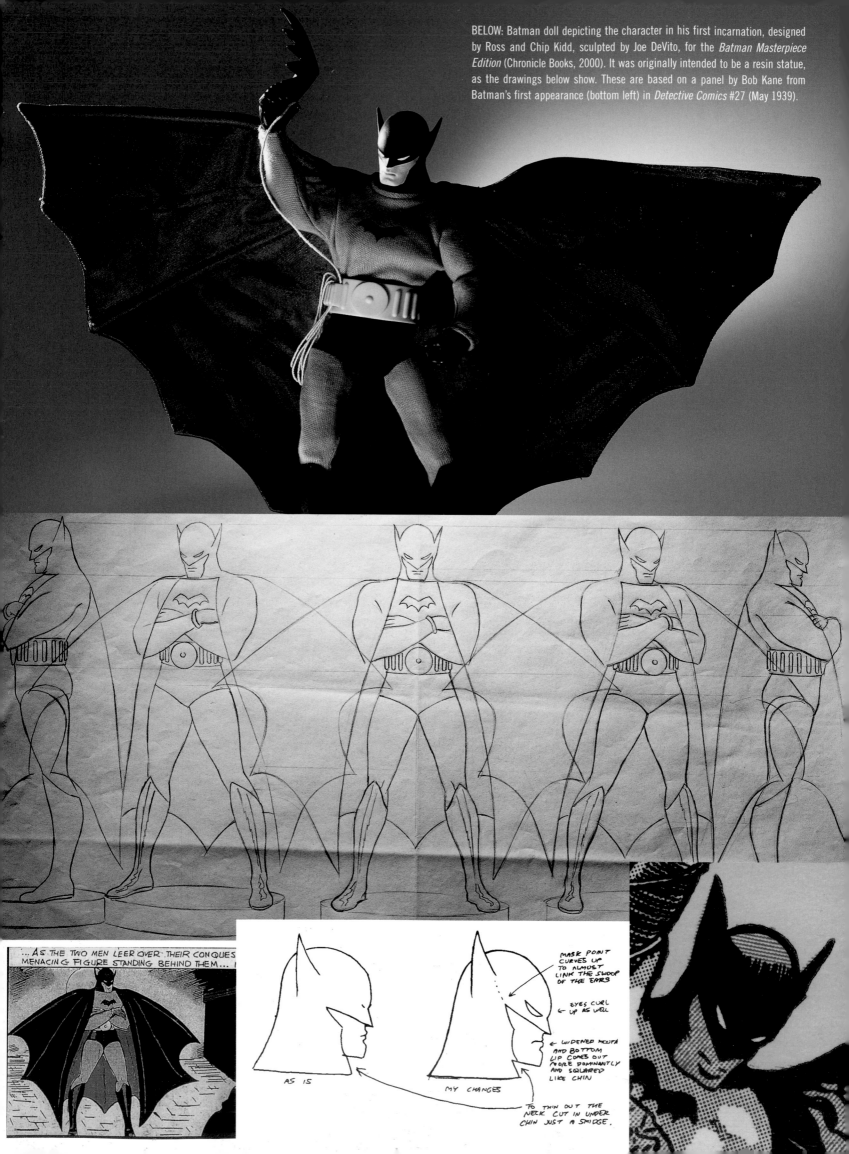

BELOW: Batman doll depicting the character in his first incarnation, designed by Ross and Chip Kidd, sculpted by Joe DeVito, for the *Batman Masterpiece Edition* (Chronicle Books, 2000). It was originally intended to be a resin statue, as the drawings below show. These are based on a panel by Bob Kane from Batman's first appearance (bottom left) in *Detective Comics* #27 (May 1939).

...AS THE TWO MEN LEER OVER THEIR CONQUES... MENACING FIGURE STANDING BEHIND THEM...

MASK POINT CURVES UP TO ALMOST LINK THE SWOOP OF THE EARS

EYES CURL UP AS WELL

WIDENED MOUTH AND BOTTOM LIP COMES OUT MORE DOMINANTLY AND SQUARED LIKE CHIN

AS IS

MY CHANGES

TO THIN OUT THE NECK CUT IN UNDER CHIN JUST A SMIDGE.

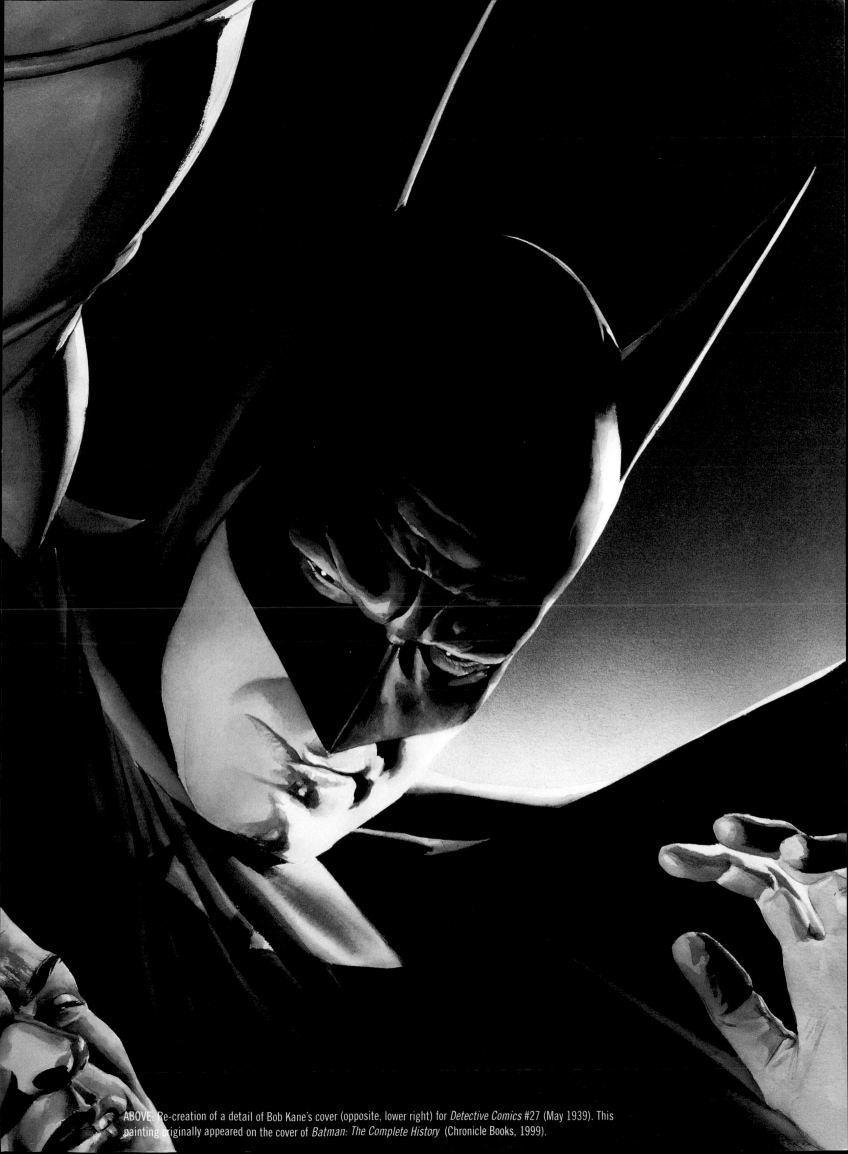

ABOVE: Re-creation of a detail of Bob Kane's cover (opposite, lower right) for *Detective Comics* #27 (May 1939). This painting originally appeared on the cover of *Batman: The Complete History* (Chronicle Books, 1999).

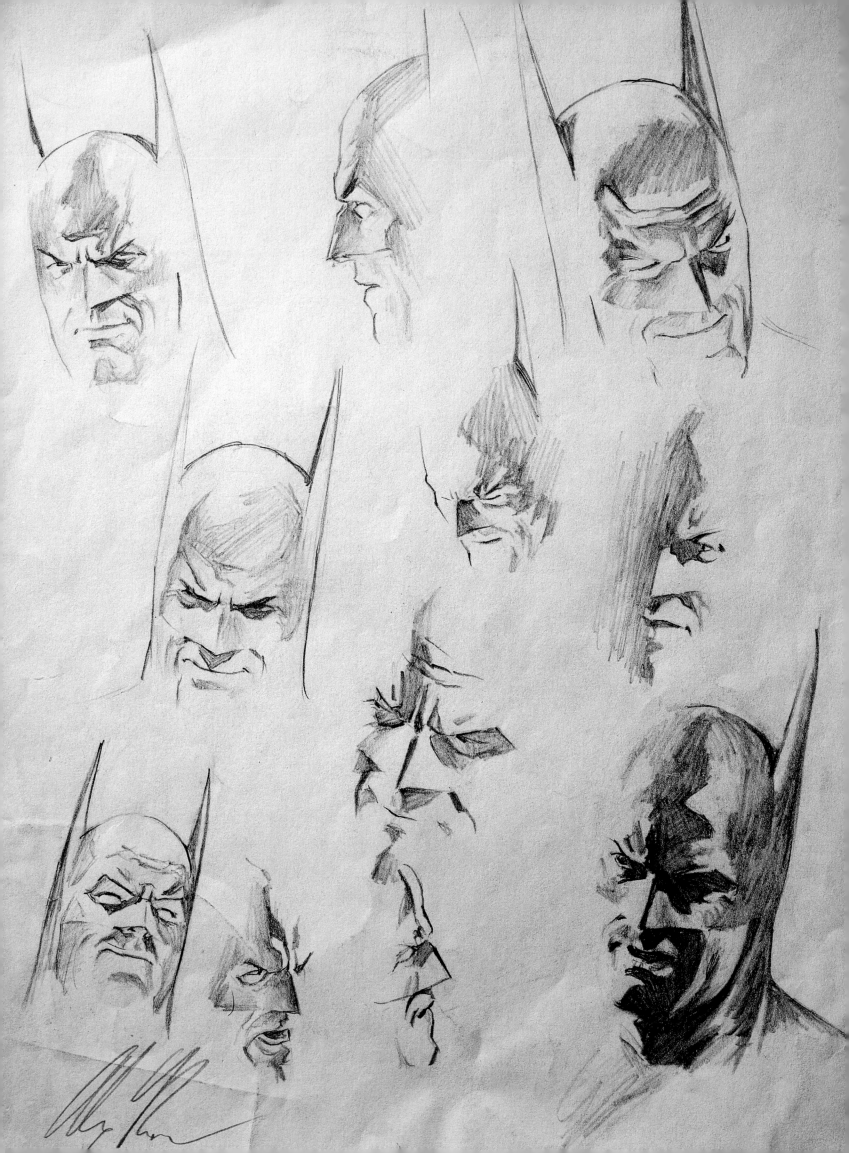

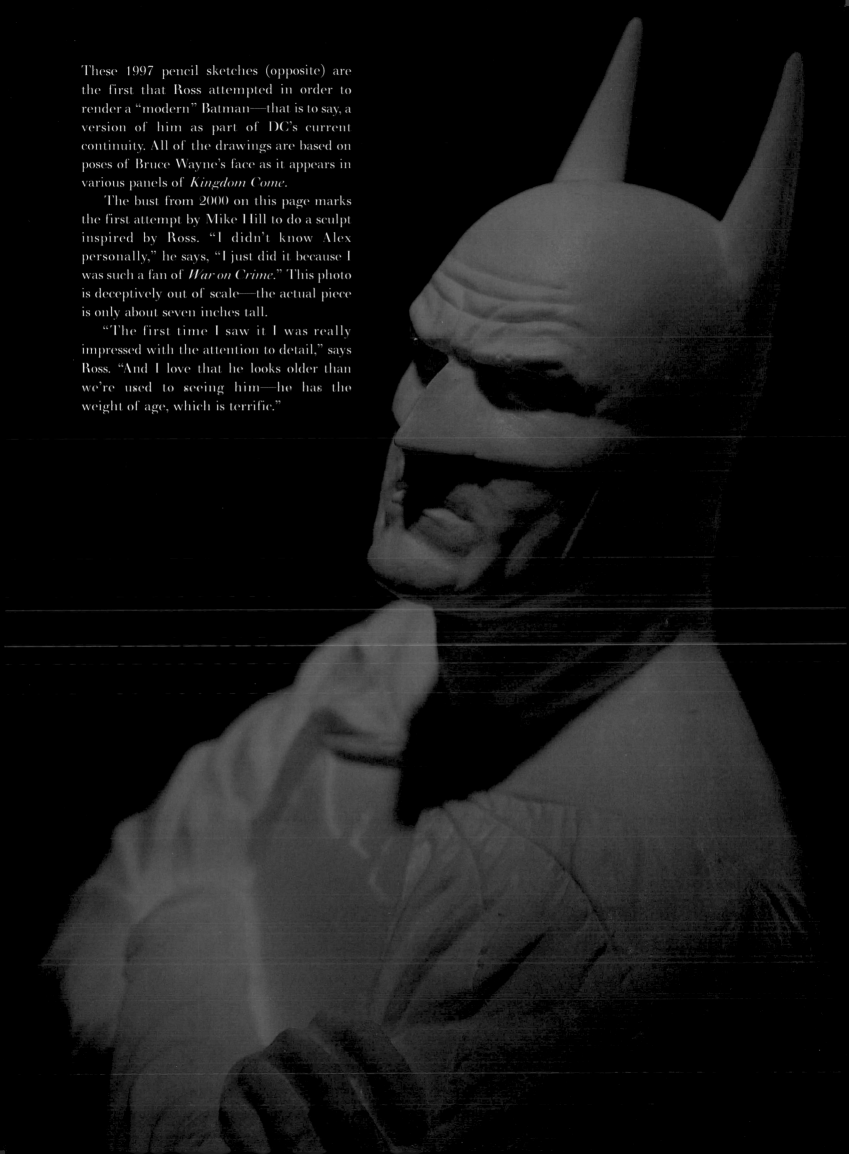

These 1997 pencil sketches (opposite) are the first that Ross attempted in order to render a "modern" Batman—that is to say, a version of him as part of DC's current continuity. All of the drawings are based on poses of Bruce Wayne's face as it appears in various panels of *Kingdom Come*.

The bust from 2000 on this page marks the first attempt by Mike Hill to do a sculpt inspired by Ross. "I didn't know Alex personally," he says, "I just did it because I was such a fan of *War on Crime*." This photo is deceptively out of scale—the actual piece is only about seven inches tall.

"The first time I saw it I was really impressed with the attention to detail," says Ross. "And I love that he looks older than we're used to seeing him—he has the weight of age, which is terrific."

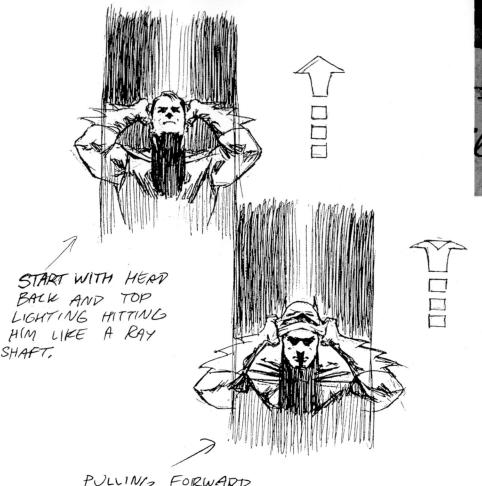

START WITH HEAD BACK AND TOP LIGHTING HITTING HIM LIKE A RAY SHAFT.

PULLING FORWARD THE MASK SLOWLY PULLS FORWARD OVER ~~██~~ FOREHEAD WITH FEATURES MOSTLY IN DARKNESS

Proposed concept sketches for the cover of *Batman: No Man's Land* #1 (January 1999), to be used in a lenticular animation.

PULLED ON COMPLETELY, SORT OF HUNCHED OVER WITH NEW UNDERLIGHTING HITTING FROM BELOW WHILE TOP LIGHTING IS MORE LIKE RIM LIGHTING, FRAMING THE FIGURE.

The sketches and photos on the opposite page represent the product of a young comic fan's dream. "I always thought the 1950 Batmobile, with that fin, was the coolest ever. When I was nineteen I came upon a small inheritance, and I decided I would use it to make a Batmobile for myself. My older brother Lindsay (who urged me to pursue this dream) had a keen interest in cars, and could see that the 1950 Studebaker, designed by Raymond Loewy, was the basis for the comic book Batmobile. Lindsay eventually found one in 1991 in California, towed it to Chicago, and worked for the next several years to restore and customize it with fiberglass attachments. I admit I've never actually driven it. By the time it was working, I felt less comfortable with the idea of attracting all that attention, which I must have needed more of when I was nineteen."

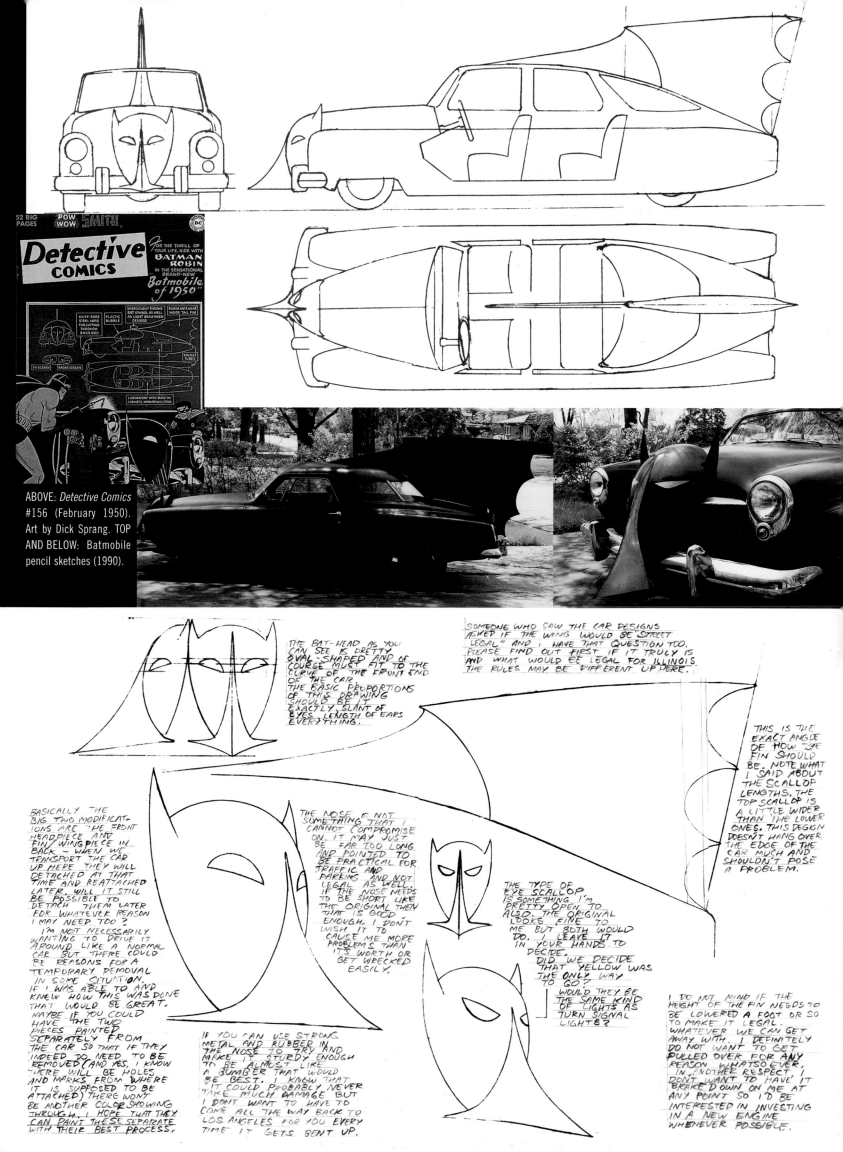

ABOVE: *Detective Comics* #156 (February 1950). Art by Dick Sprang. TOP AND BELOW: Batmobile pencil sketches (1990).

THE BAT-HEAD AS YOU CAN SEE IS PRETTY OVAL-SHAPED AND OF COURSE MUST FIT TO THE CURVE OF THE FRONT END OF THE CAR. THE BASIC PROPORTIONS OF THIS DRAWING SHOULD BE IT EXACTLY, SLANT OF EYES, LENGTH OF EARS, EVERYTHING.

SOMEONE WHO SAW THE CAR DESIGNS ASKED IF THE WING WOULD BE "STREET LEGAL" AND I HAVE THAT QUESTION TOO. PLEASE FIND OUT FIRST IF IT TRULY IS AND WHAT WOULD BE LEGAL FOR ILLINOIS. THE RULES MAY BE DIFFERENT UP HERE.

THIS IS THE EXACT ANGLE OF HOW THE FIN SHOULD BE. NOTE WHAT I SAID ABOUT THE SCALLOP LENGTHS. THE TOP SCALLOP IS A LITTLE WIDER THAN THE LOWER ONES. THIS DESIGN DOESN'T HANG OVER THE EDGE OF THE CAR MUCH AND SHOULDN'T POSE A PROBLEM.

BASICALLY THE BIG TWO MODIFICAT-IONS ARE THE FRONT HEADPIECE AND FIN/WINGPIECE IN BACK — WHEN WE TRANSPORT THE CAR UP HERE THEY WILL DETACHED AT THAT TIME AND REATTACHED LATER. WILL IT STILL BE POSSIBLE TO DETACH THEM LATER FOR WHATEVER REASON I MAY NEED TOO? I'M NOT NECESSARILY WANTING TO DRIVE IT AROUND LIKE A NORMAL CAR BUT THERE COULD BE REASONS FOR A TEMPORARY REMOVAL IN SOME SITUATION. IF I WAS ABLE TO AND KNEW HOW THIS WAS DONE THAT WOULD BE GREAT. MAYBE IF YOU COULD HAVE THE TWO PIECES PAINTED SEPARATELY FROM THE CAR SO THAT IF THEY INDEED DO NEED TO BE REMOVED (AND YES, I KNOW THERE WILL BE HOLES AND MARKS FROM WHERE IT IS SUPPOSED TO BE ATTACHED) THERE WON'T BE ANOTHER COLOR SHOWING THROUGH. I HOPE THAT THEY CAN PAINT THESE SEPARATE WITH THEIR BEST PROCESS.

THE NOSE IS NOT SOMETHING THAT I CANNOT COMPROMISE ON. IT MAY JUST BE FAR TOO LONG AND POINTED TO BE PRACTICAL FOR TRAFFIC AND PARKING AND NOT LEGAL AS WELL. IF THE NOSE NEEDS TO BE SHORT LIKE THE ORIGINAL THEN THAT IS GOOD ENOUGH. I DON'T WISH IT TO CAUSE ME MORE PROBLEMS THAN IT'S WORTH OR GET WRECKED EASILY.

IF YOU CAN USE STRONG METAL AND RUBBER TO TRY AND MAKE IT STURDY ENOUGH TO BE ALMOST LIKE A BUMPER THAT WOULD BE BEST. I KNOW THAT IT COULD PROBABLY NEVER TAKE MUCH DAMAGE BUT I DON'T WANT TO HAVE TO COME ALL THE WAY BACK TO LOS ANGELES FOR YOU EVERY TIME IT GETS BENT UP.

THE TYPE OF EYE SCALLOP IS SOMETHING I'M PRETTY OPEN TO ALSO. THE ORIGINAL LOOKS FINE TO ME BUT BOTH WOULD DO. I LEAVE IT IN YOUR HANDS TO DECIDE.
DID WE DECIDE THAT YELLOW WAS THE ONLY WAY TO GO?
WOULD THEY BE THE SAME KIND OF LIGHTS AS TURN SIGNAL LIGHTS?

I DO NOT MIND IF THE HEIGHT OF THE FIN NEEDS TO BE LOWERED A FOOT OR SO TO MAKE IT LEGAL. WHATEVER WE CAN GET AWAY WITH. I DEFINITELY DO NOT WANT TO GET PULLED OVER FOR ANY REASON WHATSOEVER. IN ANOTHER RESPECT, I DON'T WANT TO HAVE IT BRAKE DOWN ON ME AT ANY POINT SO I'D BE INTERESTED IN INVESTING IN A NEW ENGINE WHENEVER POSSIBLE.

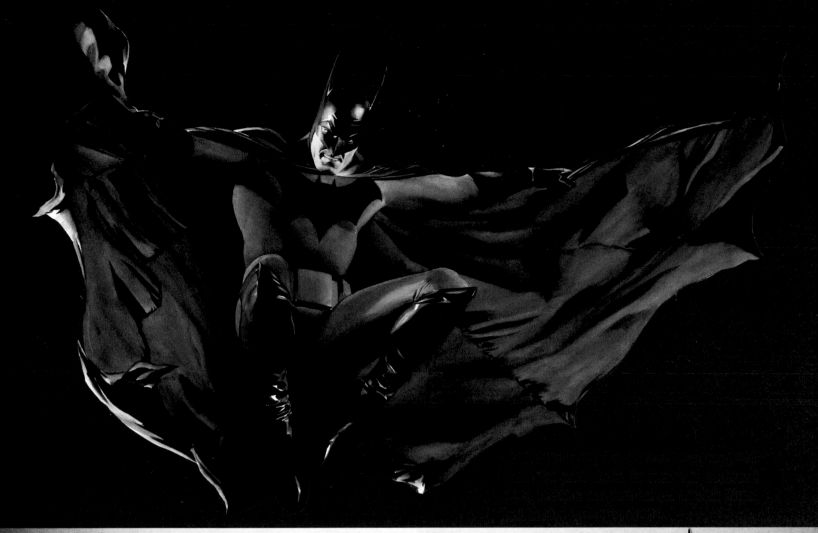

The chief distinction of Alex's version of the Dark Knight Detective might not seem so radical to people used to watching the Batman movies of the eighties and nineties, but to avid fans of the classic comics version of the character (me among them), his modification is pretty drastic: you can now look Batman right in the eye. Since 1939, the Caped Crusader's eyes had always been glowing white slits, as inscrutable as they were fear-inducing. But they do not translate into the logic of the "real" world that Alex imagines. "The only thing that makes sense is for the eye holes in his mask to come right up to his upper and lower eyelids," he says. "Then the mask *becomes* his face. But the eyes have to be exposed. They make him look more fearsome than if they're just white."

Curiously, this does not apply to Batman's appearance in *Kingdom Come*, because in that story (set in the future) he does not wear a simple cowl; he wears hi-tech robotic battle armor, complete with bright white beaming eyes in their classic crescent shapes.

BATMAN HEAD TURNS

On the heels of his life-size Ross-inspired Superman wax figure, Mike Hill set about to do the same for Ross's Batman. Only the head (opposite) was finished as this book went to press. Amazingly, it looks even more like a real person than its super-counterpart. "I set this next to similar busts I have of Val Kilmer and George Clooney," says Hill, "and it looks like he's about to eat them for breakfast."

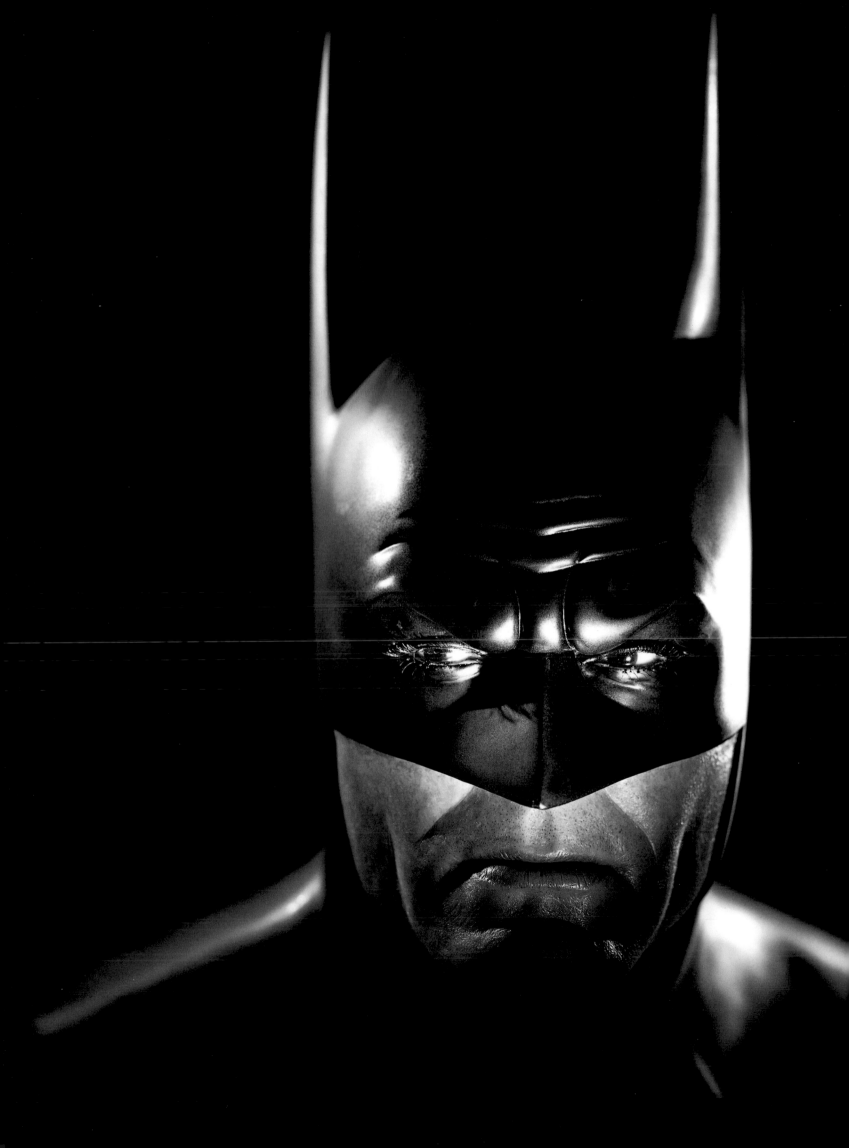

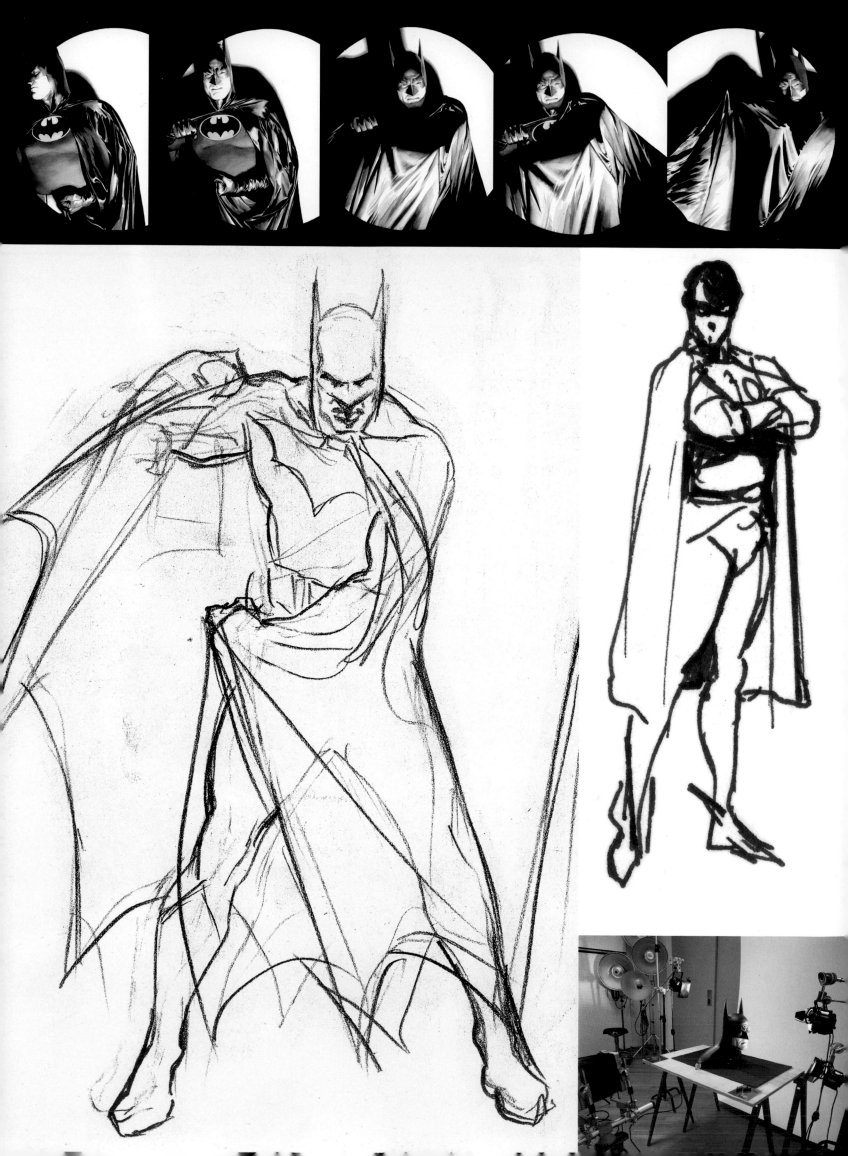

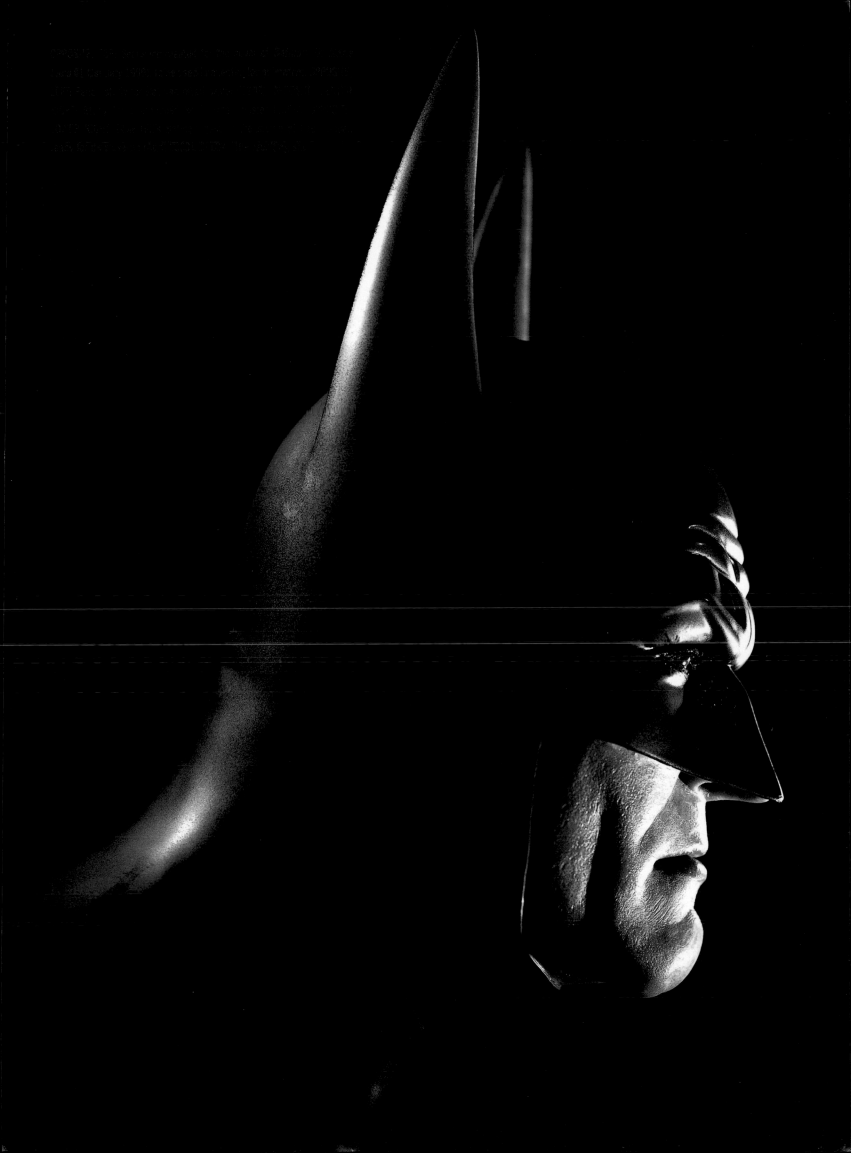

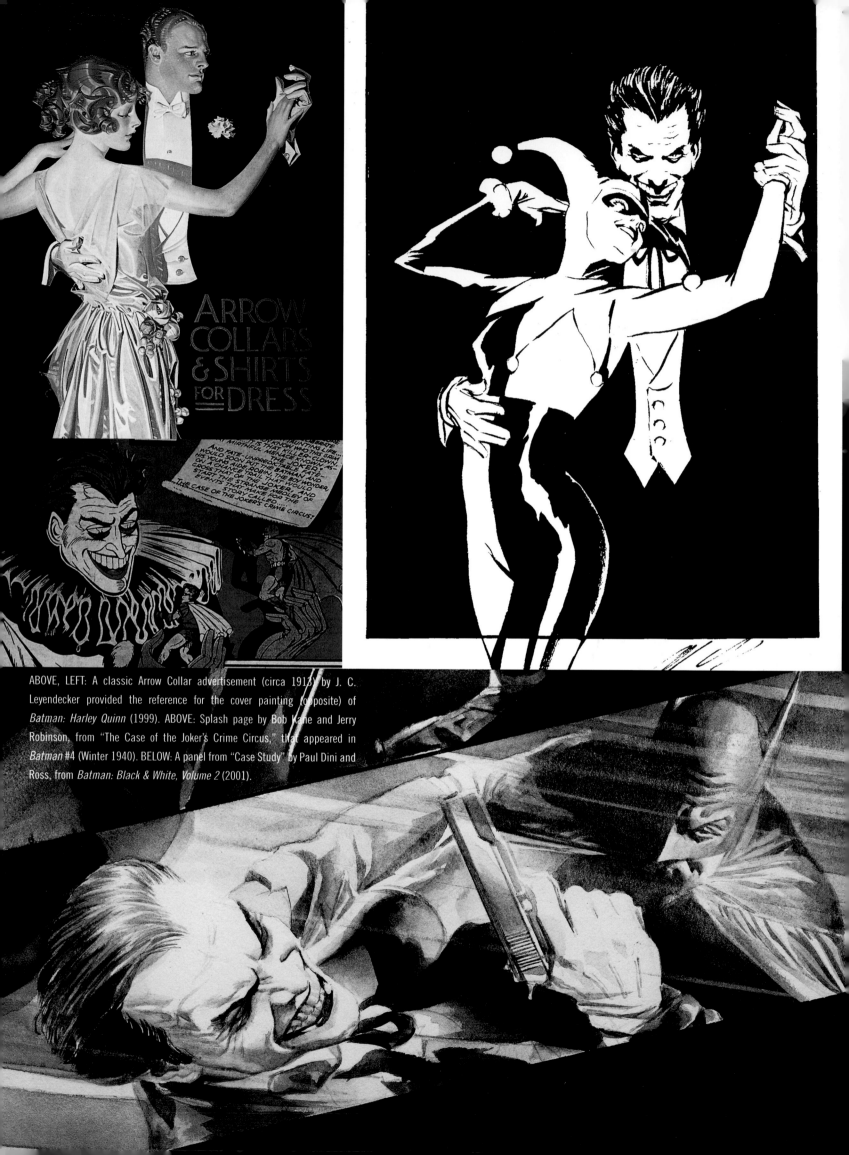

ABOVE, LEFT: A classic Arrow Collar advertisement (circa 1913) by J. C. Leyendecker provided the reference for the cover painting (opposite) of *Batman: Harley Quinn* (1999). ABOVE: Splash page by Bob Kane and Jerry Robinson, from "The Case of the Joker's Crime Circus," that appeared in *Batman* #4 (Winter 1940). BELOW: A panel from "Case Study" by Paul Dini and Ross, from *Batman: Black & White, Volume 2* (2001).

THE JOKER.

Undoubtedly the greatest of all the Batman villains, the Joker first appeared in *Batman* #1 (Spring 1940). It is that version that most inspires Alex. "Looking back at the original Bob Kane/Jerry Robinson artwork, it seems to me that the Joker's suit was intended to be black with purple highlights, which makes the most sense—so the only thing you focus on is that vampirish, glowing clown head. When he appears, he's dressed to the nines, and the shocking starkness of his face puts terror into his victims. Also, he didn't start off in the comics as this stick-thin anorexic guy—I wanted to give him

the appearance of being long and lean, but also physically powerful, not underweight. He was originally based on Conrad Veidt in the 1928 silent movie *The Man Who Laughs*, and that's what I'm seeking to capture—the true face of Joker." In the comics, the origin of the character involves a small-time hood falling into a vat of chemicals at a playing card company and emerging from it as the Joker we've come to know. But Ross has his own theories. "In my

mind it wouldn't have given him green hair and red lips—the chemical bath would only have turned his skin white. He adds the rest himself to complete the picture. There's a panel at the end of *Batman* #1 in which the Joker is stabbed and we see that his chest is white. I never forgot that—the realization that his whole body was white. Eerie. Also, he can't die, which makes his color seem to represent that he is undead—more than simply a clown metaphor."

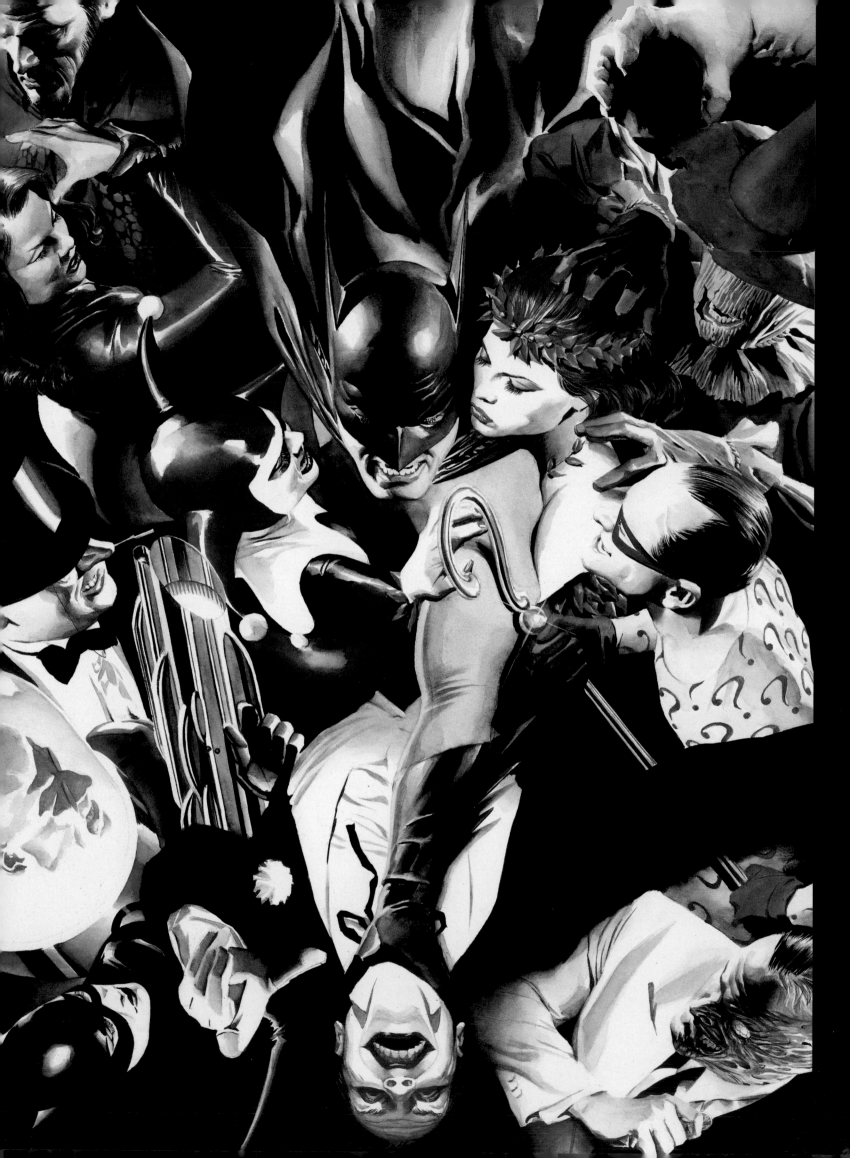

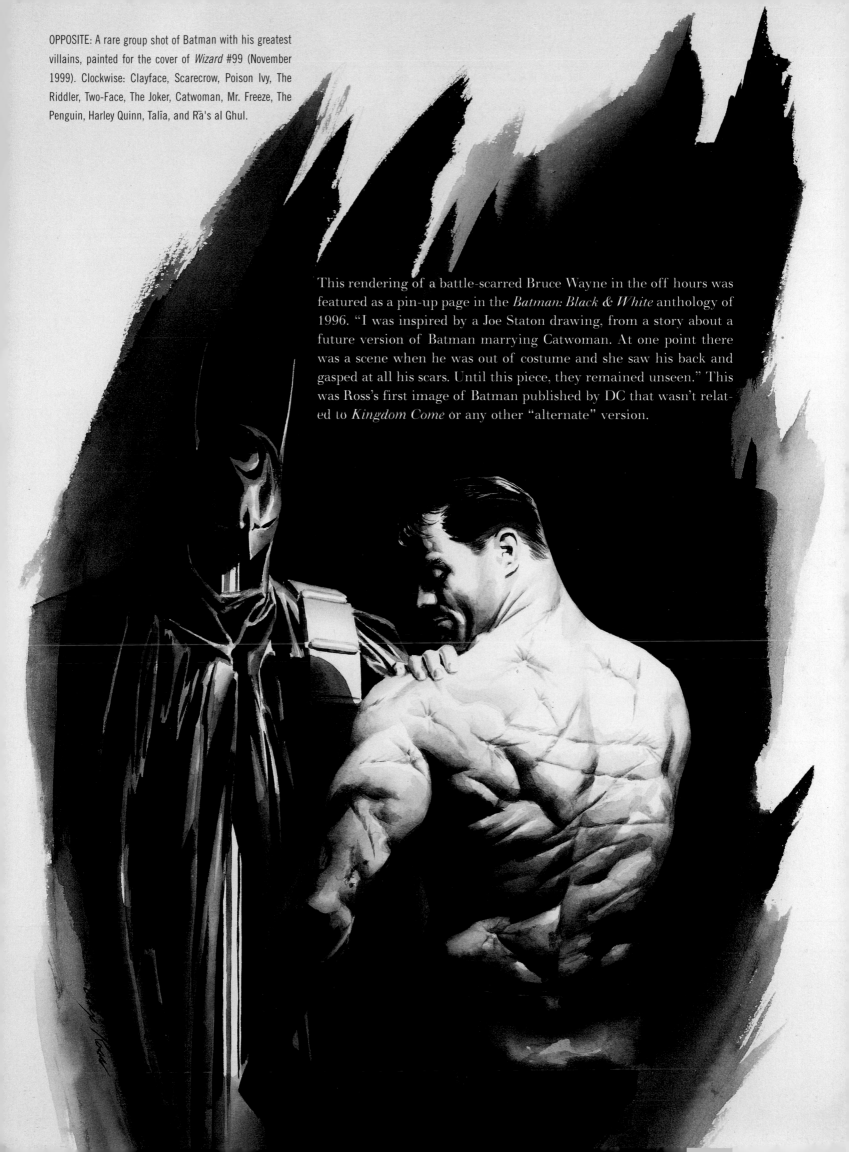

OPPOSITE: A rare group shot of Batman with his greatest villains, painted for the cover of *Wizard* #99 (November 1999). Clockwise: Clayface, Scarecrow, Poison Ivy, The Riddler, Two-Face, The Joker, Catwoman, Mr. Freeze, The Penguin, Harley Quinn, Talīa, and Rā's al Ghul.

This rendering of a battle-scarred Bruce Wayne in the off hours was featured as a pin-up page in the *Batman: Black & White* anthology of 1996. "I was inspired by a Joe Staton drawing, from a story about a future version of Batman marrying Catwoman. At one point there was a scene when he was out of costume and she saw his back and gasped at all his scars. Until this piece, they remained unseen." This was Ross's first image of Batman published by DC that wasn't related to *Kingdom Come* or any other "alternate" version.

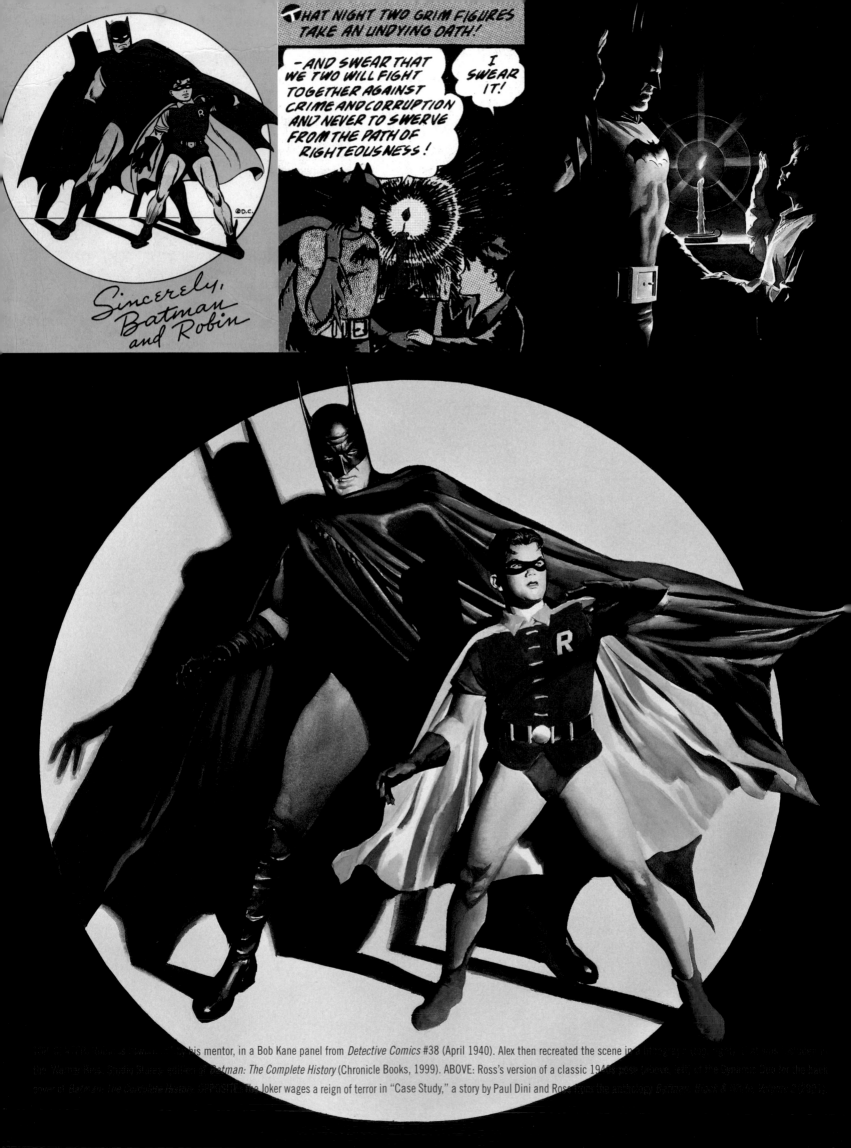

...his mentor, in a Bob Kane panel from *Detective Comics* #38 (April 1940). Alex then recreated the scene in... the Warner Bros. Studio Stores... of *Batman: The Complete History* (Chronicle Books, 1999). ABOVE: Ross's version of a classic 1940... ...of *Batman: The Complete History.* OPPOSITE: The Joker wages a reign of terror in "Case Study," a story by Paul Dini and Ross... the anthology *Batman: Black & White*, volume 2 (1999).

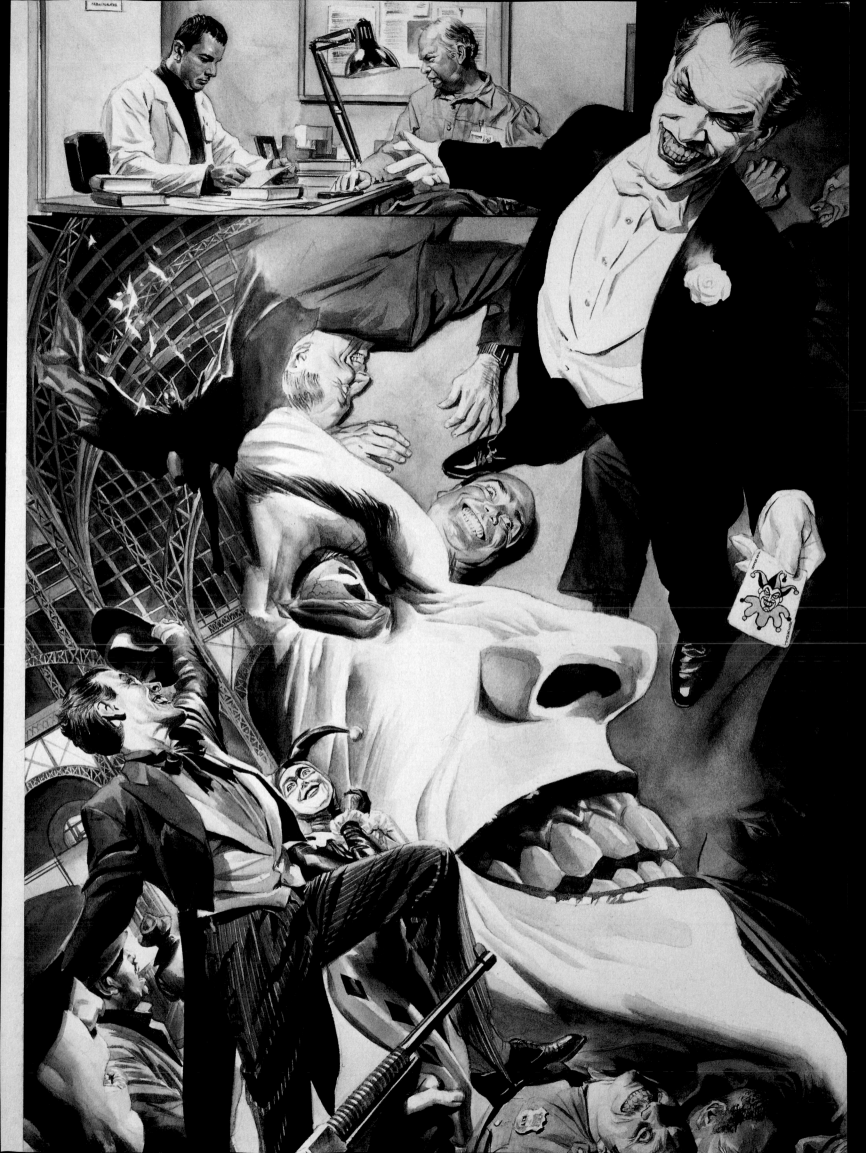

My name is Richard Grayson, otherwise known as

Robin-
THE BOY WONDER

TEXT BY PAUL DINI
ART BY ALEX ROSS

I know what you're thinking. The late hours, the cool gadgets, the death-defying action–this kid has it all. Yeah, sometimes it's pretty cool.

But I had it better.

Then one night, it all came to an end. There was an "accident."

Sleazy hoods were trying to scare protection money out of our circus, and killed my folks as a warning.

But then Batman turned to me.

Once I was part of the Flying Graysons aerial act, and more important, I was part of a family.

I found out about it, but there was no one I could turn to for help.

He had uncovered the truth about the shakedown and wanted me to help him bring the killers to justice.

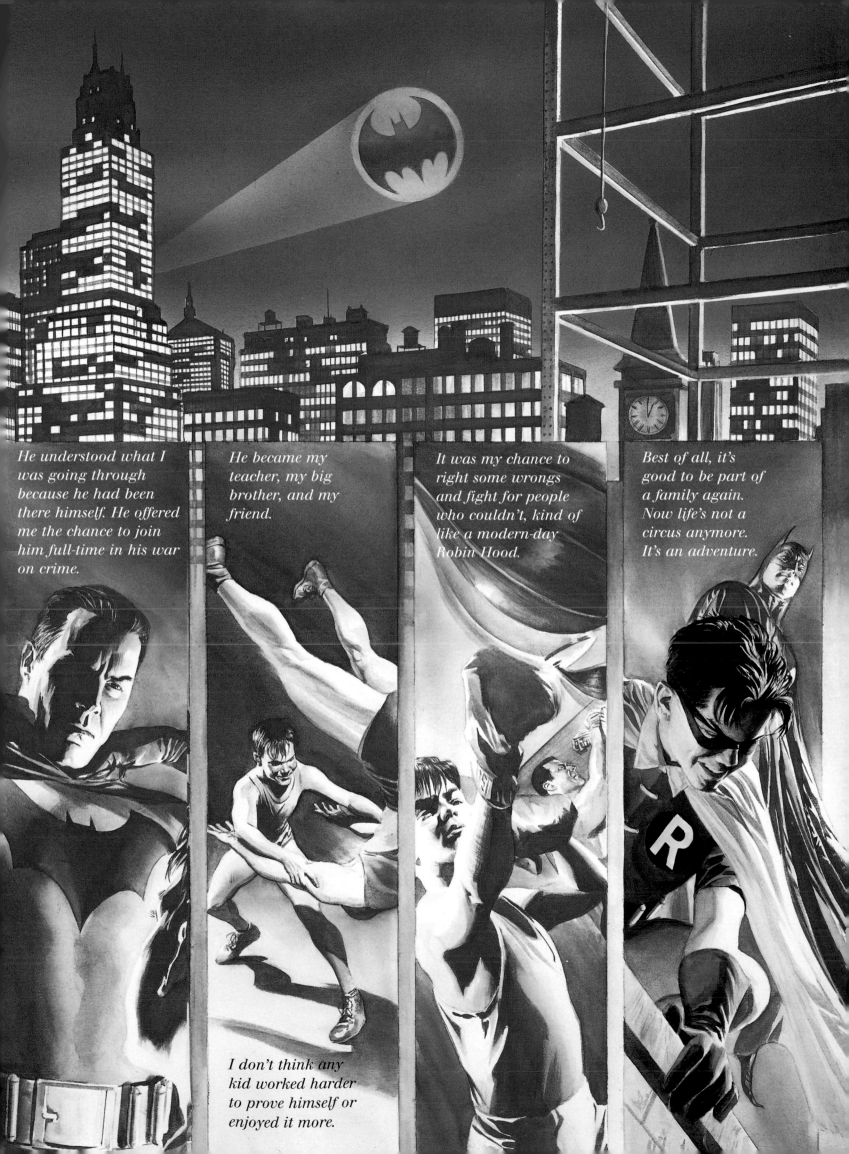

He understood what I was going through because he had been there himself. He offered me the chance to join him full-time in his war on crime.

He became my teacher, my big brother, and my friend.

I don't think any kid worked harder to prove himself or enjoyed it more.

It was my chance to right some wrongs and fight for people who couldn't, kind of like a modern-day Robin Hood.

Best of all, it's good to be part of a family again. Now life's not a circus anymore. It's an adventure.

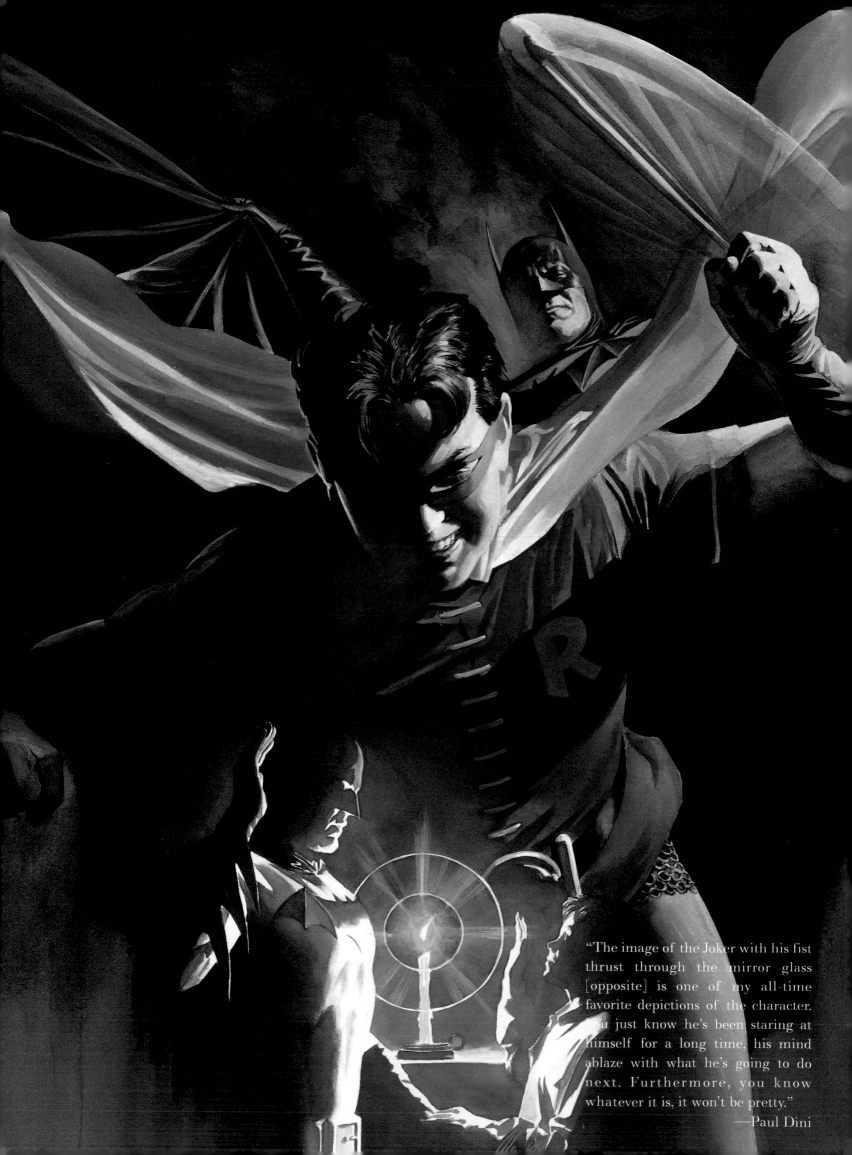

"The image of the Joker with his fist thrust through the mirror glass [opposite] is one of my all-time favorite depictions of the character. You just know he's been staring at himself for a long time, his mind ablaze with what he's going to do next. Furthermore, you know whatever it is, it won't be pretty."
—Paul Dini

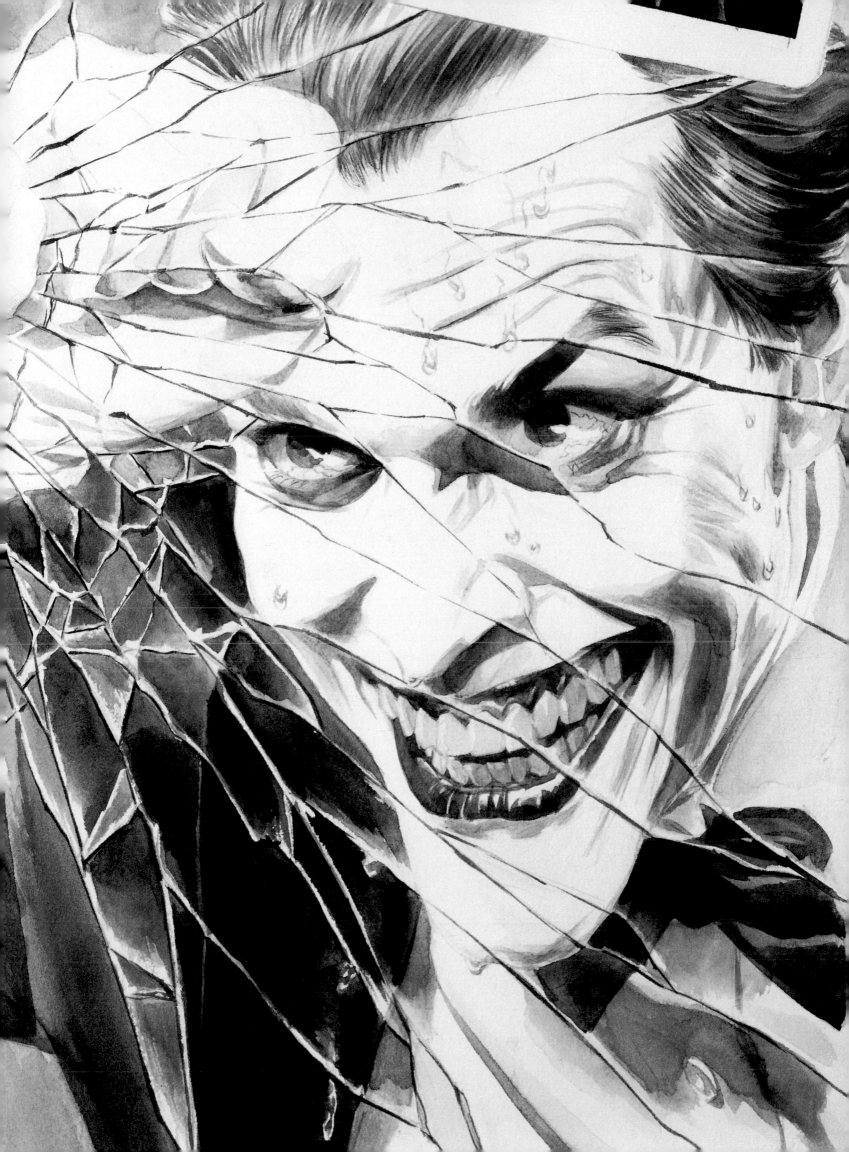

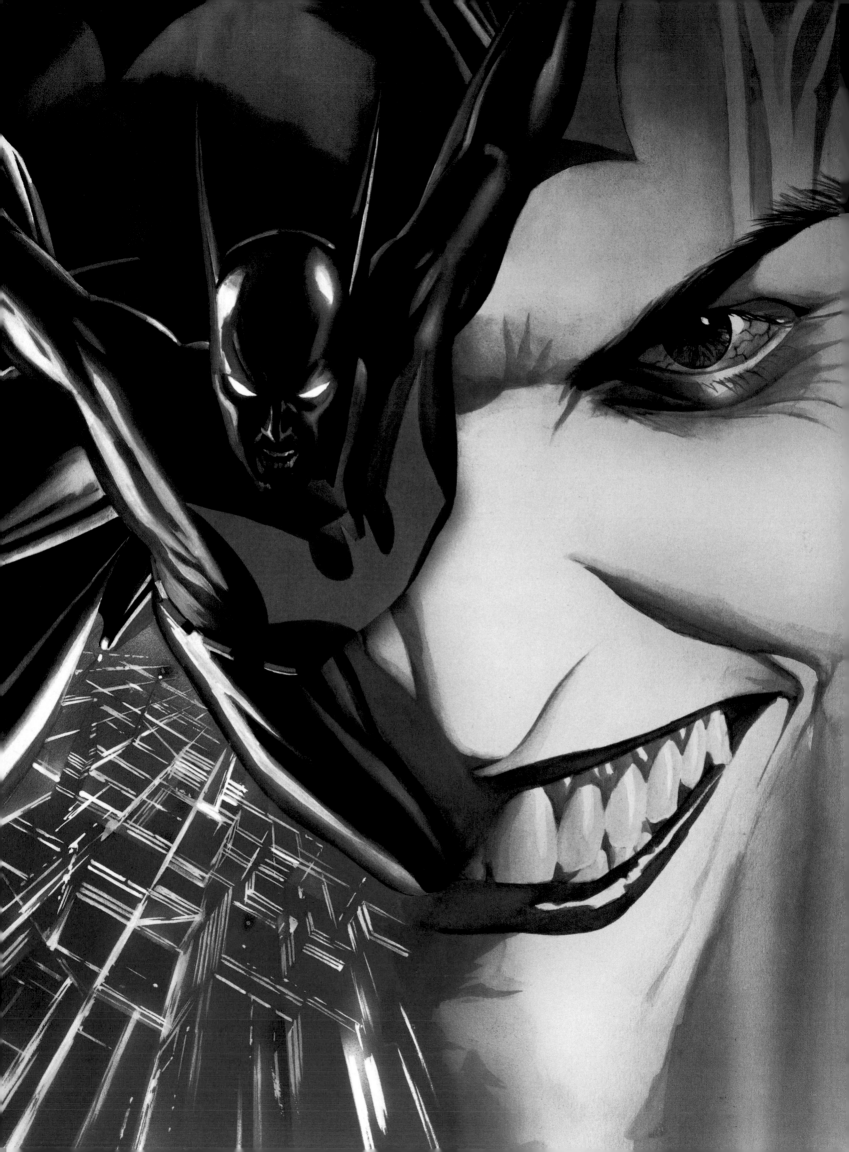

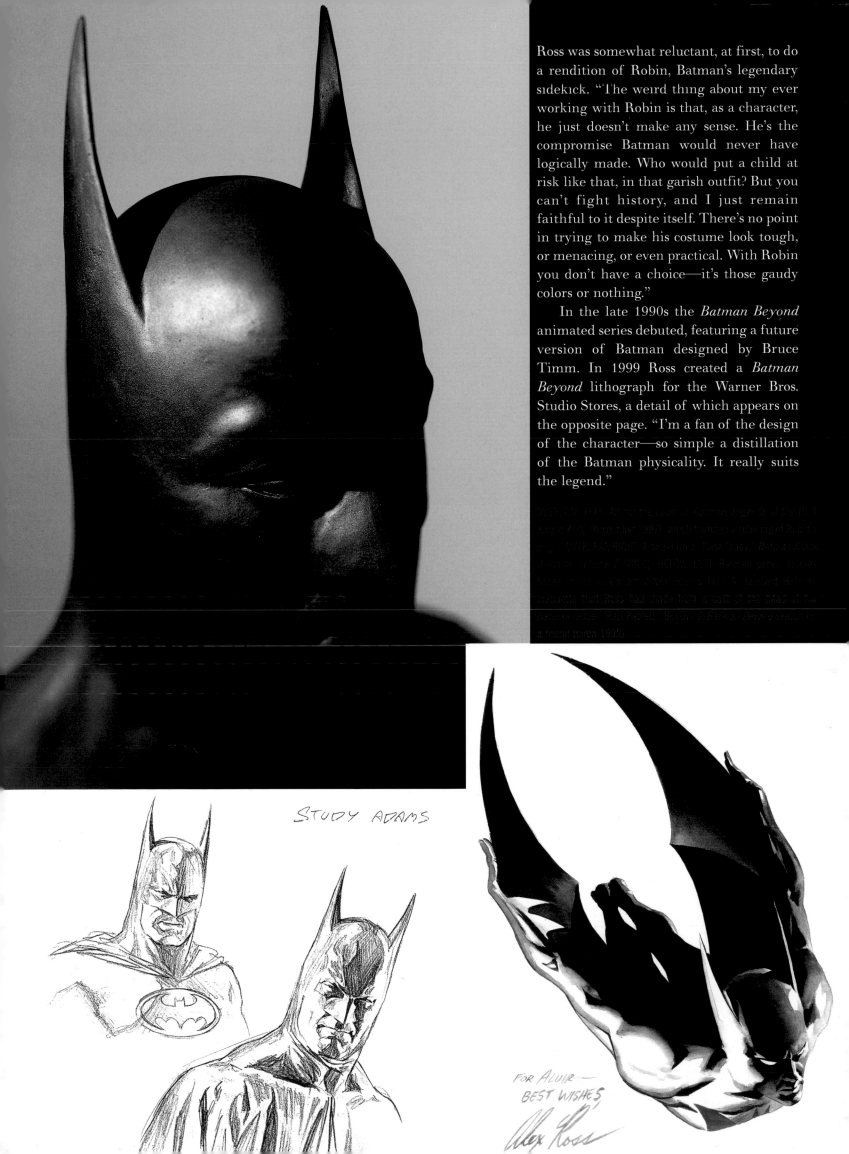

Ross was somewhat reluctant, at first, to do a rendition of Robin, Batman's legendary sidekick. "The weird thing about my ever working with Robin is that, as a character, he just doesn't make any sense. He's the compromise Batman would never have logically made. Who would put a child at risk like that, in that garish outfit? But you can't fight history, and I just remain faithful to it despite itself. There's no point in trying to make his costume look tough, or menacing, or even practical. With Robin you don't have a choice—it's those gaudy colors or nothing."

In the late 1990s the *Batman Beyond* animated series debuted, featuring a future version of Batman designed by Bruce Timm. In 1999 Ross created a *Batman Beyond* lithograph for the Warner Bros. Studio Stores, a detail of which appears on the opposite page. "I'm a fan of the design of the character—so simple a distillation of the Batman physicality. It really suits the legend."

STUDY ADAMS

FOR ALUIR—
BEST WISHES
Alex Ross

BATMAN

WAR ON CRIME.

The second of the DC tabloid books (this one featuring Batman), Ross and Dini chose the problem of crime itself, and more specifically, crime as it exists in the real world. "It's not about the Joker or any of the outlandish Batman villains. It's about economic strife. Some of my peers in comics thought it was wrong to pit Batman solely against 'common criminals,' but for us it was the only way to go."

The plot of the story involves Batman arriving at the scene of a fatal convenience-store robbery that has left the proprietors dead and their son Marcus, an eight-year-old African-American boy, an orphan. Batman sees something of himself in the boy's tragic circumstances, the difference of course being his family's wealth as opposed to the boy's poverty. As Batman makes the rounds, he ponders what will become of this newest victim of crime, until their paths cross again in unexpected and tragically similar circumstances.

It was important for Ross that no previous knowledge of Batman was required to understand the story. "I wanted this series to exist as an olive branch to new readers."

As with *Peace on Earth*, the original art from *War on Crime* was auctioned by Sotheby's to benefit an appropriate charity, in this case the John A. Reisenbach Foundation benefitting the Reisenbach Charter School in Harlem. The auction raised $157,400. "The important thing about that charity is that it really speaks to the heart of the story, which is that economic disparity is the root of crime."

ABOVE: The cover for *Batman: War on Crime* (1999).

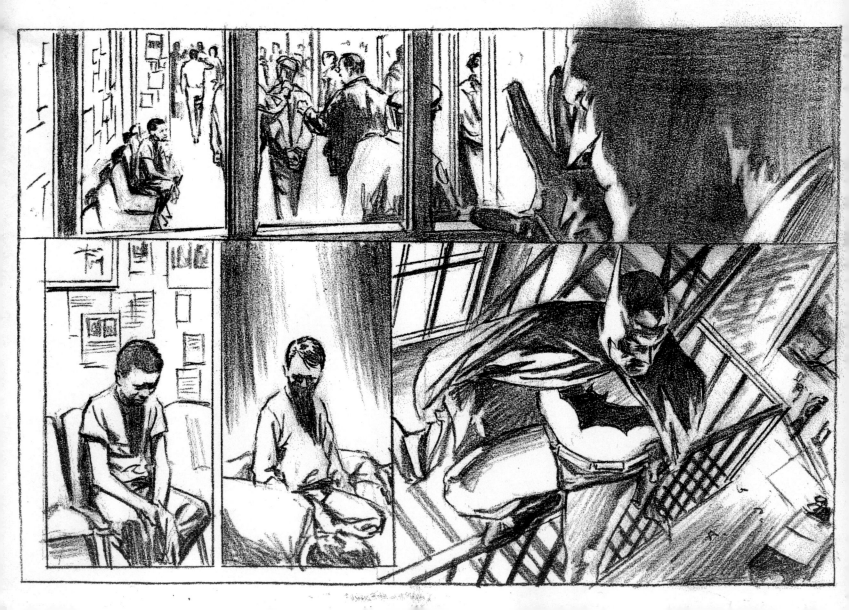

AFTER WITNESSING THE BOY'S PREDICAMENT (BEING ORPHANED OF BOTH PARENTS IN ONE NIGHT BY AN ACT OF VIOLENCE), BATMAN FOLLOWS HIM CURIOUSLY TO THE POLICE PRECINCT WHERE IT SEEMS THE BOY IS MORE VIVIDLY ABANDONED INTO A HARSH, VIOLENT WORLD. SEEING HIMSELF IN THIS YOUNG KID OF COMPARITIVE AGE TO WHEN HE LOST HIS PARENTS, STARTS THE PROCESS OF BATMAN QUESTIONING WHAT TRULY SEPARATES PEOPLE, AS THE EVENT THAT HE WOULD CREDIT WITH DEFINING HIS LIFE AND CHARACTER CAN SO EASILY HAPPEN TO ANOTHER.

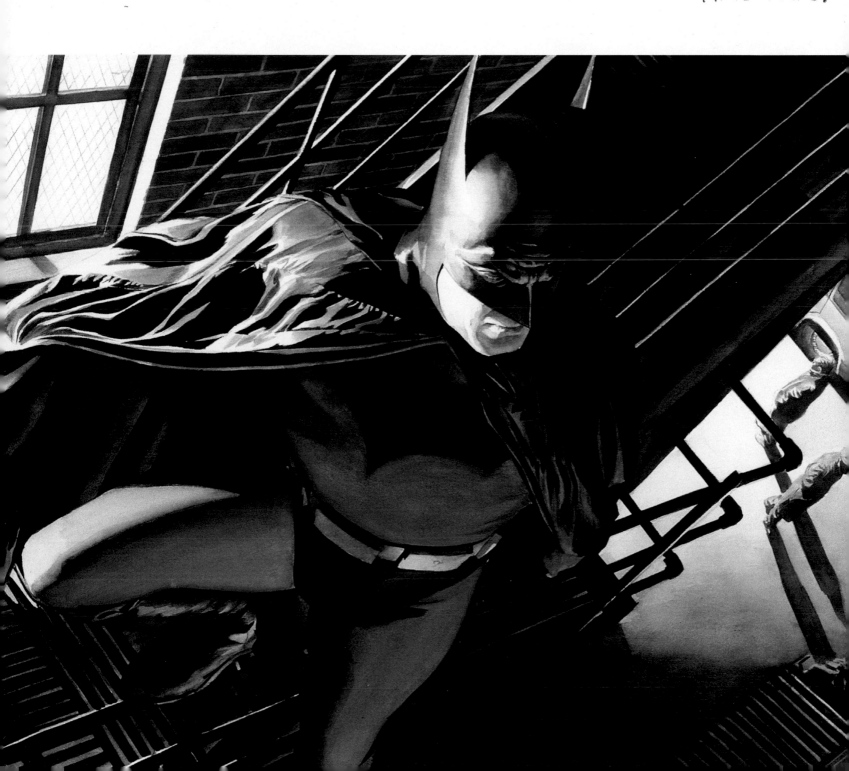

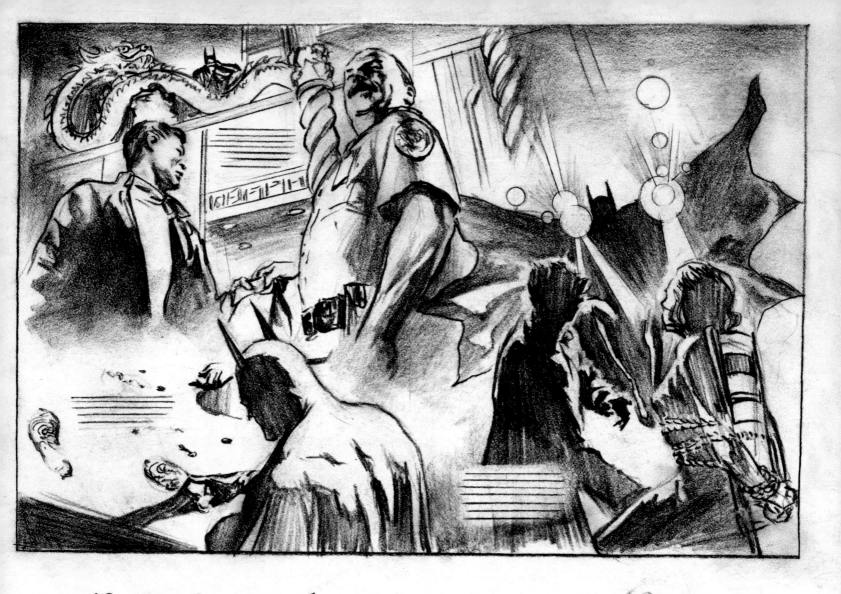

AS MORE OF THE TRAVELOGUE OF CRIME, WE GO INTO DARKER FORMS OF THE CITY'S MANY SINS BY WITNESSING POLICE CORRUPTION, INVESTIGATING MURDER (IF YOU THINK THIS IS SHOWN TOO STRONG I'M OPEN TO TRYING OTHER WAYS AS LONG AS WE DO REPRESENT THIS) AND CATCHING KIDNAPPERS. THE LATTER OF THESE I THINK CAN BE USED THROUGH THE NARRATIVE TO RELATE EVEN MORE BASE VILLAINY THAT COMES WITH RAPE AND TORTURE.

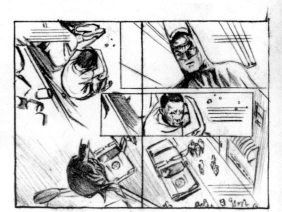

14 15 WHITE GUY 16 17 WHITE GUY W/ LONG HAIR 18 19

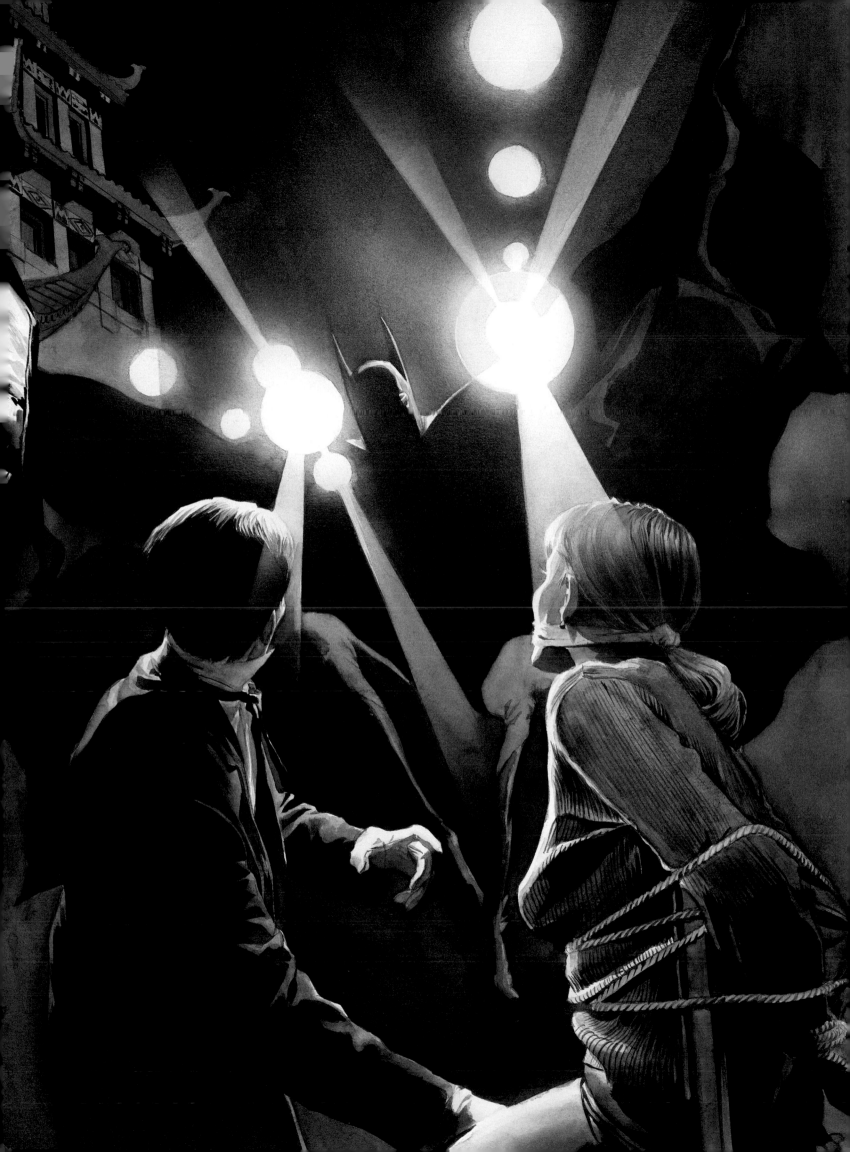

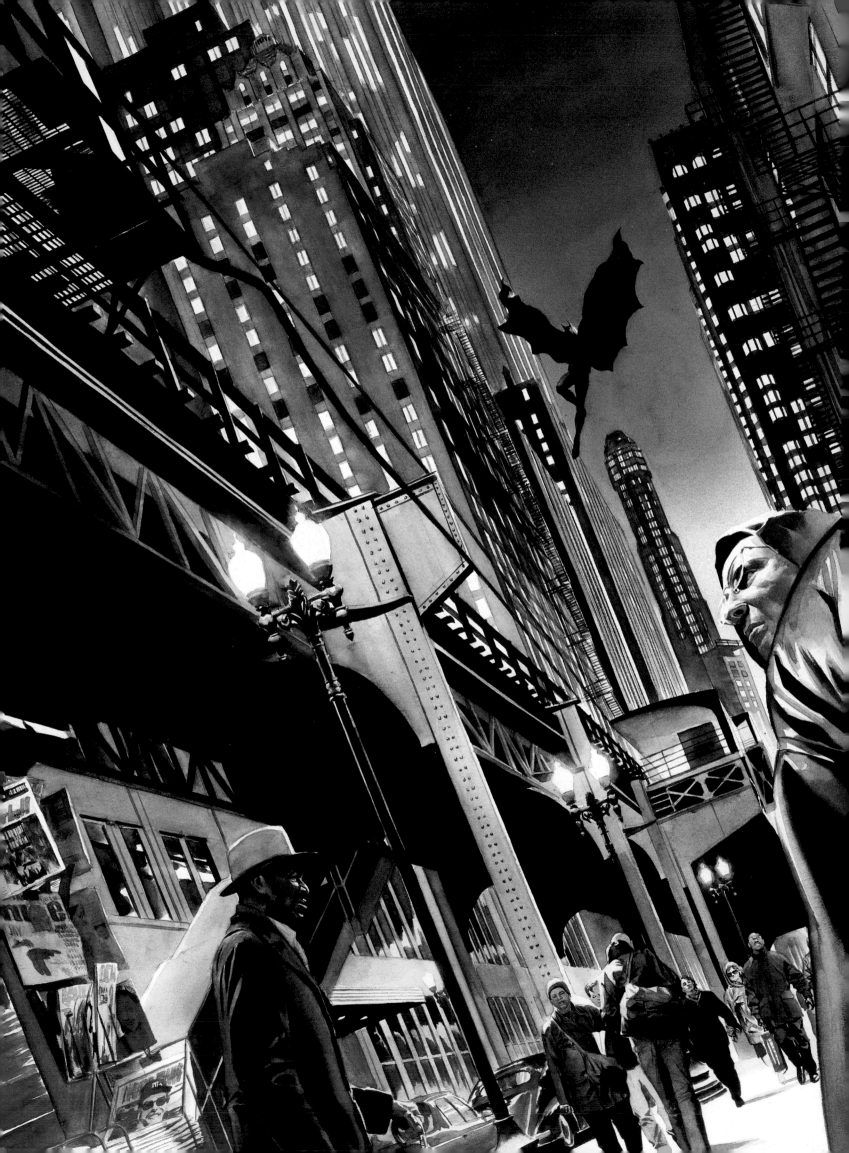

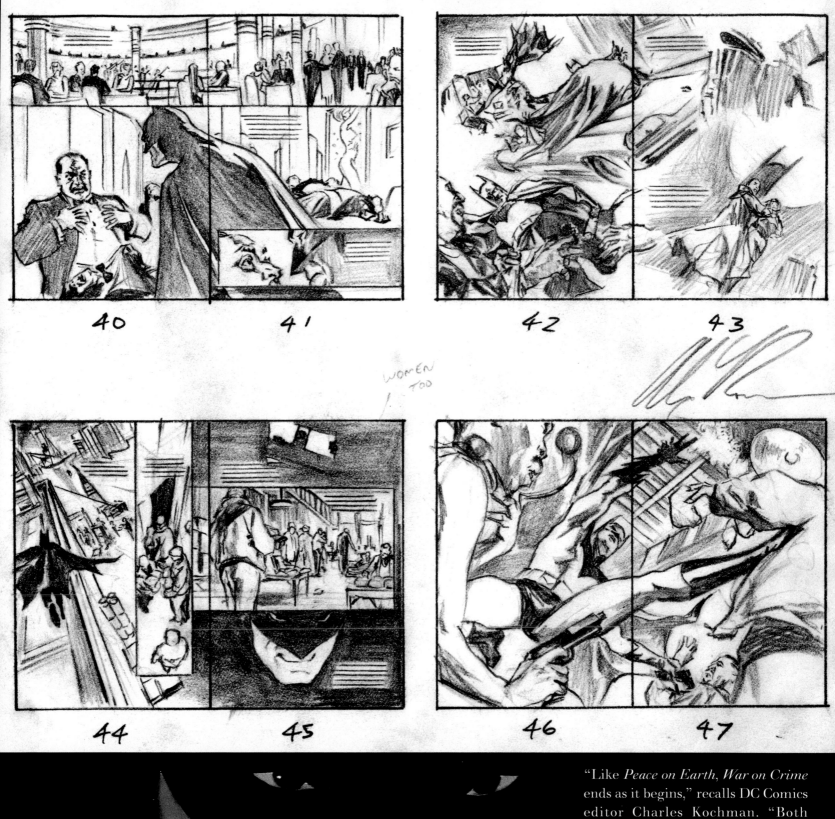

40 41 42 43

WOMEN
TOO

44 45 46 47

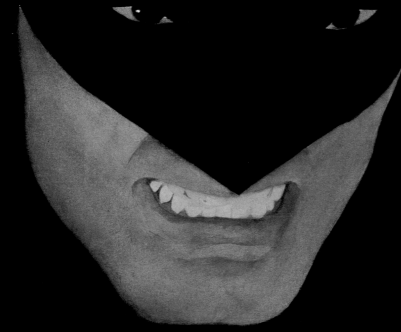

"Like *Peace on Earth, War on Crime* ends as it begins," recalls DC Comics editor Charles Kochman. "Both books are very cinematic. Dini's writing is economical and compelling, and it perfectly captures the tone and voice of the characters in a way that's individually distinct. As the Emmy Award-winning writer of *Batman: The Animated Series,* Paul's facility with this character is especially striking."

Says Dini: "Like a restless spirit, Batman is cursed to seek salvation for a terrible sin he committed in his past life, which in his mind was not being able to prevent the murder of his parents. Batman's war on crime is a symbolic war against himself."

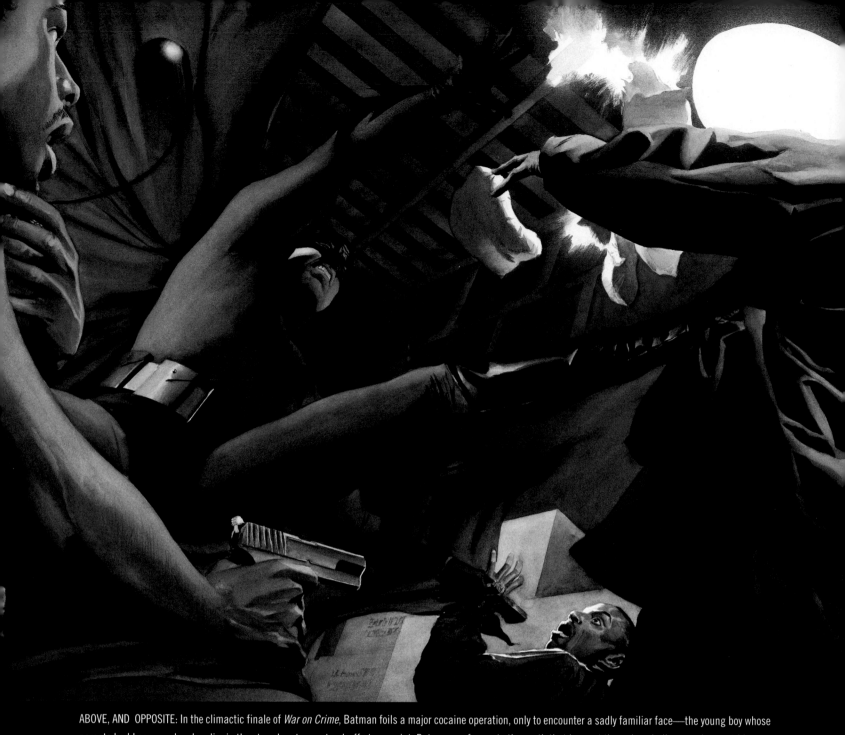

ABOVE, AND OPPOSITE: In the climactic finale of *War on Crime*, Batman foils a major cocaine operation, only to encounter a sadly familiar face—the young boy whose parents had been murdered earlier in the story. In a tense stand-off at gunpoint, Batman confesses to the youth that he went through a similar experience at his age, and pleads with the boy to summon the courage to choose another path for his life. OVERLEAF: The original art for this parting shot of Batman over Gotham City brought in an astounding $65,000 at a Sotheby's charity auction on June 17, 2000.

48 49 50 51

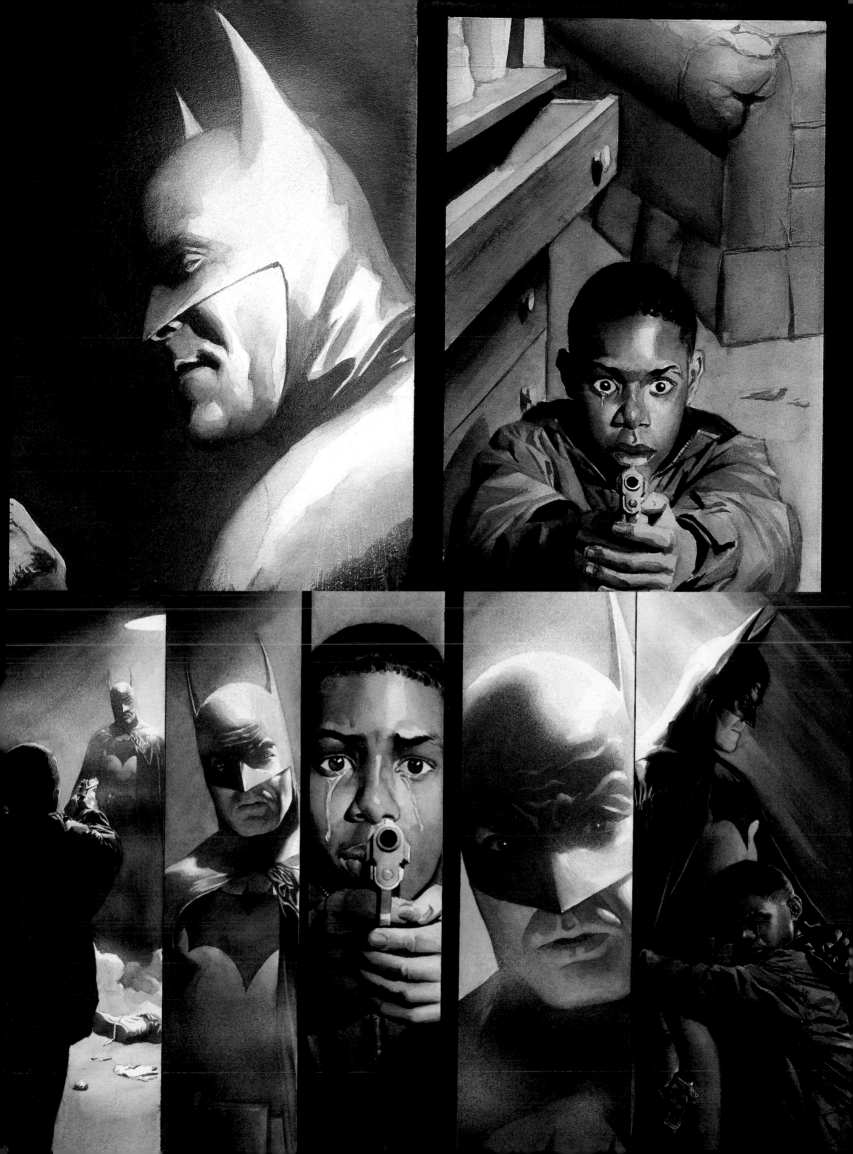

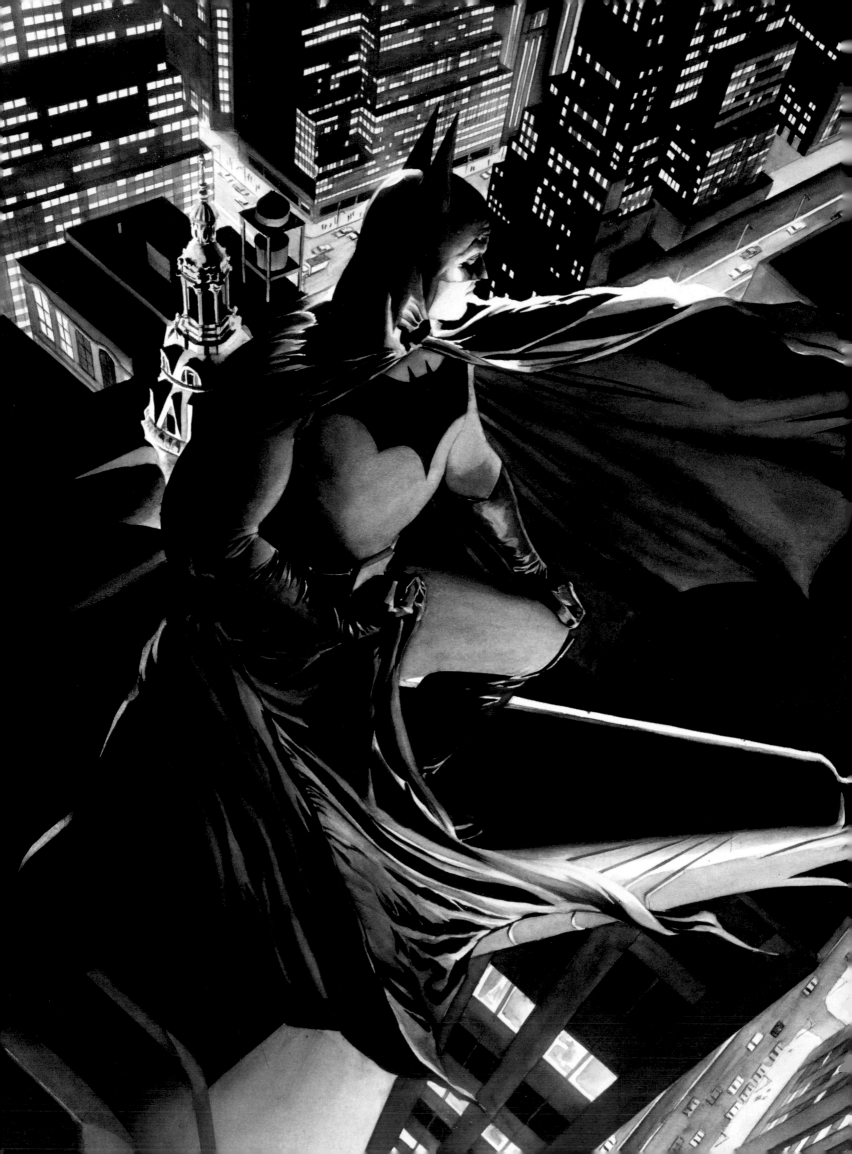

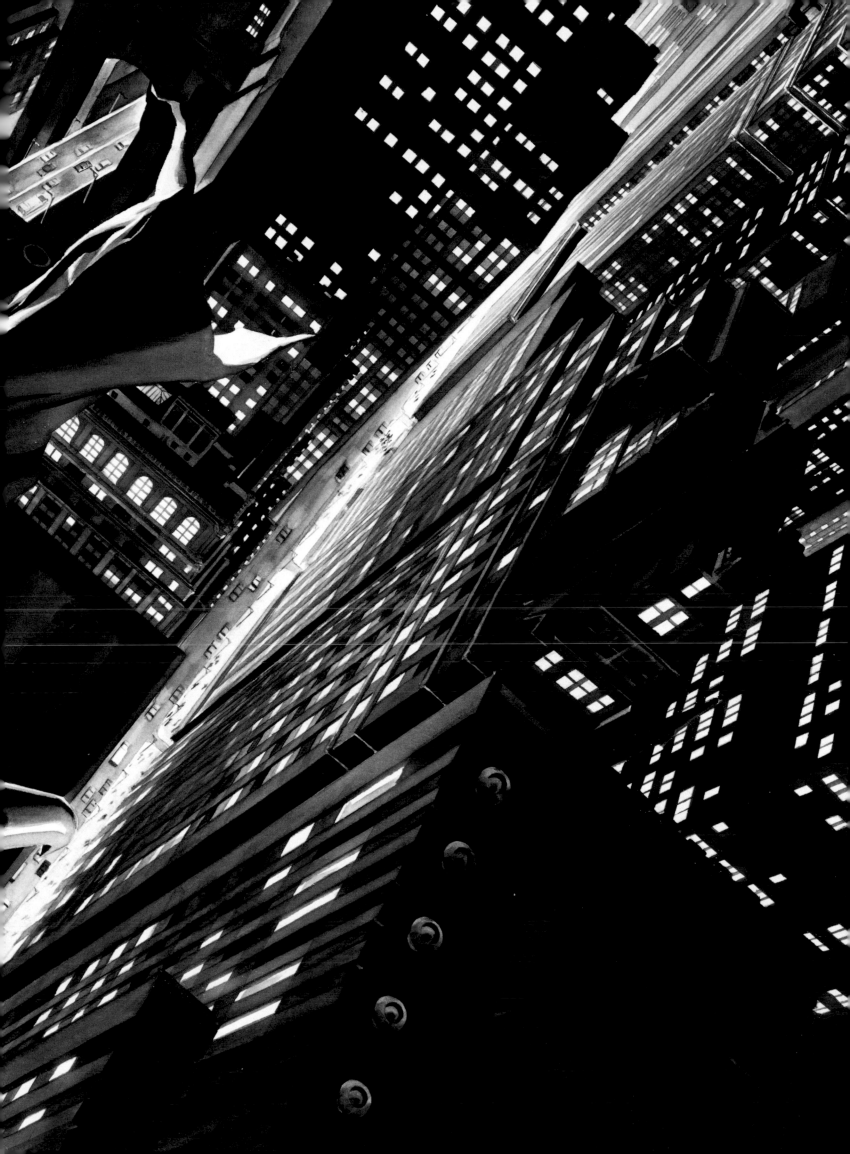

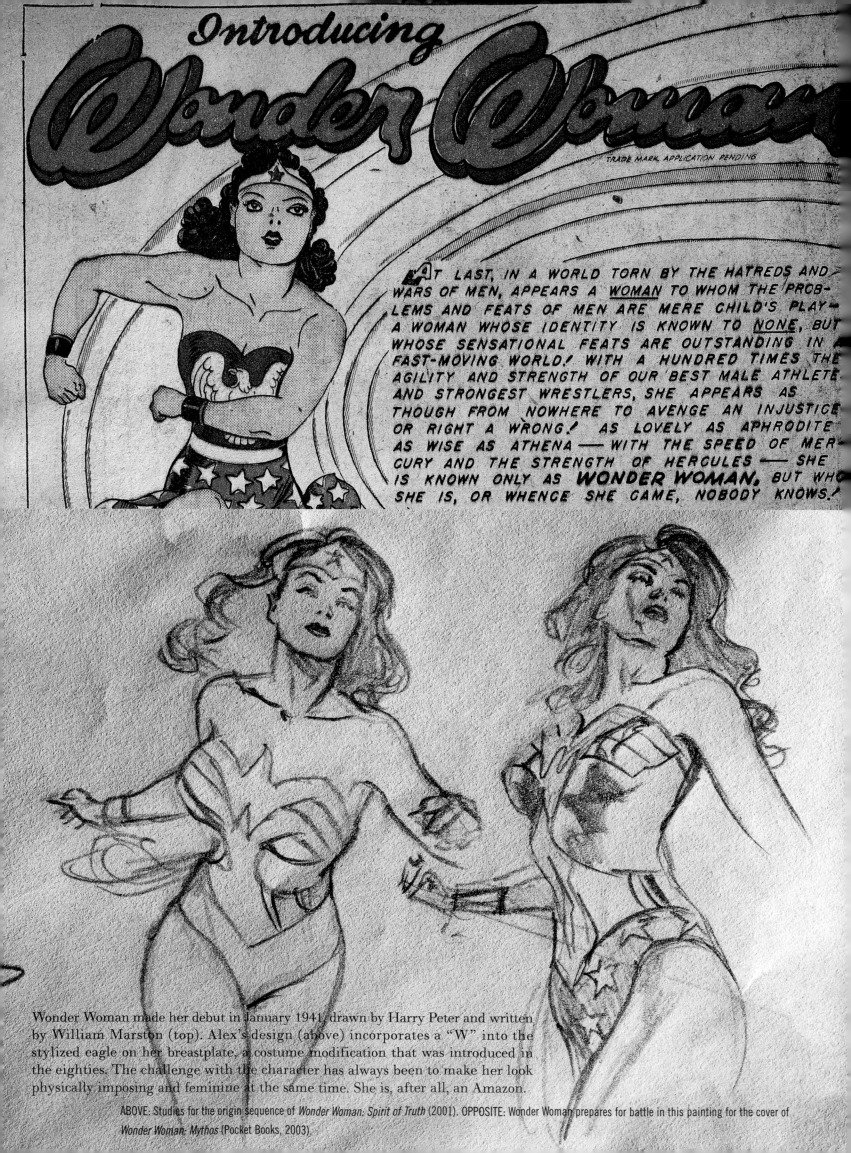

Introducing Wonder Woman

TRADE MARK APPLICATION PENDING

AT LAST, IN A WORLD TORN BY THE HATREDS AND WARS OF MEN, APPEARS A WOMAN TO WHOM THE PROBLEMS AND FEATS OF MEN ARE MERE CHILD'S PLAY— A WOMAN WHOSE IDENTITY IS KNOWN TO NONE, BUT WHOSE SENSATIONAL FEATS ARE OUTSTANDING IN A FAST-MOVING WORLD! WITH A HUNDRED TIMES THE AGILITY AND STRENGTH OF OUR BEST MALE ATHLETE AND STRONGEST WRESTLERS, SHE APPEARS AS THOUGH FROM NOWHERE TO AVENGE AN INJUSTICE OR RIGHT A WRONG! AS LOVELY AS APHRODITE AS WISE AS ATHENA — WITH THE SPEED OF MERCURY AND THE STRENGTH OF HERCULES — SHE IS KNOWN ONLY AS WONDER WOMAN. BUT WHO SHE IS, OR WHENCE SHE CAME, NOBODY KNOWS!

Wonder Woman made her debut in January 1941, drawn by Harry Peter and written by William Marston (top). Alex's design (above) incorporates a "W" into the stylized eagle on her breastplate, a costume modification that was introduced in the eighties. The challenge with the character has always been to make her look physically imposing and feminine at the same time. She is, after all, an Amazon.

ABOVE: Studies for the origin sequence of *Wonder Woman: Spirit of Truth* (2001). OPPOSITE: Wonder Woman prepares for battle in this painting for the cover of *Wonder Woman: Mythos* (Pocket Books, 2003).

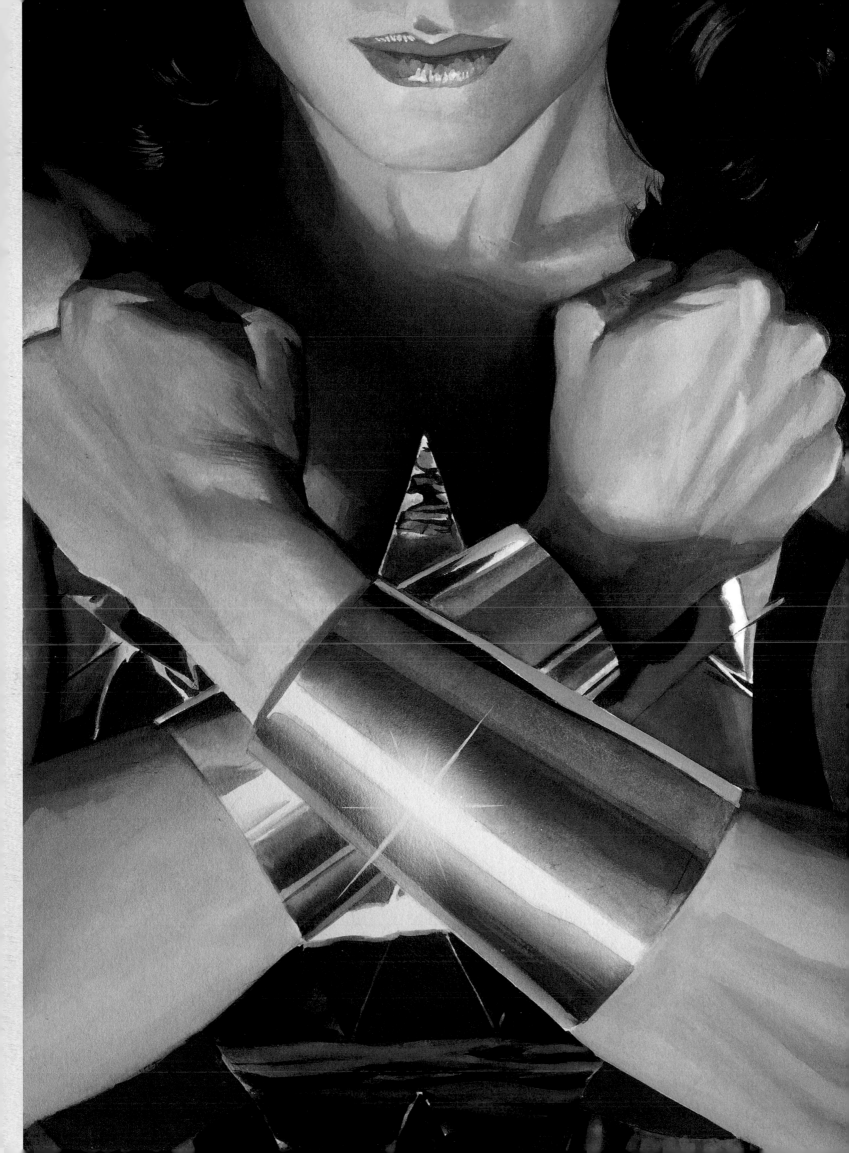

"As much as I've tried to make it all about revisiting the past, there's only so much you can do with Wonder Woman. Her original look is dated to the 1940s, so unless I'm depicting her in that era, it doesn't work. That's much less a problem with Superman and Batman because their costumes don't rely on any specific period. So Wonder Woman needs to be updated, which has its own potential problems. What I identify Wonder Woman with (as does most of the public, if they think about it at all) is, frankly, Lynda Carter [the star of the *Wonder Woman* TV show of the 1970s]. She made the greatest single impression on the character in the 20th century—ironically more than any artist who drew her. In fact, Lynda Carter was so perfect, it was hard to come up with a good variation that wasn't exactly her, but I had to. Luckily the live models I use leave their mark and guide me visually."

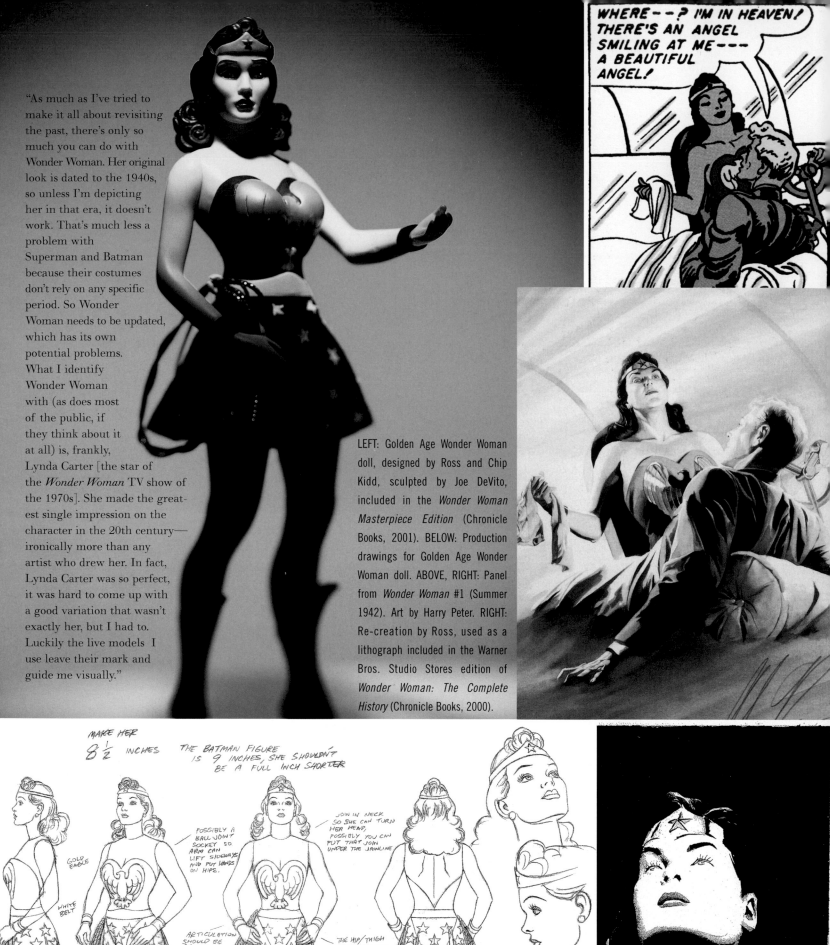

LEFT: Golden Age Wonder Woman doll, designed by Ross and Chip Kidd, sculpted by Joe DeVito, included in the *Wonder Woman Masterpiece Edition* (Chronicle Books, 2001). BELOW: Production drawings for Golden Age Wonder Woman doll. ABOVE, RIGHT: Panel from *Wonder Woman #1* (Summer 1942). Art by Harry Peter. RIGHT: Re-creation by Ross, used as a lithograph included in the Warner Bros. Studio Stores edition of *Wonder Woman: The Complete History* (Chronicle Books, 2000).

WHERE--? I'M IN HEAVEN! THERE'S AN ANGEL SMILING AT ME--- A BEAUTIFUL ANGEL!

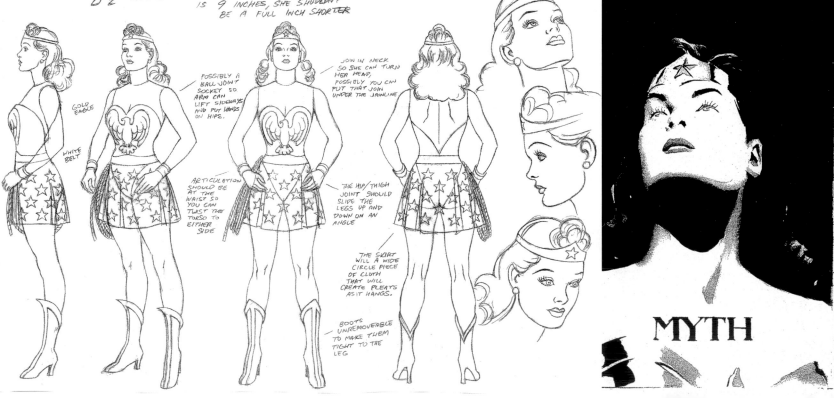

MAKE HER 8½ INCHES THE BATMAN FIGURE IS 9 INCHES, SHE SHOULDN'T BE A FULL INCH SHORTER

GOLD EAGLE

WHITE BELT

POSSIBLY A BALL JOINT SOCKET SO ARM CAN LIFT SIDEWAYS AND PUT HANDS ON HIPS.

JOIN IN NECK SO SHE CAN TURN HER HEAD, POSSIBLY YOU CAN PUT THAT JOIN UNDER THE JAWLINE

ARTICULATION SHOULD BE AT THE WAIST SO YOU CAN TURST THE TORSO TO EITHER SIDE

THE HIP/THIGH JOINT SHOULD SLIDE THE LEGS UP AND DOWN ON AN ANGLE

THE SKIRT WILL A WIDE CIRCLE PIECE OF CLOTH THAT WILL CREATE PLEATS AS IT HANGS.

BOOTS UNREMOVEABLE TO MAKE THEM TIGHT TO THE LEG

MYTH

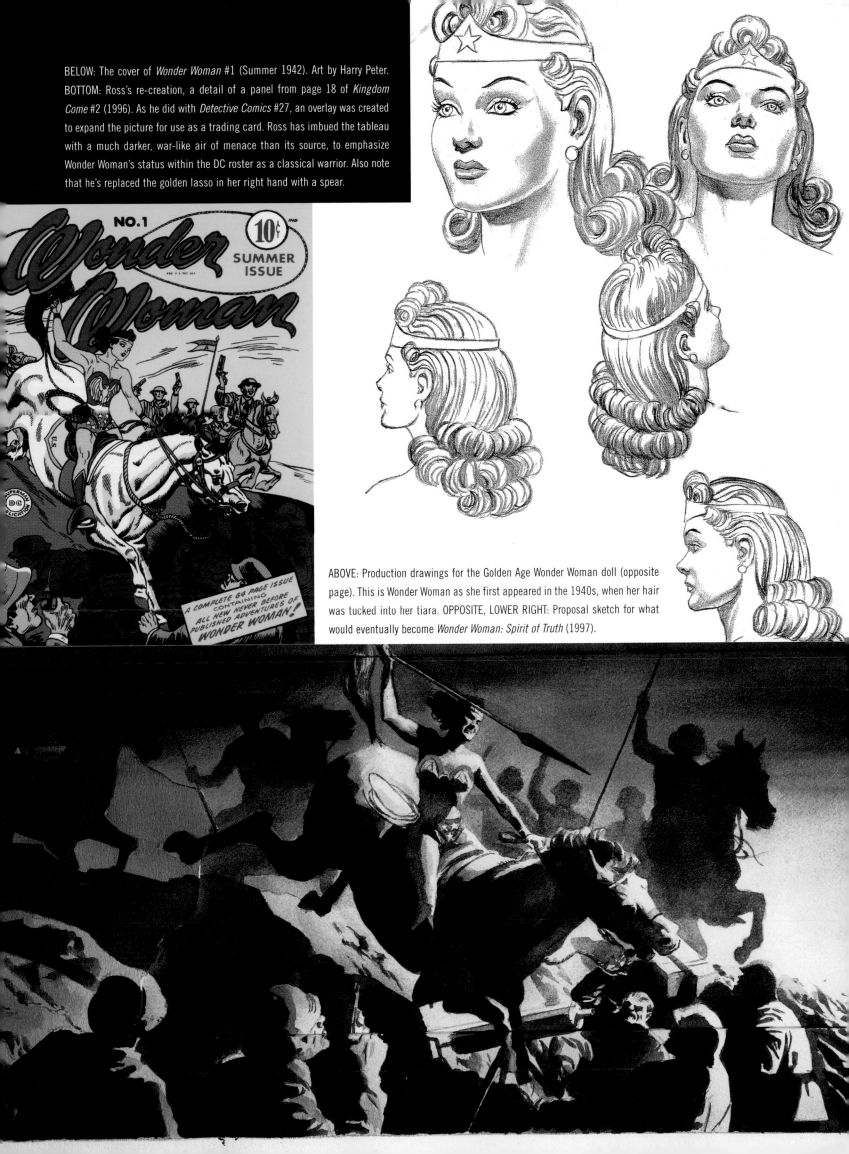

BELOW: The cover of *Wonder Woman* #1 (Summer 1942). Art by Harry Peter. BOTTOM: Ross's re-creation, a detail of a panel from page 18 of *Kingdom Come* #2 (1996). As he did with *Detective Comics* #27, an overlay was created to expand the picture for use as a trading card. Ross has imbued the tableau with a much darker, war-like air of menace than its source, to emphasize Wonder Woman's status within the DC roster as a classical warrior. Also note that he's replaced the golden lasso in her right hand with a spear.

ABOVE: Production drawings for the Golden Age Wonder Woman doll (opposite page). This is Wonder Woman as she first appeared in the 1940s, when her hair was tucked into her tiara. OPPOSITE, LOWER RIGHT: Proposal sketch for what would eventually become *Wonder Woman: Spirit of Truth* (1997).

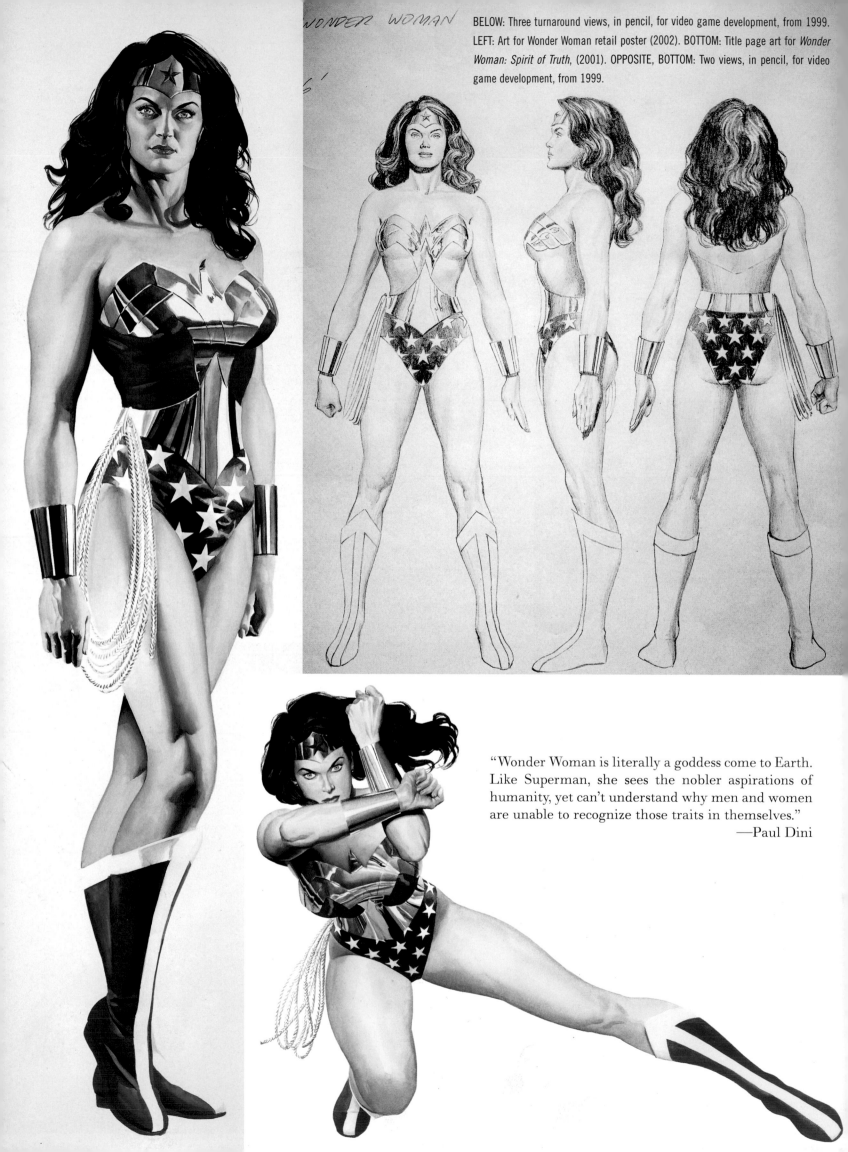

BELOW: Three turnaround views, in pencil, for video game development, from 1999. LEFT: Art for Wonder Woman retail poster (2002). BOTTOM: Title page art for *Wonder Woman: Spirit of Truth*, (2001). OPPOSITE, BOTTOM: Two views, in pencil, for video game development, from 1999.

"Wonder Woman is literally a goddess come to Earth. Like Superman, she sees the nobler aspirations of humanity, yet can't understand why men and women are unable to recognize those traits in themselves."
—Paul Dini

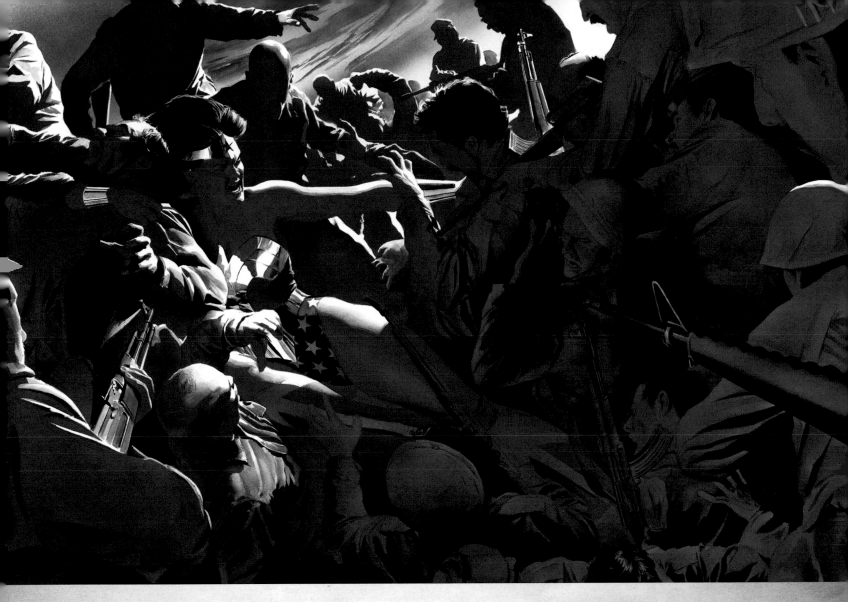

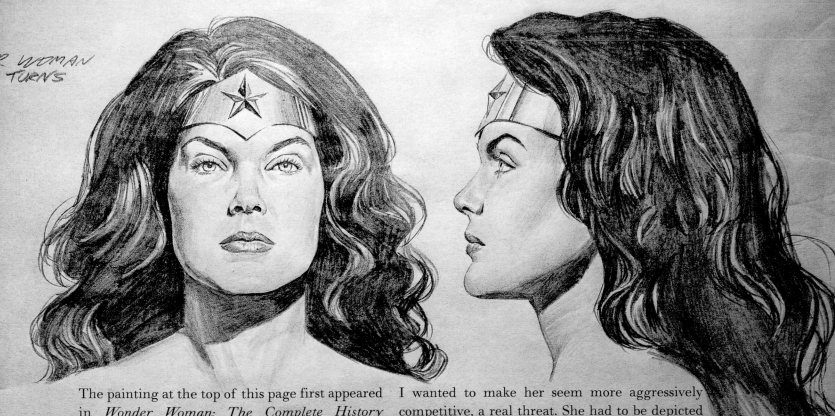

The painting at the top of this page first appeared in *Wonder Woman: The Complete History* (Chronicle Books, 2000), and deals with the problem of imparting a sense of ferocity to a protagonist clad in what amounts to a one-piece bathing suit. "It took years to find a home for this image of her engaged in war, swarmed over by an enemy army. I wanted to make her seem more aggressively competitive, a real threat. She had to be depicted fighting an actual battle, and it had to be in the Middle East, because it's the most troubled part of the world." This is a theme that Ross and Dini would eventually pursue in their Wonder Woman graphic album, *Spirit of Truth*.

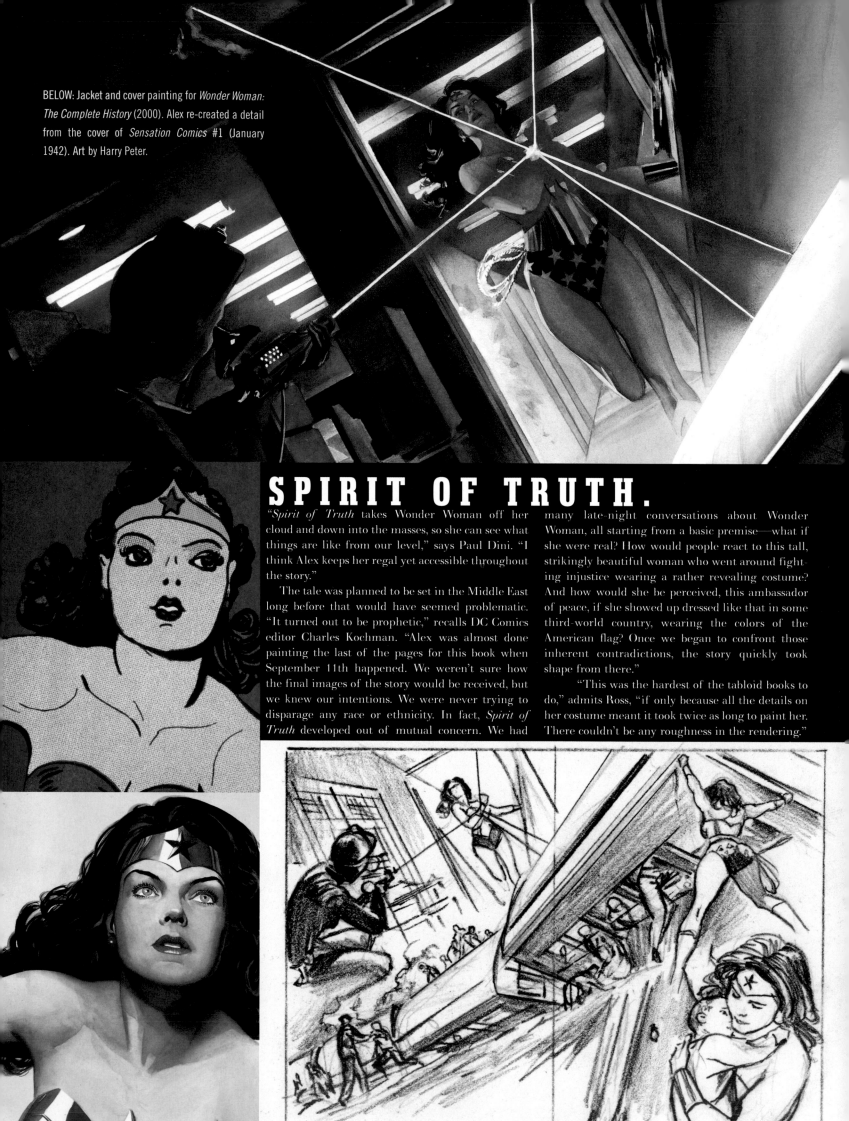

SPIRIT OF TRUTH.

"*Spirit of Truth* takes Wonder Woman off her cloud and down into the masses, so she can see what things are like from our level," says Paul Dini. "I think Alex keeps her regal yet accessible throughout the story."

The tale was planned to be set in the Middle East long before that would have seemed problematic. "It turned out to be prophetic," recalls DC Comics editor Charles Kochman. "Alex was almost done painting the last of the pages for this book when September 11th happened. We weren't sure how the final images of the story would be received, but we knew our intentions. We were never trying to disparage any race or ethnicity. In fact, *Spirit of Truth* developed out of mutual concern. We had

many late-night conversations about Wonder Woman, all starting from a basic premise—what if she were real? How would people react to this tall, strikingly beautiful woman who went around fighting injustice wearing a rather revealing costume? And how would she be perceived, this ambassador of peace, if she showed up dressed like that in some third-world country, wearing the colors of the American flag? Once we began to confront those inherent contradictions, the story quickly took shape from there."

"This was the hardest of the tabloid books to do," admits Ross, "if only because all the details on her costume meant it took twice as long to paint her. There couldn't be any roughness in the rendering."

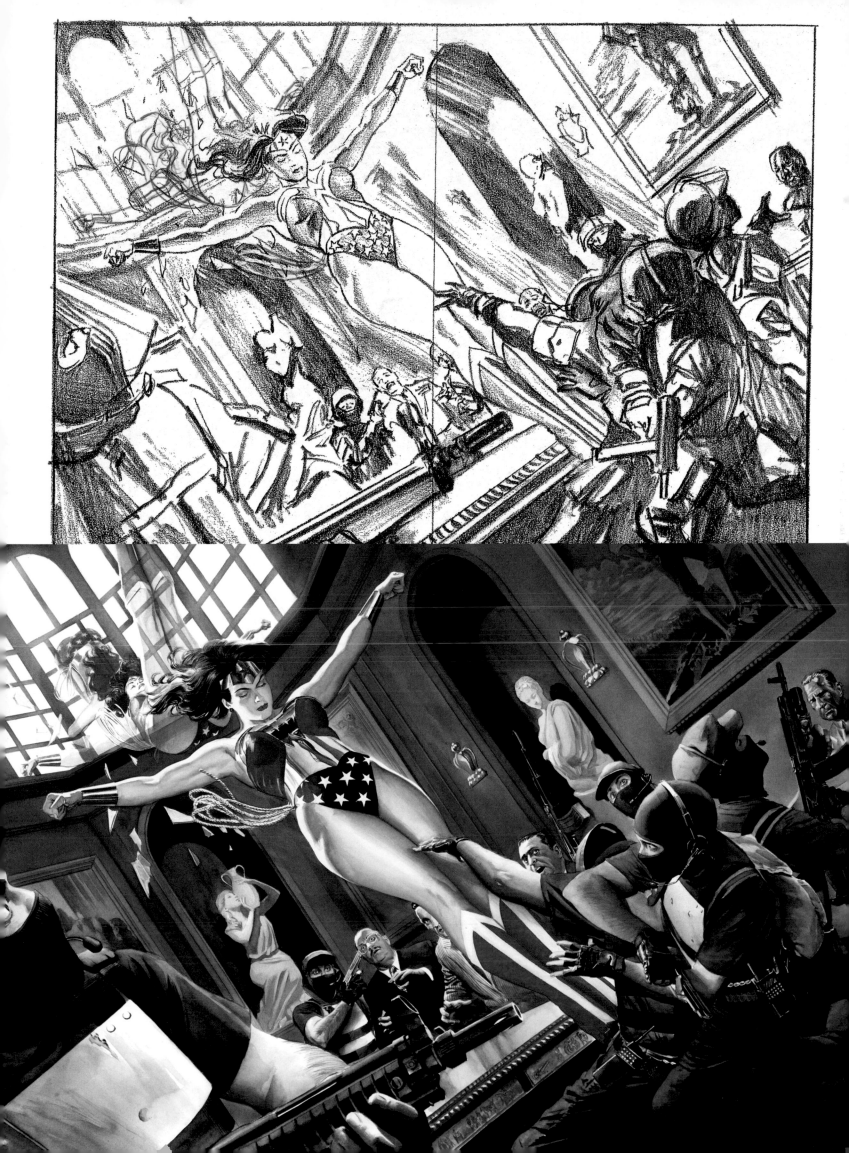

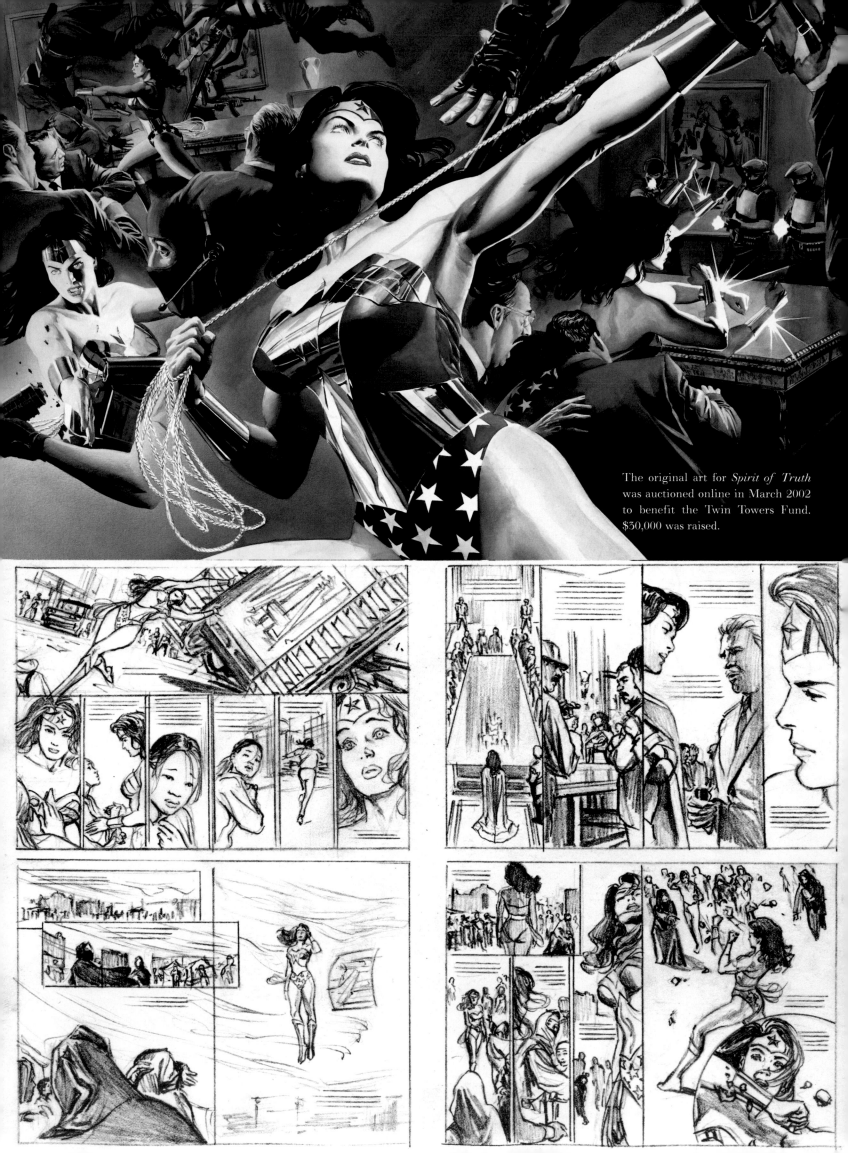

The original art for *Spirit of Truth* was auctioned online in March 2002 to benefit the Twin Towers Fund. $30,000 was raised.

The thumbnail pencil layouts on the opposite page and to the right reveal Wonder Woman attempting to connect with women of other cultures and finding little or no success. A lot of the action takes place in a nameless Muslim country, and even though the Amazing Amazon foils an "oppressive regime," that doesn't stop her burka-clad sisters from viewing her with fear and resentment.

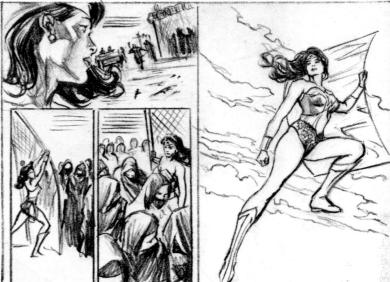

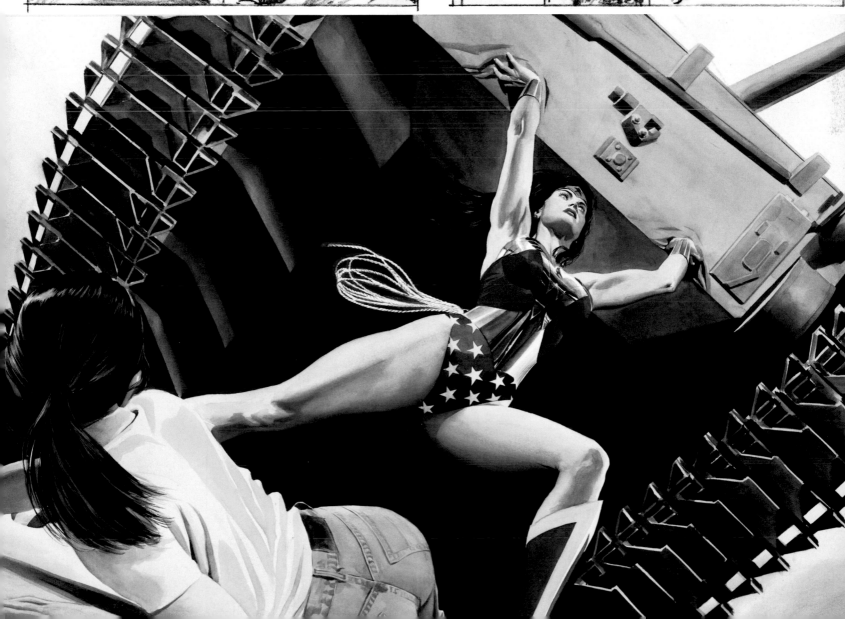

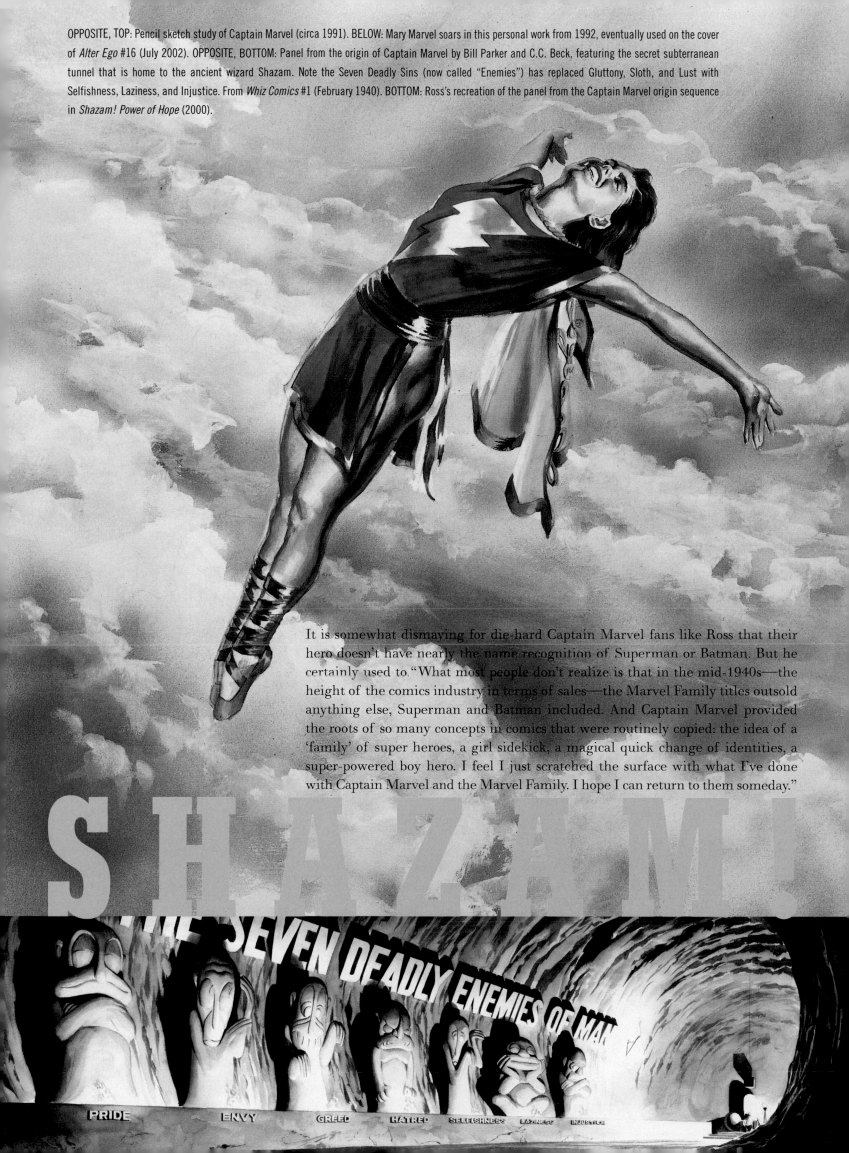

OPPOSITE, TOP: Pencil sketch study of Captain Marvel (circa 1991). BELOW: Mary Marvel soars in this personal work from 1992, eventually used on the cover of *Alter Ego* #16 (July 2002). OPPOSITE, BOTTOM: Panel from the origin of Captain Marvel by Bill Parker and C.C. Beck, featuring the secret subterranean tunnel that is home to the ancient wizard Shazam. Note the Seven Deadly Sins (now called "Enemies") has replaced Gluttony, Sloth, and Lust with Selfishness, Laziness, and Injustice. From *Whiz Comics* #1 (February 1940). BOTTOM: Ross's recreation of the panel from the Captain Marvel origin sequence in *Shazam! Power of Hope* (2000).

It is somewhat dismaying for die-hard Captain Marvel fans like Ross that their hero doesn't have nearly the name recognition of Superman or Batman. But he certainly used to. "What most people don't realize is that in the mid-1940s—the height of the comics industry in terms of sales—the Marvel Family titles outsold anything else, Superman and Batman included. And Captain Marvel provided the roots of so many concepts in comics that were routinely copied: the idea of a 'family' of super heroes, a girl sidekick, a magical quick change of identities, a super-powered boy hero. I feel I just scratched the surface with what I've done with Captain Marvel and the Marvel Family. I hope I can return to them someday."

SHAZAM!

THE SEVEN DEADLY ENEMIES OF MAN

PRIDE ENVY GREED HATRED SELFISHNESS LAZINESS INJUSTICE

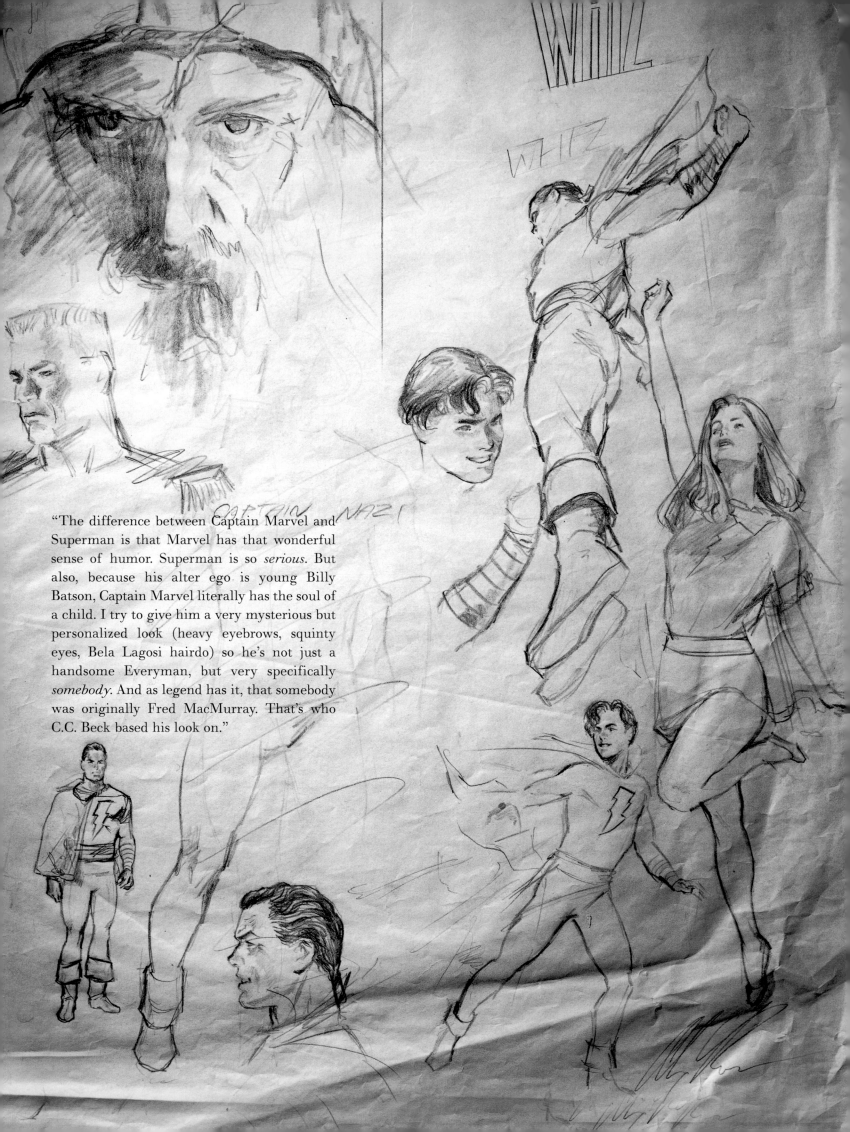

"The difference between Captain Marvel and Superman is that Marvel has that wonderful sense of humor. Superman is so *serious*. But also, because his alter ego is young Billy Batson, Captain Marvel literally has the soul of a child. I try to give him a very mysterious but personalized look (heavy eyebrows, squinty eyes, Bela Lagosi hairdo) so he's not just a handsome Everyman, but very specifically *somebody*. And as legend has it, that somebody was originally Fred MacMurray. That's who C.C. Beck based his look on."

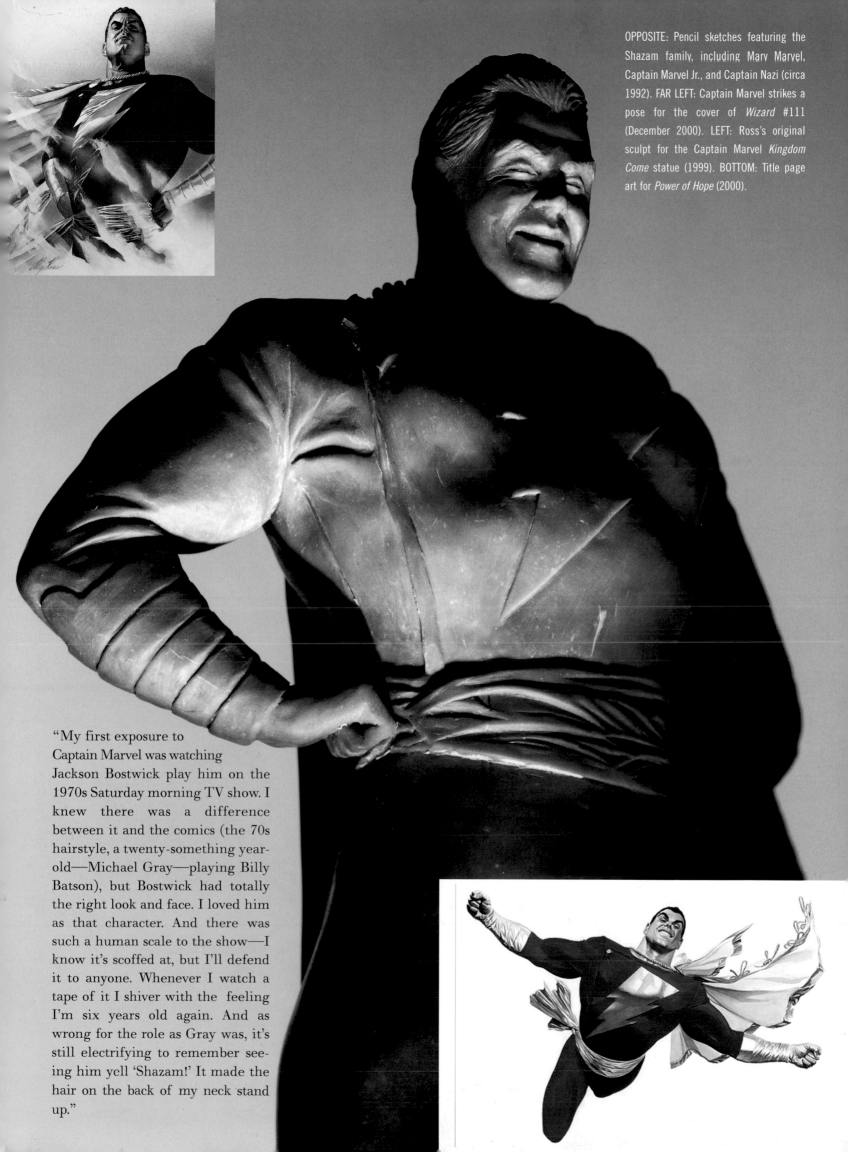

OPPOSITE: Pencil sketches featuring the Shazam family, including Mary Marvel, Captain Marvel Jr., and Captain Nazi (circa 1992). FAR LEFT: Captain Marvel strikes a pose for the cover of *Wizard* #111 (December 2000). LEFT: Ross's original sculpt for the Captain Marvel *Kingdom Come* statue (1999). BOTTOM: Title page art for *Power of Hope* (2000).

"My first exposure to Captain Marvel was watching Jackson Bostwick play him on the 1970s Saturday morning TV show. I knew there was a difference between it and the comics (the 70s hairstyle, a twenty-something year-old—Michael Gray—playing Billy Batson), but Bostwick had totally the right look and face. I loved him as that character. And there was such a human scale to the show—I know it's scoffed at, but I'll defend it to anyone. Whenever I watch a tape of it I shiver with the feeling I'm six years old again. And as wrong for the role as Gray was, it's still electrifying to remember seeing him yell 'Shazam!' It made the hair on the back of my neck stand up."

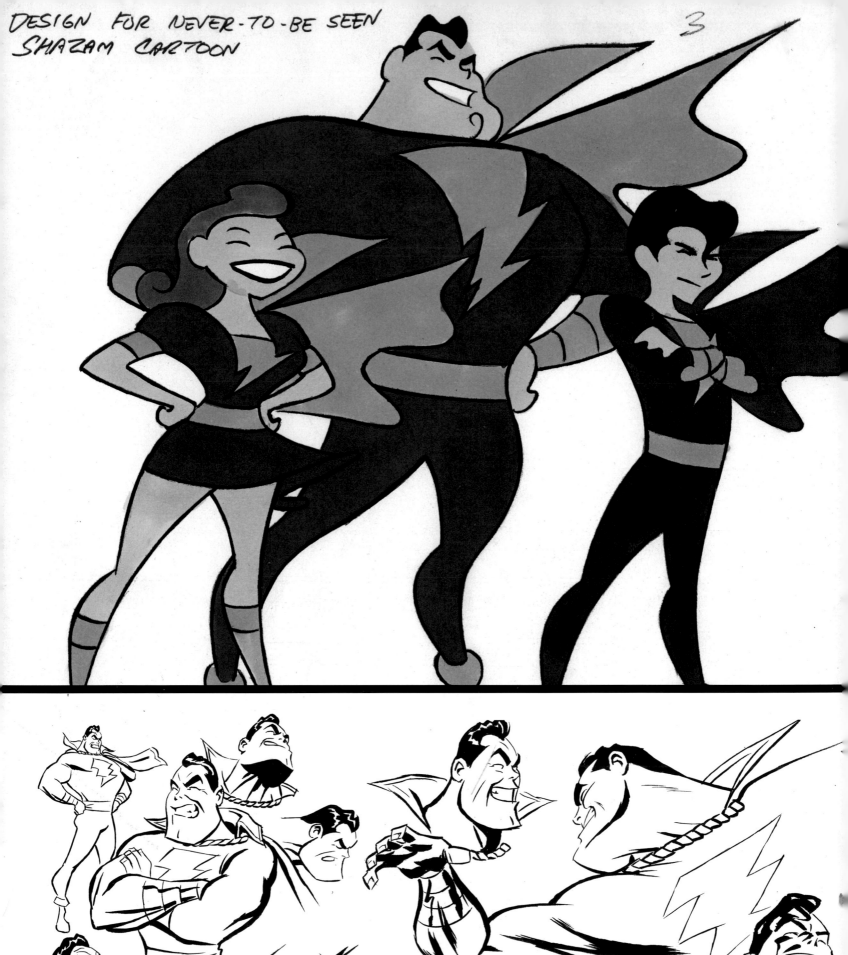

DESIGN FOR NEVER-TO-BE SEEN
SHAZAM CARTOON

3

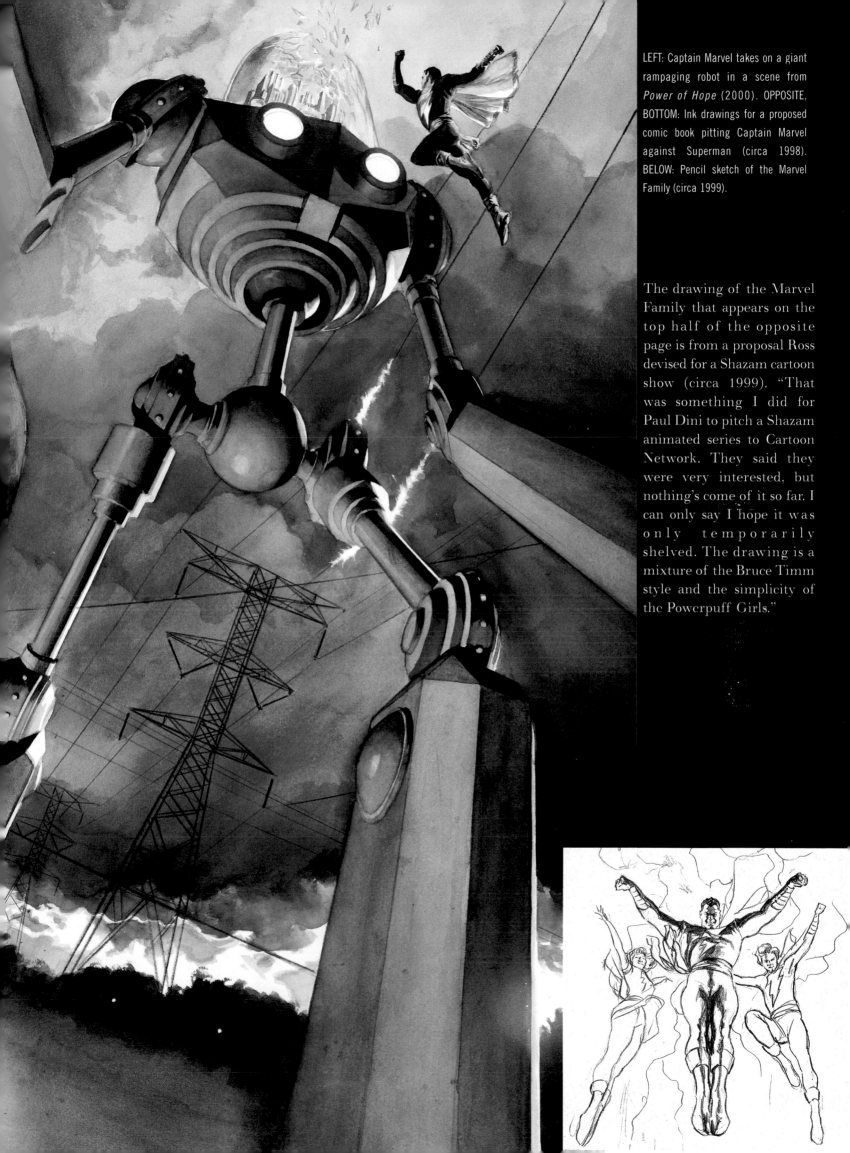

LEFT: Captain Marvel takes on a giant rampaging robot in a scene from *Power of Hope* (2000). OPPOSITE, BOTTOM: Ink drawings for a proposed comic book pitting Captain Marvel against Superman (circa 1998). BELOW: Pencil sketch of the Marvel Family (circa 1999).

The drawing of the Marvel Family that appears on the top half of the opposite page is from a proposal Ross devised for a Shazam cartoon show (circa 1999). "That was something I did for Paul Dini to pitch a Shazam animated series to Cartoon Network. They said they were very interested, but nothing's come of it so far. I can only say I hope it was only temporarily shelved. The drawing is a mixture of the Bruce Timm style and the simplicity of the Powerpuff Girls."

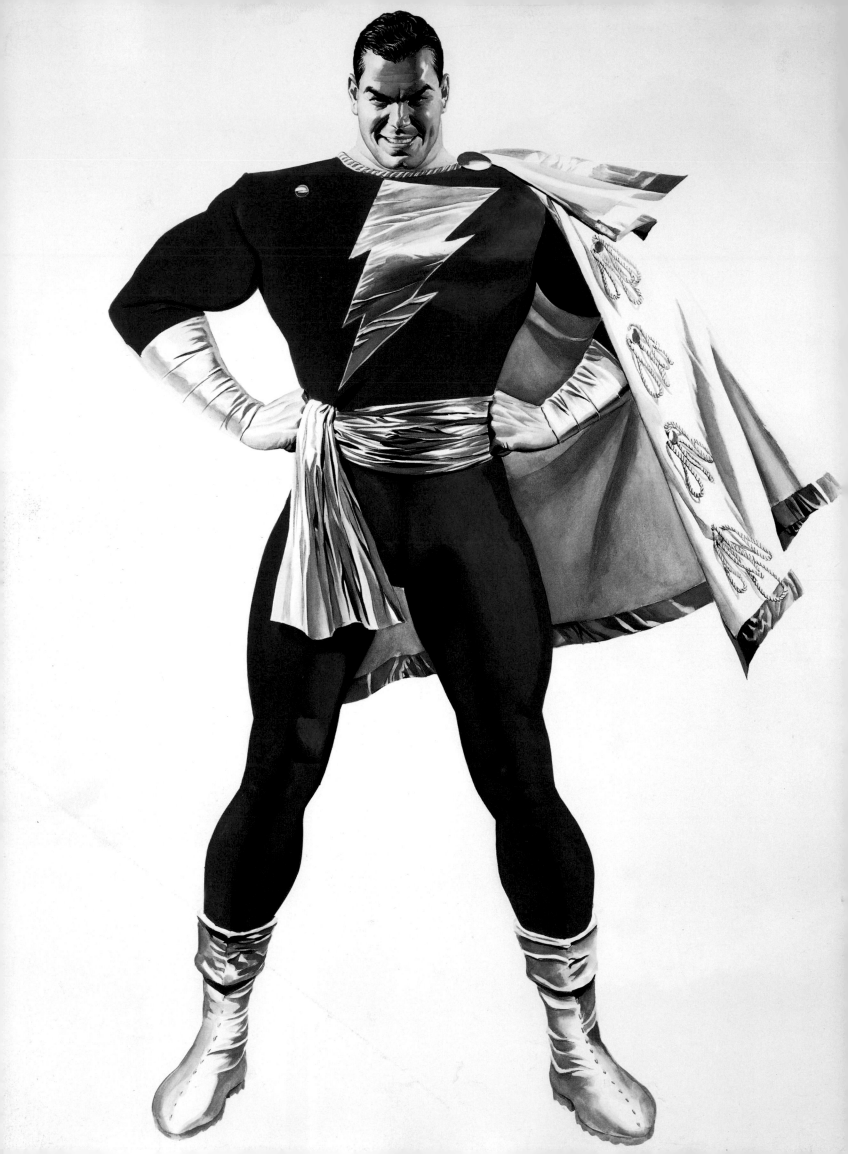

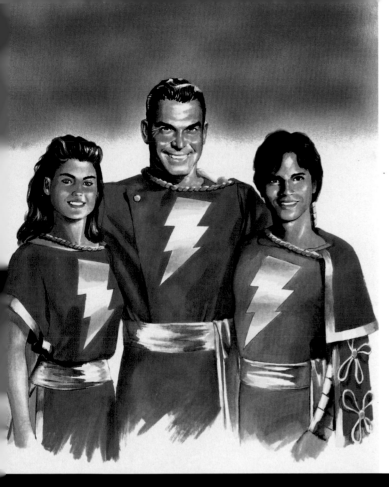

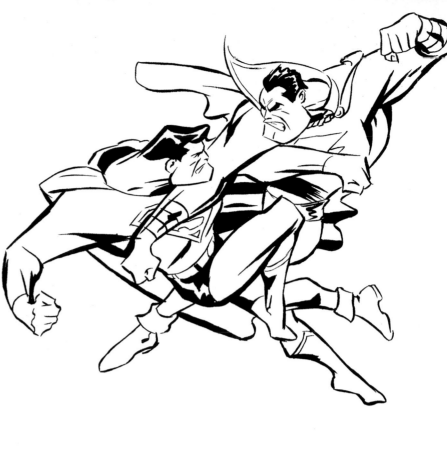

ABOVE: A sketch of the Marvel Family from 1992, with Mary Marvel based on the model Kathy Ireland, Fred MacMurray as Captain Marvel, and Michael Gray as Captain Marvel Jr. BELOW: The cover of *Whiz Comics* # 22 (October 1941). Art by C.C. Beck. OPPOSITE: Art for a Captain Marvel retail poster (DC Direct, 2001).

ABOVE: Superman and Captain Marvel go at it in this ink drawing, part of a unproduced comic proposal (circa 1998). BELOW: Tom Tyler played Captain Marvel in the 1940s Republic movie serials. "His costume was the major inspiration for how I depict him. Especially the gold on his chest and cape. That series is commonly considered the best super hero movie serial of the period ever made. I sure think so."

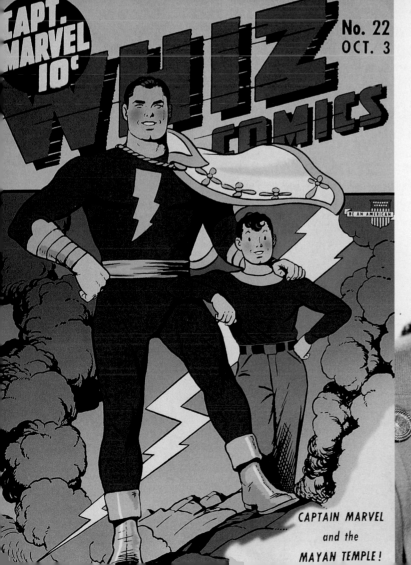

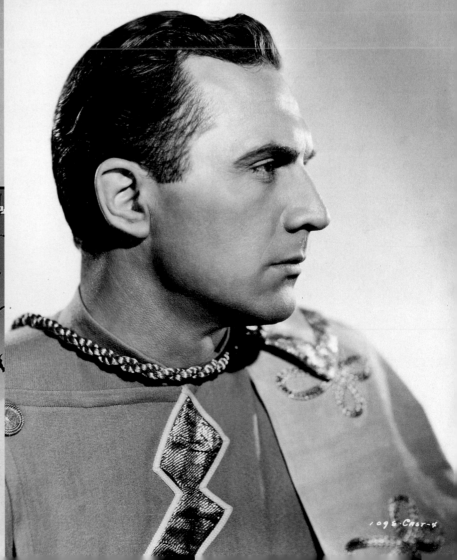

POWER OF HOPE.

"In many ways this book is a childhood dream come true," recalls DC Comics editor Charles Kochman. "When Alex and I first spoke, we discovered we both shared a love for the original Captain Marvel. In conceptualizing the series of tabloids, this was the book that excited us from the start. His story had everything: a terrific origin, an amazing roster of sidekicks and villains, and a super hero who embodied the ultimate in wish fulfillment. Not only could Billy Batson become an adult at will, with just one magic word—'Shazam!'—he could become an adult *with superpowers*. And he was not just *any* super hero, he was the World's Mightiest Mortal. If one were to indulge in that favorite childhood pastime of 'Who is stronger than whom?', for my money, Captain Marvel was the strongest of them all. Creating a story that lived up to that hyperbole was actually easy. For all his grandeur, deep down Captain Marvel was just a little boy. And that's how he sees the world. He's very, very human. I think *Power of Hope* is perhaps the most human of all the stories Paul and Alex have told." Ross agrees: "There was originally a lot more of the Shazam cast in the script, but that would have taken away from the focus we wanted to give it, which was the very human scale of how Captain Marvel would deal with troubled children, because he is essentially a child, too."

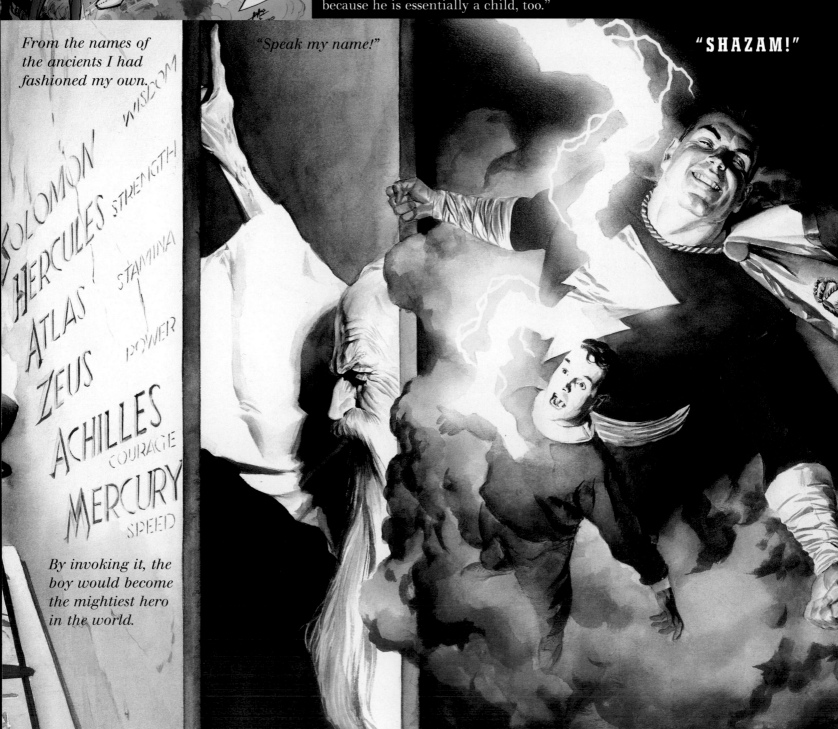

From the names of the ancients I had fashioned my own.

"*Speak my name!*"

"SHAZAM!"

WISDOM
SOLOMON
HERCULES STRENGTH
ATLAS STAMINA
ZEUS POWER
ACHILLES COURAGE
MERCURY SPEED

By invoking it, the boy would become the mightiest hero in the world.

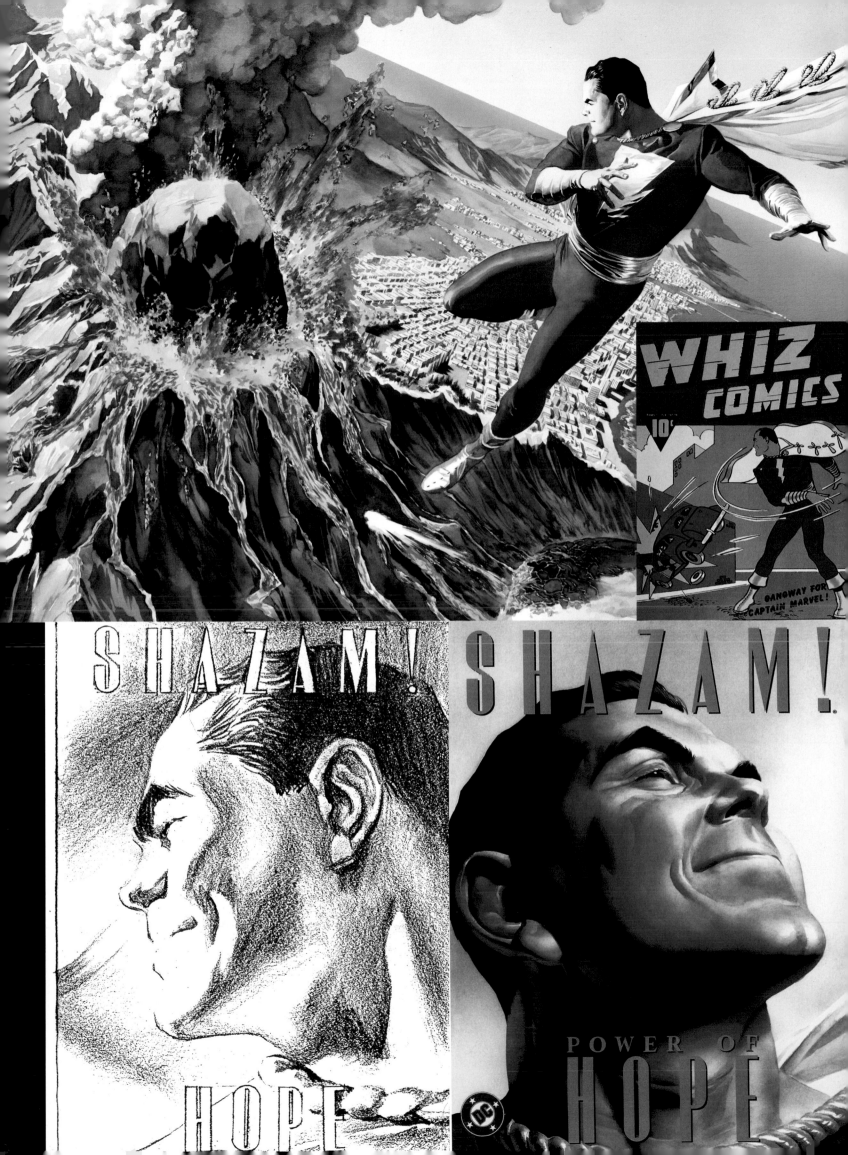

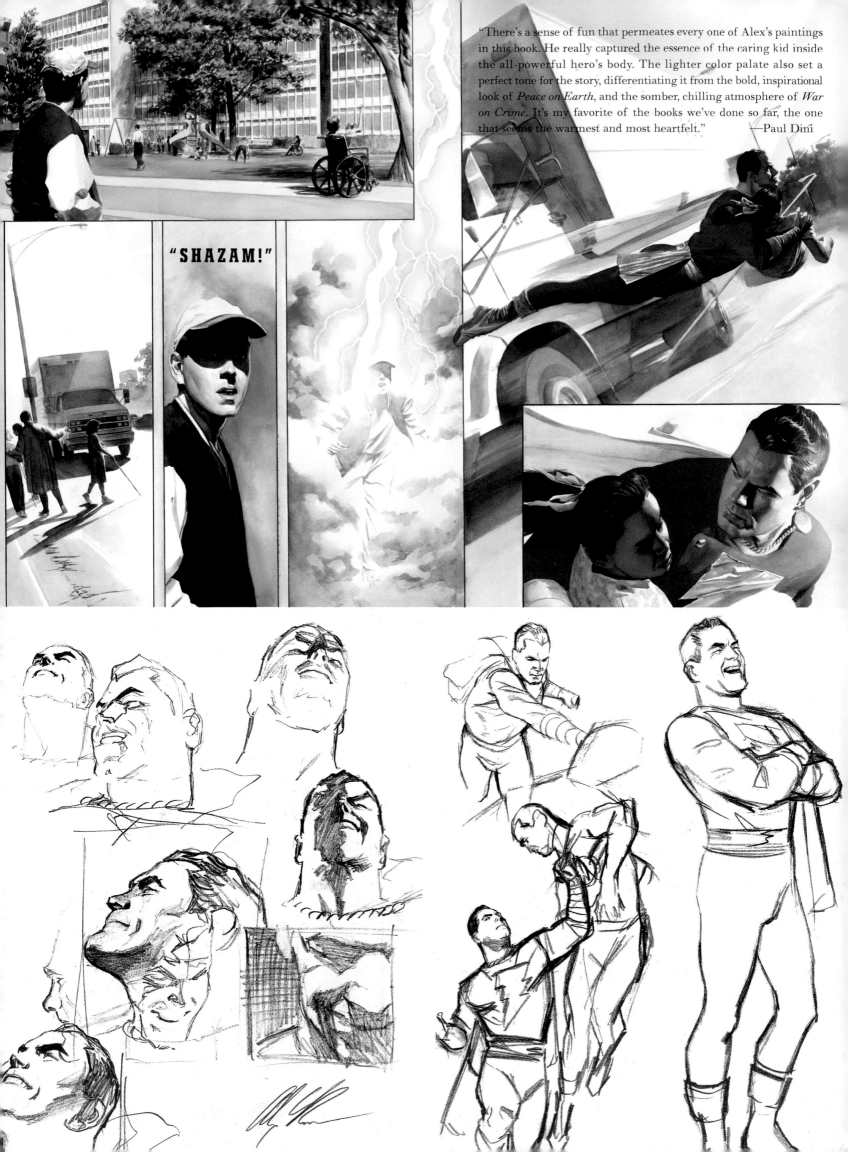

"SHAZAM!"

"There's a sense of fun that permeates every one of Alex's paintings in this book. He really captured the essence of the caring kid inside the all-powerful hero's body. The lighter color palate also set a perfect tone for the story, differentiating it from the bold, inspirational look of *Peace on Earth*, and the somber, chilling atmosphere of *War on Crime*. It's my favorite of the books we've done so far, the one that seems the warmest and most heartfelt."
—Paul Dini

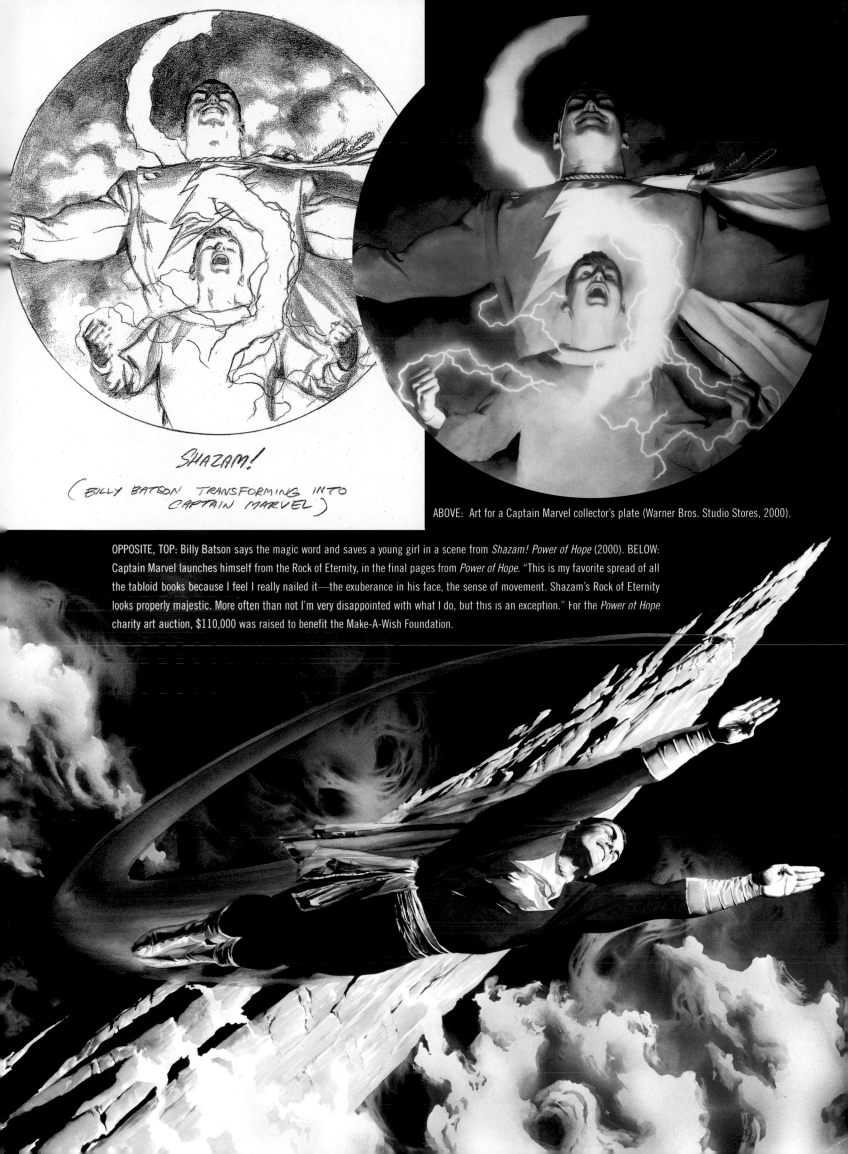

SHAZAM!

(BILLY BATSON TRANSFORMING INTO CAPTAIN MARVEL)

ABOVE: Art for a Captain Marvel collector's plate (Warner Bros. Studio Stores, 2000).

OPPOSITE, TOP: Billy Batson says the magic word and saves a young girl in a scene from *Shazam! Power of Hope* (2000). BELOW: Captain Marvel launches himself from the Rock of Eternity, in the final pages from *Power of Hope*. "This is my favorite spread of all the tabloid books because I feel I really nailed it—the exuberance in his face, the sense of movement. Shazam's Rock of Eternity looks properly majestic. More often than not I'm very disappointed with what I do, but this is an exception." For the *Power of Hope* charity art auction, $110,000 was raised to benefit the Make-A-Wish Foundation.

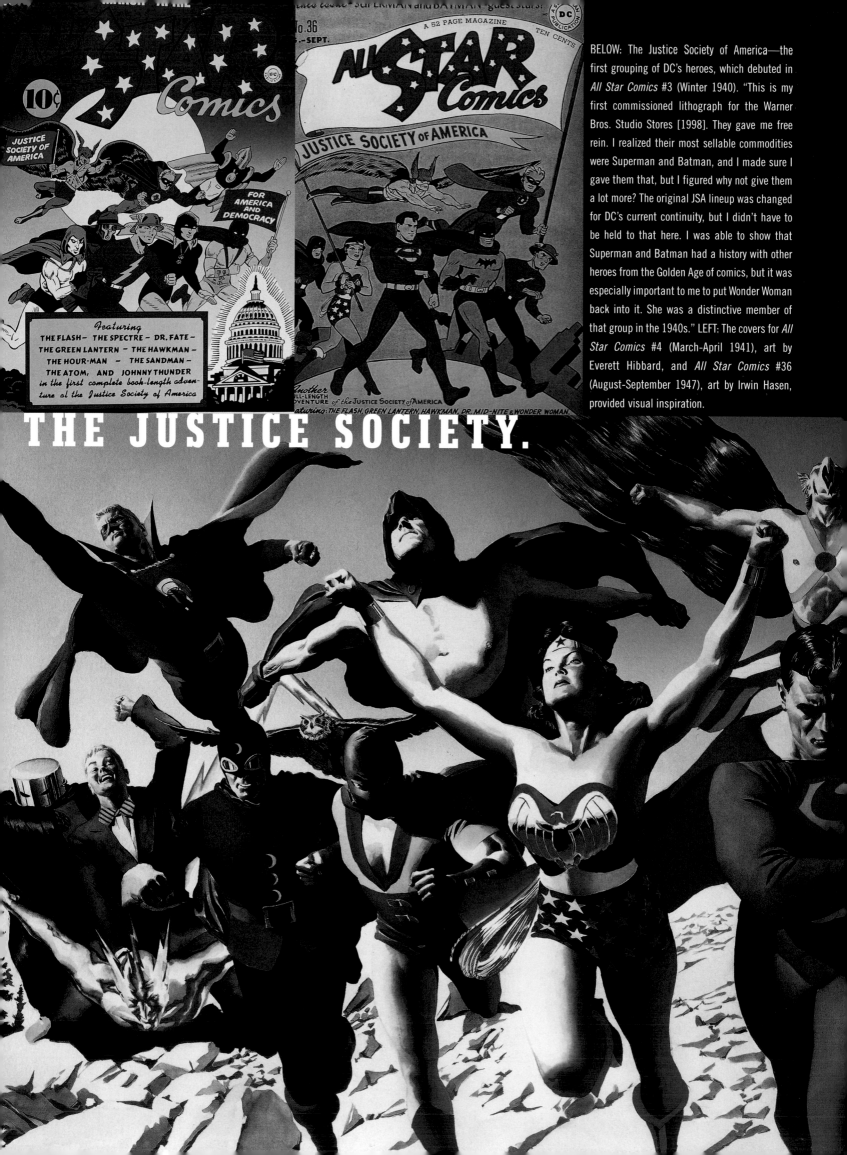

BELOW: The Justice Society of America—the first grouping of DC's heroes, which debuted in *All Star Comics* #3 (Winter 1940). "This is my first commissioned lithograph for the Warner Bros. Studio Stores [1998]. They gave me free rein. I realized their most sellable commodities were Superman and Batman, and I made sure I gave them that, but I figured why not give them a lot more? The original JSA lineup was changed for DC's current continuity, but I didn't have to be held to that here. I was able to show that Superman and Batman had a history with other heroes from the Golden Age of comics, but it was especially important to me to put Wonder Woman back into it. She was a distinctive member of that group in the 1940s." LEFT: The covers for *All Star Comics* #4 (March-April 1941), art by Everett Hibbard, and *All Star Comics* #36 (August-September 1947), art by Irwin Hasen, provided visual inspiration.

THE JUSTICE SOCIETY.

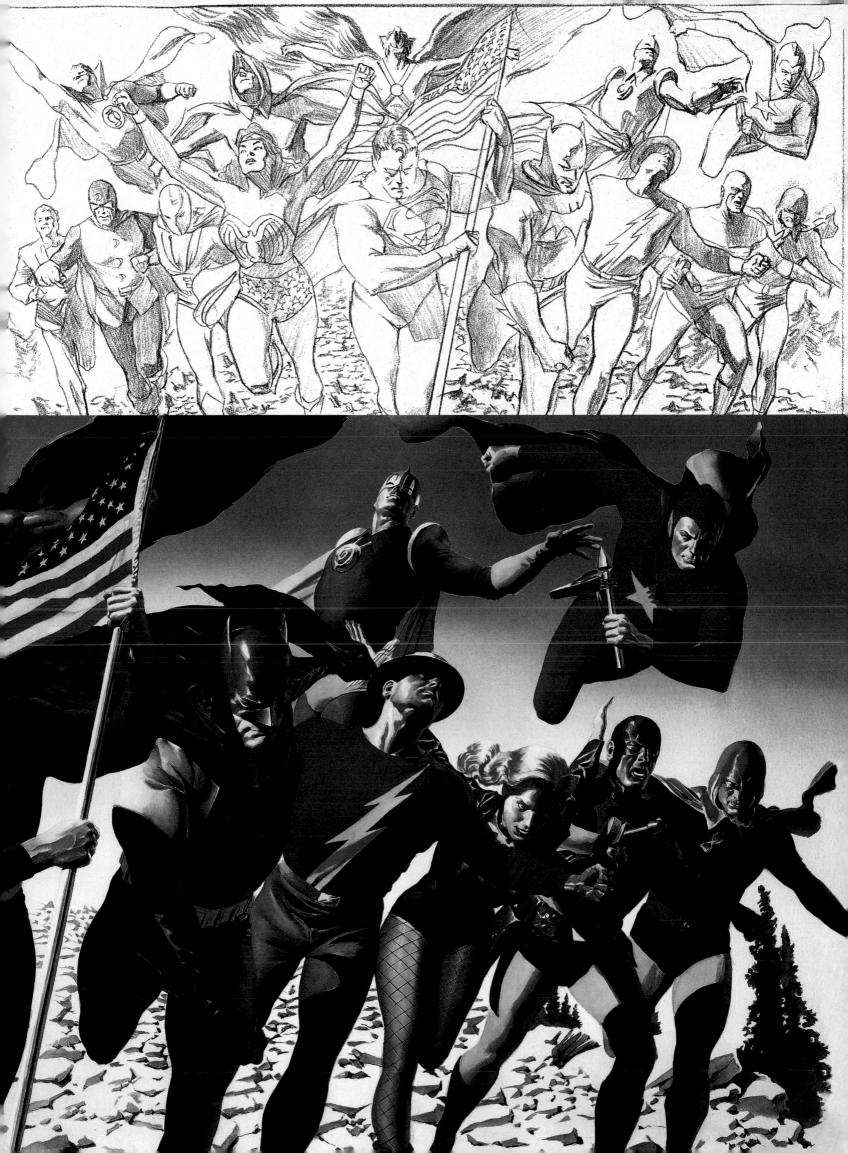

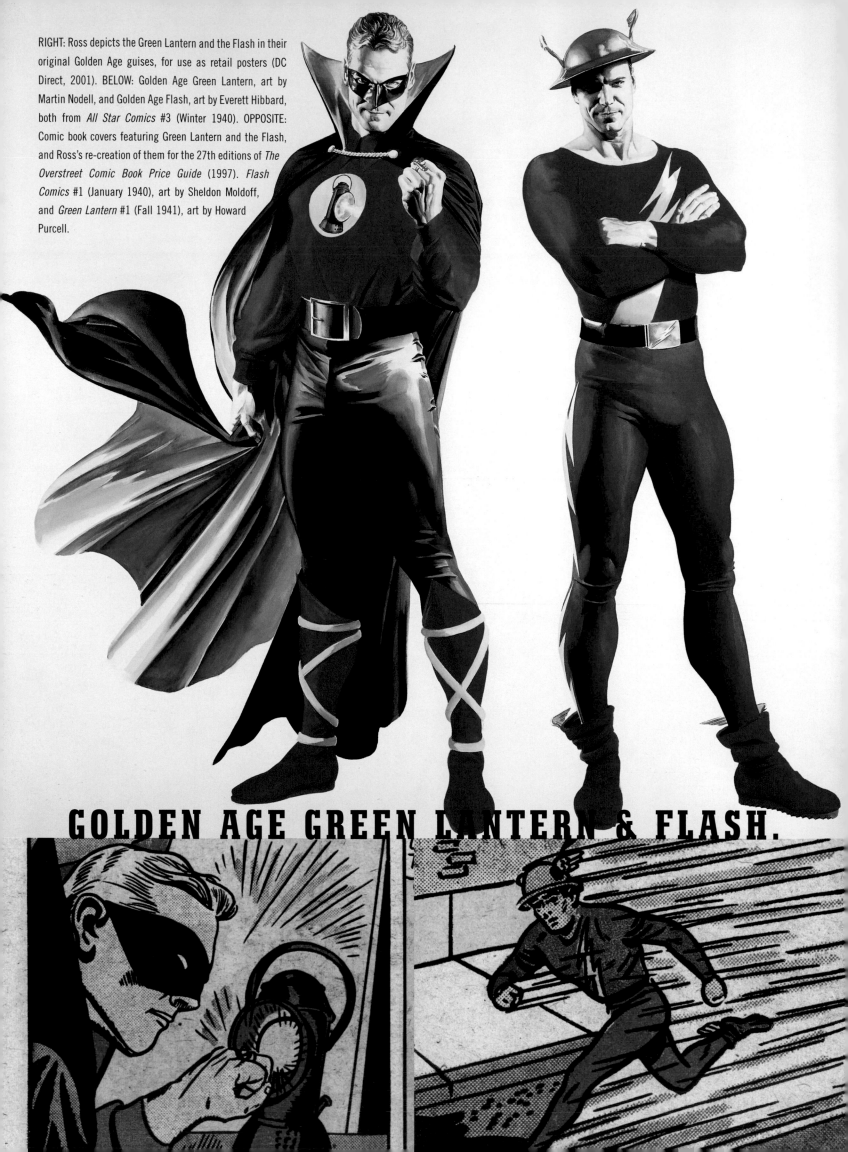

RIGHT: Ross depicts the Green Lantern and the Flash in their original Golden Age guises, for use as retail posters (DC Direct, 2001). BELOW: Golden Age Green Lantern, art by Martin Nodell, and Golden Age Flash, art by Everett Hibbard, both from *All Star Comics* #3 (Winter 1940). OPPOSITE: Comic book covers featuring Green Lantern and the Flash, and Ross's re-creation of them for the 27th editions of *The Overstreet Comic Book Price Guide* (1997). *Flash Comics* #1 (January 1940), art by Sheldon Moldoff, and *Green Lantern* #1 (Fall 1941), art by Howard Purcell.

GOLDEN AGE GREEN LANTERN & FLASH.

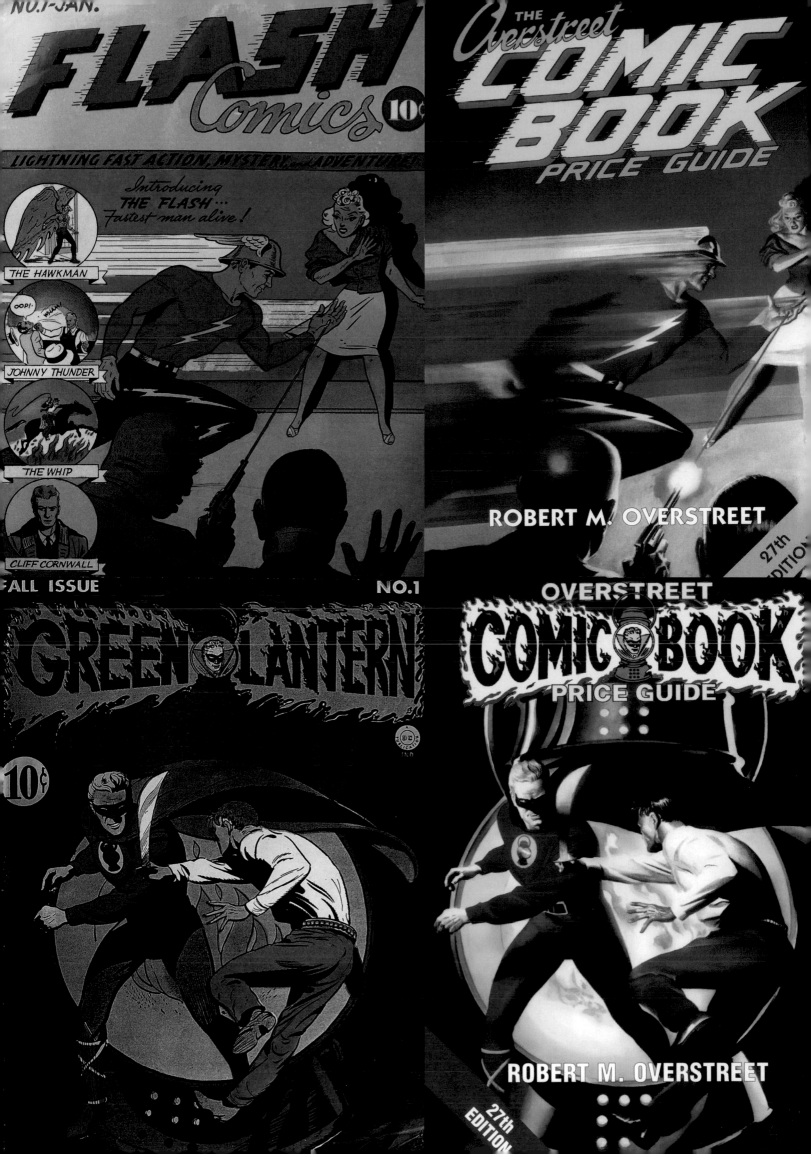

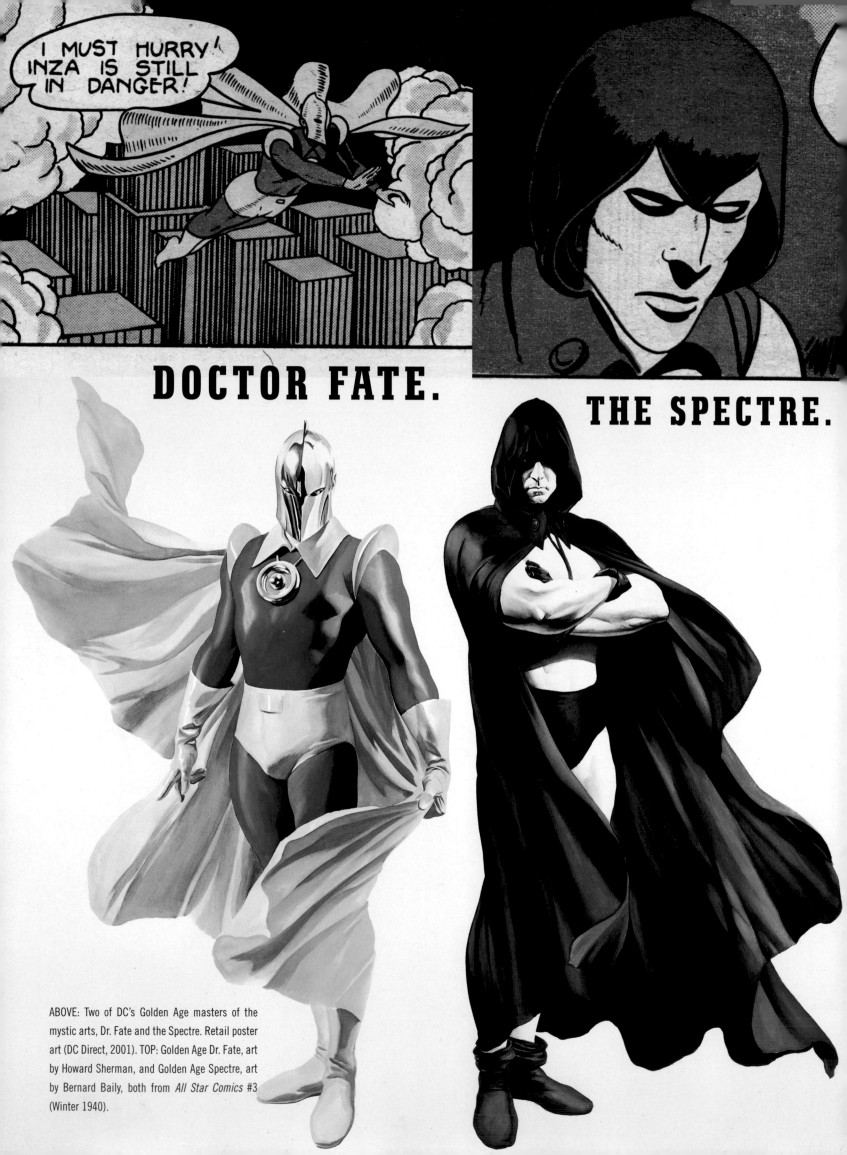

I MUST HURRY! INZA IS STILL IN DANGER!

DOCTOR FATE.

THE SPECTRE.

ABOVE: Two of DC's Golden Age masters of the mystic arts, Dr. Fate and the Spectre. Retail poster art (DC Direct, 2001). TOP: Golden Age Dr. Fate, art by Howard Sherman, and Golden Age Spectre, art by Bernard Baily, both from *All Star Comics* #3 (Winter 1940).

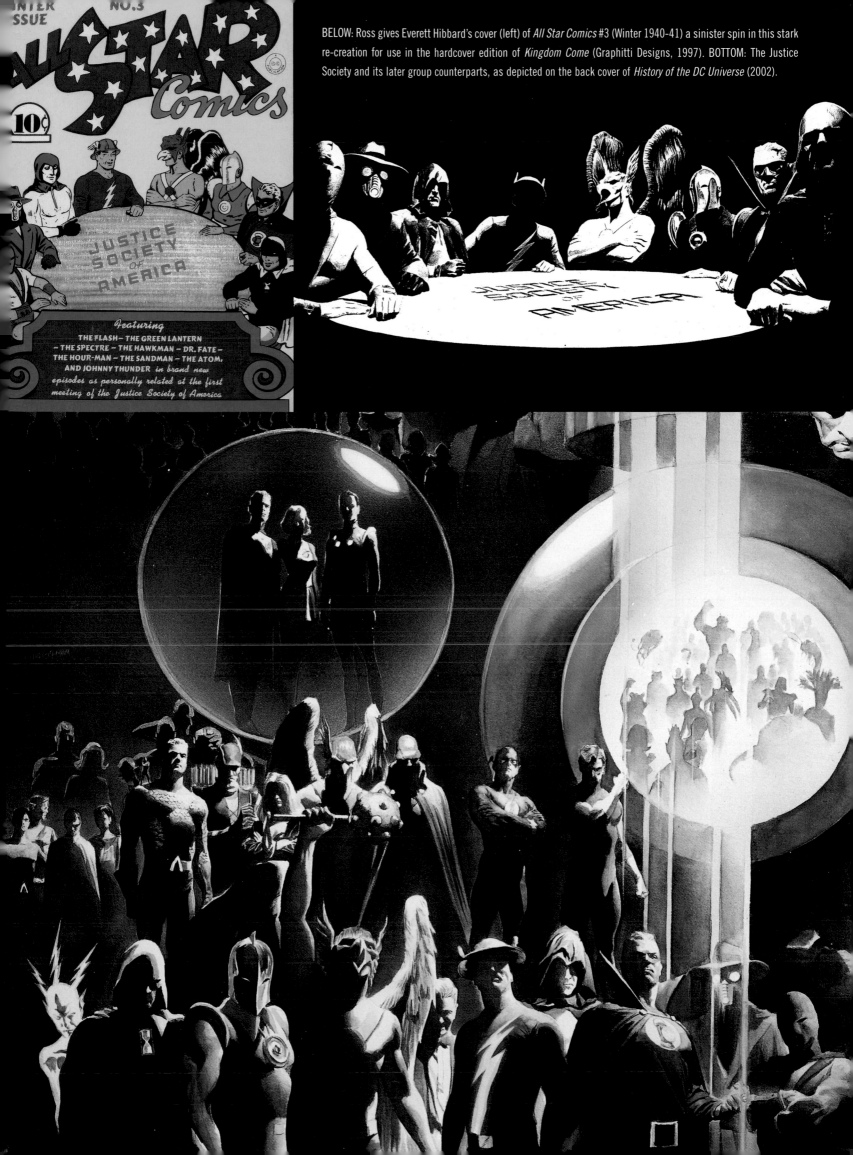

BELOW: Ross gives Everett Hibbard's cover (left) of *All Star Comics* #3 (Winter 1940-41) a sinister spin in this stark re-creation for use in the hardcover edition of *Kingdom Come* (Graphitti Designs, 1997). BOTTOM: The Justice Society and its later group counterparts, as depicted on the back cover of *History of the DC Universe* (2002).

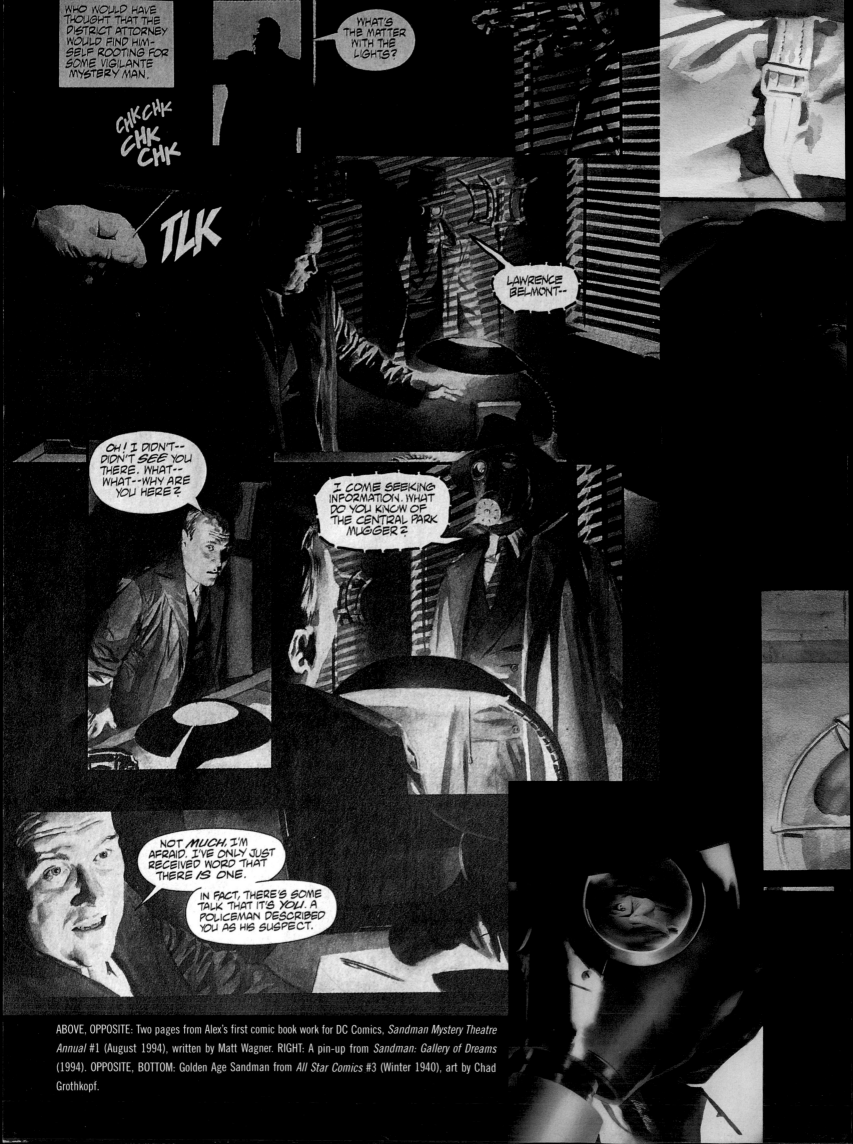

ABOVE, OPPOSITE: Two pages from Alex's first comic book work for DC Comics, *Sandman Mystery Theatre Annual* #1 (August 1994), written by Matt Wagner. RIGHT: A pin-up from *Sandman: Gallery of Dreams* (1994). OPPOSITE, BOTTOM: Golden Age Sandman from *All Star Comics* #3 (Winter 1940), art by Chad Grothkopf.

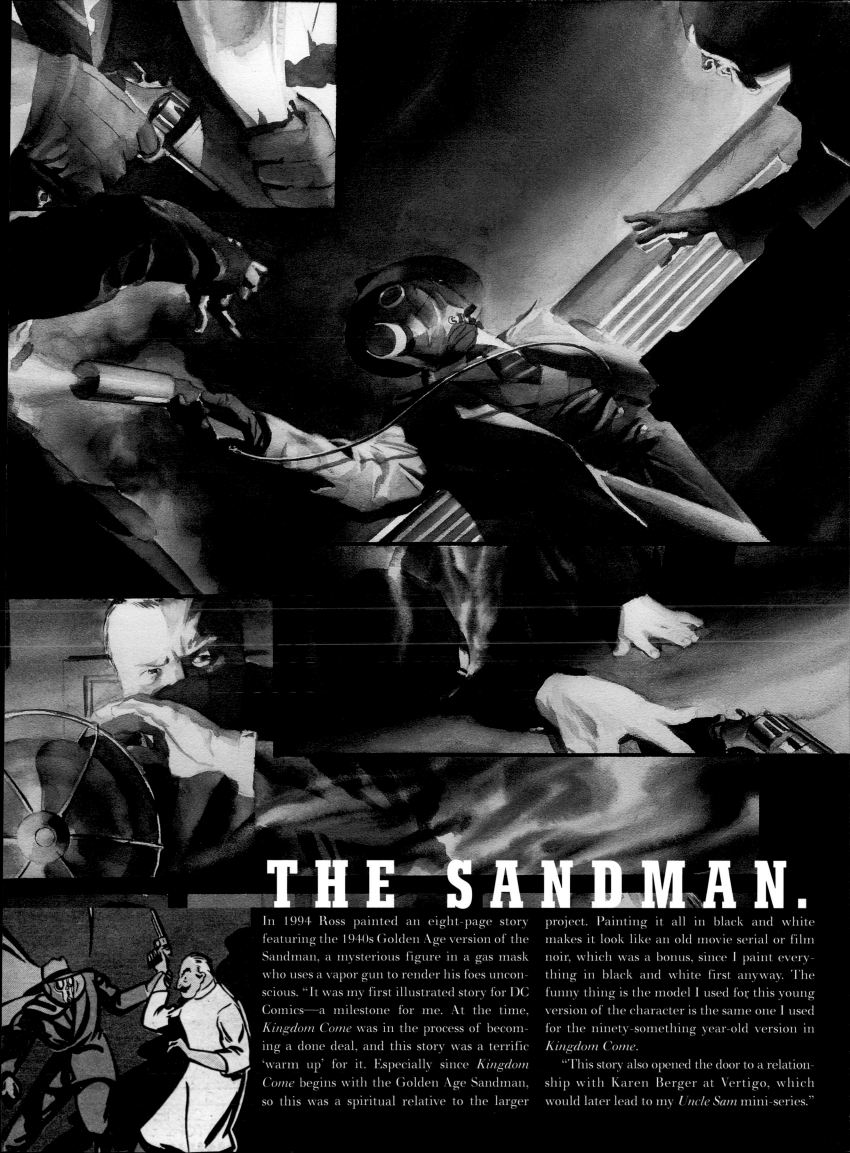

THE SANDMAN.

In 1994 Ross painted an eight-page story featuring the 1940s Golden Age version of the Sandman, a mysterious figure in a gas mask who uses a vapor gun to render his foes unconscious. "It was my first illustrated story for DC Comics—a milestone for me. At the time, *Kingdom Come* was in the process of becoming a done deal, and this story was a terrific 'warm up' for it. Especially since *Kingdom Come* begins with the Golden Age Sandman, so this was a spiritual relative to the larger project. Painting it all in black and white makes it look like an old movie serial or film noir, which was a bonus, since I paint everything in black and white first anyway. The funny thing is the model I used for this young version of the character is the same one I used for the ninety-something year-old version in *Kingdom Come*.

"This story also opened the door to a relationship with Karen Berger at Vertigo, which would later lead to my *Uncle Sam* mini-series."

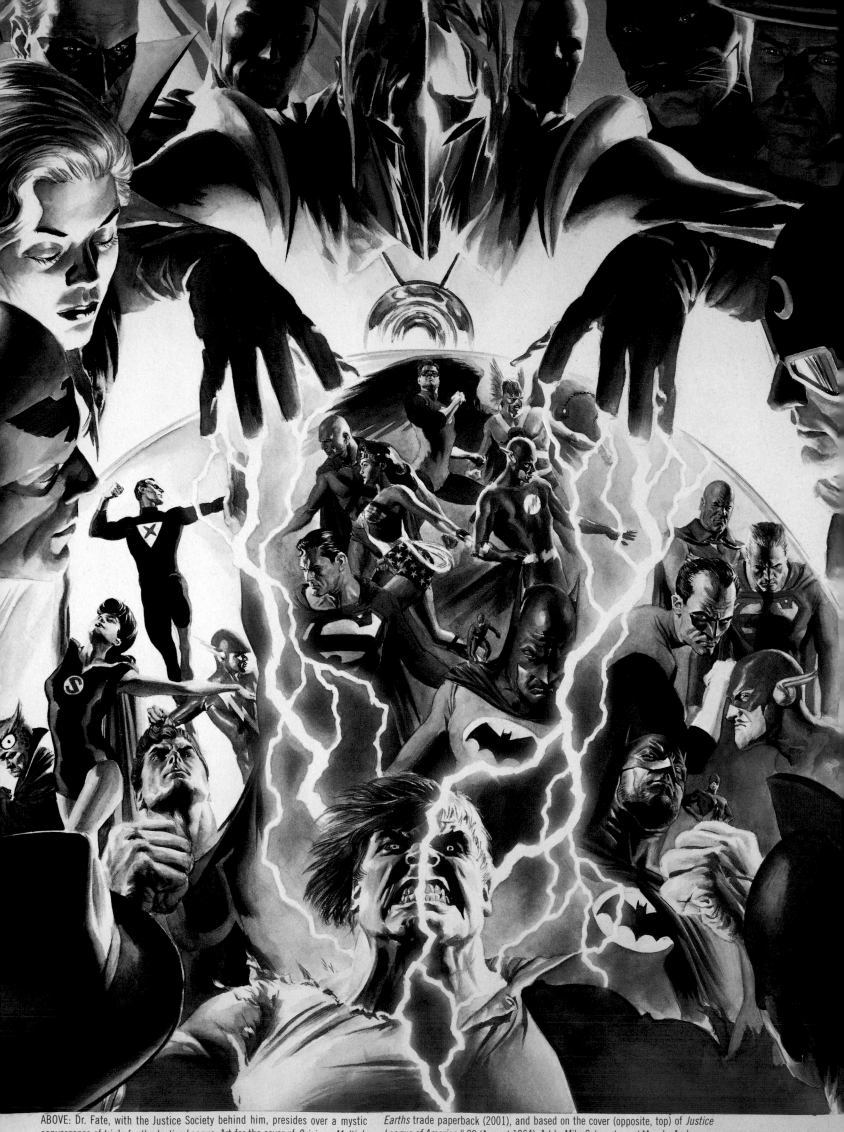

ABOVE: Dr. Fate, with the Justice Society behind him, presides over a mystic convergence of trials for the Justice League. Art for the cover of *Crisis on Multiple Earths* trade paperback (2001), and based on the cover (opposite, top) of *Justice League of America* # 29 (August 1964). Art by Mike Sekowsky and Murphy Anderson.

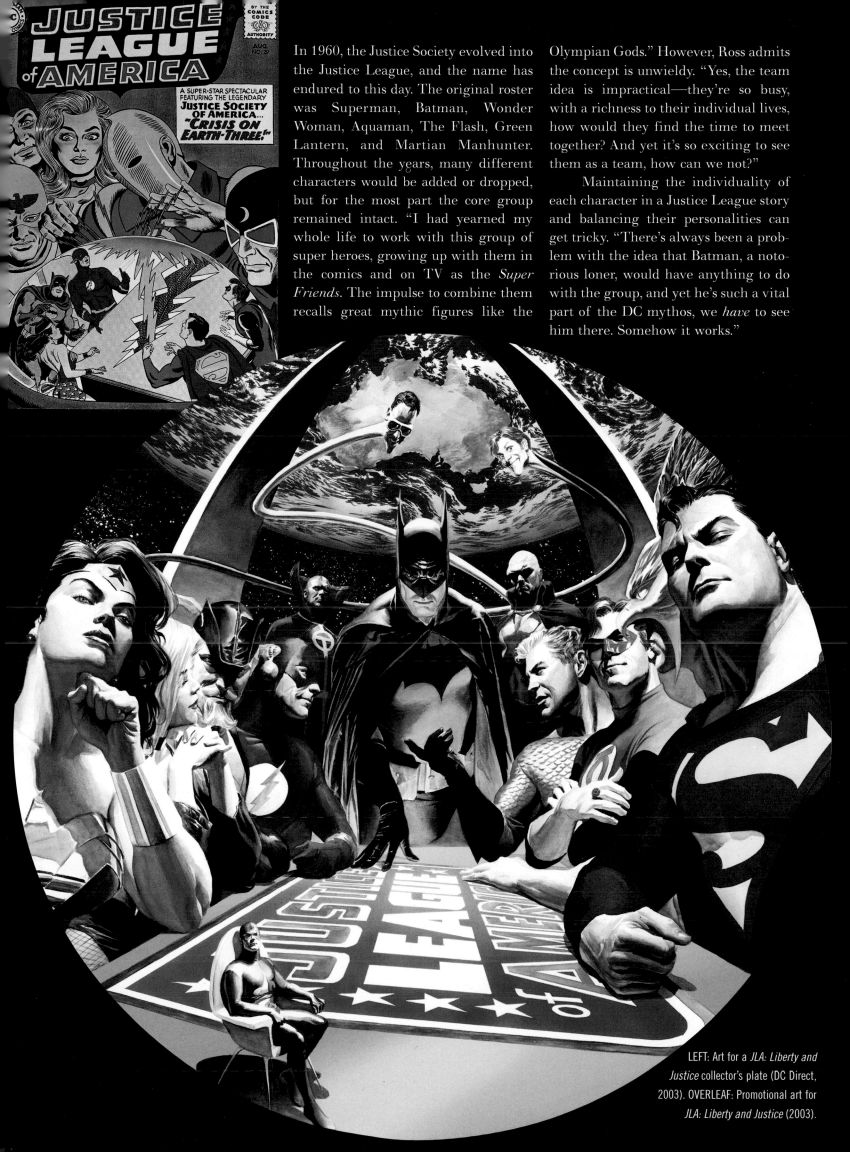

In 1960, the Justice Society evolved into the Justice League, and the name has endured to this day. The original roster was Superman, Batman, Wonder Woman, Aquaman, The Flash, Green Lantern, and Martian Manhunter. Throughout the years, many different characters would be added or dropped, but for the most part the core group remained intact. "I had yearned my whole life to work with this group of super heroes, growing up with them in the comics and on TV as the *Super Friends*. The impulse to combine them recalls great mythic figures like the Olympian Gods." However, Ross admits the concept is unwieldy. "Yes, the team idea is impractical—they're so busy, with a richness to their individual lives, how would they find the time to meet together? And yet it's so exciting to see them as a team, how can we not?"

Maintaining the individuality of each character in a Justice League story and balancing their personalities can get tricky. "There's always been a problem with the idea that Batman, a notorious loner, would have anything to do with the group, and yet he's such a vital part of the DC mythos, we *have* to see him there. Somehow it works."

LEFT: Art for a *JLA: Liberty and Justice* collector's plate (DC Direct, 2003). OVERLEAF: Promotional art for *JLA: Liberty and Justice* (2003).

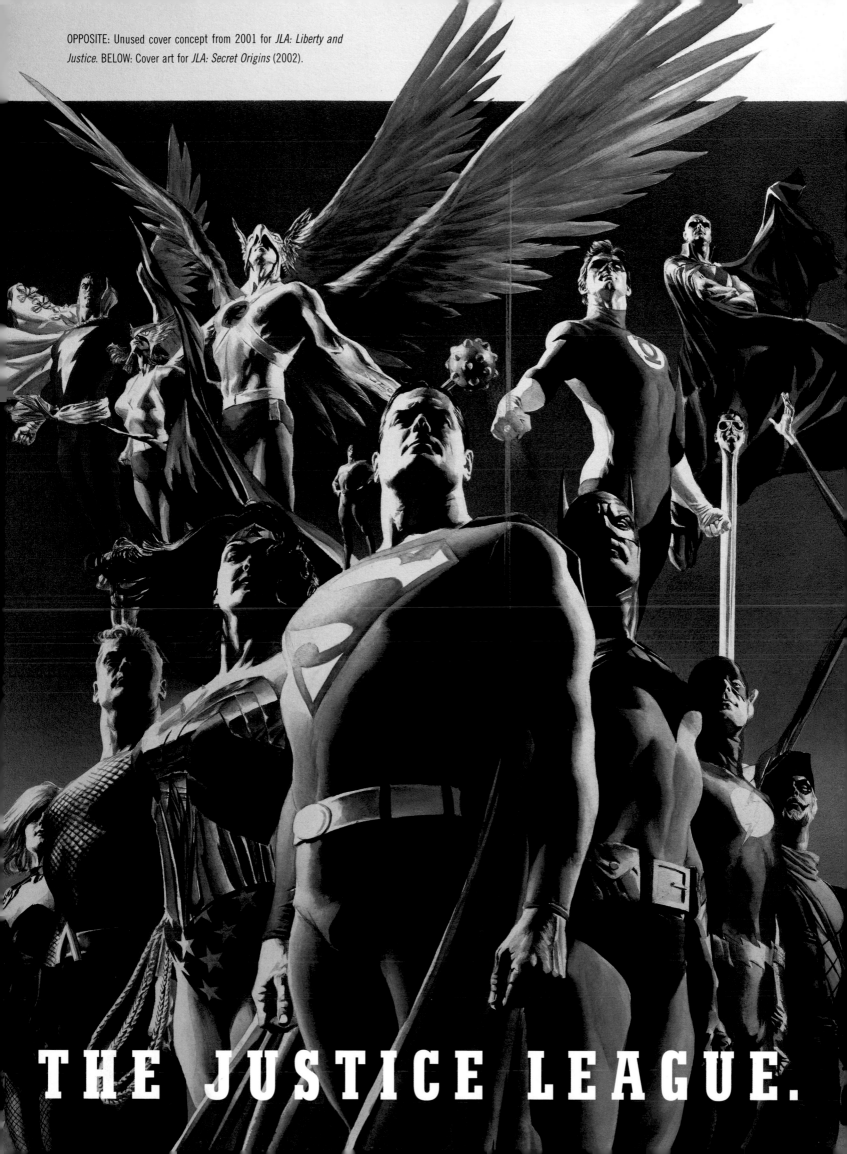

THE JUSTICE LEAGUE.

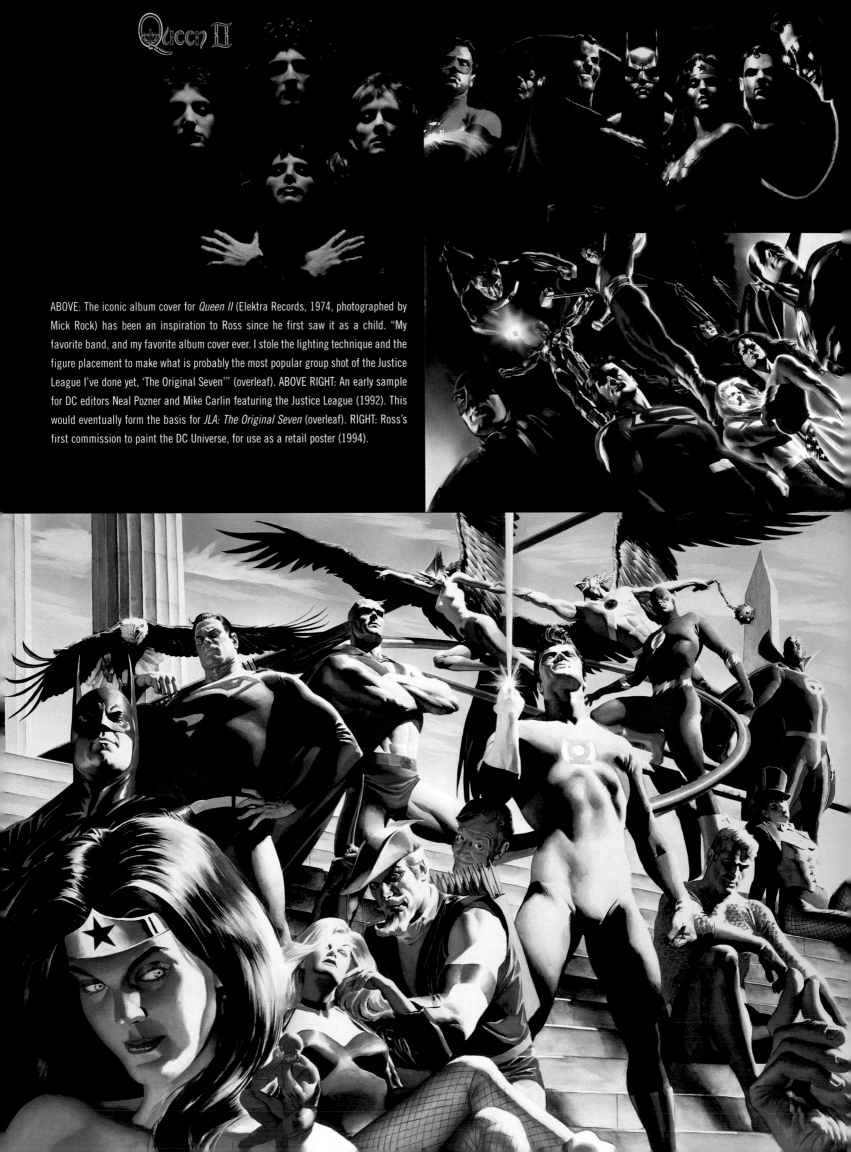

ABOVE: The iconic album cover for *Queen II* (Elektra Records, 1974, photographed by Mick Rock) has been an inspiration to Ross since he first saw it as a child. "My favorite band, and my favorite album cover ever. I stole the lighting technique and the figure placement to make what is probably the most popular group shot of the Justice League I've done yet, 'The Original Seven'" (overleaf). ABOVE RIGHT: An early sample for DC editors Neal Pozner and Mike Carlin featuring the Justice League (1992). This would eventually form the basis for *JLA: The Original Seven* (overleaf). RIGHT: Ross's first commission to paint the DC Universe, for use as a retail poster (1994).

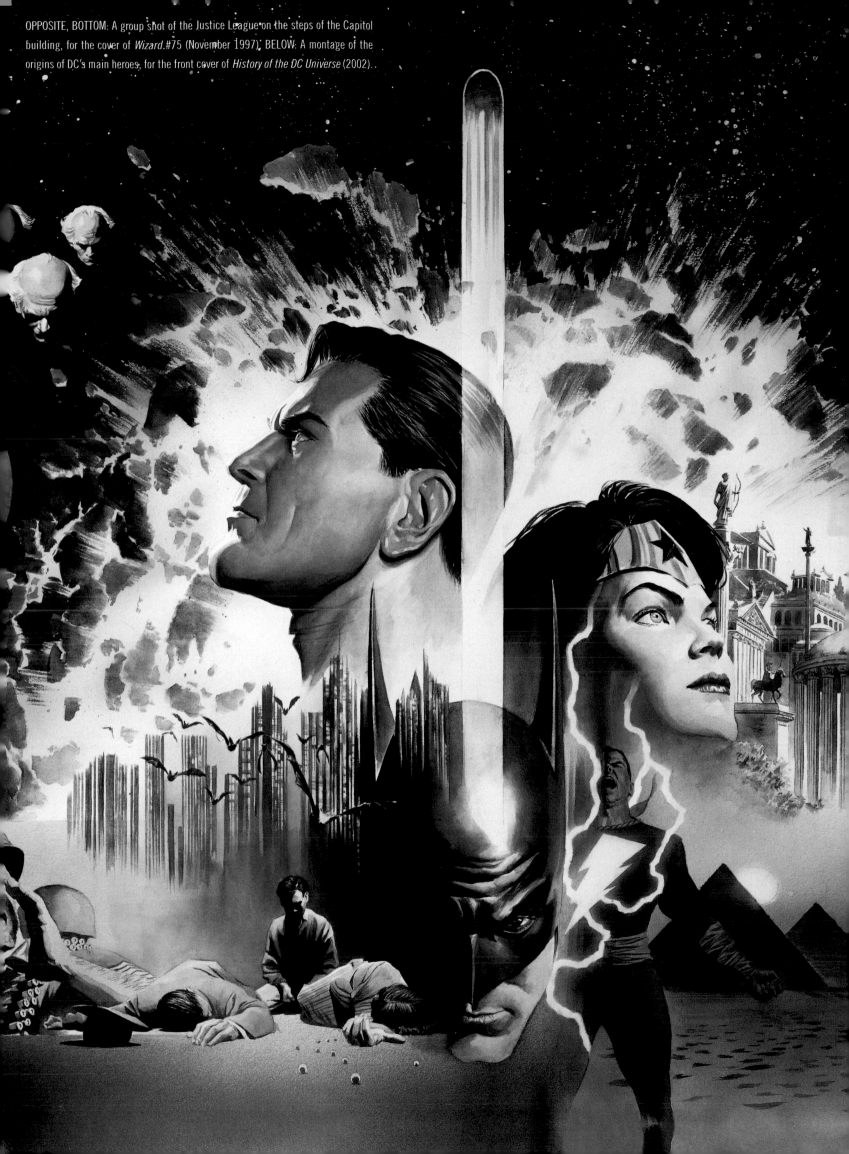

OPPOSITE, BOTTOM: A group shot of the Justice League on the steps of the Capitol building, for the cover of *Wizard* #75 (November 1997). BELOW: A montage of the origins of DC's main heroes, for the front cover of *History of the DC Universe* (2002).

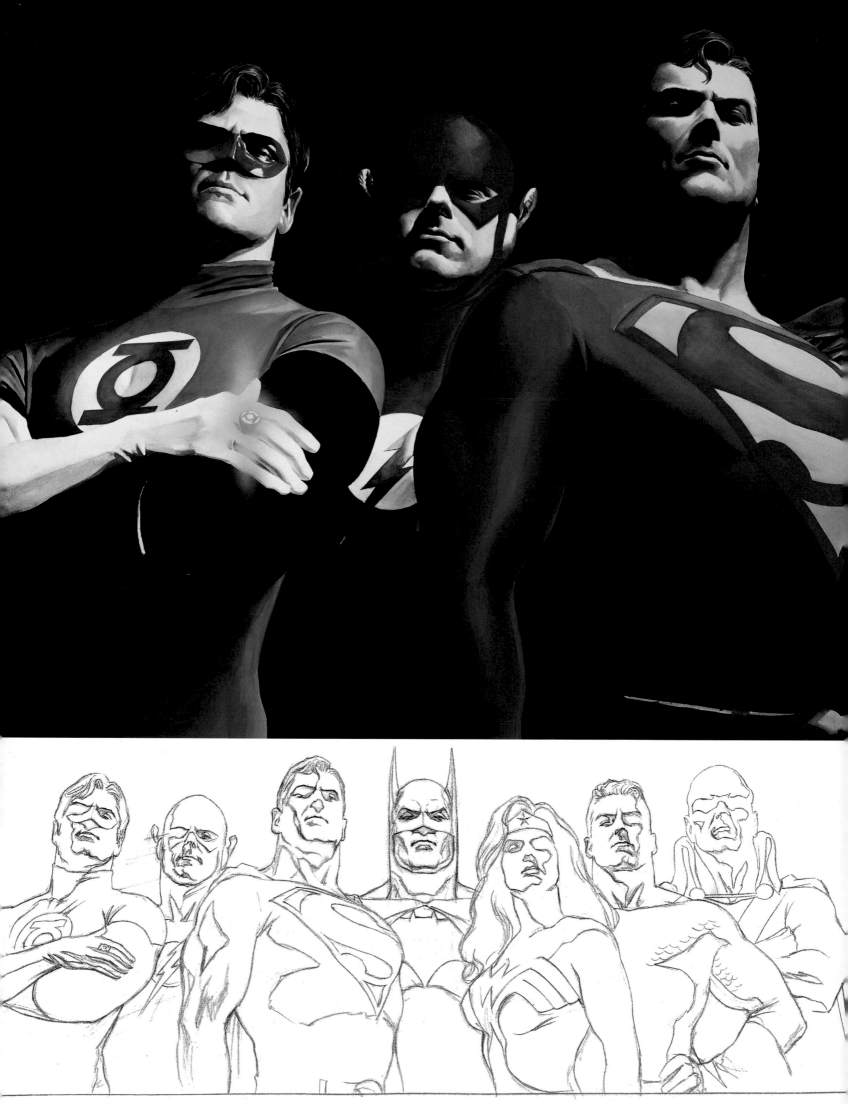

THE SEVEN

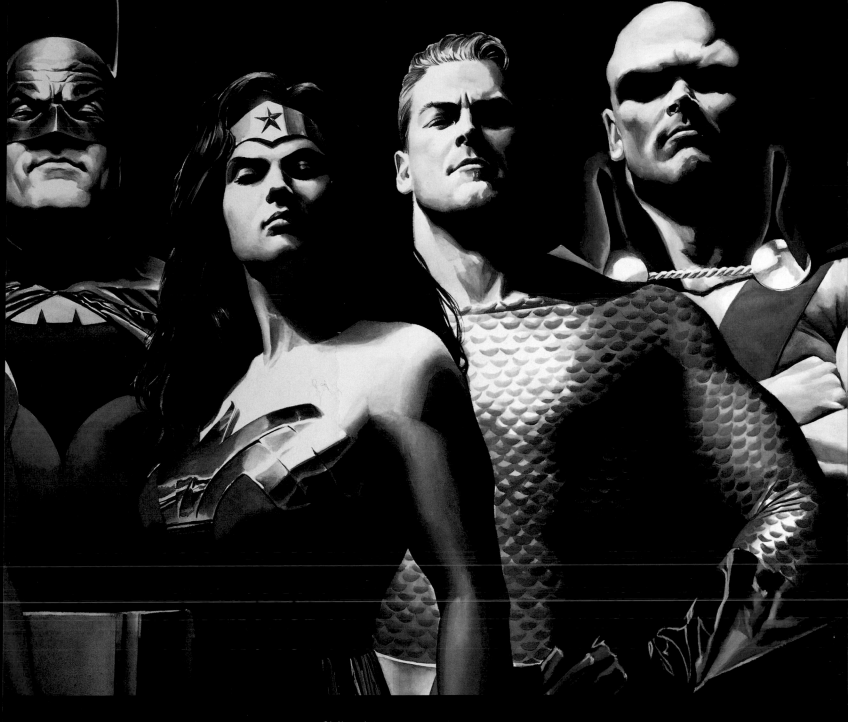

OPPOSITE, BOTTOM: Pencils for the Warner Bros. Studio Stores Giclèe print *JLA: The Original Seven* (2000).
ABOVE: The final art.

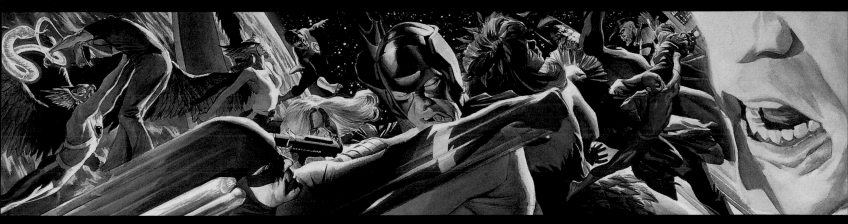

ABOVE: The JLA on their satellite, in battle—a scene originally from *Justice League of America* #143 (June 1977). "A nice big knock-down drag-out, with a supervillain enemy team, the Injustice Gang of the World. A precursor to the Legion of Doom." This panel, turned on its side, is a detail from a page of *JLA: Liberty and Justice* (2003).

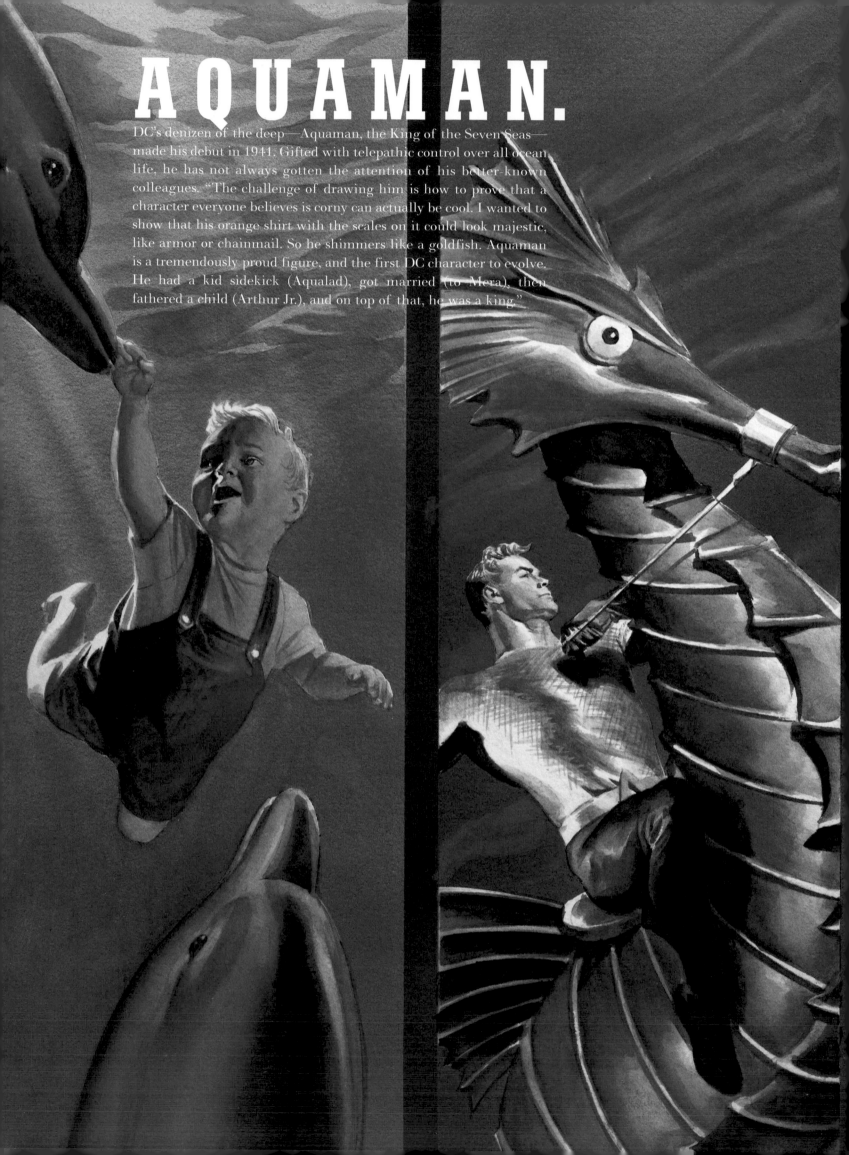

AQUAMAN.

DC's denizen of the deep—Aquaman, the King of the Seven Seas—made his debut in 1941. Gifted with telepathic control over all ocean life, he has not always gotten the attention of his better-known colleagues. "The challenge of drawing him is how to prove that a character everyone believes is corny can actually be cool. I wanted to show that his orange shirt with the scales on it could look majestic, like armor or chainmail. So he shimmers like a goldfish. Aquaman is a tremendously proud figure, and the first DC character to evolve. He had a kid sidekick (Aqualad), got married (to Mera), then fathered a child (Arthur Jr.), and on top of that, he was a king."

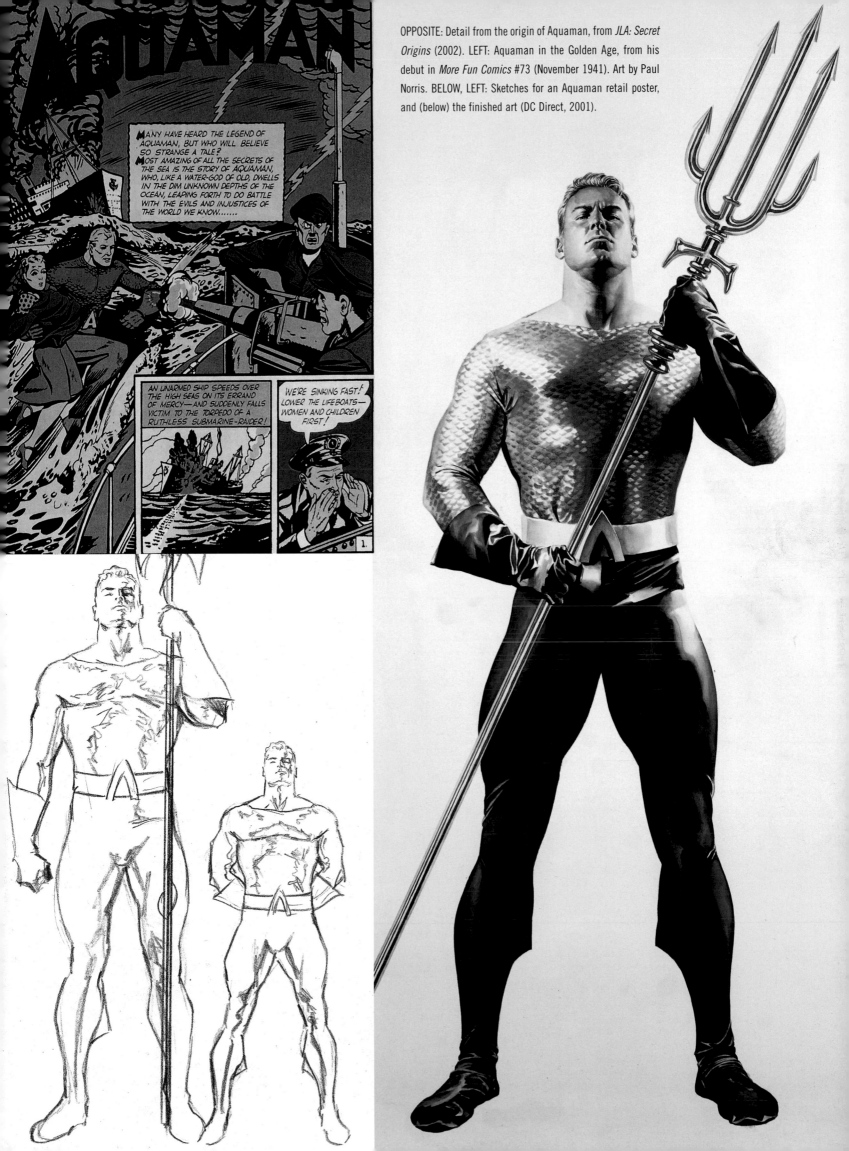

OPPOSITE: Detail from the origin of Aquaman, from *JLA: Secret Origins* (2002). LEFT: Aquaman in the Golden Age, from his debut in *More Fun Comics* #73 (November 1941). Art by Paul Norris. BELOW, LEFT: Sketches for an Aquaman retail poster, and (below) the finished art (DC Direct, 2001).

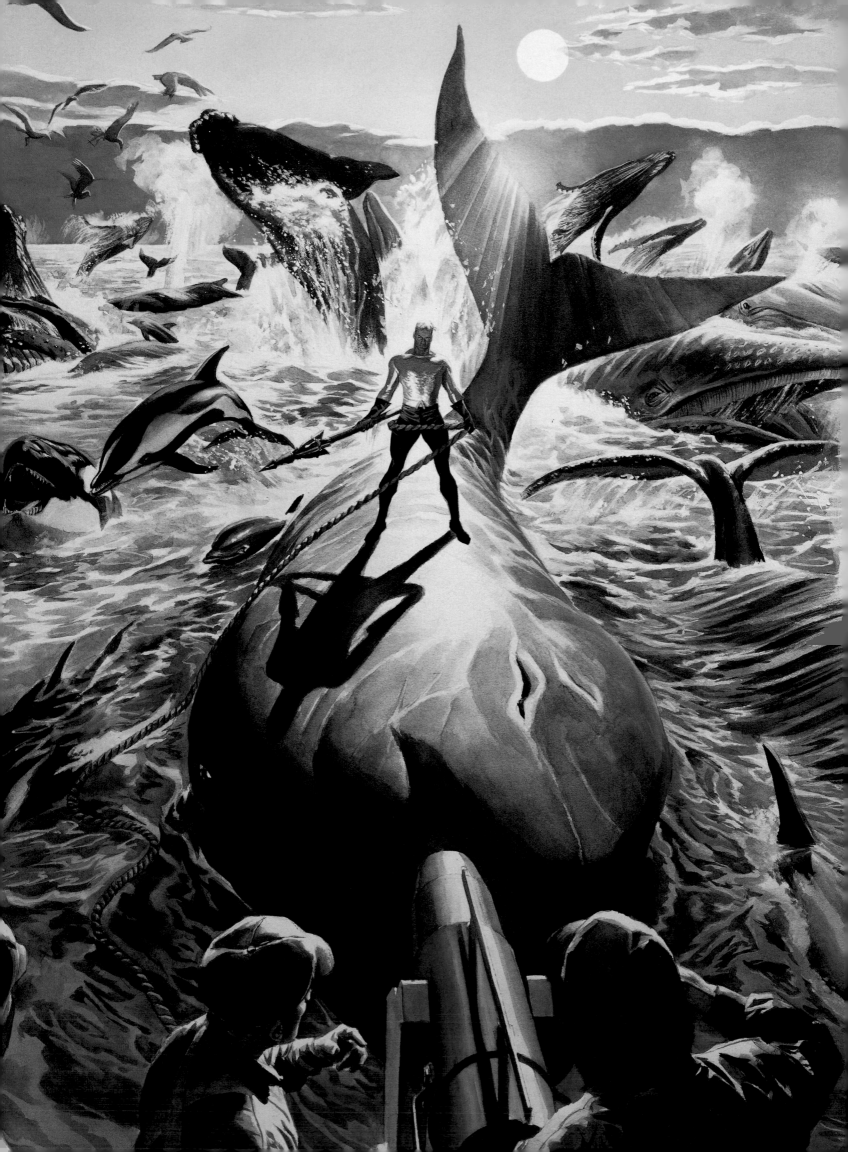

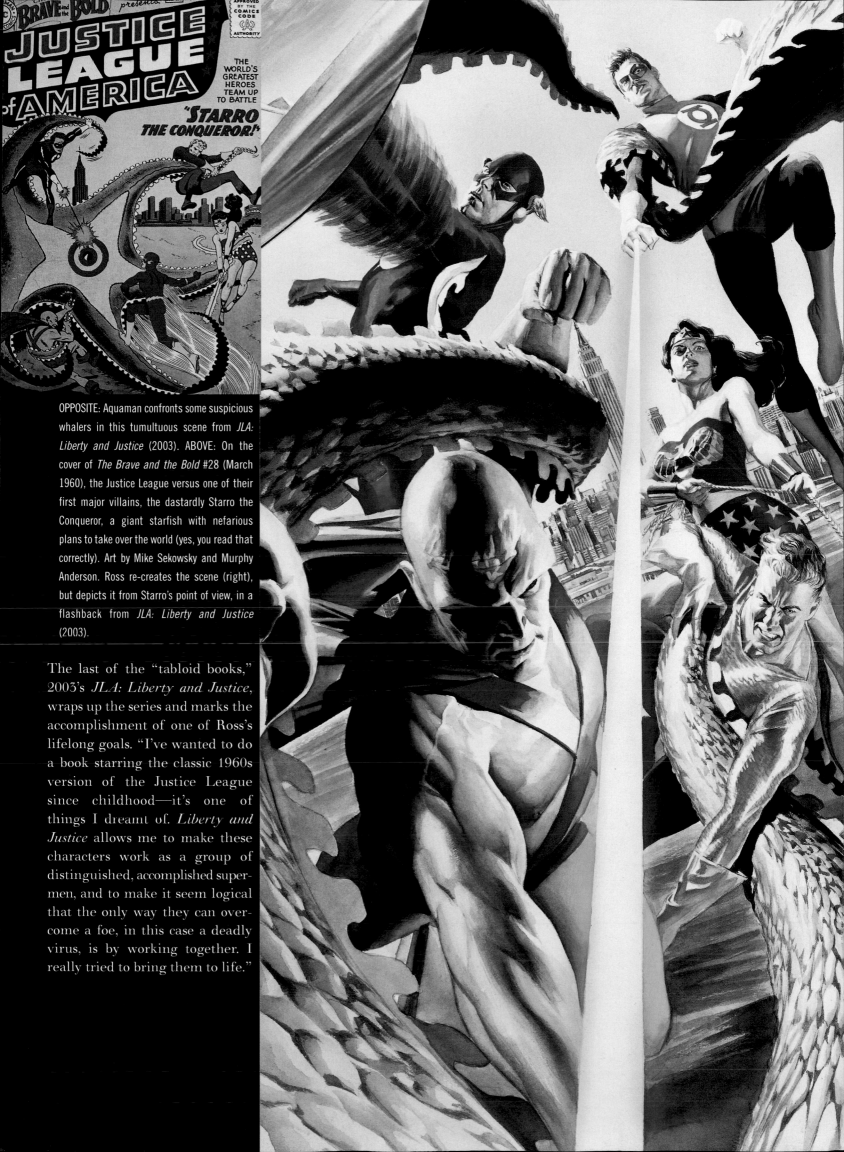

THE BRAVE and the BOLD presents

JUSTICE LEAGUE of AMERICA

APPROVED BY THE COMICS CODE AUTHORITY

THE WORLD'S GREATEST HEROES TEAM UP TO BATTLE

"STARRO THE CONQUEROR!"

OPPOSITE: Aquaman confronts some suspicious whalers in this tumultuous scene from *JLA: Liberty and Justice* (2003). ABOVE: On the cover of *The Brave and the Bold* #28 (March 1960), the Justice League versus one of their first major villains, the dastardly Starro the Conqueror, a giant starfish with nefarious plans to take over the world (yes, you read that correctly). Art by Mike Sekowsky and Murphy Anderson. Ross re-creates the scene (right), but depicts it from Starro's point of view, in a flashback from *JLA: Liberty and Justice* (2003).

The last of the "tabloid books," 2003's *JLA: Liberty and Justice*, wraps up the series and marks the accomplishment of one of Ross's lifelong goals. "I've wanted to do a book starring the classic 1960s version of the Justice League since childhood—it's one of things I dreamt of. *Liberty and Justice* allows me to make these characters work as a group of distinguished, accomplished supermen, and to make it seem logical that the only way they can overcome a foe, in this case a deadly virus, is by working together. I really tried to bring them to life."

OPPOSITE: A work in progress, (and reversed, at that), this detail from the origin of J'onn J'onzz eventually appeared in *JLA: Secret Origins* (2002). RIGHT: Art for the Martian Manhunter retail poster (DC Direct, 2000). BELOW: A panel from the first Martian Manhunter story, from *Detective Comics* #225 (November 1955). Art by Joe Certa. BOTTOM: J'onn J'onzz in flight, a detail from *JLA: Liberty and Justice* (2003).

WHAT HAVE I WROUGHT-- WHAT HAS THE BRAIN DONE? WHO ARE YOU? WHERE ARE YOU FROM?

I AM FROM THE FOURTH PLANET FROM THE SUN! I AM A SCIENTIST ON MY WORLD! AND I AM KNOWN AS J'ONN J'ONZZ! NOW-- YOU EXPLAIN HOW I CAME HERE!

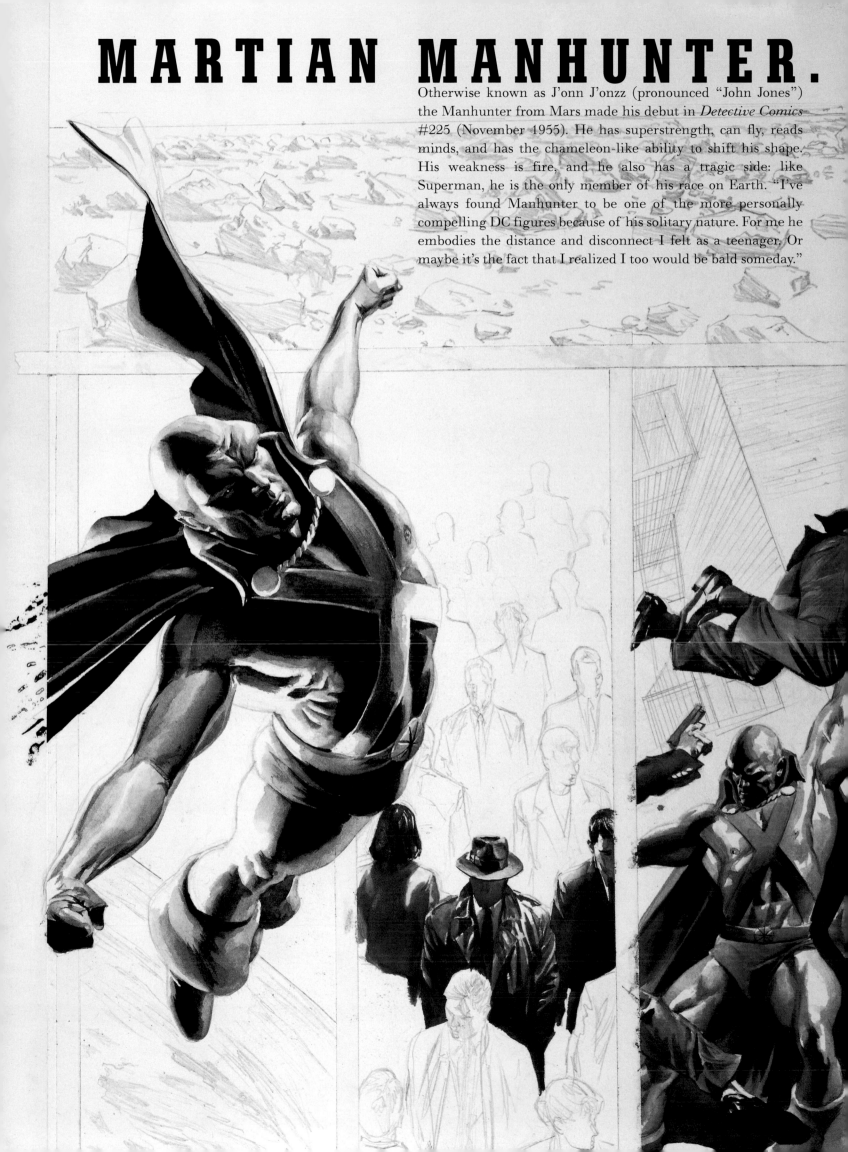

MARTIAN MANHUNTER.

Otherwise known as J'onn J'onzz (pronounced "John Jones") the Manhunter from Mars made his debut in *Detective Comics* #225 (November 1955). He has superstrength, can fly, reads minds, and has the chameleon-like ability to shift his shape. His weakness is fire, and he also has a tragic side: like Superman, he is the only member of his race on Earth. "I've always found Manhunter to be one of the more personally compelling DC figures because of his solitary nature. For me he embodies the distance and disconnect I felt as a teenager. Or maybe it's the fact that I realized I too would be bald someday."

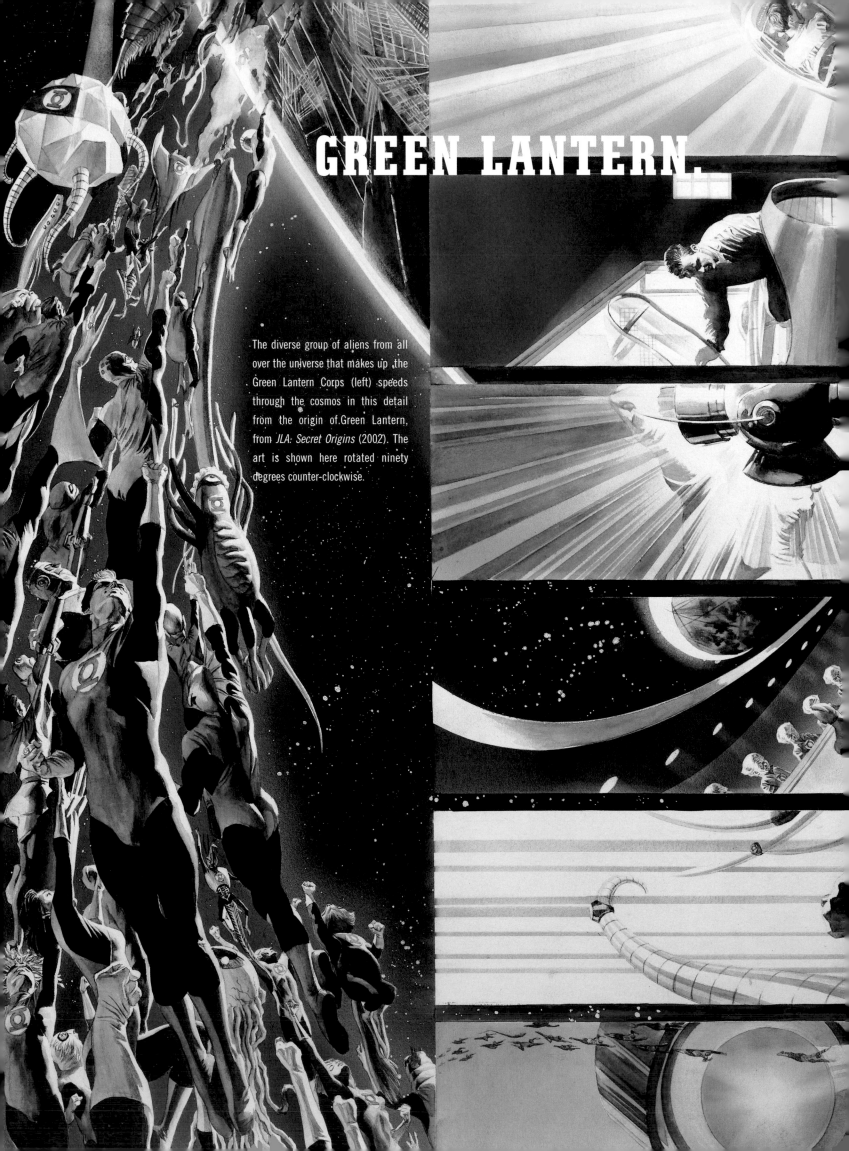

GREEN LANTERN.

The diverse group of aliens from all over the universe that makes up the Green Lantern Corps (left) speeds through the cosmos in this detail from the origin of Green Lantern, from *JLA: Secret Origins* (2002). The art is shown here rotated ninety degrees counter-clockwise.

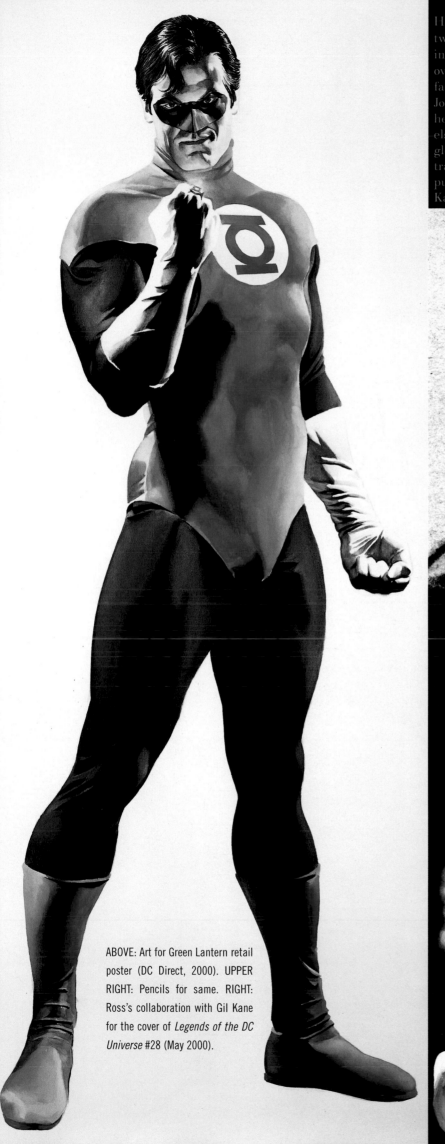

His power comes from a ring that must be recharged every twenty-four hours, bequeathed to him by an ancient order of intergalactic elders. There have been several Green Lanterns over the years, but his Silver Age alter ego, Hal Jordan, is the fan favorite. "There's a unique aesthetic value to the Hal Jordan Green Lantern that sets him apart from all the other heroes—he wears green, and he has brown hair when everyone else has blond or black hair and blue eyes. And the white gloves—a super hero with *white gloves*? But it *works*, and it translates beautifully to all the aliens of the GL Corps. You can put any life-form in that suit and it's instantly recognizable. Gil Kane's costume design is perfect."

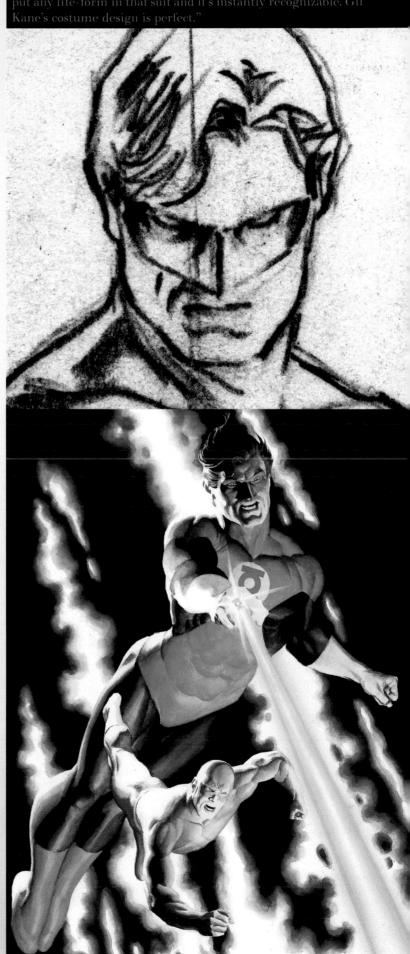

ABOVE: Art for Green Lantern retail poster (DC Direct, 2000). UPPER RIGHT: Pencils for same. RIGHT: Ross's collaboration with Gil Kane for the cover of *Legends of the DC Universe* #28 (May 2000).

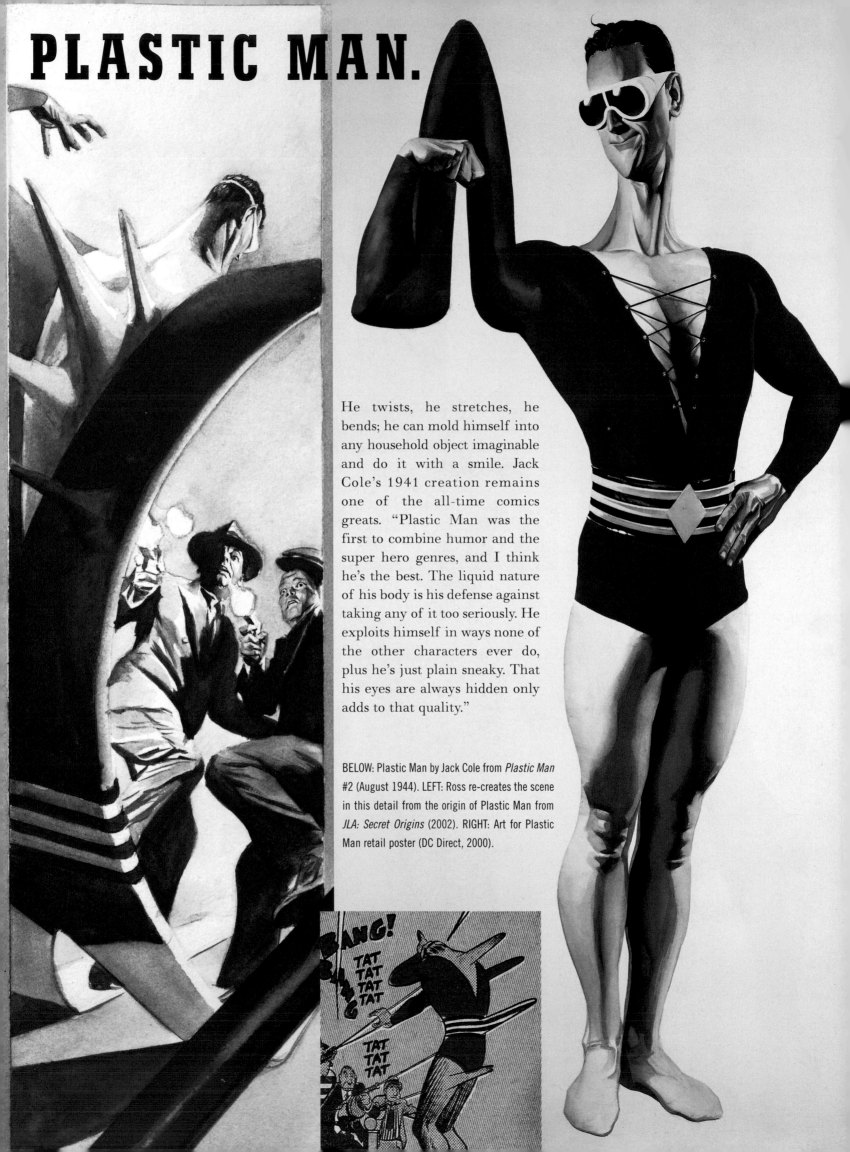

PLASTIC MAN.

He twists, he stretches, he bends; he can mold himself into any household object imaginable and do it with a smile. Jack Cole's 1941 creation remains one of the all-time comics greats. "Plastic Man was the first to combine humor and the super hero genres, and I think he's the best. The liquid nature of his body is his defense against taking any of it too seriously. He exploits himself in ways none of the other characters ever do, plus he's just plain sneaky. That his eyes are always hidden only adds to that quality."

BELOW: Plastic Man by Jack Cole from *Plastic Man* #2 (August 1944). LEFT: Ross re-creates the scene in this detail from the origin of Plastic Man from *JLA: Secret Origins* (2002). RIGHT: Art for Plastic Man retail poster (DC Direct, 2000).

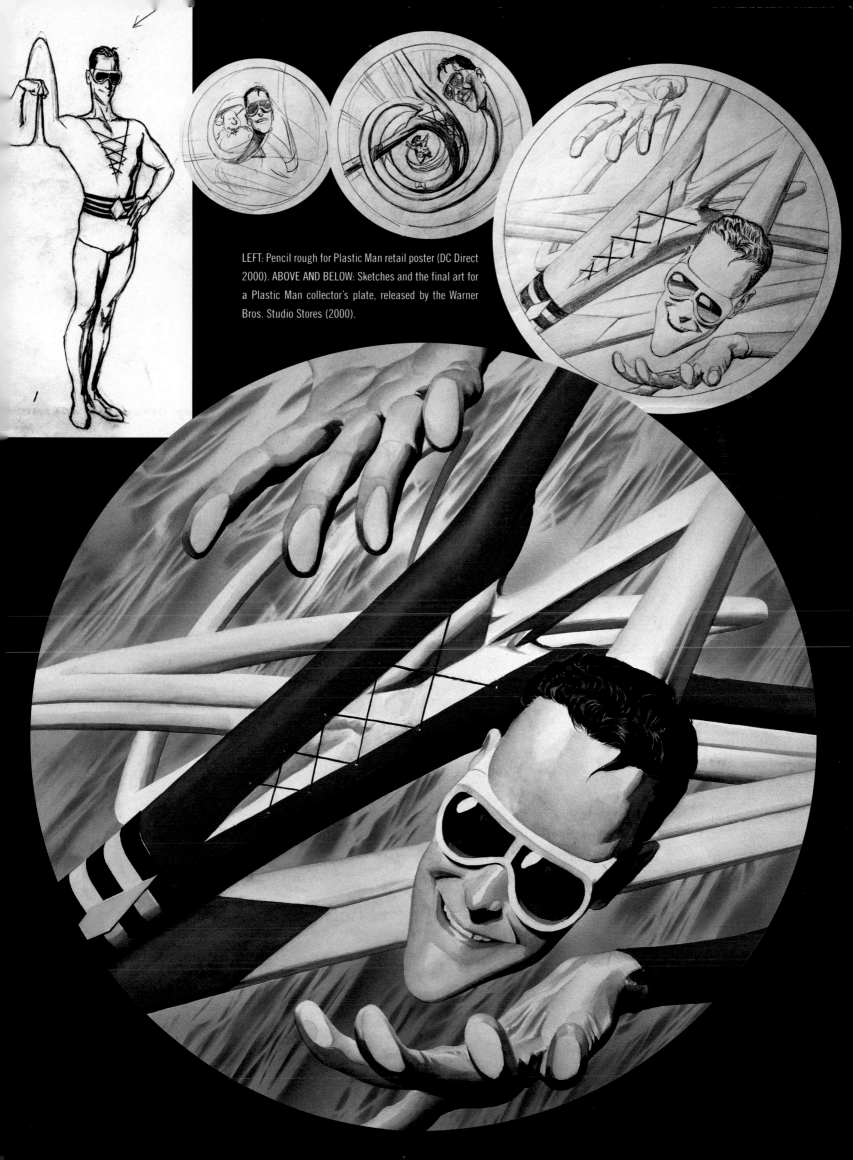

LEFT: Pencil rough for Plastic Man retail poster (DC Direct 2000). ABOVE AND BELOW: Sketches and the final art for a Plastic Man collector's plate, released by the Warner Bros. Studio Stores (2000).

GREEN ARROW.

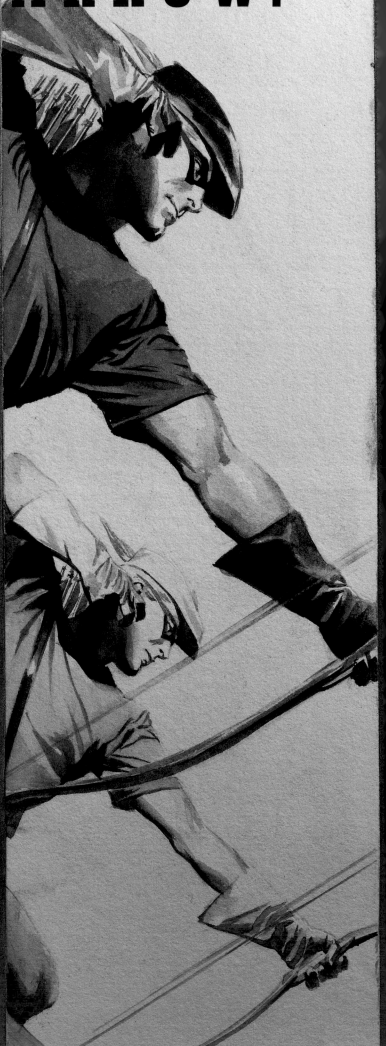

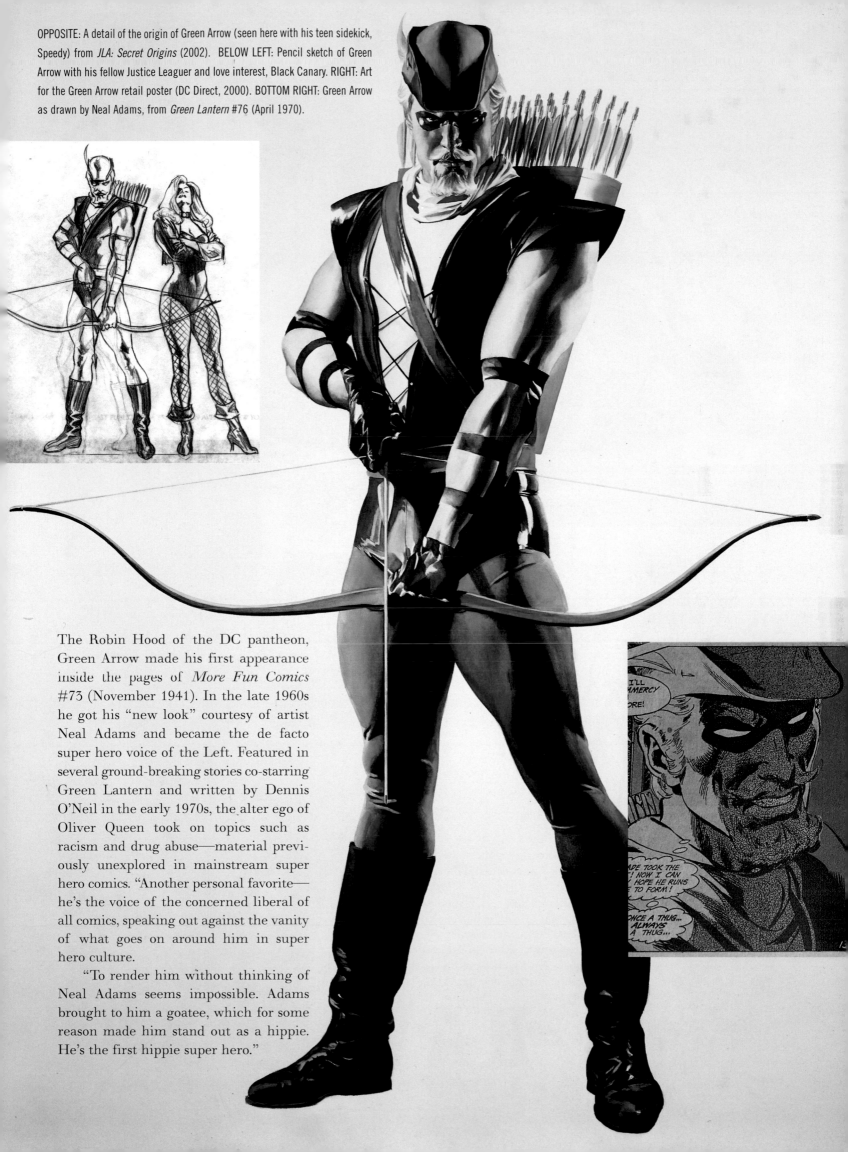

OPPOSITE: A detail of the origin of Green Arrow (seen here with his teen sidekick, Speedy) from *JLA: Secret Origins* (2002). BELOW LEFT: Pencil sketch of Green Arrow with his fellow Justice Leaguer and love interest, Black Canary. RIGHT: Art for the Green Arrow retail poster (DC Direct, 2000). BOTTOM RIGHT: Green Arrow as drawn by Neal Adams, from *Green Lantern* #76 (April 1970).

The Robin Hood of the DC pantheon, Green Arrow made his first appearance inside the pages of *More Fun Comics* #73 (November 1941). In the late 1960s he got his "new look" courtesy of artist Neal Adams and became the de facto super hero voice of the Left. Featured in several ground-breaking stories co-starring Green Lantern and written by Dennis O'Neil in the early 1970s, the alter ego of Oliver Queen took on topics such as racism and drug abuse—material previously unexplored in mainstream super hero comics. "Another personal favorite— he's the voice of the concerned liberal of all comics, speaking out against the vanity of what goes on around him in super hero culture.

"To render him without thinking of Neal Adams seems impossible. Adams brought to him a goatee, which for some reason made him stand out as a hippie. He's the first hippie super hero."

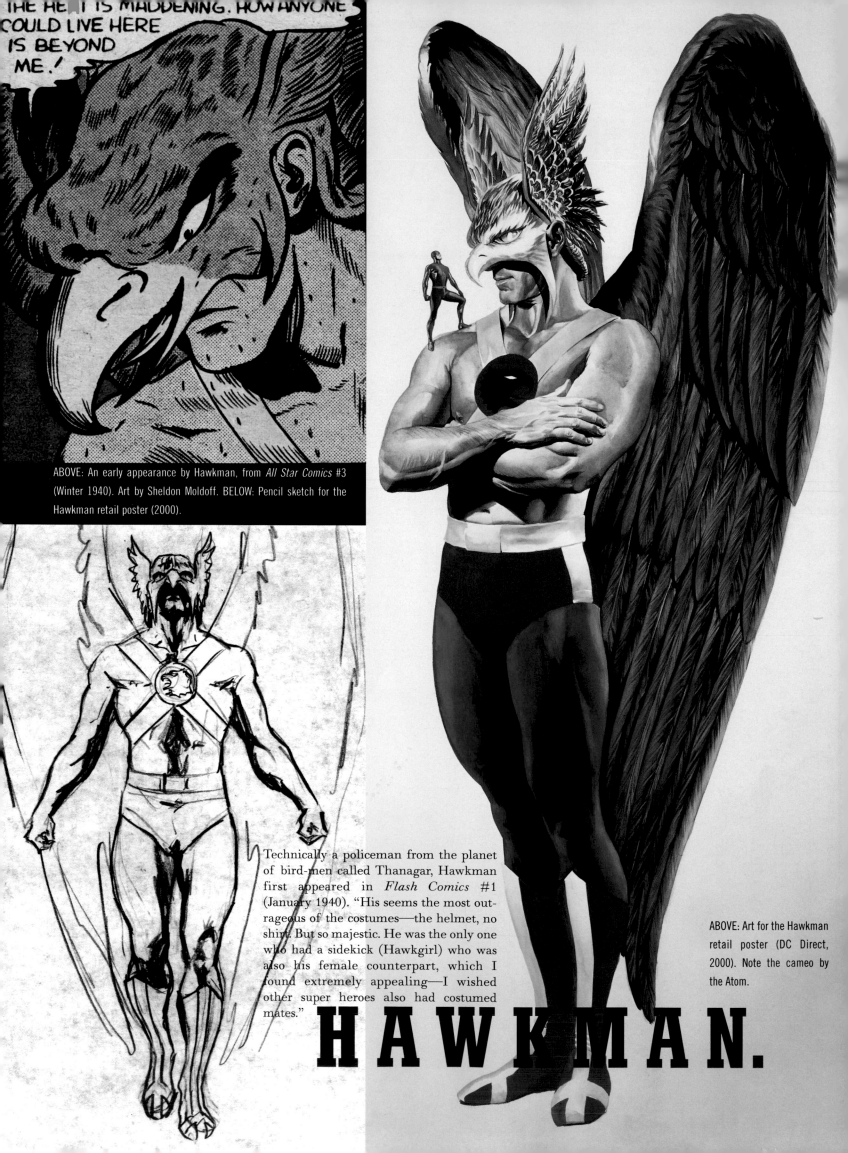

THE HEAT IS MADDENING. HOW ANYONE COULD LIVE HERE IS BEYOND ME.!

ABOVE: An early appearance by Hawkman, from *All Star Comics* #3 (Winter 1940). Art by Sheldon Moldoff. BELOW: Pencil sketch for the Hawkman retail poster (2000).

Technically a policeman from the planet of bird-men called Thanagar, Hawkman first appeared in *Flash Comics* #1 (January 1940). "His seems the most outrageous of the costumes—the helmet, no shirt. But so majestic. He was the only one who had a sidekick (Hawkgirl) who was also his female counterpart, which I found extremely appealing—I wished other super heroes also had costumed mates."

ABOVE: Art for the Hawkman retail poster (DC Direct, 2000). Note the cameo by the Atom.

HAWKMAN.

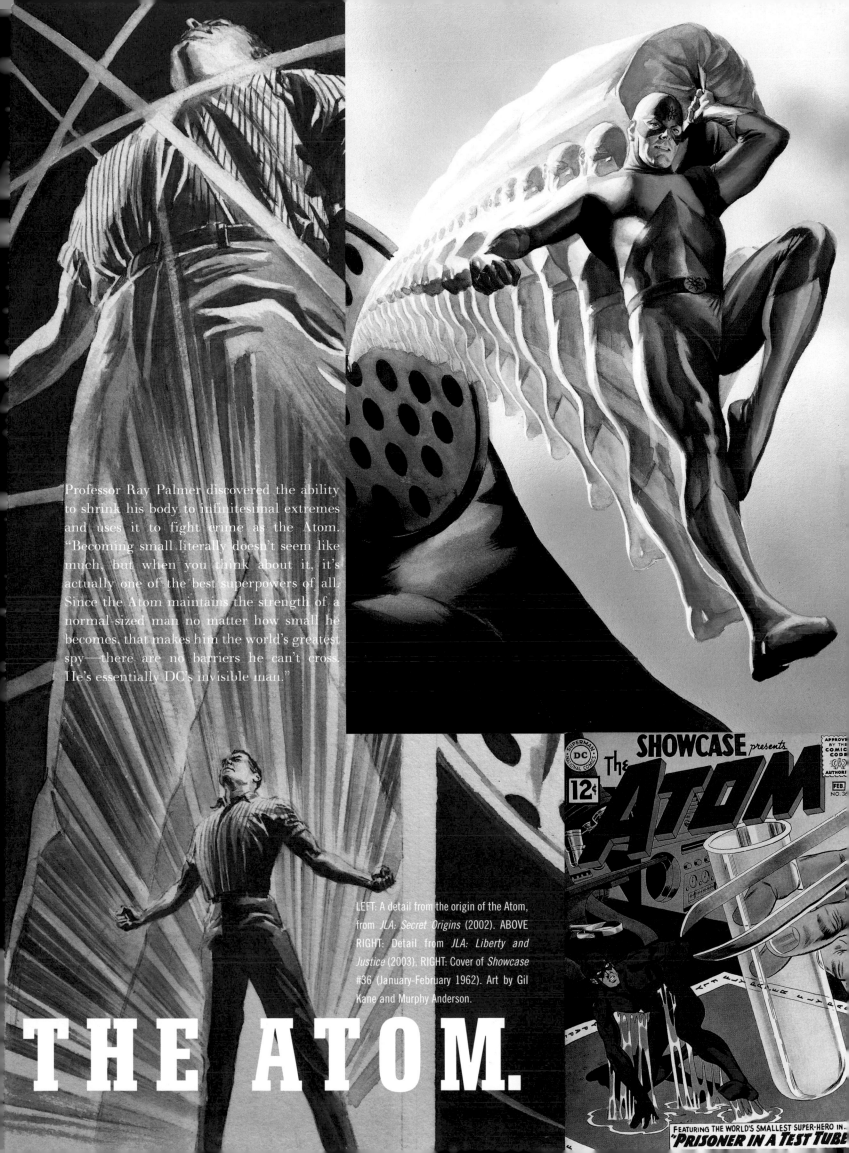

Professor Ray Palmer discovered the ability to shrink his body to infinitesimal extremes and uses it to fight crime as the Atom. "Becoming small literally doesn't seem like much, but when you think about it, it's actually one of the best superpowers of all. Since the Atom maintains the strength of a normal-sized man no matter how small he becomes, that makes him the world's greatest spy—there are no barriers he can't cross. He's essentially DC's invisible man."

LEFT: A detail from the origin of the Atom, from *JLA: Secret Origins* (2002). ABOVE RIGHT: Detail from *JLA: Liberty and Justice* (2003). RIGHT: Cover of *Showcase* #36 (January-February 1962). Art by Gil Kane and Murphy Anderson.

THE ATOM.

SHOWCASE presents THE ATOM

FEATURING THE WORLD'S SMALLEST SUPER-HERO IN "PRISONER IN A TEST TUBE"

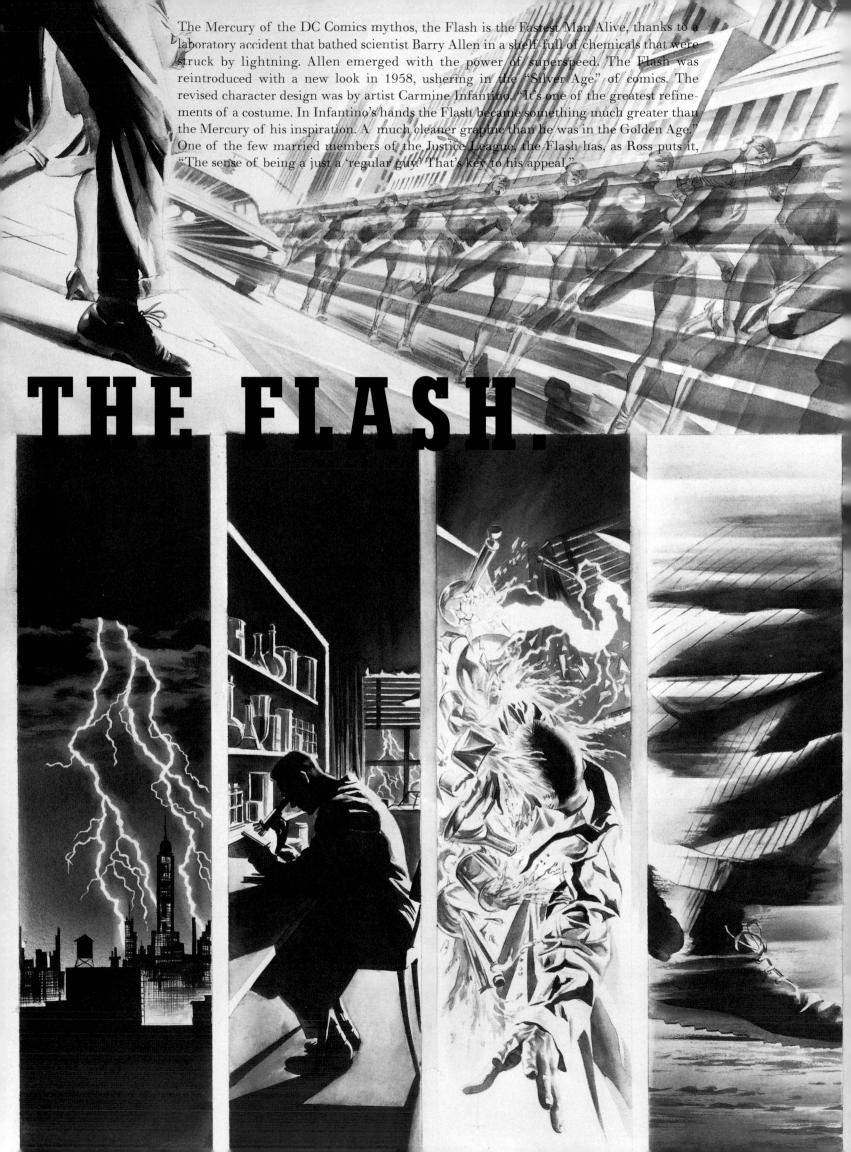

The Mercury of the DC Comics mythos, the Flash is the Fastest Man Alive, thanks to a laboratory accident that bathed scientist Barry Allen in a shelf-full of chemicals that were struck by lightning. Allen emerged with the power of superspeed. The Flash was reintroduced with a new look in 1958, ushering in the "Silver Age" of comics. The revised character design was by artist Carmine Infantino. "It's one of the greatest refinements of a costume. In Infantino's hands the Flash became something much greater than the Mercury of his inspiration. A much cleaner graphic than he was in the Golden Age." One of the few married members of the Justice League, the Flash has, as Ross puts it, "The sense of being a just a 'regular guy. That's key to his appeal."

THE FLASH.

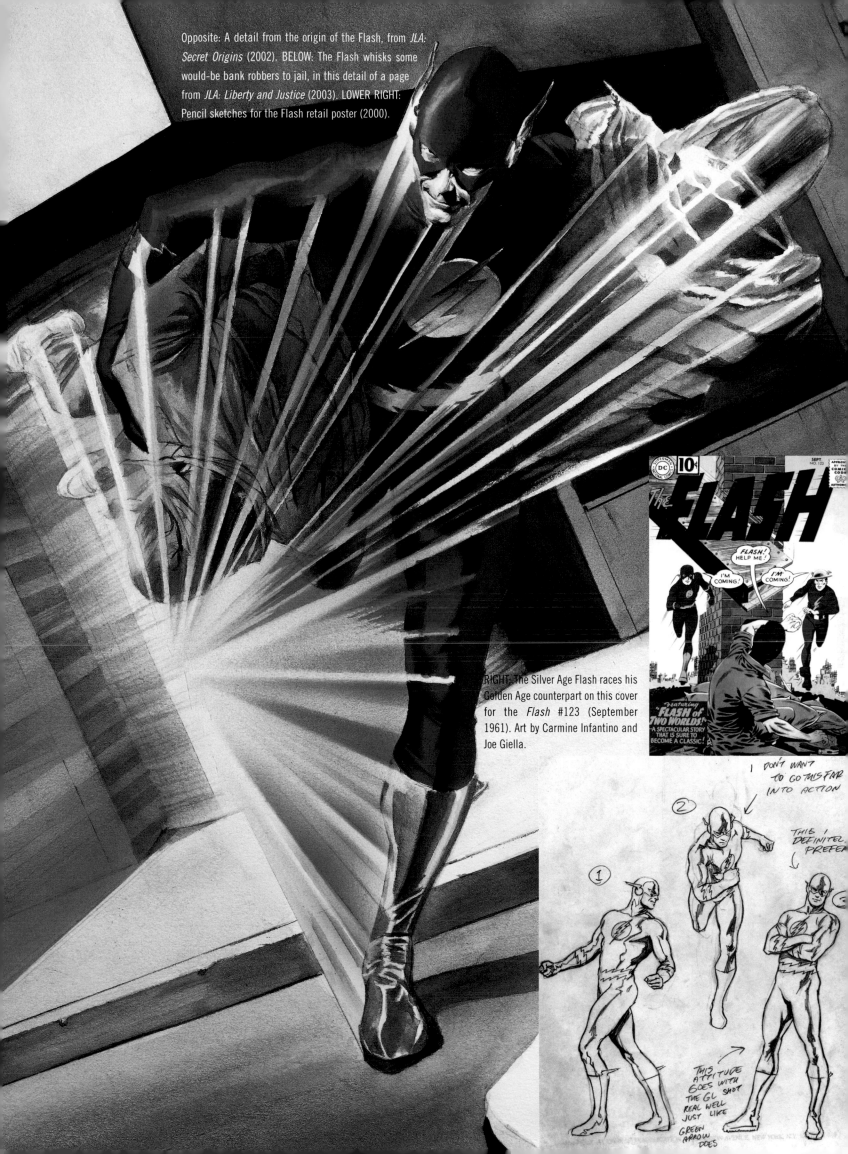

Opposite: A detail from the origin of the Flash, from *JLA: Secret Origins* (2002). BELOW: The Flash whisks some would-be bank robbers to jail, in this detail of a page from *JLA: Liberty and Justice* (2003). LOWER RIGHT: Pencil sketches for the Flash retail poster (2000).

RIGHT: The Silver Age Flash races his Golden Age counterpart on this cover for the *Flash* #123 (September 1961). Art by Carmine Infantino and Joe Giella.

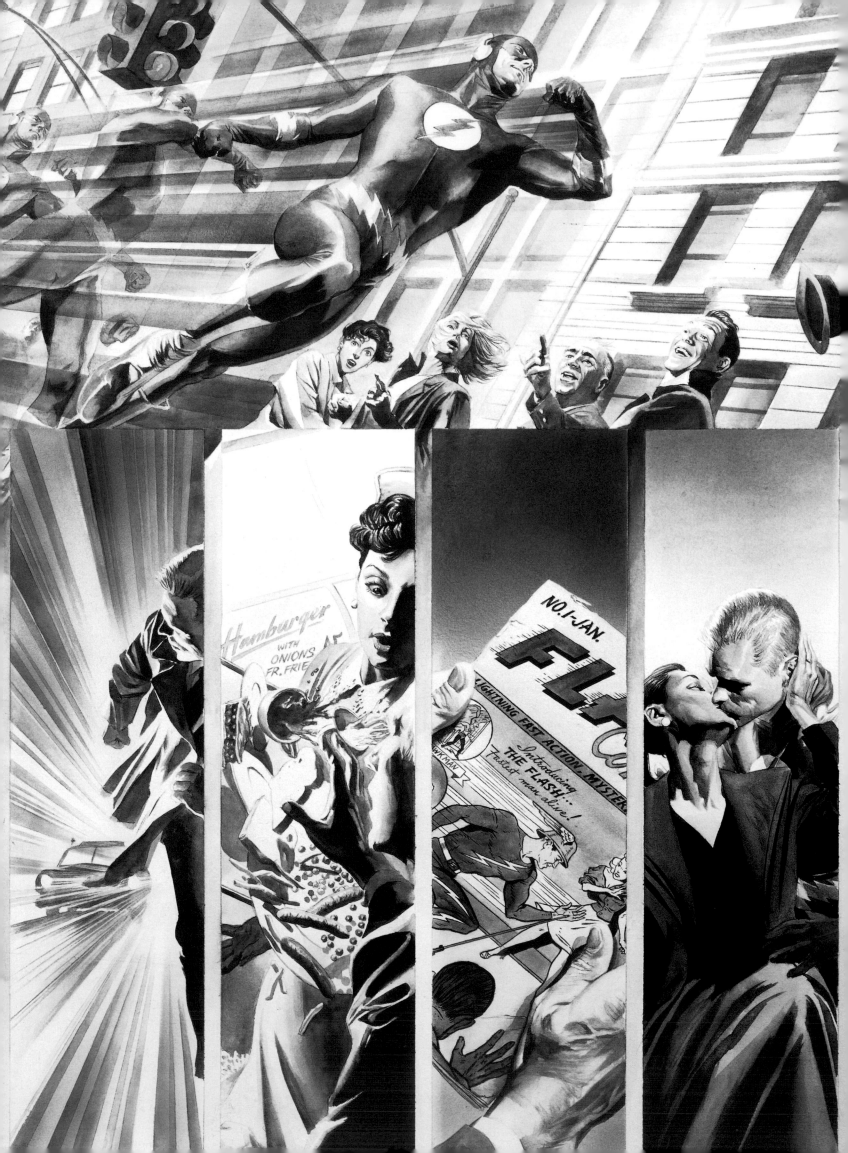

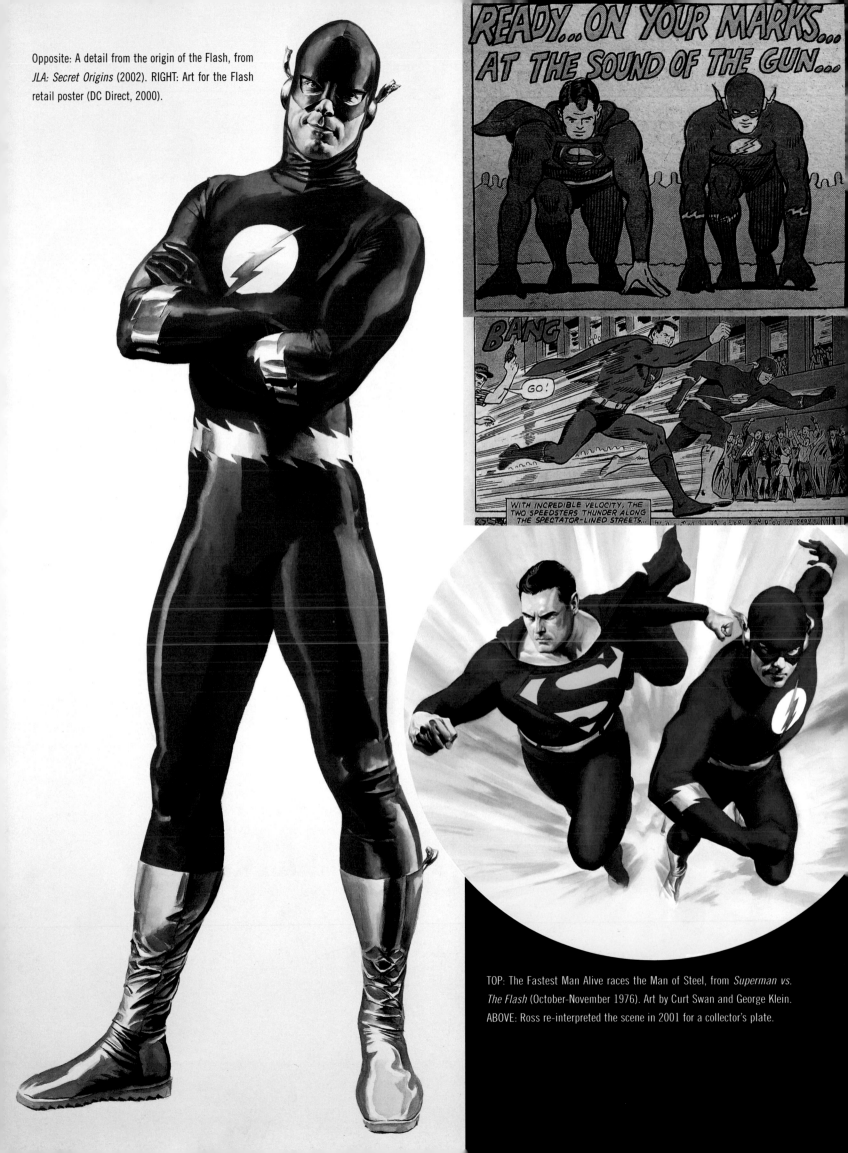

Opposite: A detail from the origin of the Flash, from *JLA: Secret Origins* (2002). RIGHT: Art for the Flash retail poster (DC Direct, 2000).

READY... ON YOUR MARKS...
AT THE SOUND OF THE GUN...

BANG

GO!

WITH INCREDIBLE VELOCITY, THE TWO SPEEDSTERS THUNDER ALONG THE SPECTATOR-LINED STREETS...

TOP: The Fastest Man Alive races the Man of Steel, from *Superman vs. The Flash* (October-November 1976). Art by Curt Swan and George Klein.
ABOVE: Ross re-interpreted the scene in 2001 for a collector's plate.

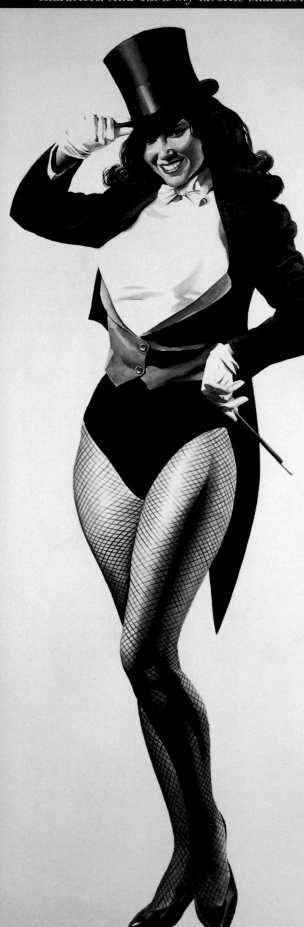

ZATANNA.

Master magician Zatanna is the daughter of Zatara, an early DC character from the Golden Age of comics. The model for this poster art was especially enticing for Ross to work with. "This is my wife, T.J., posing as one of Paul Dini's favorite characters. And T.J. is *my* favorite character."

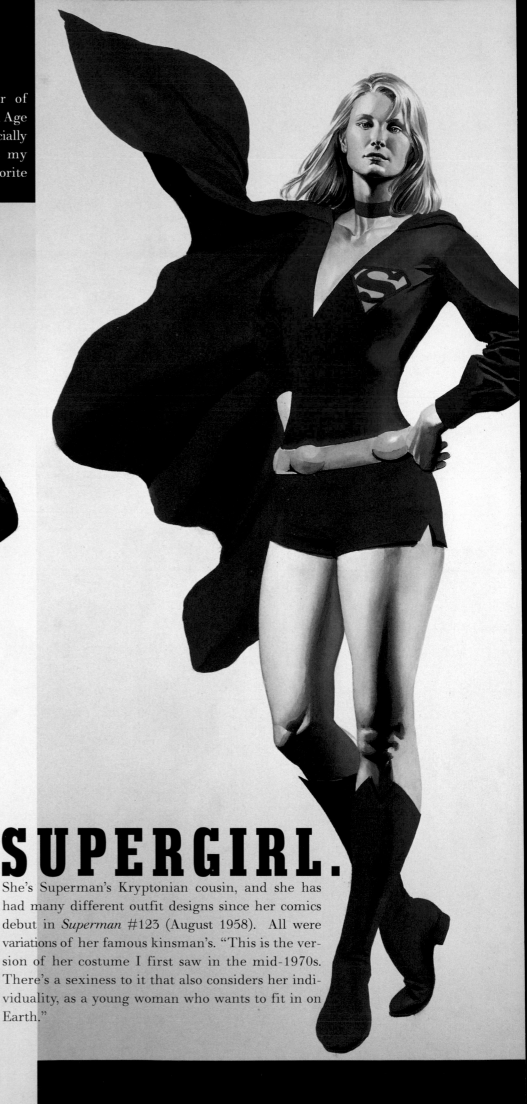

SUPERGIRL.

She's Superman's Kryptonian cousin, and she has had many different outfit designs since her comics debut in *Superman* #123 (August 1958). All were variations of her famous kinsman's. "This is the version of her costume I first saw in the mid-1970s. There's a sexiness to it that also considers her individuality, as a young woman who wants to fit in on Earth."

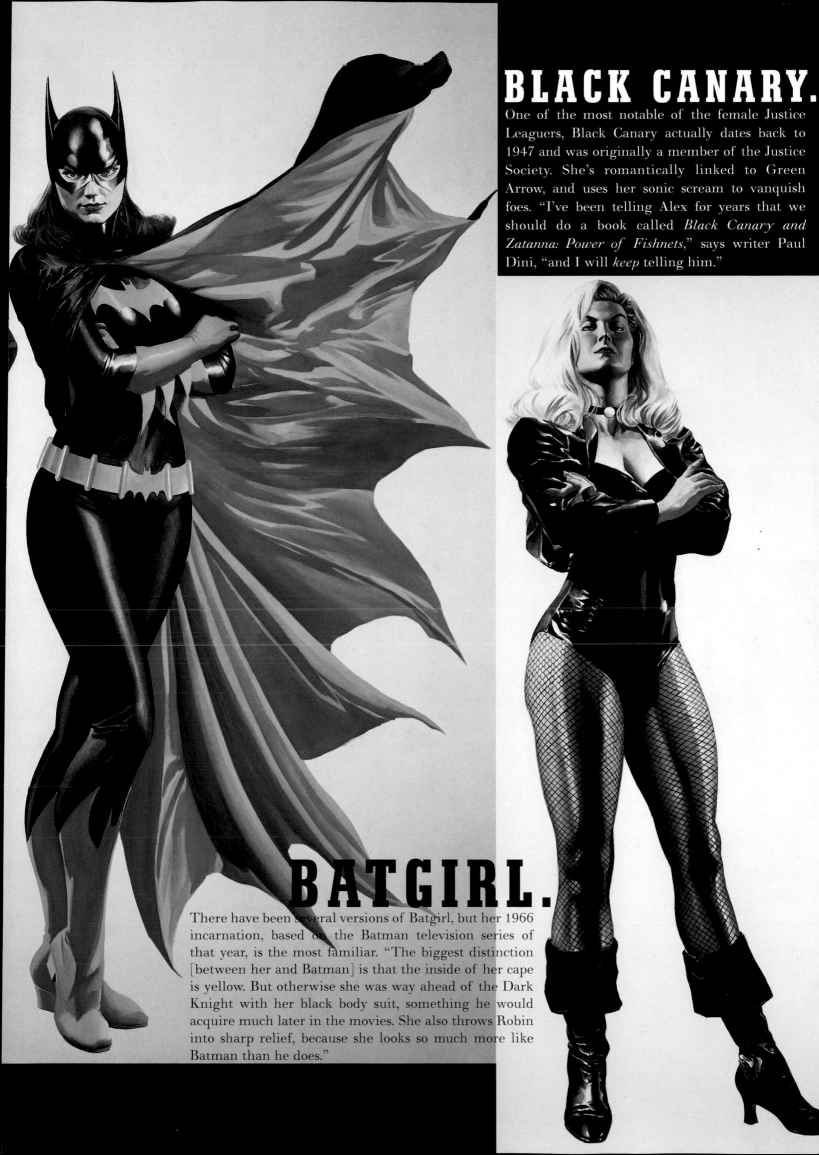

BLACK CANARY.

One of the most notable of the female Justice Leaguers, Black Canary actually dates back to 1947 and was originally a member of the Justice Society. She's romantically linked to Green Arrow, and uses her sonic scream to vanquish foes. "I've been telling Alex for years that we should do a book called *Black Canary and Zatanna: Power of Fishnets*," says writer Paul Dini, "and I will *keep* telling him."

BATGIRL.

There have been several versions of Batgirl, but her 1966 incarnation, based on the Batman television series of that year, is the most familiar. "The biggest distinction [between her and Batman] is that the inside of her cape is yellow. But otherwise she was way ahead of the Dark Knight with her black body suit, something he would acquire much later in the movies. She also throws Robin into sharp relief, because she looks so much more like Batman than he does."

FAR RIGHT: The Justice League battles the Shaggy Man, in this panel from *JLA: Liberty and Justice* (2003). It's an homage to a scene (center) that appeared in *Justice League* #104, (February 1973). Art by Nick Cardy. RIGHT: The cover of *Metal Men* #1 (April-May 1963). Art by Ross Andru and Mike Esposito. OPPOSITE: Retail poster for *JLA: Liberty and Justice* (DC Direct, 2003), seen here on its side.

THE METAL MEN.

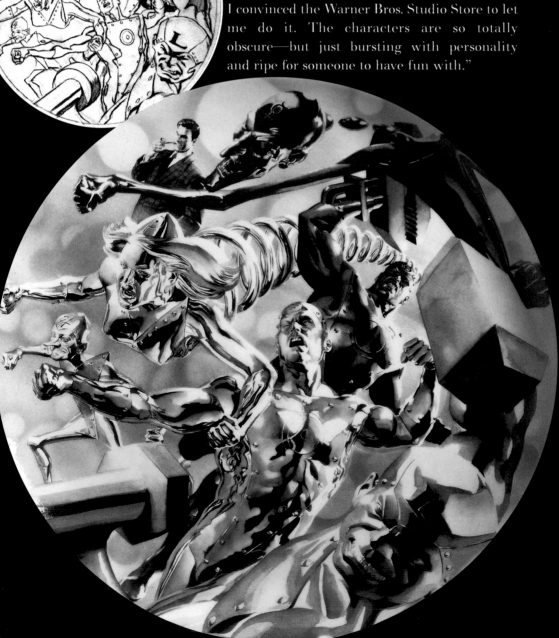

Shape-shifting androids, each named for a different element, the Metal Men debuted in *Showcase* #37 (April 1962). Ross jumped at the chance to paint them when given an open-ended commission to create a collector's plate in 1999. "The most amazing thing about it is that I convinced the Warner Bros. Studio Store to let me do it. The characters are so totally obscure—but just bursting with personality and ripe for someone to have fun with."

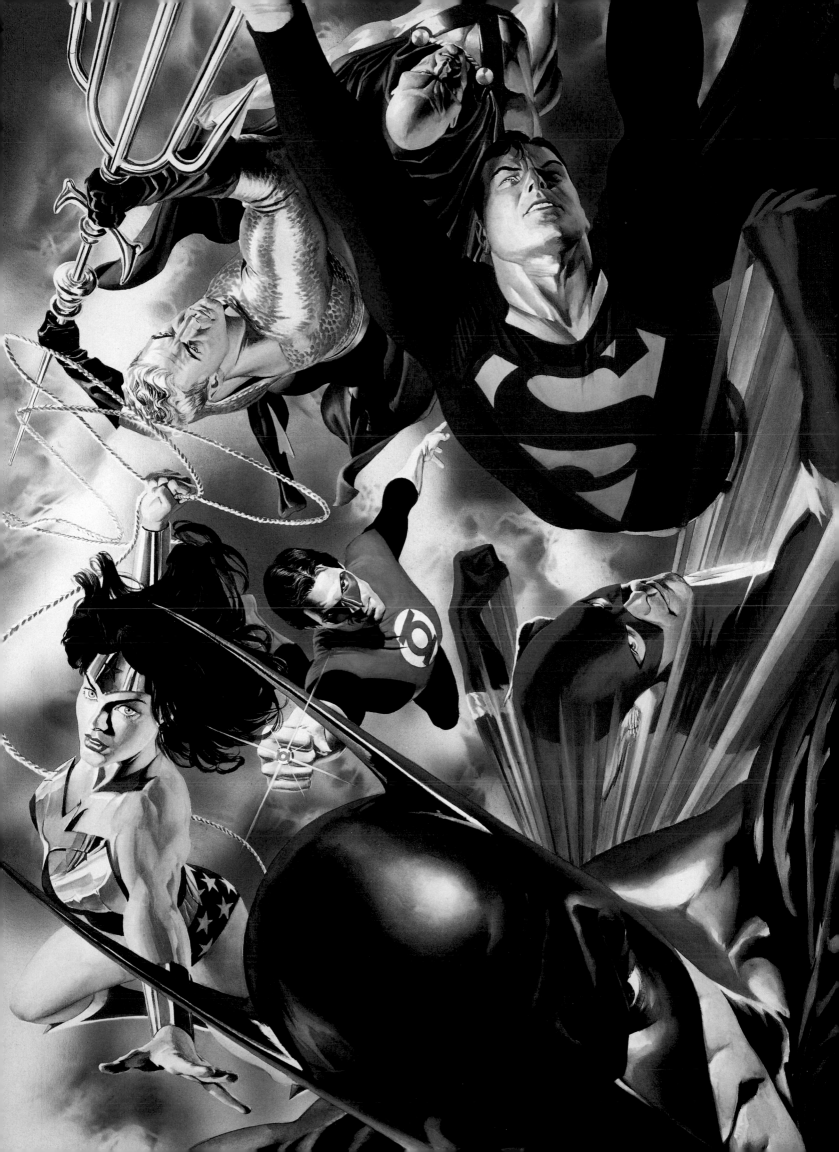

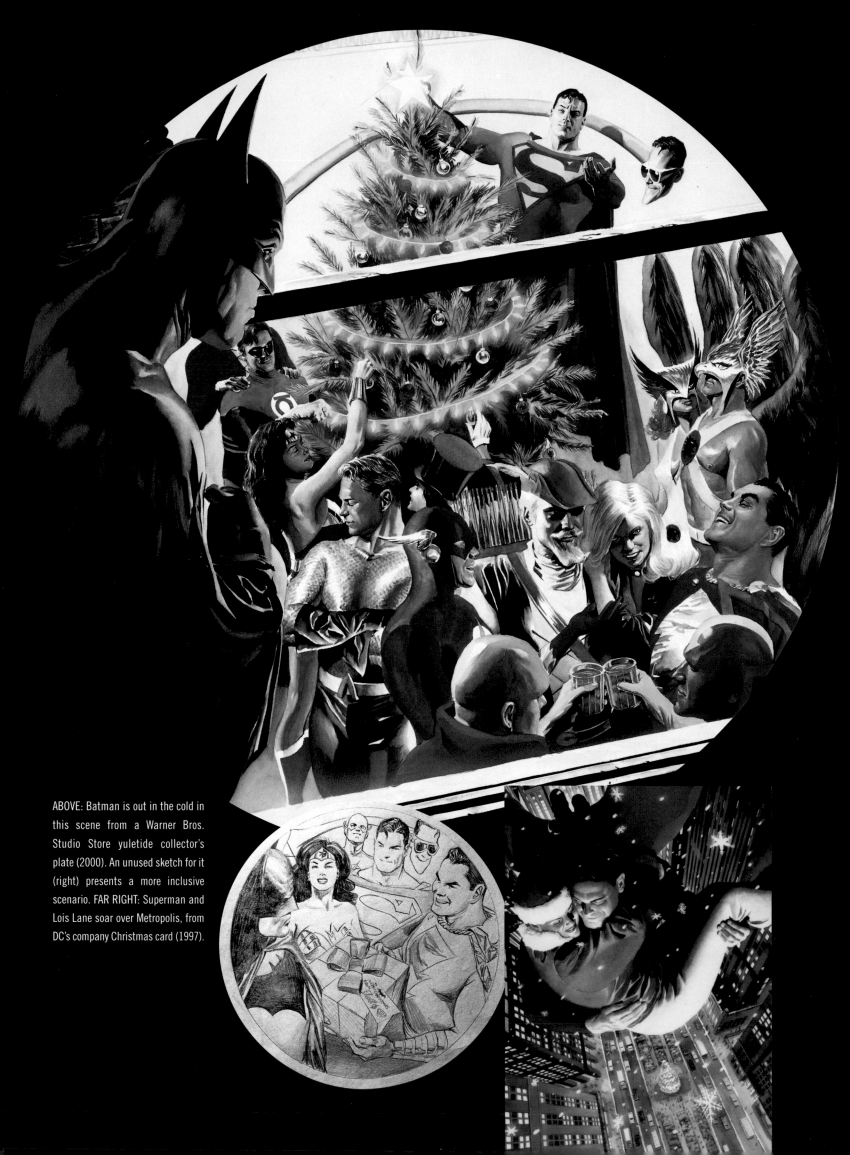

ABOVE: Batman is out in the cold in this scene from a Warner Bros. Studio Store yuletide collector's plate (2000). An unused sketch for it (right) presents a more inclusive scenario. FAR RIGHT: Superman and Lois Lane soar over Metropolis, from DC's company Christmas card (1997).

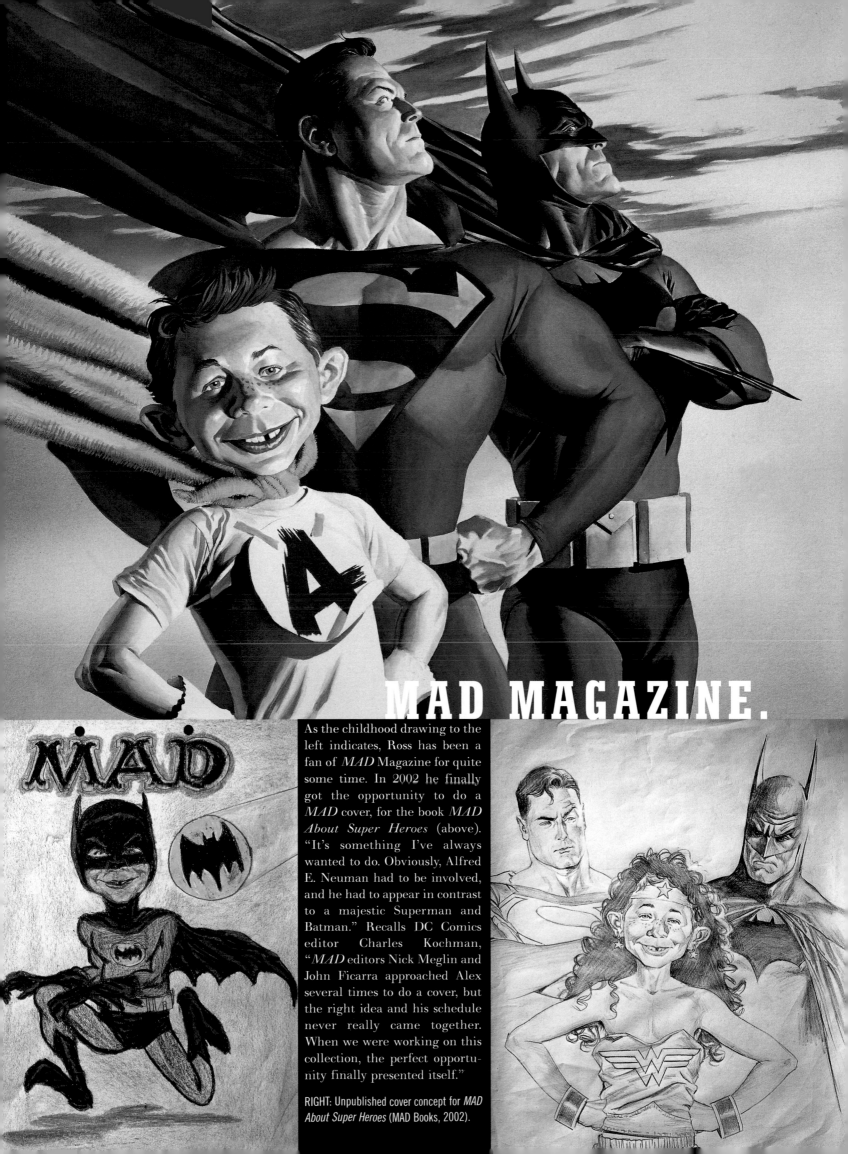

MAD MAGAZINE.

As the childhood drawing to the left indicates, Ross has been a fan of *MAD* Magazine for quite some time. In 2002 he finally got the opportunity to do a *MAD* cover, for the book *MAD About Super Heroes* (above). "It's something I've always wanted to do. Obviously, Alfred E. Neuman had to be involved, and he had to appear in contrast to a majestic Superman and Batman." Recalls DC Comics editor Charles Kochman, "*MAD* editors Nick Meglin and John Ficarra approached Alex several times to do a cover, but the right idea and his schedule never really came together. When we were working on this collection, the perfect opportunity finally presented itself."

RIGHT: Unpublished cover concept for *MAD About Super Heroes* (MAD Books, 2002).

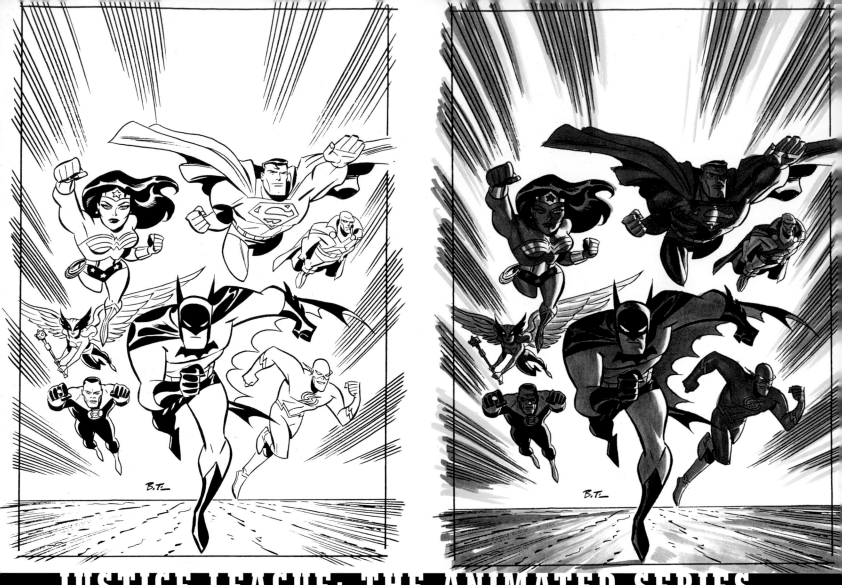

JUSTICE LEAGUE: THE ANIMATED SERIES.

Justice League debuted in 2001 on the Cartoon Network. Ross collaborated with Bruce Timm, the show's producer and character designer, for the cover (opposite) of the first issue of a tie-in comic book, *Justice League Adventures* (June 2002). "I love the design of the show, and I wanted to create a very dramatic lighting situation for the cover—I did a marker comp to figure it out [above, right]. I'd always wanted to see what it would be like to paint over Bruce Timm's pencils."

The piece below, eventually used as an ad for the show to appear on the side of a bus, was first laid out by artist David Williams, and then refined by Ross. It was then further changed by Darwyn Cooke for the final illustration.

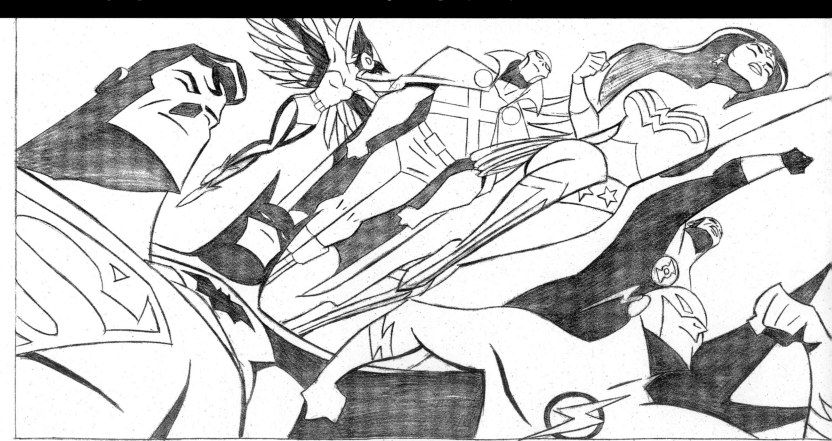

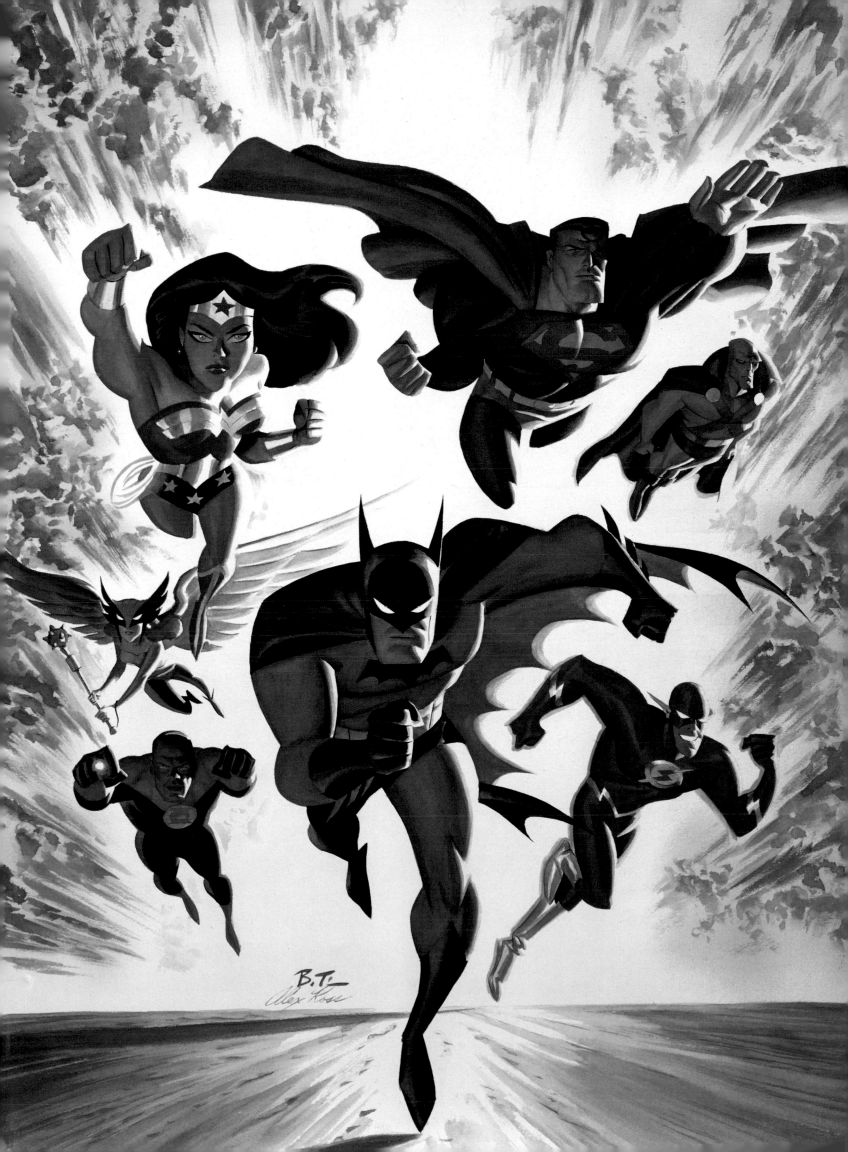

Alex has taken opportunities wherever he could to work on the DC characters he grew up with, including those that belong to the *Super Friends* mythology. Featured here in this Giclèe print for the Warner Bros. Studio Stores in 2001 are the many heroes of the various Hanna-Barbera cartoon shows (from top left to right): Blip, Jan, Jace, Space Ghost (*Space Ghost*), Blue Falcon, Dyno-Mutt (*Blue Falcon & Dyno-Mutt*), Shazzan, Kaboobie, Chuck, Nancy (*Shazzan*), Tundro, Gleep, Igoo, Gloop, Zok, Tara, King Zandor, Dorno (*Herculoids*), Samson, Goliath (*Samson & Goliath*), Jayna, Gleek, Apache Chief, Black Vulcan, Zan, Samurai, Marvin, Wendy, Wonder Dog (*Super Friends*), Mightor (*Mightor*), Avenger, Birdman (*Birdman*), Vapor Man, Meteor Man, Gravity Girl (*Galaxy Trio*), Raseem, Bez, Fariik, Prince Turhan, Princess Nida, Zazuum (*Arabian Knights*), and Jana (*Jana of the Jungle*).

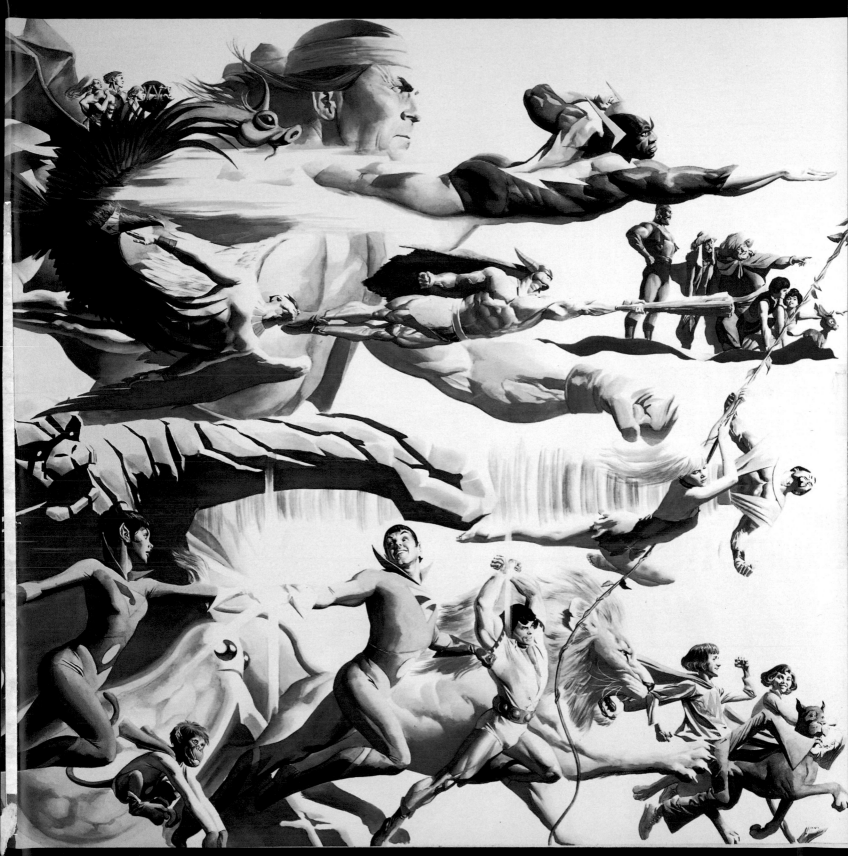

THE LEGION OF SUPER-HEROES.

Led by Superboy, the Legion was formed in the pages of *Adventure Comics* (below, left). Or, more accurately, they *will* be formed in the 30th century, since they exist in the future. (It's all very complicated.) "This is one of my single favorite paintings. Call it fanboy love. My particular obsession with Shadow Lass influenced other character designs from my childhood. This wasn't a commissioned piece initially; I just did it because I loved the characters and I was thrilled when the Warner Bros. Studio Stores made it into a Giclèe print. How can you not love the Legion? They're young, they're idyllic, they gleam with innocent sexuality. Lots of intertwining. It's the super hero comic as college fashion show."

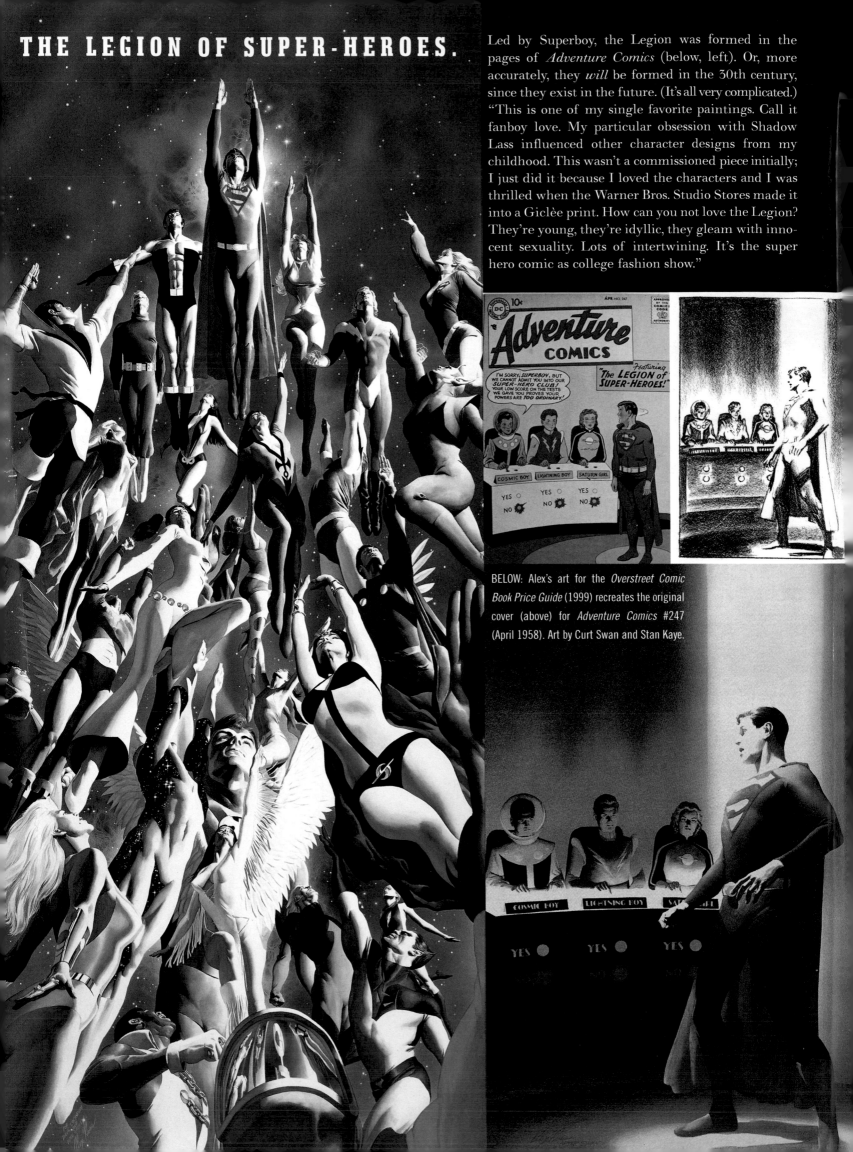

BELOW: Alex's art for the *Overstreet Comic Book Price Guide* (1999) recreates the original cover (above) for *Adventure Comics* #247 (April 1958). Art by Curt Swan and Stan Kaye.

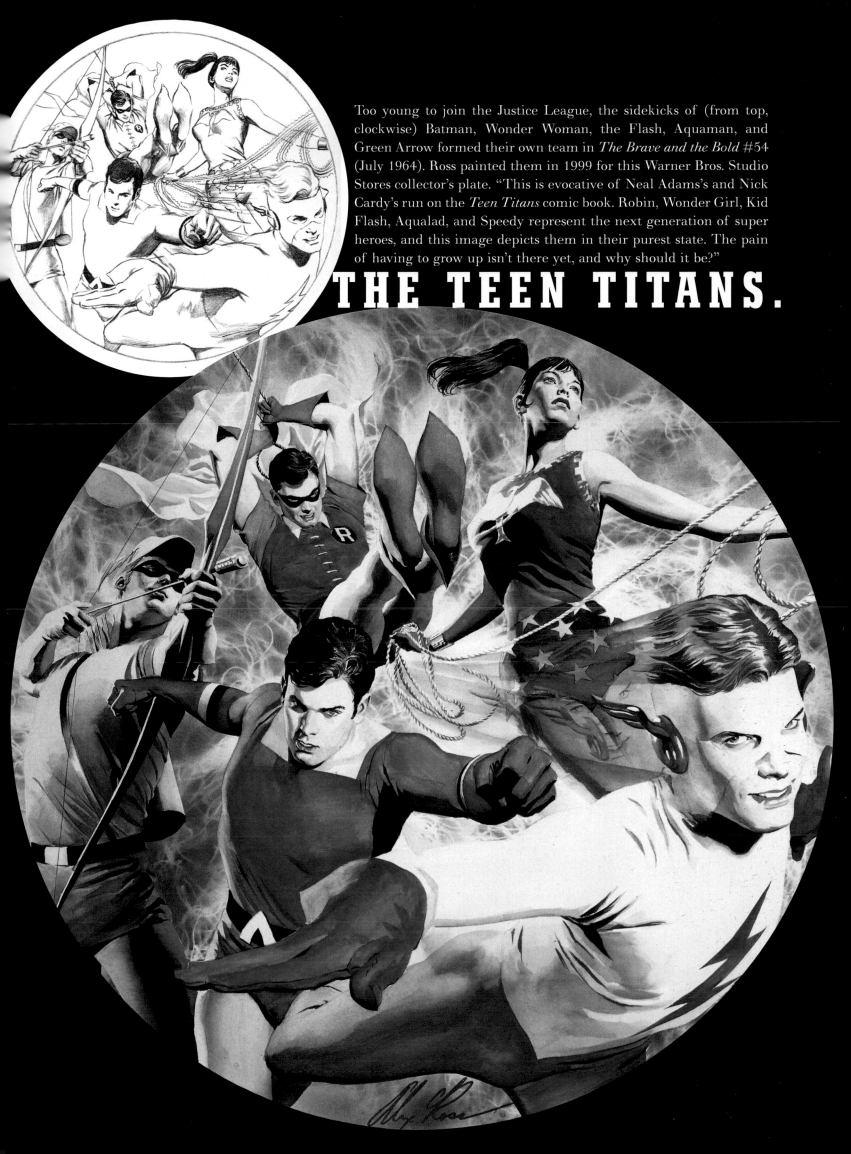

Too young to join the Justice League, the sidekicks of (from top, clockwise) Batman, Wonder Woman, the Flash, Aquaman, and Green Arrow formed their own team in *The Brave and the Bold* #54 (July 1964). Ross painted them in 1999 for this Warner Bros. Studio Stores collector's plate. "This is evocative of Neal Adams's and Nick Cardy's run on the *Teen Titans* comic book. Robin, Wonder Girl, Kid Flash, Aqualad, and Speedy represent the next generation of super heroes, and this image depicts them in their purest state. The pain of having to grow up isn't there yet, and why should it be?"

THE TEEN TITANS.

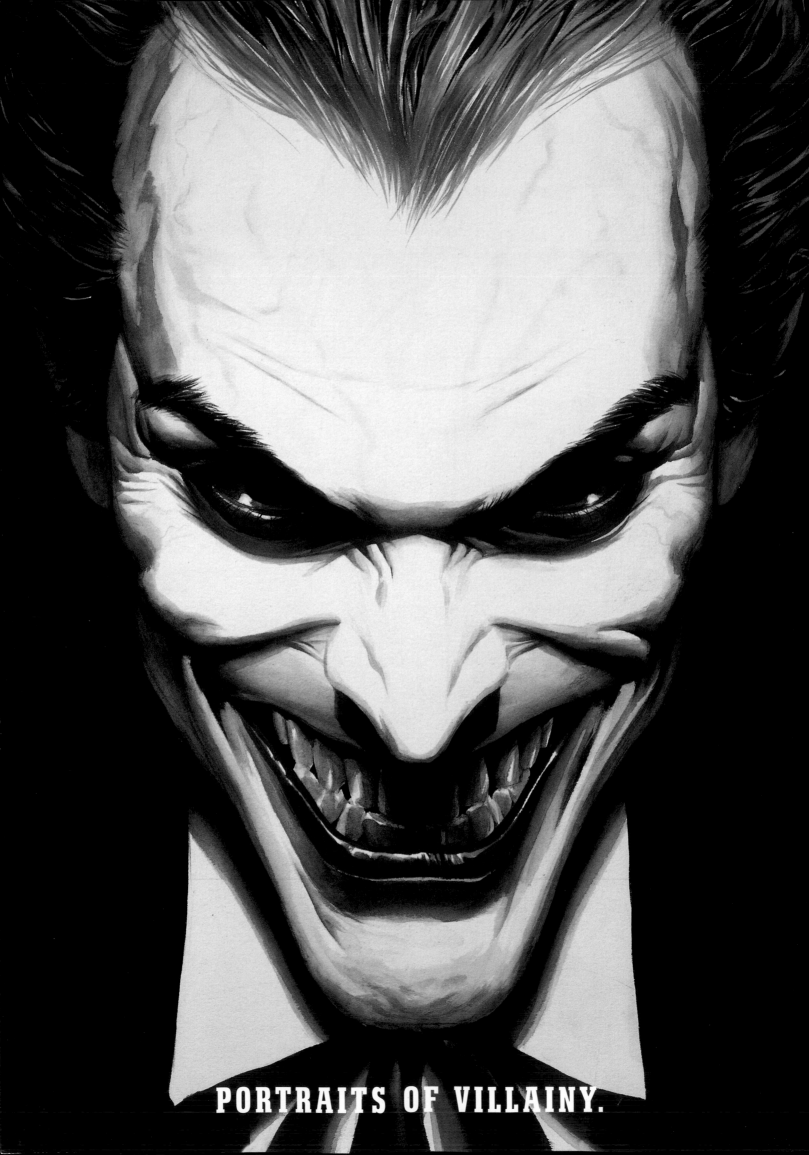

PORTRAITS OF VILLAINY.

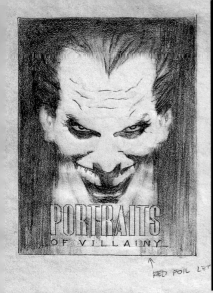

PORTRAITS
OF VILLAINY

↑ RED FOIL LET

An unpublished proposal from 1999, *Portraits of Villainy* was to have been just that: fully painted iconic head shots of the greatest bad guys (and girls) in the DC Universe. Although it never got past the penciled rough stage, Ross did complete his intended cover featuring the Joker (opposite).

PENGUIN

GORILLA

GRODD

BRAINIAC

GREEN

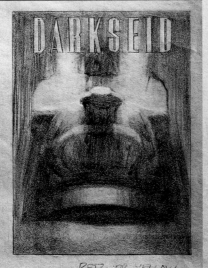

DARKSEID

RED OR YELLOW

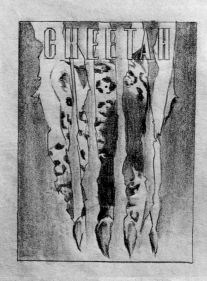

CHEETAH

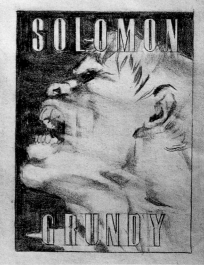

SOLOMON

GRUNDY

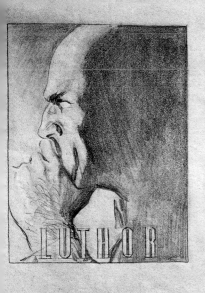

LUTHOR

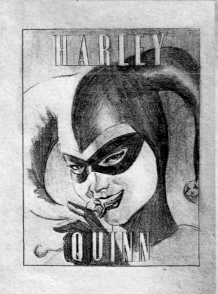

HARLEY

QUINN

BIZARRO

LIGHT BLUE?

CATWOMAN

PURPLE?

REVERSE

FLASH

SCARECROW

POISON

IVY

TWO-FACE

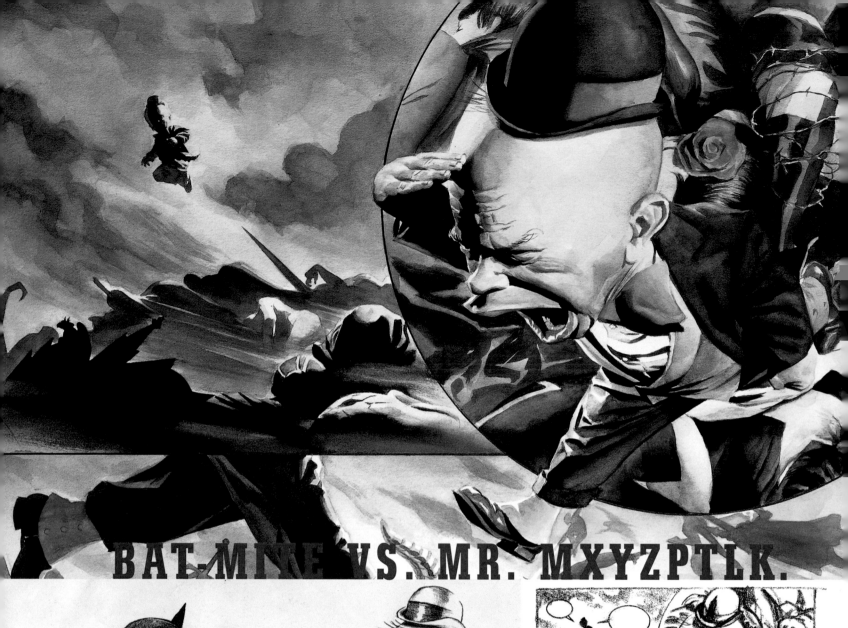

BAT-MITE VS. MR. MXYZPTLK.

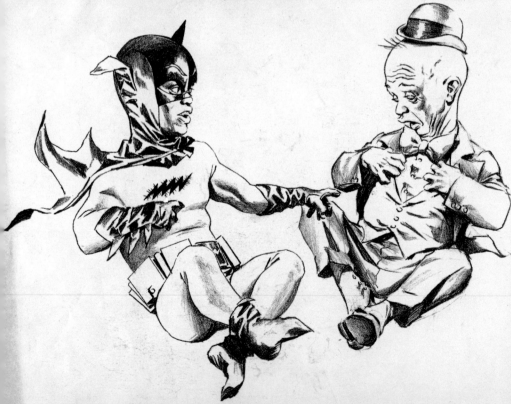

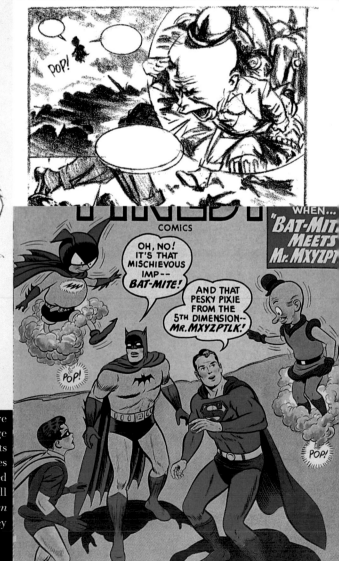

Those outer-dimensional mischievous imps, Bat-Mite and Mr. Mxyzptlk, joined forces (or, more accurately, knocked heads) in *Superman and Batman: World's Funnest* (2000)—a 48-page "prestige" format comic book that featured contributions from an astonishing array of artists including David Mazzucchelli, Bruce Timm, and Frank Miller. Ross's witty installment takes place in the "universe" of *Kingdom Come*, and literally explodes when Mxy becomes outraged that he's been painted photo-realistically, blasting the pigment off the penciled drawings in all directions (opposite, the image rotated 90° clockwise). "This is, technically, the last *Kingdom Come* image that I did, and this is how Bat-Mite and Mr. Mxyzptlk would have looked had they appeared in that original story—they'd look like actual dwarves and midgets."

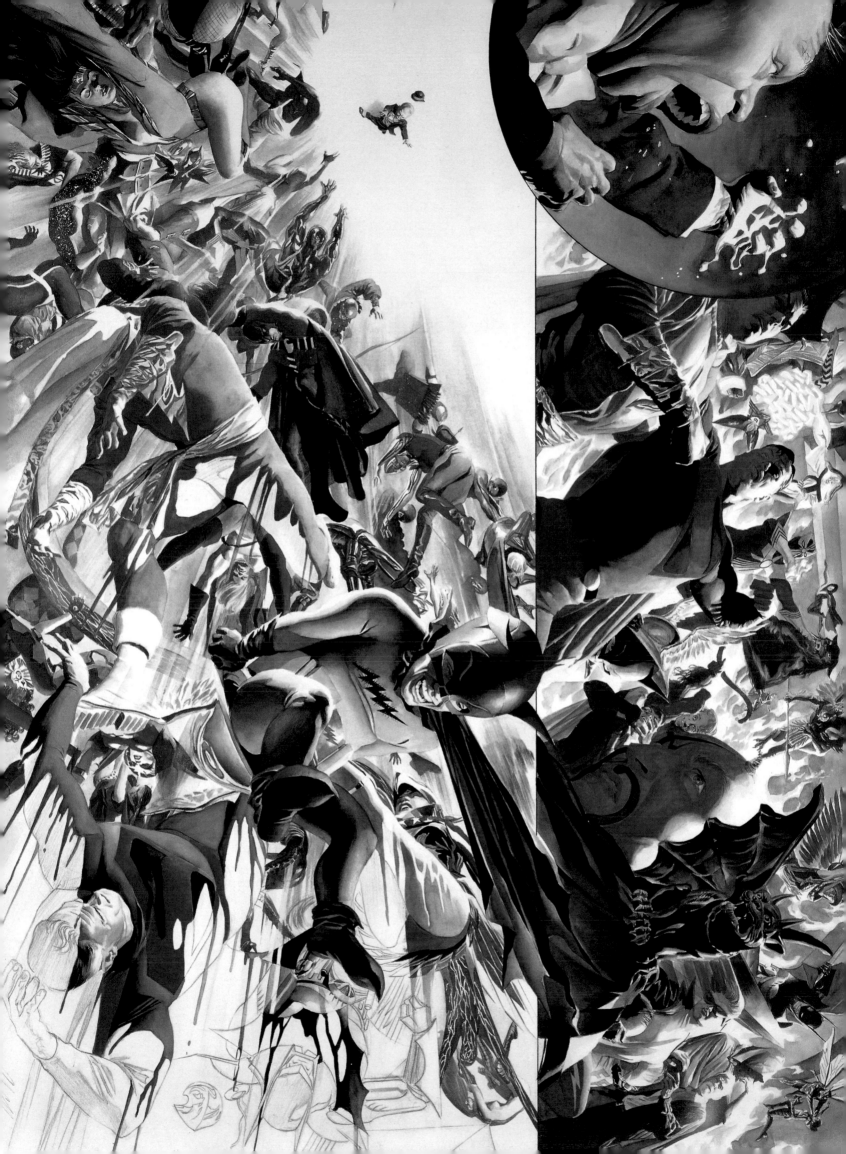

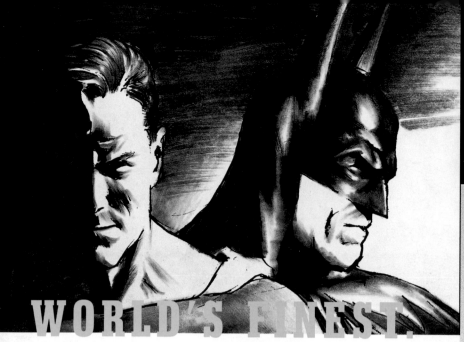

WORLD'S FINEST.

Superman and Batman actually teamed-up for adventures on the radio in the 1940s before they ever did in the comics. It wasn't until 1952, when they accidentally discovered each other's secret identities (see below) that they began appearing regularly together in print in *World's Finest* comics. Ross envisioned them for a Warner Bros. Studio Stores Giclèe print (opposite) in 1999, the image here rotated 90° counterclockwise. His preparatory pencil sketches are seen on this page.

RIGHT: Pencil sketch (circa 1998) for "life-size" Superman and Batman cardboard displays (the latter unproduced).

THIS IS MY PREFERRED HEAD & BODY SHOT. LET ME KNOW WHAT YOU THINK.

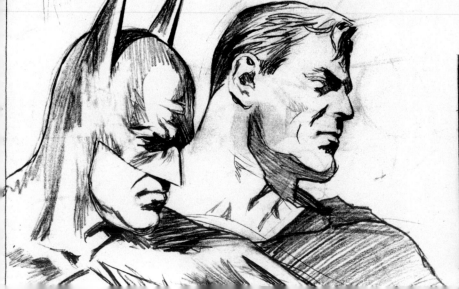

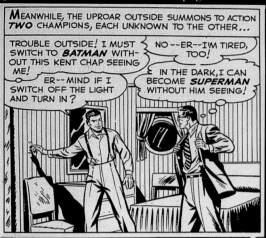

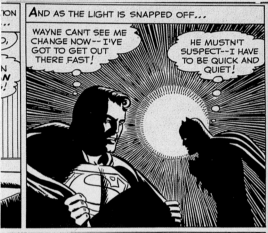

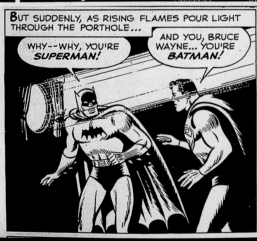

ABOVE: Batman and Superman discover each other's secret identities in *Superman* #76 (May-June 1952). Art by Curt Swan and John Fischetti. Script by Edmond Hamilton.

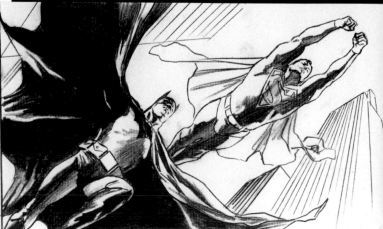

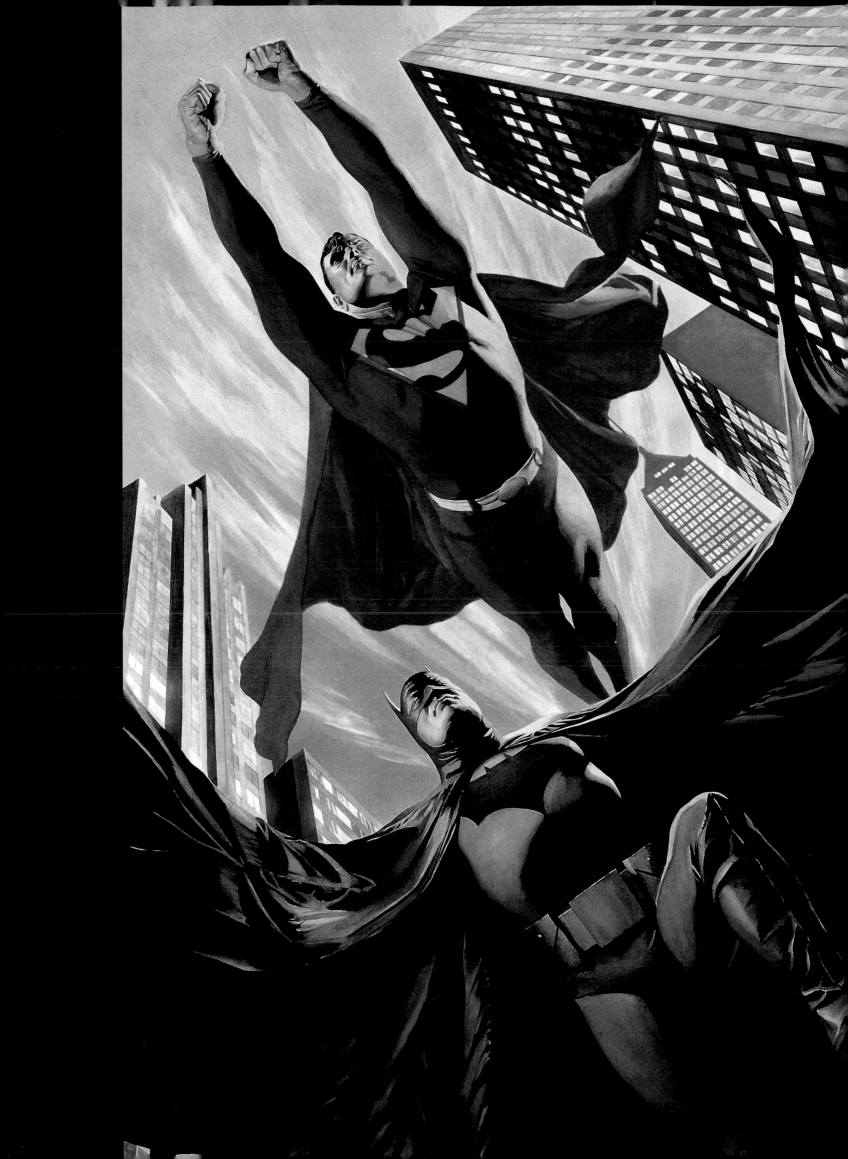

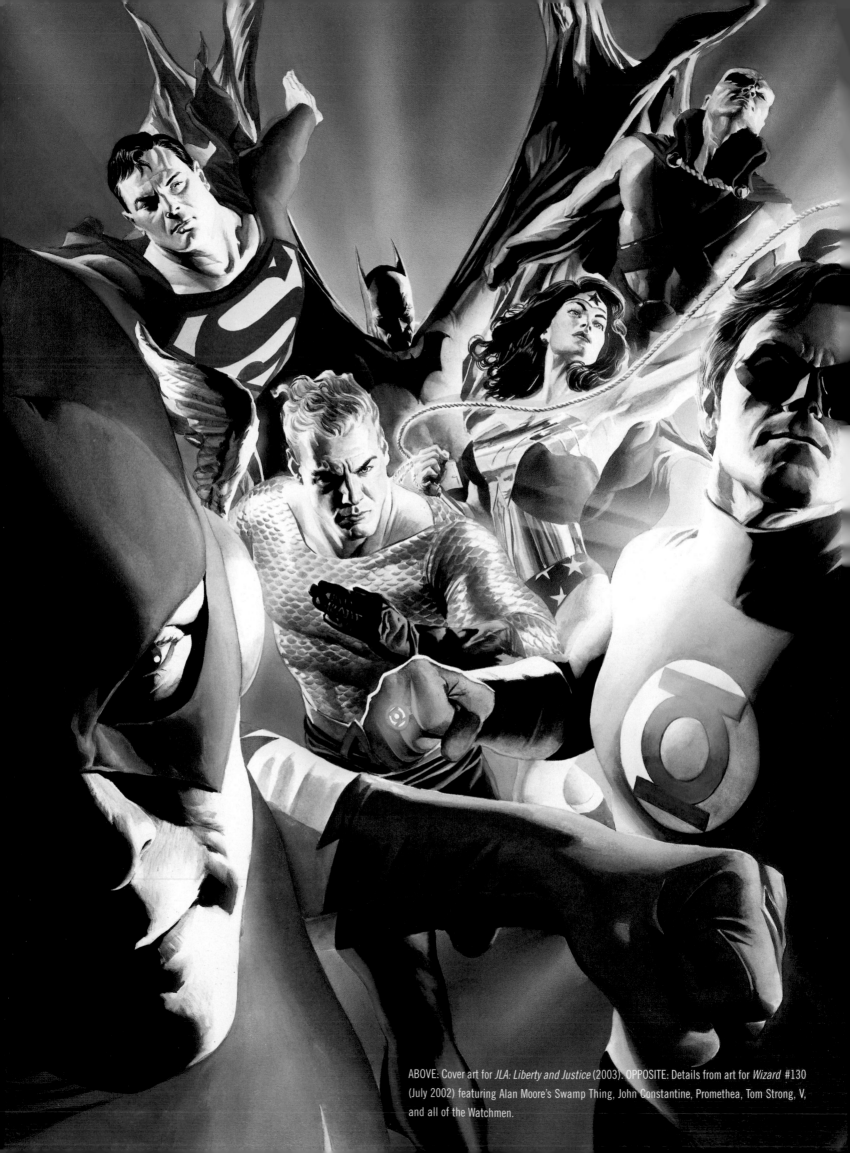

ABOVE: Cover art for *JLA: Liberty and Justice* (2003). OPPOSITE: Details from art for *Wizard* #130 (July 2002) featuring Alan Moore's Swamp Thing, John Constantine, Promethea, Tom Strong, V, and all of the Watchmen.

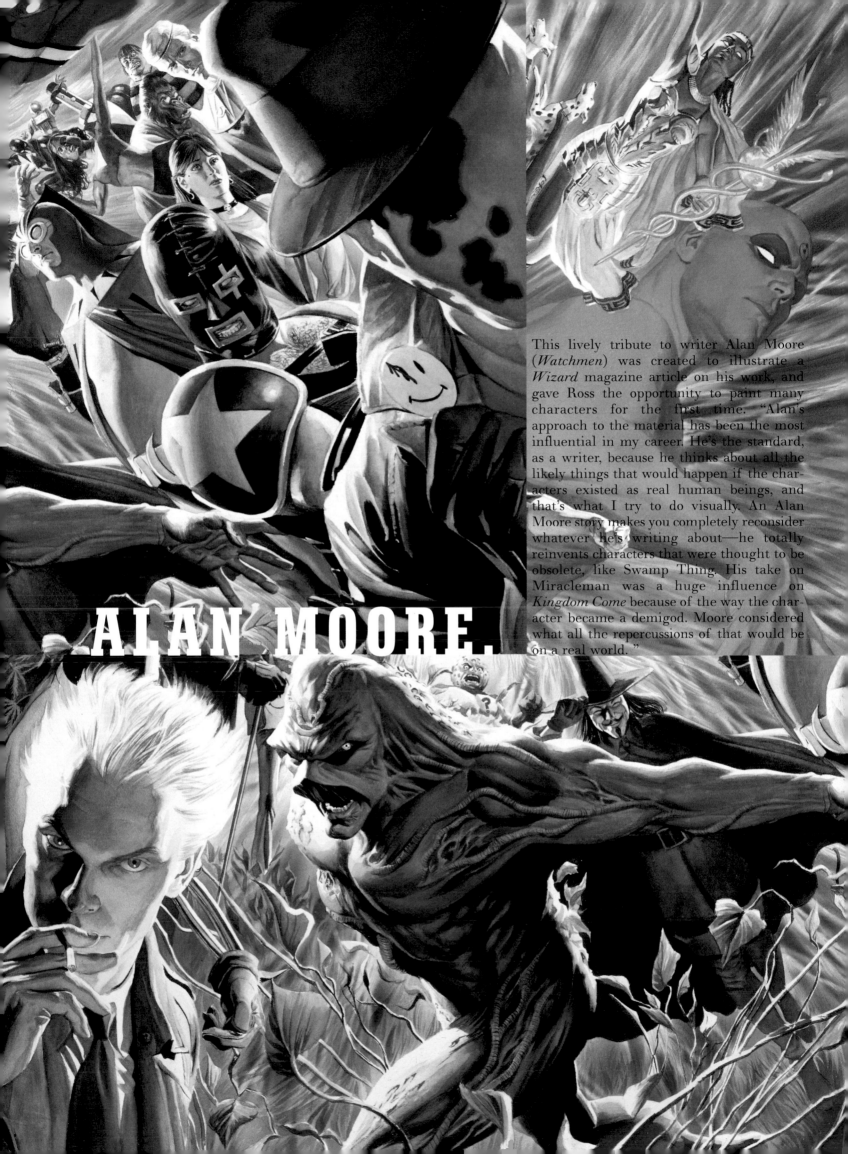

ALAN MOORE.

This lively tribute to writer Alan Moore (*Watchmen*) was created to illustrate a *Wizard* magazine article on his work, and gave Ross the opportunity to paint many characters for the first time. "Alan's approach to the material has been the most influential in my career. He's the standard, as a writer, because he thinks about all the likely things that would happen if the characters existed as real human beings, and that's what I try to do visually. An Alan Moore story makes you completely reconsider whatever he's writing about—he totally reinvents characters that were thought to be obsolete, like Swamp Thing. His take on Miracleman was a huge influence on *Kingdom Come* because of the way the character became a demigod. Moore considered what all the repercussions of that would be on a real world."

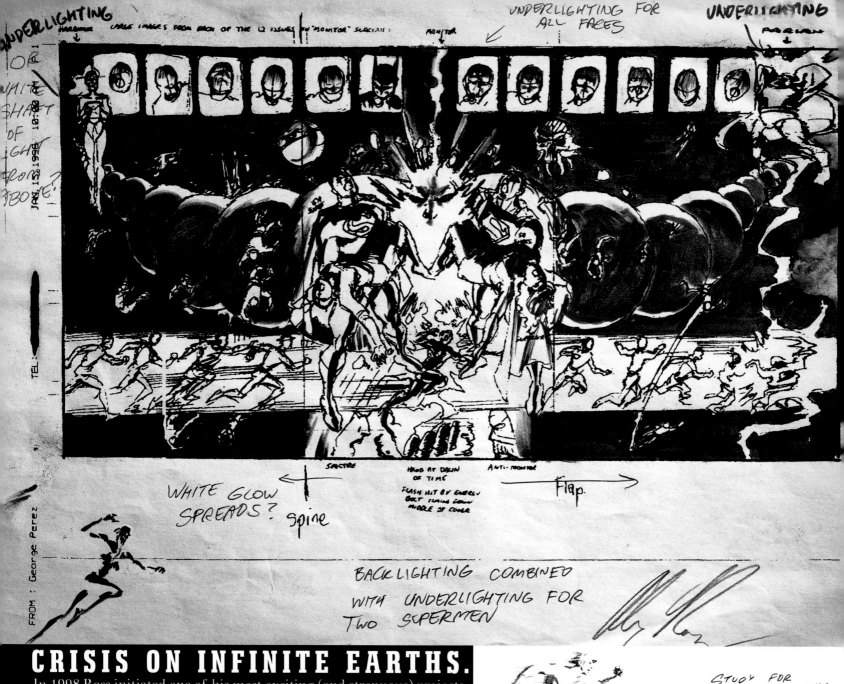

UNDERLIGHTING

LARGE IMAGES FROM EACH OF THE 12 ISSUES BY "MONITOR" SERIAL #?

MONITOR

UNDERLIGHTING FOR ALL FACES

UNDERLIGHTING

FROM: George Pérez

SPECTRE

HAND AT DAWN OF TIME

ANTI-MONITOR

FLASH HIT BY ENERGY BOLT ISSUED DOWN MIDDLE OF COVER

Flap.

WHITE GLOW SPREADS? spine

BACKLIGHTING COMBINED WITH UNDERLIGHTING FOR TWO SUPERMEN

CRISIS ON INFINITE EARTHS.

In 1998 Ross initiated one of his most exciting (and strenuous) projects: to paint a panoramic tableau over George Pérez's pencils for the cover of the hardcover publication of *Crisis on Infinite Earths*, the cataclysmic 1985 mini-series that forever changed the DC Universe. The result makes the ceiling of the Sistine Chapel look minimalist. "It was a total dream project for me—over five-hundred characters, it took over a month to do, working every day—by far the one piece I've ever spent the most time on. Every single character required a frisket mask in order to airbrush the background, a hugely laborious undertaking." But definitely a labor of love. "I was fifteen when the original was published, and it was the culmination of everything I enjoyed about DC Comics—they [writer Marv Wolfman and artist Pérez] were giving DC's history the most dramatic send-off ever. The story is the very heart of an insider's longing for knowledge about all of them. George and Marv tried to include *everybody*, and it completely thrilled me."

RIGHT: Superman mourns the death of Supergirl, on the cover of *Crisis on Infinite Earths* #7 (October 1985). Art by George Pérez.

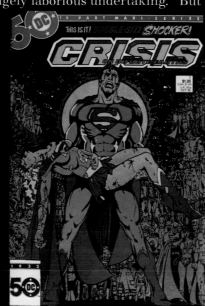

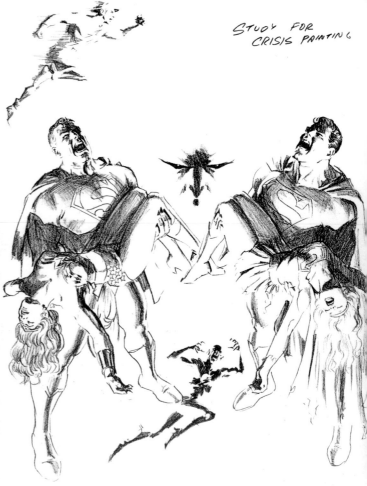

STUDY FOR CRISIS PAINTING

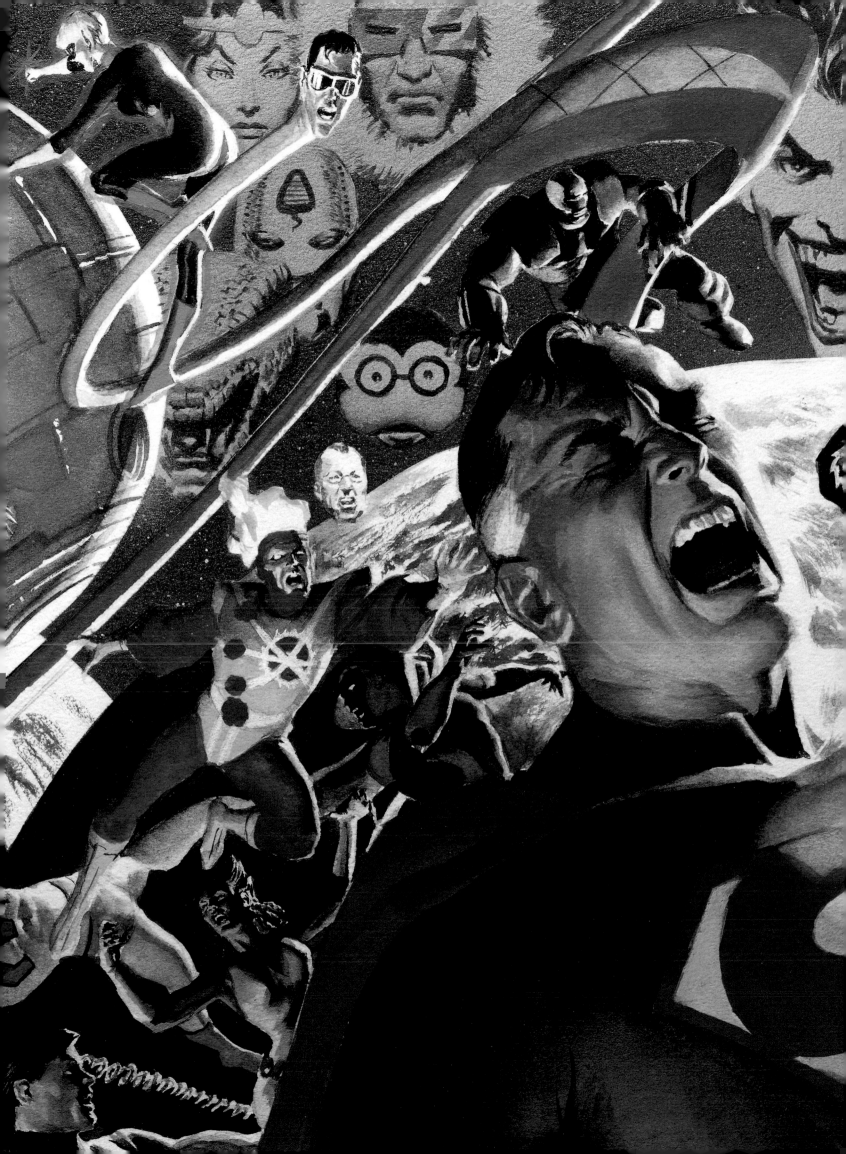

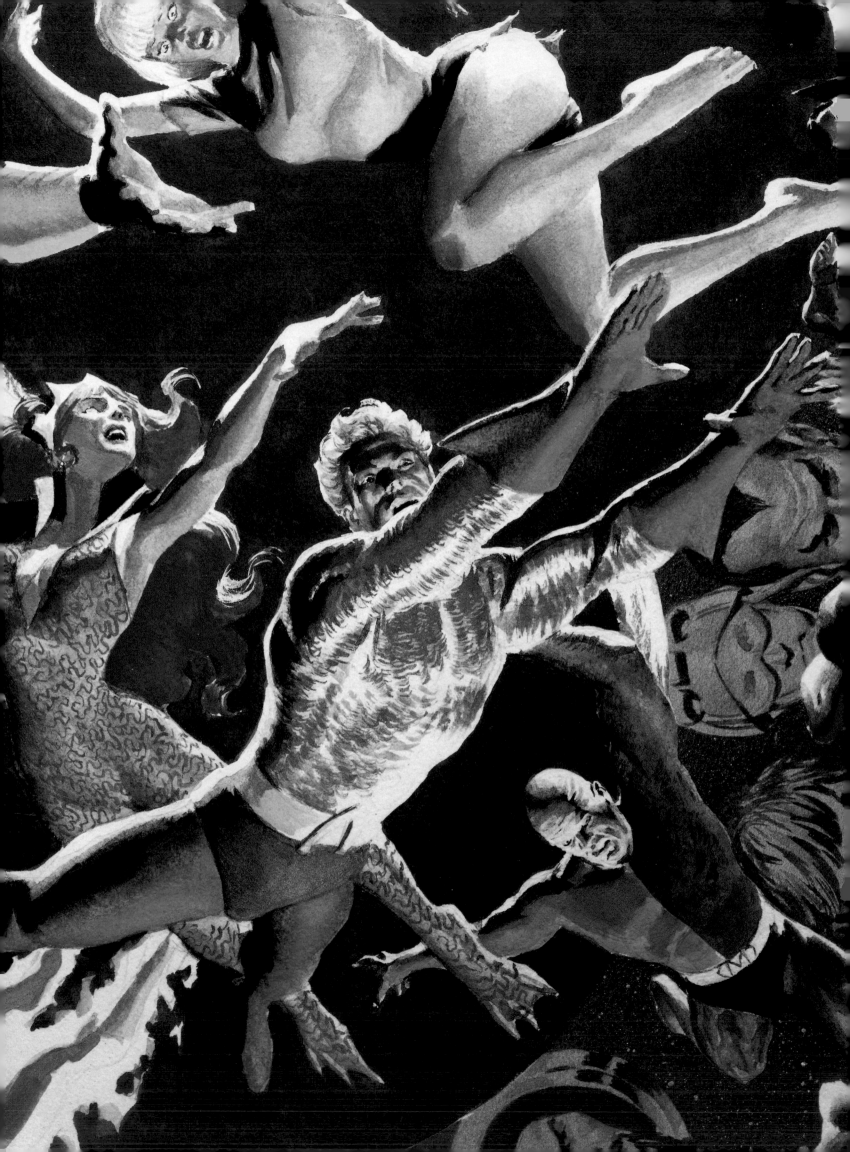

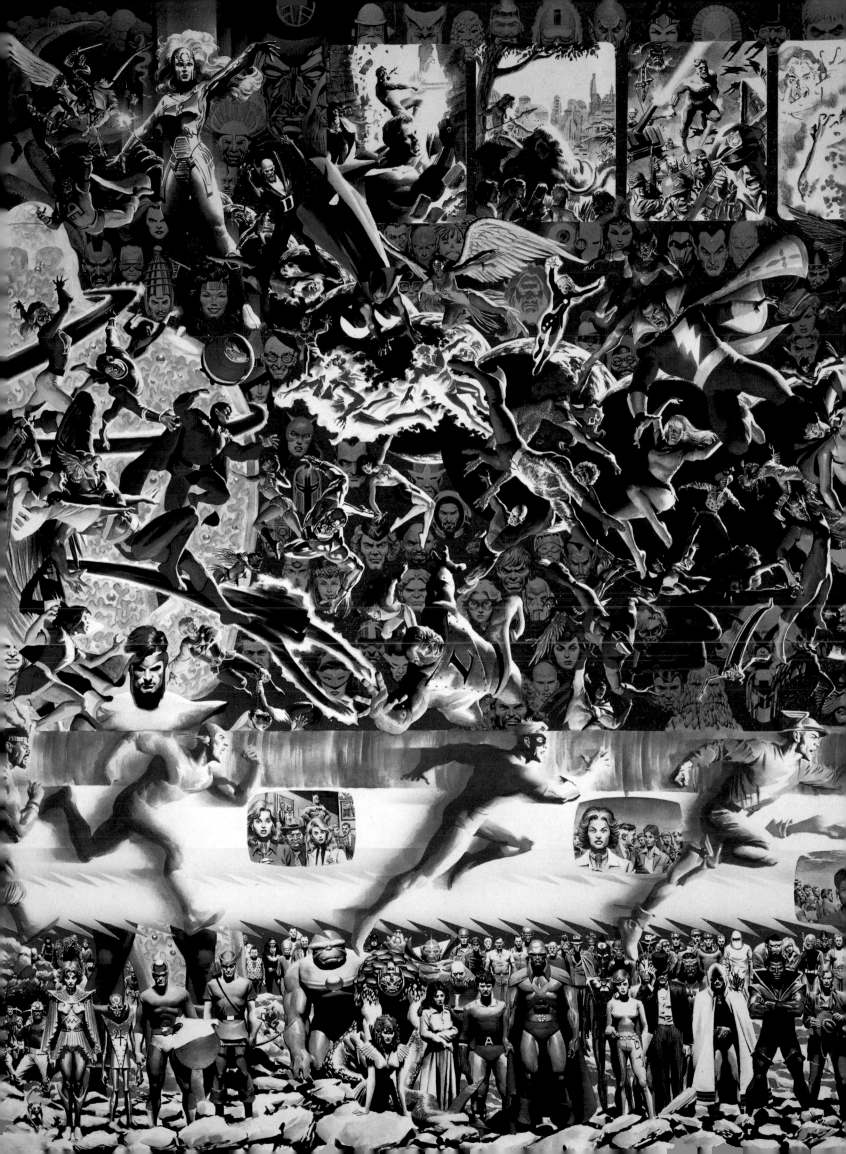

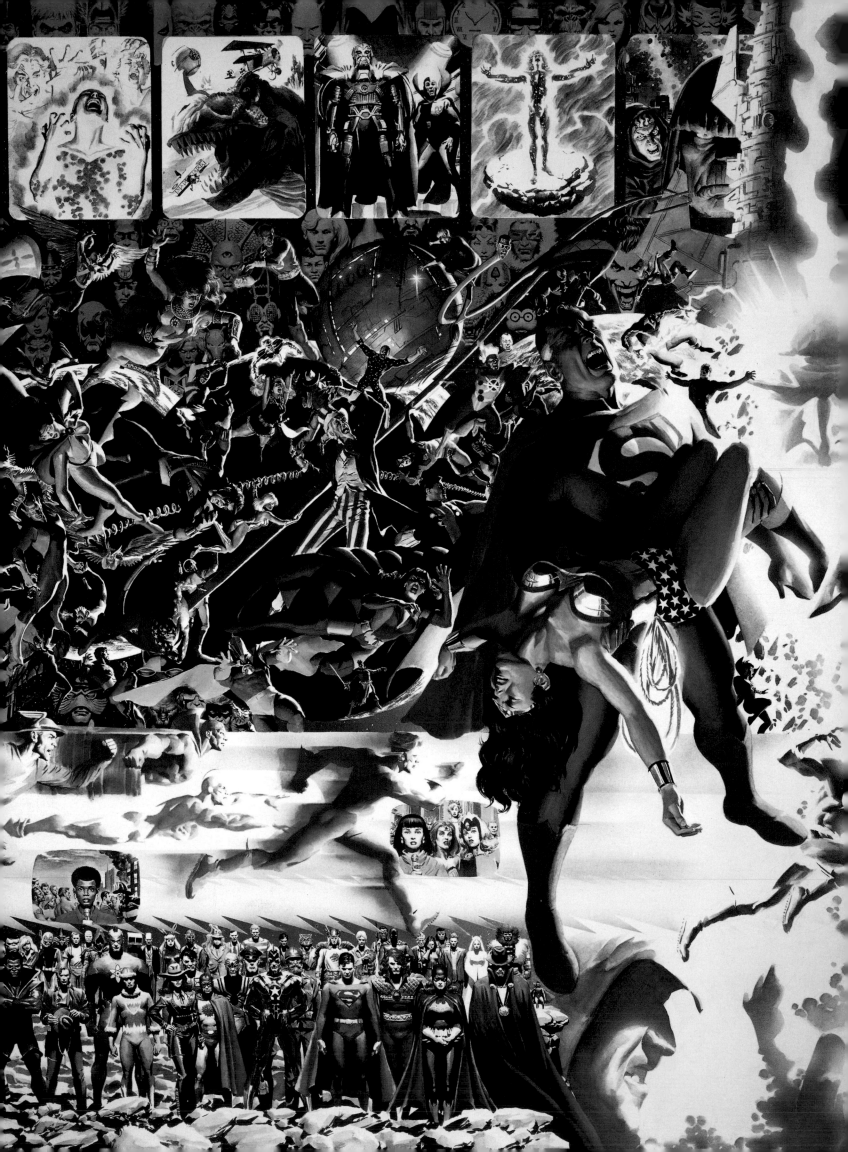

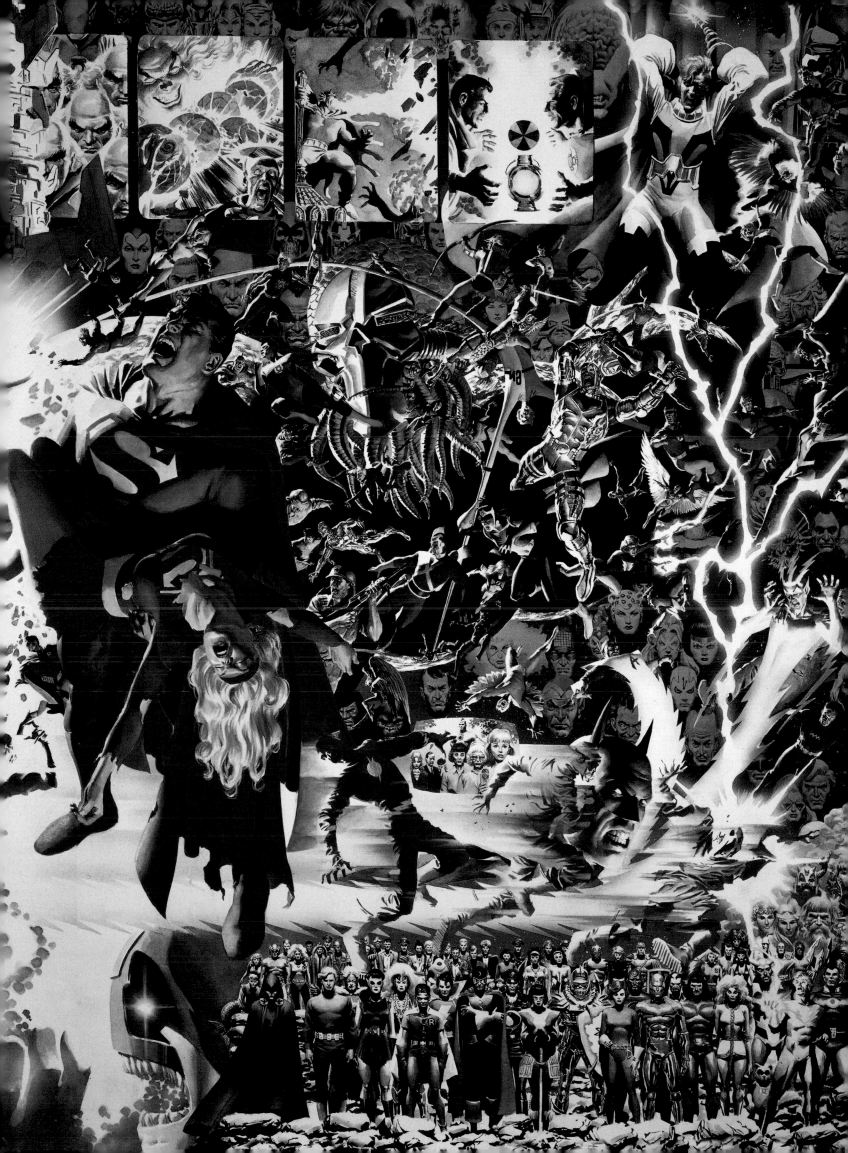

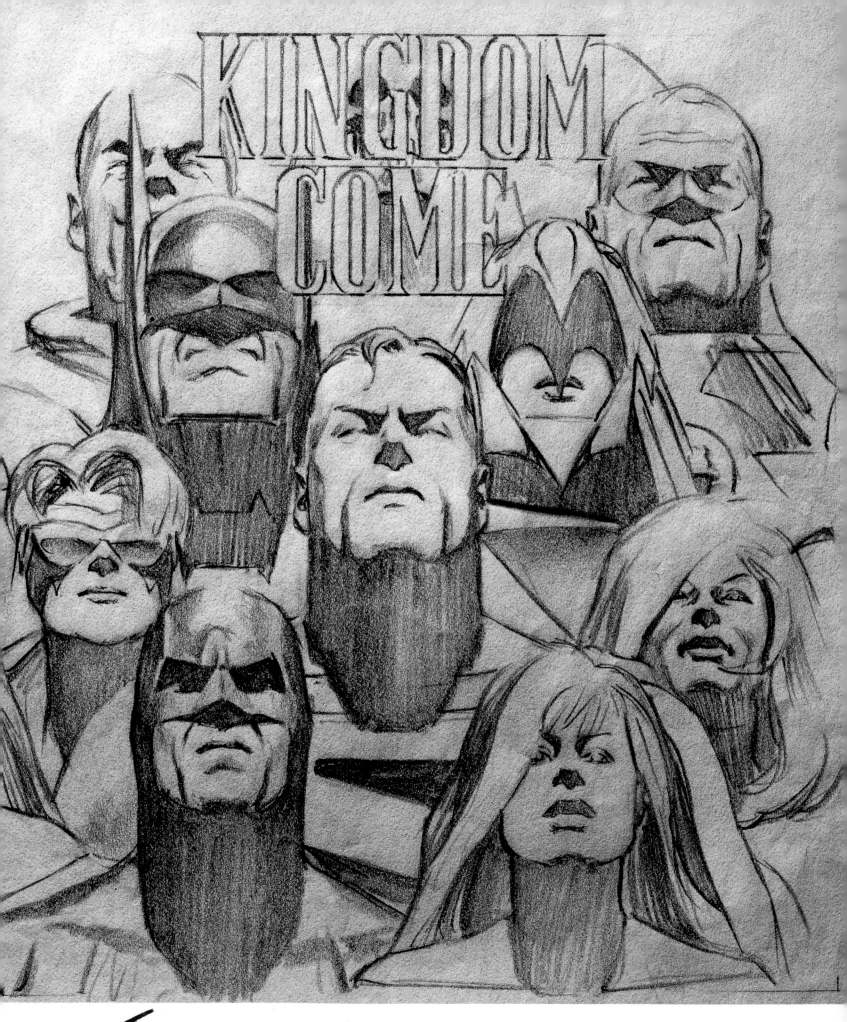

THIS IS WHAT I WAS ORIGINALLY THINKING . . .

WHOSE WILL BE DONE?

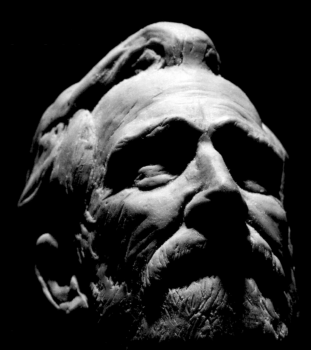

The seeds of *Kingdom Come* were planted long before the staff at DC Comics (or anyone else in the comics industry) had ever heard of Alex Ross.

In his early teens, Alex began conceiving of an epic, apocalyptic super hero story (with religious overtones) that would re-examine the whole idea of what the DC characters mean and how their roles in their world would evolve. He made copious notes and sketches, developing his ideas, resulting in a sort of amalgam of *Action Comics* and *Revelations* (see overleaf).

It would be more than ten years from conception to realization. Working with writer Mark Waid, *Kingdom Come* appeared in 1996, and it changed everything—for the publisher, the industry, and its prolific young artist.

Chronologically, this material should appear earlier in this book—it's Ross's first major work for DC. But it is presented here, after the key DC players have been introduced, in order to more fully appreciate Ross's thought process regarding their evolution.

RIGHT: A resin-cast bust of Norman McCay, the everyman protagonist of *Kingdom Come*, based on the likeness of Ross's father, Clark, and sculpted by Jarrod Shiflett and Ross (1995). OPPOSITE: Pencil sketch for the front of a *Kingdom Come* T-shirt (1996). BELOW: Art for the cover of *Kingdom Come* #1 (1996).

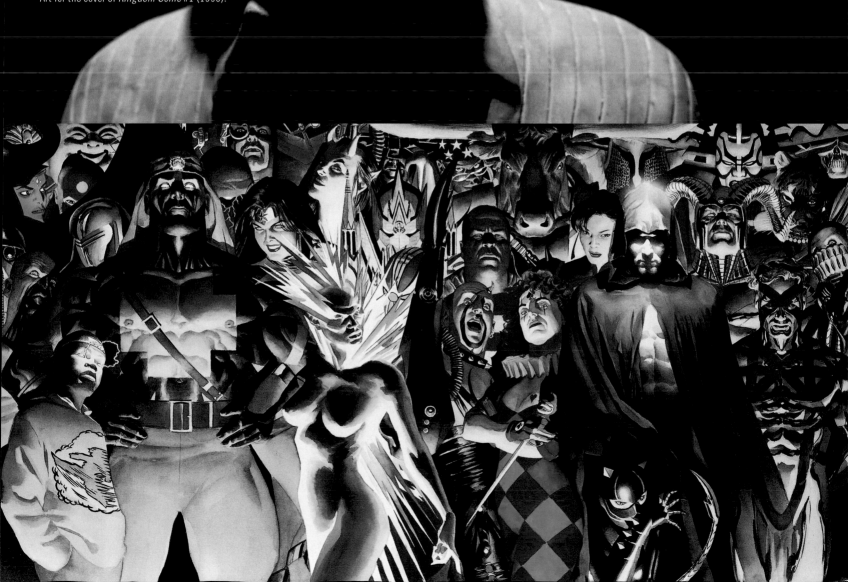

present problem: the character is a combination of the legends of Samson and Superman with overpowering semblance of Jesus of Nazareth.

Originally he was supposed to be Christ and look like the actual man would have. I thereby assumed him to be a small man with dark hair, skin, and eyes. This offered me the opportunity to have him be bi-racial or tri-racial as the case may be. Also I would have his eyes be totally black as it would show an inhuman reception to light as the pupil is enlarged and taking in so much more.

History — throughout the centuries Christ has been mostly (or at least most well known) depicted as a tall Anglo-Saxon with light-brown hair, angular European-type features, and blue eyes. These characteristics, similar to my own, would be incorporated into the character to some degree but would generally bear the coloring and size of someone native to that time, place, and race.

Recently a person who claimed to have studied that period and how Jesus would have appeared told me that her research concluded that he was not an ordinary looking person and quite a sight to see. The two things that still tied were colorization of hair and skin but she says him to have been recorded as having blue eyes and being over six feet in height (this putting him in terrific contrast with the general population of his area). This study places him in accordance with characteristics of mine again so I find my previous conclusions in jeopardization leaving me with some researching of my own to do.

5'5" or 5'7"

← DARK BLUE SHIRT AND PANTS

PUPIL IS SO ENLARGED THAT IT HIDES OUT TRUE COLOR OF THE EYE.

?

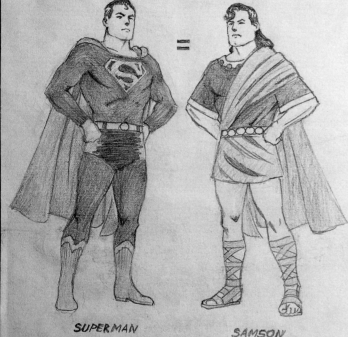

SUPERMAN
Super Hero Character
1930's - 40's

=

SAMSON
Bible Hero Character

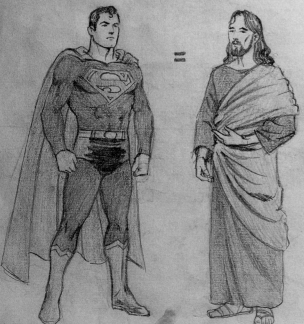

SUPERMAN
Super Hero Character
1960's - 70's

=

JESUS
Bible Hero Character

Creation of Story

As I can tell it from memory the initial creation started in 1984 with 2 totally different movie stories that I conjured up.

MESSIAH
COMING FROM THE FUTURE TO SAVE US IN OUR PAST

&

SON OF KRYPTON

ONE OF THE FIRST FILM IDEAS THAT I HAD FOR MYSELF TO STAR IN IN THE MAGICAL OTHER-REALITY OF NELSON ALEXANDER ROSS — CHILD PROTEGY SCRIPT WRITER, ARTIST, STAR PERSONALITY. HEAVILY INFLUENCED BY JESUS CHRIST SUPERSTAR THIS CONCEPT SHOWED THE BEGINNINGS OF MY CHRIST-LIKE VISION OF MYSELF. AT THE TIME I HAD NO LONG HAIR AND DID NOT LOOK LIKE JESUS PAINTINGS VERY MUCH AT ALL.

THIS STORY INITIALLY BEGAN WITH DEEP THOUGHT AT GRANDMA'S HOUSE IN EVANSTON, ILLINOIS. IN MY BOREDOM I WONDERED HOW IT WOULD BE IF I FOUND MYSELF ALL OF A SUDDEN BACK IN MY MOTHER'S WOMB ABOUT TO BE BORN AGAIN WITH ALL OF MY MEMORIES OF WHAT I HAD JUST LIVED INTACT. AFTER I FINALLY RE-AQUIRED THE PHYSICAL ABILITY TO TALK I WOULD SLOWLY REVEAL MY INTELLIGENCE TO MY OLDER SISTER GENEVA AS I WAS STILL A FEW MONTHS OLD IN THE CRIB IN THE ROOM WE USED TO SHARE TOGETHER IN OUR HOUSE IN PORTLAND, OREGON, 1970. EVENTUALLY I FIGURE THAT MY PARENTS WOULD BRING ME BEFORE A DOCTOR, THEN A COMMITTEE, THEN A LARGER COMMITTEE, AND SO ON SO THAT EVENTUALLY THE WORLD WOULD KNOW OF THIS MIRACLE BABY FROM THE FUTURE. I FIGURED THAT THIS WAS A FASCINATING CONCEPT BUT THERE MUST BE SOME REASON, SOMETHING THAT THE CHILD HAS COME TO DO. THIS WAS THE BASIS FOR THE SAVIOR SYMBOLISM AND THE REST OF MY COMPOSITION.

WAR IS BREWING BETWEEN AMERICA AND RUSSIA AND A NUCLEAR HOLOCAUST IS AT HAND. A WORKING ARTIST AND HIS WIFE AND YOUNG DAUGHTER LIVE AMONG THESE TIMES. AS THE SITUATION GETS WORSE THEY TREK WESTWARD. ON THEIR RUN, THE NUCLEAR WAR STARTS AND A BOMB BLAST NEAR THE FAMILY KILLS THEM. THE LAST THING THE MAN SEES IS THE WAVE OF FIRE CONSUMING THEM AND THEN HIMSELF. THE PLANET IS SUPPOSEDLY A CATASTROPHE. HE NEXT AWAKES IN HIS MOTHER'S WOMB AGAIN AND IS DISORIENTED TILL A WHILE AFTER BIRTH. HE THEN REALIZES ALL AND REVEALS HIMSELF TO HIS BROTHER AND SISTERS, THEN PARENTS AND EVENTUALLY THE WORLD. A CHILD WITH PERFECT KNOWLEGE OF A PAST LIFE, OF FUTURE EVENTS (AND HOLOCAUSTS), AND OF THINGS THAT SHOULD BE DONE STRUCK THE WORLD. HE WAS APART FROM FAMILY AND PLAYED AN AMAZING ROLE IN NEW WORLD AFFAIRS. HE SET IN THE PROCESS FOR CHANGING HISTORY. AS HE GOT OLDER THE WORLD BECAME LESS INTERESTED IN HIS PROPHECIES. WHEN A YOUNG MAN IN HIS LATE TEENS HE AQUIRED A GREAT NUMBER OF CLOSE FOLLOWERS WHO RALLIED UNDER HIM AGAINST THE NEW WARFARE ATROCITIES THAT HAD RESULTED INSTEAD OF THOSE HE HAD COME TO PREVENT. AS HIS INFLUENCE COMES CLOSER AND CLOSER TO ACHIEVING A SHUTDOWN OF CERTAIN MILITARY ACTIVITIES, AN ATTEMPT ON HIS LIFE IS MADE BY THE GOVERNMENT. HE PROVES IT UNSUCCESSFUL AND LEADS THE GREATEST, OVERWHELMING MARCH ON THE WHITE HOUSE WHERE HE SPEAKS TO THE PRESIDENT (AND PEOPLE) OF HIS AIM FOR NUCLEAR PEACE AND HOW HE WAS SENT BACK TO BE THE SAVIOR OF THE WORLD.

ANOTHER OF THE FILM IDEAS FOR ME TO STAR IN — NOT VERY DEVELOPED IN IT'S ORIGINAL FORM BUT IT PROVIDES A GOOD SPRINGBOARD TO BETTER IDEAS. MAINLY INSPIRED FROM SUPERMAN AND SUPER-STRENGTH/ABILITY CHARACTERS IN MOVIES WHO AMAZE THE WORLD AND JUSTLY DISPATCH THE UNJUST WITH THEIR POWERS. BASICALLY THE STORY RESULTED OUT OF GROWING FRUSTRATION WITH SCHOOLMATES AND ANYONE THAT I FELT ANNOYED AT OR OPPRESSED BY. THE CHARACTER WAS BASICALLY MYSELF WITH SUPERMAN'S POWERS IN HIGH SCHOOL AND WHAT SORT OF VENGEFUL THINGS THAT I WOULD DO WITH THEM. THIS CREATION ONLY RESULTED FROM ANGER AND INJUSTICES REAPED UPON MYSELF. THE STORY WAS A VERY SELFISH AND USELESS ONE. I MEANT IT TO SHOW HOW IF A SUPERMAN CHILD FROM KRYPTON WAS SENT NOW THAT HE WOULD TURN OUT TO BE A VERY ANGRY YOUNG MAN LIKE MYSELF AND WOULD USE HIS SPECIAL ABILITIES TO EXECUTE ALL THOSE HORRIBLE REVENGES THAT I WISHED TO. LIKE MESSIAH, IT WAS TO BE TOLD IN A LIFE STORY FORM. STILL IT WAS A VERY UNDEVELOPED, COLD STORY OF NASTY ADOPTIVE PARENTS, BEATING UP OTHER KIDS IN SCHOOL, USING X-RAY VISION TO SEE THROUGH WOMEN'S CLOTHING, AND LITERALLY TEARING APART A SMALL SOUTHERN HIC TOWN FOR REASONS OF VENGEANCE. INCOMPLETE COMPOSITION.

NOTE: OTHER INSPIRATIONS FOR THE WRITING OF THESE TWO STORIES OCCURED WITH MUSIC. IN MESSIAH THE SONG "HAD A DREAM/SLEEPING WITH THE ENEMY" WAS THOUGHT TO UNDERSCORE THE SCENES OF HIM PLAYING A ROLE IN WORLD AFFAIRS AS A LITTLE BOY. AT THE END OF THE FILM AS HE SPEAKS BEFORE THE PEOPLE AND THE SHOT RISES UP AND AWAY FROM HIM IN THE CROWD, THEIR CHANT INTERCUTS WITH "ALL THE YOUNG DUDES" TILL THE CLOSE. IN SON OF KRYPTON THE SONG "SHOUT" WAS IN MY MIND AS I THOUGHT OF HOW I'D LIKE TO SMASH AN ONCOMING HORDE OF POLICE AUTOMOBILES WITH A LAMPOST ON ONE OF THE BUSIEST STREETS IN LUBBOCK.

ROGER HODGSON OF SUPERTRAMP

DAVID BOWIE

TEARS FOR FEARS

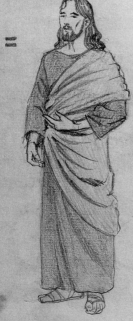

The concept follows an oft-told tale: an older generation of warriors is forced out of retirement to face down the new guard, who are completely out of control. The result is a superhuman civil war, with the stakes no less than the fate of mankind and the future of the world. "Several specific scenarios fascinated me since my teens," says Ross. "One was Superman pulling down the columns of the White House, the way Samson pulled down the pillars of the Temple of Dagon. Another was Superman surviving a U. S. government-sanctioned nuclear blast, and then taking his vengeance for it. I've had a Jesus obsession since childhood, and I wanted to explore putting Superman in the same role. I was haunted by the idea of him punishing America for introducing the nuclear age, but then eventually calming down about it, embracing peace, and getting beyond the need to wage war."

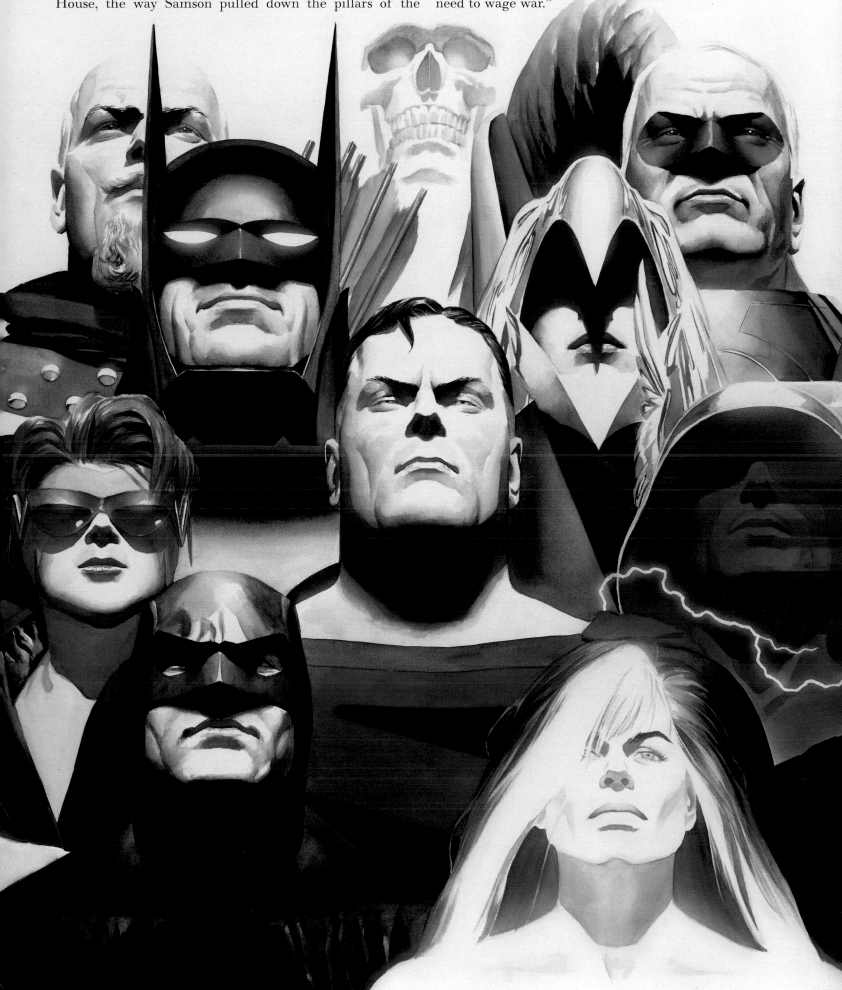

But of course, waging war is a large part of what super heroes are all about. The famous line about Superman's "Never-Ending Battle" comes to mind. "I don't want to be told there's an end to any of these myths. And yet I wanted to be the one to define the end of DC's Arthurian saga, even though it would never be an 'official' ending."

Ross was paired by editors Dan Raspler and Pete Tomasi with veteran comics writer Mark Waid to produce four individual monthly installments of the series, which totalled 180 pages when finished and was heralded as a DC Comics milestone. Certainly tales based on the "future" of the DC characters had been done before (and were in fact a story-telling staple since the 1950s), but the meticulous execution of *Kingdom Come* made it seem like this story was real, like it was actually happening.

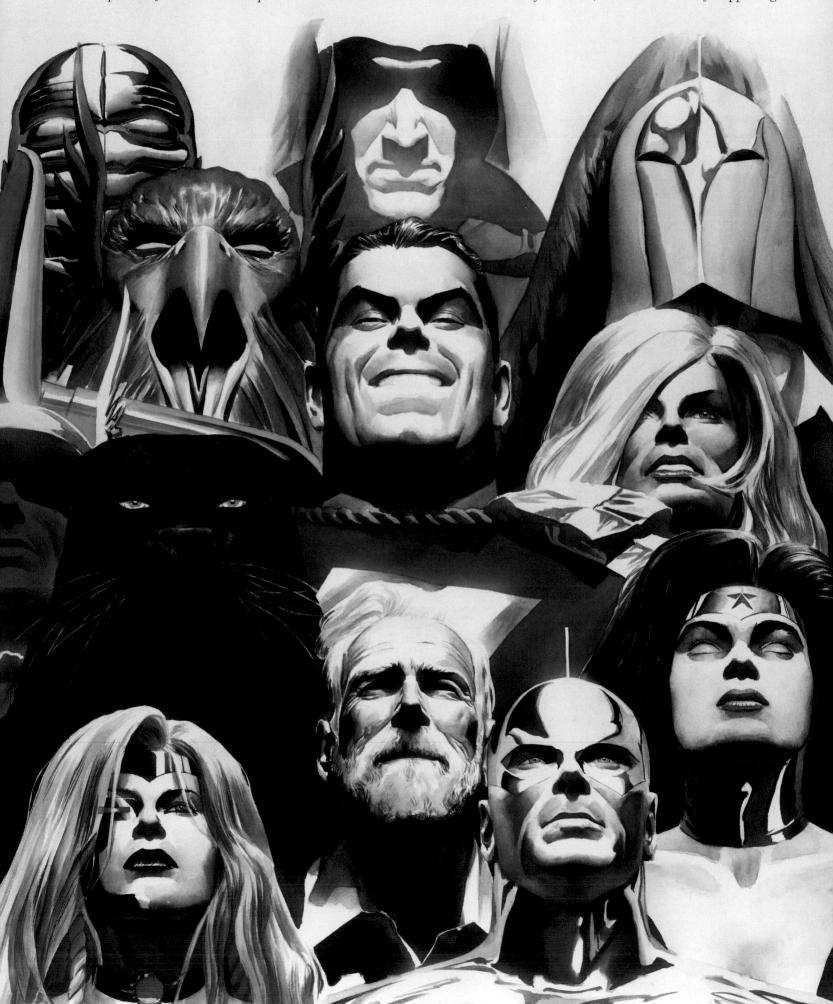

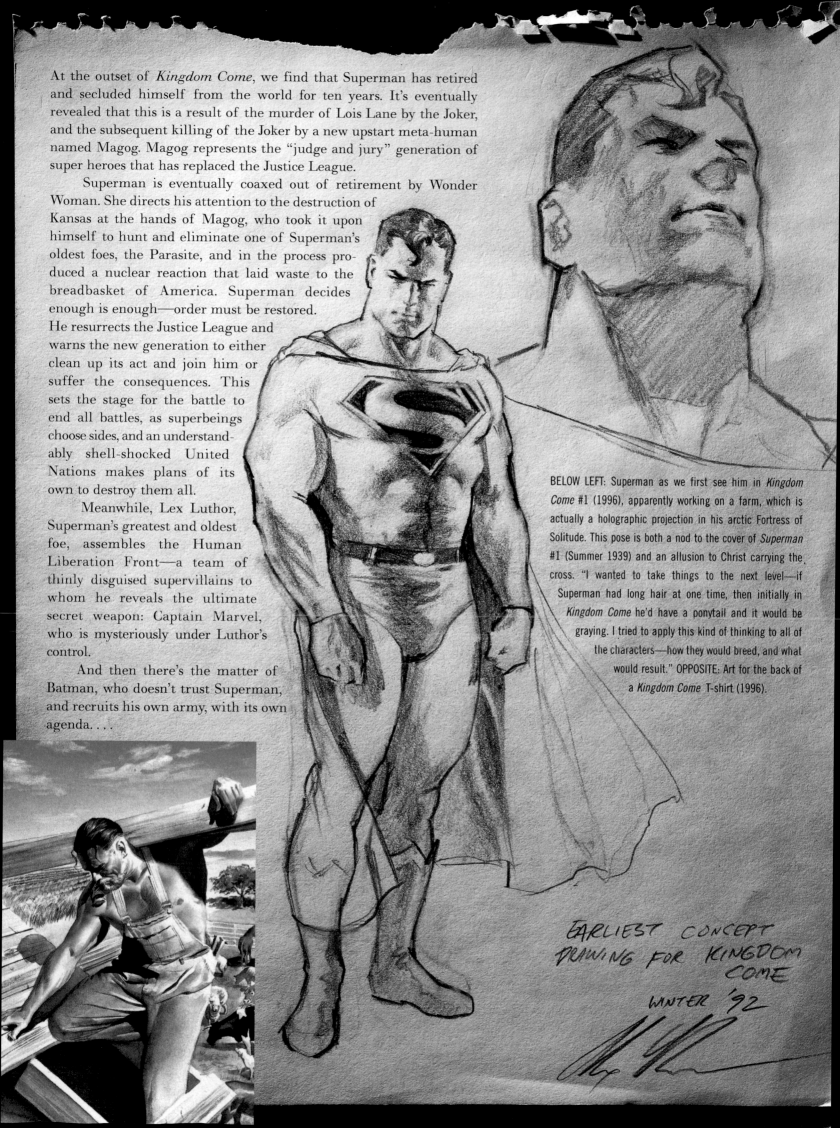

At the outset of *Kingdom Come*, we find that Superman has retired and secluded himself from the world for ten years. It's eventually revealed that this is a result of the murder of Lois Lane by the Joker, and the subsequent killing of the Joker by a new upstart meta-human named Magog. Magog represents the "judge and jury" generation of super heroes that has replaced the Justice League.

Superman is eventually coaxed out of retirement by Wonder Woman. She directs his attention to the destruction of Kansas at the hands of Magog, who took it upon himself to hunt and eliminate one of Superman's oldest foes, the Parasite, and in the process produced a nuclear reaction that laid waste to the breadbasket of America. Superman decides enough is enough—order must be restored. He resurrects the Justice League and warns the new generation to either clean up its act and join him or suffer the consequences. This sets the stage for the battle to end all battles, as superbeings choose sides, and an understandably shell-shocked United Nations makes plans of its own to destroy them all.

Meanwhile, Lex Luthor, Superman's greatest and oldest foe, assembles the Human Liberation Front—a team of thinly disguised supervillains to whom he reveals the ultimate secret weapon: Captain Marvel, who is mysteriously under Luthor's control.

And then there's the matter of Batman, who doesn't trust Superman, and recruits his own army, with its own agenda. . . .

BELOW LEFT: Superman as we first see him in *Kingdom Come* #1 (1996), apparently working on a farm, which is actually a holographic projection in his arctic Fortress of Solitude. This pose is both a nod to the cover of *Superman* #1 (Summer 1939) and an allusion to Christ carrying the cross. "I wanted to take things to the next level—if Superman had long hair at one time, then initially in *Kingdom Come* he'd have a ponytail and it would be graying. I tried to apply this kind of thinking to all of the characters—how they would breed, and what would result." OPPOSITE: Art for the back of a *Kingdom Come* T-shirt (1996).

EARLIEST CONCEPT
DRAWING FOR KINGDOM
COME
WINTER '92

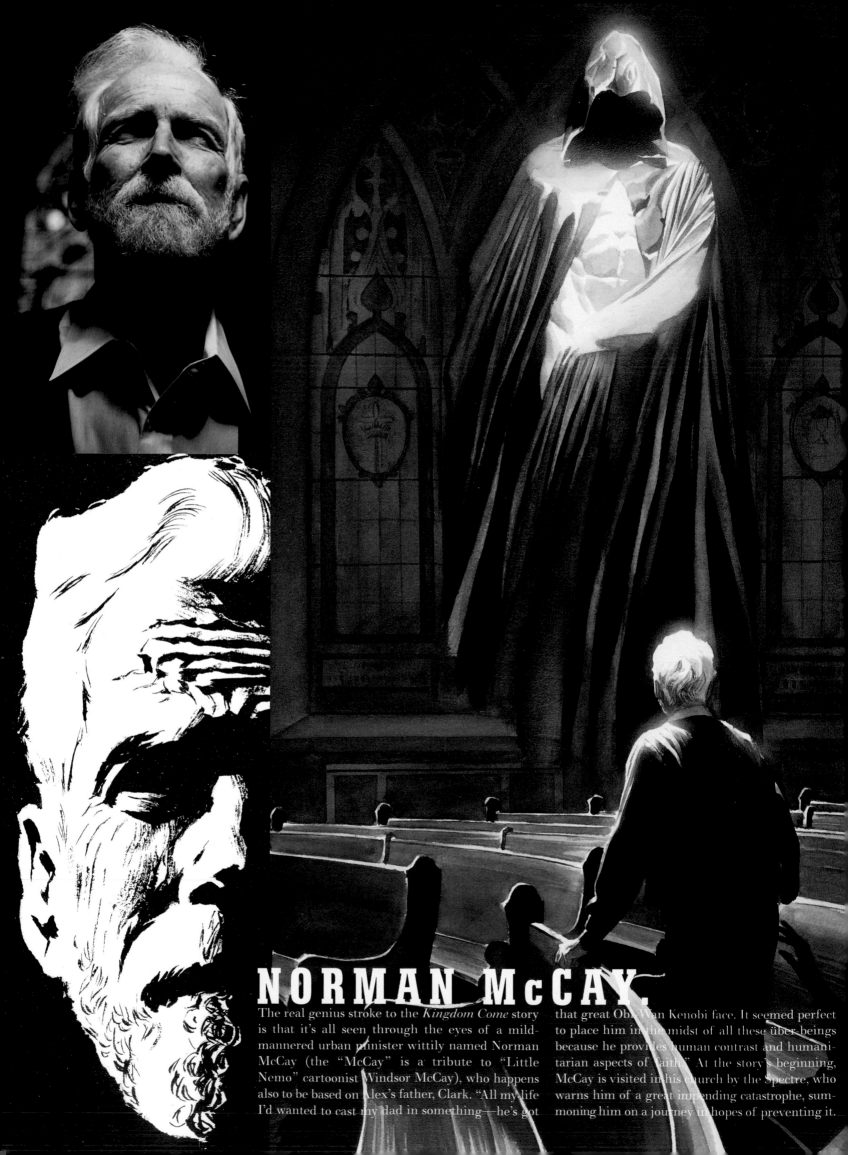

NORMAN McCAY.

The real genius stroke to the *Kingdom Come* story is that it's all seen through the eyes of a mild-mannered urban minister wittily named Norman McCay (the "McCay" is a tribute to "Little Nemo" cartoonist Windsor McCay), who happens also to be based on Alex's father, Clark. "All my life I'd wanted to cast my dad in something—he's got that great Obi-Wan Kenobi face. It seemed perfect to place him in the midst of all these über-beings because he provides human contrast and humanitarian aspects of faith." At the story's beginning, McCay is visited in his church by the Spectre, who warns him of a great impending catastrophe, summoning him on a journey in hopes of preventing it.

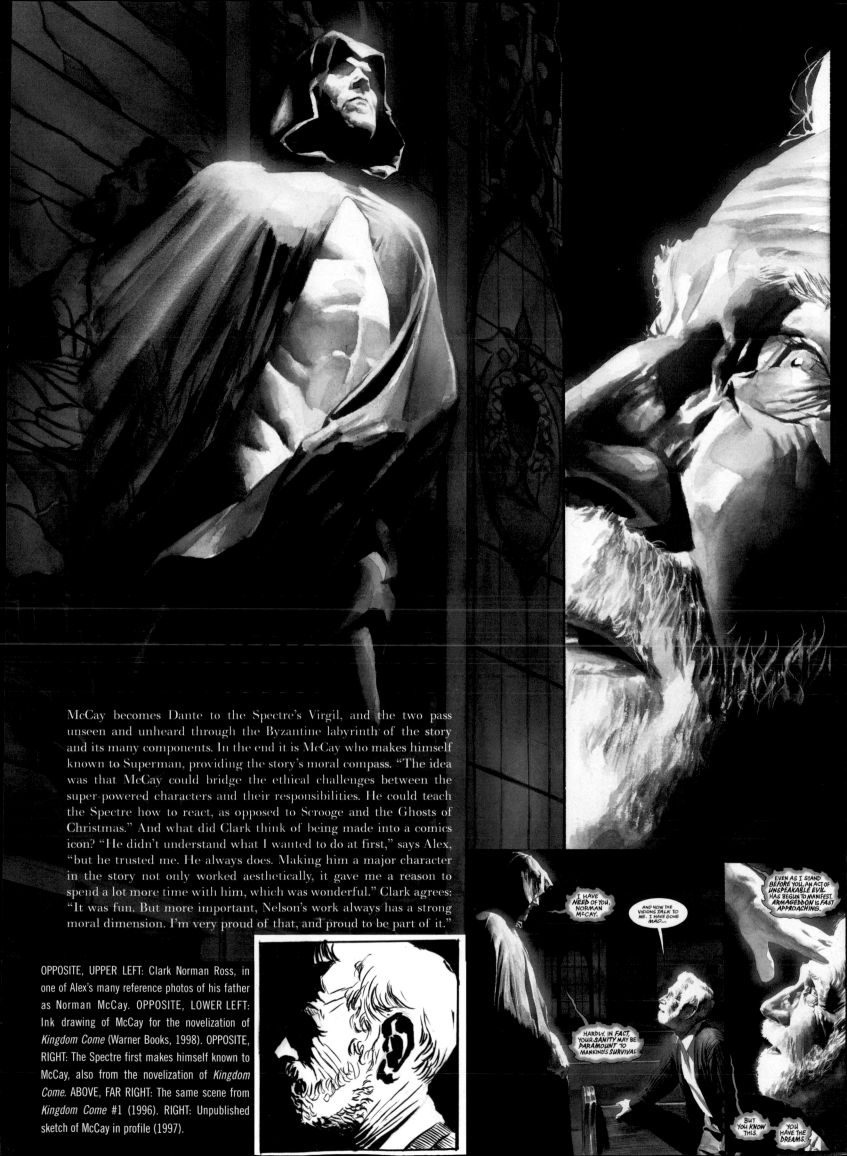

McCay becomes Dante to the Spectre's Virgil, and the two pass unseen and unheard through the Byzantine labyrinth of the story and its many components. In the end it is McCay who makes himself known to Superman, providing the story's moral compass. "The idea was that McCay could bridge the ethical challenges between the super-powered characters and their responsibilities. He could teach the Spectre how to react, as opposed to Scrooge and the Ghosts of Christmas." And what did Clark think of being made into a comics icon? "He didn't understand what I wanted to do at first," says Alex, "but he trusted me. He always does. Making him a major character in the story not only worked aesthetically, it gave me a reason to spend a lot more time with him, which was wonderful." Clark agrees: "It was fun. But more important, Nelson's work always has a strong moral dimension. I'm very proud of that, and proud to be part of it."

OPPOSITE, UPPER LEFT: Clark Norman Ross, in one of Alex's many reference photos of his father as Norman McCay. OPPOSITE, LOWER LEFT: Ink drawing of McCay for the novelization of *Kingdom Come* (Warner Books, 1998). OPPOSITE, RIGHT: The Spectre first makes himself known to McCay, also from the novelization of *Kingdom Come*. ABOVE, FAR RIGHT: The same scene from *Kingdom Come* #1 (1996). RIGHT: Unpublished sketch of McCay in profile (1997).

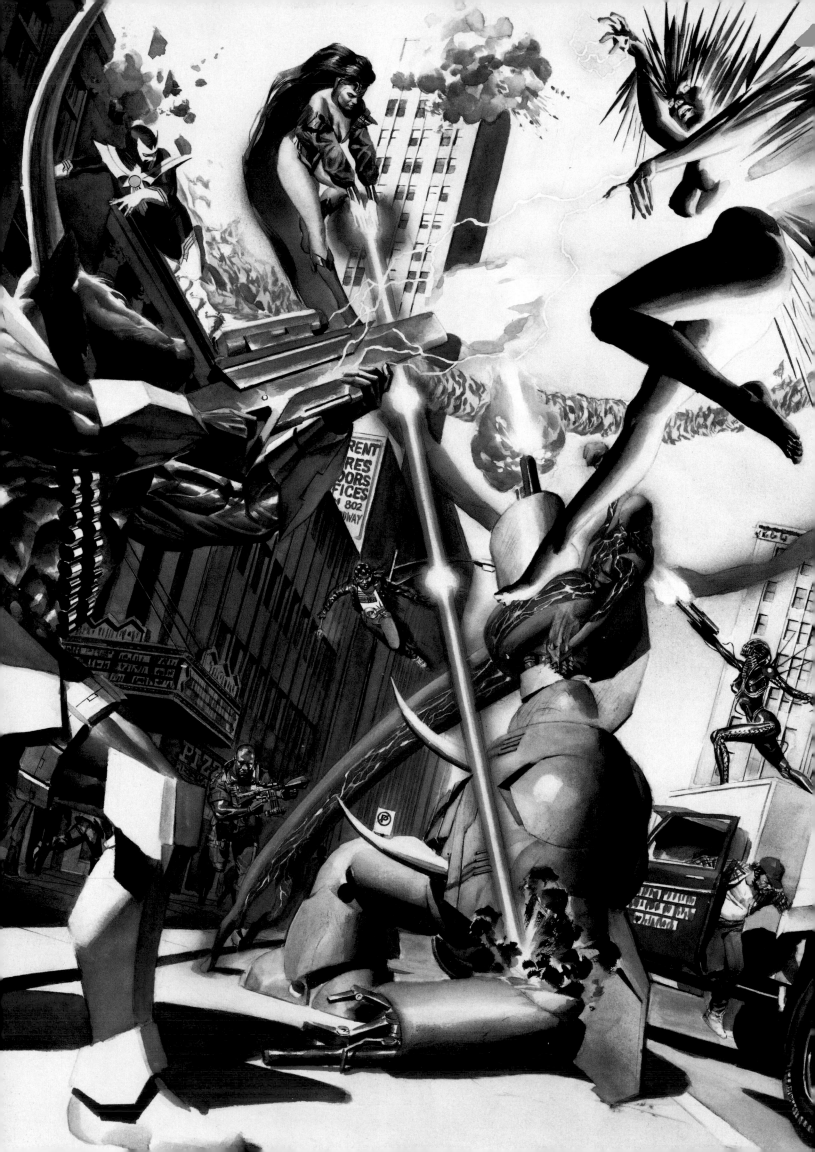

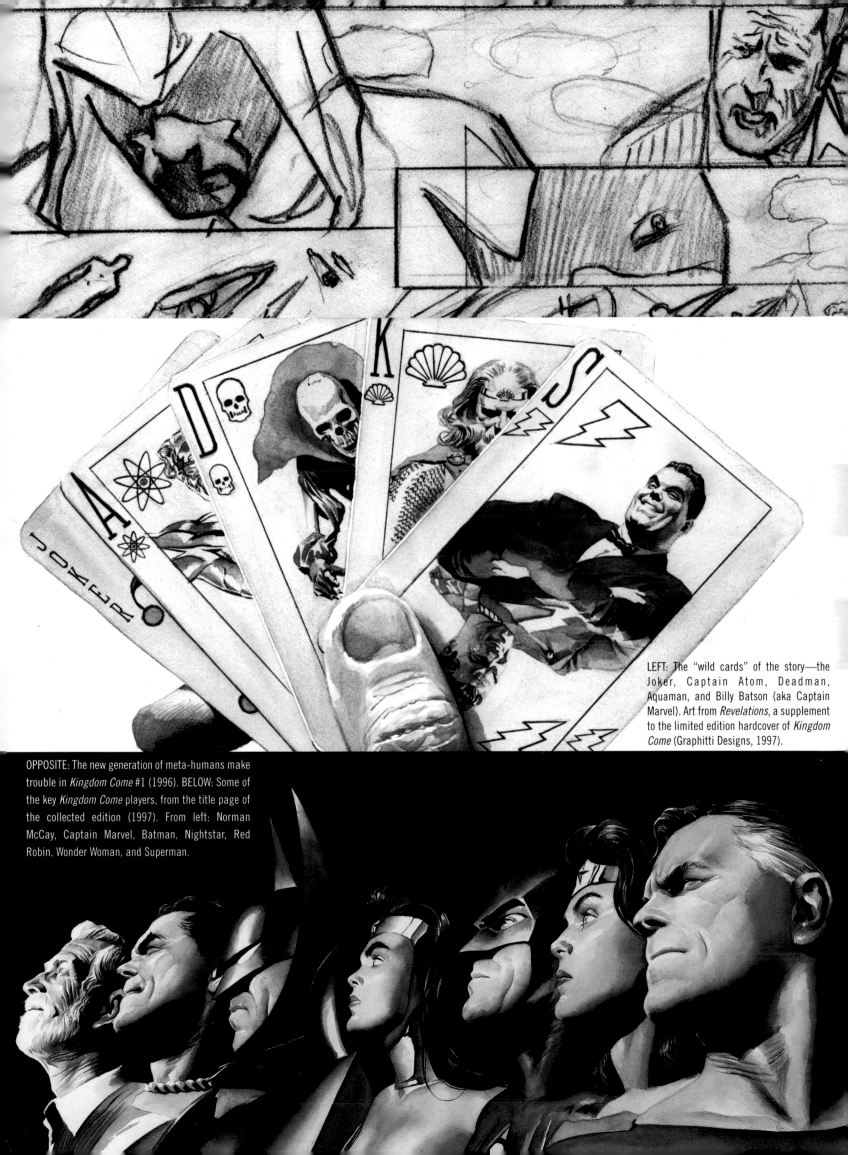

LEFT: The "wild cards" of the story—the Joker, Captain Atom, Deadman, Aquaman, and Billy Batson (aka Captain Marvel). Art from *Revelations*, a supplement to the limited edition hardcover of *Kingdom Come* (Graphitti Designs, 1997).

OPPOSITE: The new generation of meta-humans make trouble in *Kingdom Come* #1 (1996). BELOW: Some of the key *Kingdom Come* players, from the title page of the collected edition (1997). From left: Norman McCay, Captain Marvel, Batman, Nightstar, Red Robin, Wonder Woman, and Superman.

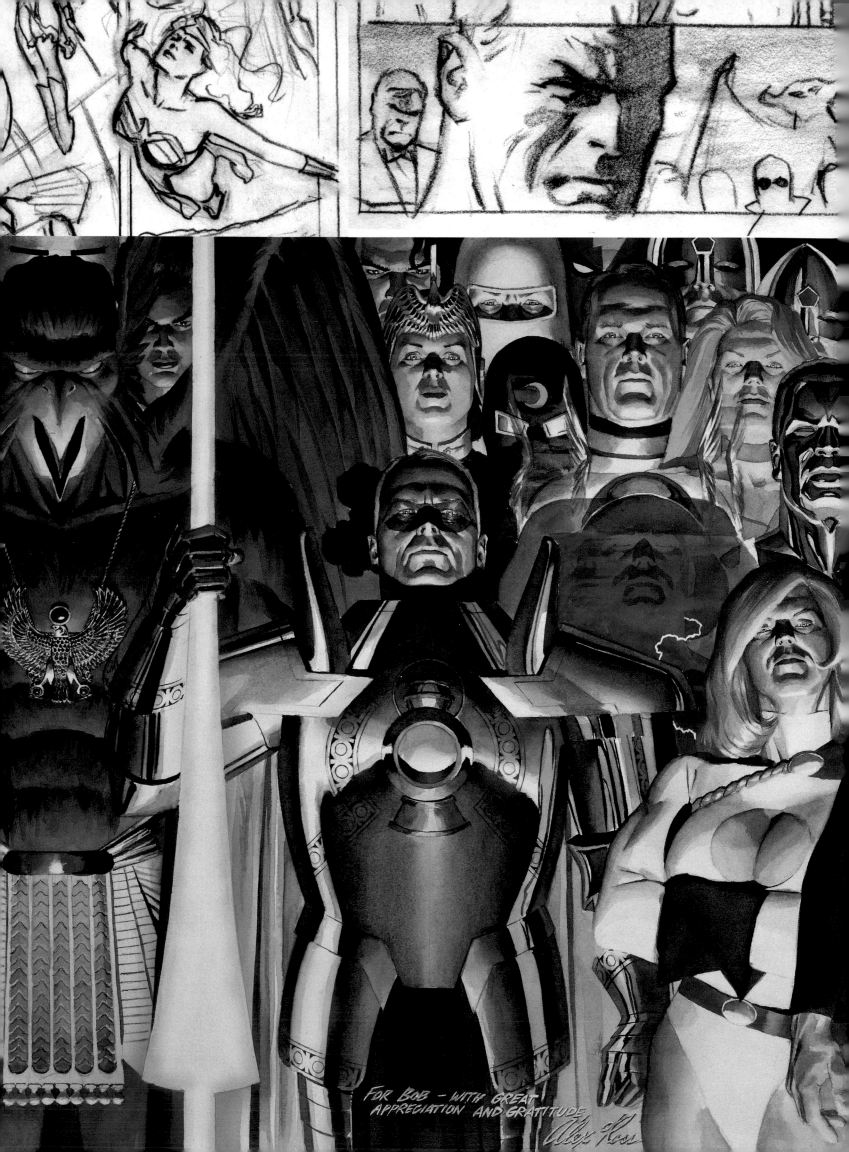

For Bob — with great appreciation and gratitude

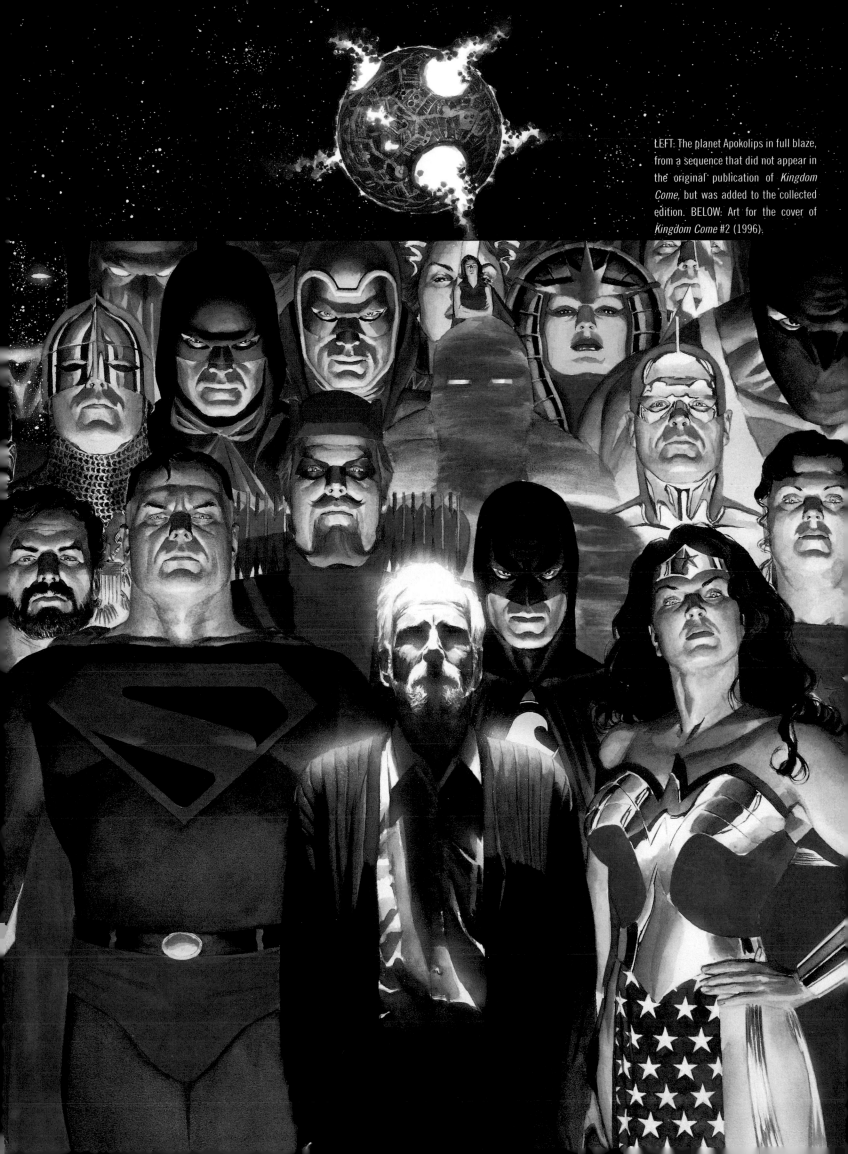

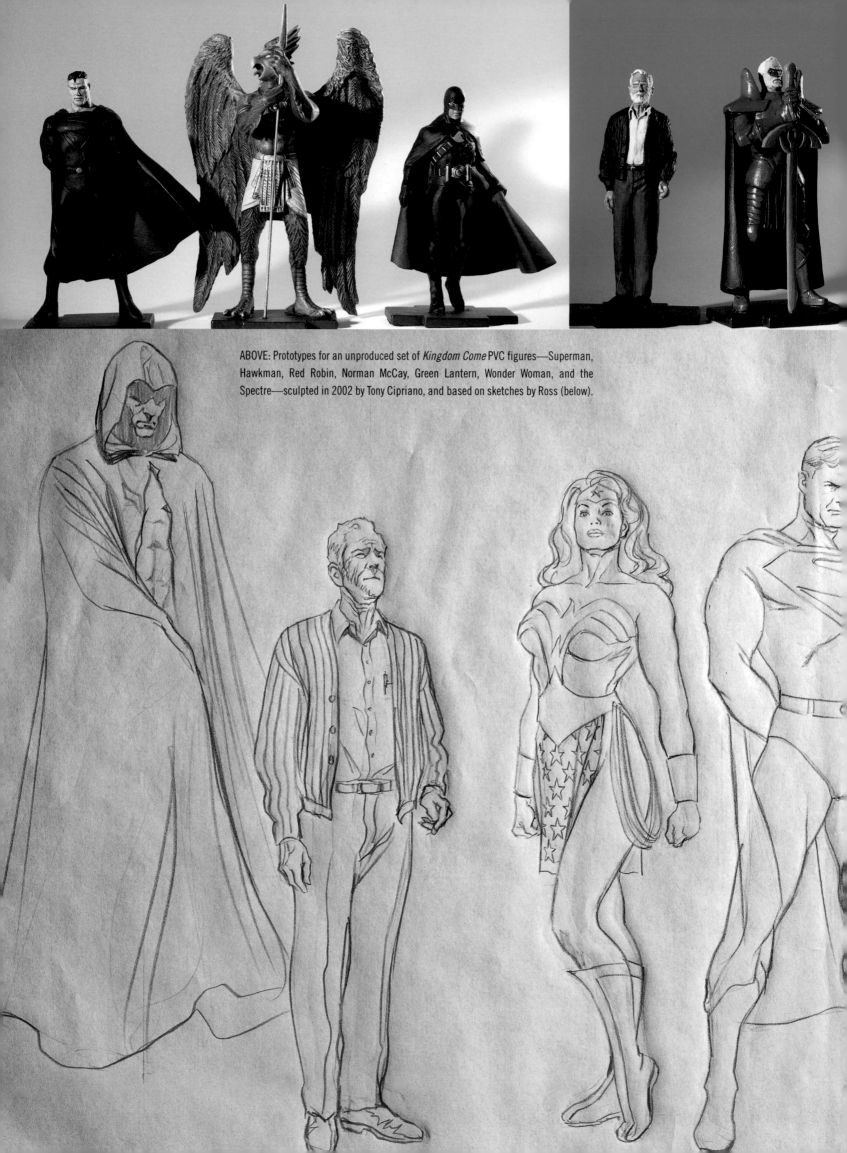

ABOVE: Prototypes for an unproduced set of *Kingdom Come* PVC figures—Superman, Hawkman, Red Robin, Norman McCay, Green Lantern, Wonder Woman, and the Spectre—sculpted in 2002 by Tony Cipriano, and based on sketches by Ross (below).

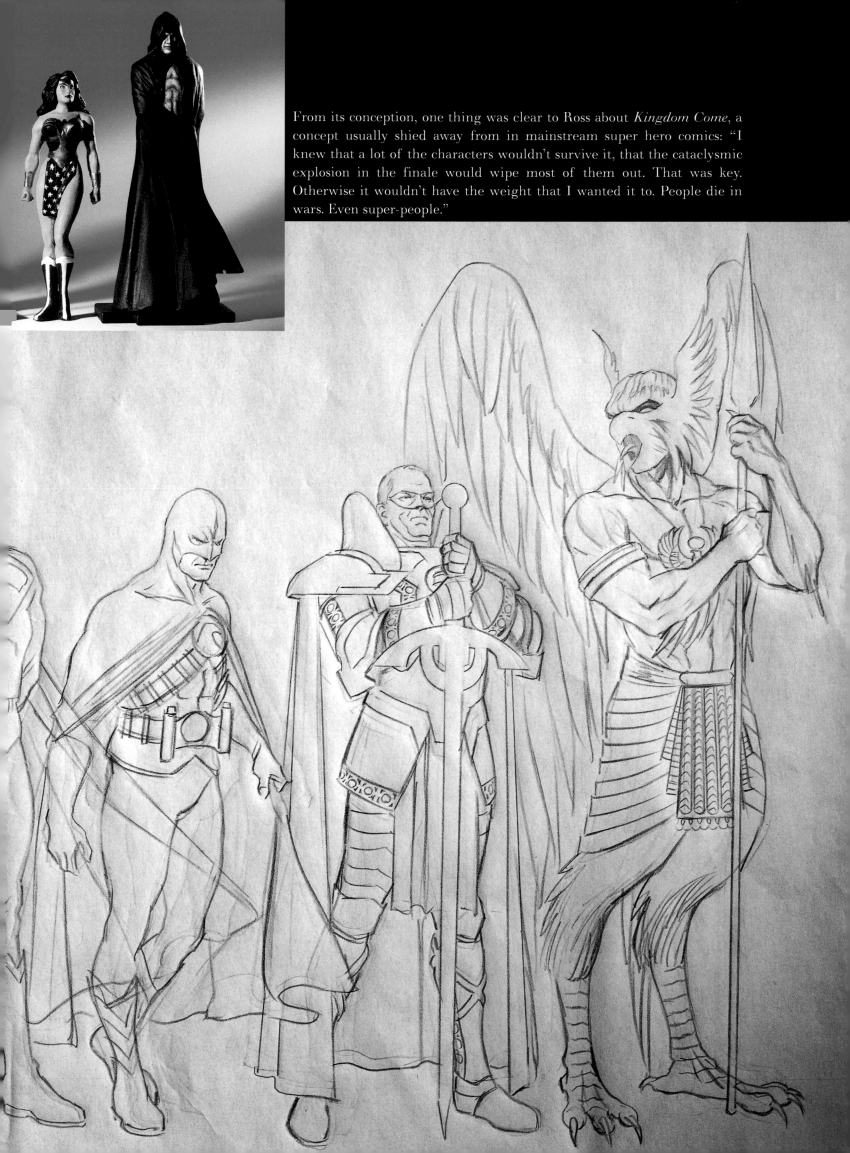

From its conception, one thing was clear to Ross about *Kingdom Come*, a concept usually shied away from in mainstream super hero comics: "I knew that a lot of the characters wouldn't survive it, that the cataclysmic explosion in the finale would wipe most of them out. That was key. Otherwise it wouldn't have the weight that I wanted it to. People die in wars. Even super-people."

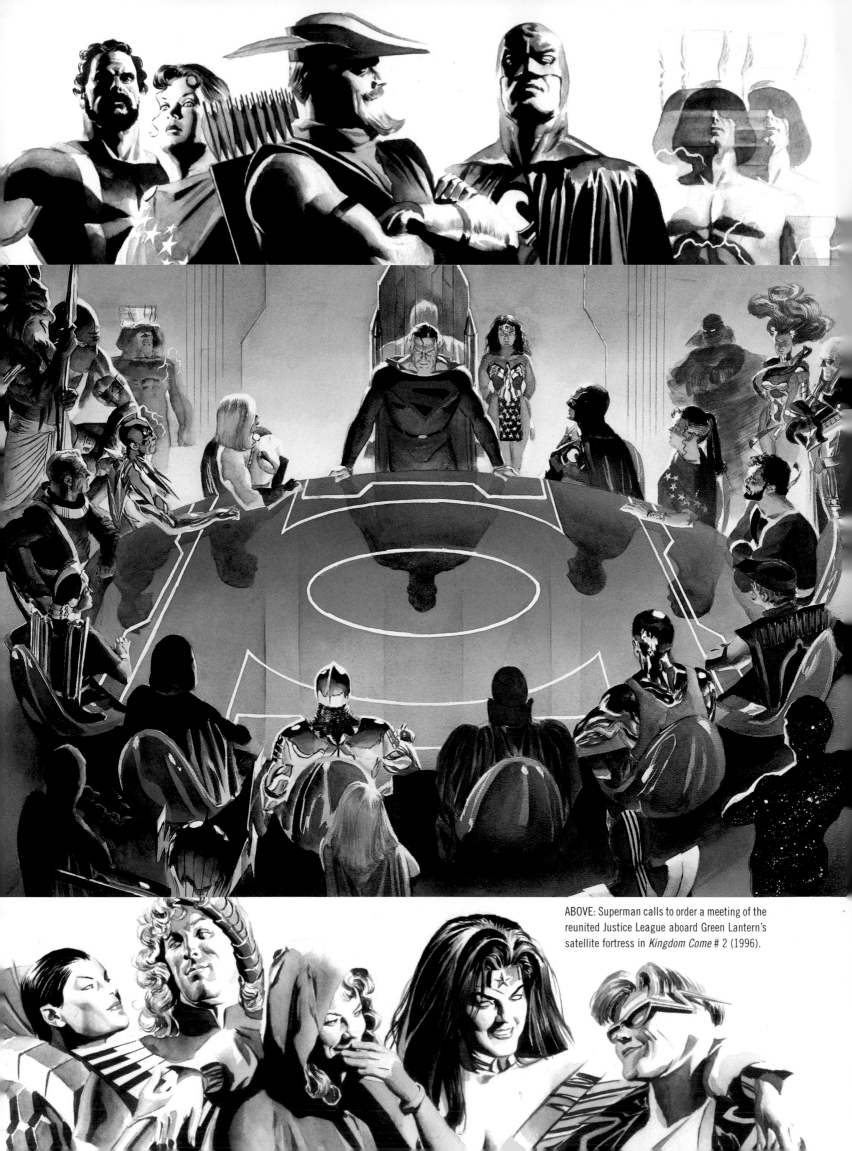

ABOVE: Superman calls to order a meeting of the reunited Justice League aboard Green Lantern's satellite fortress in *Kingdom Come* # 2 (1996).

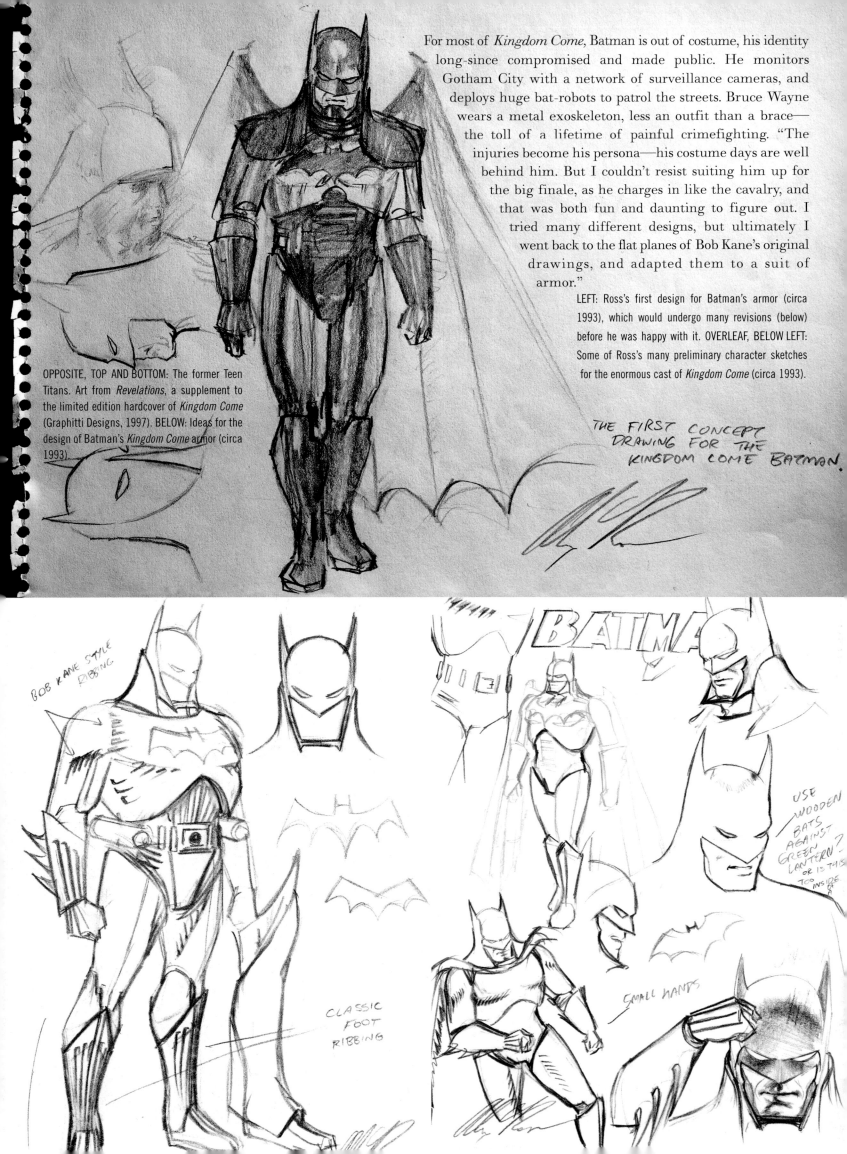

For most of *Kingdom Come*, Batman is out of costume, his identity long-since compromised and made public. He monitors Gotham City with a network of surveillance cameras, and deploys huge bat-robots to patrol the streets. Bruce Wayne wears a metal exoskeleton, less an outfit than a brace—the toll of a lifetime of painful crimefighting. "The injuries become his persona—his costume days are well behind him. But I couldn't resist suiting him up for the big finale, as he charges in like the cavalry, and that was both fun and daunting to figure out. I tried many different designs, but ultimately I went back to the flat planes of Bob Kane's original drawings, and adapted them to a suit of armor."

LEFT: Ross's first design for Batman's armor (circa 1993), which would undergo many revisions (below) before he was happy with it. OVERLEAF, BELOW LEFT: Some of Ross's many preliminary character sketches for the enormous cast of *Kingdom Come* (circa 1993).

OPPOSITE, TOP AND BOTTOM: The former Teen Titans. Art from *Revelations*, a supplement to the limited edition hardcover of *Kingdom Come* (Graphitti Designs, 1997). BELOW: Ideas for the design of Batman's *Kingdom Come* armor (circa 1993).

THE FIRST CONCEPT DRAWING FOR THE KINGDOM COME BATMAN.

BOB KANE STYLE RIBBING

CLASSIC FOOT RIBBING

BATMAN

USE WOODEN BATS AGAINST GREEN LANTERN? OR IS THIS TOO INSIDE

SMALL HANDS

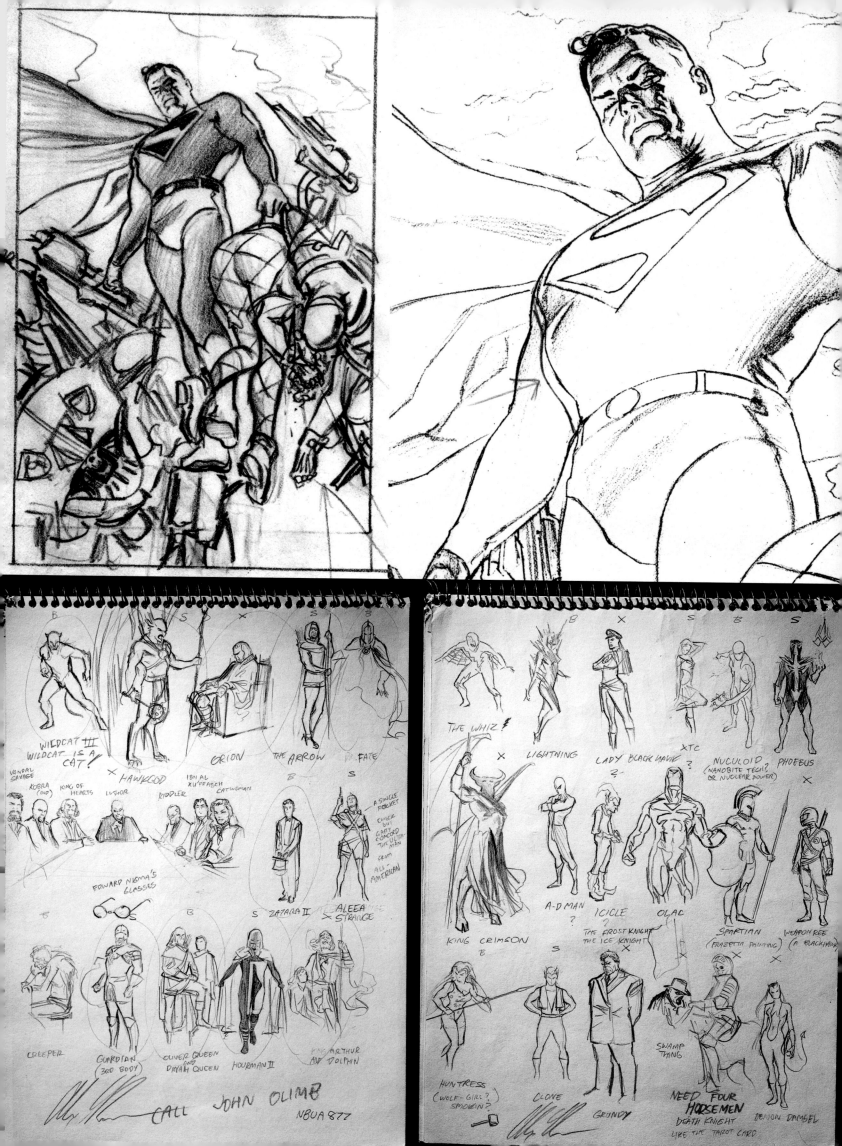

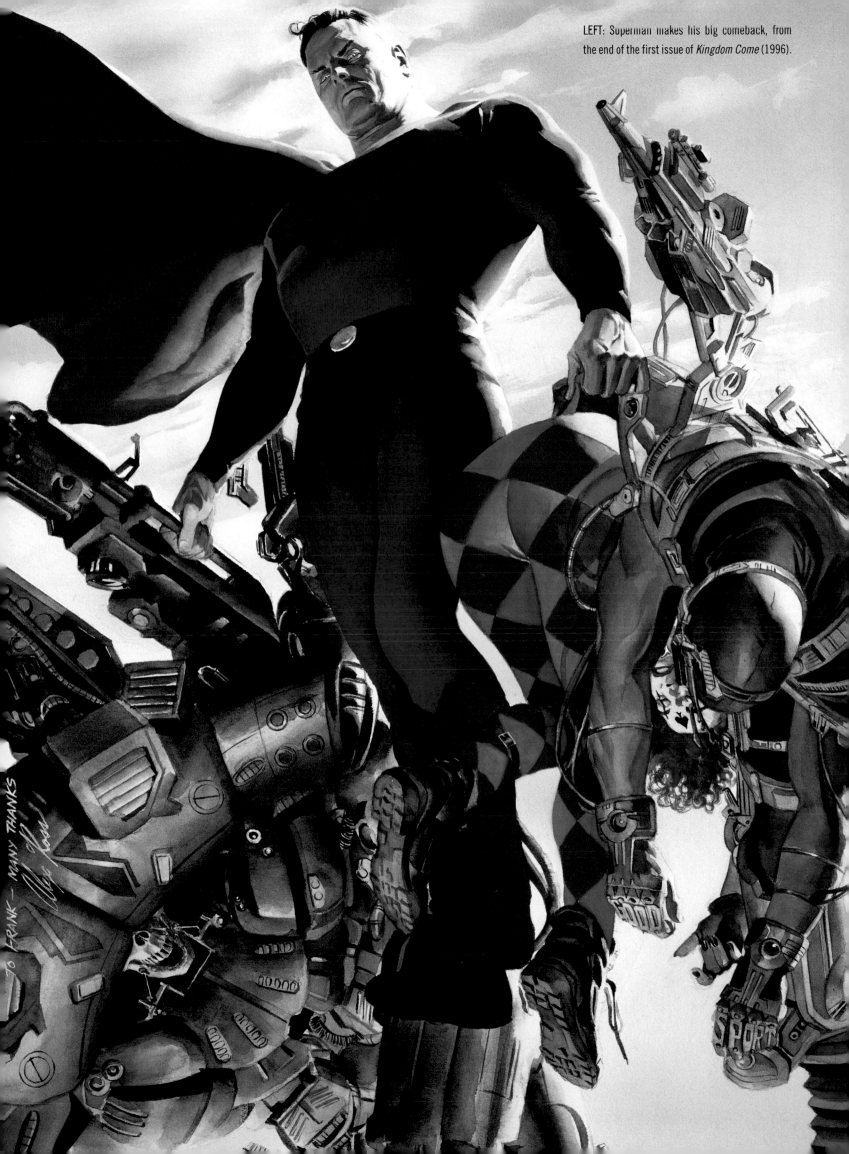

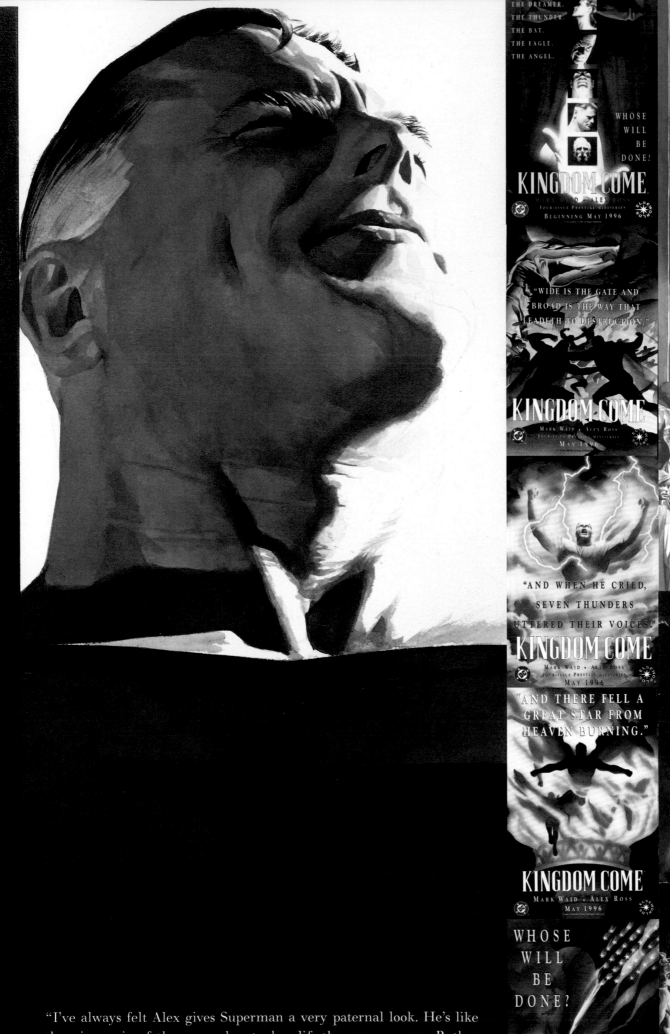

"I've always felt Alex gives Superman a very paternal look. He's like the wise, caring father we seek out when life throws us a curve. Rather than simply solving the problem for us, Alex's Superman, like any good parent, encourages us to find the answers for ourselves." —Paul Dini

OPPOSITE, LEFT: Art from *Revelations*, a supplement to the limited edition hardcover of *Kingdom Come* (Graphitti Designs, 1997). OPPOSITE, CENTER: Trade advertisements for *Kingdom Come* (1996). OPPOSITE, UPPER RIGHT: The reunited Justice League, led by Superman, also from *Revelations*.

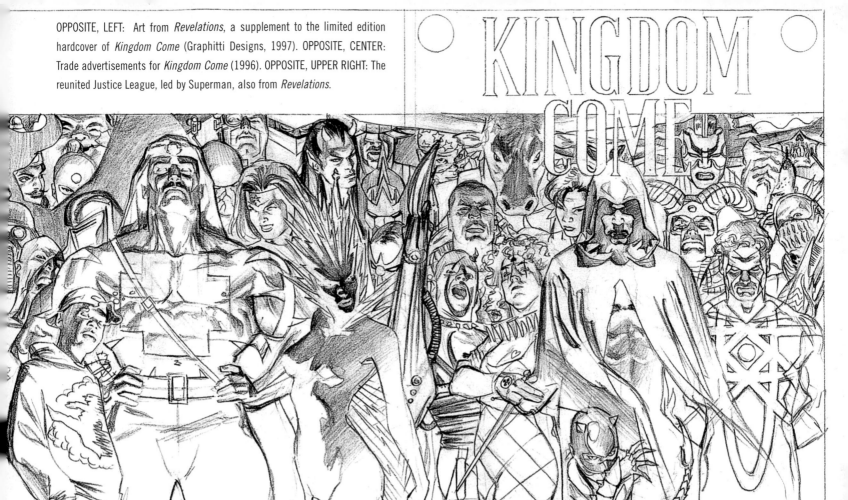

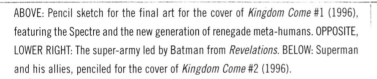

ABOVE: Pencil sketch for the final art for the cover of *Kingdom Come* #1 (1996), featuring the Spectre and the new generation of renegade meta-humans. OPPOSITE, LOWER RIGHT: The super-army led by Batman from *Revelations*. BELOW: Superman and his allies, penciled for the cover of *Kingdom Come* #2 (1996).

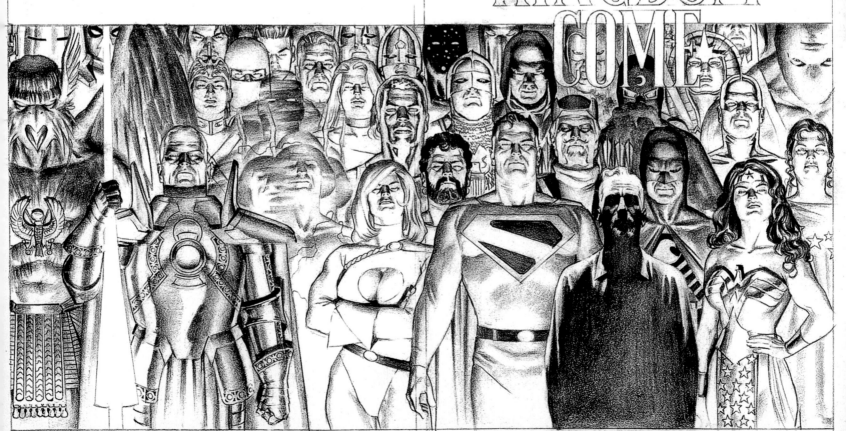

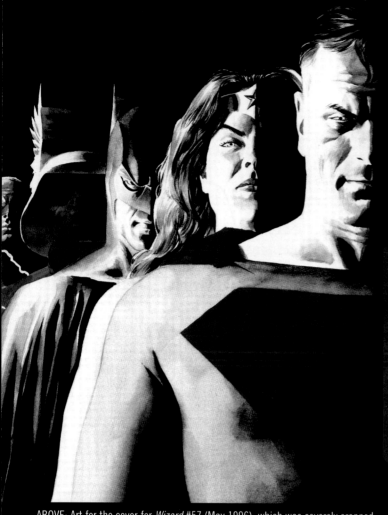

ABOVE: Art for the cover for *Wizard* #57 (May 1996), which was severely cropped for publication. The figure behind Wonder Woman is actually Robin, though the Flash's left "wing" behind his head makes him appear to be Batman. ABOVE, RIGHT: Art for the cover of *Overstreet's Fan* #14 (August 1996).

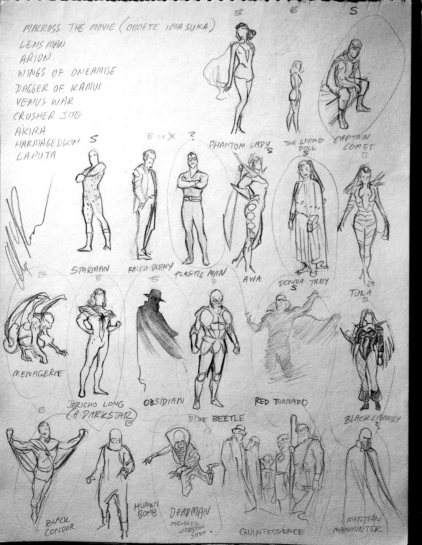

MACROSS THE MOVIE (OOOETE IMA SUKA)
LENS MAN
ARION
WINGS OF ONEAMISE
DAGGER OF KAMUI
VENUS WAR
CRUSHER JOE
AKIRA
HARMAGEDDON
LAPUTA

PHANTOM LADY
THE LIVING DOLL
CAPTAIN COMET
STARMAN
RALPH TAENY
PLASTIC MAN
AVIA
DONNA TROY
TULA
MENAGERIE
JERICHO LONG (A DARKSTAR)
OBSIDIAN
BLUE BEETLE
RED TORNADO
BLACK CANARY
BLACK CONDOR
HUMAN BOMB
DEADMAN MICHAEL JORDON SHOT.
QUINTESSENCE
MARTIAN MANHUNTER

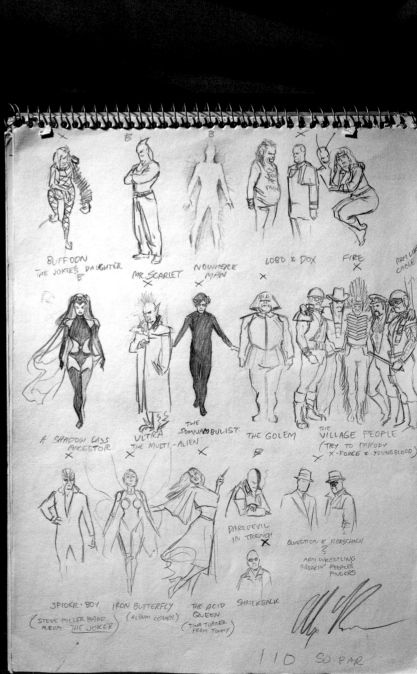

BUFFOON THE JOKER'S DAUGHTER
MR. SCARLET
NOWHERE MAN
LOBO & DOX
FIRE
ARM WR... CABLE
A SHADOW LASS ANCESTOR
ULTRA THE MULTI-ALIEN
THE SOMNAMBULIST
THE GOLEM
THE VILLAGE PEOPLE (TRY TO PARODY X-FORCE & YOUNGBLOOD)
DAREDEVIL IN TRENCH
QUESTION & RORSCHACH ARM WRESTLING BREAKIN' PEOPLES FINGERS
SPIDER-BOY (STEVE MILLER BAND ALBUM THE JOKER)
IRON BUTTERFLY (ALBUM COVER)
THE ACID QUEEN (TINA TURNER FROM TOMMY)
SHRIEKBACK

110 SO FAR

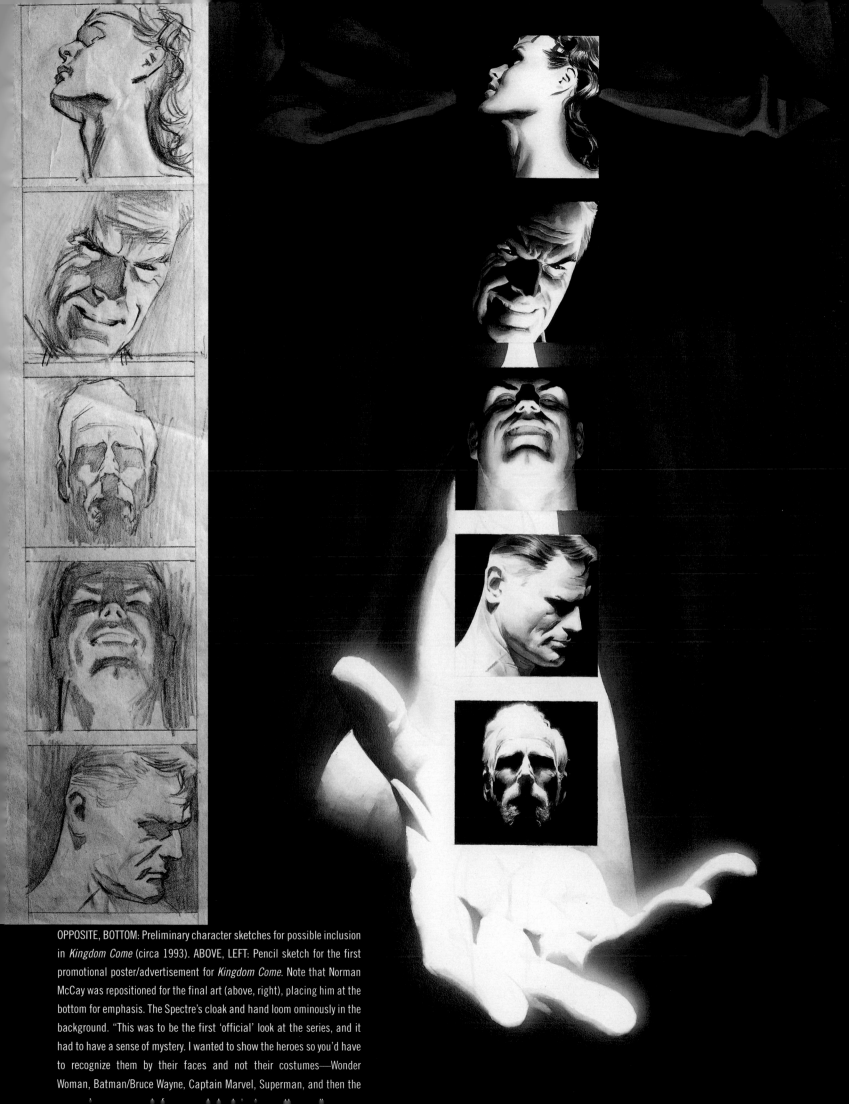

OPPOSITE, BOTTOM: Preliminary character sketches for possible inclusion in *Kingdom Come* (circa 1993). ABOVE, LEFT: Pencil sketch for the first promotional poster/advertisement for *Kingdom Come*. Note that Norman McCay was repositioned for the final art (above, right), placing him at the bottom for emphasis. The Spectre's cloak and hand loom ominously in the background. "This was to be the first 'official' look at the series, and it had to have a sense of mystery. I wanted to show the heroes so you'd have to recognize them by their faces and not their costumes—Wonder Woman, Batman/Bruce Wayne, Captain Marvel, Superman, and then the

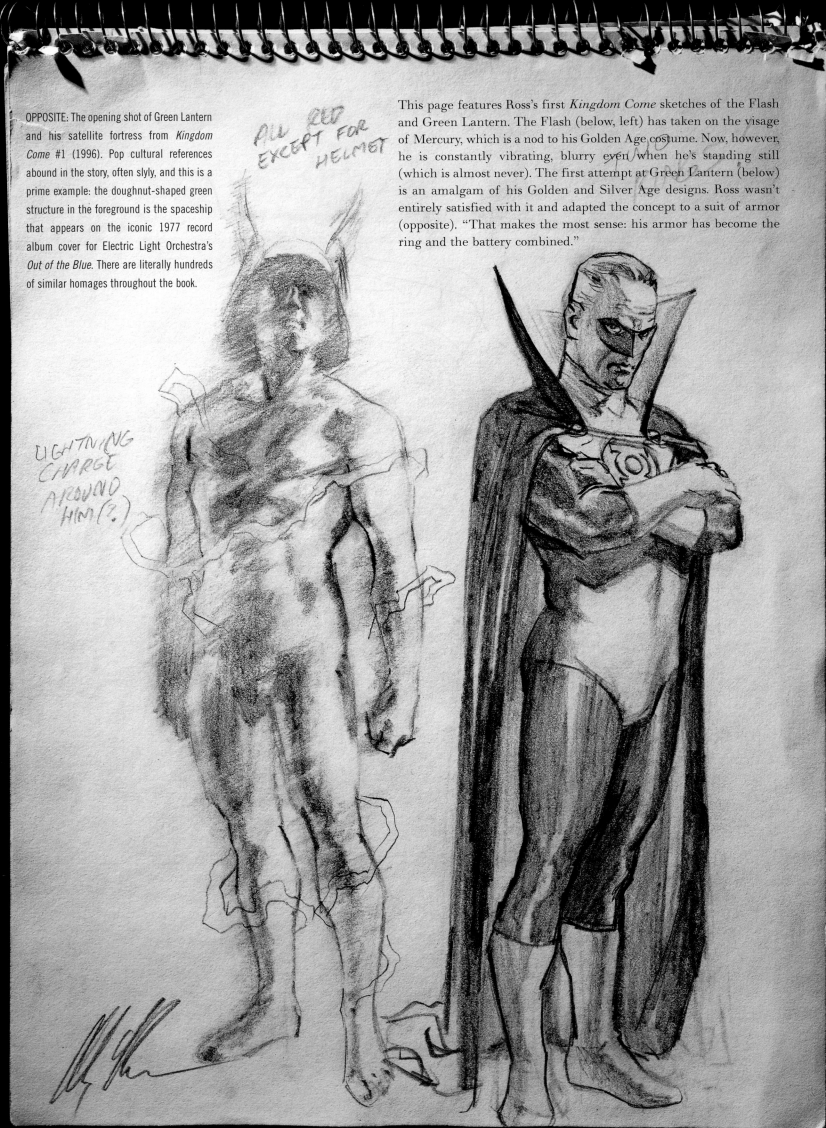

OPPOSITE: The opening shot of Green Lantern and his satellite fortress from *Kingdom Come* #1 (1996). Pop cultural references abound in the story, often slyly, and this is a prime example: the doughnut-shaped green structure in the foreground is the spaceship that appears on the iconic 1977 record album cover for Electric Light Orchestra's *Out of the Blue*. There are literally hundreds of similar homages throughout the book.

This page features Ross's first *Kingdom Come* sketches of the Flash and Green Lantern. The Flash (below, left) has taken on the visage of Mercury, which is a nod to his Golden Age costume. Now, however, he is constantly vibrating, blurry even when he's standing still (which is almost never). The first attempt at Green Lantern (below) is an amalgam of his Golden and Silver Age designs. Ross wasn't entirely satisfied with it and adapted the concept to a suit of armor (opposite). "That makes the most sense: his armor has become the ring and the battery combined."

ALL RED EXCEPT FOR HELMET

LIGHTNING CHARGE AROUND HIM (?)

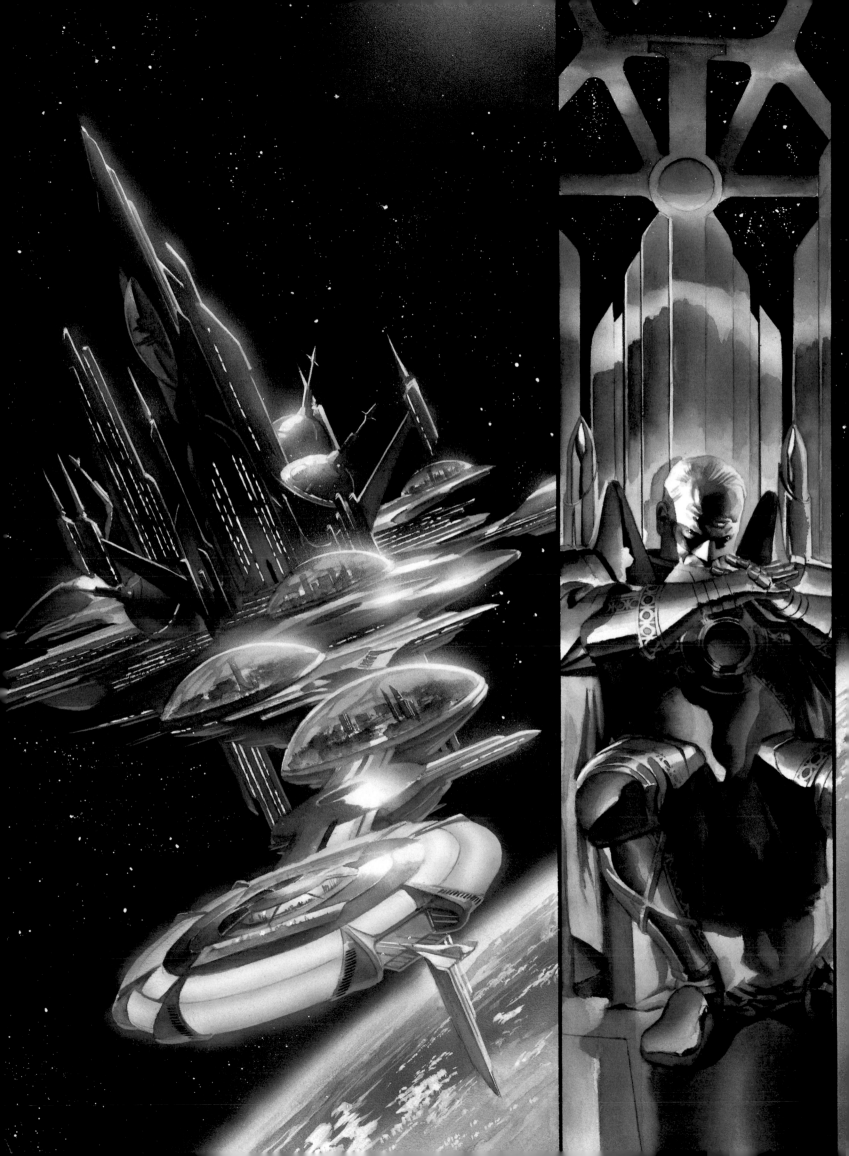

THE GREEN
KNIGHT

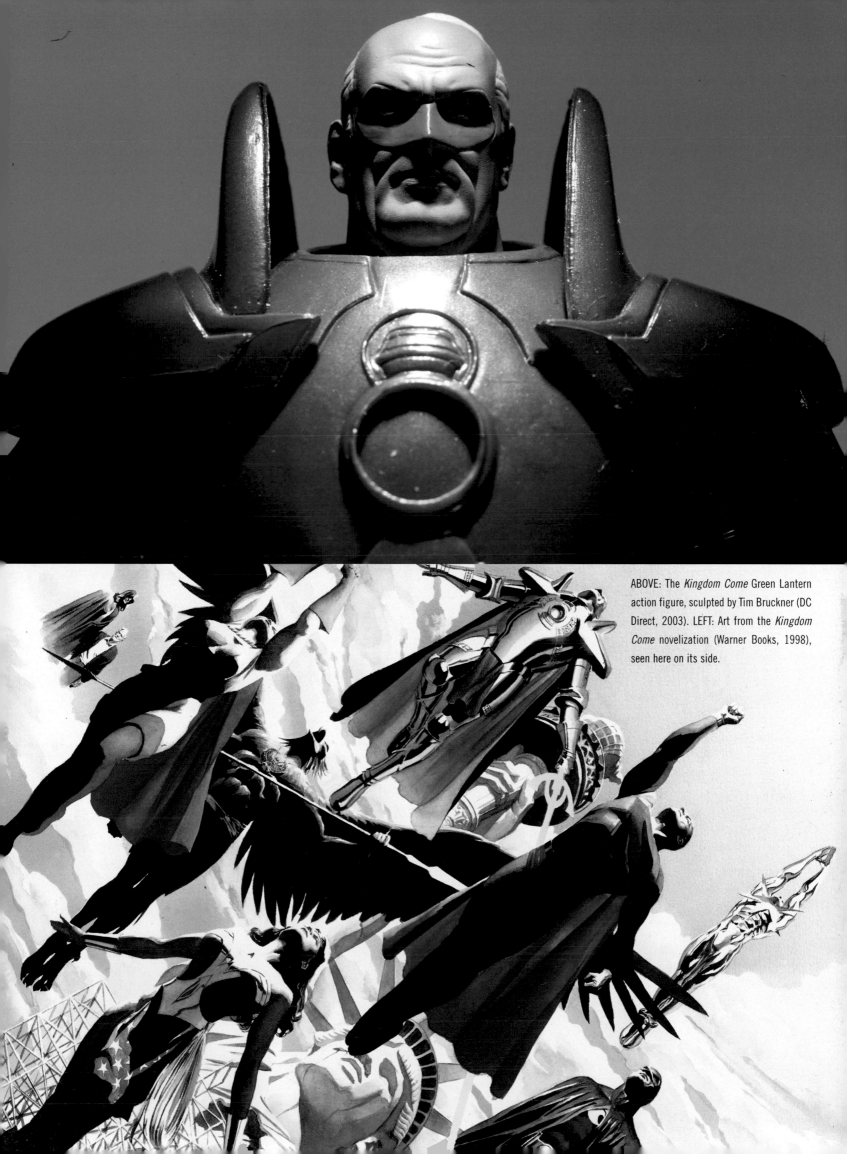

ABOVE: The *Kingdom Come* Green Lantern action figure, sculpted by Tim Bruckner (DC Direct, 2003). LEFT: Art from the *Kingdom Come* novelization (Warner Books, 1998), seen here on its side.

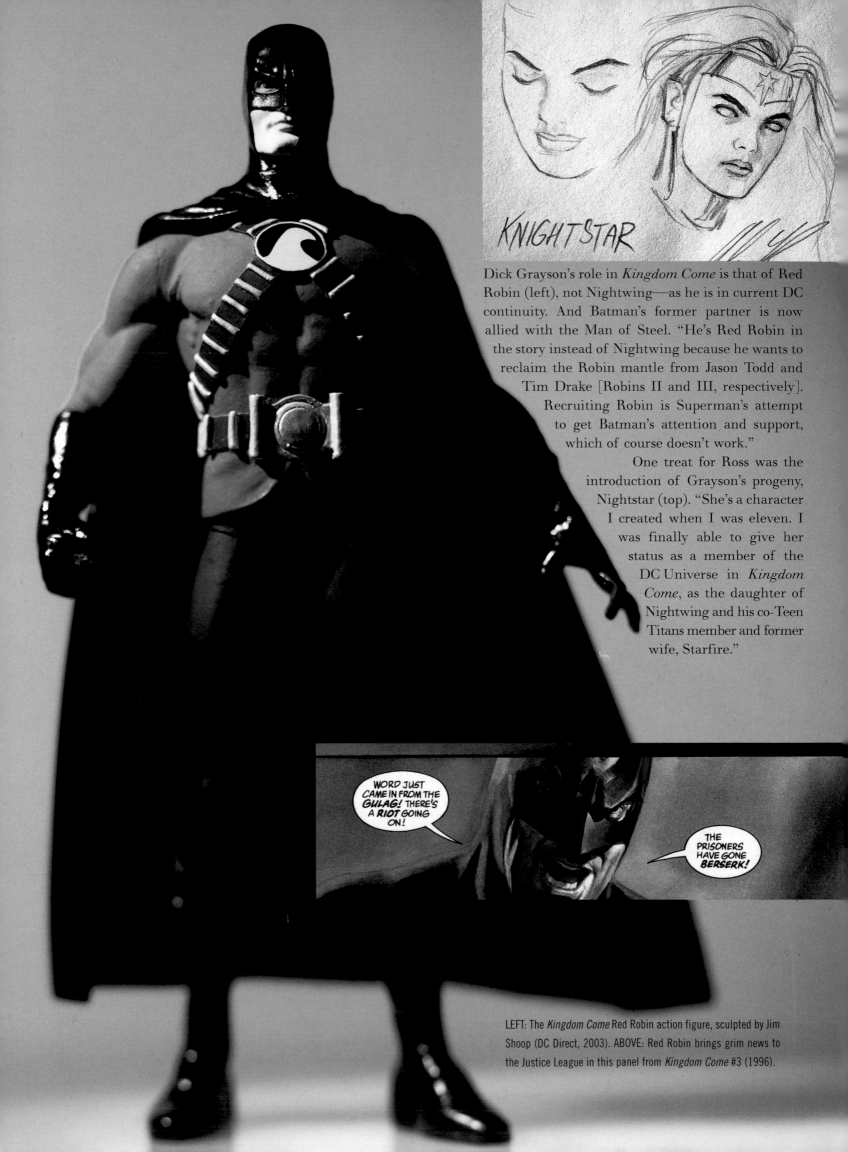

KNIGHTSTAR

Dick Grayson's role in *Kingdom Come* is that of Red Robin (left), not Nightwing—as he is in current DC continuity. And Batman's former partner is now allied with the Man of Steel. "He's Red Robin in the story instead of Nightwing because he wants to reclaim the Robin mantle from Jason Todd and Tim Drake [Robins II and III, respectively]. Recruiting Robin is Superman's attempt to get Batman's attention and support, which of course doesn't work."

One treat for Ross was the introduction of Grayson's progeny, Nightstar (top). "She's a character I created when I was eleven. I was finally able to give her status as a member of the DC Universe in *Kingdom Come*, as the daughter of Nightwing and his co-Teen Titans member and former wife, Starfire."

WORD JUST CAME IN FROM THE **GULAG!** THERE'S A **RIOT** GOING ON!

THE PRISONERS HAVE GONE **BERSERK!**

LEFT: The *Kingdom Come* Red Robin action figure, sculpted by Jim Shoop (DC Direct, 2003). ABOVE: Red Robin brings grim news to the Justice League in this panel from *Kingdom Come* #3 (1996).

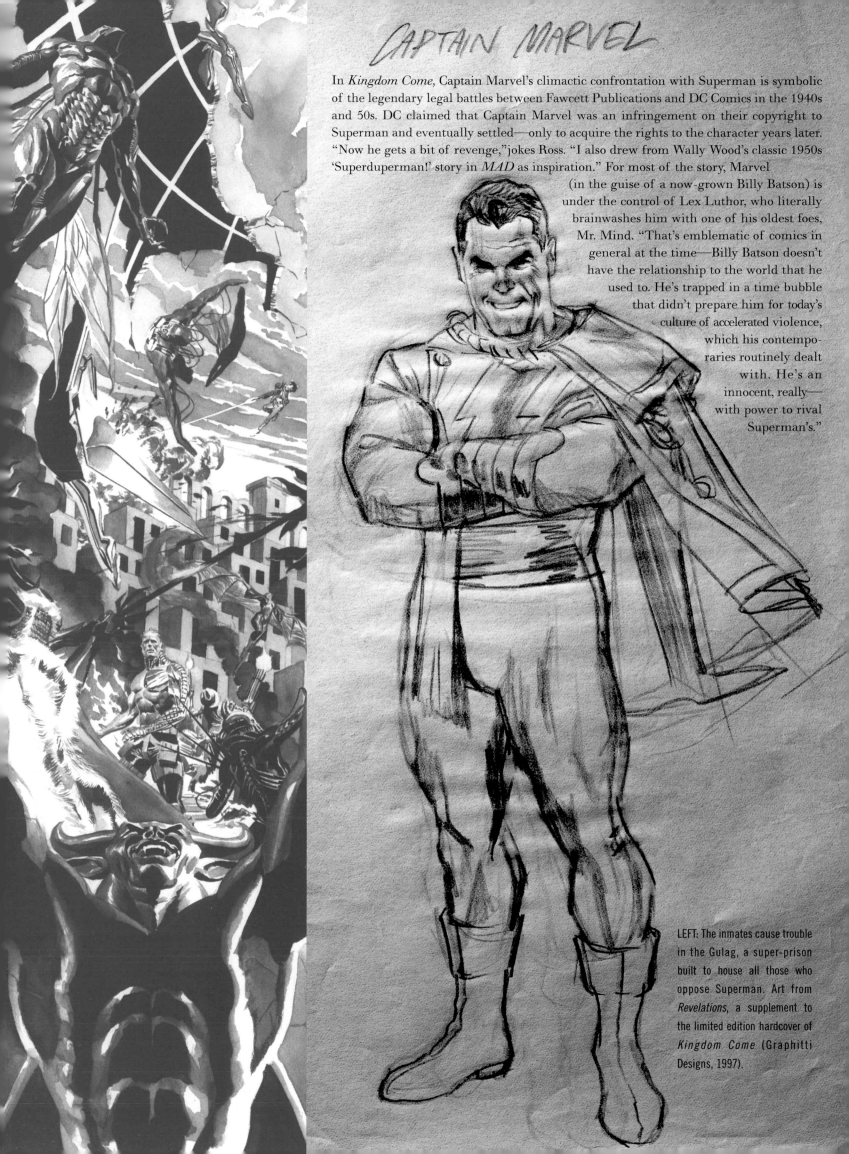

CAPTAIN MARVEL

In *Kingdom Come*, Captain Marvel's climactic confrontation with Superman is symbolic of the legendary legal battles between Fawcett Publications and DC Comics in the 1940s and 50s. DC claimed that Captain Marvel was an infringement on their copyright to Superman and eventually settled—only to acquire the rights to the character years later. "Now he gets a bit of revenge," jokes Ross. "I also drew from Wally Wood's classic 1950s 'Superduperman!' story in *MAD* as inspiration." For most of the story, Marvel (in the guise of a now-grown Billy Batson) is under the control of Lex Luthor, who literally brainwashes him with one of his oldest foes, Mr. Mind. "That's emblematic of comics in general at the time—Billy Batson doesn't have the relationship to the world that he used to. He's trapped in a time bubble that didn't prepare him for today's culture of accelerated violence, which his contemporaries routinely dealt with. He's an innocent, really—with power to rival Superman's."

LEFT: The inmates cause trouble in the Gulag, a super-prison built to house all those who oppose Superman. Art from *Revelations*, a supplement to the limited edition hardcover of *Kingdom Come* (Graphitti Designs, 1997).

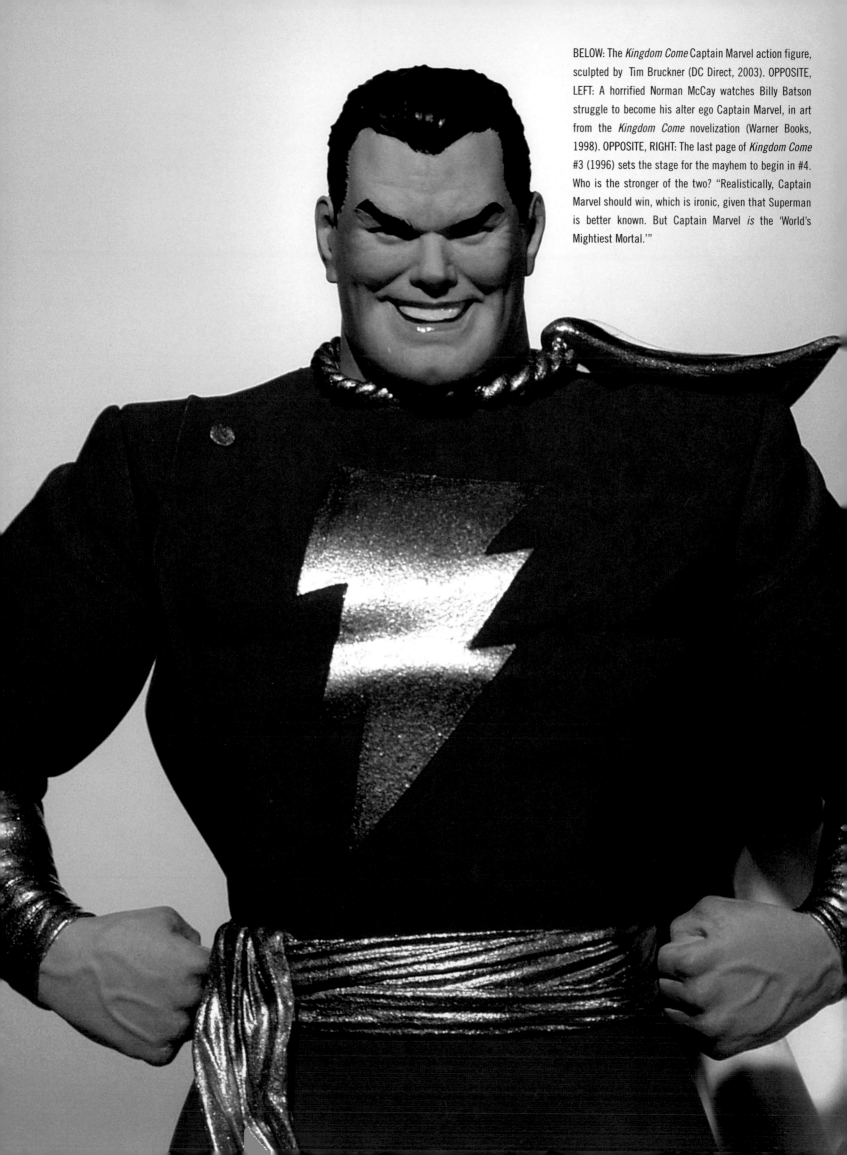

BELOW: The *Kingdom Come* Captain Marvel action figure, sculpted by Tim Bruckner (DC Direct, 2003). OPPOSITE, LEFT: A horrified Norman McCay watches Billy Batson struggle to become his alter ego Captain Marvel, in art from the *Kingdom Come* novelization (Warner Books, 1998). OPPOSITE, RIGHT: The last page of *Kingdom Come* #3 (1996) sets the stage for the mayhem to begin in #4. Who is the stronger of the two? "Realistically, Captain Marvel should win, which is ironic, given that Superman is better known. But Captain Marvel *is* the 'World's Mightiest Mortal.'"

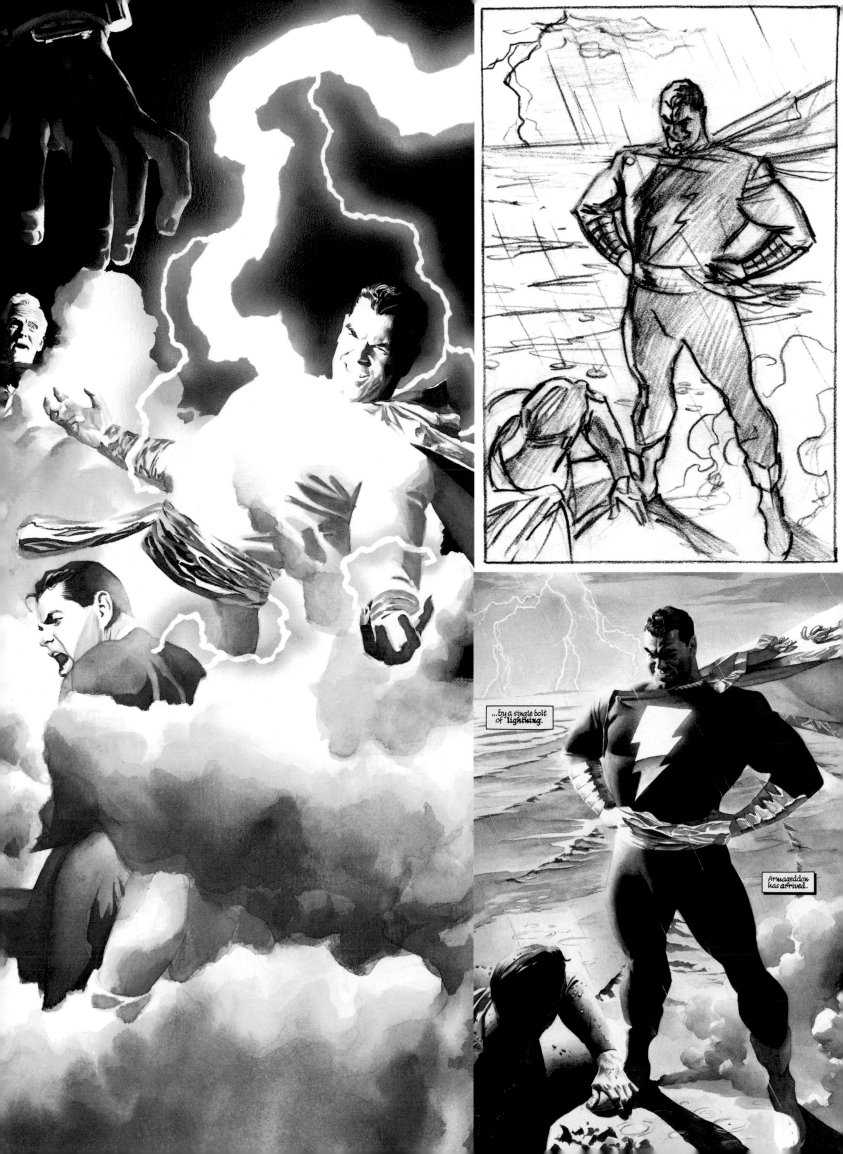

...by a single bolt of lightning.

Armageddon has arrived.

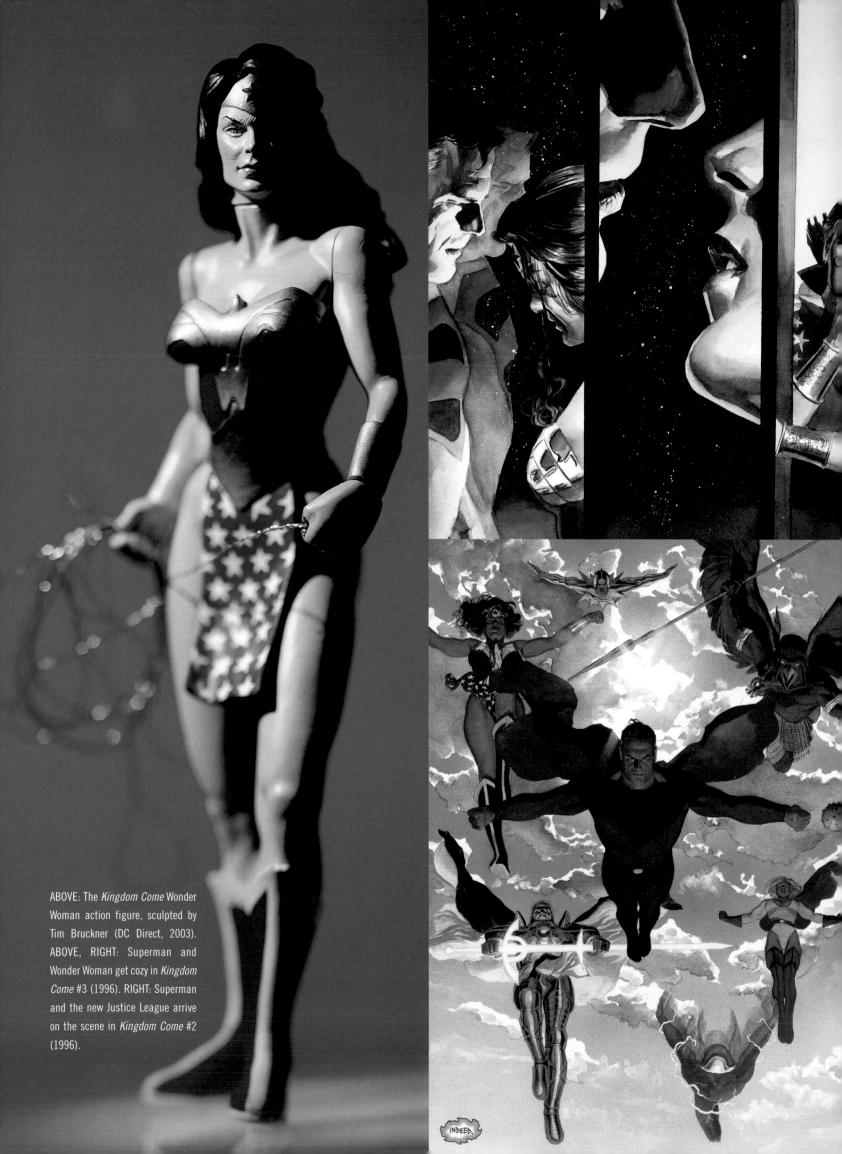

ABOVE: The *Kingdom Come* Wonder Woman action figure, sculpted by Tim Bruckner (DC Direct, 2003). ABOVE, RIGHT: Superman and Wonder Woman get cozy in *Kingdom Come* #3 (1996). RIGHT: Superman and the new Justice League arrive on the scene in *Kingdom Come* #2 (1996).

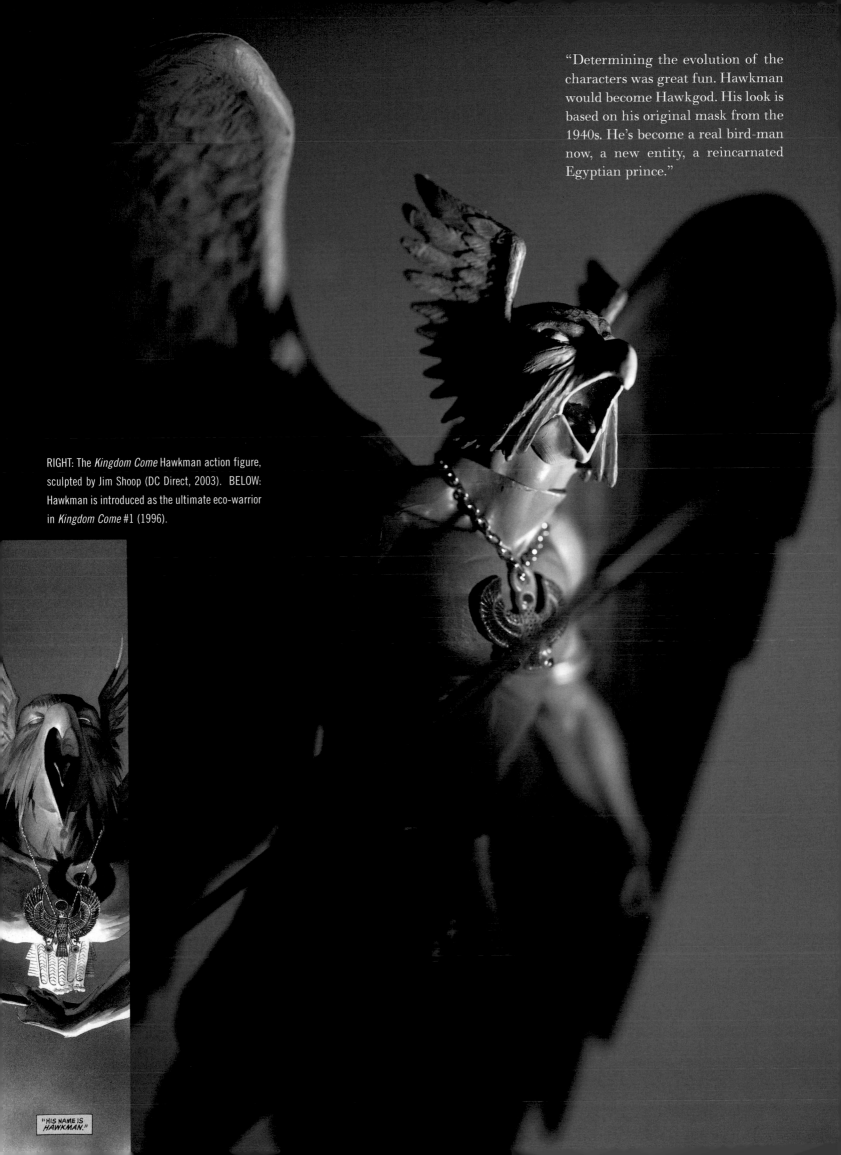

"Determining the evolution of the characters was great fun. Hawkman would become Hawkgod. His look is based on his original mask from the 1940s. He's become a real bird-man now, a new entity, a reincarnated Egyptian prince."

RIGHT: The *Kingdom Come* Hawkman action figure, sculpted by Jim Shoop (DC Direct, 2003). BELOW: Hawkman is introduced as the ultimate eco-warrior in *Kingdom Come* #1 (1996).

"HIS NAME IS HAWKMAN."

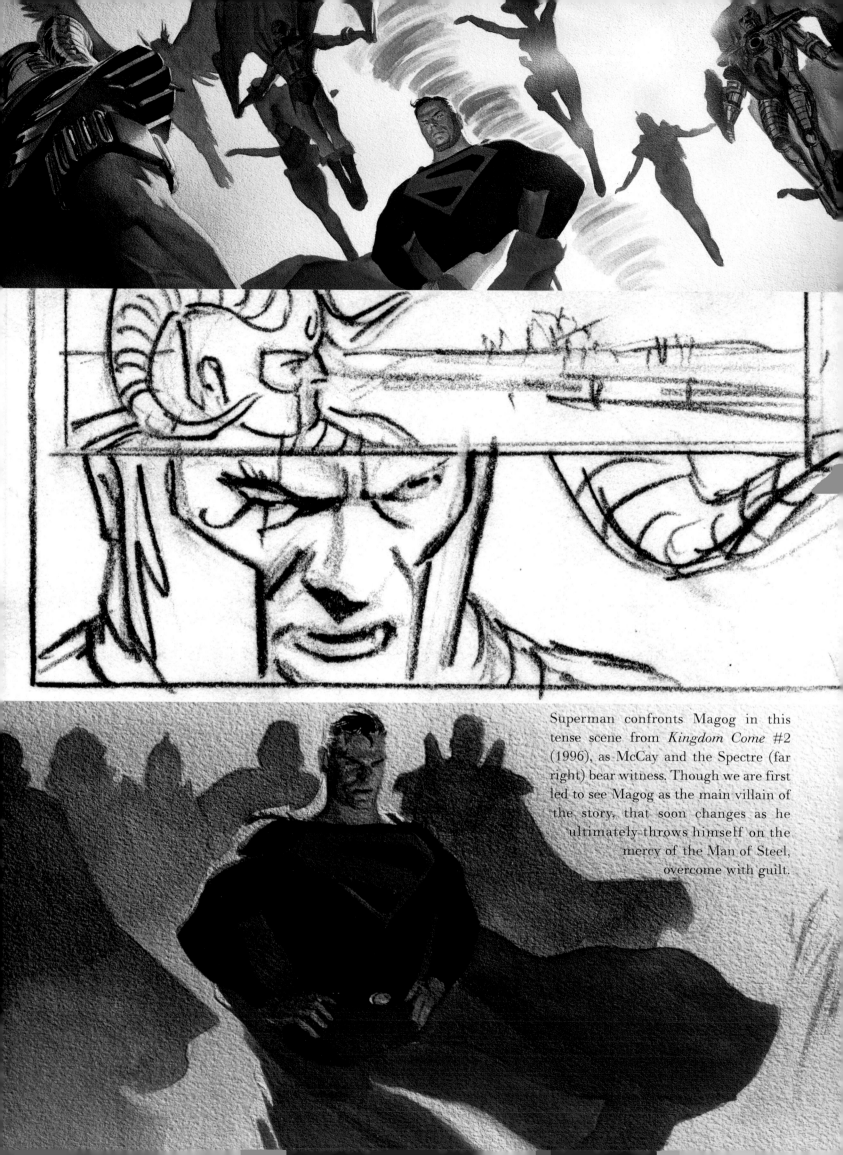

Superman confronts Magog in this tense scene from *Kingdom Come* #2 (1996), as McCay and the Spectre (far right) bear witness. Though we are first led to see Magog as the main villain of the story, that soon changes as he ultimately throws himself on the mercy of the Man of Steel, overcome with guilt.

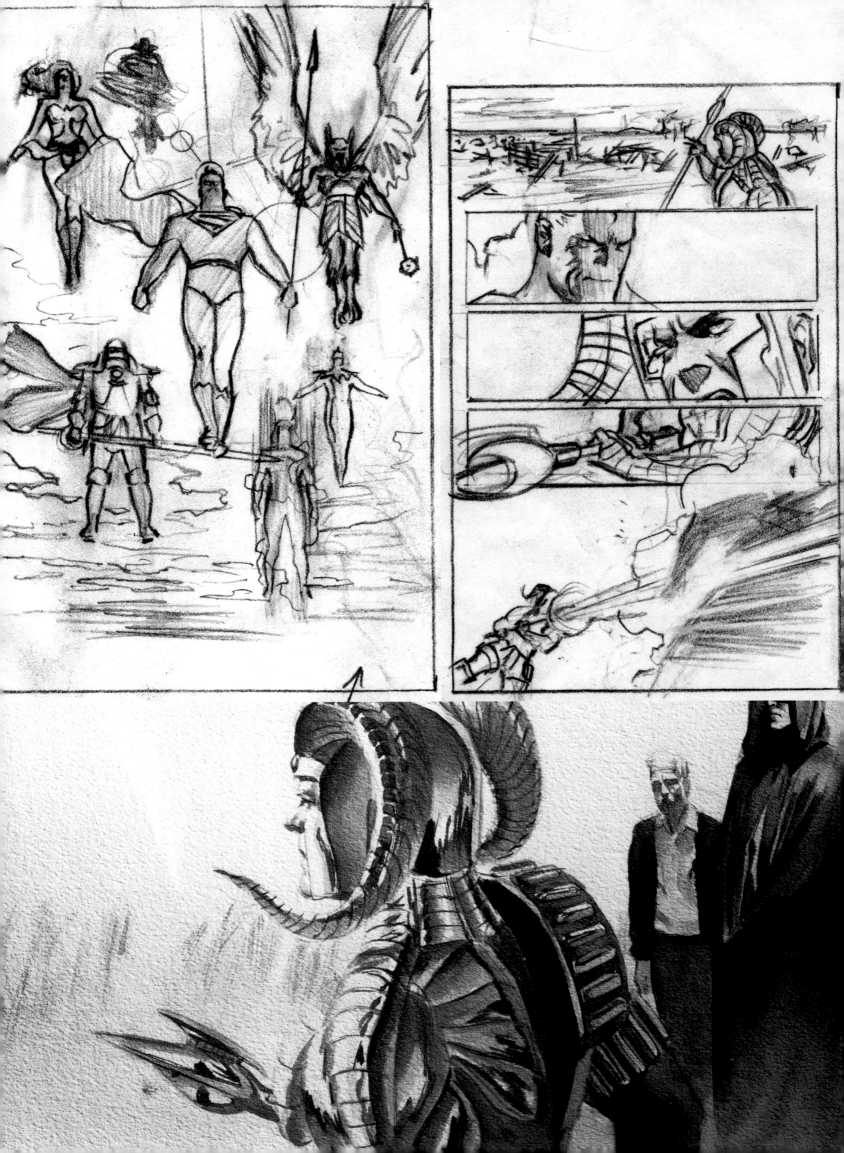

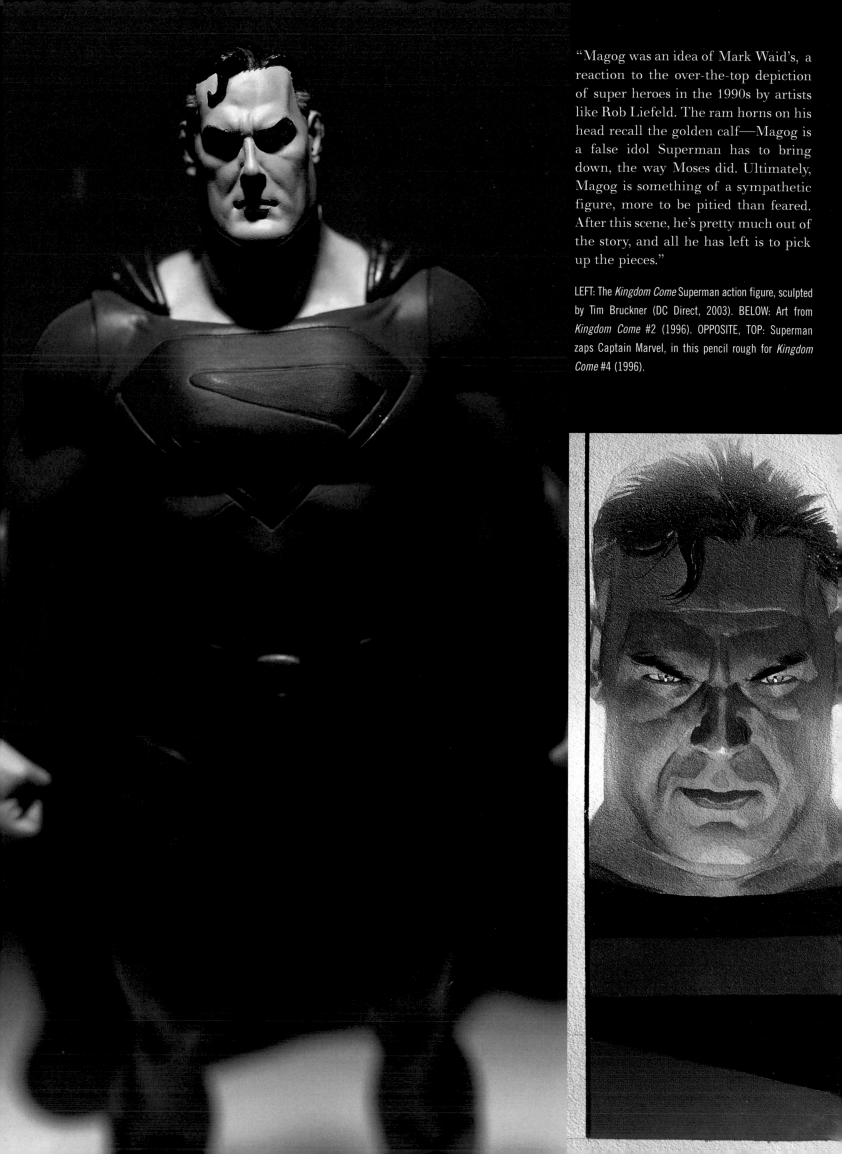

"Magog was an idea of Mark Waid's, a reaction to the over-the-top depiction of super heroes in the 1990s by artists like Rob Liefeld. The ram horns on his head recall the golden calf—Magog is a false idol Superman has to bring down, the way Moses did. Ultimately, Magog is something of a sympathetic figure, more to be pitied than feared. After this scene, he's pretty much out of the story, and all he has left is to pick up the pieces."

LEFT: The *Kingdom Come* Superman action figure, sculpted by Tim Bruckner (DC Direct, 2003). BELOW: Art from *Kingdom Come* #2 (1996). OPPOSITE, TOP: Superman zaps Captain Marvel, in this pencil rough for *Kingdom Come* #4 (1996).

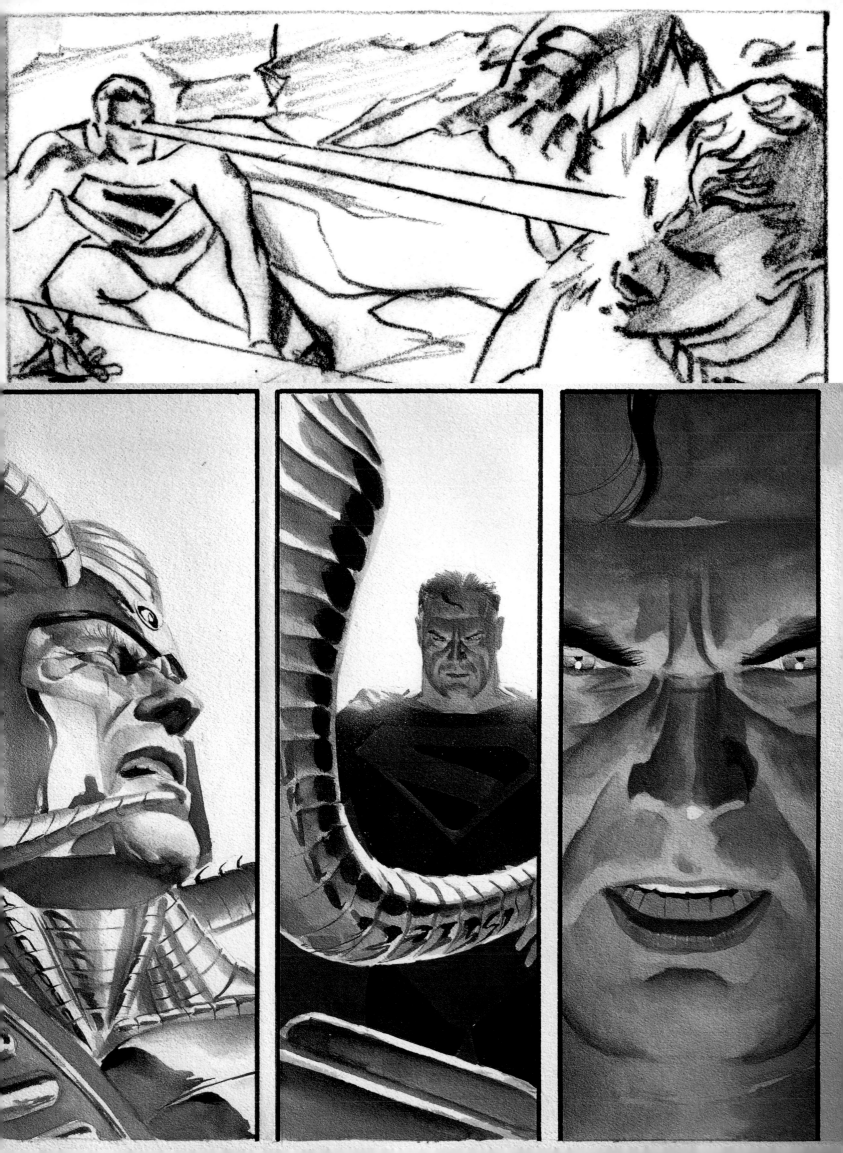

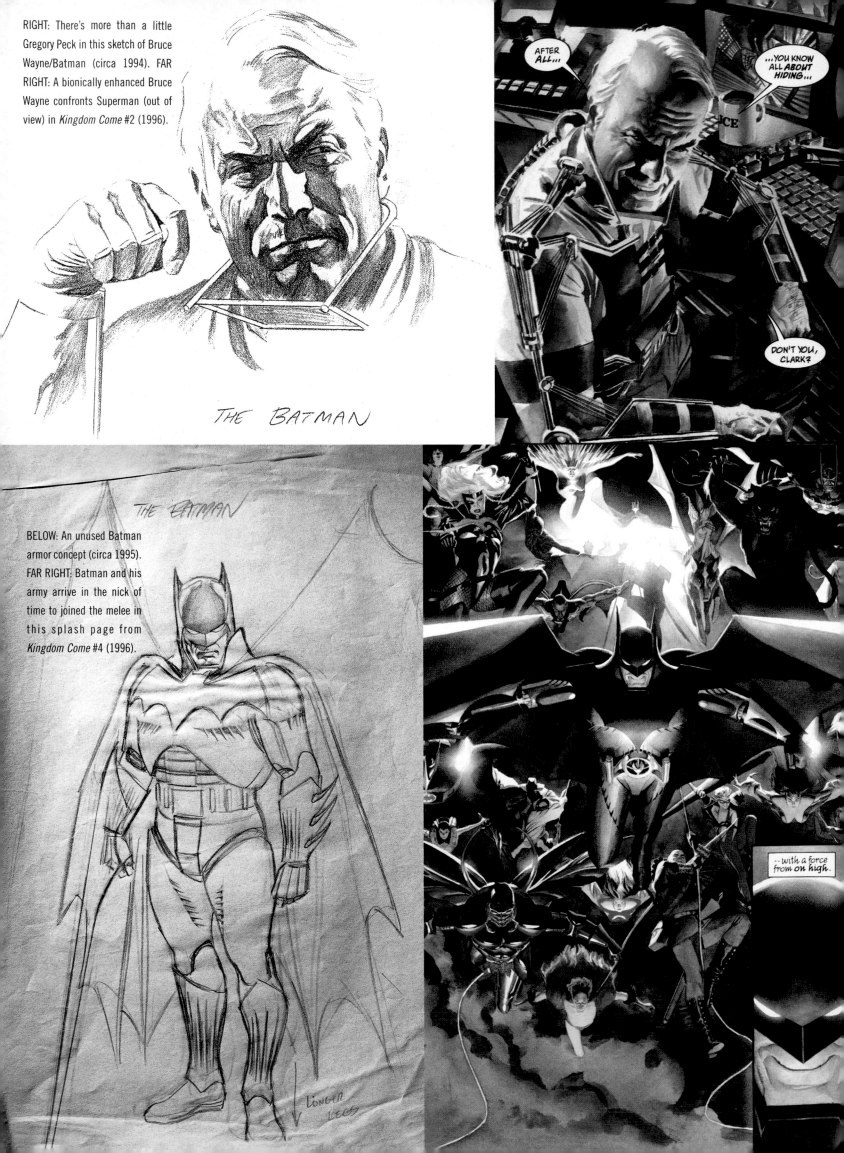

RIGHT: There's more than a little Gregory Peck in this sketch of Bruce Wayne/Batman (circa 1994). FAR RIGHT: A bionically enhanced Bruce Wayne confronts Superman (out of view) in *Kingdom Come* #2 (1996).

THE BATMAN

AFTER ALL...

...YOU KNOW ALL *ABOUT* HIDING...

DON'T YOU, CLARK?

THE BATMAN

BELOW: An unused Batman armor concept (circa 1995). FAR RIGHT: Batman and his army arrive in the nick of time to joined the melee in this splash page from *Kingdom Come* #4 (1996).

LONGER LEGS

--with a force from on high.

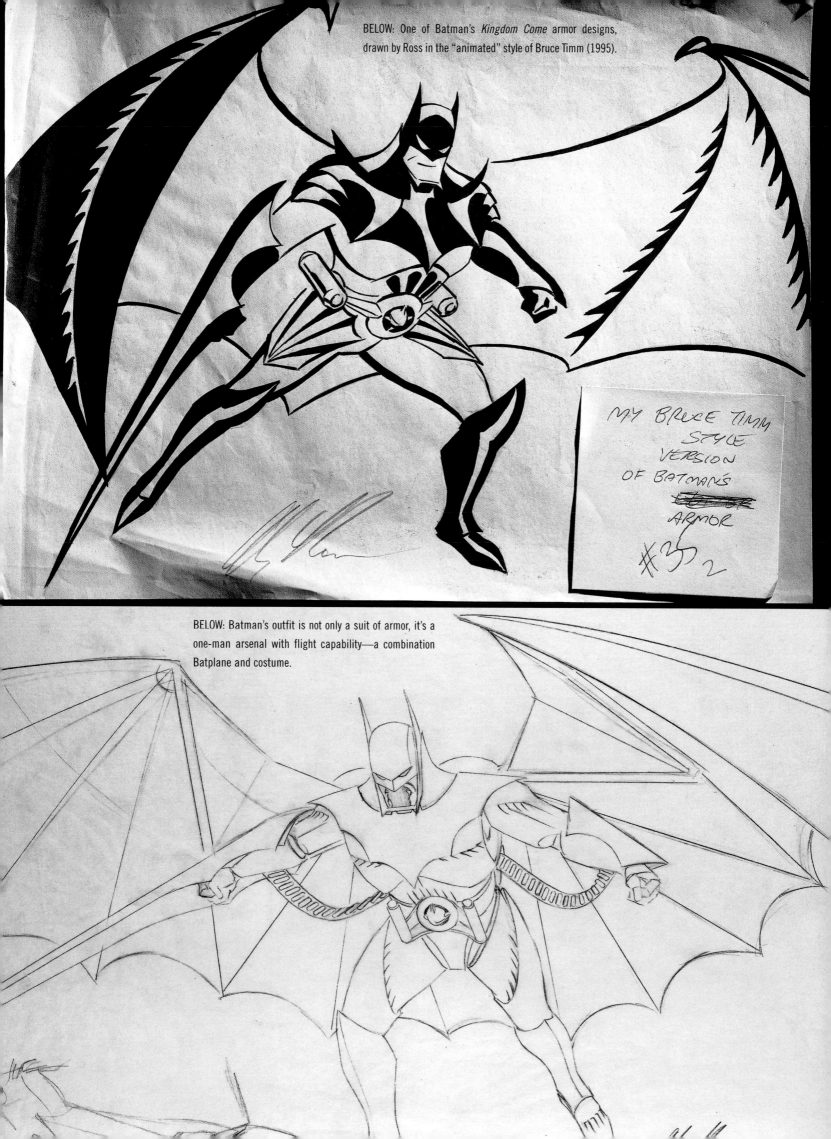

BELOW: One of Batman's *Kingdom Come* armor designs, drawn by Ross in the "animated" style of Bruce Timm (1995).

MY BRUCE TIMM STYLE VERSION OF BATMAN'S ~~ARMOR~~ ARMOR

BELOW: Batman's outfit is not only a suit of armor, it's a one-man arsenal with flight capability—a combination Batplane and costume.

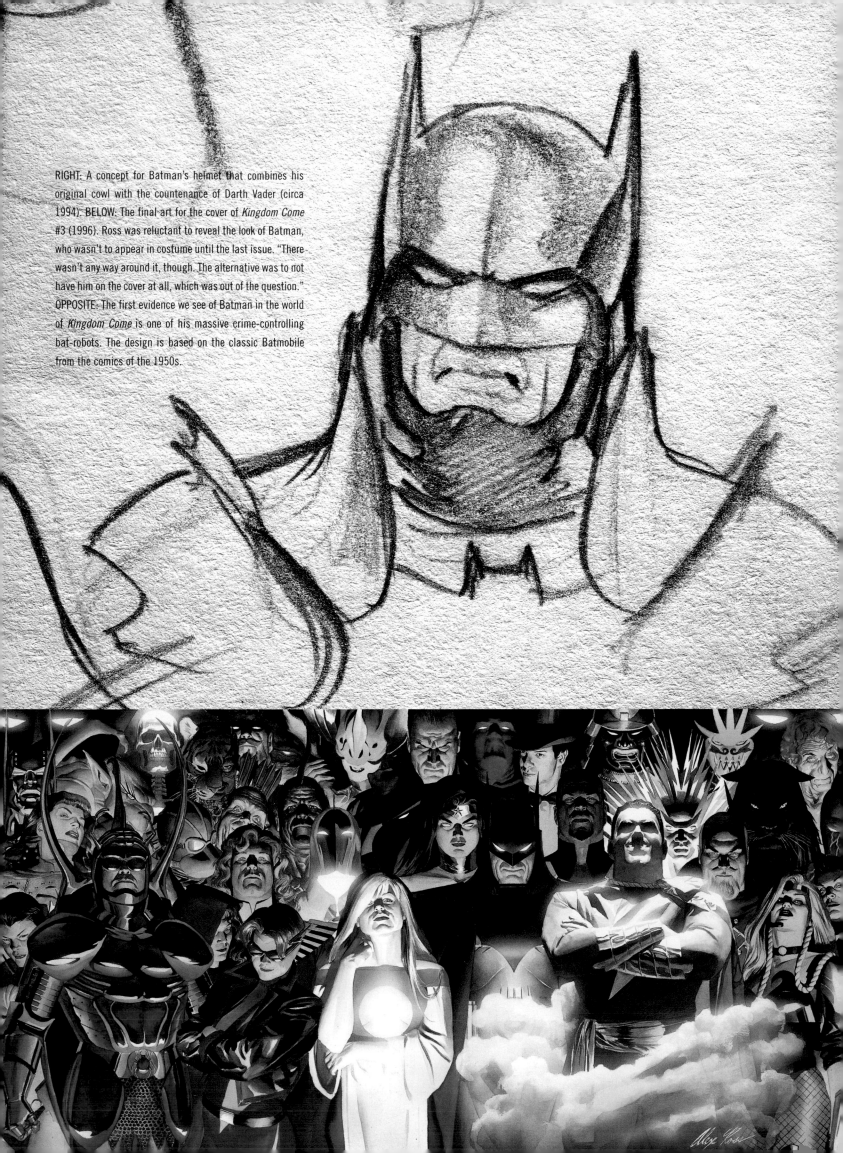

RIGHT: A concept for Batman's helmet that combines his original cowl with the countenance of Darth Vader (circa 1994). BELOW: The final art for the cover of *Kingdom Come* #3 (1996). Ross was reluctant to reveal the look of Batman, who wasn't to appear in costume until the last issue. "There wasn't any way around it, though. The alternative was to not have him on the cover at all, which was out of the question." OPPOSITE: The first evidence we see of Batman in the world of *Kingdom Come* is one of his massive crime-controlling bat-robots. The design is based on the classic Batmobile from the comics of the 1950s.

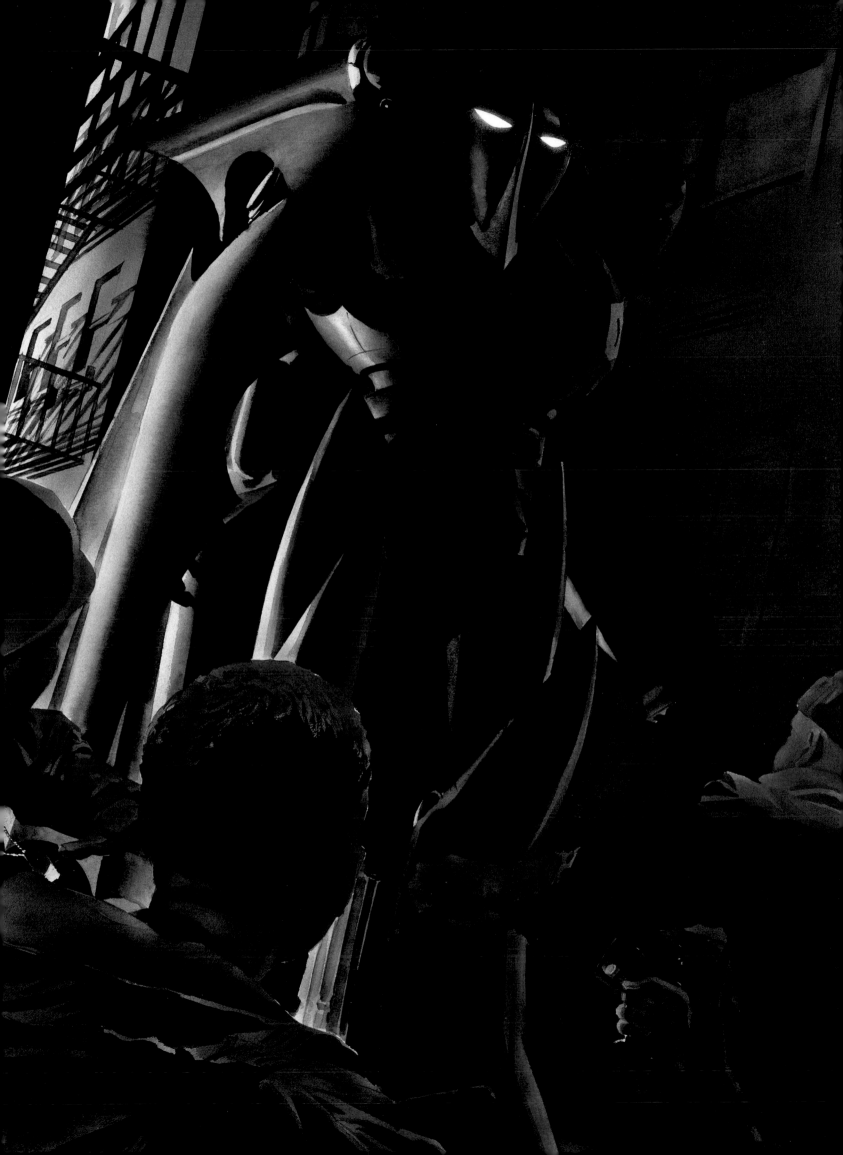

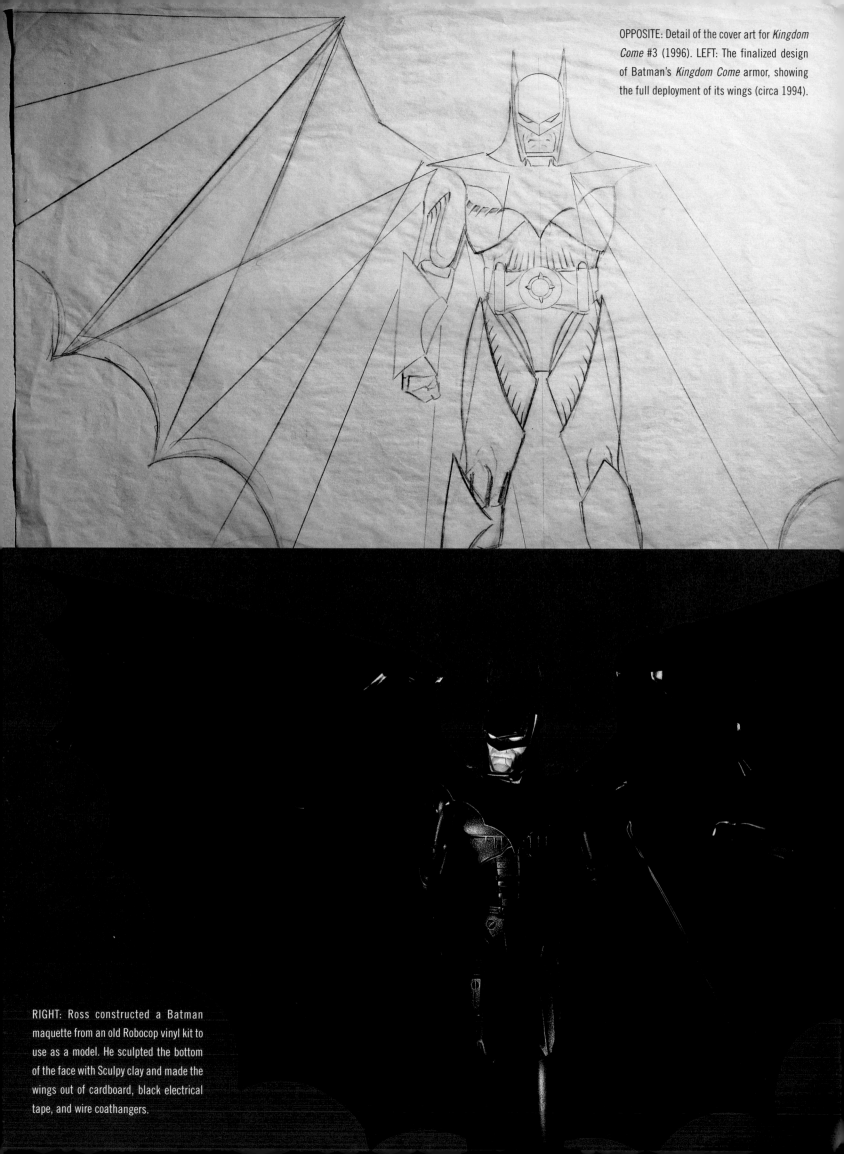

OPPOSITE: Detail of the cover art for *Kingdom Come* #3 (1996). LEFT: The finalized design of Batman's *Kingdom Come* armor, showing the full deployment of its wings (circa 1994).

RIGHT: Ross constructed a Batman maquette from an old Robocop vinyl kit to use as a model. He sculpted the bottom of the face with Sculpy clay and made the wings out of cardboard, black electrical tape, and wire coathangers.

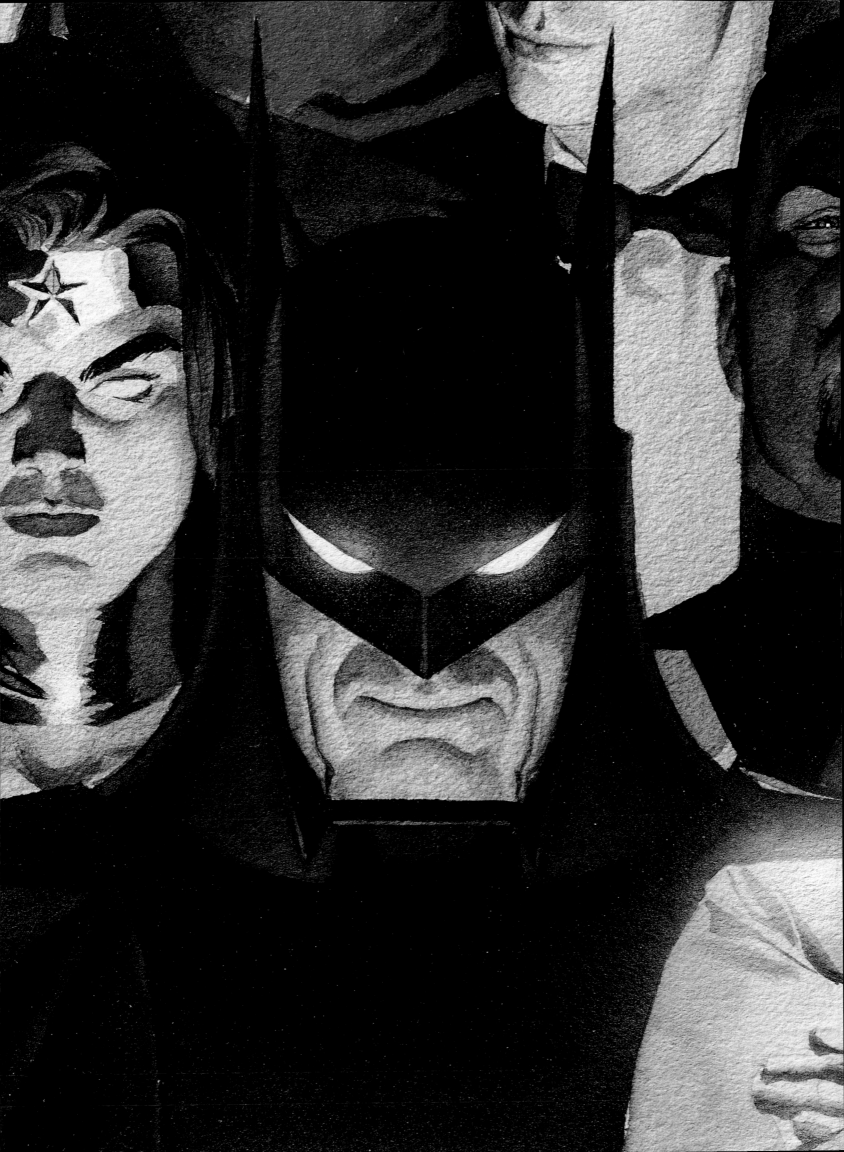

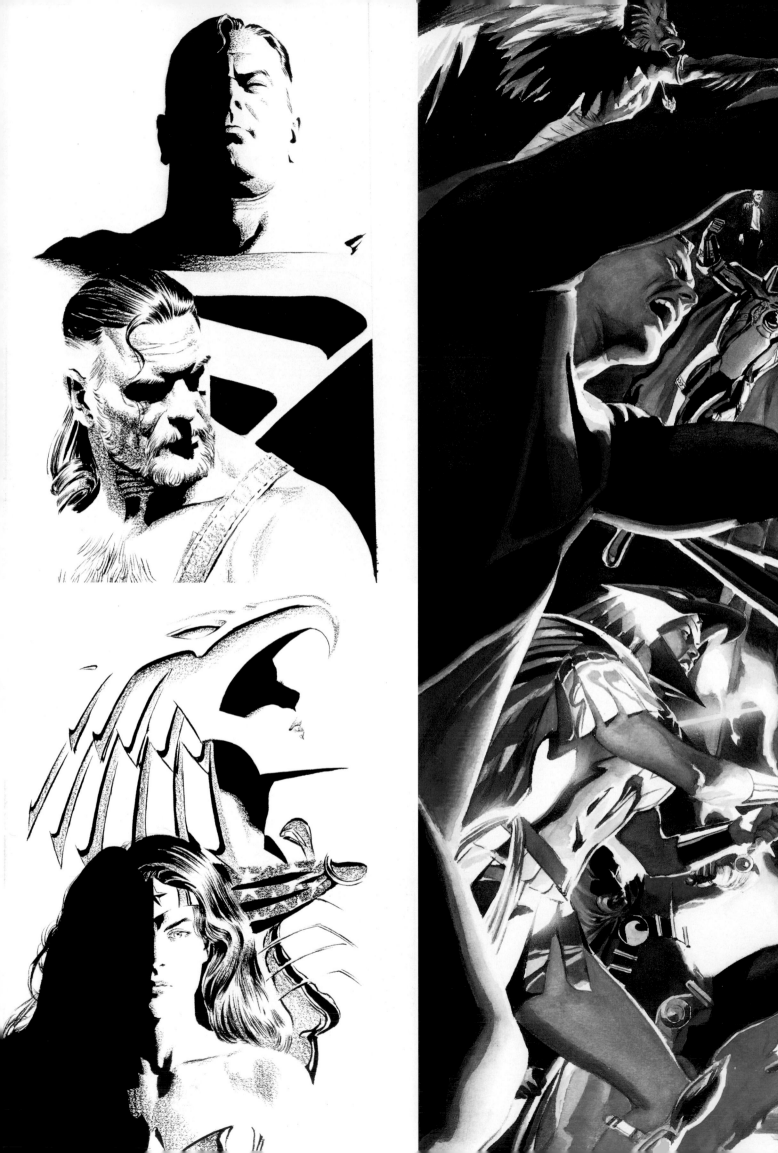

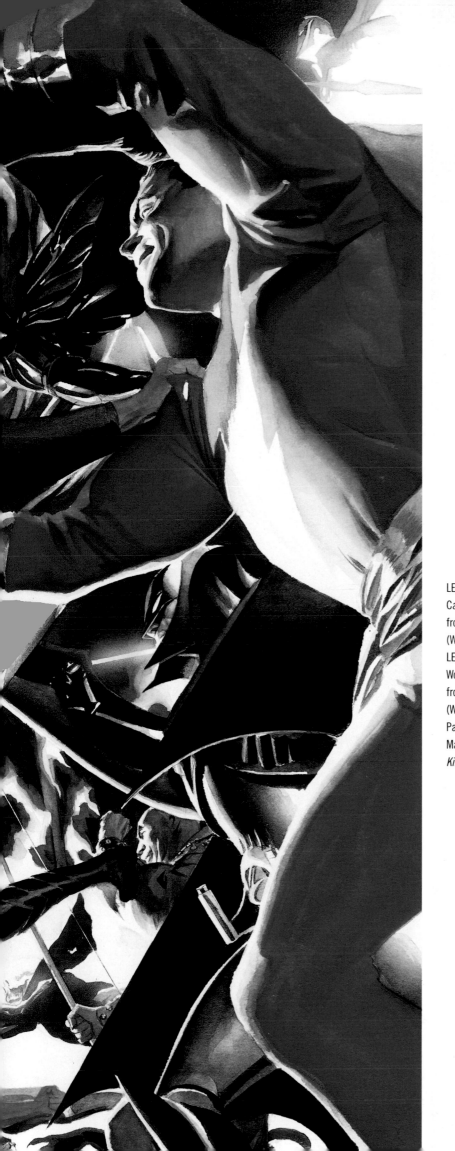

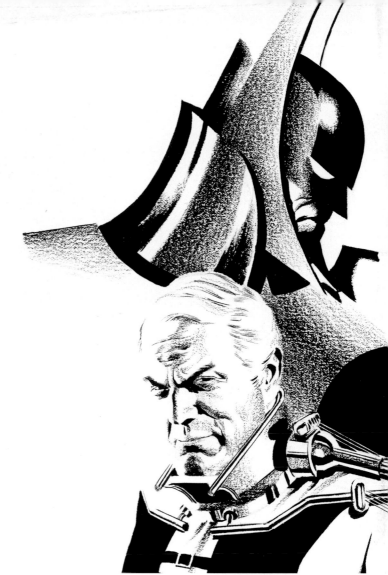

LEFT: The final battle between Superman, Captain Marvel, and everyone else, in art from the novelization of *Kingdom Come* (Warner Books, 1998). OPPOSITE, FAR LEFT: Chapter-title art of Superman and Wonder Woman, in and out of costume, from the novelization of *Kingdom Come* (Warner Books, 1998). ABOVE AND BELOW: Part-title art for Batman and Captain Marvel, also from from the novelization of *Kingdom Come*.

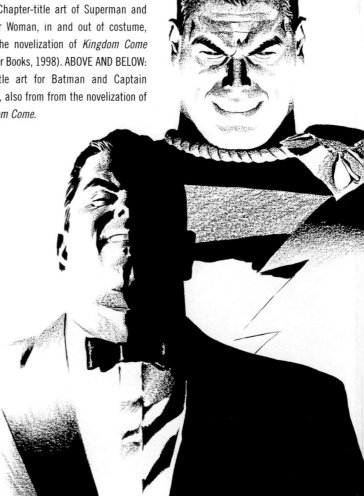

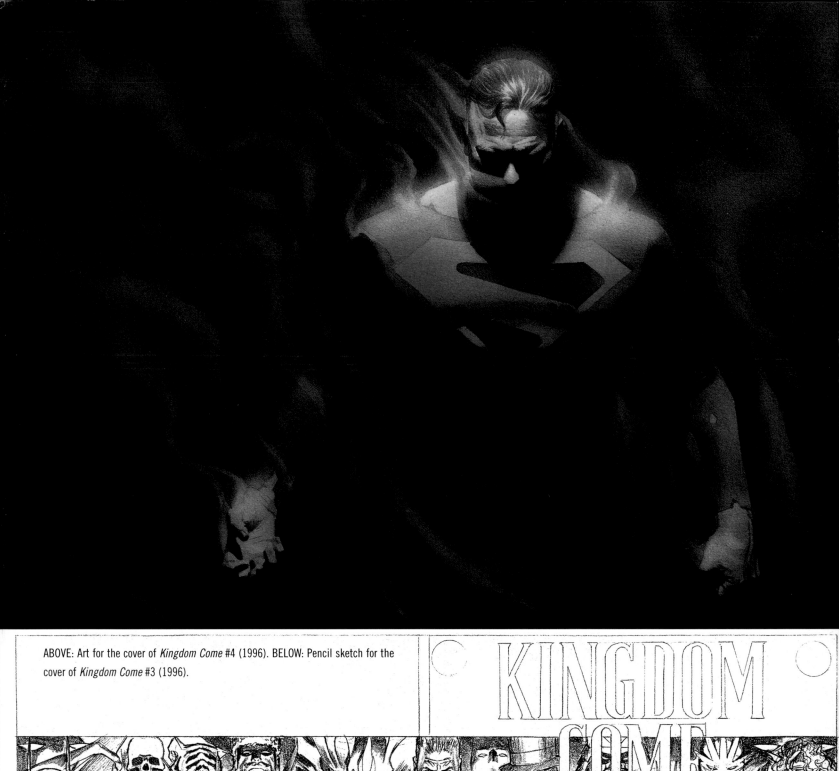

ABOVE: Art for the cover of *Kingdom Come* #4 (1996). BELOW: Pencil sketch for the cover of *Kingdom Come* #3 (1996).

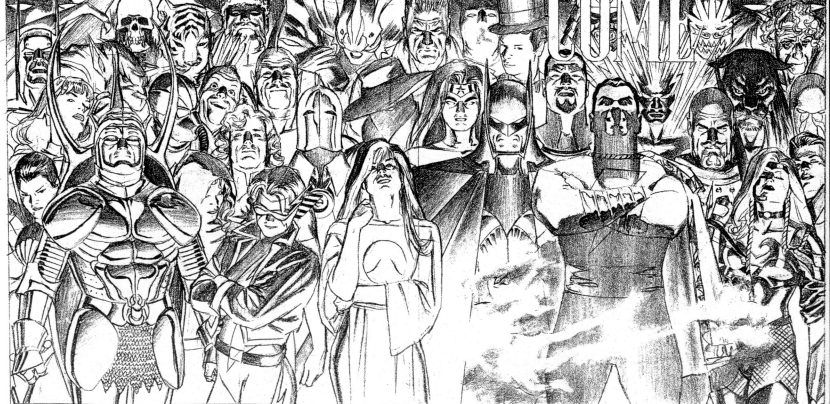

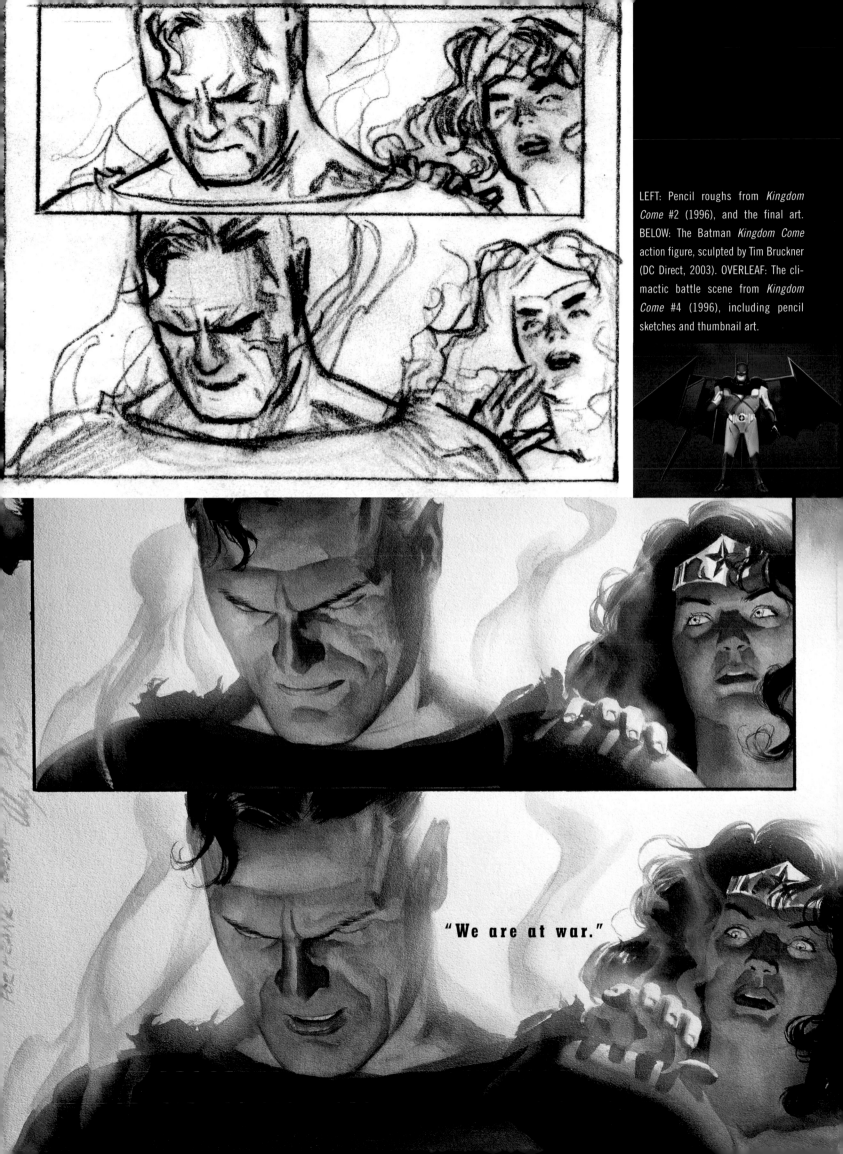

LEFT: Pencil roughs from *Kingdom Come* #2 (1996), and the final art. BELOW: The Batman *Kingdom Come* action figure, sculpted by Tim Bruckner (DC Direct, 2003). OVERLEAF: The climactic battle scene from *Kingdom Come* #4 (1996), including pencil sketches and thumbnail art.

"We are at war."

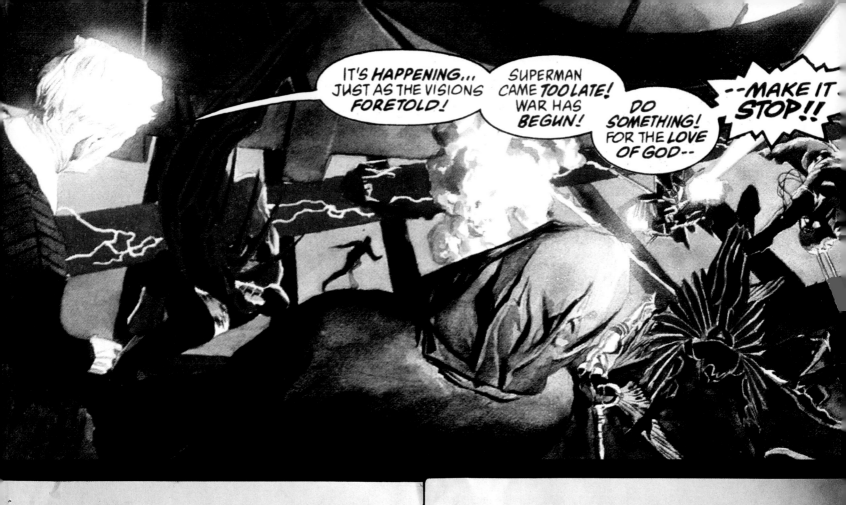

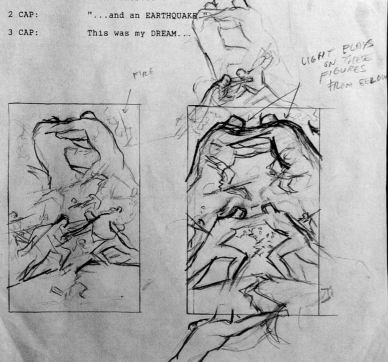

KINGDOM COME #4
"NEVER-ENDING BATTLE"
SCRIPT FOR *FIRST 32 of 45* PAGES
FIRST DRAFT, ROUGHER THAN BURLAP
OCTOBER 31, 1995

PAGE ONE

FULL-PAGE SPLASH. AS SEEN BY NORMAN McCAY--THE WAR BETWEEN THE
HEROES. EVERYTHING IS HAZY, BLURRY...NO DISTINCT IMAGES, BUT
CHAOS NONETHELESS.

1 CAP: "There were VOICES...and THUNDERINGS, and
 LIGHTNINGS...

2 CAP: "...and an EARTHQUAKE..."

3 CAP: This was my DREAM...

PAGES TWO-THREE

TWO-PAGE SPREAD. IT'S NO DREAM, WE REALIZE AS WE JUMP TO A
CRYSTAL-CLEAR FOCUS. WE ARE AT WAR. CAPTAIN MARVEL AND SUPERMAN
DOMINATE IN THE FOREGROUND, THE EARTH CRACKING BENEATH THEIR
STRIDES; BEHIND THEM, THE WAR RAGES AND PRISONERS CONTINUE TO
SPILL OUT OF THE GULAG.
 LIGHTNING, LOW CLOUDS.

1 CAP: ...no MORE.

ABOVE: Pages from Mark Waid's script for the climactic battle scene that opens *Kingdom Come* #4, annotated with sketches by Ross. OPPOSITE: Additional pencil
thumbnails for the scene. The final painting is revealed inside the gatefold. Note how little the composition changed from initial conception to finished art.

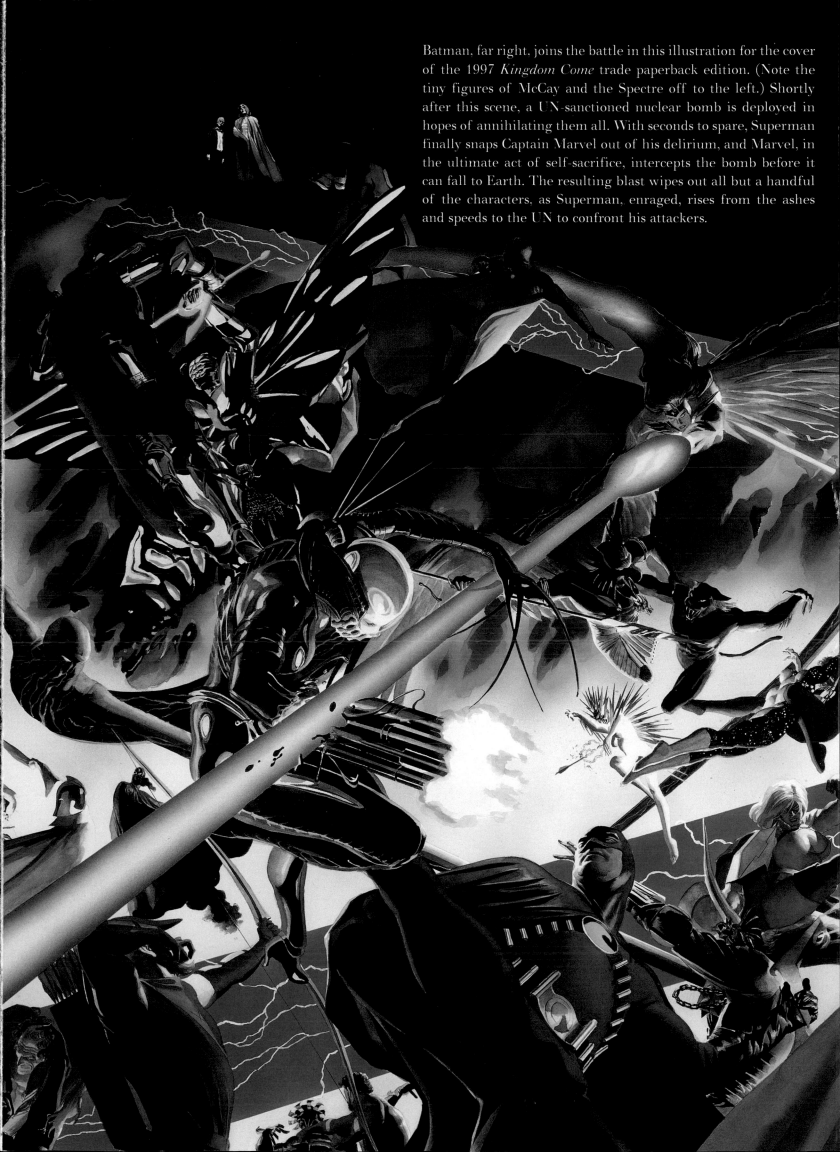

Batman, far right, joins the battle in this illustration for the cover of the 1997 *Kingdom Come* trade paperback edition. (Note the tiny figures of McCay and the Spectre off to the left.) Shortly after this scene, a UN-sanctioned nuclear bomb is deployed in hopes of annihilating them all. With seconds to spare, Superman finally snaps Captain Marvel out of his delirium, and Marvel, in the ultimate act of self-sacrifice, intercepts the bomb before it can fall to Earth. The resulting blast wipes out all but a handful of the characters, as Superman, enraged, rises from the ashes and speeds to the UN to confront his attackers.

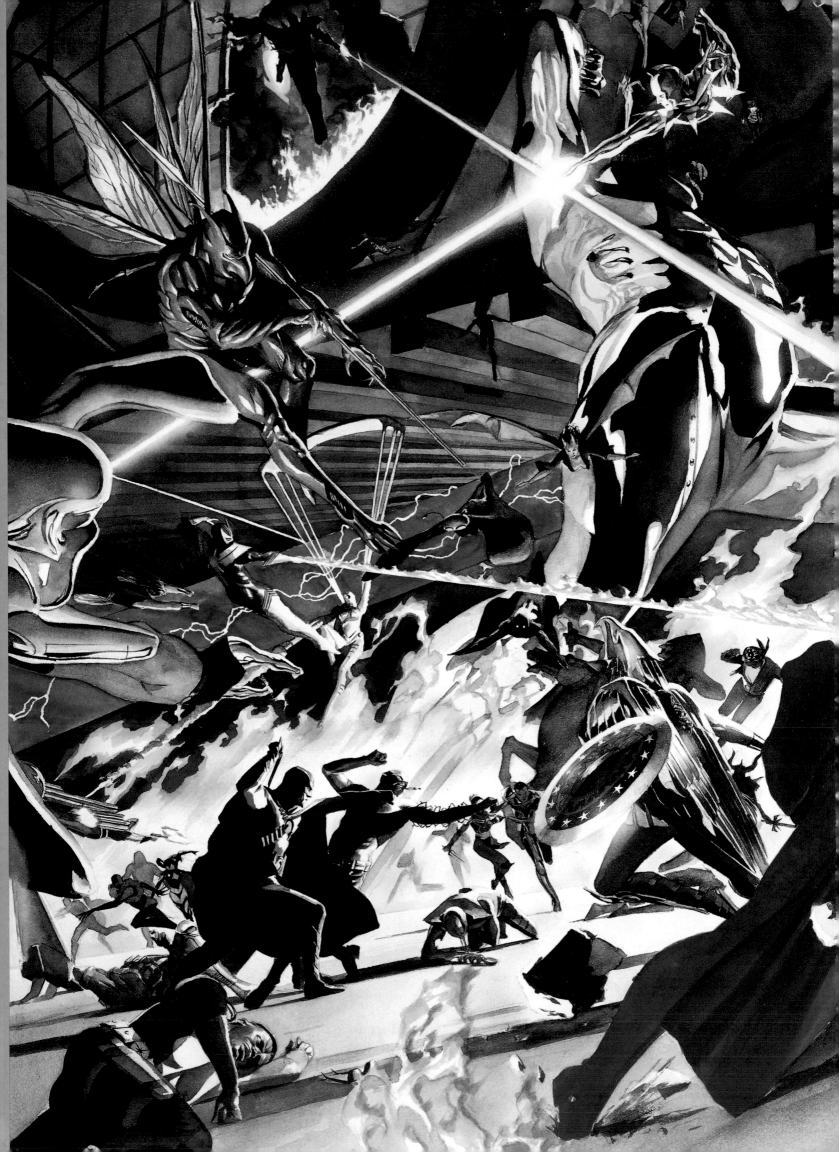

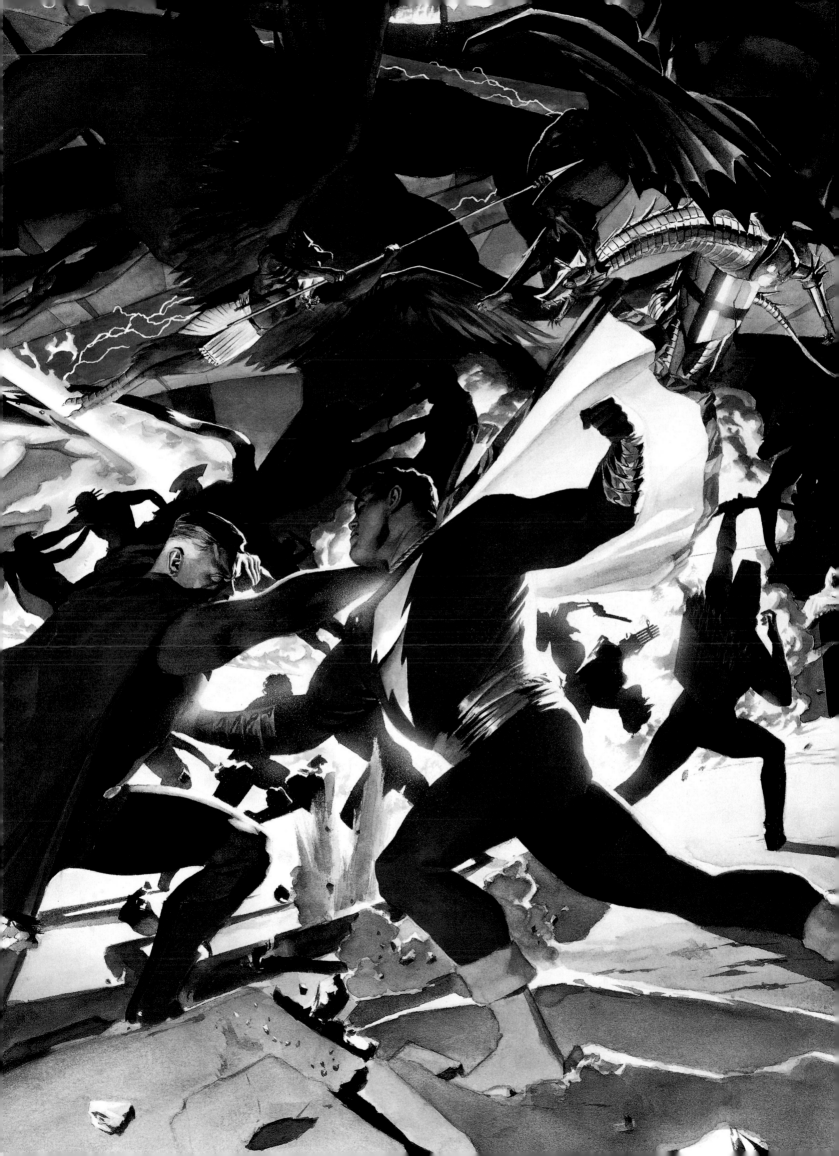

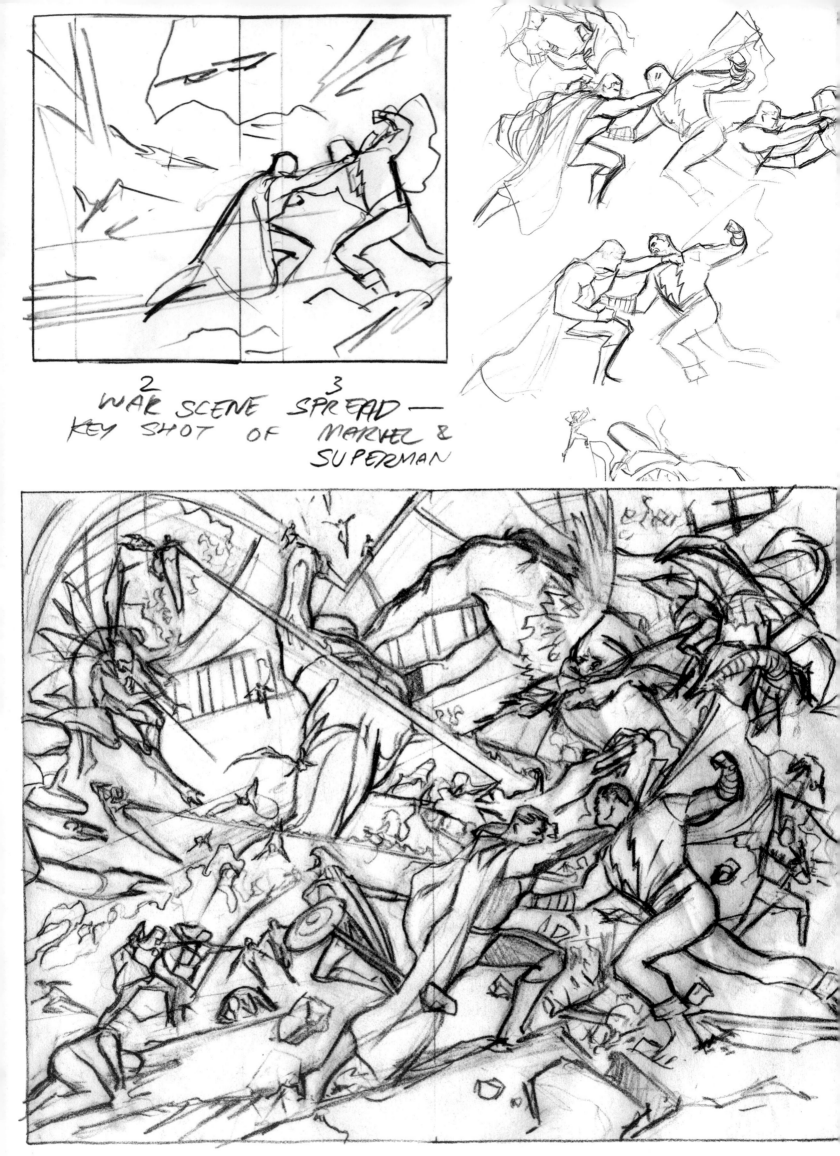

2
WAR SCENE SPREAD—
KEY SHOT OF MARVEL &
SUPERMAN
3

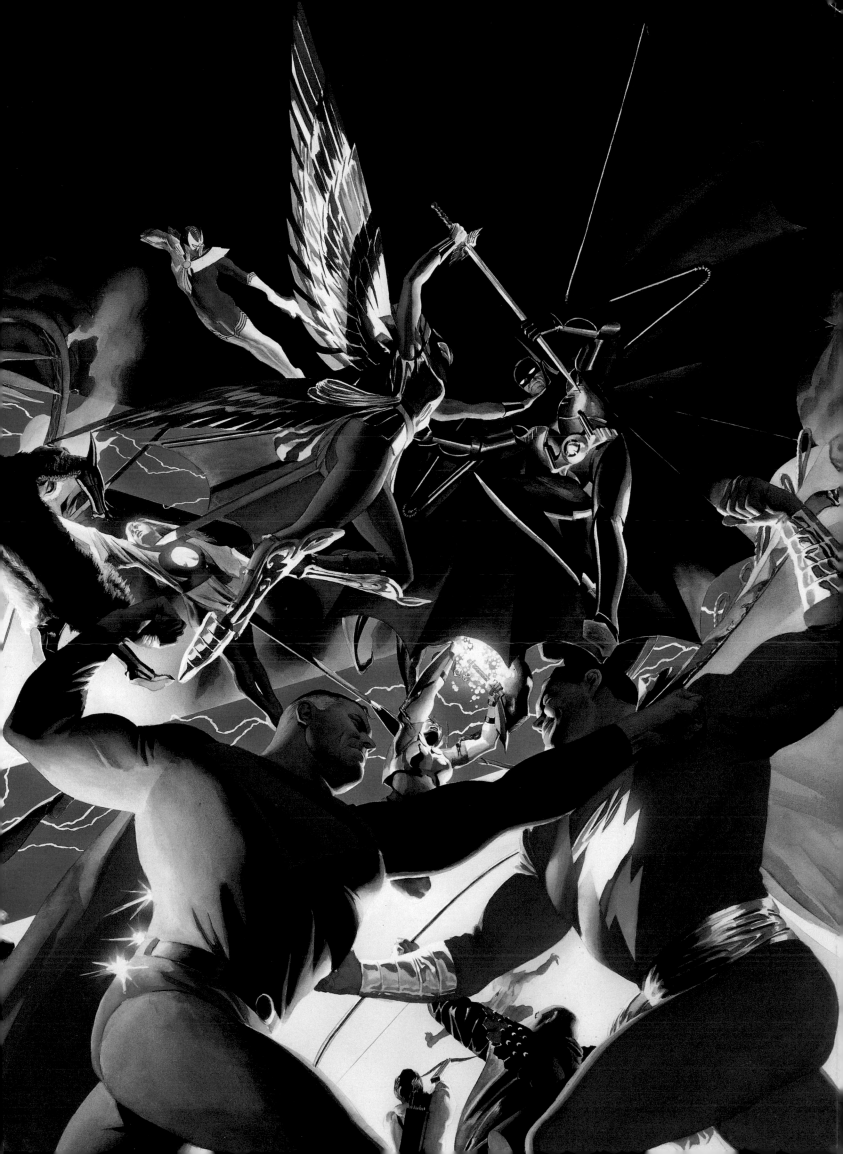

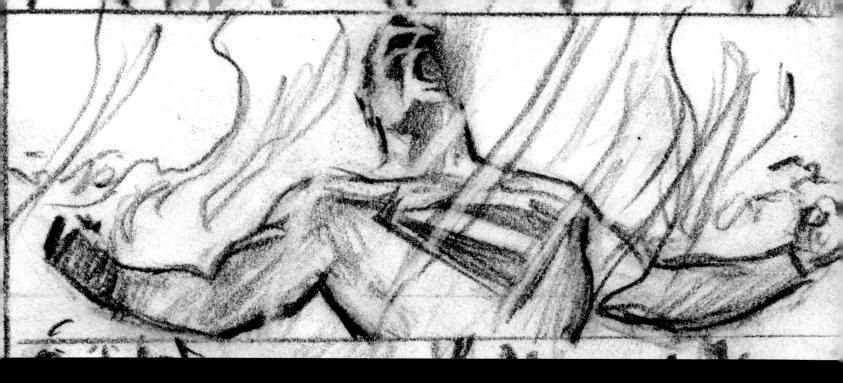

ABOVE: Superman cries out in rage after the devastating nuclear explosion that has killed most of the Justice League and its enemies alike. Thumbnail design for *Kingdom Come* #4 (1996). BELOW: Norman McCay reminds Superman of his responsibility to mankind and himself in this penultimate scene from *Kingdom Come* #4 (1996). OPPOSITE, BOTTOM: McCay, safely back in the pulpit, at the end of the story. The red-headed man in the front pew to the right is Jim Corrigan, the Spectre's human form.

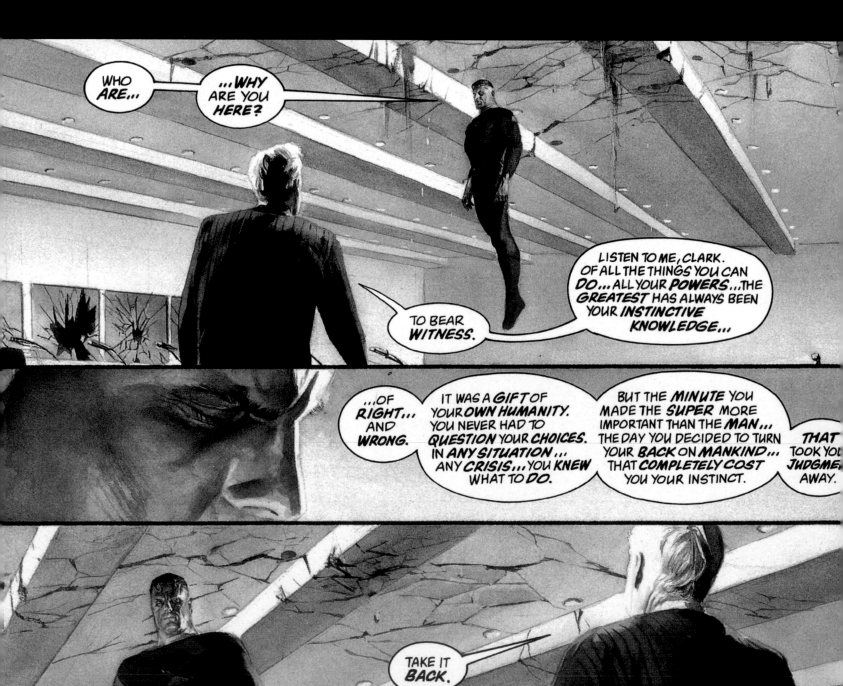

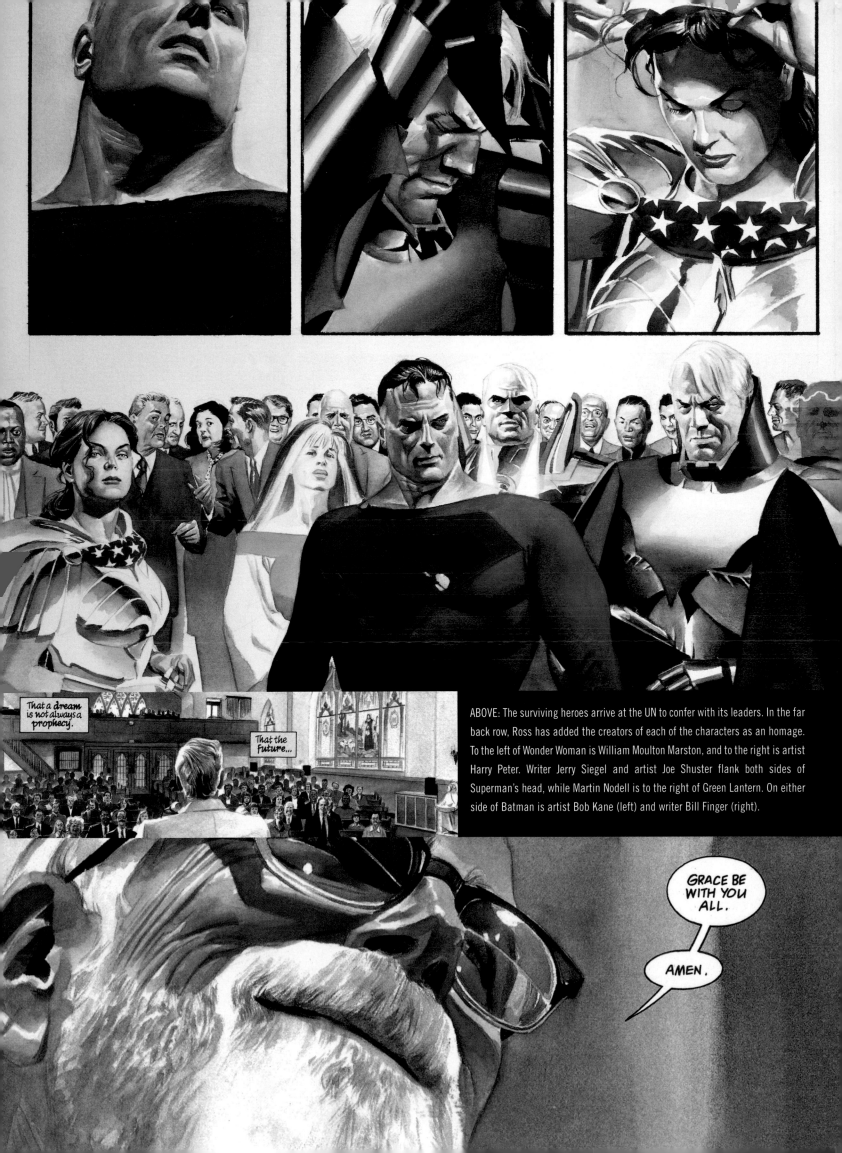

That a dream is not always a prophecy.

That the Future...

ABOVE: The surviving heroes arrive at the UN to confer with its leaders. In the far back row, Ross has added the creators of each of the characters as an homage. To the left of Wonder Woman is William Moulton Marston, and to the right is artist Harry Peter. Writer Jerry Siegel and artist Joe Shuster flank both sides of Superman's head, while Martin Nodell is to the right of Green Lantern. On either side of Batman is artist Bob Kane (left) and writer Bill Finger (right).

GRACE BE WITH YOU ALL.

AMEN.

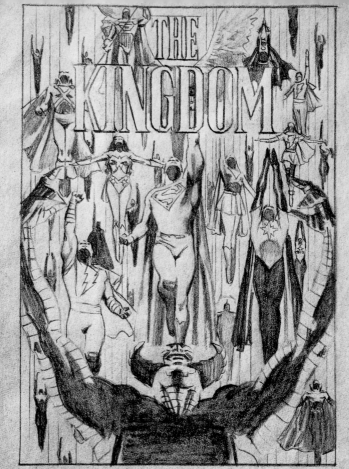

PROPOSED FIRST ISSUE COVER

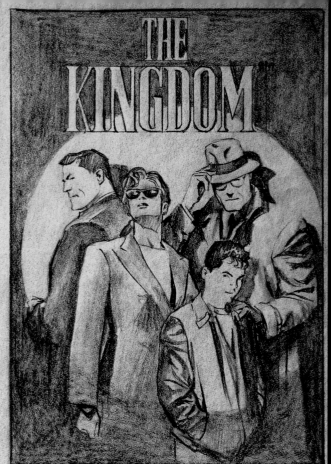

THIS COVER CONCEPT MAY NOT NECESSARILY BE LITERAL TO THE STORY BUT WORKS WELL TO REPRESENT AN ANGLE WHERE THE HEROES ARE DEALT WITH IN THEIR PERSONAL IDENTITIES.

LEFT: Sketches and notes for covers of *The Kingdom*, a "prequel" to *Kingdom Come* as Ross would have seen it (1996). OPPOSITE: Rough sketch for a trade ad for *The Kingdom* (1996).

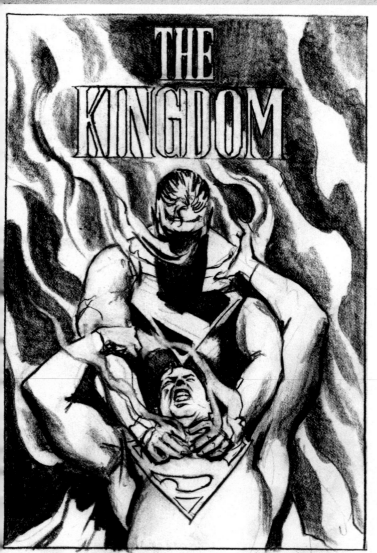

A FUTURE CONFLICT BROUGHT TO LIFE IN A DELUSION GIVEN TO SUPERMAN BY THOSE WHO WOULD WANT HIM TO FEAR THE FUTURE.

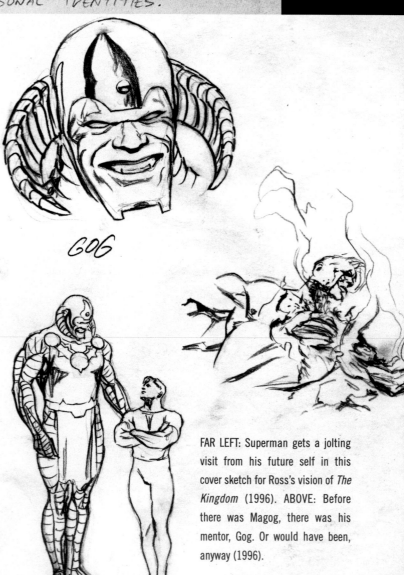

GOG

FAR LEFT: Superman gets a jolting visit from his future self in this cover sketch for Ross's vision of *The Kingdom* (1996). ABOVE: Before there was Magog, there was his mentor, Gog. Or would have been, anyway (1996).

Plans for a sequel, *The Kingdom*, never came to pass as Ross envisioned it. His few preparatory sketches are seen on these two pages. A mini-series with that title was eventually produced, but Ross was not involved. "I was going along with DC's suggestion to do a prequel, and yet take it a step forward in an unexpected way. Magog would kill Gog, his mentor, which would set off a chain of events with cataclysmic results." How would it have

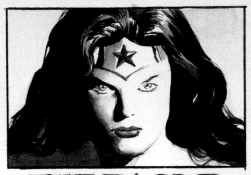

THE EAGLE

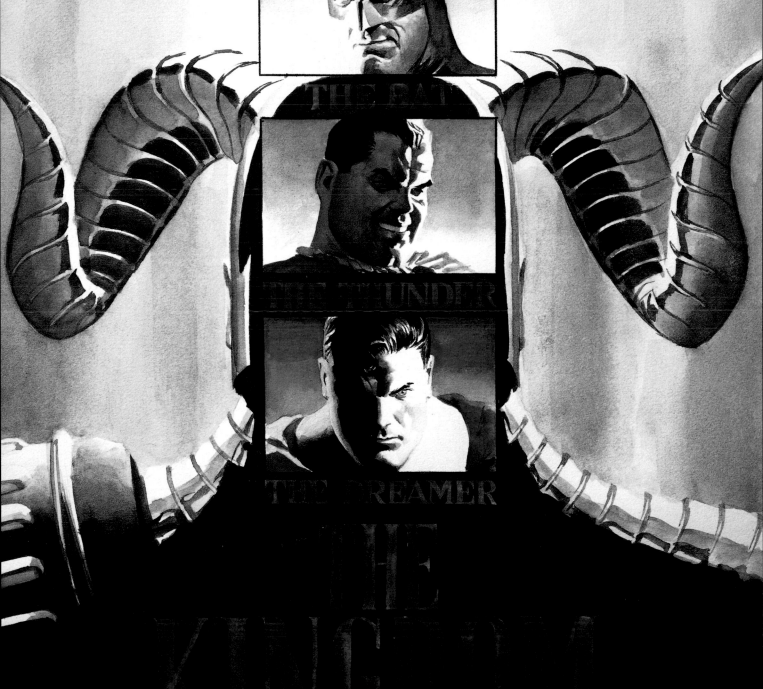

ended? "It ultimately would have suggested that *Kingdom Come* wouldn't necessarily come to be—that it coexisted with the present, a resurrected Earth 2, and is a warning to not repeat the fate of this alternate reality, leaving the current DC heroes to find a different future. It's probably for the good that we didn't go through with it. *Kingdom Come* is supposed to be something of an ending, and it's best left that way."

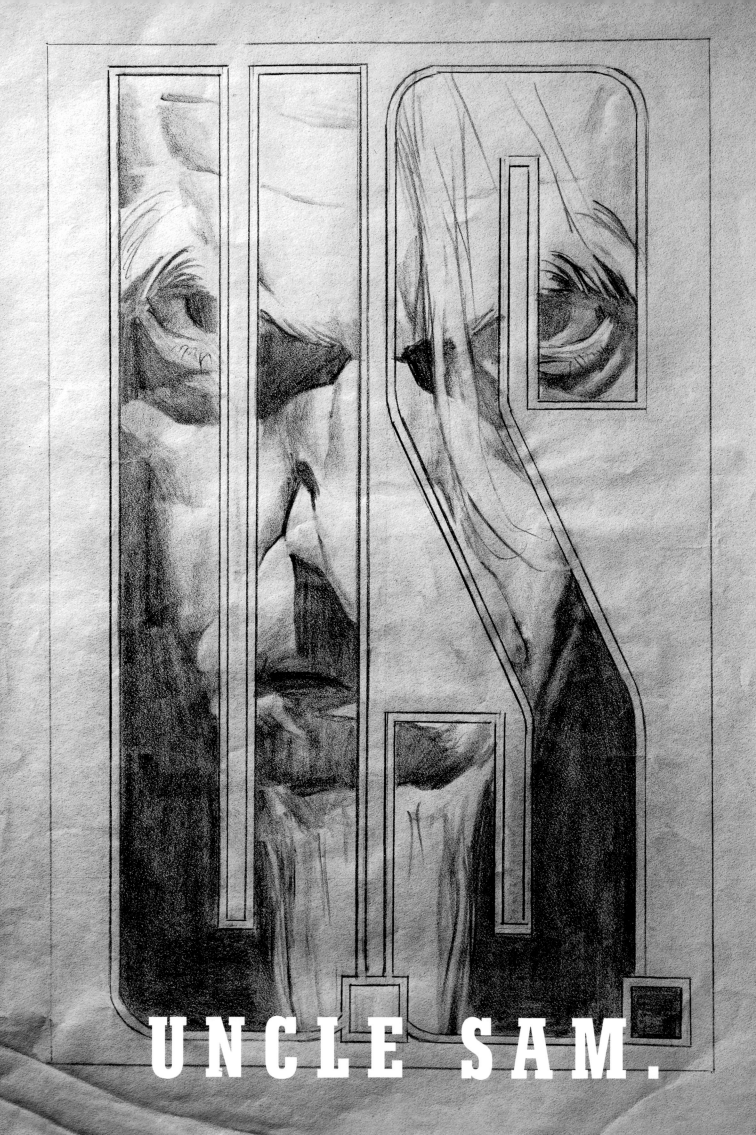

UNCLE SAM.

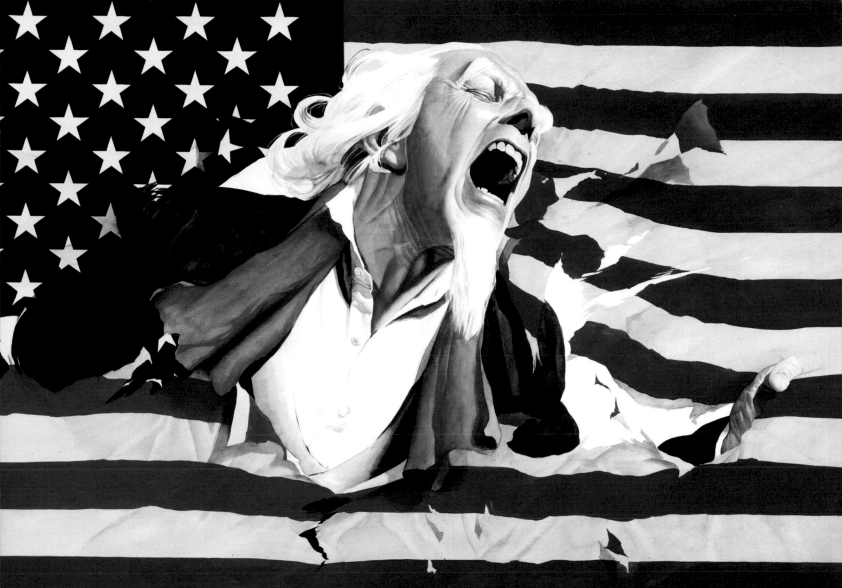

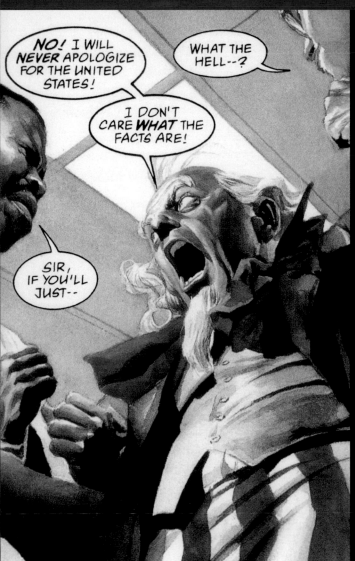

After the phenomenal success of *Kingdom Come*, Ross found himself in an enviable position: he could name whatever project he wanted to do next. That he chose *Uncle Sam* is a testament to his willingness to grow beyond the super hero genre into the realm of serious political and historical commentary. That DC was willing to follow him there and support such a potentially controversial enterprise is also no small leap of faith.

Working with editors Karen Berger and Joan Hilty, Alex and writer Steve Darnall produced a surreal combination of James Montgomery Flagg, The History Channel, and *The Twilight Zone*. *Uncle Sam* depicts what appears to be a homeless man's delirium and his attempts to cope with first-hand memories and visions of America's history—many of them horrific and terrifying—while stumbling through various locales both present and past in the nation's landscape.

The action starts in a mid-town Manhattan emergency room as "Sam," clad in a disheveled version of his traditional star-spangled garb, is dragged by orderlies and forcibly ejected as he babbles seemingly incoherent phrases like "I am not a crook!" and "We begin bombing in *five minutes*!" and "What a waste it is to lose one's mind . . ."

ABOVE: Book jacket art for the *Uncle Sam* hardcover edition (Vertigo/DC Comics, 1998).
FAR LEFT: Ross and Darnall's Sam, as we first see him in *Uncle Sam* #1 (1997).
OPPOSITE: Unpublished concept sketch for the cover of the *Uncle Sam* trade paperback (1998).

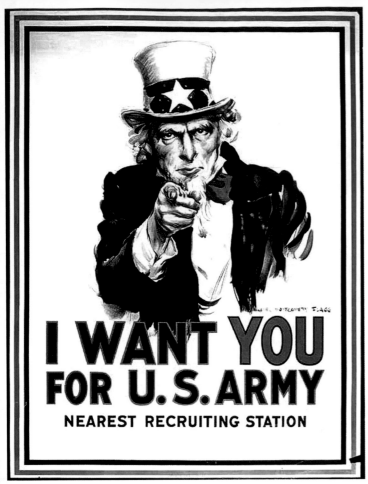

ABOVE LEFT: Original Uncle Sam "I Want You" U. S. Army recruitment poster by James Montgomery Flagg (1917). ABOVE: Uncle Sam model Mike Reidy poses for *Uncle Sam* #1 (1997). BELOW LEFT: Sketch for the cover of *Uncle Sam* #1 (1997). BELOW: Cover art for *Uncle Sam* #1 (1997). "Each of the two covers for *Uncle Sam* symbolize taboos concerning the American flag. The first is walking on it. The second is burning it."

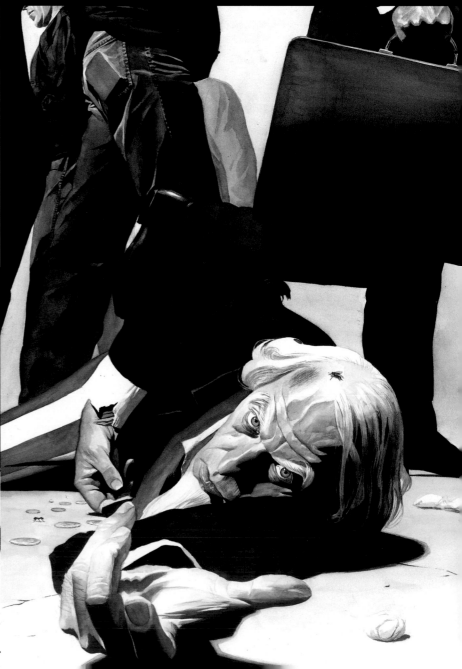

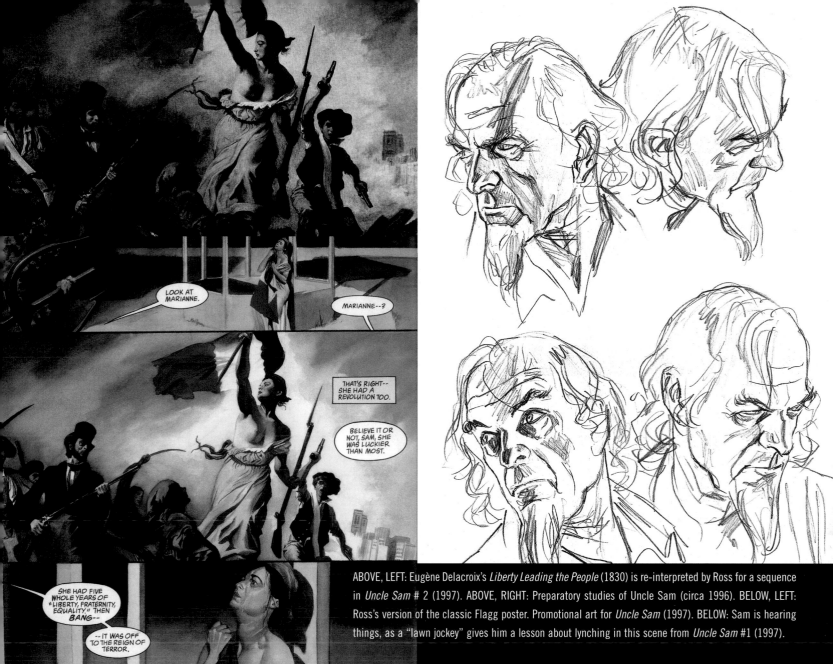

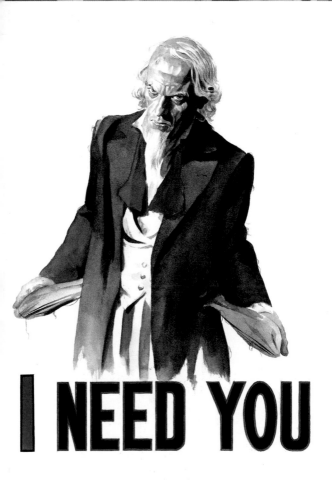

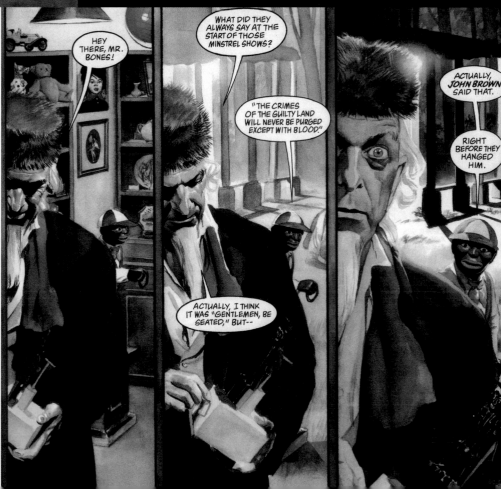

ABOVE, LEFT: Eugène Delacroix's *Liberty Leading the People* (1830) is re-interpreted by Ross for a sequence in *Uncle Sam* # 2 (1997). ABOVE, RIGHT: Preparatory studies of Uncle Sam (circa 1996). BELOW, LEFT: Ross's version of the classic Flagg poster. Promotional art for *Uncle Sam* (1997). BELOW: Sam is hearing things, as a "lawn jockey" gives him a lesson about lynching in this scene from *Uncle Sam* #1 (1997).

I NEED YOU

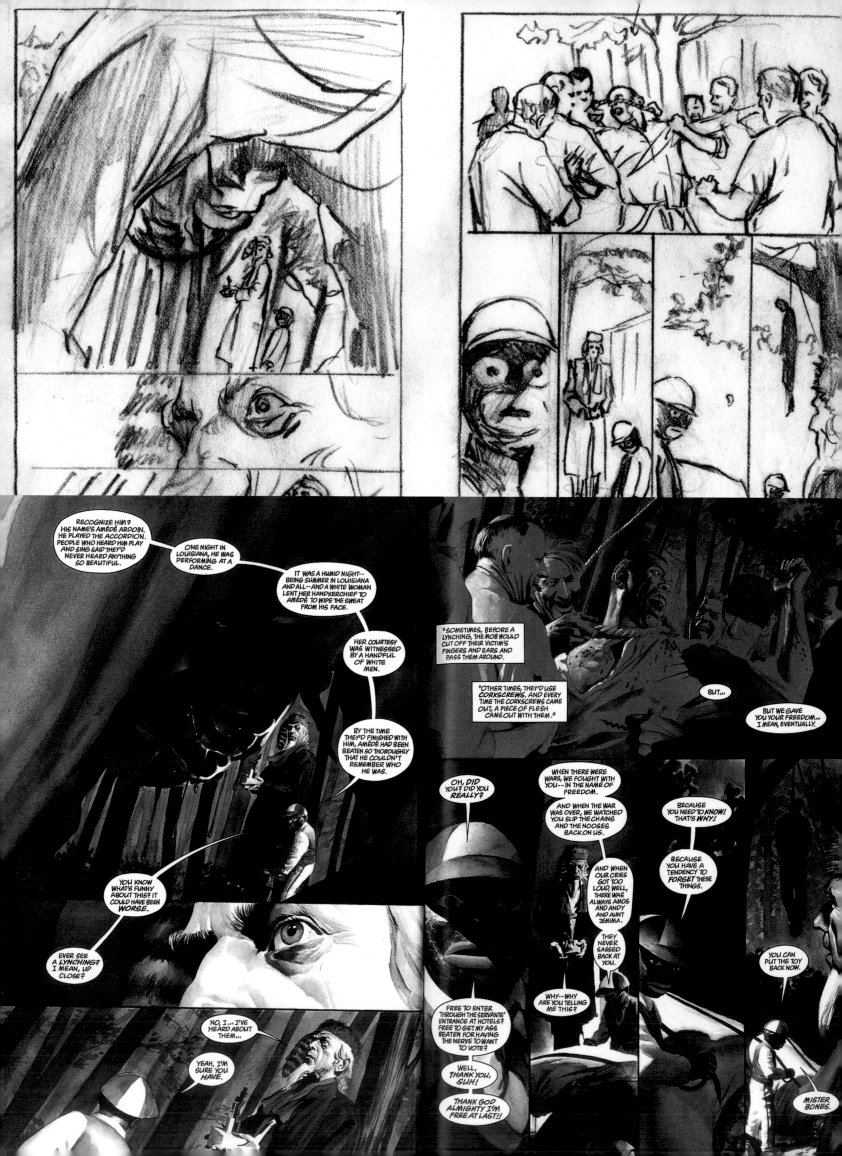

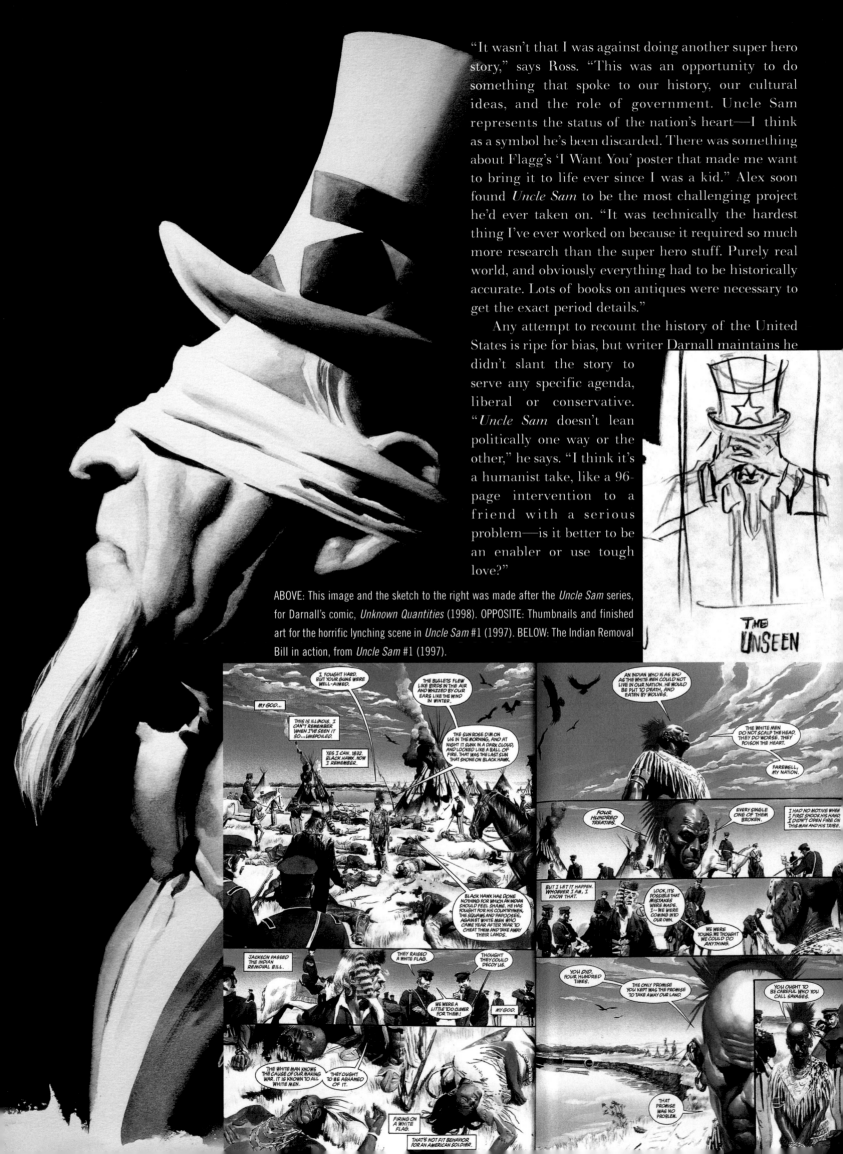

"It wasn't that I was against doing another super hero story," says Ross. "This was an opportunity to do something that spoke to our history, our cultural ideas, and the role of government. Uncle Sam represents the status of the nation's heart—I think as a symbol he's been discarded. There was something about Flagg's 'I Want You' poster that made me want to bring it to life ever since I was a kid." Alex soon found *Uncle Sam* to be the most challenging project he'd ever taken on. "It was technically the hardest thing I've ever worked on because it required so much more research than the super hero stuff. Purely real world, and obviously everything had to be historically accurate. Lots of books on antiques were necessary to get the exact period details."

Any attempt to recount the history of the United States is ripe for bias, but writer Darnall maintains he didn't slant the story to serve any specific agenda, liberal or conservative. "*Uncle Sam* doesn't lean politically one way or the other," he says. "I think it's a humanist take, like a 96-page intervention to a friend with a serious problem—is it better to be an enabler or use tough love?"

ABOVE: This image and the sketch to the right was made after the *Uncle Sam* series, for Darnall's comic, *Unknown Quantities* (1998). OPPOSITE: Thumbnails and finished art for the horrific lynching scene in *Uncle Sam* #1 (1997). BELOW: The Indian Removal Bill in action, from *Uncle Sam* #1 (1997).

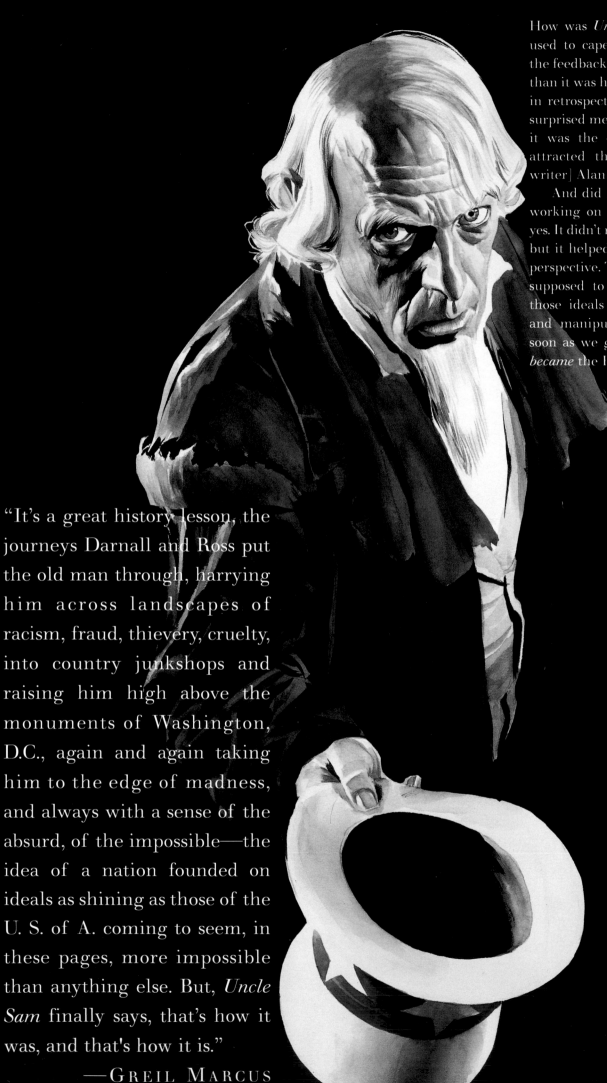

How was *Uncle Sam* received by fans used to capes and spandex? "Abroad, the feedback was much more favorable than it was here," says Ross. "I suppose in retrospect that's no mystery, but it surprised me at the time. For example, it was the one thing I'd done that attracted the notice of [*Watchmen* writer] Alan Moore."

And did Alex learn anything from working on the book? "Oh, my God, yes. It didn't make me anti-government, but it helped me put my feelings into perspective. The heart of this system is supposed to be based on ideals, but those ideals have been compromised and manipulated from the start. As soon as we got rid of the British, we *became* the British."

"It's a great history lesson, the journeys Darnall and Ross put the old man through, harrying him across landscapes of racism, fraud, thievery, cruelty, into country junkshops and raising him high above the monuments of Washington, D.C., again and again taking him to the edge of madness, and always with a sense of the absurd, of the impossible—the idea of a nation founded on ideals as shining as those of the U. S. of A. coming to seem, in these pages, more impossible than anything else. But, *Uncle Sam* finally says, that's how it was, and that's how it is."

—GREIL MARCUS

I CAN'T LET THEM KEEP ME HERE.

THIS GENERATION HAS A RENDEZVOUS WITH DESTINY!

UH-HUH. TELL IT TO THE JUDGE, PARTNER.

"There's a well-known quote that says: 'Eternal vigilance is the price of liberty.' And that's the whole point of *Uncle Sam*. America is a work in progress, and you can't finally say it's a success, because it's never over. Jefferson recommended a revolution every generation or so."

—STEVE DARNALL

OPPOSITE, LEFT: Art for an *Uncle Sam* print for the San Diego Comic-Con (1997). OPPOSITE, RIGHT: Sam quotes Ronald Reagan in this panel from *Uncle Sam* #1 (1997). LEFT: This radical take on James Montgomery Flagg's iconic poster was deemed too provocative for the jacket of the *Uncle Sam* hardcover, (1998). BELOW: The 1893 Columbian Exposition in Chicago, complete with Columbia herself, in a stunning sequence from *Uncle Sam* #2 (1997).

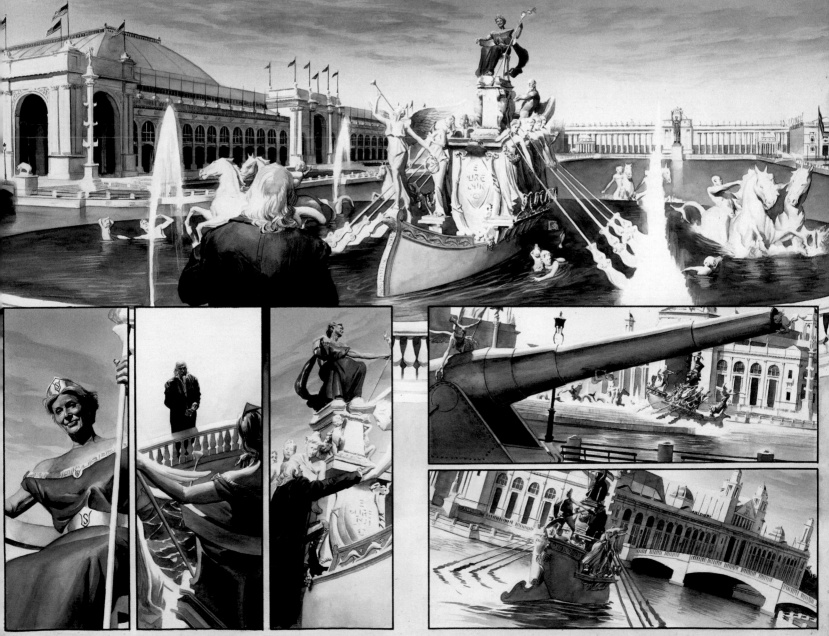

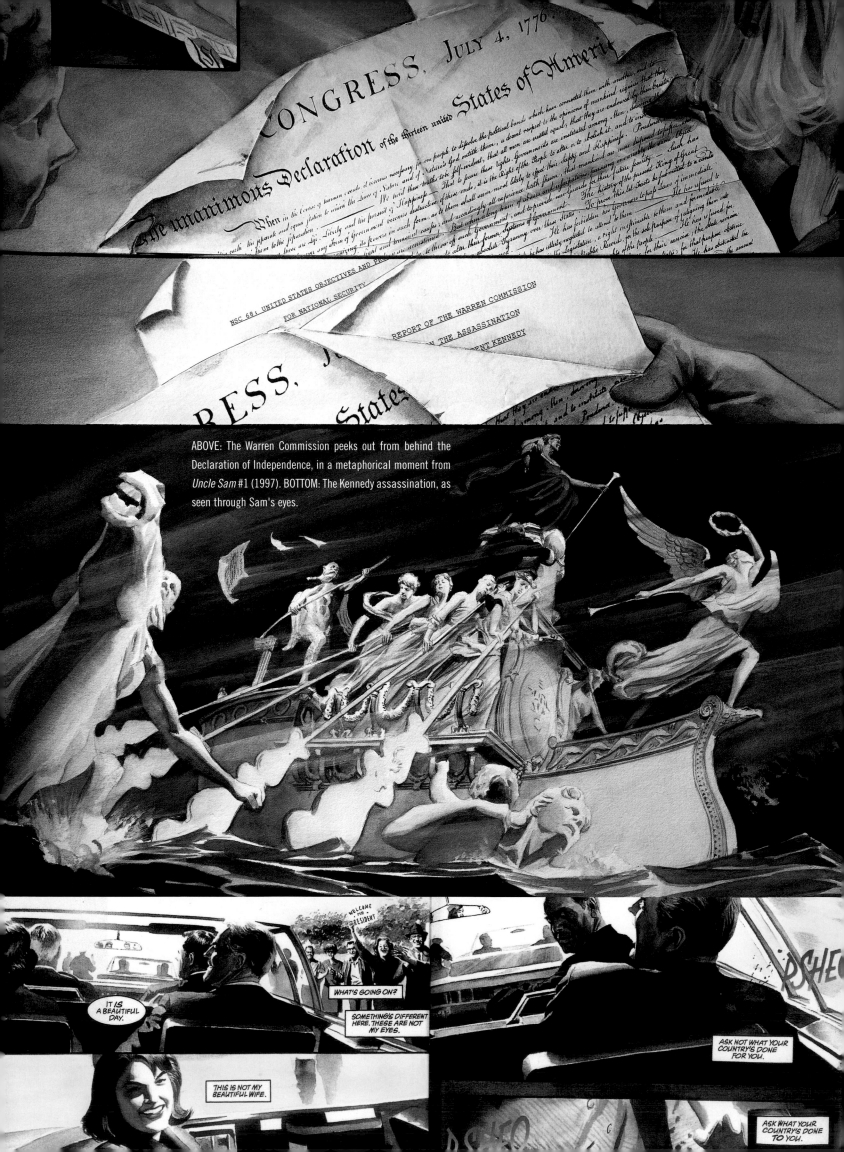

ABOVE: The Warren Commission peeks out from behind the Declaration of Independence, in a metaphorical moment from *Uncle Sam* #1 (1997). BOTTOM: The Kennedy assassination, as seen through Sam's eyes.

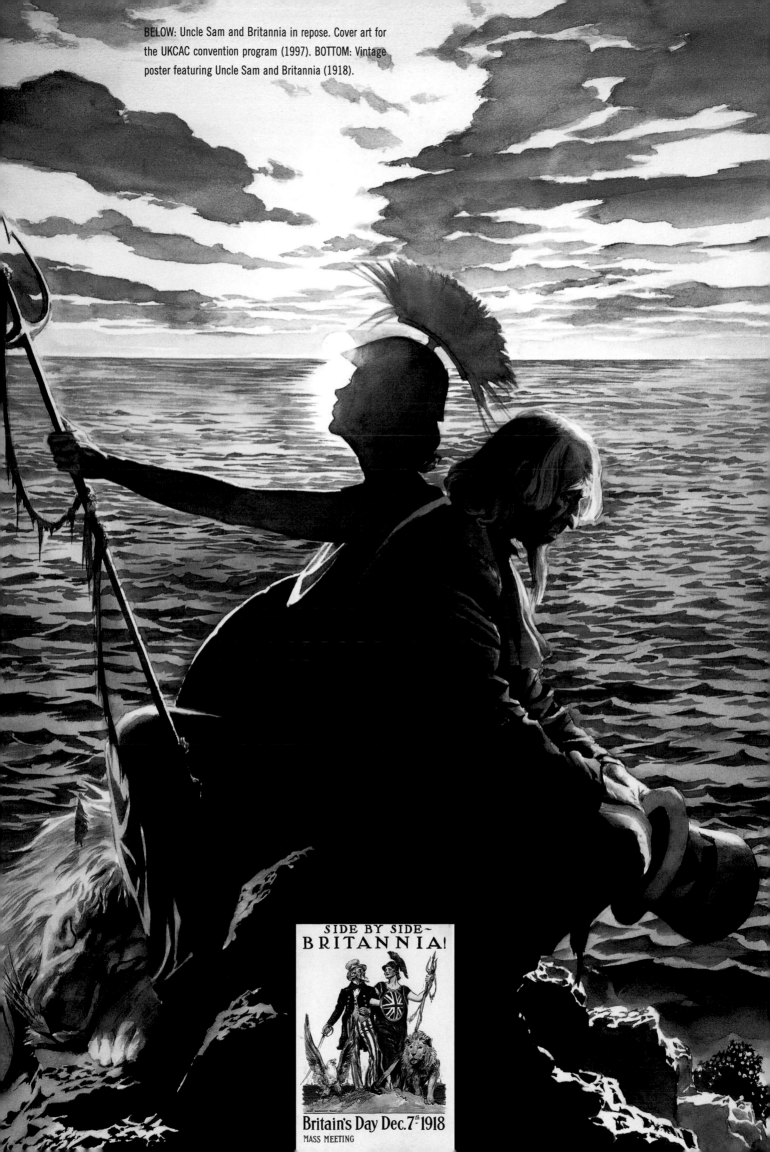

BELOW: Uncle Sam and Britannia in repose. Cover art for the UKCAC convention program (1997). BOTTOM: Vintage poster featuring Uncle Sam and Britannia (1918).

SIDE BY SIDE ~
BRITANNIA!

Britain's Day Dec. 7th 1918
MASS MEETING

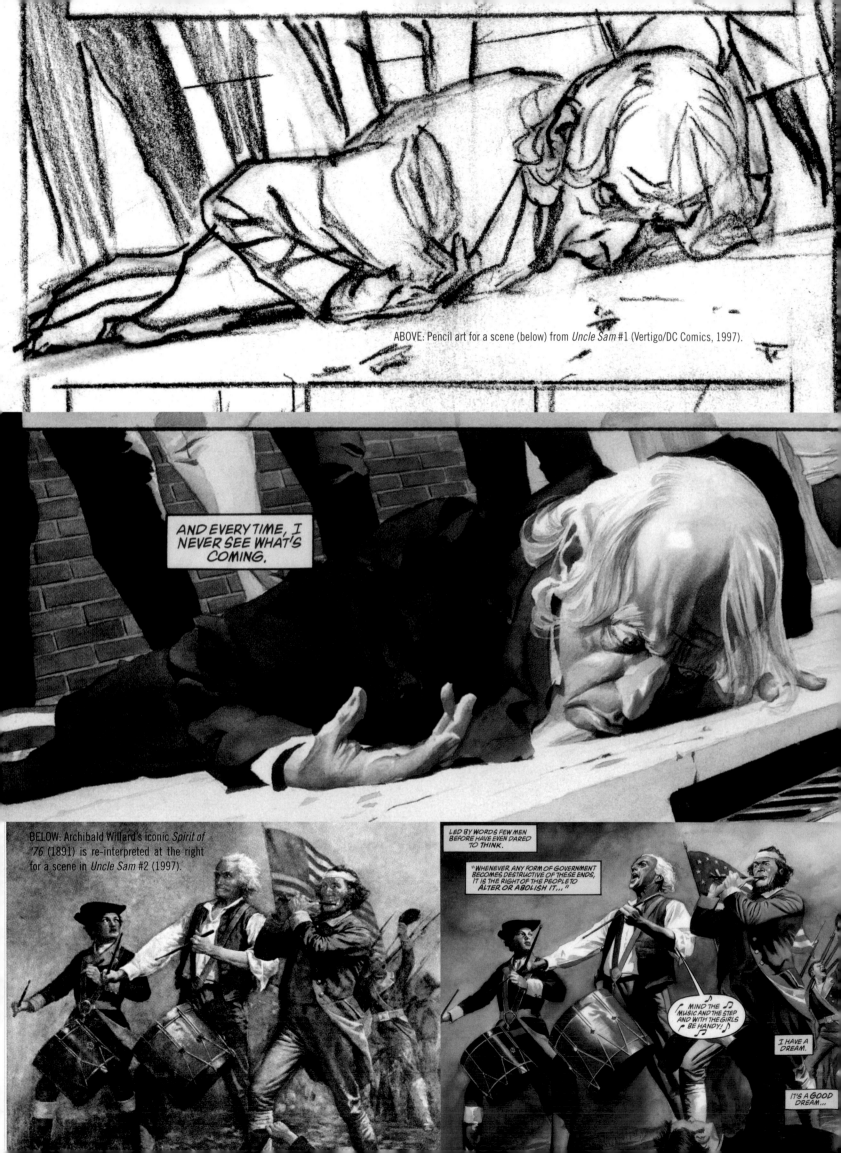

ABOVE: Pencil art for a scene (below) from *Uncle Sam* #1 (Vertigo/DC Comics, 1997).

AND EVERY TIME, I NEVER SEE WHAT'S COMING.

BELOW: Archibald Willard's iconic *Spirit of '76* (1891) is re-interpreted at the right for a scene in *Uncle Sam* #2 (1997).

LED BY WORDS FEW MEN BEFORE HAVE EVEN DARED TO THINK.

"WHENEVER ANY FORM OF GOVERNMENT BECOMES DESTRUCTIVE OF THESE ENDS, IT IS THE RIGHT OF THE PEOPLE TO ALTER OR ABOLISH IT..."

MIND THE MUSIC AND THE STEP AND WITH THE GIRLS BE HANDY!

I HAVE A DREAM.

IT'S A GOOD DREAM...

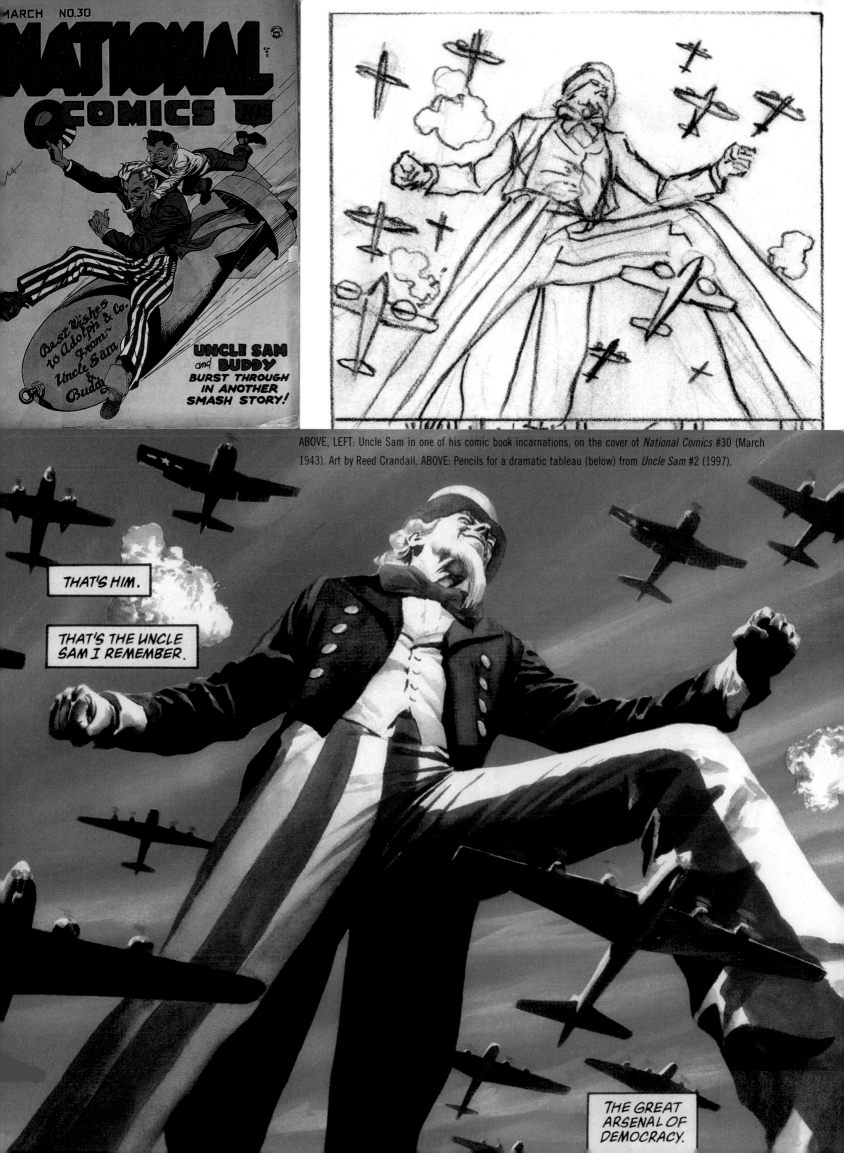

ABOVE, LEFT: Uncle Sam in one of his comic book incarnations, on the cover of *National Comics* #30 (March 1943). Art by Reed Crandall. ABOVE: Pencils for a dramatic tableau (below) from *Uncle Sam* #2 (1997).

THIS IS AN OBVIOUS ALLEGORY
TO THE CONCEPT "BLOOD ON HIS HANDS"
AND/OR "BLOOD ON THE FLAG".

P. 44
OR
45

BLOOD FLOWING
DOWN LIKE STRIPE
BANDS ON THE WALL
BEHIND HIM.
(SHOULD HE AT SOME
POINT BEFORE PASSING
OUT SAY, "I SEE STARS"?)

CARRIE
MEETS
UNCLE SAM

THIS IMAGE PLAYS TOWARD ~~THE~~
IDEA THAT THE SOLDIER'S BLOOD
IS ON HIS HANDS. SOME KIND OF
PANEL ~~BEFORE~~ WOULD PRECEDE THIS, FORESHADOWING
THE SHAY'S REBELLION (AND POSSIBLY
ADDITIONAL WAR MARTYRDOM FROM OTHER
POINTS IN HISTORY) AND SETTING UP
HIS GUILT FOR ISSUE #2.

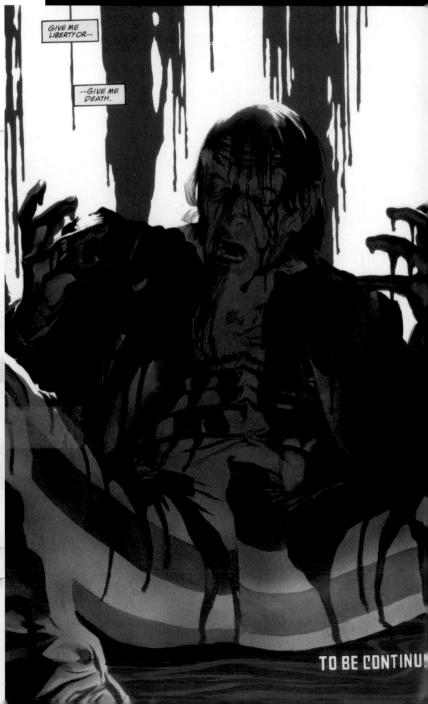

GIVE ME
LIBERTY OR--

--GIVE ME
DEATH.

TO BE CONTINU

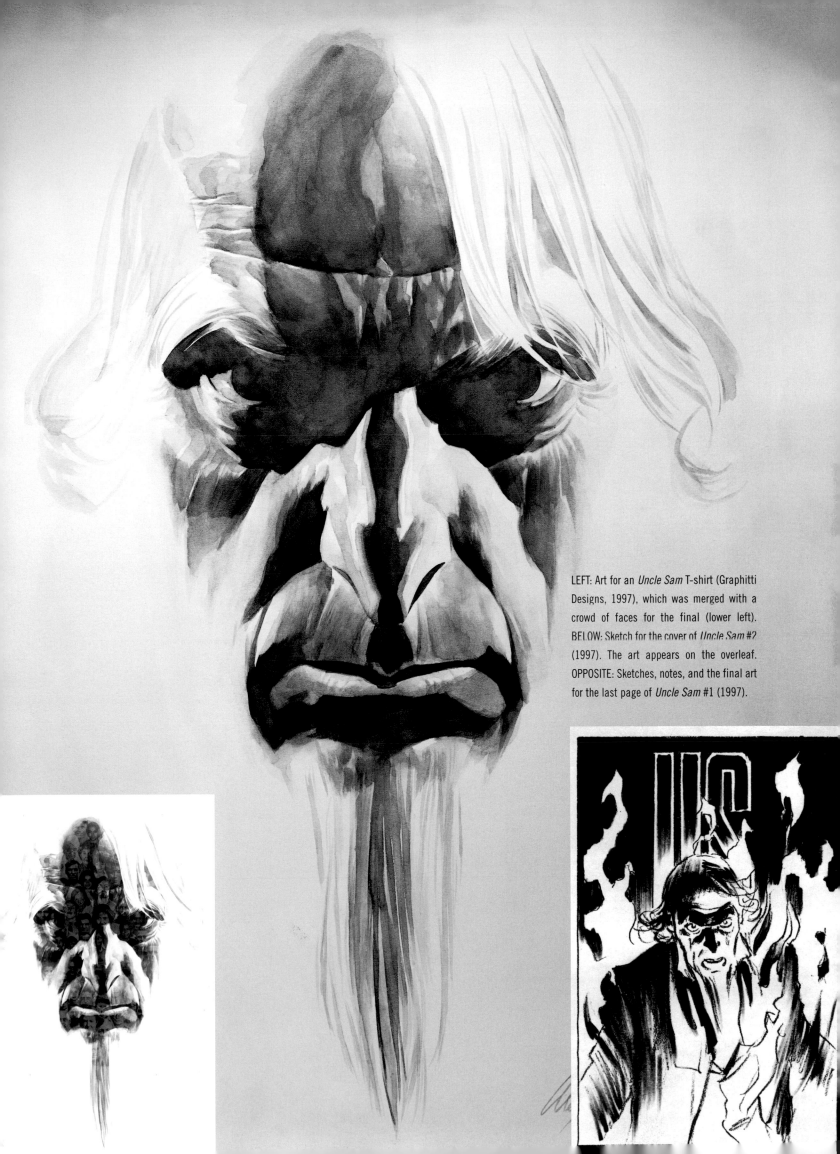

LEFT: Art for an *Uncle Sam* T-shirt (Graphitti Designs, 1997), which was merged with a crowd of faces for the final (lower left).
BELOW: Sketch for the cover of *Uncle Sam* #2 (1997). The art appears on the overleaf.
OPPOSITE: Sketches, notes, and the final art for the last page of *Uncle Sam* #1 (1997).

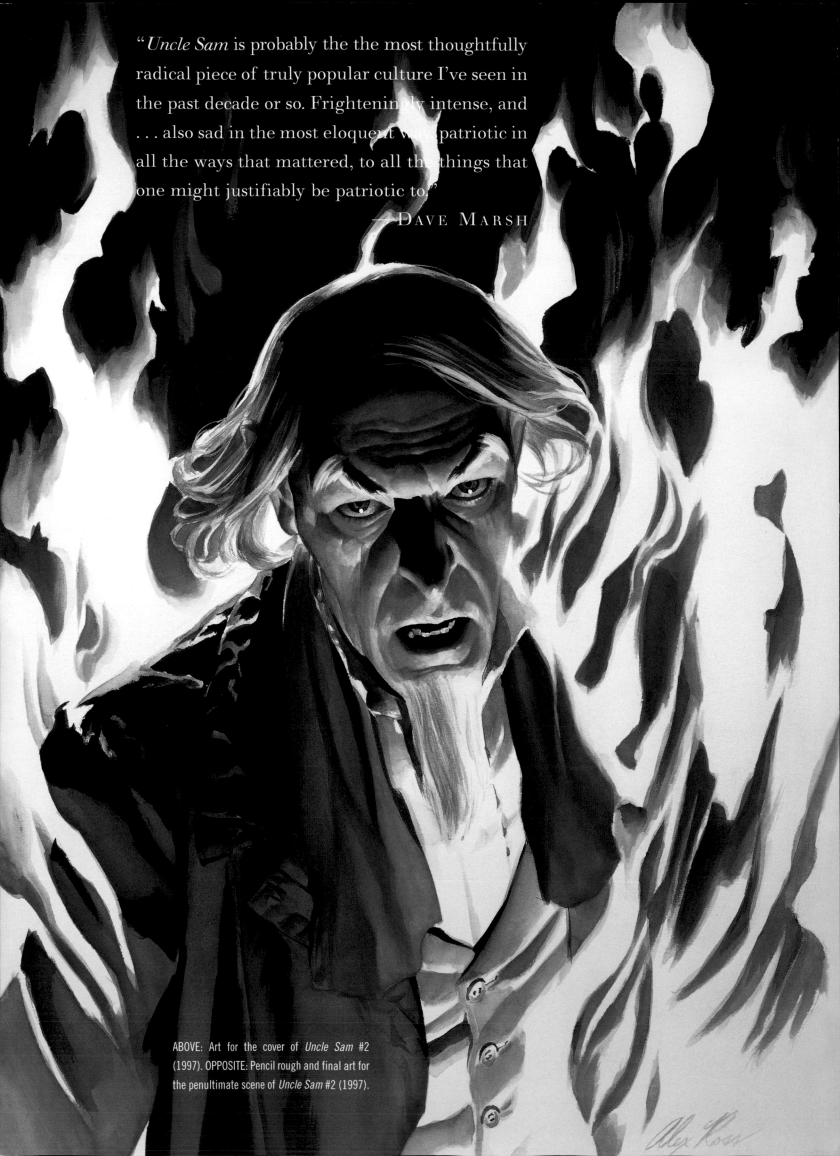

"*Uncle Sam* is probably the the most thoughtfully radical piece of truly popular culture I've seen in the past decade or so. Frighteningly intense, and . . . also sad in the most eloquent way, patriotic in all the ways that mattered, to all the things that one might justifiably be patriotic to."

— DAVE MARSH

ABOVE: Art for the cover of *Uncle Sam* #2 (1997). OPPOSITE: Pencil rough and final art for the penultimate scene of *Uncle Sam* #2 (1997).

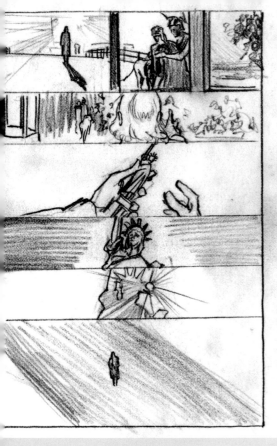
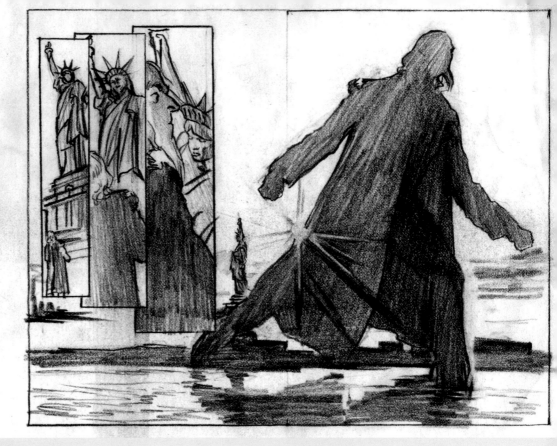

"THAT'S THE BEAUTY OF FREEDOM . . . YOU NEVER KNOW WHAT HAPPENS NEXT.
AND THE ONLY WAY TO KNOW HOW FREEDOM WORKS . . . IS TO WORK AT IT."
—from *Uncle Sam* #2 (1997)

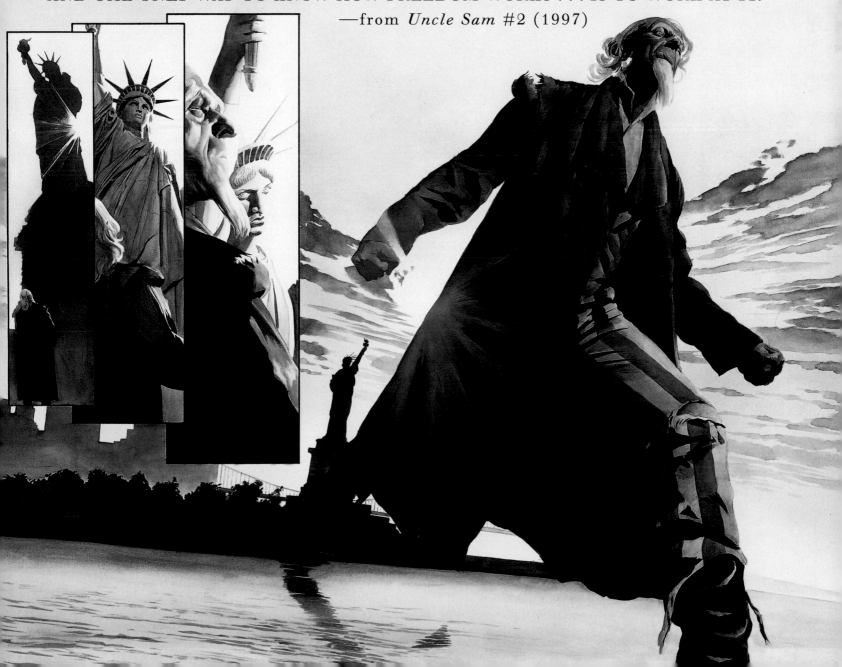

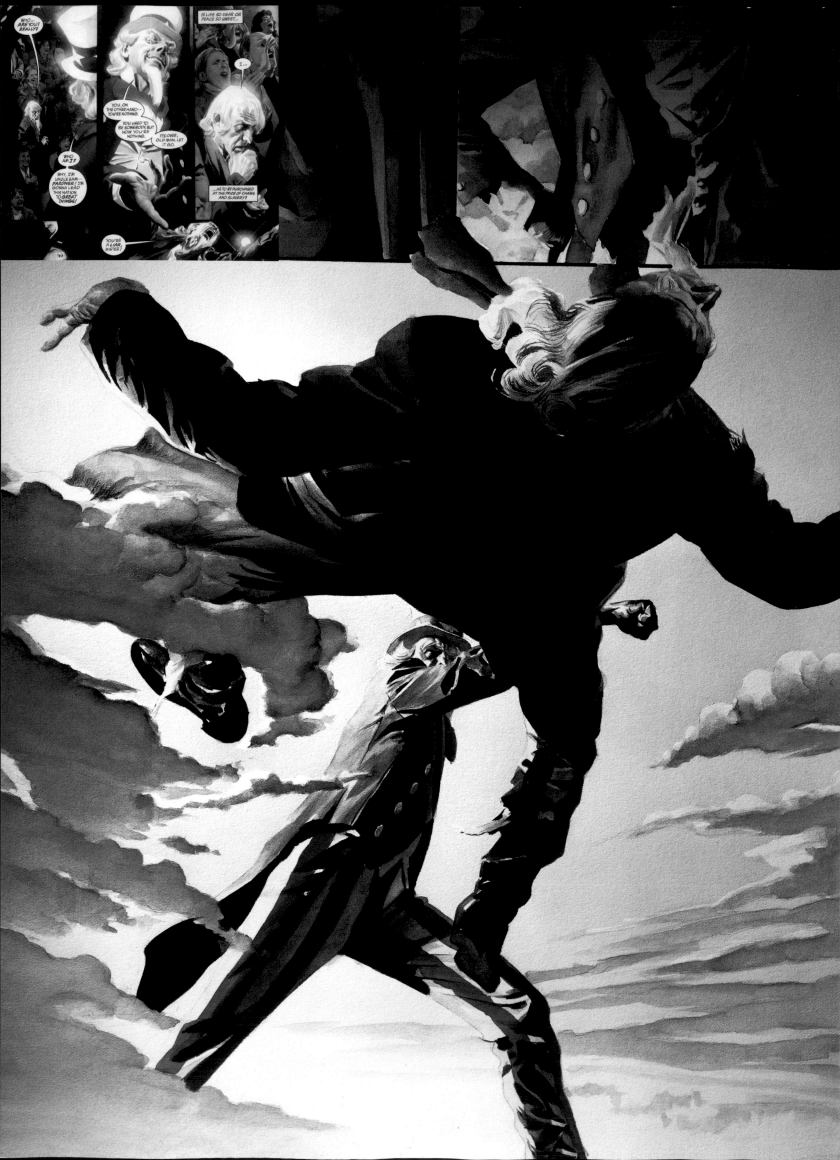

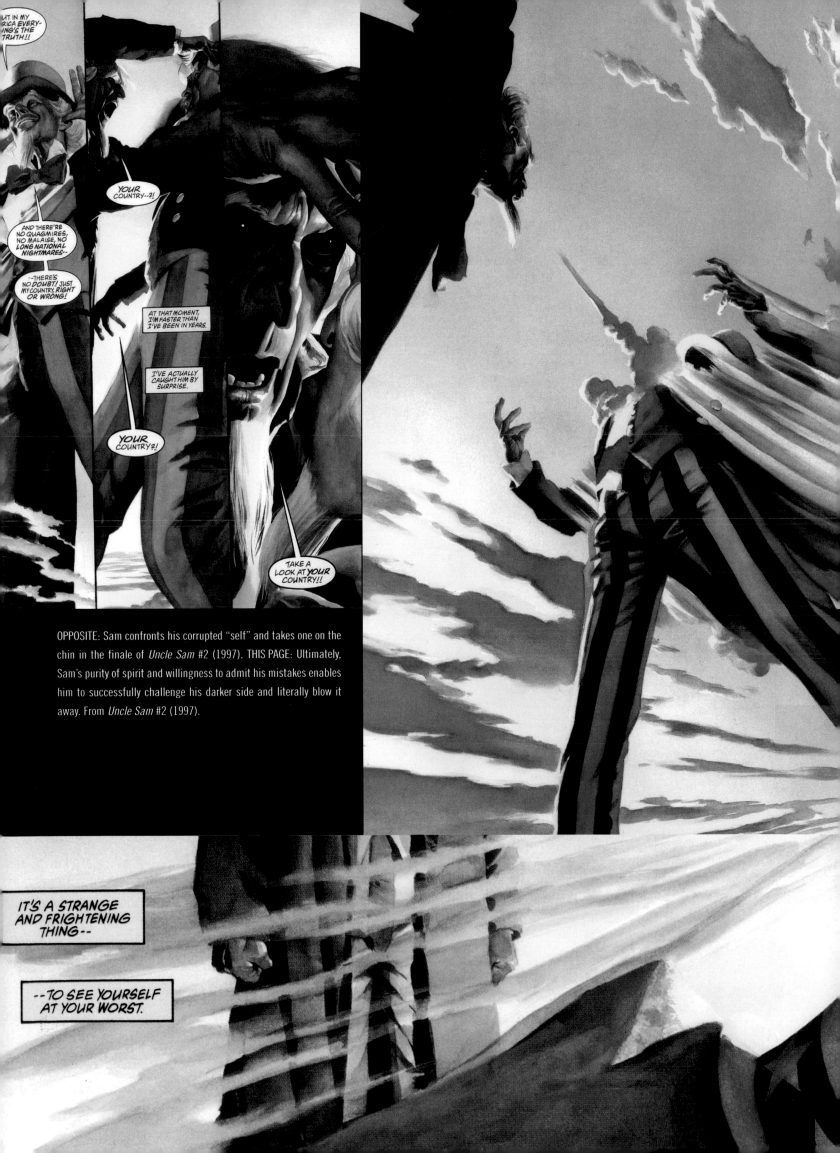

OPPOSITE: Sam confronts his corrupted "self" and takes one on the chin in the finale of *Uncle Sam* #2 (1997). THIS PAGE: Ultimately, Sam's purity of spirit and willingness to admit his mistakes enables him to successfully challenge his darker side and literally blow it away. From *Uncle Sam* #2 (1997).

The first cover concept—Superman flying head-on at the viewer—was suggested by the author, but deemed too similar to one of Ross's earlier paintings.

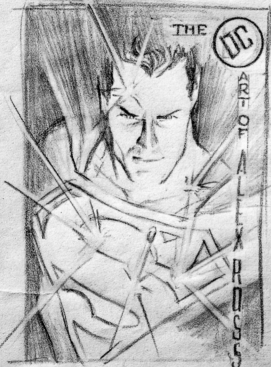

Ross suggested that the same lighting and position of the head could be maintained, while changing the figure's stance. The light source would now come from bullets ricocheting off of his chest. This design also allows for Superman's iconic "S" to literally shine. (Ross added a sketch of a DC Comics logo from the early 1970s, just for fun.)

Not used to typography running through the middle of his work, Ross nonetheless tried it and was surprisingly pleased. The fact that this design has an impact even reduced in black and white is a very good sign—the final execution could only increase its power.

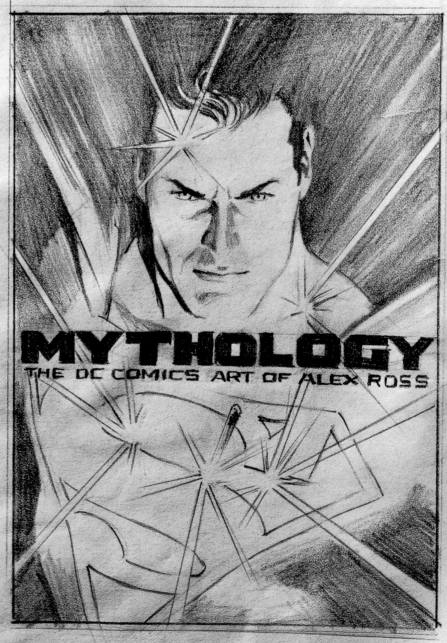

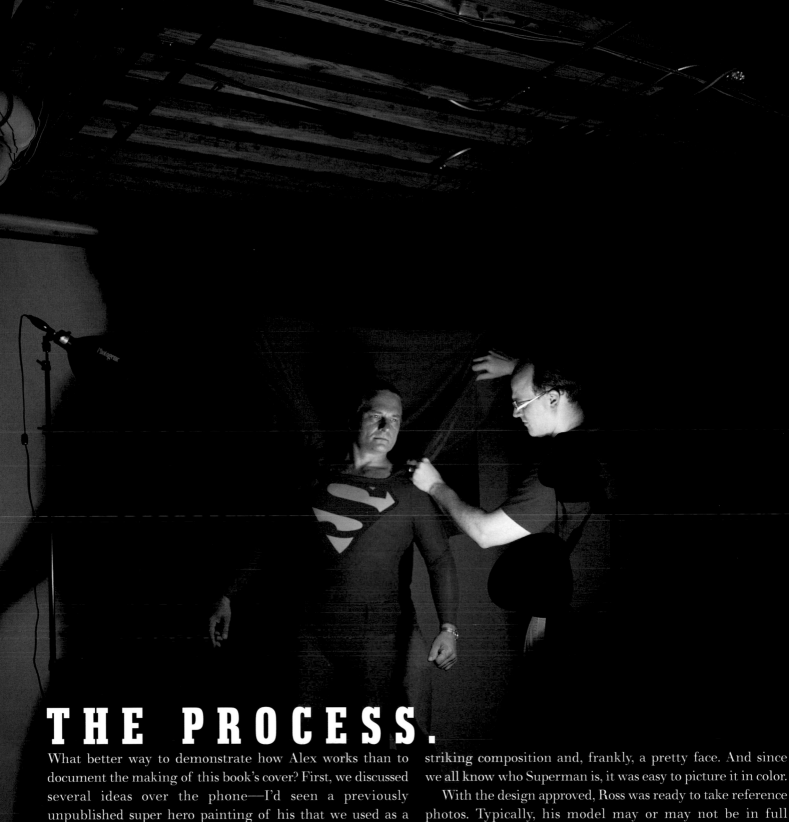

THE PROCESS.

What better way to demonstrate how Alex works than to document the making of this book's cover? First, we discussed several ideas over the phone—I'd seen a previously unpublished super hero painting of his that we used as a starting point. It featured a Superman-like character flying directly at the viewer, lit from below. He didn't want to copy it exactly, so he adapted it to a different pose while keeping its lighting and confrontational tone. The addition of ricocheting bullets worked for both of us because they provided a light source that also symbolized strength. (I also liked the implication that the reader was shooting at the book, don't ask me why.)

He faxed me his sketches on an ordinary 8-1/2 x 11 sheet (opposite). I enlarged the one on the lower right to size on our Xerox machine, wrapped it around a blank book dummy, and presented it to our editor-in-chief for approval. Even in its distressed black-and-white state you could tell it had everything: instant engagement, iconic presence,

striking composition and, frankly, a pretty face. And since we all know who Superman is, it was easy to picture it in color.

With the design approved, Ross was ready to take reference photos. Typically, his model may or may not be in full costume, depending on the character. Backgrounds can vary too, though less so now that Ross has a small photo studio of his own (see above). What matters is the right subject. "The connection to a person grounds me to the work, and feeds my imagination, which is not infinite. I wish it were, but it's not. If all I ever looked at was comic books for reference, then everything I did would just be flat. Interacting with a model gets me back into the real world. It earns me the right to do what I'm doing."

Which, amazingly, is in watercolor. What led him to the medium of gouache? "Trial and error. Acrylic is more like a plastic—once it dries, that's it. You can't pick it up again. With gouache you can. But it also has that range from opacity to transparency, depending on how thin you make it."

Ross's biggest breakthrough as an illustrator came in June 1987 at the American Academy of Art, when he was introduced to the use of live models. "Before that I had no idea how much I could grow as a draftsman. It was a *huge* turning point, because all through grade school I hadn't so much as drawn from photographs— I'd always thought that you had to make it all up out of your head, and that's how you did 'fantasy' illustration. Now I wonder if I would have developed even sooner had I drawn from life as a child."

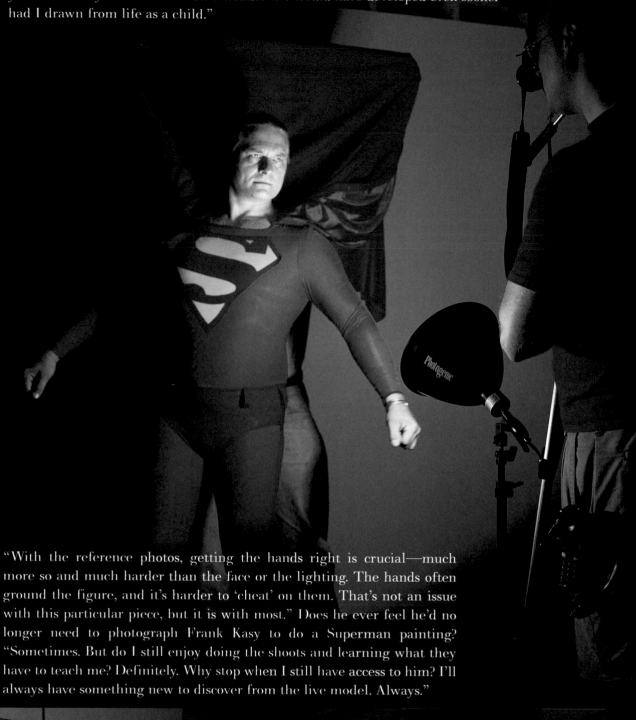

"With the reference photos, getting the hands right is crucial—much more so and much harder than the face or the lighting. The hands often ground the figure, and it's harder to 'cheat' on them. That's not an issue with this particular piece, but it is with most." Does he ever feel he'd no longer need to photograph Frank Kasy to do a Superman painting? "Sometimes. But do I still enjoy doing the shoots and learning what they have to teach me? Definitely. Why stop when I still have access to him? I'll always have something new to discover from the live model. Always."

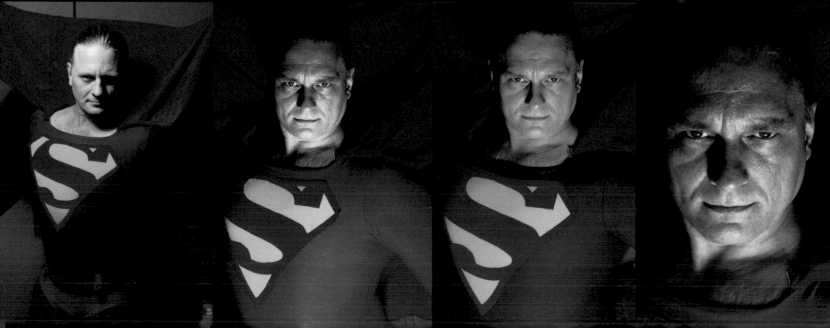

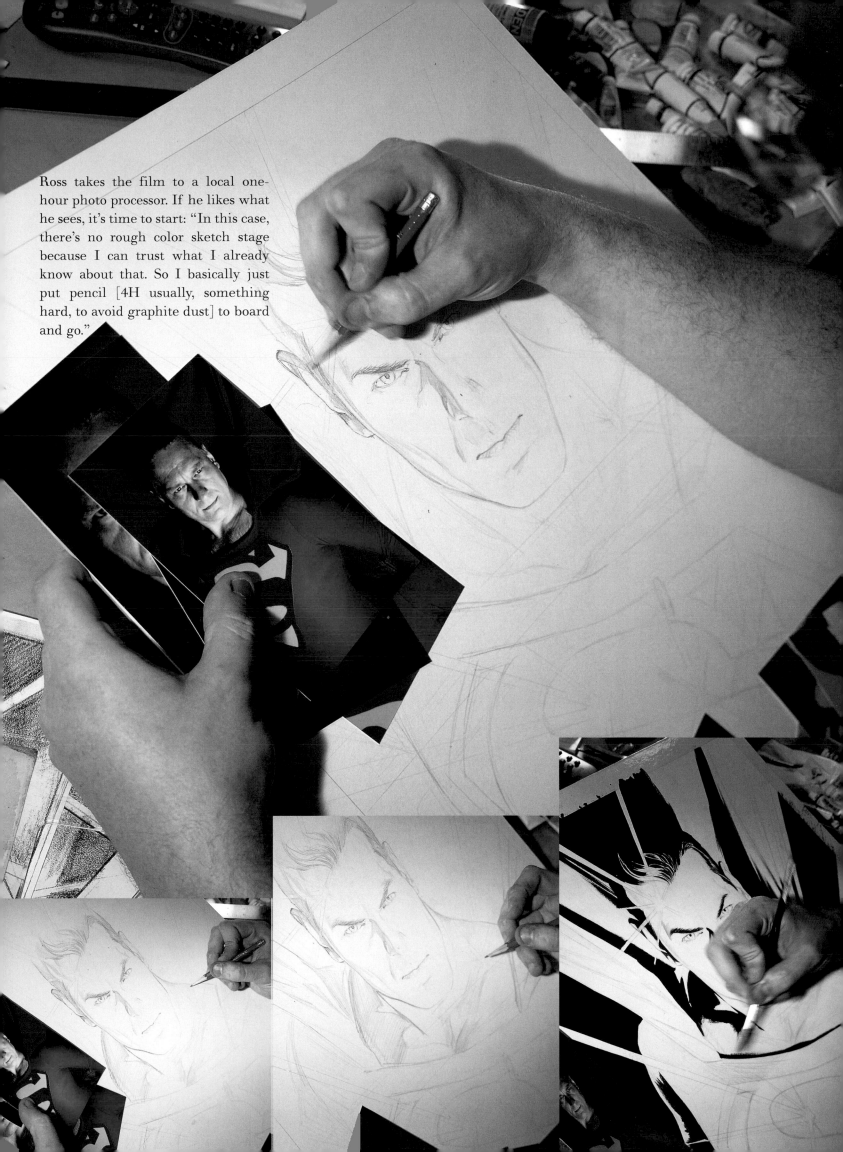

Ross takes the film to a local one-hour photo processor. If he likes what he sees, it's time to start: "In this case, there's no rough color sketch stage because I can trust what I already know about that. So I basically just put pencil [4H usually, something hard, to avoid graphite dust] to board and go."

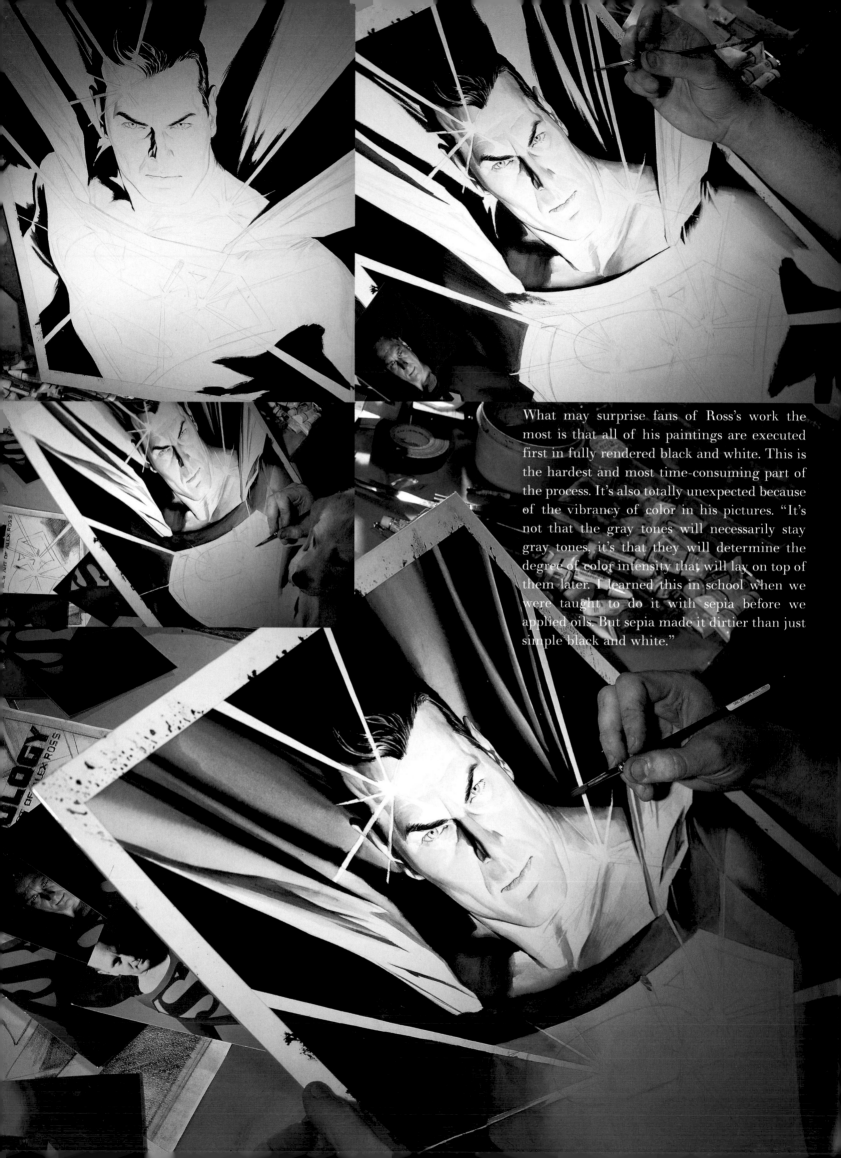

What may surprise fans of Ross's work the most is that all of his paintings are executed first in fully rendered black and white. This is the hardest and most time-consuming part of the process. It's also totally unexpected because of the vibrancy of color in his pictures. "It's not that the gray tones will necessarily stay gray tones, it's that they will determine the degree of color intensity that will lay on top of them later. I learned this in school when we were taught to do it with sepia before we applied oils. But sepia made it dirtier than just simple black and white."

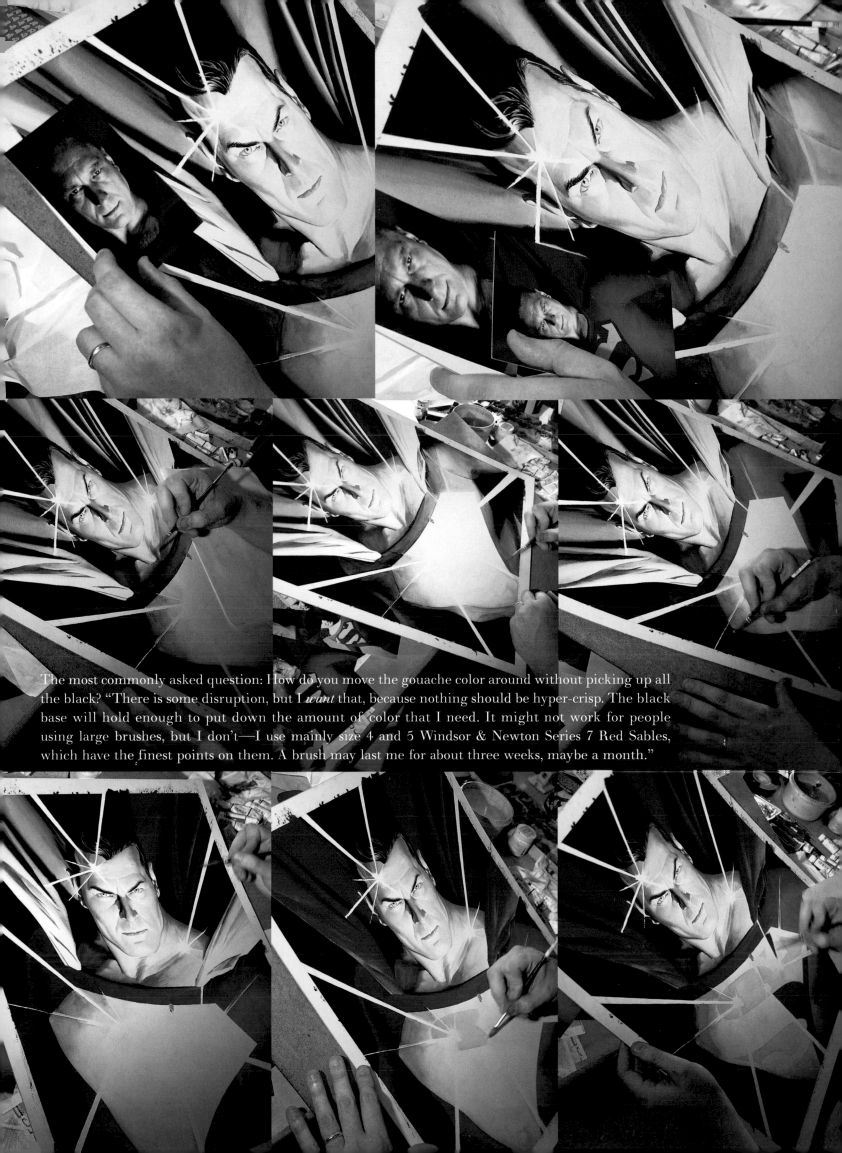

The most commonly asked question: How do you move the gouache color around without picking up all the black? "There is some disruption, but I *want* that, because nothing should be hyper-crisp. The black base will hold enough to put down the amount of color that I need. It might not work for people using large brushes, but I don't—I use mainly size 4 and 5 Windsor & Newton Series 7 Red Sables, which have the finest points on them. A brush may last me for about three weeks, maybe a month."

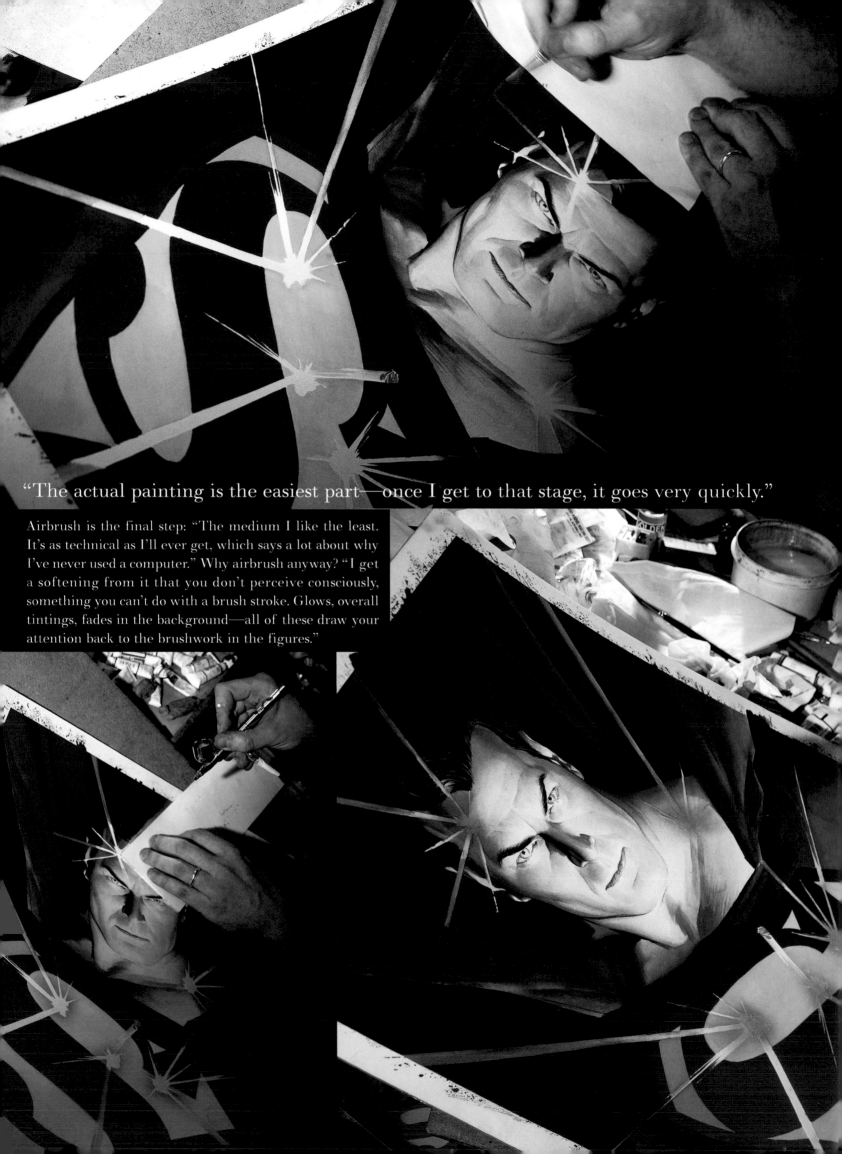

"The actual painting is the easiest part—once I get to that stage, it goes very quickly."

Airbrush is the final step: "The medium I like the least. It's as technical as I'll ever get, which says a lot about why I've never used a computer." Why airbrush anyway? "I get a softening from it that you don't perceive consciously, something you can't do with a brush stroke. Glows, overall tintings, fades in the background—all of these draw your attention back to the brushwork in the figures."

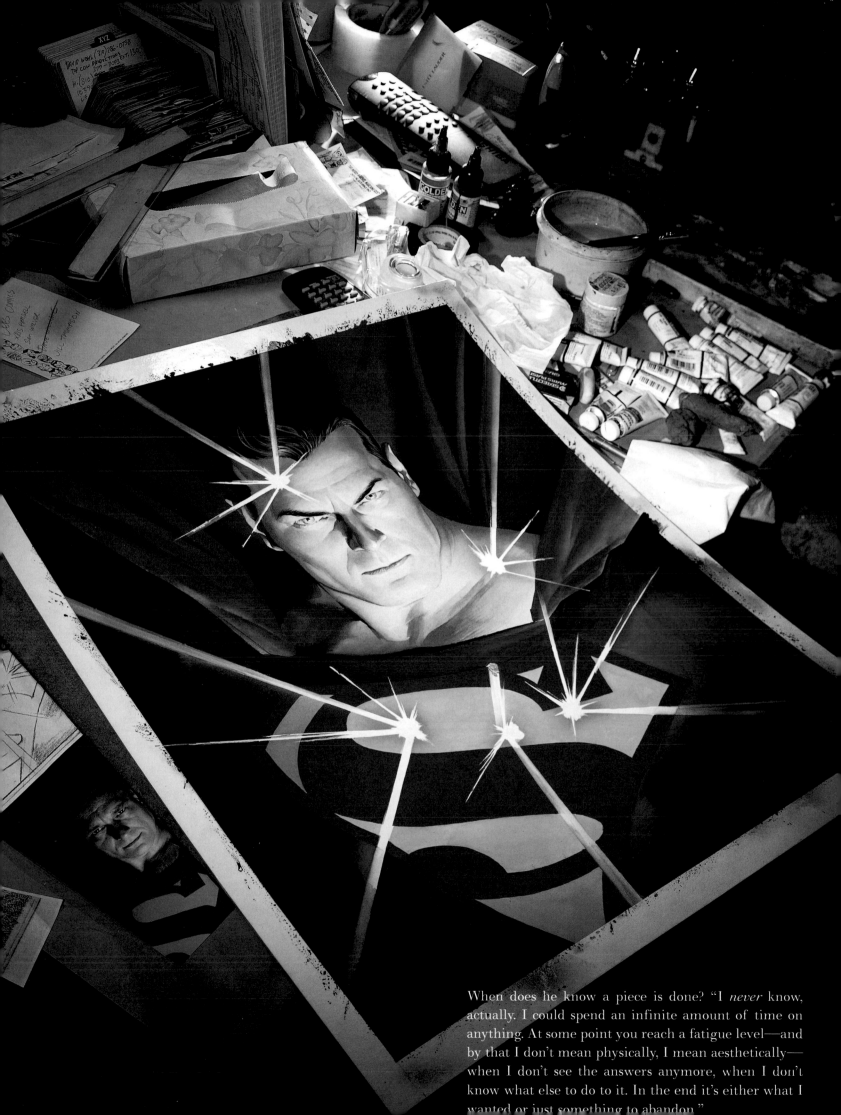

When does he know a piece is done? "I *never* know, actually. I could spend an infinite amount of time on anything. At some point you reach a fatigue level—and by that I don't mean physically, I mean aesthetically— when I don't see the answers anymore, when I don't know what else to do to it. In the end it's either what I wanted or just something to abandon."

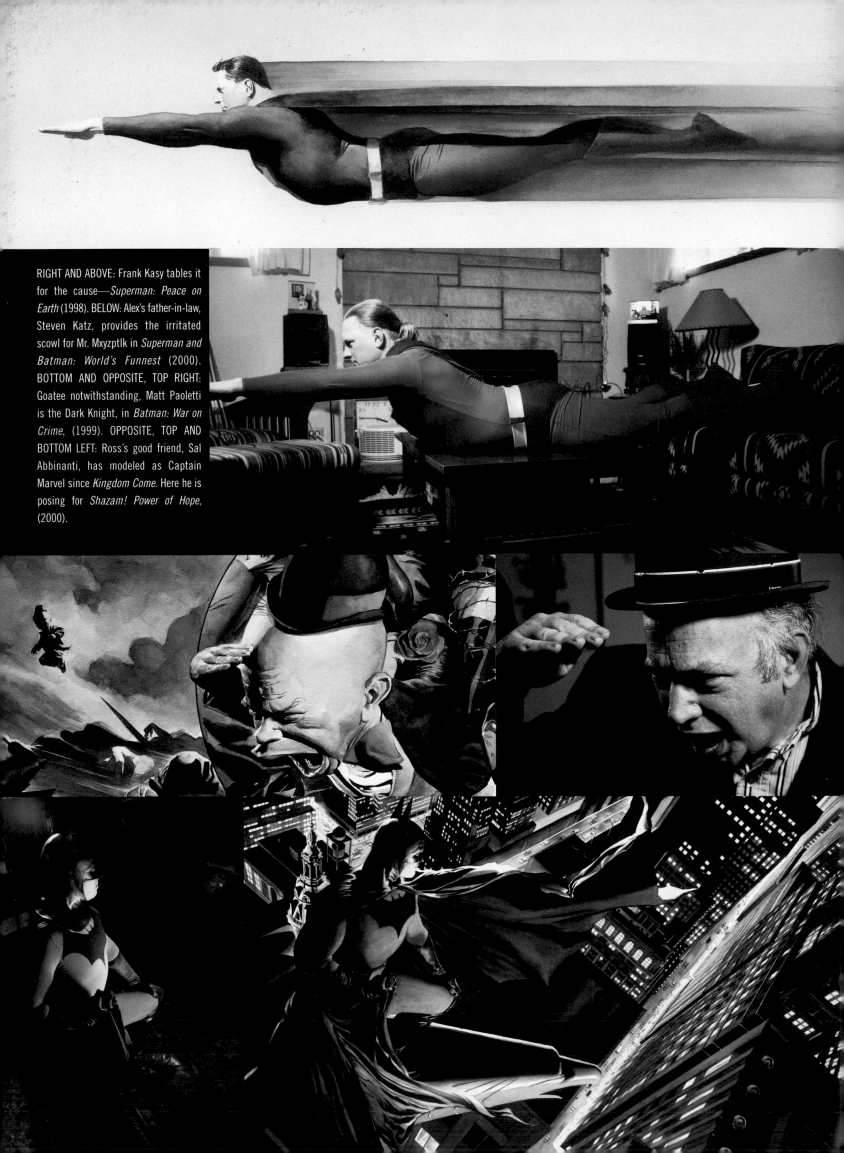

RIGHT AND ABOVE: Frank Kasy tables it for the cause—*Superman: Peace on Earth* (1998). BELOW: Alex's father-in-law, Steven Katz, provides the irritated scowl for Mr. Mxyzptlk in *Superman and Batman: World's Funnest* (2000). BOTTOM AND OPPOSITE, TOP RIGHT: Goatee notwithstanding, Matt Paoletti is the Dark Knight, in *Batman: War on Crime*, (1999). OPPOSITE, TOP AND BOTTOM LEFT: Ross's good friend, Sal Abbinanti, has modeled as Captain Marvel since *Kingdom Come*. Here he is posing for *Shazam! Power of Hope*, (2000).

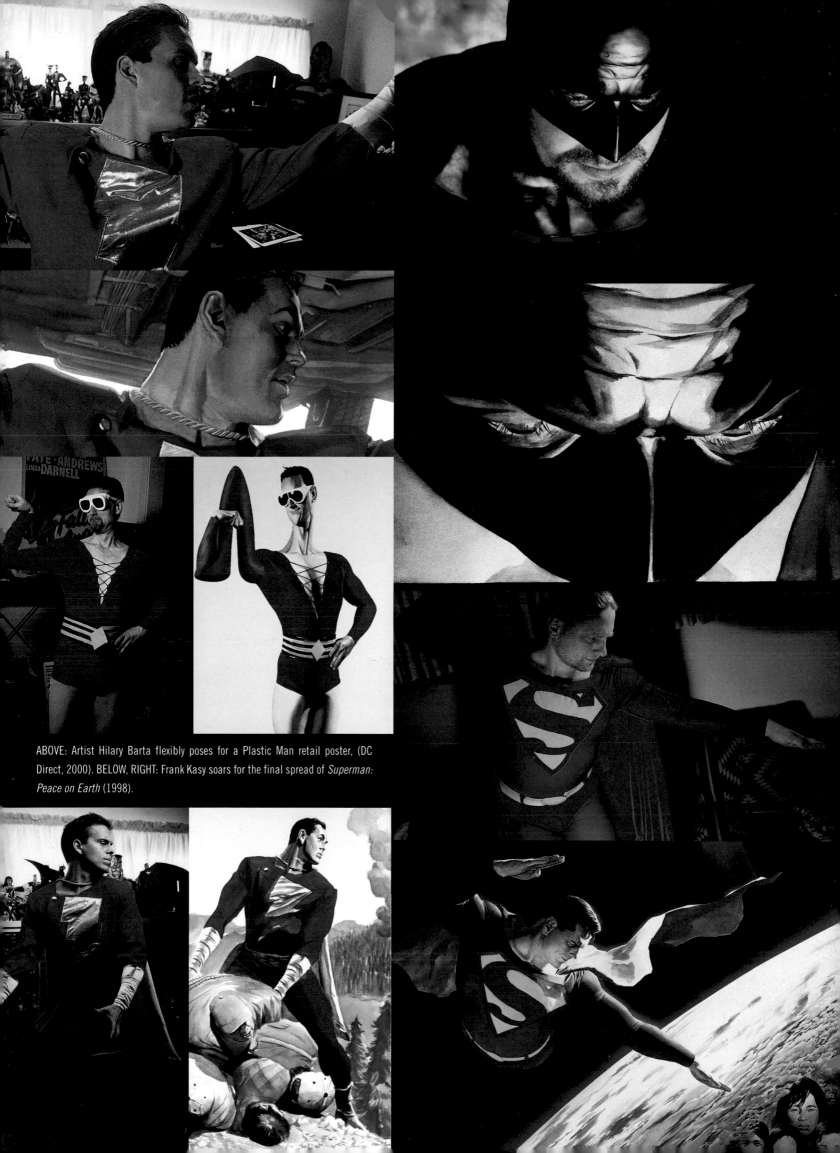

ABOVE: Artist Hilary Barta flexibly poses for a Plastic Man retail poster, (DC Direct, 2000). BELOW, RIGHT: Frank Kasy soars for the final spread of *Superman: Peace on Earth* (1998).

CREATING A STORY.

It promised to be either a dream come true or one of the most profoundly intimidating assignments I'd ever gotten: write an eight-page story for Alex to paint especially for this book. It turned out to be both, though much more the former than the latter.

We settled on Superman and Batman together, thanks to an idea from editor Charles Kochman, who also suggested opening with Superman bursting through the globe atop the Daily Planet Building. There's been a trend in the last fifteen years or so toward the idea that the two are actually adversaries and mistrustful of one another. I suppose this is considered "edgy." Call me sentimental, but I've never liked it—it's too much like George Washington turning on Ben Franklin. We wanted to show them as the "World's Finest" team we grew up on. Charlie pointed us in the direction of a story by Roger Stern, Bob McLeod, and Brett Breeding that appeared in *Action Comics* #654 ("Deadly Covenant," June 1990). The last three panels are below. Where that story ends, ours begins: what happens when Superman, for no discernable reason, goes mad and starts destroying Metropolis? Batman has the means to stop him, but does that mean stopping him, literally, for good?

Given scheduling and budget constraints, we had eight pages. Alex's biggest reservation was how to fit something so epic into such a relatively small amount of space. Starting the story after it's begun and ending it before it's over was the answer. One aspect of the length did allow for a new creative experience. Ross says: "I'd never before roughed out an entire story in one shot, with the writer sitting right next to me. It was the most collaborative storytelling process I've been involved in to date." I'd have to agree, and will never forget the sight of Ross producing rough pencils (with no reference) that were so fully formed—the final art didn't change, compositionally, at all. (A better case for alchemy I've never seen.)

Several matters of final dialogue were settled on after the art was completed. For example, on page three Batman attempts to get Superman's attention by shouting "Kal!," which is short for Kal-El, his Kryptonian birthname. I originally wrote "Clark!," but Alex felt that Batman wouldn't compromise Kent's secret identity by screaming his name out loud in public.

Be sure and check out the treads on Batman's boots, and keep your eyes peeled for a certain designer/author and his photographer sidekick masquerading as high-rise wage slaves on the second-to-last page. . . .

BELOW: Alex's very first rough sketches for "The Trust," (left). Note he initially had Superman bursting through the Daily Planet globe from above and heading down toward the street. I urged him to reverse it and put the "camera" high above and launch him upward, right, because most of the story takes place in the sky. I also thought it would add a sense of disorientation to position him upside down in relation to the reader. The shot of Batman with the gun was Alex's idea—very "Dirty Harry" and shocking, given Batman's distaste for such weapons. We knew what the ending would be, but I'll admit I had absolutely no idea how we would get there. Alex solved it beautifully.

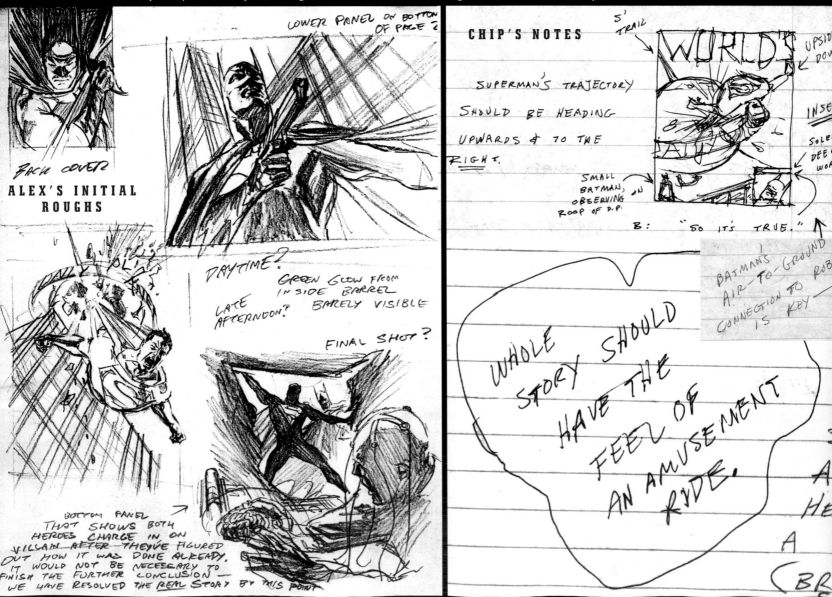

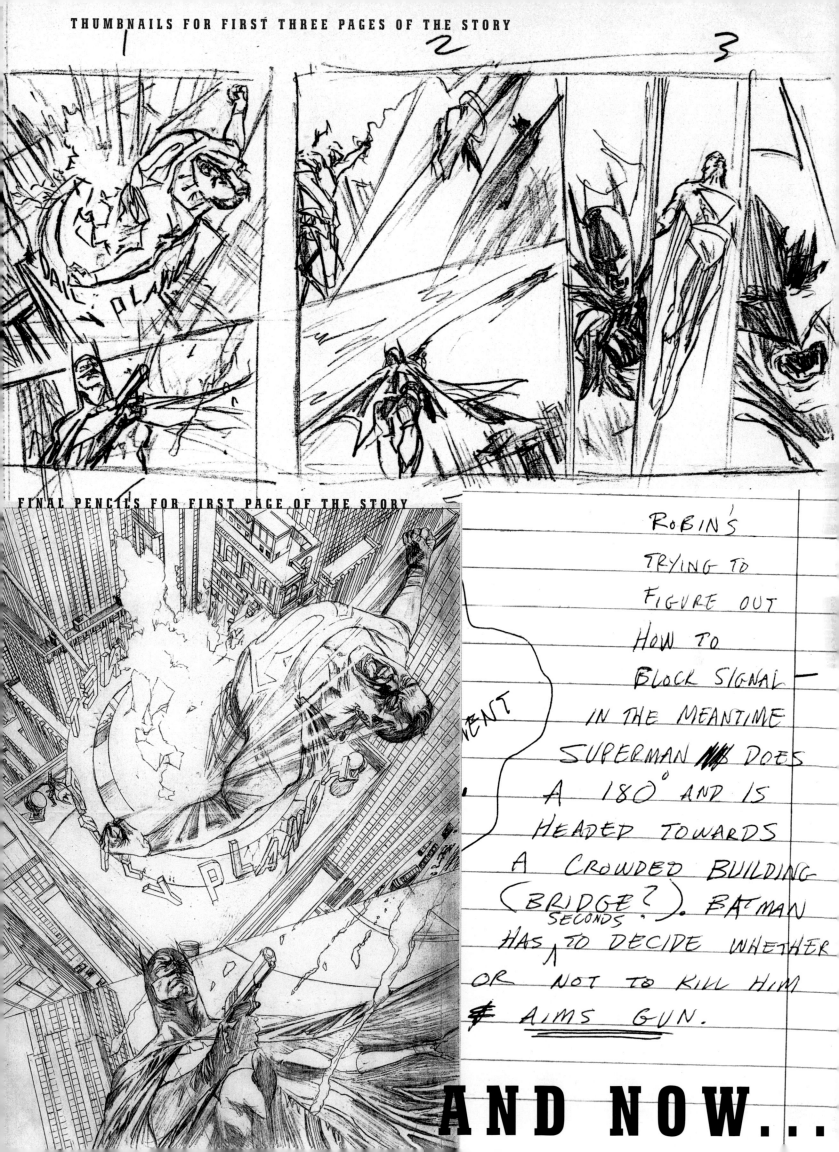

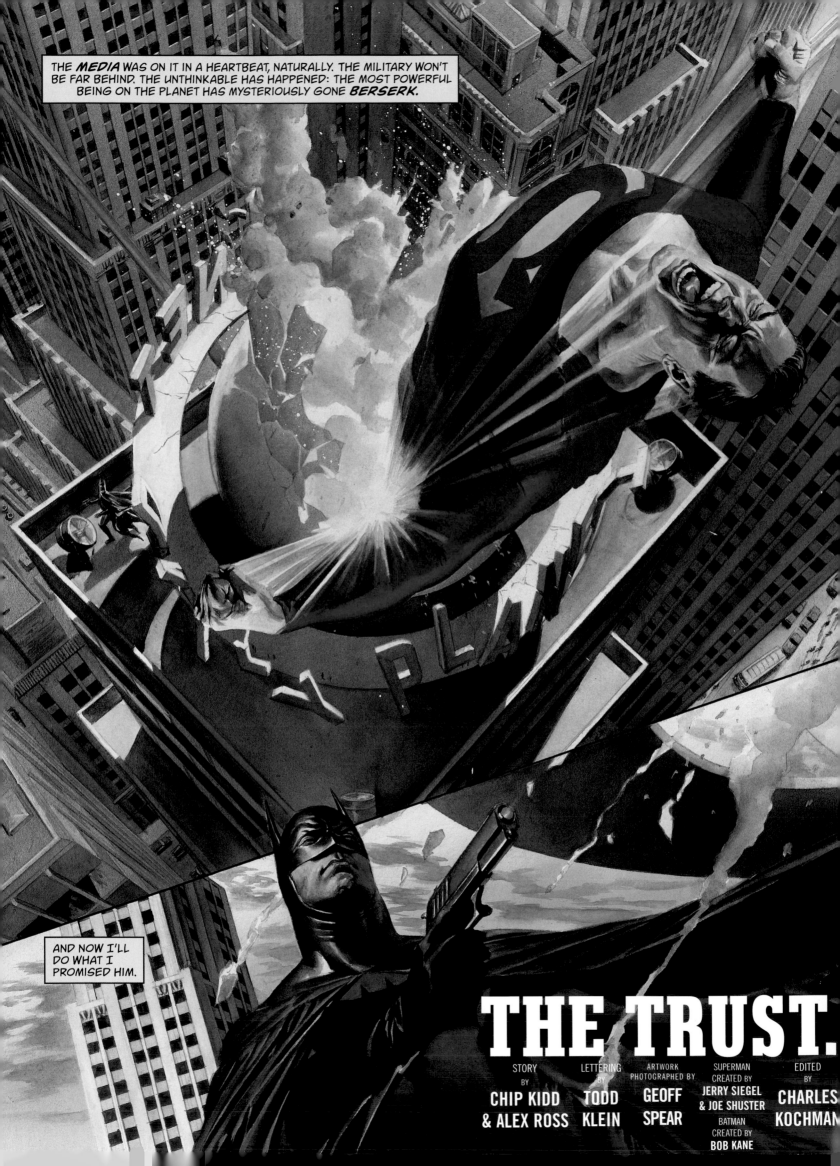

THE *MEDIA* WAS ON IT IN A HEARTBEAT, NATURALLY. THE MILITARY WON'T BE FAR BEHIND. THE UNTHINKABLE HAS HAPPENED: THE MOST POWERFUL BEING ON THE PLANET HAS MYSTERIOUSLY GONE *BERSERK*.

AND NOW I'LL DO WHAT I PROMISED HIM.

THE TRUST.

STORY BY
CHIP KIDD & ALEX ROSS

LETTERING BY
TODD KLEIN

ARTWORK PHOTOGRAPHED BY
GEOFF SPEAR

SUPERMAN CREATED BY
JERRY SIEGEL & JOE SHUSTER

BATMAN CREATED BY
BOB KANE

EDITED BY
CHARLES KOCHMAN

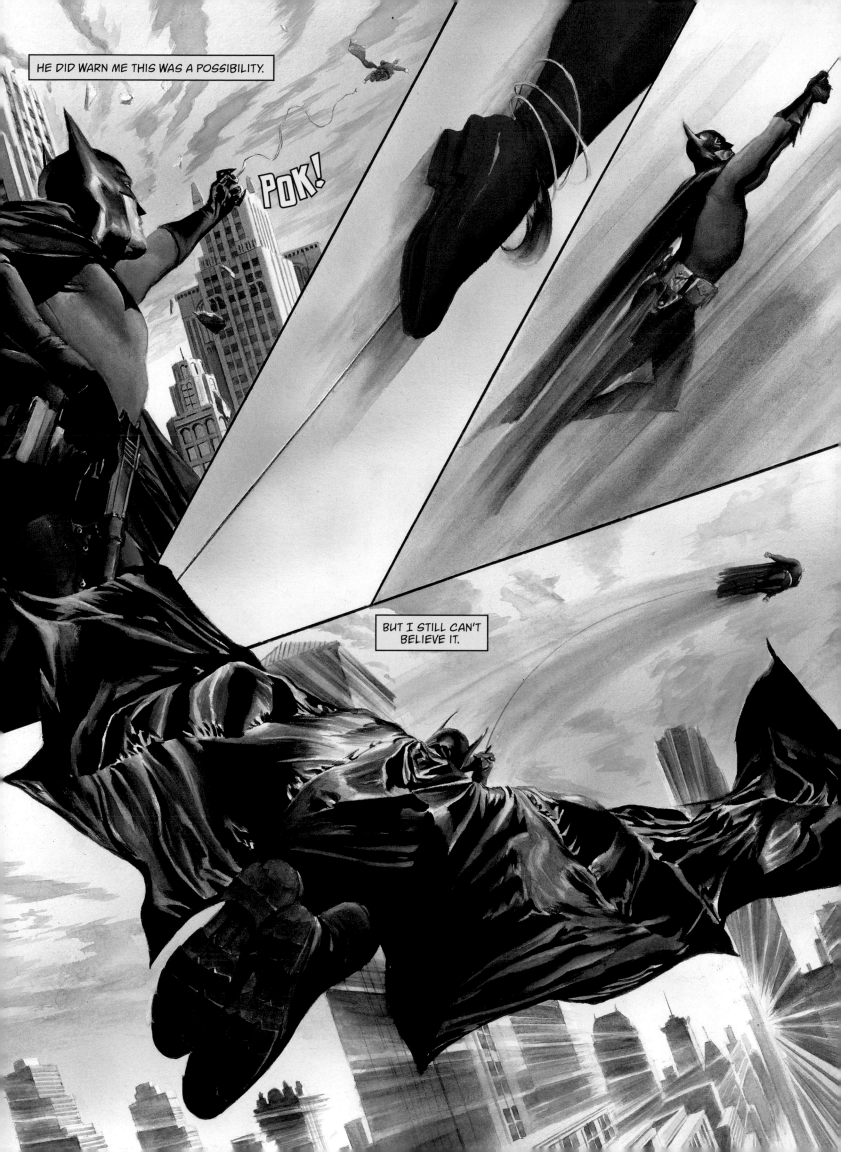

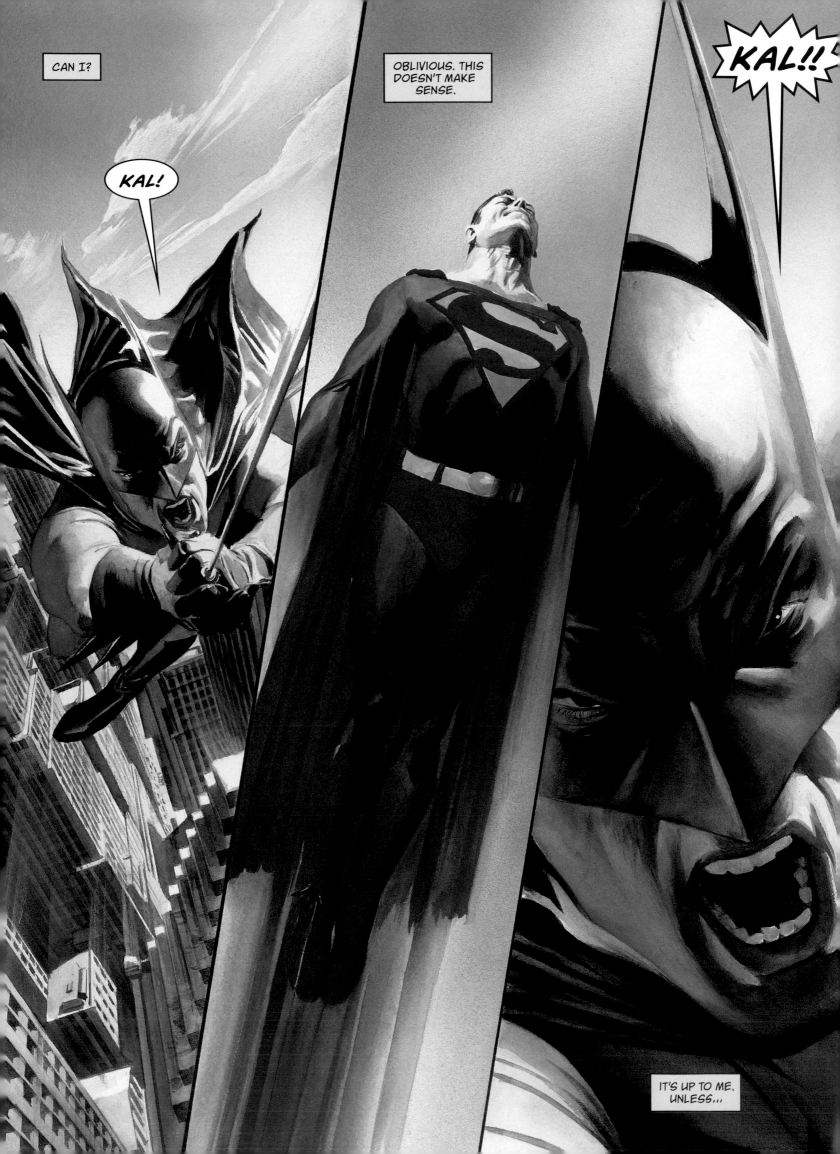

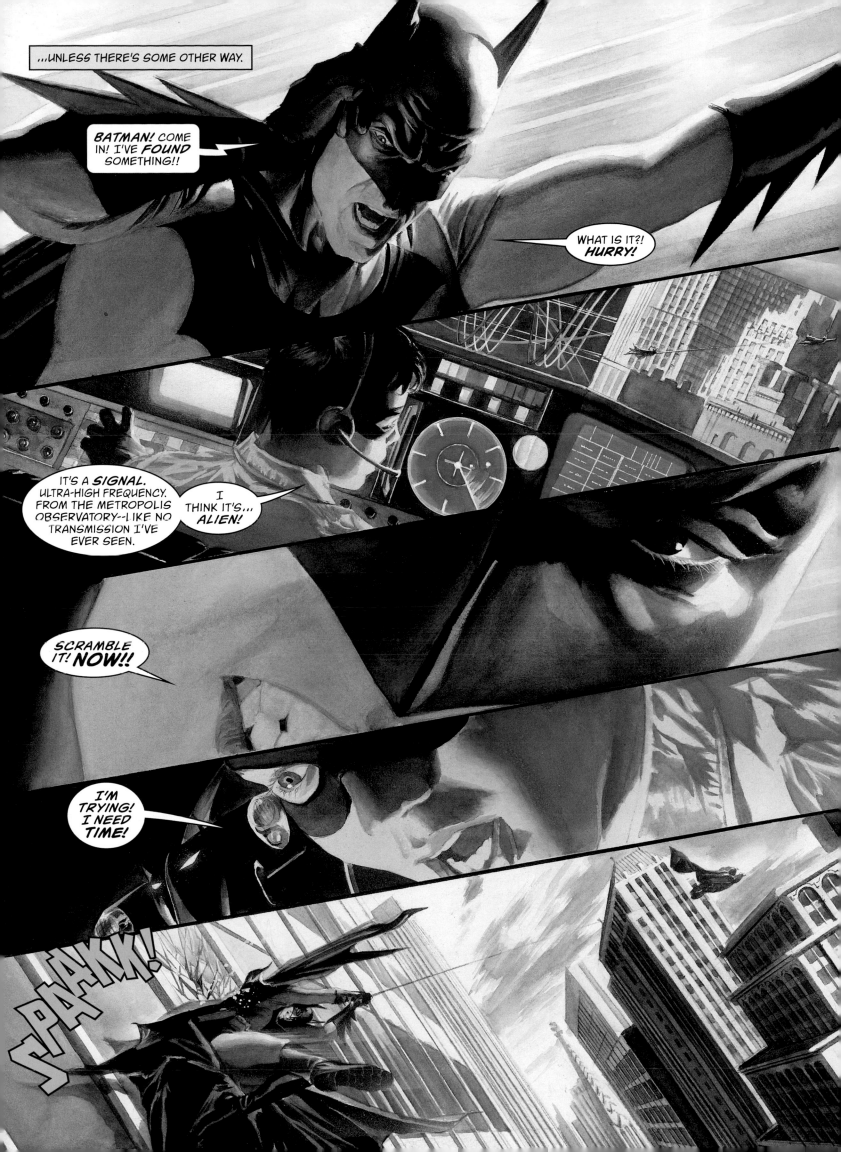

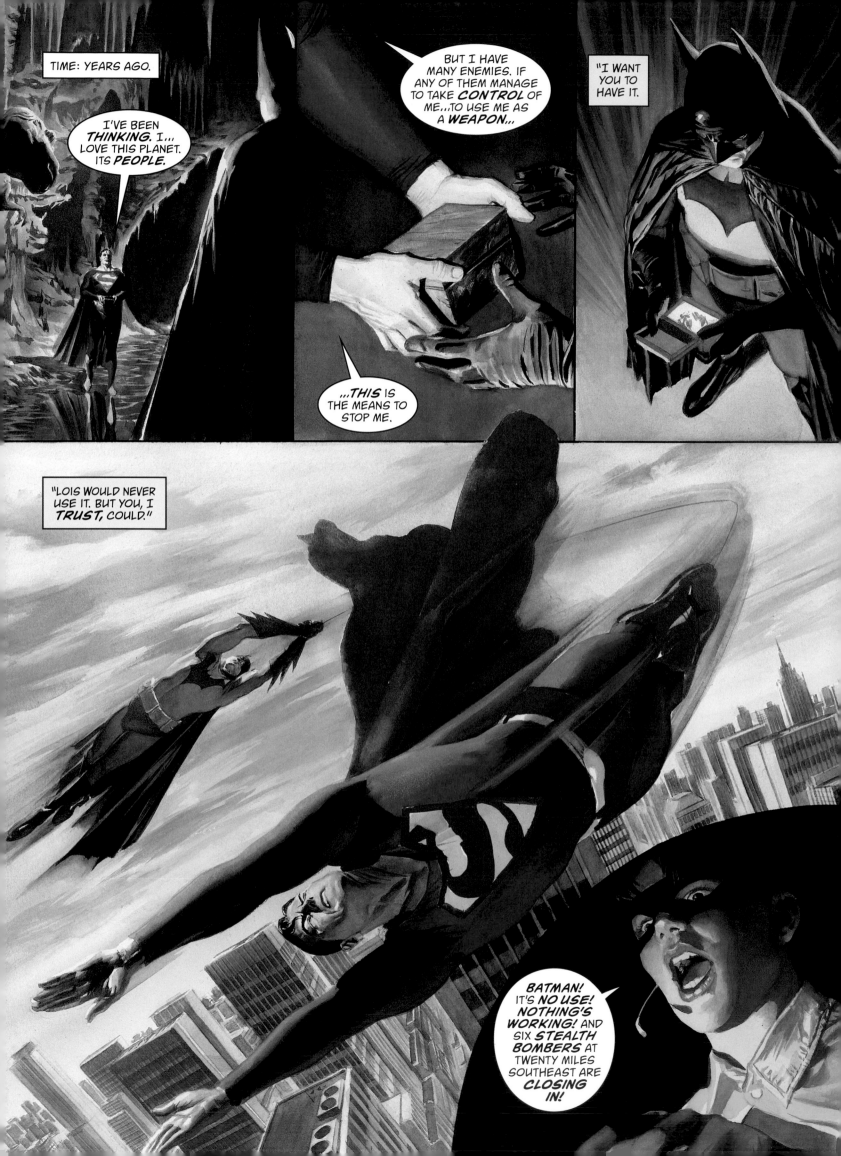

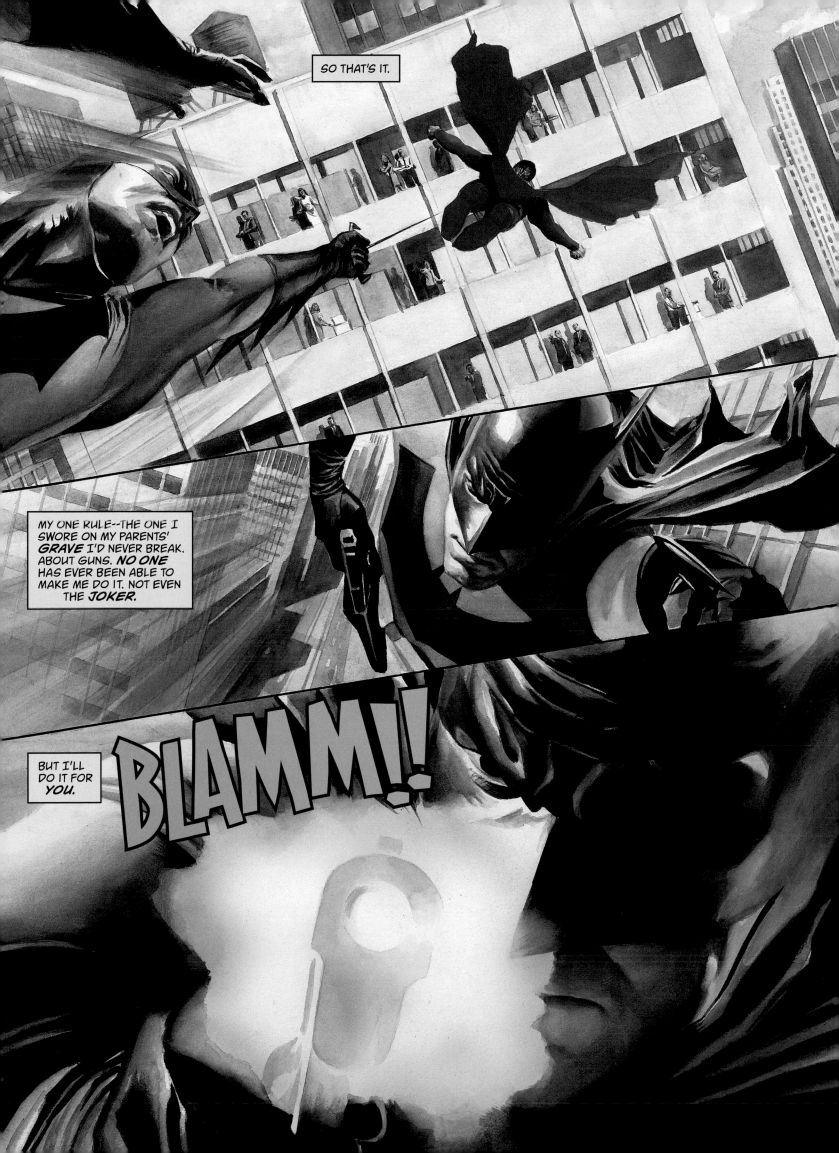

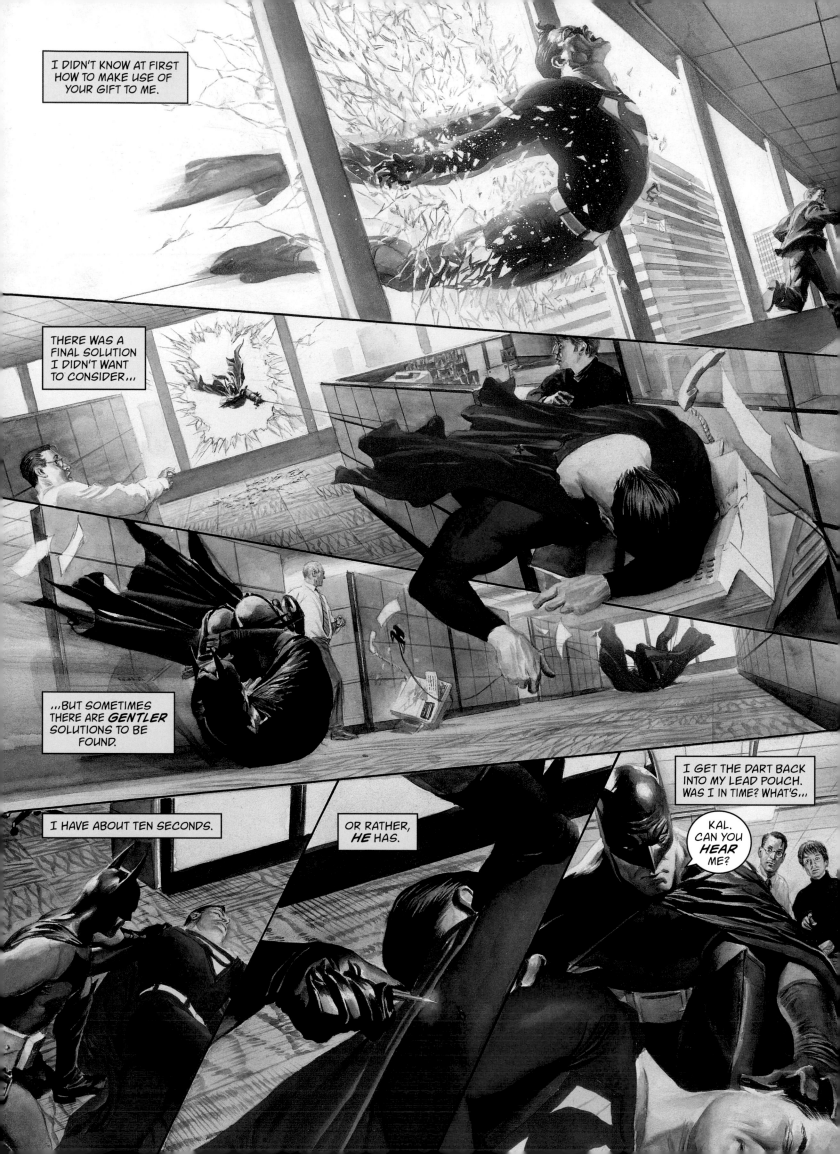

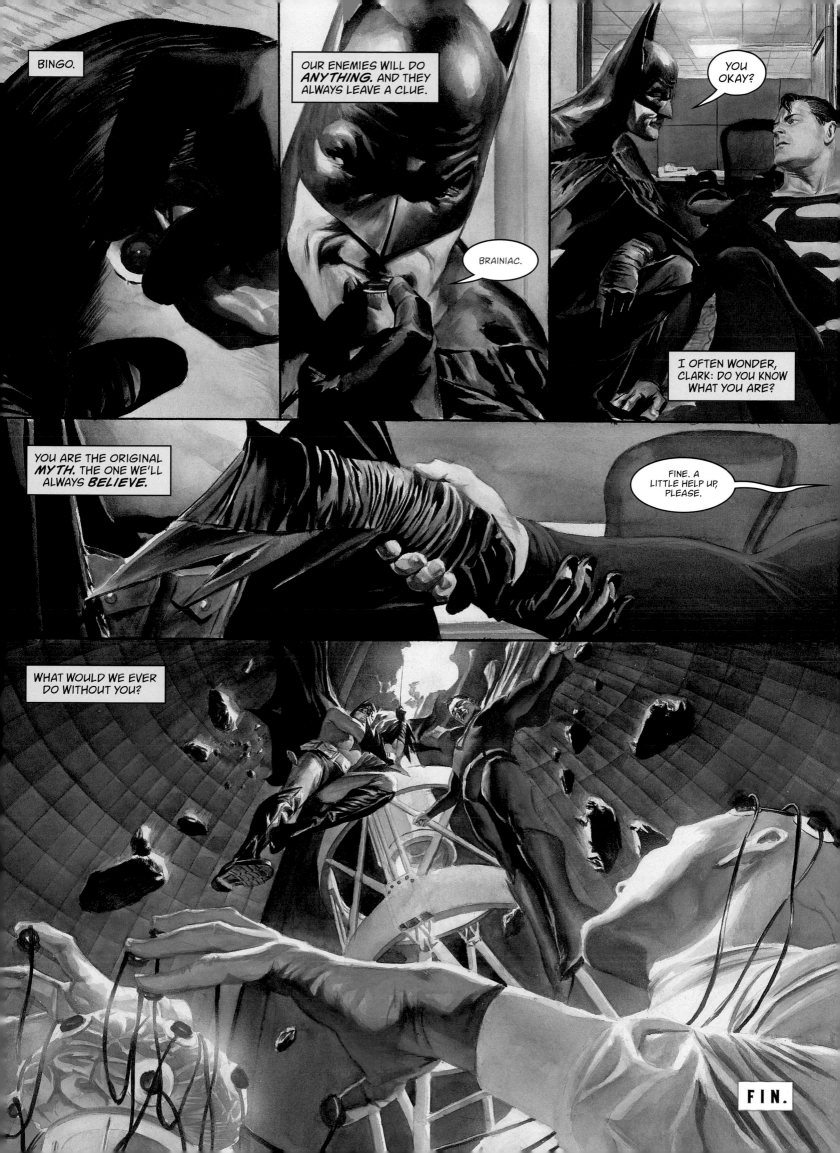

SELECTED BIBLIOGRAPHY.

AUTHOR'S NOTE: As substantial as the contents of this book and the list below may be (Alex has to-date painted more than a thousand pages of story-telling material—not counting covers and other ancillary art), it must be pointed out that they only represent about half of Ross's output over the last ten years. When you consider that Alex has done just as much work for Marvel Comics and other companies, and to adequately document it all this book would have to be at least two-and-a-half times its length, you start to get the idea. When does this man sleep?

COMIC BOOKS

Kingdom Come #1 (May 1996) w/ Mark Waid
Kingdom Come #2 (June 1996) w/ Mark Waid
Kingdom Come #3 (July 1996) w/ Mark Waid
Kingdom Come #4 (August 1996) w/ Mark Waid
Uncle Sam #1 (November 1997) w/ Steve Darnall
Uncle Sam #2 (December 1997) w/ Steve Darnall
Superman: Peace on Earth (November 1998) w/ Paul Dini
Batman: War on Crime (November 1999) w/ Paul Dini
Shazam! Power of Hope (November 2000) w/ Paul Dini
Wonder Woman: Spirit of Truth (November 2001) w/ Paul Dini
JLA: Secret Origins (November 2002) w/ Paul Dini
JLA: Liberty and Justice (November 2003) w/ Paul Dini

COLLECTED EDITIONS

Kingdom Come w/ Revelations (Graphitti Designs limited edition, 1997)
 w/ Mark Waid
Kingdom Come (hardcover, 1997) w/ Mark Waid
Kingdom Come (paperback, 1997) w/ Mark Waid
Uncle Sam (hardcover, 1998) w/ Steve Darnall
Uncle Sam (paperback, 1998) w/ Steve Darnall

COMIC BOOK STORIES

Sandman Mystery Theatre Annual #1, "The D.A." (October 1994)
 w/ Matt Wagner
Superman and Batman: World's Funnest (November 2000) w/ Evan Dorkin
Batman: Black & White, Volume 2, "Case Study" (September 2002)
 w/ Paul Dini

COMIC BOOK COVERS/COLLECTIONS

The Spectre #22 (September 1994)
Batman: Legends of the Dark Knight #100 (November 1997)
Superman Forever #1 (June 1998)
Crisis on Infinite Earths (hardcover) (November 1998) w/ George Pérez
Batman: No Man's Land #1 (January 1999)
Superman/Fantastic Four (March 1999) w/ Dan Jurgens
Batman: Harley Quinn (October 1999)
Starman #57 (September 1999) w/ Tony Harris
Starman #58 (October 1999) w/ Tony Harris
Starman #59 (November 1999) w/ Tony Harris
Starman #60 (December 1999) w/ Tony Harris
Starman #61 (January 2000) w/ Tony Harris
Starman #62 (February 2000) w/ Tony Harris
Flinch #9 (February 2000)
Legends of the DC Universe #28 (May 2000) w/ Gil Kane
Legends of the DC Universe #29 (June 2000) w/ Gil Kane
Crisis on Infinite Earths (paperback) (February 2001) w/ George Pérez
Super Friends! (August 2001)
Superman Adventures #58 (August 2001)
Crisis on Multiple Earths (September 2001)
9-11, Volume 2: The World's Finest Comic Book Writers and Artists Tell Stories
 to Remember (January 2002)
History of the DC Universe (April 2002)
Justice League Adventures #1 (June 2002) w/ Bruce Timm
Superman/Savage Dragon: Chicago (June 2002) w/ Erik Larsen
Justice League Adventures (trade paperback) (April 2003) w/ Bruce Timm

BOOK COVERS

Superman: Doomsday & Beyond by Louise Simonson (Bantam Books, 1993)
Kingdom Come by Elliot S. Maggin (Warner Books, 1998)
Kingdom Come by Elliot S. Maggin (Diamond edition, 1998)
Superman: The Complete History by Les Daniels (Chronicle Books, 1998)
Superman: The Complete History by Les Daniels (Diamond edition, 1998)
Kingdom Come by Elliot S. Maggin (paperback) (Warner Books, 1999)
Batman: The Complete History by Les Daniels (Chronicle Books, 1999)
Batman: The Complete History by Les Daniels (Diamond edition, 1999)
Wonder Woman: The Complete History by Les Daniels (Chronicle Books, 2000)
Wonder Woman: The Complete History by Les Daniels (Diamond edition, 2000)
Wonder Woman Masterpiece Edition by Les Daniels (Chronicle Books, 2001)
Batman: The Stone King by Alan Grant (Pocket Books, 2002)
Batman: The Stone King by Alan Grant (Bookspan hardcover, 2002)

MAD About Super Heroes (MAD Books, 2002)
Wonder Woman: Mythos by Carol Lay (Pocket Books, 2003)
Wonder Woman: Mythos by Carol Lay (Bookspan hardcover, 2003)
A Celebration of the World's Favorite Comic Book Heroes
 by Les Daniels (Watson-Guptill, 2003)
The Flash: Stop Motion by Mark Schultz (Pocket Books, 2004)
Green Lantern: Hero's Quest by Dennis O'Neil (Pocket Books, 2004)

TIP-IN PLATES

Superman: The Complete History (Warner Bros. Studio Stores, 1998)
 — Superman/Lois Lane
Batman: The Complete History (Warner Bros. Studio Stores, 1999)
 — Batman/Robin
Wonder Woman: The Complete History (Warner Bros. Studio Stores, 2000)
 —Wonder Woman/Steve Trevor

PIN-UPS

The Sandman: Gallery of Dreams (October 1994)
Batman: Black & White #4 (September 1996)
UKCAC Convention Program (1998) —Britannia/Uncle Sam
Wizard #2000 (December 1999) —Kingdom Come vs. Earth X
Wizard #104 (May 2000) —Wonder Twins: Form of Water
Wonder Woman: The Complete History by Les Daniels (Chronicle Books, 2000)
Wizard #130 (July 2002) —Alan Moore
Action Comics #800 (April 2003) —Superman/Action Comics #1

TRADING CARDS/CALENDAR/HOLIDAY CARD/AUDIO

Kingdom Come (SkyBox, 1996)
DC Comics 1997 (Bulfinch Press, 1996) —DC Universe
Company Holiday Card (DC Comics, 1997) —Superman and Lois Lane
Kingdom Come by Elliot S. Maggin (adapted by John Whitman)
 (Time Warner AudioBooks, 1998)

MAGAZINE COVERS/PROGRAMS

Beyond Zero Hour (Wizard Entertainment, 1994)
 —Superman and Batman
Wizard #57 (May 1996) —Kingdom Come
Overstreet's Fan #14 (August 1996)
 —Kingdom Come Superman
WonderCon Convention Program (April 1997)
Wizard #75 (November 1997)
 —The Justice League
The Overstreet Comic Book Price Guide
 (27th edition, 1997) —Green Lantern
The Overstreet Comic Book Price Guide
 (27th edition, 1997) —The Flash
Wizard World Chicago Convention Program
 (July 1998)
San Diego Comic-Con International
 Convention Program (August 1998)
The Overstreet Comic Book Price Guide
 (29th edition, 1999) —Superboy and the
 Legion of Super-Heroes
Wizard #89 (January 1999)
 —Superman/Spider-Man
Alex Ross Millennium Edition
 (Wizard Entertainment, 1999)
Alter Ego #3 (2001) —Shazam!
Alter Ego #16 (July 2002)
 —Mary Marvel
Wizard #99 (November 1999)
 —Batman: War on Crime
Wizard #111 (December 2000)
 —Shazam! Power of Hope
Wizard #123 (December 2001)
 —Wonder Woman: Spirit of Truth
Wizard #2000 (December 1999)
 —Kingdom Come vs. Earth X
TV Guide (December 8-14,
 2001) —Smallville (4 covers)

Alex Ross Millennium Edition (update)
 (Wizard Entertainment, 2003)
Wizard #141 (May 2003) —JLA: Liberty and Justice
Wizard #144 (August 2003) —JLA: Liberty and Justice
Wizard #146 October 2003) —JLA: Liberty and Justice

POSTERS/PRINTS

DC Universe (poster) (DC Direct, 1994)
Kingdom Come (poster) (DC Direct, 1996)
Kingdom Come II (poster) (DC Direct, 1996)
Uncle Sam (print) (San Diego Comic-Con, 1997)
Arena of Heroes (lithograph)
 (Warner Bros. Studio Stores, 1998)
Superman: Twentieth Century (lithograph)
 (Warner Bros. Studio Stores, 1998)
Justice Society (lithograph)
 (Warner Bros. Studio Stores, 1998)
Kingdom Come III (poster) (DC Direct, 1998)
Kingdom Come Superman (autographed print w/ statue)
 (DC Direct, 1998)
Superman Forever Print Set (DC Direct, 1998)
Batman: No Man's Land Print Set (DC Direct, 1999)
World's Finest (Giclée) (Warner Bros. Studio Stores, 1999)
Batman: Knight Over Gotham (Giclée)
 (Warner Bros. Studio Stores, 1999)
Batman: Knight Over Gotham (Giclée on canvas)
 (Warner Bros. Studio Stores, 1999)
Batman Beyond (Giclée on canvas)
 (Warner Bros. Studio Stores, 1999)
Batman Beyond (lithograph)
 (Warner Bros. Studio Stores, 1999)
Superboy and the Legion of Super-Heroes (Giclée)
 (Warner Bros. Studio Stores, 1999)
The Origin of Superman (lithograph)
 (Warner Bros. Studio Stores, 1999)
The Origin of Batman (lithograph)
 (Warner Bros. Studio Stores, 1999)
Crisis on Infinite Earths (poster) (DC Direct, 1999)
 w/ George Pérez
Crisis on Infinite Earths (Giclée)
 (Warner Bros. Studio Stores, 1999) w/ George Pérez
Kingdom Come Shazam! (autographed print w/ statue)
 (DC Direct, 1999)
Superman/Fantastic Four (poster) (DC Direct, 1999)
 w/ Dan Jurgens
JLA: The Original Seven (Giclée)
 (Warner Bros. Studio Stores, 2000)
JLA: The Original Seven (Giclée on canvas)
 (Warner Bros. Studio Stores, 2000)
Superman Signature Print (DC Direct, 2001)
Batman Signature Print (DC Direct, 2001)
A Tribute to Hanna-Barbera & Their Heroes (Giclée)
 (Warner Bros. Studio Stores, 2001)
Superman Portrait (Giclée on canvas)
 (Warner Bros. Studio Stores, 2001)
Starman (poster) (DC Direct, 2003) w/ Tony Harris
Crisis on Multiple Earths (DC Direct, 2003)
JLA: Liberty and Justice (DC Direct, 2003)

Aquaman (poster) (DC Direct, 2001)
Batgirl (poster) (DC Direct, 2002)
Batman (poster) (DC Direct, 2001)
Batman (full-figure poster) (DC Direct, 2003)
Black Canary (poster) (DC Direct, 2000)
Dr. Fate (poster) (DC Direct, 2001)
The Flash (poster) (DC Direct, 2000)
Golden Age Flash (poster) (DC Direct, 2001)
Green Arrow (poster) (DC Direct, 2000)
Green Lantern (poster) (DC Direct, 2000)
Green Lantern (full-figure poster) (DC Direct, 2001)
Golden Age Green Lantern (poster) (DC Direct, 2001)
Hawkman/The Atom (poster) (DC Direct, 2000)
Martian Manhunter (poster) (DC Direct, 2000)
Plastic Man (poster) (DC Direct, 2000)
Shazam! (poster) (DC Direct, 2001)
The Spectre (poster) (DC Direct, 2001)
Supergirl (poster) (DC Direct, 2002)
Superman (poster) (DC Direct, 2002)
Wonder Woman (poster) (DC Direct, 2002)
Wonder Woman (full-figure poster) (DC Direct, 2003)
Zatanna (poster) (DC Direct, 2000)

PROMOTIONAL (NEW ART)

Kingdom Come (poster) (1996)
Uncle Sam (flyer) (1997)
Superman (standee) (1998)
Superman: Peace on Earth (riser) (1998)
Batman: War on Crime (riser) (1999)
Shazam! Power of Hope (riser) (2000)
Wonder Woman: Spirit of Truth (riser) (2001)

COLLECTOR'S PLATES

Justice League (Warner Bros. Studio Stores, 1998)
Teen Titans (Warner Bros. Studio Stores, 1999)
Metal Men (Warner Bros. Studio Stores, 1999)
Shazam! (Warner Bros. Studio Stores, 2000)
Plastic Man (Warner Bros. Studio Stores, 2000)
JLA Christmas (Warner Bros. Studio Stores, 2000)
JLA: Liberty and Justice (DC Direct, 2003)
Superman Racing the Flash (DC Direct)

T-SHIRTS/BANNER

Kingdom Come (DC Comics, 1996)
Kingdom Come II (DC Comics, 1996)
Kingdom Come III (Graphitti Designs, 1996)
 —Superman logo
Uncle Sam (Graphitti Designs, 1997)
Uncle Sam Banner (1998)

ARTICULATED FIGURES

Batman Masterpiece Edition (Chronicle Books, 2000)
 by Joe DeVito, Chip Kidd
Wonder Woman Masterpiece Edition
 (Chronicle Books, 2001) by Joe DeVito, Chip Kidd

STATUES

Kingdom Come Superman (silver) (DC Direct, 1998)
Kingdom Come Shazam! (copper) (DC Direct, 1999)
Superman Masterpiece Edition (Chronicle Books, 1999)
 by Joe DeVito, Chris Ware
Kingdom Come Superman (color) (DC Comics, 2001)
Kingdom Come Shazam! (color) (DC Comics, 2001)

TOYS (DESIGN ONLY)

Kingdom Come Batman (DC Direct, 2003)
 by Tim Bruckner
Kingdom Come Deadman (DC Direct) by Tim Bruckner
Kingdom Come Green Lantern (DC Direct, 2003)
 by Tim Bruckner
Kingdom Come Hawkman (DC Direct, 2003)
 by Jim Shoop
Kingdom Come The Flash (DC Direct) by Tim Bruckner
Kingdom Come Kid Flash (DC Direct, 2003)
 by Tim Bruckner
Kingdom Come Magog (DC Direct) by Tim Bruckner
Kingdom Come Red Robin (DC Direct, 2003)
 by Jim Shoop
Kingdom Come Shazam! (DC Direct, 2003)
 by Tim Bruckner
Kingdom Come Superman (DC Direct, 2003)
 by Tim Bruckner
Kingdom Come Wonder Woman (DC Direct, 2003)
 by Tim Bruckner
Kingdom Come Wonder Woman II DC Direct)
 by Tim Bruckner

COLOPHON.

The text of this book was set in WALBAUM.
Captions were set in **Trade Gothic**, a staple of twentieth-century magazines and newspapers.
The display face is **Stymie Extra Bold Condensed**, *chosen for its classic, sturdy, presence.*

Every effort was made to photograph from original artwork whenever possible, using Linhoff 4″ x 5″ and 8″ x 11″ cameras. 292 shots were taken, comprising over 1,314 exposures, taken from August 2002 through May 2003.

The layout was assembled in QuarkExpress 4.11.

ACKNOWLEDGMENTS.

This book would not exist without the efforts of Charlie Kochman at DC Comics and Shelley Wanger at Pantheon Books. Their commitment and tireless efforts made it happen. I wouldn't have believed it possible, but fearless photographer Geoff Spear somehow outdid himself yet again—you're no myth, my friend. Also at Pantheon, thanks to the best book production team on planet Earth: Andy Hughes, Serena Park, Altie Karper, and Elizabeth Woyke. At DC Comics, thanks to Allan Asherman, Madeleine Blaustein, Ed Bolkus, Georg Brewer, Richard Bruning, Todd Klein, Domingo Leon, Paul Levitz, Sandy Resnick, Sam Viviano, and Marc Witz. Many, *many* thanks to Mike Hill for his talent and his generosity. And, as always, thanks to J. D. McClatchy for everything else. — C. K.

My greatest thanks to Chip Kidd for being manipulated into doing this book by forces he is only now beginning to comprehend. And to our particular Svengali, Charlie Kochman, who conceived this project and who has had more faith in me than anyone I've worked with. Thanks deeply to Sal Abbinanti for monumental support on this book as well as our website, and for his continued help and friendship throughout my career. The art reproduction here wouldn't have been possible without these people entrusting us with their original artwork: Keith Anderson, Sal Abbinanti, Bob Chapman, John Cogan, Steve Darnall, Paul Dini, Ron Garney, Dan Jurgens, Frank Kasy, Eric Ko, Charlie Kochman, Steve Korté, Rich Kryczka, Simon Powell, and Clark and Lynette Ross. There would be no Batmobile in the garage without the work of Lindsay Ross. Clint Borucki of Acme Designs provided the Batman head casting. My models would be naked without the costumes created by Teresa Vitale and Leeman Yuen. I will be sleeping on the front lawn if I don't thank my wife and muse, T.J., whom I love more than the air that I breathe, the pop that I drink, and Sal. My heartfelt thanks to all the helpful folks willing to be models: Frank Kasy, Cory Smith, Logan Smith, Clark Ross, Lisa Beaderstadt, Rhonda Hampton, Scott Beaderstadt, Tony Vitale, Chris Fleming, Lynn Armstrong, Sal Abbinanti, Holly Blessen, Matt Paoletti, Wayne Potrue, Via Osgood, T.J. Ross, Hilary Barta, Rick McCoy, Jr., Teresa Vitale, Kenn Kooi, Karen Kooi, Mike Reidy, Keith Anderson, Rachel Silverman, Lindsay Ross, Jonathan Kasy, Mark Braun, Valerie Studnik, Eric Eastman, Elizabeth Braun, Kevin Boren, Brian Azzarello, Jill Thompson, Tony Akins, Mark Kolodny, Steve Darnall, Meg Guttman, Marilyn Darnall, and Indiana Ross. — A. R.

IN LOVING MEMORY OF STEVEN D. KATZ.

ABOVE: Detail of sculptor Mike Hill's life-size wax statue of Ross's version of Superman (2000). OPPOSITE, OVERLEAF: The Justice League looks to the future and their next battle. Three interlocking covers for *Wizard* #141, 144, 146 (May, August, and October 2003).

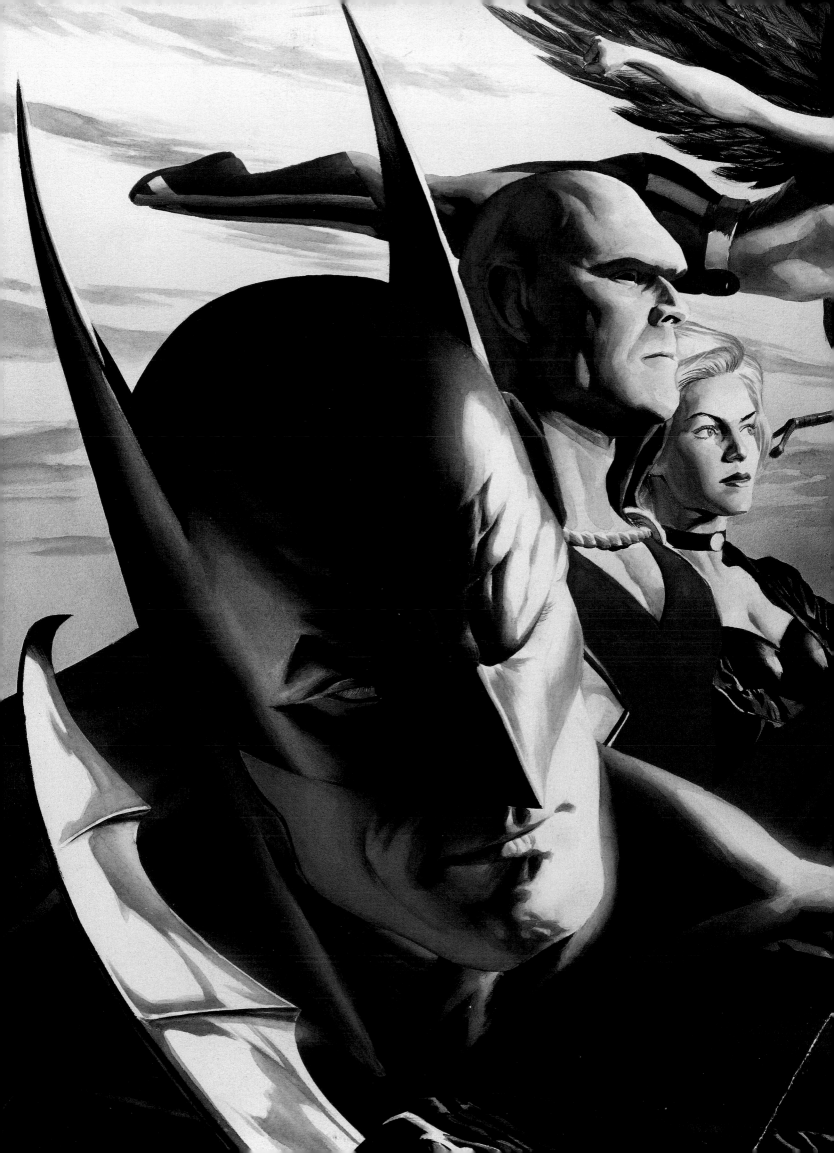

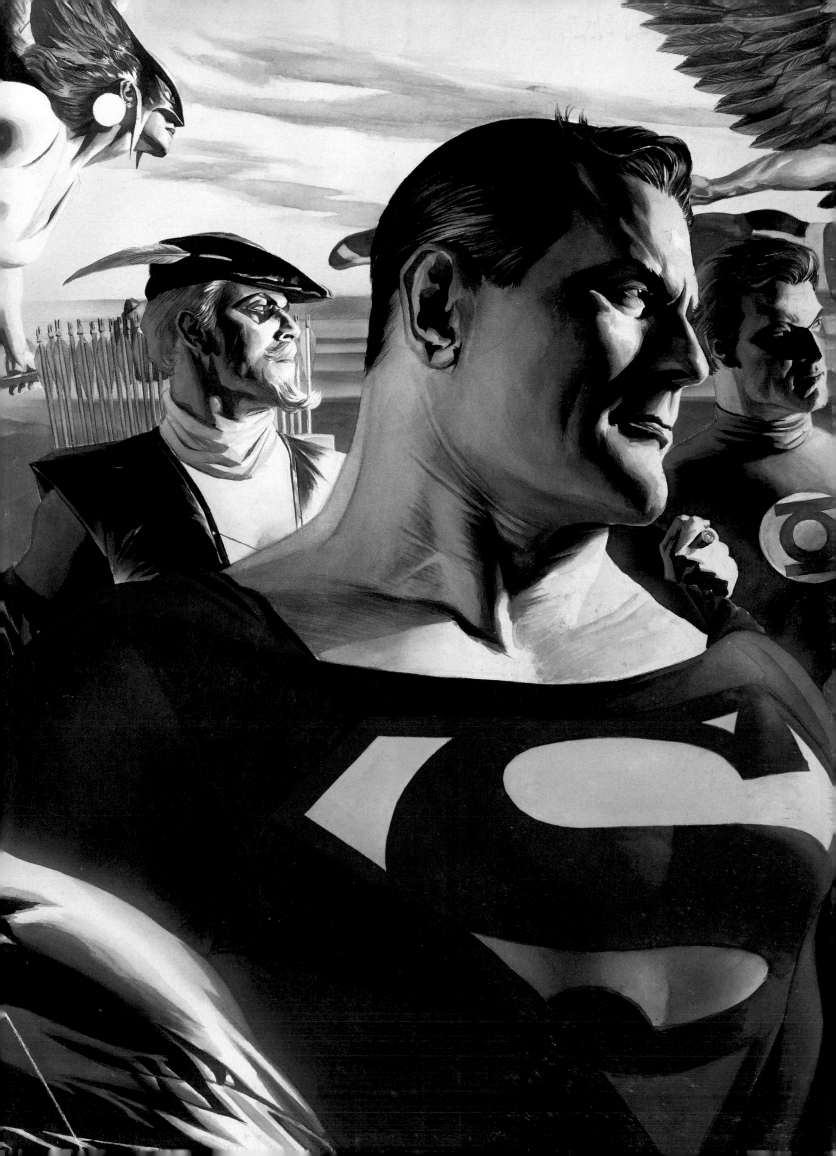